EYES OF THE ANCESTORS

THE ARTS OF
ISLAND SOUTHEAST ASIA

AT THE DALLAS MUSEUM OF ART

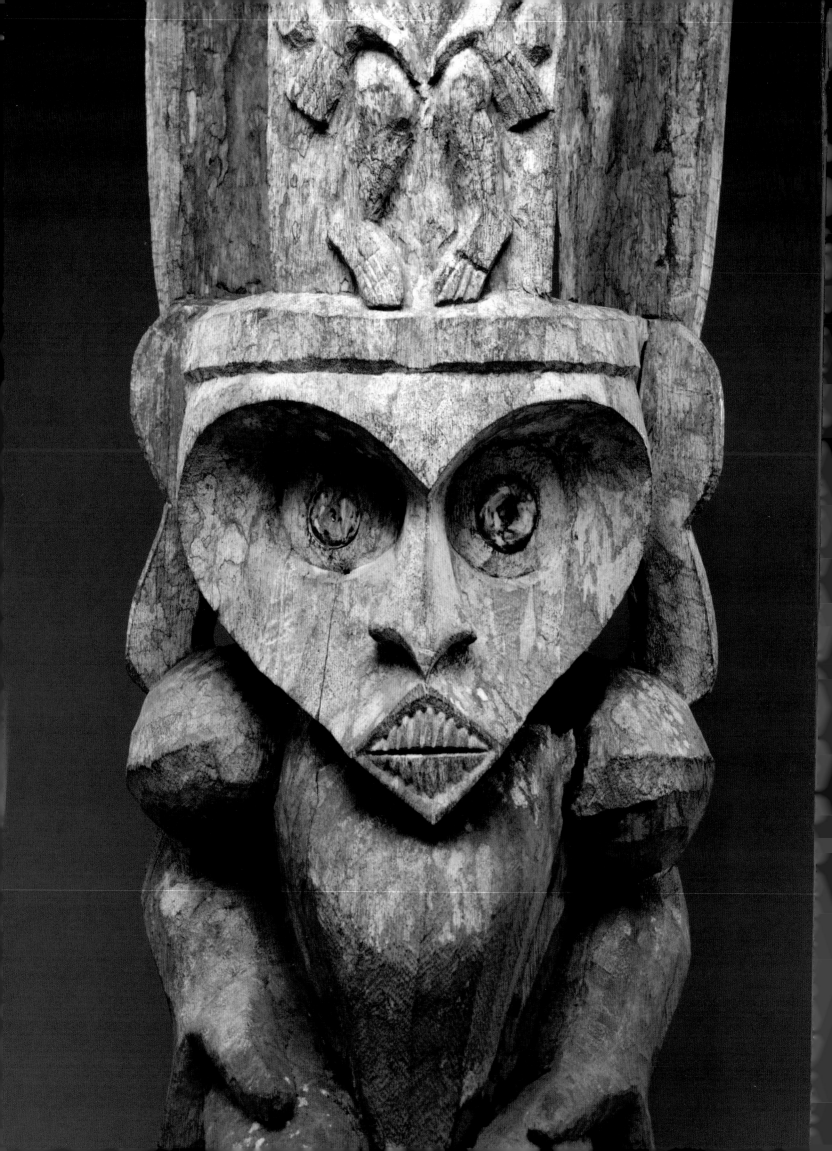

EYES OF THE ANCESTORS

THE ARTS OF ISLAND SOUTHEAST ASIA

AT THE DALLAS MUSEUM OF ART

Edited by Reimar Schefold
in collaboration with Steven G. Alpert

With contributions by
Steven G. Alpert
George Ellis
Nico de Jonge
Vernon Kedit
Reimar Schefold
Achim Sibeth
Roxana Waterson

TUTTLE Publishing

Tokyo | Rutland, Vermont | Singapore

There is nothing at all on this earth that is not paired. Everything must have its counterpart. The man and the woman are like the right hand and the left hand. The right hand is not worth much without the left hand. You must work hard to put everything in order, in balance. You must work especially hard to overcome one's debt to death and one's debt to life—for they too are a pair. We depend on the ancestors like swords hanging from a pole. We cannot do without them.

— Lende Mbatu, a Weyewa elder, Sumba

This book is dedicated to all our parents—especially to the ancestors, makers of these marvelous creations—and to Mrs. Eugene McDermott, whose generosity and vision have enriched us all.

CONTENTS

8 Director's Foreword and Acknowledgments
 Maxwell L. Anderson

11 The Arts of Island Southeast Asia at the
 Dallas Museum of Art: A Brief History

16 Map of Island Southeast Asia

17 General Introduction: Art and Its Themes
 in Indonesian Tribal Traditions
 Reimar Schefold

29 **CHAPTER ONE**
 ## Toys for the Souls:
 ## The Art of Mentawai
 Introduction by Reimar Schefold
 Entries by Reimar Schefold

43 **CHAPTER TWO**
 ## The Art of the Ono Niha
 Introduction by Achim Sibeth
 Entries by Achim Sibeth

61 **CHAPTER THREE**
 ## The Art of the Batak of Sumatra
 Introduction by Achim Sibeth
 Entries by Achim Sibeth

81 **CHAPTER FOUR**
 ## Lampung Ship Cloths:
 ## Ancient Symbolism and Cultural
 ## Adaptation in South Sumatran Art
 Introduction by Nico de Jonge
 Entries by Steven G. Alpert

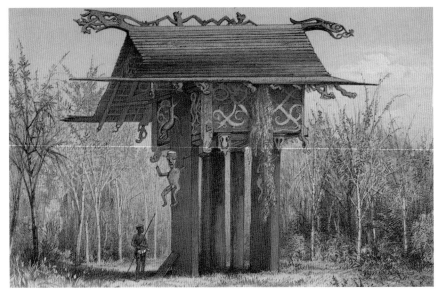

117 CHAPTER FIVE

Borneo: The Island—Its Peoples

Introduction by Steven G. Alpert

Entries by Steven G. Alpert

Iban textile entries by Vernon Kedit

173 CHAPTER SIX

The Art of Sulawesi

Introduction by Roxana Waterson

Entries by Roxana Waterson

209 CHAPTER SEVEN

The Art of East Nusa Tenggara:
Sumba and Flores

Introduction by George Ellis

Entries by George Ellis

Mendaka pendant entry by Steven G. Alpert

245 CHAPTER EIGHT

Traditional Art in Timorese
Princedoms

Introduction by Nico de Jonge

Entries by Steven G. Alpert

275 CHAPTER NINE

Life and Death in Southeast
Moluccan Art

Introduction by Nico de Jonge

Entries by Nico de Jonge

305 Notes

321 Selected Bibliography

329 Index

336 Illustration and Copyright Credits

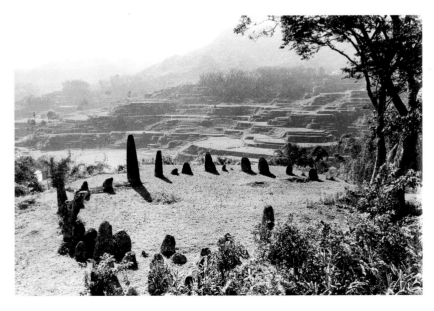

DIRECTOR'S FOREWORD AND ACKNOWLEDGMENTS

For many years the Dallas Museum of Art has collected, exhibited, and championed the arts of Island Southeast Asia, encompassing Indonesia, Malaysia, Brunei, and East Timor. Inaugurated in 1980 and comprised of wood carvings, textiles, gold objects, and other materials, this collection forms a vital part of the Museum's overall holdings. Now numbering more than 300 representative works of superlative quality, it ranks as one of the most outstanding collections of art from Island Southeast Asia to be found anywhere in the world.

A catalogue celebrating this collection has long been the ambition of Museum trustees, donors, and staff. *Eyes of the Ancestors* is our first publication devoted solely to the Island Southeast Asian collection, taken both as a whole and with object entries showcasing many of its most dazzling treasures. It is also the third in a series of catalogues documenting the important collections housed in our museum.

I am especially grateful to Mrs. Eugene (Margaret) McDermott, to whom, along with the ancestors of the makers of these objects, this book is warmly dedicated. Her gift of the iconic standing funerary figure (or *tau-tau*) from Sulawesi constitutes the foundation of the collection, and a series of masterworks donated by Mrs. McDermott over the ensuing years has guaranteed its continuing growth. Equally passionate in his support of the collection's growth is Steven G. Alpert, who has shepherded a number of acquisitions to their final home at the Museum, including both outright and promised gifts of art. The publication of this catalogue was generously and jointly underwritten by Steven G. Alpert and The Eugene McDermott Foundation.

I would like to thank all of the past and current trustees and donors, whose guidance has nurtured the Museum's collecting vision, along with my predecessors and their staffs, particularly former director Bonnie L. Pitman (under whose tenure work on this publication commenced), who have cultivated the programs and contributed to the growth of the collection. I sincerely thank all of the generous donors of works of art and funds that have enabled the Museum's Island Southeast Asia collection to attain both depth and quality throughout the years: The Estate of Jerry L. Abramson; The Estate of Corrine Galinger Alpert; Hannah Allene Alpert; Robert Alpert; Sarah Elizabeth Alpert; Steven G. Alpert and Family; The Art Museum League; Helen Bankston; J. Gabriel Barbier-Mueller; Jean-Paul and Monique Barbier; Mary Bloom; Sally Brice; Mr. and Mrs. Jerry Bywaters; The Roberta Coke Camp Fund; The DFW Indonesian Community Association; The Otis and Velma Davis Dozier Fund; Sally R. and William C. Estes; Virginia Eulich; Margaret Folsom; Tootsie and Peter Fonberg; Mary Ellen Fox; Honu Frankel; Ethel S. Frankfurt; The General Acquisitions Fund; Ebby Halliday-Acers; Betty Jo Hay; Sarah Dorsey Hudson; Mr. and Mrs. James H.W. Jacks; Linda and Charles Jackson; Mr. and Mrs. John Ridings Lee; LaVerne McCall; The Eugene and Margaret McDermott Art Fund, Inc.; Mrs. Eugene D. McDermott; The Eugene McDermott Foundation; Jan and Jack McDonald; Silas R. Mountsier III; The Nasher Foundation; The Pacific American Corporation; Jean Pogue; Carol and George Poston; Diane and Andyan Rahardja; Rita Rasansky; Richard Brooks Fabrics; Rita and Fred M. Richman; The Textile Purchase Fund; The Deborah Tompkins Memorial Fund; Mr. and Mrs. Martin Tycher; Dr. Albert and Elissa Yellin; and several anonymous donors. I would also like to thank Marsha Brill, Roger Dashow, and Bruce Moore for making objects from their collections available to the Museum on loan.

Gratefully, I acknowledge the connoisseurship and specialized knowledge of the scholars and collectors who have had a particular influence on the growth and development of the Museum's art collection from Island Southeast Asia: John Lunsford, Carol Robbins, Steven G. Alpert, and Dr. Reimar Schefold. We also extend our thanks to the scholars, academicians, and other specialists who contributed texts to this publication: Dr. Reimar Schefold, professor emeritus of the anthropology and sociology of Indonesia at Leiden University and former chairman of the Netherlands Institute of Southeast Asian and Caribbean Studies, for his general introduction and essay and object entries on Mentawai; Steven G. Alpert, longtime collector, art dealer, and expert on Indonesian art, for his essay on Borneo and his object entries on Borneo, Lampung, and Timor/Atauro; George Ellis,

President and Director of the Honolulu Academy of Arts (retired), for his essay and object entries on Sumba and Flores; Nico de Jonge, Vice-Director and Curator of Ethnology of the University Museum of the University of Groningen, the Netherlands, for his essays on Lampung and Timor, and his essay and object entries on Maluku Tenggara; Vernon Kedit, a scholar specializing in traditions of master weavers, for his object entries on Iban textiles from Sarawak; Dr. Achim Sibeth, Curator (retired) of the Southeast Asian collection at the Museum of World Cultures, Frankfurt am Main, Germany, for his essays and object entries on Nias and Batakland; and Dr. Roxana Waterson, Associate Professor of Social Anthropology, National University of Singapore (retired), for her essay and object entries on Sulawesi. The following scholars and specialists also contributed their advice and expertise to this project: Jet Bakels, Nancy Ellis, Mattiebelle Gittinger, Antonio Guerreiro, Michael Heppell, Wellem Ingan, Goh Tjin Liong, Ruslan Mursalin, Michael Palmieri, and Mary-Louise Totton.

I offer profound thanks to Carol Robbins, curator emerita, who retired last year after a record forty-seven years at the DMA as the Ellen and Harry S. Parker III Curator of the Arts of the Americas and the Pacific; to Dr. Roslyn Adele Walker, Senior Curator of the Arts of Africa, the Americas, and the Pacific and The Margaret McDermott Curator of African Art; to Steven G. Alpert; and to Dr. Reimar Schefold. Carol Robbins and Steven Alpert worked together to select the objects featured in this publication and amassed a vast store of research notes, references, and bibliographic material, in addition to overseeing the photography. Dr. Schefold served as the scholarly editor of the catalogue, in collaboration with Steven G. Alpert. Roslyn Walker took over as project lead after Robbins's retirement and guided work on the publication to its successful conclusion. For their dedication, expertise, and many contributions to the enrichment of the DMA's collection of art from Island Southeast Asia, I offer my most sincere appreciation.

A publication of this size, scale, and ambition requires the committed expertise of a team of people to bring it to fruition. I would like particularly to recognize Tamara Wootton-Bonner, Associate Director of Collections and Exhibitions, for her contributions in directing the planning for the publications focused on our collection and for her work on this catalogue, and Eric Zeidler, Publications Manager, for his numerous administrative and editorial contributions on behalf of this project—he worked tirelessly to compile information and assist with every detail related to the publication. Brad Flowers, the lead photographer for this publication, worked meticulously with object after object to re-create the unique texture and complexity of each one on the printed page. Giselle Castro-Brightenburg, Imaging Manager, supervised the shooting and sorting of all the photography and worked with Steven Alpert, Eric Zeidler, and Marquand Books to coordinate the selection of images. It is with deep gratitude that I also acknowledge the contributions of the other DMA staff and colleagues who have helped in some way to bring this publication to fruition, making particular mention of Kylie Quave, Sarah Stolte, and Wendy Earle, McDermott Graduate Curatorial Interns; Auriel Garza, Curatorial Administrative Assistant; Mary Leonard and Jacqueline Allen, Mayer Library; Hillary Bober, DMA Archives; Jeff Zilm of the Imaging Department; John Dennis and Vince Jones of the Collections Department; the editor Dr. Kristina Youso; the indexer Frances Bowles; the proofreader Laura Iwasaki; the typesetter Marie Weiler; Ed Marquand, Jeff Wincapaw, Ryan Polich, and Jeremy Linden of Marquand Books; Patricia Fidler and Lindsay Toland of Yale University Press; and Jessica Beasley, former curatorial assistant for Anne Bromberg, Carol Robbins, and Roslyn Walker.

On behalf of the donors, trustees, scholars, staff, and most especially the McDermott family, I am delighted to share these treasures with you on this momentous occasion. We hope that this volume will bring pleasure and enlightenment to its readers and encourage a deeper understanding of the beauty and importance of all of the arts of the Island Southeast Asian archipelago.

Dr. Maxwell L. Anderson
Former Eugene McDermott Director

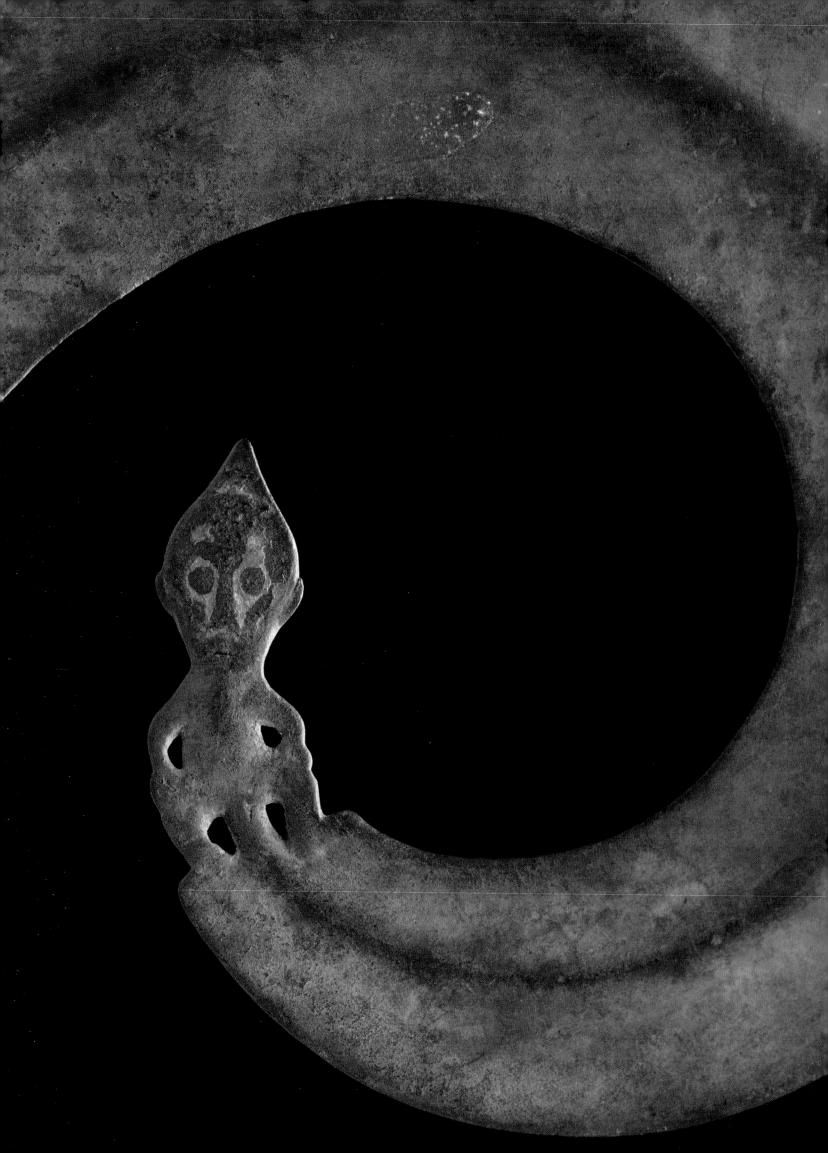

THE ARTS OF ISLAND SOUTHEAST ASIA AT THE DALLAS MUSEUM OF ART: A BRIEF HISTORY

One of the Dallas Museum of Art's most significant collection areas is currently displayed in three galleries featuring the regional arts of Island Southeast Asia, including those of Indonesia, Sarawak, East Malaysia, the Sultanate of Brunei, and the Republic of Timor-Leste (East Timor). The Museum's collection is internationally known for its iconic pieces and for its subtle mixture of sculpture, textiles, metalwork, and jewelry. Traditional artists from this region created objects of extraordinary quality and aesthetic appeal, working in a wide variety of media including wood, woven cloth, beads, iron, gold, ivory, horn, bone, clay, and rattan—all of which are represented at the Dallas Museum of Art. The DMA's collection is not encyclopedic and cannot be said to represent the artistic traditions of the entire region; it is rather a small, exemplary collection based on artistic excellence and drawn from indigenous peoples who created these items during the apogee of their traditional cultures.

At first glance, it may seem odd that such an important collection of Indonesian art found an adopted home in Dallas. However, Texas and Indonesia, initially through the oil and gas industry and today on many additional levels, have close social, educational, and commercial ties. The story of the DMA's Indonesian collection is one of serendipity spurred by two parallel developments whose auspicious beginnings date back to 1979 and 1980.[1]

Jean Paul Barbier, who founded the Barbier-Mueller Museum in Geneva, knew Mrs. Eugene (Margaret) McDermott, former president of the board of trustees and a major benefactor of the Dallas Museum of Art, through the International Council of the Museum of Modern Art. He encouraged her, along with John Lunsford, curator of the non-Western collections, and director Harry S. Parker III, to collect Indonesian art. Indonesian sculpture was often as inventively stylized as the sculpture of sub-Saharan Africa or of Papua New Guinea, two better-known tribal art traditions that were already well represented at the Museum. Through Mr. Barbier's enthusiasm, and their friendship, Mrs. McDermott was first exposed to this material in depth, and later generously supported the Museum's growing interest in Indonesian art.

John Lunsford traveled to Brussels and with Mr. Barbier looked at Indonesian sculpture there. He was especially attracted to a funerary figure from the island of Sulawesi. The Toraja *tau-tau* he had in mind was not an easy piece. Its surface was weathered from having stood for generations on a balcony chiseled from the face of a cliff. Yet the emotional quality of the figure remained intense. Mrs. McDermott saw that immediately. The open-mouthed expression of the *tau-tau* reminded her of Edvard Munch's evocative painting *The Scream*. The Eugene and Margaret McDermott Art Fund, Inc. purchased the figure for the Museum (cat. 66). Then J. Gabriel Barbier-Mueller donated two Indonesian objects to the Museum, a carving of a mythical creature from a Batak house façade (fig. 1) and a betel nut masher with a figurative handle from the island of Lombok. The major sculptural themes of the human figure and animals, both real and fantastical, were established with these first acquisitions, as was the architectural context of much Indonesian sculpture.

At the same time, John Lunsford met Steven G. Alpert, who was beginning his career as an art dealer in the United States after years of living in Indonesia. He went to visit Mr. Alpert at his parents' home outside of Chicago, and there saw his collection of textiles and sculptures. From this group, and with his discretionary budget, Lunsford selected a pair of Batak knives for the Museum. In his quest for Indonesian art, he applied the same enthusiasm, all-encompassing knowledge, and keen eye that were instrumental to the development of the Museum's Pre-Columbian and African collections.

The Museum's interest in Indonesia quickened during the early 1980s. The first Indonesian textiles were purchased, and the Art Museum League funded the hanging ancestor figure from Atauro (cat. 92). The Museum also hosted the seminal exhibition *Art of the Archaic Indonesians*, which included the DMA's Batak *singa* and the Toraja *tau-tau*. Local benefactor Judy Tycher acted as the catalyst for three sculpture acquisitions, each funded by a group of donors. Rita and Fred M. Richman of New York gave groups of objects in 1982

and 1984 (including cat. 12) that further broadened the scope of the collection.

In 1983, the Eugene McDermott Foundation made possible the purchase of the Steven G. Alpert Collection of Indonesian Textiles—seventy-six pieces (including fig. 2) that represent the major textile styles of southern Sumatra, Sarawak, Sulawesi, Sumba, and eastern Indonesia, many of them illustrated in this catalogue. This purchase gave the Museum its core masterworks of Indonesian textiles and set the tone for future acquisitions in this area. When Steven Alpert brought some of his favorite textiles over to Mrs. McDermott's home, a warm relationship began as Mrs. McDermott felt a deep kinship with this material, which she likened to the quilts and stitching of her frontier forebears.

When the Dallas Museum of Art opened its new downtown building in January 1984, a long-term loan from the Barbier-Mueller Museum in Geneva—fifty sculptures, some of which had appeared in the *Art of the Archaic Indonesians* exhibition—filled a gallery devoted to the sculpture of Island Southeast Asia. Gifts from Sarah Dorsey Hudson, the Barbier-Mueller family (fig. 3), and Margaret McDermott further enhanced the collection, but in general the acquisition of Indonesian sculpture slowed after John Lunsford's departure in 1986. As Lunsford's designated successor, and as the eventual Ellen and Harry S. Parker III Curator of the Arts of the

Americas and the Pacific, Carol Robbins, who had formerly curated the textile collection, became the curator of the entire Indonesian collection. During this transitional time, important additions were made in the textile area. In 1987, the exhibition *Woven to Honor: Textiles from the Steven G. Alpert Collection* was paired with *Power and Gold: Jewelry from Indonesia, Malaysia, and the Philippines* from the collection of the Barbier-Mueller Museum.

Thanks in part to this exhibition, textiles and gold, quintessential elements of Indonesian art, ignited the interest of local collectors. Among the Dallas area's patrons and collectors, three women, Margaret McDermott, Patsy Nasher, and Sally Estes, were especially instrumental not only to the formation of the DMA's Indonesian collection but also to its character. When asked to describe a special moment in his association with the Dallas Museum of Art, Steven Alpert responded: "One day, Margaret rang and asked me to give a tour of *Woven to Honor* for a close friend. The friend was none other than Lady Bird Johnson. Escorting two such charming *grandes dames* through the exhibition was a privilege; hearing them discourse on the quality of weave, or a particular stitch—that was a revelation."

In 1988, at the age of seventy-six, Mrs. McDermott went to Indonesia and visited both the Batak and Toraja homelands. In Sulawesi, while in the Toraja highlands, she purchased a very fine

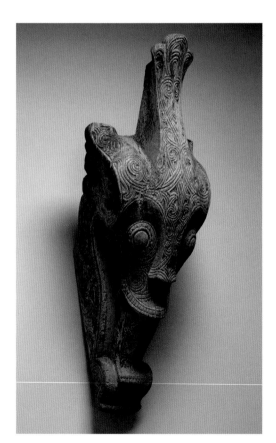

FIG 1 House façade ornament representing a *singa*, Indonesia, Sumatra, Lake Toba region, Toba Batak people, c. 1875–1900. Wood. Gift of J. Gabriel Barbier-Mueller, 1980.22.

FIG 2 Ceremonial cloth (*tampan*), Indonesia, Sumatra, Lampung region, probably mid-19th century. Homespun cotton. The Steven G. Alpert Collection of Indonesian Textiles, gift of The Eugene McDermott Foundation, 1983.77.

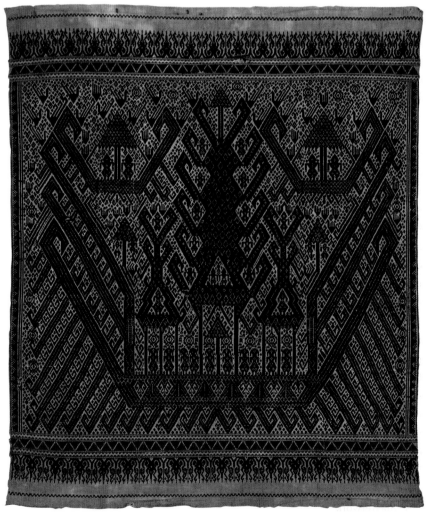

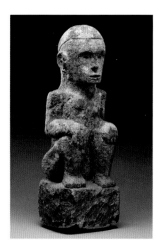

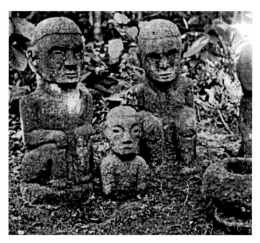

FIG 3 Seated figure (*pangulubalang*), Indonesia, Sumatra, late 19th to early 20th century. Stone. Gift of Mr. and Mrs. Jean Paul Barbier, 1985.6.

FIG 4 Squatting stone sculptures (*pangulubalang*) in situ. Simalungun Batak. Taken in Marjanji Asih, Tanah Jawa, Simalungun, c. 1938. KIT Tropenmuseum, Amsterdam 10000895.

ceremonial gold bracelet (*komba lola'*) that is illustrated in this catalogue (cat. 56).

The return of the Barbier-Mueller loans to Switzerland in 1990 challenged the staff to plan a new installation that would rely on the Dallas Museum of Art's own holdings and on loans from local private collections. The result was an impressive combination of sculpture, textiles, and metalwork. The potential for excellence was apparent. Director Rick Brettell and Deputy Director Emily Sano supported significant purchases, as did their successors, Jay Gates and Charles Venable—through Museum funds and the continued generosity of both The Eugene and Margaret McDermott Art Fund, Inc., and The Eugene McDermott Foundation. Gifts of art came from the Steven G. Alpert family and from Mr. and Mrs. James H. W. Jacks. Indonesia was the theme of the 1995 Beaux Arts Ball, *Shadows of Gold*, chaired by Jeanne Marie Clossey, and the Museum League Purchase Fund supported the acquisition of a pair of mythical animals from Sarawak from the Alpert collection (cat. 33).

During the 1990–91 nationwide Festival of Indonesia in the United States, Mrs. McDermott's role in promoting the arts of Indonesia was officially acknowledged by the government of Indonesia. In 1996, Dallas's Indonesian Community Association sponsored a gala event under the leadership of Mrs. Lely White for the benefit of the Museum's Indonesian collection, and for the acquisition of a very fine Lampung skirt (cat. 26). Given the growth of the collection, and the public's enthusiasm, gallery space was increased with the reinstallation in 1996 of the arts of Africa, Asia, and the Pacific, a project initiated by then-director Jay Gates.

The primary acquisitions of the 1990s exemplify the aesthetic qualities of the arts of Island Southeast Asia: mastery of materials; primal artistic themes, which usually embody religious conceptions; and an animation of form that conveys emotion, whether subtle and serene or bold and energetic—evocative components that in equal measure are found in the area's most profound art (fig. 6). With sculpture, especially, the acquisitions have often been one of a kind rather than representative and have been characteristic of collecting from about 1880 to 1920 (common in European museums but rare in United States collections). Seven important masterworks purchased from Steven Alpert by The Eugene

and Margaret McDermott Art Fund, Inc., in 2001, championed by director Jack Lane and deputy director Bonnie Pitman, reaffirmed these aesthetic qualities and brought the Dallas Museum of Art's Indonesian holdings further international acclaim.

In this setting, the Indonesian collection has continued to grow and enthrall Museum visitors. After seeing Dallas's standing Dayak guardian figure (cat. 36) in the gallery, the great African art collector Saul Stanoff opined that "having just one universal masterpiece of this level, by itself, constitutes a collection." Overall, the high quality of the material in this collection represents the concerted efforts of many persons, among them six directors, two curators, and many interested parties. It is important to mention that while

FIG 5 Steven G. Alpert with Carol Robbins, the former Ellen and Harry S. Parker III Curator of the Arts of the Americas and the Pacific, at the opening of the exhibition *Woven to Honor: The Steven G. Alpert Collection of Indonesian Textiles* in 1987.

most of these items came from Steven Alpert, they in fact represent a broad spectrum of sources. These include not only Alpert's field-collected pieces, but also materials purchased from old colonial families, missions, other museums and dealers, and private collectors. As word of Dallas' collecting mission spread, important collectors became interested in the installation, and allowed Steven Alpert access to material on the understanding that it would go to the Dallas Museum of Art. In this regard, two important persons must be mentioned. The first, Bernard M. Tursch, was the source for the Museum's Leti mouth mask (cat. 96) and male Batak figure (cat. 16). In addition, Dr. Reimar Schefold, the renowned ethnographer of Mentawai, upon seeing its commitment to showing this caliber of Indonesian art in the public domain, allowed the Museum to acquire the four glorious Mentawaian pieces that appear in this catalogue (see chapter 1, "Toys for the Souls: The Art of Mentawai"). The Museum is indebted to all these persons and to many more.

In the past decade, collectors such as Elissa and Dr. Albert Yellin donated a superb Iban mask (cat. 40), and in addition the Museum acquired a famous Leti statue (cat. 95) and Toraja shield (cat. 53) from them. The Alpert family gave pieces to the Museum. In 2008, the Museum was the recipient of a remarkable group of ornaments, jewelry, and gold items that broadened, and in many ways perfected, the collection. Most of the art world is acquainted with the Nasher Sculpture Center and its extraordinary collection of twentieth-century sculpture. The material in this catalogue from the Nasher family represents Patsy Nasher's last collecting effort.

Her connoisseurship and appreciation for Indonesian art are readily reflected in the pieces she chose to acquire. Mrs. Nasher had a passionate, authentic commitment to the arts, and her discerning eye was capable of evaluating the artwork of many different disciplines. Twenty-two Indonesian pieces (including fig. 7) were given to the Museum by the Nasher Foundation in memory of Ray and Patsy Nasher. Many of these masterworks are illustrated in the following pages.

Starting in 2004, Sally and Bill Estes also began to donate Indonesian pieces from their collection to the Museum. These included a fine Alor drum (fig. 8), a superb ceremonial stone seat from Nias in the form of a mythical dragon (cat. 10), and two carved megalithic stones from Sumba that recall both the region's historical depth and the prerogatives of traditional rulers (cats. 78 and 79). Lastly, in honor of this publication, the Esteses also gave as a promised gift a particularly outstanding example of a ceremonial spoon from the island of Timor fashioned from buffalo horn (cat. 84).

Dallasites Diane and Andyan Rahardja also recently donated an important figurative Timor door from the same region as the Esteses' spoon (cat. 86). This door was given in honor of Mrs. Rahardja's mother, Louise Steinman Ansberry, who worked as a pioneer in public relations in the 1960s for Pertamina, Indonesia's national oil company, to encourage tourism there. In response to both the Esteses' and Rahardjas' generosity, the Alpert family recently promised a particularly sensitive and haunting *ai tos* statue from the Republic of East Timor that will complement these new additions.

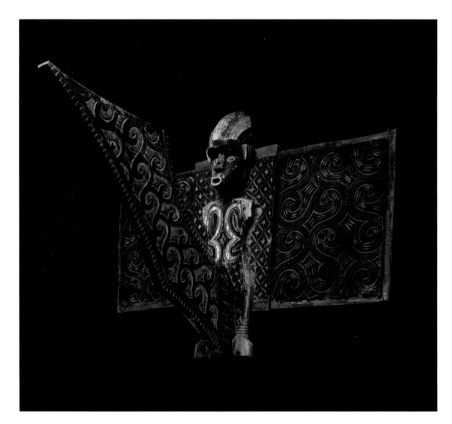

FIG 6 Section from a house façade with human figure, Indonesia, Central Sulawesi, Mamasa Toraja people, late 19th to early 20th century. Wood, paint. General Acquisitions Fund, 1991.363.

FIG 7 Man's symbolic pendant (*mendaka*), Indonesia, Lesser Sunda Islands, West Sumba, Anakalang, 19th century or earlier. Gold. Gift of The Nasher Foundation in honor of Patsy R. and Raymond D. Nasher, 2008.64.

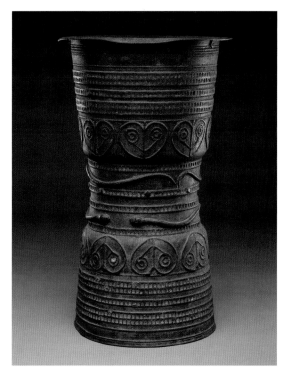

FIG 8 Drum (*moko*), Indonesia, Lesser Sunda Islands, Alor, 19th century or earlier. Bronze or brass. Promised gift of Sally R. and William C. Estes to the Dallas Museum of Art, PG.2013.3.

FIG 9 Former director Bonnie Pitman with Grace Cook, Margaret McDermott, and Steven Alpert at the Dallas Museum of Art in 2008.

FIG 10 Ceremonial entrance to the Dallas Museum of Art, 2009.

This reciprocity and civic involvement reflect once again the philanthropic spirit of Margaret McDermott, who both encouraged and challenged others to participate in the evolution of the Museum's holdings. No art collection is ever complete, but a foundation, as well as the criteria for future acquisitions, have been clearly established over the past thirty years.[2] The collection at the Dallas Museum of Art has become both a regional and an international draw for all those fascinated by—or wishing to learn more about—the traditional arts of Island Southeast Asia.

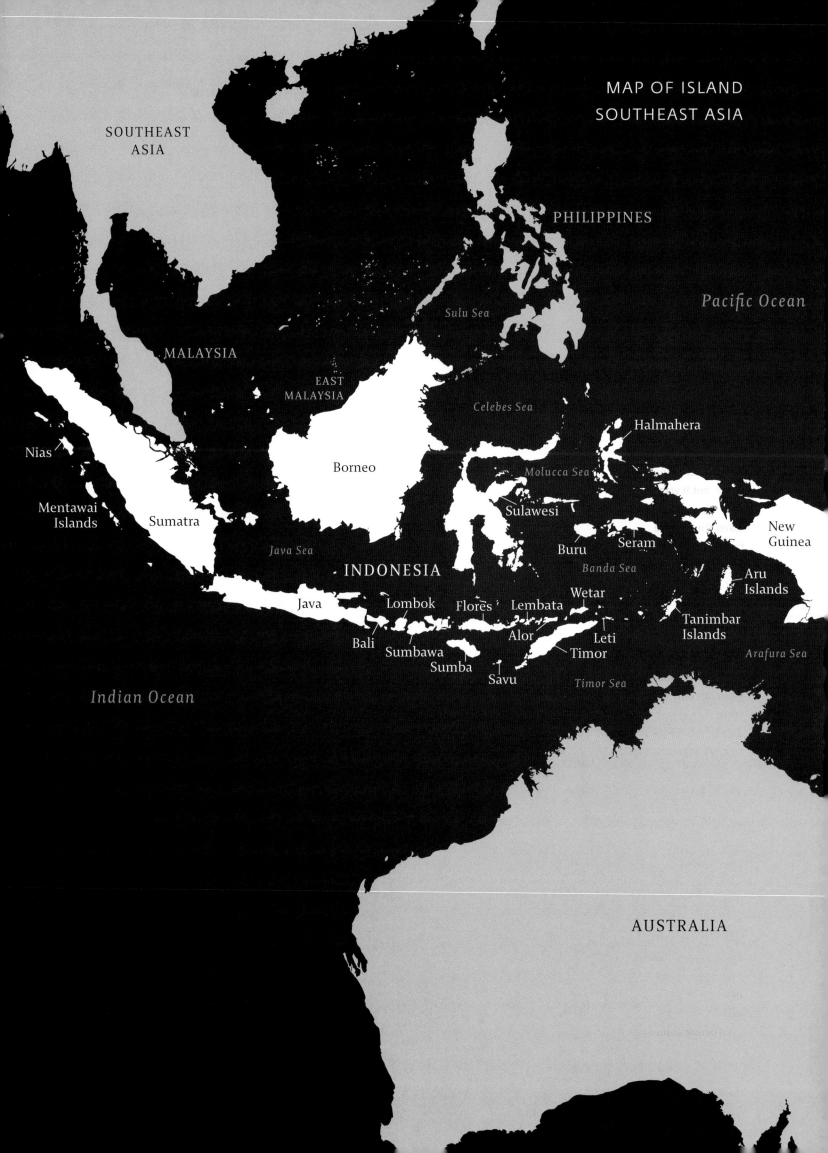

MAP OF ISLAND
SOUTHEAST ASIA

SOUTHEAST
ASIA

PHILIPPINES

Pacific Ocean

MALAYSIA

EAST
MALAYSIA

Sulu Sea

Celebes Sea

Halmahera

Nias

Borneo

Molucca Sea

Mentawai
Islands

Sumatra

Sulawesi

Seram

New
Guinea

Buru

Banda Sea

Java Sea

INDONESIA

Aru
Islands

Wetar

Java

Lombok

Flores

Lembata

Bali

Sumbawa

Alor

Leti

Tanimbar
Islands

Sumba

Timor

Arafura Sea

Savu

Timor Sea

Indian Ocean

AUSTRALIA

GENERAL INTRODUCTION
ART AND ITS THEMES IN INDONESIAN TRIBAL TRADITIONS

Reimar Schefold

Introduction

One of the great merits of the Dallas Museum of Art is that it displays World Art in its true sense. Its diverse and carefully assembled collections enable the visitor to appreciate and compare the artistic histories and achievements of Europe, Africa, the Americas, Asia, and not least Indonesia. This approach may be widely accepted today, but it was not so long ago that the supposed superiority of Western art over non-Western indigenous artistic creations was taken for granted. "Their woodcarvings are very elementary and the resulting objects are like caricatures, per se skilfully executed, but not done with the intention to create a caricature."[1] Such was a government physician's impression, as late as 1947, of the art of the people of the Mentawai Islands west of Sumatra, a region where he had been stationed shortly before the Second World War and one that features prominently in the present volume.

Anyone who admires the magnificent collection of Indonesian tribal art assembled by the Dallas Museum of Art in the past few years can only note how fundamentally our thinking has changed since that assessment. Although the objects come to us from a distant world, we are able to admire their outstanding artistic qualities. We even allow ourselves to be drawn into the cosmological imagery of protective ancestor figures, the abundantly leafed "tree of life," and mythological, sometimes abstracted, animal figures. In most cases, these objects now represent mere memories of a way of life that has become overshadowed by a "modern" and globalized world. Perhaps it is precisely for this reason that we feel intrigued by what these objects might tell us.

In the Museum's Indonesian display cases, the present-day public encounters a masterfully controlled sense of line and a wealth of imaginative variations on basic forms. Viewers are immediately struck by the spirituality expressed in these objects, the very quality that European artists such as Vlaminck, Matisse, and Picasso found so captivating in the tribal art of Africa at the beginning of the twentieth century. In these artists' search for new forms of expression outside the straitjacket of naturalism, they discovered, even before anthropologists, the rich artistry of such works (fig. 11).

As a result of that sudden reappraisal, a number of studies of "primitive" artistic traditions were published, some of them more general, some focused on a specific locality. Anthropologists began to study how these intriguing artworks related to religion and the specific social context, as well as what it was that motivated the artists who fashioned them.[2] It soon became apparent in the relevant publications that, in contrast to the Western conception of "l'art pour l'art," the art of indigenous peoples is usually functional, in most cases in a religious sense. In local languages, generally no distinction is made between arts and crafts, no special role being

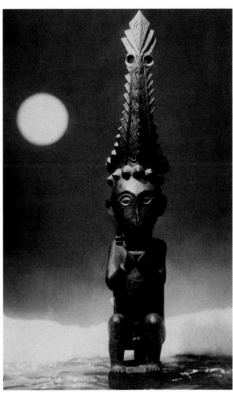

FIG 11 Man Ray (1890–1976) © ARS, NY. *La lune se lève sur l'île de Nias* *(The moon rising over the island of Nias)*. Musée National d'Art Moderne, Centre Georges Pompidou, Paris, AM1987-887. The ancestor statue *(adu siraha salawa)* depicted in this photograph is very similar to one in the DMA's collection (see cat. 6).

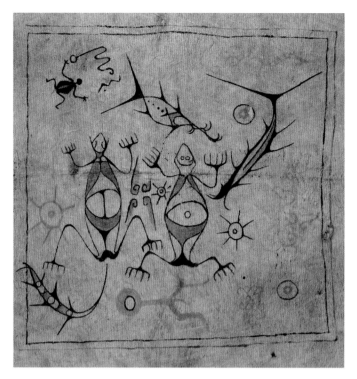

FIG 12 Painted *Maro* barkcloth from the Lake Sentani region, Papua, Indonesia, c. 1915. Private collection, Dallas.

known for a professional artist. The fact that people are nonetheless well aware of the aesthetic merits of individual works of art is a proposition that appears repeatedly in the entries in this volume.

Initially, the art of Indonesia was largely ignored, overshadowed by the more spectacular forms of its New Guinean neighbors. Expressionist and Surrealist painters of the early twentieth century were especially fascinated by highly emotional and expressive artifacts from that region. A superb barkcloth from Lake Sentani in northwest New Guinea (fig. 12) is a case in point. It belongs to a tradition that was widely admired by the surrealist painters in the 1920s in Paris and whose influence on artists like Max Ernst and Joán Miró has generally been acknowledged. Interest in the art of the Indonesian archipelago itself at that time centered on the classical heritage of the Hindu-Javanese period. In terms of Indonesian influences on Western art, this is best demonstrated by Paul Gauguin's seminal 1891 painting *Ia Orana Maria* (*Hail Mary*) (fig. 13), which was based in part on views of the Borobudur temple (fig. 14) captured in photographs that Gauguin had purchased in Paris at the Exposition Universelle, the 1889 world's fair.

The first monographs on Indonesian art appeared only in the second half of the twentieth century. They were often related to museum exhibitions and, like them, documented a growing fascination with the tribal artistic heritage of the newly independent (since 1945) Republic of Indonesia.

After independence, however, a certain ambivalence soon became evident in the official government stance regarding local artistic traditions. The great variety of characteristic forms that was so admired internationally was a clear expression of regional identities within Indonesia, and certain localities were motivated to promote their own traditional artistic forms as a way of distinguishing themselves

from their neighbors. To the new authorities, intent on forging a transregional national identity, such local distinctions were unwelcome. In many places, any expression of regional cultural traditions was deemed "irrelevant" and officially banned.[3]

Beginning in 1998, however, following the resignation of President Suharto, successor to founding president Sukarno, the ban ceased to be upheld. Today greater regional autonomy gives the various provinces the political space in which to cultivate and further develop what distinguishes them. Tribal cultures—especially as expressed in dances and clothing, which also serve to attract tourists—are experiencing a revival and have reaffirmed regional identities.

It is my hope that the present book and the accompanying installation of masterworks from the Dallas Museum of Art will attract new admirers of Indonesian art, and that they will serve as inspiration to members of the ethnic groups in question. A review of the historical background of the archipelago's cultures makes it clear that their wealth of local traditions is by no means in conflict with the notion of national unity.

Beginnings

Modern Indonesia is the world's fourth-most-populous country, comprising almost 250 million inhabitants speaking more than 300 different languages. The majority (approximately 86 percent of the population) are Muslim, but sizable minorities practice Christianity, Buddhism, and Hinduism, in addition to various ancient animistic traditions. An enormous biodiversity characterizes this vast archipelago of islands, which straddles the equator for thousands of miles.[4] This regional diversity has influenced local cultural adaptations of seafaring immigrants who settled the archipelago in prehistoric times.

The history of this settlement belongs to one of mankind's greatest adventures, which began some 6,000 years ago.[5] In the beginning it was quite modest in scale. At that time, Late Stone Age cultures had arisen on the southern Chinese mainland, the earlier nomadic tradition of local hunter-gatherers having given way to an economy based on agriculture and animal husbandry. Once these peoples became sedentary, their populations increased dramatically. New woodworking techniques, including the skilled use of the mortise and tenon, made possible the construction of houses erected on stilts.

In response to the pressure of population growth, some groups applied the new woodworking techniques to the building of seaworthy boats with outriggers in which to set out in search of new lands to settle. They first sailed across the South China Sea to Taiwan. Identified as Southern Mongoloids, these people spoke a language that would evolve into more than a thousand contemporary tongues. This language family has come to be called Austronesian, and its original speakers Austronesians.

We do not know for certain for how long Austronesian expansion remained limited to Taiwan—some have estimated a thousand years or so—but we do know that Austronesian is perhaps the

largest language family in the world. Suddenly Austronesian peoples began migrating farther south, across the Philippines to Sulawesi. From there they traveled eastward through the Moluccas and Melanesia to the scattered islands of the as yet uninhabited Pacific, where they became the ancestors of today's Polynesians (see map, p. 20).[6] Another branch sailed to the west, reaching the islands of Borneo, Java, and Sumatra. Roughly 2,000 years ago, members of this second group arrived in Madagascar, off the east coast of Africa, thereby completing migrations that encompassed more than half of the globe.

This vast migration took place in such a brief period of time that it has been referred to, with slight exaggeration, as the "express train to the Pacific." Indonesia itself provides some distinct clues to what could have occasioned such a rapid dispersal. The obvious assumption would be that it was triggered by expanding populations and a shortage of land, but this is surely inadequate: there are too many instances of major migrations from regions that were far from being fully developed. It appears that an ideological constant throughout the Austronesian realm was of greater significance— the notion of the emigrant who discovers new territory, establishes a community there, acquires considerable prestige, and as founder-ancestor assumes virtually godlike stature among subsequent generations. The widespread distribution of these peoples could have been motivated by just such an ambition, and it is one that touches on a central feature of the art of Indonesia: the supreme importance of ancestors.

In the region's art, two additional aspects of this migration come into play.[7] The first has to do with the way the immigrant peoples conceived of the newly discovered land and incorporated it into their sense of the cosmos. In most of the more than 300 ethnic groups in Indonesia, one encounters the tradition that when claiming the new land, the mythical founder first had to deal with its autochthonous inhabitants—some of them human, some of them the spirits that had always been there, associated with the natural world and predating the arrival of humankind. These were the true owners of the land, and only after concluding a pact of reciprocal respect with them could the newcomers settle on it for good. In many places, there are still groups who trace their lineage back to the tie between the founder-ancestor and one of the mythical original inhabitants. Only their members can perform the sacred function of the *tuan tanah*, or lord of the land. In contrast, the descendants of later immigrants are differentiated by the possession of secular authority and political power.[8]

It will be necessary to return to this issue of the original environment and how it was understood by the first immigrants. Meanwhile, there is a third feature of importance in any consideration of Indonesian art forms. To seal the pact concluded between the immigrants and the autochtonous populace, it was common for the founder-ancestor to take a native woman as his bride. This not only guaranteed his future progeny but also gave him access to the land's fertility and to the blessings of the wilderness, which had existed before the arrival of the first immigrants. In traditional Indonesian belief, every marriage is a reaffirmation of that primal union. It is customary to marry outside of one's immediate kin group. This tends to forge ties of amity between different groups and reduces the danger of conflict within a given region. The community that furnishes the bride bestows fertility, is therefore ritually superior to the one that receives her, and can expect the respect and active support of the groom's community.

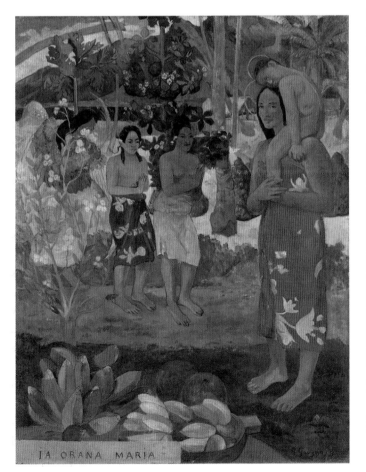

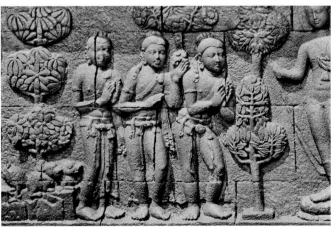

FIG 13 Paul Gauguin (1848–1903), *Ia Orana Maria (Hail Mary)*, 1891. Oil on canvas. The Metropolitan Museum of Art, Bequest of Sam A. Lewisohn, 1951 (51.112.2).

FIG 14 Detail of a frieze from Borobudur, a Mahayana Buddhist monument, Shailendra dynasty, 9th century, Central Java.

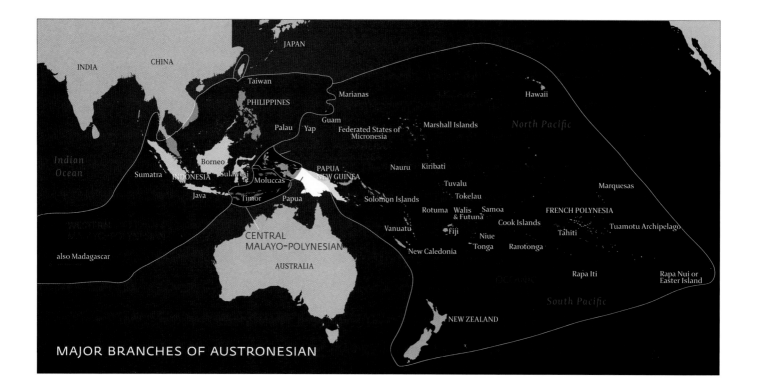

MAJOR BRANCHES OF AUSTRONESIAN

In another context, I have referred to ancestors, representatives of the original cosmos, and wife-givers as three sources of blessings in Indonesia,[9] all of which find expression in art. It is common in Indonesian tribal art forms to encounter depictions of ancestors, indications of how a community's environment is perceived, and records of matrimonial alliances. Works of art are connected with the major rituals by which associated families assure themselves of divine protection.

In addition to these three themes, there are also more personal forms of aesthetic expression, namely tattooing and other kinds of body ornament, but these lie outside the boundaries of what is generally collected and exhibited in museums and will not be explored further in the present study.

Indonesian tribal art is by no means limited in its formal aspects to its Austronesian heritage. Of far greater importance are the influences of a later artistic tradition that dates back to the early Bronze Age, one that reached the archipelago long after the Neolithic Austronesian immigration. It too originated on the Southeast Asian mainland, and is known by the name of the village in northern Vietnam where it was first identified: Dong Son.[10] In view of the dominance of this later tradition, it is appropriate to discuss it at some length before attempting to identify earlier Austronesian traces.

The Bronze Age culture of Dong Son evolved around the middle of the last millennium BCE.[11] Its center was located in what is today Vietnam. It is assumed that contacts with contemporaneous Chinese and even southeastern European art styles contributed to its development. Artifacts from Dong Son were traded throughout the Indonesian archipelago as far as Lake Sentani in northwestern New Guinea, and their great value added to the prestige of their Austronesian owners. Among the culture's most conspicuous

products are the instruments that have come to be known as kettledrums, some more than three feet tall, of which no fewer than fifty-six whole or partial examples are preserved in Indonesia. Variants of these drums were later produced in Indonesia itself—a late example of this tradition that continued into recent times is the Moko drum from Alor in the Dallas Museum of Art (fig. 8, p. 15). Moko drums of this type formed part of the traditional bride price, and in the early colonial period they were considered legal tender. They were probably made in Java, and up until the beginning of the twentieth century they continued to be used as local commercial currency, but many excavated examples doubtless date back to the Bronze Age. Some are ornamented with heart-shaped faces, a stylistic motif that points directly to Dong Son traditions. The Dong Son drums are especially interesting to anyone tracing the origins of Indonesian art in that they are profusely

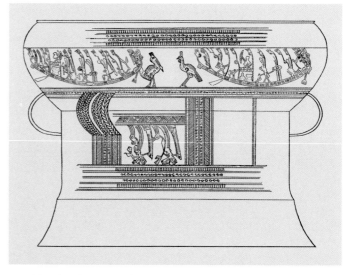

FIG 15 Drawing of a Dong Son drum, Ngoc Lu, Vietnam, 3rd–2nd century BCE.

decorated, exhibiting the wealth of formal designs employed by the prehistoric populations of Southeast Asia and passed down from them.

Their most conspicuous decorative patterns are the spirals of various kinds and other curving lines encountered in all Indonesian tribal art up to the present day.[12] These visual elements frequently suggest an elastic tension, underscored by branching vines, like that of wire springs.[13] Generally such designs appear in symmetrical arrangements, in regular repetition on a clearly structured ground. One sees these same patterns on the elaborately ornamented façades of the houses of the Toraja people in Central Sulawesi, although no certain Dong Son artifacts have as yet been discovered there (see fig. 6, p. 14, and fig. 18, p. 24, as well as the spiral carvings in cat. 67). Their inspiration could have come by way of other decorated objects that have not survived, such as fabrics, woodcarvings, and so on. It is worth noting that the introduction of the technique of patterning textiles known as *ikat*, which is so characteristic of Indonesian tribal cultures, has also been attributed to the Dong Son culture (see, for example, cats. 64 and 65, two textiles from Sulawesi). Curvilinear patterns on cloth produced in a different technique recall the Dong Son tradition even more clearly (see cat. 63).

In addition to such abstract motifs, there are also representational images on Dong Son drums, including renderings of houses with saddleback roofs and outward-slanting gables like those still being built by many ethnic groups in Indonesia today. Other drums display images of boats with their crews (fig. 15). Down to their smallest details, these recall recent drawings by the Dayak on Kalimantan of the spirit boats said to carry the deceased into the afterlife. And to this day, many local groups characterize themselves as "ships' crews" and their settlements as "boats." I will return to this point. Of special interest in the present context is a kettledrum from Bali more than a thousand years old. It is uncommonly tall—nearly six feet—and was doubtless made in a metalworking center on the island itself. It is decorated with several human faces whose meaning is no longer known. Their form is altogether characteristic—flat, heart-shaped, with huge round or oval eyes, straight narrow noses without nostrils, and small mouths set into a narrow chin (fig. 16).

This facial design is widely reproduced in more recent Indonesian tribal art. A variant with a concave, heart-shaped outline, elongated straight nose, and small parted mouth can be seen on a beautiful ironwood statue unearthed along the Wahau River in the eastern part of Kalimantan, in all probability hundreds of years old (cat. 36). Similar images are found carved in stone farther to the east, in the Bada' Valley in the highlands of Central Sulawesi (see fig. 78, p. 176). We do not know who might have created the Bada' megaliths, but it is certain that whoever did so lived many generations ago. For an ancient example from the Sa'dan Toraja in South Sulawesi, we can turn to a recently acquired sculpture in the Dallas Museum of Art. Here again is the flat, heart-shaped face, while the round, disklike eyes and slender nose recall the Bronze Age precedent (cat. 67).

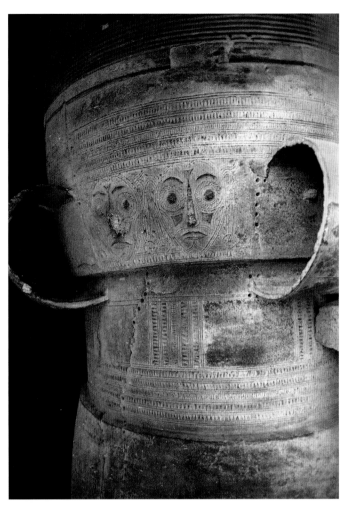

FIG 16 Heart-shaped faces on the Bronze Age "Moon of Bali" kettledrum from Pèjeng in Bali, c. 300 BCE.

Although the prehistoric piece to which these tribal examples are compared was produced in Bali, in Indonesia, it is unquestionably in the Dong Son tradition and accordingly attests to the direct and considerable influence of that tradition on the Indonesian formal repertoire. But of course this leaves one to wonder what the earlier Austronesian art might have looked like. The Dong Son influence is so strongly represented in prehistoric finds all over Indonesia itself that earlier art traditions are difficult to identify there. Yet recent archaeological finds from more far-flung Austronesian settlements that clearly predate any possible Dong Son Bronze Age influence can provide clues to the appearance of the original Austronesian artistic style—at least in the east, for these finds come mainly from Melanesia. They are attributed to the so-called Lapita culture, whose beginnings are thought to date back more than 3,000 years.[14]

The art of the maritime population of Lapita, linked through far-ranging trading networks, is known primarily from ornaments on pottery, but one assumes that similar tattooing and barkcloth patterns contributed to its distribution.[15] On the basis of such finds, one can identify more clearly the survival of these Neolithic forms in present-day Indonesia, for example, in traditional textile patterns from Sumatra, Borneo, and eastern Indonesia, and in the latter region particularly in the decoration of bamboo vessels. One immediately notes that the geometric Lapita forms are not so very

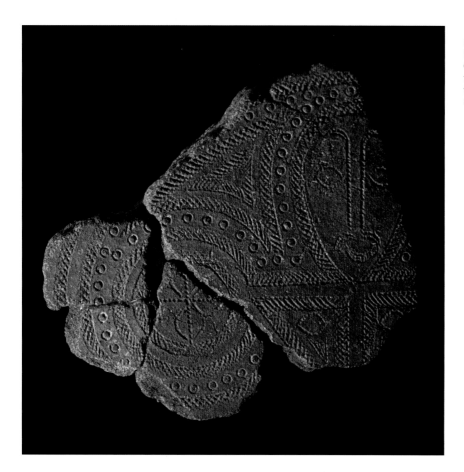

FIG 17 Pottery fragment, 1000 BCE, Solomon Islands, Reef Islands, Nenumbo site, Lapita culture. Terracotta. One of the finest examples of the Lapita potter's art, this fragment depicts a human face incorporated into the intricate geometric designs characteristic of the Lapita ceramic tradition.

different from the surface-filling patterns of Dong Son. The typical braided bands, double spirals, and elastic scrolls of Dong Son and its presumed present-day successors seem more animated and dynamic than the fussier Lapita ornaments with their serial curves or angled meanders, but the similarity of the strictly linear, repetitive patterns is unmistakable. This is true even of depictions of faces on some Lapita shards, which exhibit a striking "family likeness" with the Indonesian examples already mentioned (fig. 17; cf. cat. 36).[16] One is thus forced to the conclusion—met with again and again in contemporary scholarship—that both the Austronesians and the Dong Son people shared a common ancient Southeast Asian artistic heritage.[17]

Such a conclusion is of relevance not only for Indonesia. It would also explain startling convergences with various Polynesian art forms that can have had no connection to Dong Son from a historical point of view but whose great similarity to the Dong Son repertoire has occasionally led to detailed speculations in the literature regarding such presumed influences, as is the case, for example, with the well-known Maori spiral.

The assumption of ancient common roots in the formal canon of Indonesian tribal art still fails to account for distinctions among local traditions, which will be discussed. One encounters a breadth of variation in detail, as is only to be expected in an island realm made up of so many different isolated regions. At the same time, one must always be on the lookout for ways in which the common heritage is expressed. The three major themes outlined above (ancestors, environment, and matrimonial alliances) serve as starting points. Whenever possible, pieces in the Dallas Museum of Art will be referred to as illustrations.

Ancestors

In all Indonesian tribal cultures, ancestors are the preeminent spiritual authorities. They include the earliest settlers, and people memorize genealogies that lead from primeval, mythical times to their immediate forebears. Since memories are limited and writing is generally unknown, intervening generations are often compressed into just a few names. On the Mentawai Islands, for example, only eight generations are customarily cited to connect a person to the original settlers.

A person owes everything to his or her ancestors. One's cultural environment is associated with their arrival in ancient times. Later generations are related to historical events that lead up to one's present-day situation. A person not only owes his or her ancestors for his or her very existence, but also hopes for their protection and help in everyday life. This has its more precarious side, however: it is the ancestors who continue to watch over the cultural order they established. Especially in egalitarian tribal societies, there are no authorities to keep order and punish social offenses; it is mainly the ancestors who have to step in and strike the offender with illness and misfortune.

Through what we term "art," it is possible to draw the sacred world of the ancestors into one's own existence. In small huts in the center of the villages in eastern Indonesia there were images of the mythical clan elders from whom the community descended

and from whom they could expect fertility and new life.[18] Whereas ancestors who are actually remembered generally assume a squatting pose, legendary founders are often standing figures with outstretched arms. Many eastern Indonesian societies are matrilineal, that is to say, organized along female lines of descent, and accordingly women are frequently represented, as in the Dallas figure called *luli* (cat. 105). Her outspread arms are bent upward, and the same linear form is repeated in the center of the base beneath the figure with its many-branched spiral shapes, the ends bending back toward one another. In various ways—by association with the uterus, boats, and vegetation—this image is suggestive of the fertility that the tribal mother guarantees, and at the same time it refers to her mythical association with the wilderness, as mentioned above.

In the eastern part of the archipelago, as in all Indonesian cultures, it is believed that the soul—here called the "shadow image"—survives after death. For a time, it remains in the vicinity of the living, but then it withdraws into the realm of the ancestors, which is generally located in some uninhabited region. With offerings it is possible to lure the shadow image back into a carved figure of the deceased if one is in need of his or her help. Such figures are individualized with indications of the sex of the deceased and ornaments suggestive of his or her status. They usually assume a squatting pose, as with the figure from the island of Leti (cat. 95). This pose is found throughout the entire Southeast Asian and Pacific island realm, and is a further indication of a common prehistoric heritage. Two-dimensional versions typically take the shape of a W, like the one seen on the old Dayak relief carving (cat. 38). But the Museum also has an example of an upright ancestor figure—a shrine figure from Atauro in eastern Indonesia (cat. 91)—and still others posed with knees bent, like the ancestral couple from Flores (cat. 80) and the *itara* figure from Atauro (cat. 92).

Comparison of such ancestor figures from eastern Indonesia with their counterparts in the far west confirms that the tribal art of the entire archipelago derives from a common tradition. The art of Nias, an island roughly the size of Bali west of Sumatra, is among the richest in western Indonesia.[19] Because Nias is a patrilineal society, its figures of founding ancestors are always male. The Dallas figure from the north of Nias (cat. 6) is a fine early example. Its careful execution and its jewelry and crown are indications of the highest nobility; clearly its task was to protect the houses of nobles. The typical squatting pose with bent arms, the smooth surface treatment, and the jutting eyebrows curving sharply toward the bridge of the nose recall the example from Leti, but in contrast to that figure's elegant, flowing lines, this image is chunkier and more compact.

Nias figures of direct ancestors are similar but usually smaller. They were carved shortly after a person's death, at times tied together in long rows with rattan and hung in the house. In central Nias, such figures were also carved in stone. Another type of stone carving from Nias can be found in the Dallas Museum of Art as well (cat. 10). This is an honorary seat with a dragon's head

that would have been used by the nobleman hosting a celebration. In its execution it exhibits the same chunky angularity as do the ancestor figures. Stone seats of this kind are among the megalithic monuments associated with ancestor worship that in many places in Indonesia served to document the high rank of a given lineage.

A third area that has become famous for its images of the dead is the Toraja region in the mountains of southern Sulawesi. These portrayals represent people only recently deceased. Here the mythical founders are recalled not in the form of images but rather in enormous houses with heavily decorated walls and huge curved roofs that are among the most monumental products of Southeast Asian art. In the Mamasa area, on the most aristocratic dwellings, there is sometimes an angular carving of a person riding a buffalo in front of the façade (cat. 57). In the literature, these are referred to as guardian statues; it is unclear whether or not they refer to the founder of the house.

Upon the death of a person of high rank, it is customary among the Toraja to commission a carved image known as a *tau-tau* as part of an elaborate burial rite. In contrast to the two regions discussed above, here the tradition continues to this day, for the Toraja have reached an agreement with the dominant Christian faiths among them that such images are simply portraits and nothing more. In the traditional religion, they were literal embodiments of "the soul that is seen." They are produced by specialists who are paid for their work. The newest figures strive for a realistic rendering, whereas older ones generally had stylized, generic facial features. Archaic examples once again have the prominent brows curving into the bridge of the nose in the flat, heart-shaped face so frequently encountered in the artworks discussed above. An unusual *tau-tau* feature that contributes greatly to its hypnotic aura is its fixed gaze. The eyes are rendered with inlays of almond-shaped pieces of bone upon which the pupils are indicated with black dots. The archaic example in the Dallas Museum of Art collection (cat. 66), with its unusual open mouth and hanging arms, shows how greatly even old ones can differ. It is surprisingly reminiscent of figures from Flores.[20]

All *tau-tau* wear individualized clothing corresponding to that of the deceased and that is replaced every few years. Seeing such figures perched high up in rock-cut niches can be awe-inspiring. From there they stare out over the world of the living, receiving offerings and dispensing their blessings with arms bent at the elbows.

Clothing conceals the fact that, traditionally, a *tau-tau*'s penis, if it has one, is erect. The same is true of numerous figures from eastern Indonesia and always of those from Nias; it is not entirely clear whether this characteristic is meant to indicate potency or to serve an apotropaic function.

Ancestor images are found throughout the Indonesian archipelago. These three examples demonstrate how regional styles have evolved in different directions despite their fundamental similarities. The same can be said of a second artistic genre: images relating to the world apart from the ancestors.

The wider world

Everywhere in Indonesia, but most especially in the west, one encounters a consistent worldview. The cosmos is made up of a middle realm in which we live, and above and below it an upper world and an underworld, both realms inhabited by gods, spirits, and demonic creatures. This notion is reflected in figurative and ornamental designs produced by virtually all ethnic groups. A first example is one of the Museum's more recent acquisitions, a so-called wooden *jaraik* from the island of Siberut in the Mentawai archipelago (cat. 4). The *jaraik* serves to maintain a spiritual equilibrium within the longhouse and to ward off evil.

Once the carver has finished a *jaraik*, it is imbued with magical powers in an elaborate ritual. The nature of this magic is suggested by the peculiar form of the carving. The two arms curving upward form a crescent-shaped horizontal curve that has been seen in the literature as a "pervasive form . . . throughout insular Southeast Asia."[21] In the *jaraik*, however, this curve is interrupted by a vertical element at the base of which an ornamented monkey skull is affixed. To my mind, it is this second element that reveals the original meaning of the motif, one supported by the other pair of arms curving downward.

The design of the *jaraik* can be traced back into Indonesian prehistory, and in my opinion it is intimately associated with the concept of a three-layered cosmos. The three realms are said to be connected by a cosmic tree (in literature often called the "tree of life") that has its roots in the underworld and penetrates the upper world at the top. It is believed that the cosmos is supported by a gigantic buffalo that inhabits the underworld; when the beast is angry, it causes earthquakes.

The upward-curving arms of the *jaraik* can be interpreted as this buffalo's horns, the arms curving downward as its ears. The central vertical element can be seen as a reference to the cosmic tree. A glance at Indonesian houses tends to support this interpretation. The configuration of large Indonesian pile dwellings, or longhouses, often follows this same three-part scheme. The space beneath the floor and between the piles is where buffalo are kept at night, and the space above the living quarters, beneath the vast roof, is the abode of spirits and ancestors. We sometimes find a direct sculptural translation of these ideas on the front of the house. A fine example can be seen among certain magnificent buildings of the Sa'dan Toraja in South Sulawesi (fig. 18). At floor level a carved buffalo head is affixed to the center of the façade; rising from its neck like a stem is a greatly elongated curved neck crowned by the head of a *katik*, a mythical bird that inhabits the upper world.

The whole configuration seems to be a three-dimensional representation of the *jaraik* design: the head of the underworld buffalo with its upward-curving horns supports the cosmic tree, the trunk of which passes through the middle realm and into the upperworld domain of the mythical bird.[22] The Sa'dan Toraja make two-dimensional renderings of this cosmological motif as well. In them, the buffalo head is seen from the front, its ears pointing

downward and with horns curving outward and upward. In the center, there is a trunklike or ornamental vertical element (examples can be seen in the first row of carvings above the buffalo head in fig. 18).[23] The motif as a whole represents the cosmic order; it protects the living and illustrates a state that humankind must protect if accident and misfortune are to be avoided.

Similar representations can be found throughout Indonesia.[24] The motif has survived even among people like the Mentawaians who do not breed buffalo themselves. They have replaced the buffalo head with a monkey skull, while the carving as a whole has become purely ornamental. Only by comparing the various Indonesian versions is it possible to recognize the original configuration with horns and ears (see fig. 29, p. 41). Today the Mentawaians are no longer conscious of the motif's ancient cosmic references, but its original magical significance has not been lost. To this day, the ancient symbol helps to maintain the balance and harmony inherent in the cosmic order.

I would suggest that the previously mentioned Toraja carving of a person riding a buffalo (cat. 57) is inspired by the same compositional tradition. Again we see the buffalo head, but this time it is supporting not a pole and a bird but rather a human figure. The variation is easily explained; here an actual inhabitant of the

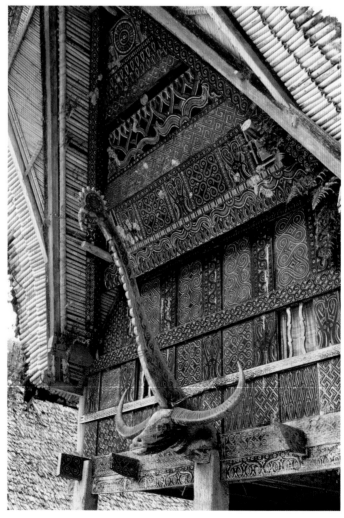

FIG 18 Sa'dan Toraja house in Nanggala, 1983.

FIG 19 Adaptation of a drawing by C.W.P. de Bie of a cist tomb painting depicting a buffalo and human figure, Tanjungara, Pasemah, South Sumatra, c. 100–700 CE.

middle realm is represented. As noted above, the figure is characterized as a guardian, but its meaning is surely related to the major role played by the buffalo in ritual feasts. Only persons of chiefly rank who have hosted certain major rituals were entitled to affix such ornaments to their houses. Since no such feasts have been given in Mamasa since the beginning of the twentieth century, the Dallas figure must be at least a hundred years old.

More radical variants of the motif are also represented at the DMA, but this time in the textile department. These reflect the seafaring nature of the majority of the archipelago's peoples and incorporate the ocean into the image of the cosmic totality.

As noted above, in numerous societies on Indonesia's islands, local groups characterize themselves as "ships' crews" and employ nautical terms in speaking of various social roles. This gives rise to a cosmic symbolism that is most strikingly represented in the famous ship cloths of the Lampung of South Sumatra. Some of these precious fabrics, the *palepai*, can reach ten feet in length, and they play an important role in rites of passage. In the woven motifs, human figures and animals can be seen standing around a treelike structure or mast on the deck of a ship, the prow and stern of which are somewhat reminiscent of horns. The word *lampung* translates as "floating on the water," an indication of how the people view their place in the cosmos. In terms of the Indonesian worldview described earlier, these motifs seem to imply that the sea is identified with the underworld and that the boat carries the world of the living on its deck, while the birds repeatedly pictured in the top half of the cloths represent the upper world. Vegetative elements recall the cosmic tree; in the most elaborate example at the Dallas Museum of Art (cat. 24), the trees are not standing on the deck of the ship but to the right and left of it. I see this implicit cosmological symbolism as a comprehensive complement to the more ethnographic layer of meanings presented by Nico de Jonge in his essay in this volume "Lampung Ship Cloths: Ancient Symbolism and Cultural Adaptation in South Sumatran Art," which elucidates many details on the cloths.

The formal relationship between the wooden and the woven versions of the three-layered motif is striking. The spreading buffalo horns viewed from the front and the boat with upturned prow and stern viewed from the side, each supporting symbols of life or human beings, follow the same basic pattern. As symbols of the cosmic order, these representations have a positive, protective function. It is impossible to state with certainty which of the two versions is older; they are both rooted in the Southeast Asian past. On several Bronze Age kettledrums, for example, some of them even found in Indonesia, one finds relief images of ships with upswept prows and sterns and festive crews quite similar to those depicted in the woven patterns of Lampung (compare fig. 15 on p. 20 with cat. 27). And no less ancient are prehistoric bronzes from China featuring buffalo-related monster heads with a vertical element sprouting up between the horns (*t'ao tieh*; see also the entry for cat. 18).

Over the course of history, each ethnic group has developed its own way of reproducing these ancient symbols. These motifs represent collective conceptions and have no aesthetic significance of their own. They are simply at the disposal, as it were, of the individual artist; they are part of the canon from which he or she can draw when creating a new artwork. It is only the artist's creative use of it that makes the resulting object a work of art.

In the dry regions of eastern Indonesia especially, another worldview has survived in addition to the notion of a three-part cosmos—a dualistic concept that opposes a male sky and a female earth.[25] They are united in a kind of "sacred marriage," and in the form of rain he makes her fertile. This notion is widespread beyond Indonesia, on the islands of Oceania, where there is no evidence

of Bronze Age influence. As in the case of the Lapita motifs, this dualistic view can be interpreted as the expression of an ancient Austronesian heritage. Conversely, the notion of a three-realm cosmos, predominant in the western part of the archipelago and corresponding to prehistoric Asian concepts, can probably be attributed to Bronze Age influences. Eastern Indonesian representations of a sky god thought to be the consort of Mother Earth are in any case a reflection of the dualistic view. In village centers, the sky god can be seen atop a pole, often squatting in a boat that has been interpreted as a reference to the earth goddess. Their union ensures fertility to the living (see fig. 120, p. 280).

In eastern Indonesia, the earthly realm is evoked in figural images as well. The idea of an ancient marriage between the male progenitor and a creature of the wilderness is reflected in totem-like associations between individual family groups and specific animals. Objects representing these associations were created in various materials and were intended to protect their owners. The fantastic mask of a bird's head from Leti, meant to be clamped between a dancer's teeth (cat. 96), was carried in periodic fertility rites celebrating the sacred marriage between heaven and earth.

In other Indonesian regions, figures of gods are virtually non-existent. Depictions of mythical creatures, by contrast, are all the more abundant. Again and again, we encounter figures from one realm or another of the three-level cosmos. I have already mentioned the stone dragonlike creature—*lasara*—from Nias in the collection of the Dallas Museum of Art (cat. 10); one writer has said that "it links the upper to the under world and thus represents the universe."[26] In this it recalls the *jaraik* motif described above. Among the Batak on Sumatra, the similarity is even more specific: there a comparable image with a dragon's head—*singa*—is created in various materials as a magical, apotropaic ornament, normally displayed at the end of the longitudinal beams supporting a house's living quarters (see fig. 1, p. 12). *Singa* are associated with the underworld, but a center element lifts up between their buffalolike horns, much as in the *jaraik* motif, that is once again thought to represent a cosmic tree rising up to heaven.[27]

Among the Dayak on Borneo, images of such mythical creatures are especially abundant. With its head often turned 180 degrees to the back, the legendary *aso* (cat. 33), which predominates in all decorative art, was clearly inspired by depictions of dragons on imported Chinese ceramics. It is frequently incorporated into decorative scroll ornaments whose spiral forms completely cover an object's surface. Here such designs are much freer, less bound by symmetry (see, for example, the Kayan shield, cat. 30), than the fussier, more repetitive ornaments on tribal art in other Indonesian regions. *Aso* actually means "dog" in some Borneo languages, but the composite, polymorpous depictions are simply imaginary underworld creatures believed to ward off evil much like the above-mentioned Batak *singa*. Cat. 39 pictures a man between two *aso*, and cat. 32 shows a warrior atop the parted tail of a monstrous beast, thereby recalling in a certain sense the Toraja figure atop a buffalo, another creature of the underworld.

In line with its cosmological significance, the *aso* is found together with images of other reptilelike or aquatic animals, all of which are protective attributes of Jata, the underworld deity who ensures fertility. Opposed to her is the hornbill, symbol of the male sky god in Dayak mythology, considered the creator of the cosmic tree that there as well serves as a link between the lower and upper worlds. In three-dimensional images of the hornbill, it is covered with fantastic raised curlicues like those of the ornamental *aso*. Incised drawings on bamboo vessels picture the inhabitants of the cosmic realms in configurations that again and again recall motifs on Dong Son drums.

It is my belief that in Indonesia headhunting was a way of celebrating the bounty of the surrounding wilderness. It was always conducted outside of the hunters' own social group and was crucial to rituals in which not only the ancestors but, more especially, nonhuman sacred beings might be supplicated for fertility and prosperity. This was particularly important when a new community house was erected, the most frequent occasion for a headhunt. The site on which the structure was to stand originally belonged to the mythical population predating the first immigrants, as mentioned above. By offering heads, it was possible to ensure their favor and consent. Headhunting expeditions were dangerous and laudable undertakings; they necessitated fine regalia such as the Dayak warrior's frontlet (cat. 32), and were celebrated in other artistic masterworks. The wall panel from Mentawai (cat. 3) depicting a headhunting victim from a rival clan is a notable example.

The blessings of the bride

Fundamental to the thinking of Indonesian peoples is the conviction that the family that provides the bride is ritually superior to that of the groom. In surrendering its daughter or sister, it has given the bridegroom and his family something that cannot be repaid, no matter how high the bride price: fertility and the prospect of future progeny. In several traditional societies in Indonesia, this idea has led to the rule that the "flow of life" accompanying the bride can never be reversed. The subsequent generations of a group who acted as wife-givers can never receive a bride from the descendants of their former wife-takers but have to take wives from a third group—a rule which leads to a circular network of alliances enhancing the internal cohesion of society. To be sure, this form of blessing, the third in the list presented above, is much less frequently expressed in art than the first two. One sees it in jewelry, the ceremonial wedding costume, and the textiles that furnish the wedding chamber.

Textiles are created by women, and it is in them—above all, in the splendid patterns produced in the *ikat* technique—that the power of the female blessing is reflected. Among the Dayak, for example, headhunting trophies were required to be wrapped in cloth made by women of the tribe if they were to provide the community with the desired benefits. There are examples of such a fabric in the Dallas Museum of Art (cats. 51 and 52). But fabrics are of greatest importance at weddings. In eastern Indonesia, the bride

price was made up not only of masculine, "hot" goods like gold and weapons but also of imported fabrics from India, associated with male booty owing to their foreign place of origin. In exchange, the bride brought to the marriage locally woven textiles, regarded as "cool" and associated with fertility.

Comparison with practices in the extreme west of the archipelago once again exposes the basic similarity among Indonesian cultures. On Mentawai, a dagger like the one in Dallas (cat. 2) was an indispensable component of the bride price, and to this day the precious goods thought of as "male" and presented to the bride's family among the Batak in Sumatra are referred to as *piso* (dagger). There, too, the bride's "female" contribution consists mainly of locally woven fabrics called *ulos*, which are meant to bring fertility and permanence to the marriage.

The artistic heritage today

As a result of missionary proselytizing, colonial rule, and the revolutionary struggle for "nation building," the majority of Indonesia's artistic traditions described here are features of the past. A few exceptions serve only to prove the rule. In remote regions of Mentawai artists are still carving birds as "toys for the souls," and the Toraja's more realistic versions of the *tau-tau* and showpiece tribal houses attest to their strong ethnic consciousness. The Batak erect large monuments made of painted concrete to their founder-ancestors, and a number of Dayak groups still produce images of the deceased for use in funeral rites. Fabrics continue to be woven in the traditional techniques on many islands. But in most cases, the cultural connotations inspiring works of art as described here have been forgotten. Unfortunately, this means that a number of issues that have only recently received the appropriate attention among anthropologists and art historians can no longer be properly investigated. For example, far too little is known about individual artists and their personalities, and still less about the aesthetic criteria by which their works were judged. From various testimonies, we know that differences in quality were recognized, and it was generally agreed among their fellow tribesmen which works were most deserving of praise.

Today surviving works of Indonesian tribal art are highly esteemed in the West, as evidenced by the increasingly high prices paid for them. In order to meet this demand, craftsmen are now producing either faithful copies or pieces mimicking traditional styles that—in contrast to more innocuous "airport art," which profits from the same interest—are often artificially aged with considerable skill but are simply counterfeits. The fact that a high-priced and obviously cleverly reproduced artifact not only ceases to be marketable once it is revealed to be a modern creation but suddenly becomes worth little more than the wood that it is made of attests to the general mind-set of potential buyers. Frequently such fakes are not even made by members of the tribes in question. In Bali numerous galleries offer supposedly antique native works in any style that customers request that are in fact new fabrications produced in the courtyard out back.

Yet such developments can have a positive side as well. Among the airport art, and even in antique shops, one often finds artifacts that cannot simply be dismissed as routine copies but that in fact expand upon the traditional repertoire of artistic forms. The creators of such objects are clearly motivated to further develop what has been passed down to them. To increase their market value, dealers frequently give them an artificial patina and offer them as authentic traditional pieces. When they are successful, there is the danger that researchers might mistake such innovations for elements of the traditional stylistic canon—a danger one must guard against.[28] But in themselves, such innovations reflect a lively degree of creativity, even though it is motivated by commercial considerations instead of traditional religious beliefs.

There is also a political aspect to the continuing focus on inherited forms and artistic traditions. In our era of globalization, it happens that educated young people are increasingly impelled to learn more about the cultural heritage on which their ethnic identity is based. One sign of this growing fascination is the unexpected revival of tattooing in many places after years of prohibition. And again and again, one is struck by the eagerness with which young people study published illustrations in their search for older, often forgotten evidence of their cultural roots. By preserving such testimony, museums can play an important role, serving as repositories in which the descendants of tribal cultures and Westerners with similar interests come together.

Needless to say, there are also artists among the descendants of earlier tribal cultures who are no longer working within the traditional formal canon but going in wholly new directions, considering themselves part of the contemporary international art scene. At most, they may take inspiration from the ancient motifs, but they by no means think of the traditional anthropological museum as the appropriate repository for their art.[29] The Dallas Museum of Art, one of the major museums to display World Art from all periods and regions without discrimination, would be a suitable venue for such works as well.

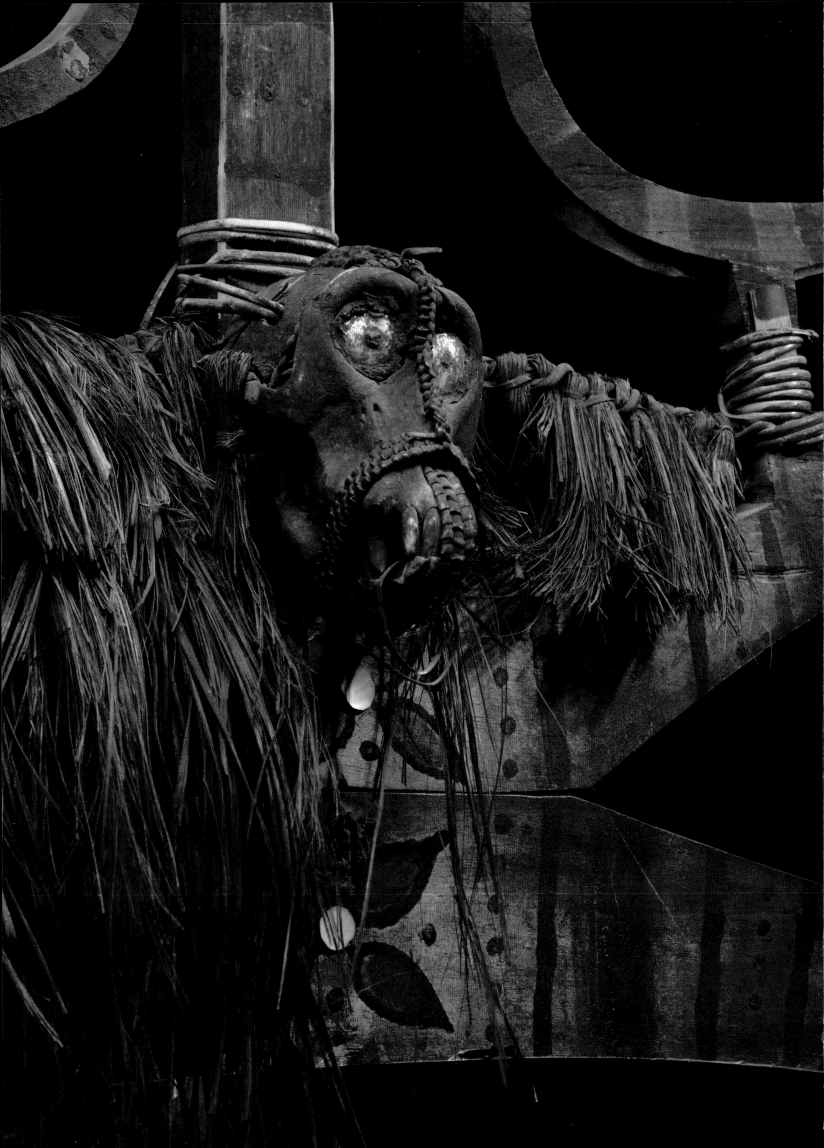

TOYS FOR THE SOULS: THE ART OF MENTAWAI

Reimar Schefold

The inhabitants of the Mentawai Archipelago, west of Sumatra, came into contact with the modern world relatively late.[1] Siberut, Mentawai's northernmost island, was especially ill-reputed for its tradition of headhunting. About the same size as Indonesia's best-known island, Bali, it consists of approximately 1,478 square miles. Given the humid and malaria-infested hill country there, and the fact that much of the landmass was covered by dense, tropical rain forests, Mentawai offered very little for Europeans to exploit economically.

The archipelago's isolation lasted until the beginning of the twentieth century, when the Dutch colonial government began in earnest to establish control over the Mentawai Islands. For the islands' indigenous inhabitants, however, apart from a prohibition on the old custom of headhunting, there was little interference with their traditional culture until Indonesia declared itself independent in 1945. This status quo radically changed in 1949 with the commencement of President Sukarno's term of office. The newly constituted Indonesian government considered the islands' inhabitants to be backward and primitive. In 1954, a new decree was promulgated to force Mentawaians to adapt to mainstream Indonesian society. This decree had devastating effects on the ancient cultural heritage there, as it required Mentawaians to give up the custom of tattooing, abandon animistic rituals, adopt a world religion, wear modern dress, and move into newly built villages of single-family dwellings rather than continue to live in scattered longhouses.

Within a few years, the best examples of Mentawai's rich artistic legacy very quickly and almost entirely vanished. Often artifacts were actively sought and burned by zealous missionary teachers or government officials. Yet despite this onslaught against their beliefs and customs, and even to this day, a few groups in the interior of Siberut have stubbornly managed to maintain much of their traditional culture. After a period of self-imposed isolation, they are now enjoying the greater tolerance practiced by the present government and have made a deliberate choice to continue with their ancient and customary way of life. The following text presents an overview of these time-honored traditions.

Traditionally, Mentawaians live off the land, cultivating sago, tubers, and bananas. They also raise chickens and pigs, and go hunting and fishing. The workload is divided between the men and the women. There are no specialized technical skills. Important basic utensils, such as iron tools and textiles that the Mentawaians cannot produce themselves, are exchanged for coconuts and rattan with coastal Malayan merchants. The Mentawaians have neither chiefs nor slaves, nor are there any inherited political positions. Their communities are organized in clan groups of about ten families. Such a group lives in one big house, the *uma*, and shares the responsibility for all important communal activities. These clan houses are built at irregular distances from one another along rivers. Traditionally, the Mentawaians did not construct trails or lay out jungle pathways. In this region, the canoe was and still is the most important means of transport. These vessels are used to collect the harvest from the gardens, and to visit neighboring *uma* in the river valley (fig. 20).

The Mentawaians take pride in producing their own ceremonial paraphernalia, conveyances, utensils, and other essential items for daily life, all with the utmost care. To make a beautifully shaped, well-balanced dugout canoe, or a well-smoothed bow with skillfully

FIG 20 Women of the Sakuddei clan paddle a canoe along the Sagulubbe river.

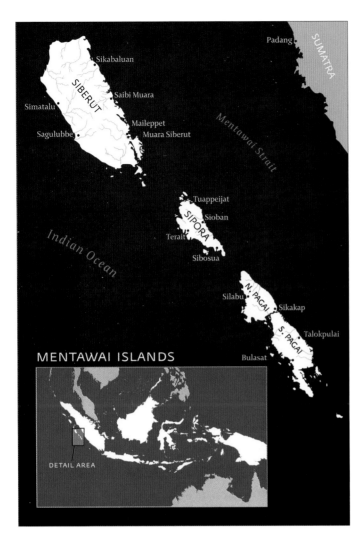

Padang

SUMATRA

Sikabaluan

SIBERUT

Saibi Muara

Simatalu

Maileppet

Sagulubbe

Muara Siberut

Indian Ocean

Mentawai Strait

Tuappeijat

SIPORA

Sioban

Terai

Sibosua

Silabu

N. PAGAI

Sikakap

S. PAGAI

Talokpulai

MENTAWAI ISLANDS

Bulasat

DETAIL AREA

ornamented ends, or a shiny black polished container fashioned out of a coconut shell and decorated with incised patterns, there are models handed down by tradition. In contrast to most other ethnic groups in Indonesia, such traditional objects are still produced today among the people of the interior. When an object satisfies the traditional requirements, it is called *makire*, which means something like "exactly corresponding," and its producer is praised for its quality.

One of the requirements for an object to qualify as *makire* is technical perfection. Another requirement regards its aesthetic execution: its outward form, ornamentation, and decoration. The Mentawaians possess a rich canon of inherited forms and patterns, which is at the artists' disposal and serves as a stimulus for their creations. This artistic canon provides a frame; within its confines there is a certain artistic freedom.

Typical of the conventional designs are various forms of the spiral motif, as well as related geometrical forms that can still be encountered in most present-day Indonesian tribal art traditions. The arrangement of these forms and elements can be traced back to two representational principles. The one most frequently encountered is a repetition of identical elements in a row. The second involves a strictly symmetrical arrangement of mirrored configurations.

Ornamental decorations are carved in relief, incised, or painted. The most beautiful examples are perhaps the shields that protected warriors during the era of headhunting (see cat. 1). Their surfaces are painted with spiral patterns. Occasionally, small human figures and animals such as monitor lizards, bats, and toads are also depicted. The surrounding compositional elements are set in various arrangements: sometimes running parallel, sometimes branching away and entering into new relationships with other sectional designs. This can create an intriguing dynamic of tensions between the inner and the outer parts of the designs, which are underlined by partial red painting. Characteristic of the execution of the spirals is the precise and regular tracing that appears both in the representation of a single spiral, and in the careful arrangements of several spirals to form symmetrical patterns. Regularity in the shaping of spirals was sometimes reached with the help of coiled strips of rattan glued to the surface with resin to guide a wooden stylus that had been dipped in black paint. The same method was also helpful in drawing the symmetrical outlines of other categories of ornamental art. Of these, the protective *jaraik* (cat. 4) can be counted among the Mentawaians' greatest masterworks. These impressive religious objects, often of an imposing scale with elaborate openwork carving and fitted with the skull of a macaque (*bokkoi*; *Macaca nemestrina pagensis*), are found above the entrance to the rear room of Siberut longhouses (see fig. 29, p. 41).

The same controlled regularity that is found in these artifacts can also be observed in tattoo motifs. It even appears in ritual dances, the patterns of which are characterized by precise single-file or mirror-image movements of the participants.

Along with the ornamental use of scrolling, spirals, and other geometric designs, figural representations of animals and humans in the round, in relief, or incised are part of the Mentawaians' artistic repertoire. Carved and painted wooden birds are put up in community houses during grand rituals with their fronts always pointing toward the entrance (fig. 21). Due to their pleasing forms, they are known as "toys for the souls" (*umat simagere*). Carvers explain that before fashioning a bird, they carefully observe birds in nature. Whenever the result of their work turns out to be lifelike, such a carved bird is labeled as *makire*. Strangely enough, this realism does not apply to the way the bird is painted, which by tradition makes use of the same spirals, stripes, and dots that characterize ornaments in general and thus contrasts quite strikingly with the natural model.

The characterization of these birds as "toys for the souls" needs some explanation. For the Mentawaians, everything—human, animal, and plant, but also every object—lives and has a *simagere*, a spiritual component that I translate here as a "soul."[2] All souls are capable of separating themselves from their possessors. As a kind of invisible double, they wander around, having their own experiences, both good and bad. That is why a person must take great care to lead an attractive life. This includes beauty in physical appearance: tattoos as well as painting one's body and adorning oneself. The beauty of the group's communal house is also a factor,

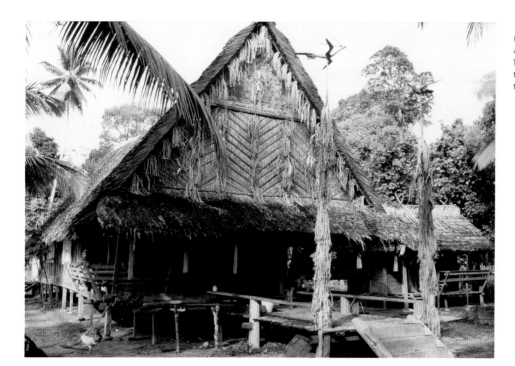

FIG 21 Mentawai communal dwelling (*uma*) in a Sagulubbe village on the west coast of Siberut, 1974. This *uma* has been decorated during a ritual to keep the souls of the residents from straying too far away.

along with the flowers planted around the house and the carved wooden figures decorating the walls. But first and foremost, an attractive life includes beautiful festivities, sometimes lasting several months. Otherwise the soul will feel neglected—it will desert its owner and move in with the ancestors. Then the owner dies. In other words, beauty is a prerequisite for life.

The "toys for the souls" help to prevent any errant souls of the *uma*'s inhabitants from going too far away by attracting them back into the house. Moreover they lure the souls of game animals as a precondition for success in hunting (fig. 22). However, these birds are not only supposed to attract various souls, but are also conceived as being endowed with souls of their own. And these souls must be respected, too. This can mean that while fashioning a bird, its creator must somehow let himself be guided by the object he is working on (fig. 23). Maybe he starts out with the intention to make an eagle, but during the process of its carving he realizes that the form begins to resemble a dove. In this case, the carver will not try to insist on his original idea, but will adapt himself to the apparent desires emanating from within the material itself, and will simply end up carving a dove.

Thus within every artifact there is a living entity. Such items cannot simply be used as objects at will but rather are subjects that may allow people to make use of them. Therefore, an item should not be clumsily produced. Otherwise, it will feel as though it is not being well suited to its category and will be less fit for its intended functions. For instance, a shield will provide good protection only if it can feel like a shield. In other words, its form should match what a proper shield should look like, and its ornamental decorations must be carefully rendered, as these attributes were handed down from the ancestors.

In still another respect, the soul of an object plays a role. There is one more seminal term that Mentawaians use to judge the aesthetic value of an object: *mateu*. In contrast to *makire*, *mateu* is not an absolute statement, as it is directed toward the relation of a given object with a perceived context. This term is perhaps best translated by equating it with the word "fitting."[3] A huge carved bird in a small house is not *mateu*; it does not fit in. A clumsily carved bow in the hands of an experienced hunter is not *mateu* either. Yet it can happen that one's relationship with an object is affected by the object's particular soul, which can exercise or exert its own influence over the object's owner in different ways. Take, for example, the clumsily carved bow. It may not appear to be fitting per se, but perhaps for a certain hunter this bow may turn out to be exactly the right one, since experience has shown him that he is most successful while hunting with this particular bow. The bow fits and is correct for him. On the other hand, it can also happen that a bow that actually is *makire* does not bring a good hunter any luck. This bow is not *mateu* for him. In both cases, the term can be explained only in relation to the fact that the bow possesses an individual soul: the first bow harmonizes with the hunter, the second one does not.

The idea of everything possessing a soul (a worldview that is often called "animistic") thus inspires the need for technical and aesthetic perfection in the fabrication of an object. No wonder the most beautiful traditional Mentawaian artifacts were made before the 1950s, at a time when this worldview was still informing their production.

The realistic ideal that the Mentawaians cherish concerning the depiction of birds is also applied to other figural representations. In times of headhunting, frontal human figures were carved in relief to commemorate the killing of an enemy and then inserted as panels along the inner walls of the *uma* (see fig. 28, p. 39). Even today, certain wild animals such as monitor lizards, monkeys, and crocodiles are occasionally carved in relief on doors and panels.

Representational details also appear on the arms of suspension hooks, the handles of daggers, or carved wooden floats for sea-turtle nets that often terminate in the depiction of small feet or of the heads of animals. Often, monkeys, too, are carved on the lids or etched into the surfaces of containers made of coconut.

Carvers are not conscious of the fact that a particular formal artistic canon is influencing their work, even when they have attentively observed a subject within the natural environment. Working within the framework of their creative canon, Mentawaians regard what they create as being true to nature, and therefore realistic. However, even when the Mentawaian image aims at the realistic, to the eyes of an outside observer it may still appear strongly stylized. For instance, in depictions of deer, Mentawaians always used to render the animal's hind legs with the joints facing the front, as in the case of a human being. During my stay on Siberut in the late sixties, I expressed astonishment at this manner of representation but was assured that all deer on Siberut were built in this way. When a stag was shot shortly afterward, I pointed out the difference, which caused all the *uma* dwellers to excitedly gather together to inspect such a wonder of nature. Obviously, they had always been accustomed to seeing the reality of the deer's hind legs in their own unencumbered way, and in this sense, their drawings were *makire*. Consequently, the local community did not show the slightest inclination to sacrifice its inner image of a deer to any vulgar external facts. Some years later, I visited the same *uma* and distributed some paper I had brought with me. When the people there set to work, they drew their deer in exactly the same manner as before, and in a fashion that was

deemed proper for as far back as their collective memory reached (fig. 24).[4]

Distinct details often determine what is to be considered realistic or not. When I myself started to draw portraits of some Mentawaians, they seemed to be barely concerned with their individual physical likenesses, but were very interested in the exact reproduction of their tattoo lines. When these were correct, they stated with satisfaction, "*Makire!*"

Therefore, it does not come as a surprise that the designs of Mentawaian artifacts are very conservative. There is no major difference in form between the oldest specimens preserved in museums, which were created more than 150 years ago, and artifacts for domestic use that have been made in recent times. Paradoxically, however, as in many other tribal cultures, the strong formal canon shared in common by the tribe invites rather than impedes individual creativity. The frame it provides comprises models that stimulate original solutions while heeding the dictates of the ancestors. Indeed, any mere replication of a traditional piece would be in direct opposition to what we have come to see as a basic Mentawaian conception. Their notion that everything is alive and that, accordingly, every production of new artifacts is equivalent to the creation of a new individual being engenders a permanent innovative confrontation with the working material. And if such individual variations are positively received, they can eventually lead to local changes and thus help to keep the style in ferment despite all its conservatism.[5]

Among the Mentawaians, there are no specialists for the production of such artifacts, nor is there an understanding or conception

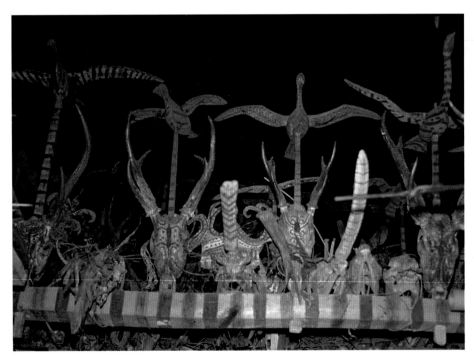
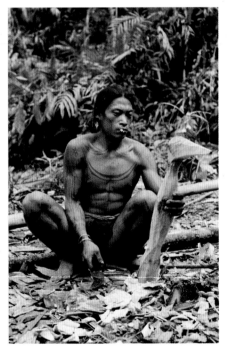

FIG 22 The skulls of hunted stags are beautifully painted and decorated with wooden birds in order to entice the souls of the animals to remain in the *uma*, and to attract the souls of new animals. They are attached to a beam in the front part of the Sakuddei *uma*, 1974.

FIG 23 Amanuisa, a man of the Sakuddei clan, carves a bird as a "toy for the souls," 1967.

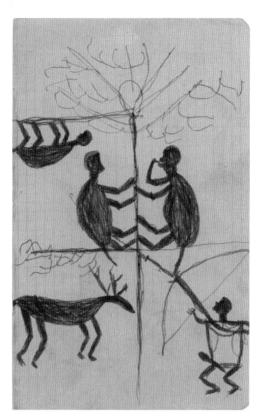

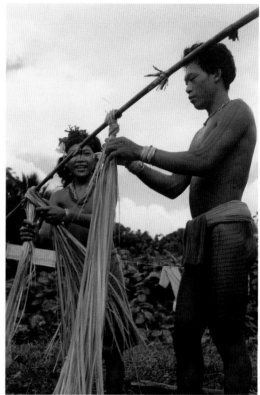

of art as a phenomenon separate from other aspects of life. Most of them believe that they can make what we would call "artifacts," and whoever makes them will be their owner. This understanding is expressed in the double meaning of the word *sibakkat*. Literally, the term is defined as "stem," but it also can be translated as both "originator" and "owner." This equation at least holds true for objects made for daily use. For artifacts used on communal ritual occasions, which are normally not sold or exchanged, the situation is somewhat different in that all members of the group cooperate. The actual carving is always a task for the men; sometimes one man carves the body of a bird, and another the wings. Women take part in its decoration by painting and embellishing it with vegetative materials (fig. 25). A short knife with a curved handle (*balugui*) is the only special tool used for carving details. For the rougher jobs carvers use axes and machetes.

In principle, every individual in the community is involved in artistic production. However, it does not pass unnoticed that one particular artifact more than others might emanate a formal strength and ingenuity while at the same time revealing unexpected and surprising details. Just as people in the Mentawaian community know very well who is the most experienced hunter, the most successful pig breeder, or the most elegant dancer on ritual occasions, they will also notice who is the most talented woodcarver. While they do not call him an artist, his ability is acknowledged and known throughout the whole region. That person is proud of his accomplishment, his personal style is recognized, and he is admired by others because of his creations.

It is to such persons that others will address themselves when artifacts of special importance must be made. In the past, this was especially the case with artistic products associated with headhunting raids, including shields, daggers, and human figures. When headhunting, Mentawaians always raided a group living in another valley. Those who were successful gained honor and greater esteem among the neighboring *uma* in their own region. This competitive spirit manifested and expressed itself in their related artistic creations. The shields, the figures, and the daggers with their ornate handles were all produced with an extremely high level of craftsmanship, attention to detail, and expressiveness. With perhaps the exception of an occasional *jaraik*, these qualities are never quite achieved in items made after the First World War, following the Dutch government's ban on headhunting raids.

The Dallas Museum of Art possesses an outstanding example from each of these four categories of artifacts. These rare items have been previously shown and documented in exhibitions of Mentawaian art in Delft and Zurich[6] and were part of the exhibition *Budaya Indonesia* at the Museum of the Royal Tropical Institute in Amsterdam from 1987 to 1988. These objects truly celebrate the past but also express the enduring spirit of Mentawai. Even as they are now appreciated as "art" by audiences that are far removed from their time, place, and original cultural domain, an examination of the twin notions of *mateu* and *makire* enriches our understanding of the objects while illuminating their inherent appeal.

1

Shield (*koraibi*)

Indonesia, West Sumatra, Mentawai Islands,
Siberut Island, Sagulubbe village
c. 1900
Wood, paint, rattan, and coconut shell
39¾ × 10¾ × 5¼ in. (101.0 × 27.0 × 13.3 cm)
Gift in loving memory of Corinne Galinger Alpert
by the Alpert Family, 1999.135

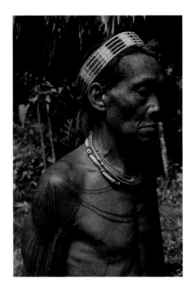

FIG 26 Matsebu, the previous owner
of the shield. Sagulubbe village, 1968.

This superb shield (*koraibi*) made from lightweight wood was acquired in 1968 from an elderly shaman of the Siriottoi clan, Matsebu (fig. 26), who had inherited it from his father as part of the latter's headhunting equipment. The old shaman had kept the shield because of its incised drawings of hands that had been carved over the shield's original designs.[1] Hands serve as a mnemonic device that is used to preserve and keep alive the memory of deceased relatives. Consequently, when all those who had known the deceased passed on, and memory had sufficiently faded, such incised items were generally no longer kept. The shield was so darkened with age that before selling it, Matsebu felt compelled to clean it. After the shield was washed in water, its original colors and designs boldly reemerged. The colors were created from local natural materials: the juice of the red *kalumanang* fruit and black soot that was mixed with the juice squeezed from the bark of the *onam* tree.

This shield's motifs are a good example of the two principles mentioned in the introductory essay—repetition and symmetrical arrangement—which are highlighted by the Mentawaians' ingenious technique for shaping beautifully balanced and exacting spirals. According to the statements of some informants, the small figures at the tapered lower ends of each side of the shield represent the victims of a headhunting raid. On some other shields, a squatting toad is depicted, which is reminiscent of the custom of tattooing warriors with the image of a toad (whose appearance suggests a headless body to Mentawaians) after a successful headhunt. The occasional figures of other small animals, however, are reported to be purely decorative.

These shields were made exclusively for headhunting raids (*pulakeubat*). Generally these raids were undertaken together by the members of a few neighboring *uma*, and they took place far from the men's own homes in other remote valleys on the island. The raiders came stealing up in a row, the first ones carrying daggers and machetes, the middle ones holding bows and poisoned arrows, and the last ones bearing sharpened spears. All except the middle group carried shields as protection against hostile arrows.

Mentawaian shields were made from slightly convex-shaped sections of the exposed buttressing roots of *gite* trees. The wood was first exposed to fire and smoked in order to make it insect-resistant. Then it was hewn into shape, finely formed, and lastly painted with natural red and black pigments. During a shield's creation, an activity that demanded all of the maker's attention, he had to abide by various taboos and to refrain from sexual intercourse. Once the shield was finished, a ritual offering of a chicken was made as a final gesture to inaugurate and prepare the *koraibi* for its protective tasks.

These shields are known to come only from Siberut, which was the one island in the Mentawai Archipelago where people practiced headhunting in historical times. They exhibit a distinctively tapering lower end, with a rounded tip below a curving middle portion that flares into a broad upper section. In the midsection is a raised protrusion formed by one-half of a split coconut shell. The coconut shell is fastened to a circular opening in the center of the shield with rattan bindings. Dividing the opening is a wooden grip. The coconut shell served as a guard to protect the warrior's hand.

According to Heinrich Hugo Karny, a biologist who traveled to Siberut in 1924, shields had become scarce even in those days. However, when I was exploring the island in 1967, I was informed that upon news of my arrival, the men of the village of Matotonan in the interior had reassembled seven shields they wanted to sell to me in exchange for machetes, cloth, and tobacco. Due to a malaria attack, I had to cut short my journey before reaching that village. Thereafter, these shields seem to have shared the fate of so many other Mentawaian artifacts, as they were left falling into ruin and thrown away. Several years later when I was visiting Siberut again, it appeared that none of these shields had survived.

The form of this shield type is documented as early as the 1890s.[2] Some shields with even older collection dates are in venerable museums with large ethnographic collections.[3] Among these specimens, there are variations in form and in the designs painted on the surface. However, since their exact pedigree or provenance is unknown, it is not clear whether these stylistic variations are due to the regional isolation of different groups or to other historical factors. R.S.

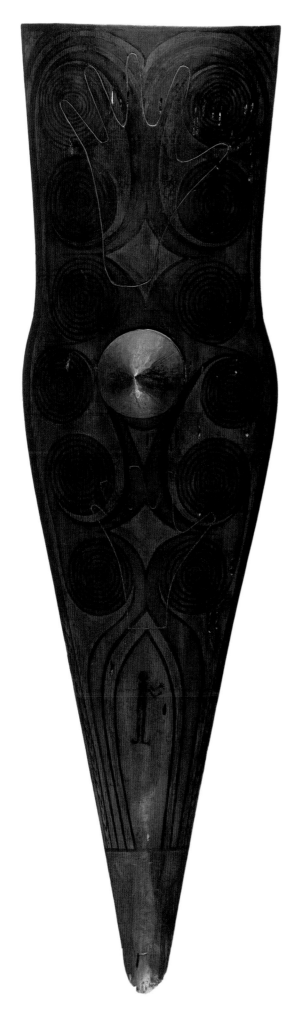

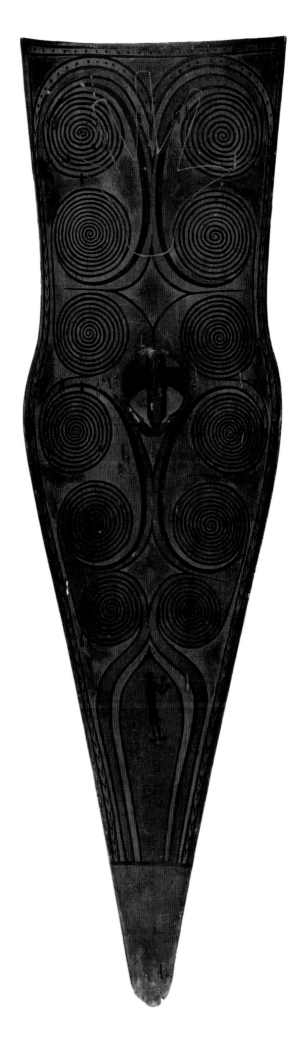

FRONT

BACK

2

Dagger (*pattei*)

Indonesia, West Sumatra, Mentawai Islands,
Siberut Island, Berisigep village
c. 1900
Wood, imported iron, chicken feathers, rattan,
bone, and cotton cloth
18⅞ × ¾ × ⅜ in. (47.9 × 1.9 × 1.0 cm)
Gift in loving memory of Corinne Galinger Alpert
by the Alpert Family, 2002.12.A–B

FIG 27 Mentawaian warrior with dagger and shield, by C.B.H. von Rosenberg, circa 1850. Courtesy of KITLV/Royal Netherlands Institute of Southeast Asian and Caribbean Studies 36A113.

This exquisite dagger (*pattei*) comes from northern Siberut (Berisigep) and was said to have been made in headhunting times more than a century ago. It has an iron blade that was obtained by barter from Sumatran traders as a blank and then ground into shape. Such blades are also used to tip spears. Unlike many of the other ethnic groups represented in this catalogue, Mentawaians did not forge their own metal.

The wooden sheath of this dagger is carefully polished and was colored red with the juice of the *kalumanang* fruit. It consists of two parts that are secured at the bottom by a bone ring and at the top by a binding of rattan, also colored red in a complicated process that involves cooking the binding with vegetal materials in a dye bath. As a final touch, clusters of chicken feathers were carefully wrapped and affixed to the rattan binding. The lower end of the dagger's sheath is slightly curved, in perfect counterpoint to the sharper curve of the solid wooden handle. This elegant grip is ornamented in the middle by a thickened ridge and ends in a spiral that, according to some informants, refers to a coiled millipede or, according to others, to the tightly wound coil of an unopened fern. The wooden parts are carefully polished, and where sheath and handle meet, there are finely incised decorative designs, the grooves of which were subsequently filled with black resin.

These daggers are tucked at a horizontal angle into the loincloth on the right-hand side (fig. 27).[1] According to this dagger's previous owner, a *pattei* was a necessary part of every bride price. As symbols of a warrior's prowess, *pattei* were carried on headhunting expeditions.

There is a Mentawai myth that reveals the significance of a dagger for its owner. It tells about a boy who asks his father to make a *pattei* for him. The father refuses, and the boy goes to his mother's brother in a neighboring house, who presents him with a beautiful dagger. Upon returning home, the boy is taken by his mother to her taro field. But although he explicitly asks her to be careful, she negligently breaks the dagger during her work. The boy then climbs a tree and magically ascends into the sky. In the sky, he meets other beings who accept him into their midst and help him to raise his own chickens. Eventually, he returns to his parental longhouse, where his mother tries to lock him up in order to keep him at home. The boy flees and returns forever to the sky people. Obviously, this story has to do with the problem of detaching oneself from the dependencies of childhood. The dagger that the boy receives at the end of his journey to the house of his mother's brother symbolizes his awakening masculinity.

Due to the ban on headhunting, such elaborate daggers are no longer made. Instead, bride price transactions now include other items that are given in explicit "replacement for a *pattei*." From the literature, daggers are also known from the southern islands of the archipelago, Sipora and Pagai. While similar in size and basic shape, some of these daggers have handles in the form of the head of a cock or a man. Examples are found in the ethnological museums in Amsterdam, Basel, Copenhagen, Leiden, New Haven, CT, Rotterdam, and Washington, D.C.[2]
R.S.

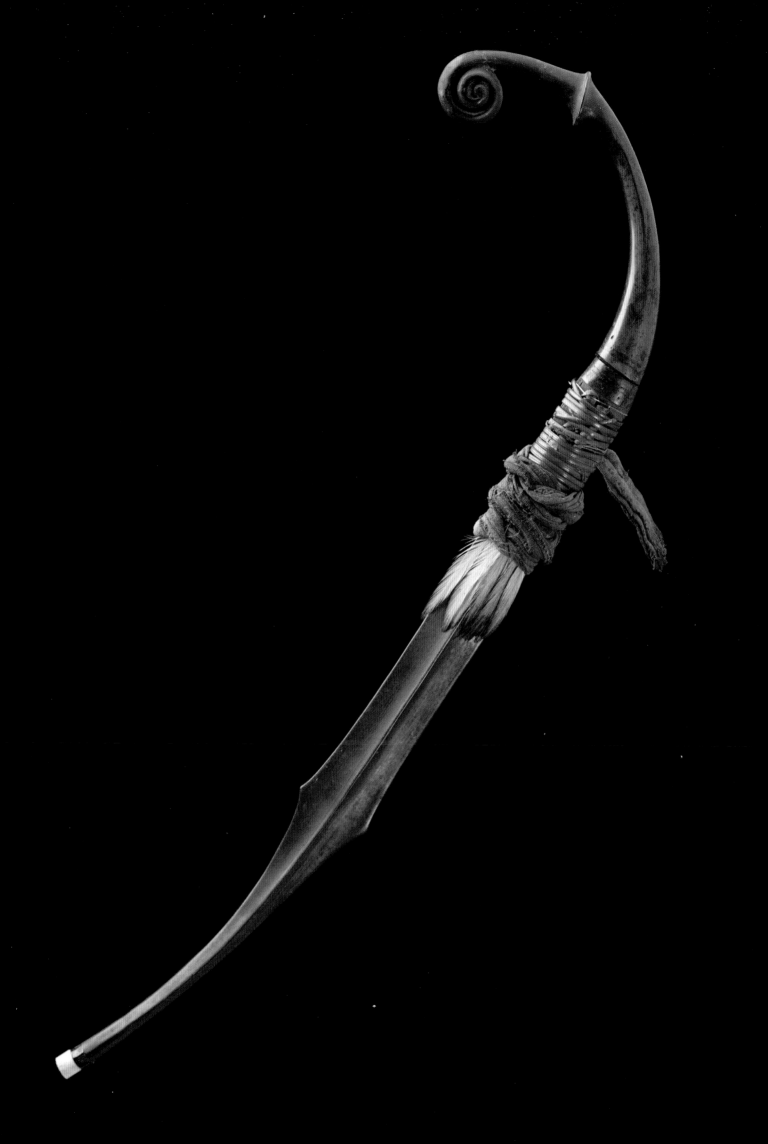

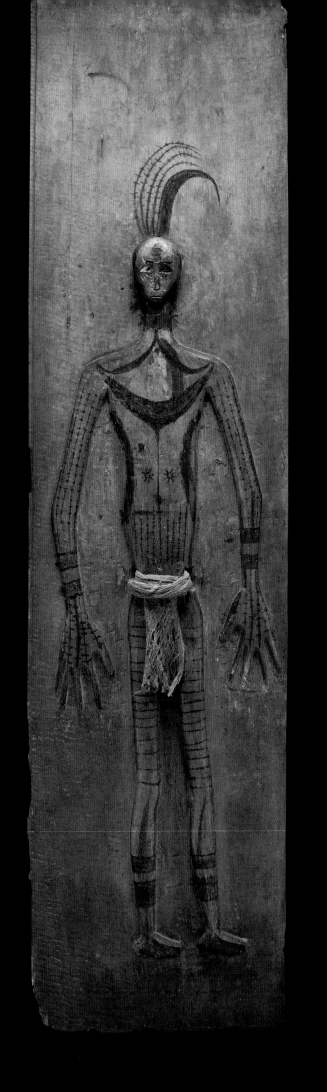

3

Wall panel with figure of a slain shaman (*tulangan sirimanua*)

Indonesia, West Sumatra, Mentawai Islands,
Siberut Island, Taileleu village
c. 1900
Wood, bark, paint, shell inlay, and cloth
69¼ × 18½ × 4 in. (1 m 75.9 cm × 47.0 cm × 10.2 cm)
General Acquisitions Fund, 1999.3

This panel with the relief of a human figure (*tulangan sirimanua*) comes from a deserted longhouse (*uma*) of the Siriottoi clan in Taileleu in the southern part of Siberut. It was acquired in 1967 from the son—then about sixty years old—of the headhunter who had made it upon returning from the successful raid that crowned the inauguration of his clan's new house. Such a figure served as a memorial and increased the renown of an *uma*; it had no special religious function. The person depicted on the panel bears the tattoo patterns of northern Siberut, the region where the Taileleu people traditionally went headhunting. The panel was inserted into the rear wall of the first interior room (fig. 28) next to a second figure (the second victim of the raid). In 1967, however, this room was nearly destroyed by termites, as were most other parts of the *uma*. The painting of a feather decoration above the head identifies the figure as the portrait of a *kerei*, a shaman.

The two figures were the last ones still in situ in Taileleu. Three or four other examples from neighboring *uma* had been taken out of the decaying houses, together with some other planks that were well preserved, and brought to the governmentally enforced modern village to serve as material for the construction of new housing. When they returned to the old Siriottoi longhouse, children played at headhunting by throwing pieces of clay at the figures, the traces of which, since washed off, can still be seen in the photograph. Their parents had taken pride in the figures that manifested the former courage and vigor of the clan. Now that the house had been relinquished and set to ruin, and memories had faded, they did not especially care whether these figures became detached from the dwelling or not.

On the wall panel, negative space has been hewn from a thick plank to reveal a nearly life-size image of a standing shaman. His head is small, but the shell inlay that survives in his right eye conveys a piercing gaze. The splayed hands are enormous, enhancing the monumental quality of the figure. The lines representing the tattoos indicate the local origin of the depicted person; indeed, after purchasing the panel, the collector was warned not to show the piece to people from northern Siberut since this could still

provoke a hostile reaction. The loincloth was added when the figure was sold in 1967, as a replacement for the original, which had not been preserved.

In both the scientific literature and in museum collections, wall panels such as these are decorated with relief figures of animals, but generally not with those of humans. This is one of a very small number of panels with human figures that has survived.
R.S.

FIG 28 The DMA panel in situ, Taileleu village, Siberut, 1967.

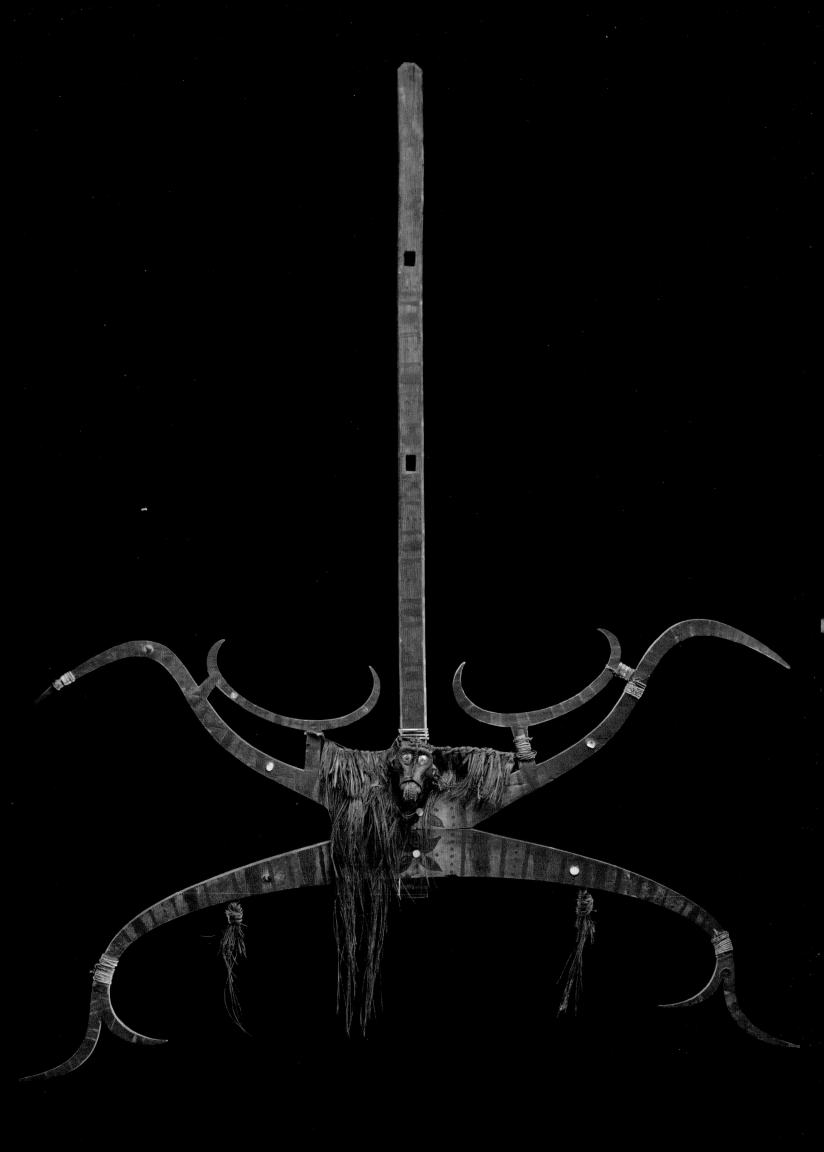

4

Sacred carving (*jaraik*) with monkey skull

Indonesia, West Sumatra, Mentawai Islands,
Siberut Island, Taileleu village
c. 1930
Wood, mother-of-pearl, pigment, plant fibers,
macaque skull, and rattan strips
70 × 56½ × 12 in. (177.8 × 143.5 × 30.5 cm)
The Eugene and Margaret McDermott Art Fund, Inc.,
2001.265.McD

Reigning from its place above the doorway to the second inner room of a communal house, the *jaraik* is a powerful sacred object that marks the entryway into the space where the women and young children traditionally sleep. Its primary task is to keep out all evil forces and to lure in positive influences for the benefit of the community. The efficaciousness of every *jaraik* is ensured by the addition of a consecrated skull from only one species of macaque (*Macaca nemestrina pagensis*), which is locally known as a *bokkoi*.

The origin of a *jaraik*'s overall shape is most likely derived from a buffalo head carrying the cosmic tree, a ubiquitous symbol that is commonly encountered among the various ethnic groups of Southeast Asia. Among the Mentawaians, who do not possess any buffalo, this conceptual convention has fallen into oblivion. Linguistically, however, there are sacred carvings in certain regions of Mentawai that are still referred to as *batu kerebau*. In all probability, this combined term is derived from the word for animal horns (*bat*), and the general name for water buffalo (*kerbau*). However, the Mentawaians are no longer aware of this, and the etymology of the word *jaraik* itself is not clear.

At least three *jaraik* are known to exist that were made around the time traditional headhunting raids came to an end in Mentawai. In my book *Speelgoed voor de zielen; kunst en cultur van de Mentawai-eilanden*, 1979–80, two of these *jaraik* (one of which is cat. 4) are illustrated.[1] A third *jaraik*, and the oldest one known in a museum's holdings, is a fragmented example that was collected in South Siberut in 1926 by Paul Wirz. That *jaraik* is in the Museum der Kulturen (Museum of Cultures) collection in Basel.[2]

The Dallas *jaraik* was purchased in Taileleu in South Siberut in 1967. It comes from the *uma* of the Samalakopa clan, whose members had converted to Christianity in the late 1950s to early 1960s. The time of its origin was given as before World War II. It is a remarkable piece whose masterly elaborations, ornately curved tendrils, and widely outstretched arms surrounding the *bokkoi* skull just below the central column reflect the spirit of those competitive times. According to its previous owners, the form of the *jaraik* was inspired by the body of a squatting gibbon, a small ape,

with outstretched arms and hanging hands. A *jaraik*'s significance was enshrined in an elaborate ritual (*liat jaraik*), whose activities were dedicated to its fabrication and included the ritual hunt for a macaque to acquire its skull. The level of artistry in this piece, along with the inimitable balance struck between a presence that is both frightening and reassuring, corresponds directly to the sacred significance and prestige of this object.

Elaborate traditional rituals were banned in Mentawai after Indonesian independence. Indeed, the fabrication of *jaraik* nearly came to an end. Two exceptions come from secluded groups, the Sakuddei and the Satepu, the latter of whose *jaraik* I found still in situ (fig. 29).

R.S.

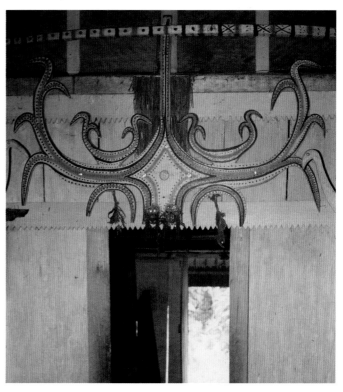

FIG 29 *Jaraik* protecting the entrance to the rear room of the Satepu *uma* in 1974.

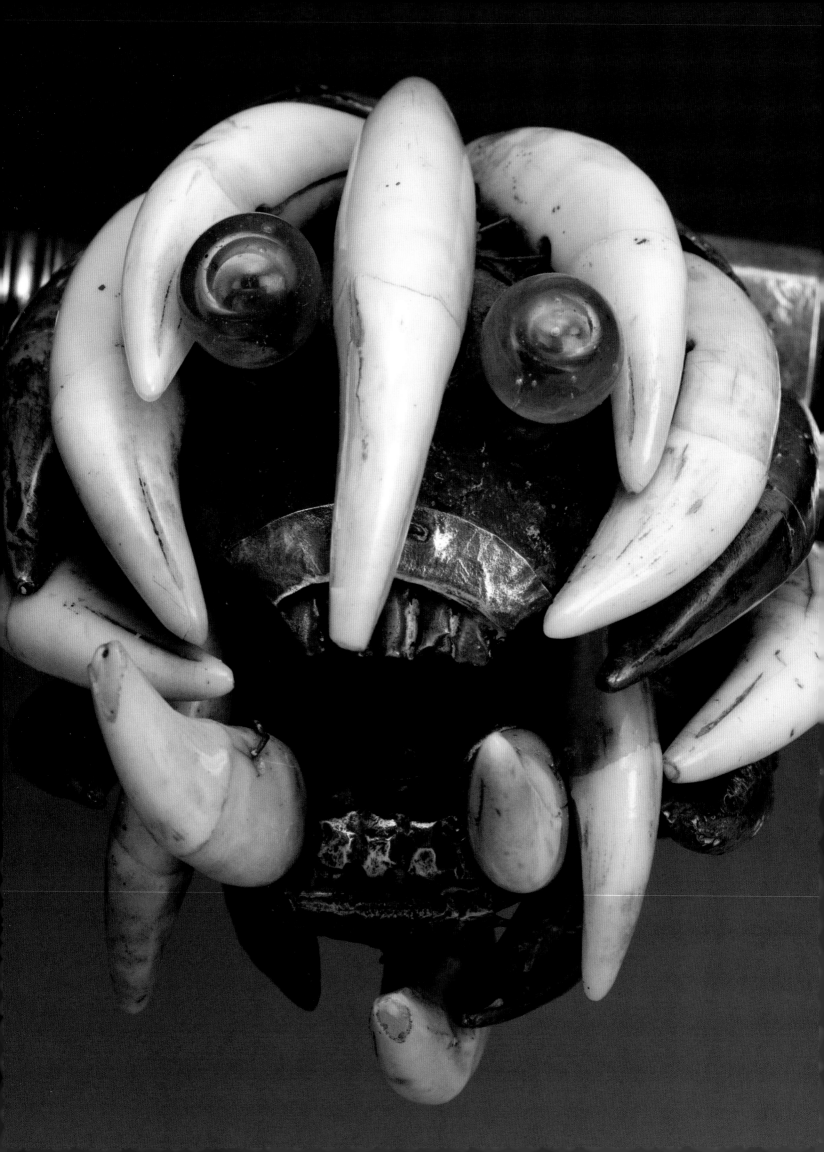

CHAPTER TWO
THE ART OF THE ONO NIHA

Achim Sibeth

Nias is an island on the western edge of the Indonesian archipelago. It is approximately seventy-eight miles long and, at its maximum, twenty-five miles wide. The Hinako Islands, situated off Nias's western coast, are also considered to be part of Nias, as are the Batu Islands located to the south, whose settlement was carried out from South Nias approximately 150 to 200 years ago. Today, approximately 700,000 people inhabit the island of Nias, among whom the vast majority practice the Christian faith. A Muslim minority live only in the port cities.

The Ono Niha, as the residents of Nias (whose origins go back to the Austronesian migration mentioned in the general introduction to this catalogue) call themselves, were not integrated into the Dutch colonial empire until the beginning of the twentieth century. An intensive slave trade provided commercial contacts with the Acehnese, the Batak, and the Minangkabau on Sumatra during the preceding two centuries. This commerce in human beings made the slave traders rich and in part served to fund the accumulation of the extensive gold jewelry of the Ono Niha, as well as the lavishness of their exceptional stonework, consisting mainly of plazas and monuments, which can be found in their villages.

The peoples of the island Nias were mentioned for the first time mostly in Arabic sources from the middle of ninth century onward.[1] European traders, however, did not establish commercial contacts with the indigenous inhabitants before the end of the seventeenth century. In their reports, they record virtually nothing about the culture of the Ono Niha. Western sailors and merchants were interested mainly in trading, and in stocking up on food and drinking water. Even at the beginning of the nineteenth century, the megaliths, architecture, and material culture of the Ono Niha were not considered worth mentioning by these authors.[2] It was not until the middle of the nineteenth century that Dutch colonial officials, soldiers, and German missionaries began to study their culture more systematically.

These first travelogues brought Nias to the attention of the Western world. For the first time, as these accounts attest, Western travelers went beyond the harbor towns and marketplaces. They now visited villages in the interior of Nias and were very impressed by their layouts and by the large houses built partly on enormous wooden pylons. In particular the unique villages of the south, with their stone stairs, village fortifications, plazas, bathing places, and conduits for running water, elicited great admiration. The sumptuous and lavish feasts of merit (*owasa*), the large numbers of pigs sacrificed, and the extensive presentation of gold jewelry among the noble and free families were particularly popular subjects in the descriptions of Western travelers to the region.

On the other hand, headhunting, slavery, alleged cannibalism, and numerous depictions of ancestors in wood and stone were considered evidence of an archaic and "heathen" culture, which had to be "civilized" from the Western point of view. Through deliberate campaigns of destruction by Western missionaries, within a few decades the great clan houses were "freed" from their "heathen" imagery. Interestingly, this fate affected only the ancestor and protective figures made of wood, while the missionaries' iconoclasm actually spared the stone sculptures, columns, tables, and benches in public spaces. As one scholar observes, "The stone artifacts were not on the iconoclastic agenda of the mission. . . . The missionaries . . . regarded these stones as primarily socio-political, therefore secular, monuments."[3] In fact the missionaries were wrong in this appraisal, probably due to a lack of knowledge—for example, that in Central Nias, the skull of an ancestor could lie underneath some of these stones[4]—otherwise many of the stone constructions would certainly have also been destroyed. Admittedly the ancestors received no sacrificial offerings at these stones—this was reserved for the wooden effigies of ancestors—although healing was expected from the stones in cases of illness. Johannes Hämmerle mentions this healing function of stone monuments in his description of a flat stone at Hili'otalua.[5] Here, at least, a direct connection to the ancestor cult can be readily recognized. Perhaps this aspect was "forgotten" during the course of Christianization, evaluated differently in different places, or simply concealed from the missionaries.

Christianization through Protestant missionaries of the German Rhenish Missionary Society, and later also by Roman Catholic

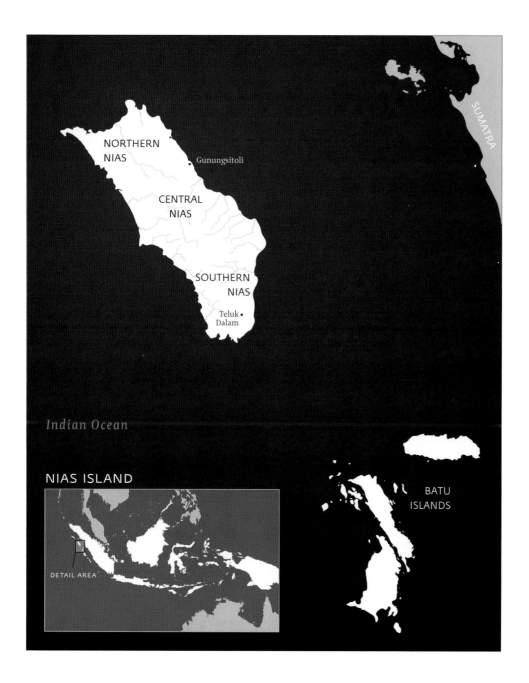

NIAS ISLAND

NORTHERN NIAS

Gunungsitoli

CENTRAL NIAS

SOUTHERN NIAS

Teluk • Dalam

Indian Ocean

SUMATRA

BATU ISLANDS

DETAIL AREA

missionaries, was responsible for the loss of many unique features of the island's culture. Headhunting, the slave trade, ancestor cults, and traditional beliefs in the supernatural were all prohibited, as were the extensive festivals (*owasa*) that celebrated the elevation in rank of nobles and kings. It was in their honor that the large stones were erected. The decline in these practices, and in the wealth that sustained them, becomes readily evident with the marked decrease in the production, quality, and use of gold ornaments among the Ono Niha during the late nineteenth and early twentieth centuries.

Nias can be subdivided into three general regions based on cultural differences in language, mythology, political organization, village layout, house architecture, art, and social rules (called *böwö* here, but otherwise known as *adat* throughout Indonesia). North Nias is larger than Central Nias, which in turn is more than twice as large as South Nias.[6]

Impressive stone monuments and residential dwellings on powerful wooden pylons characterized the traditional villages (fig. 30). Today, many old houses have unfortunately disappeared. Torn down because of their dilapidation, they have been replaced by simpler—primarily cheaper—"modern" types of houses. Only in villages where additional income has been earned through tourism do the Ono Niha living there attempt to preserve their old buildings. The obstacles they face in trying to do so arise not only from lack of money, but also from the increasing difficulty in obtaining the gigantic tree trunks necessary for the reconstruction of the traditional houses. In the context of historic preservation, the Museum Pusaka Nias should be acknowledged. It was founded in 1991 in Gunungsitoli by Father Johannes Hämmerle and is commendably dedicated to the preservation of the cultural treasures of Nias, including the island's remarkable traditional architecture.

Visitors to Nias immediately notice regional differences in the layouts of villages and the styles of houses. In the past, the villages located in the south were each like an impregnable fortress, strategically positioned on plateaus at the summit of a ridge or a

pronounced hill. The villages were surrounded by ramparts and secured by stone gates. They could be approached only by two staircases at the upper and lower ends, which might include many steep steps depending on the location. A paved village square was flanked on both sides by residential buildings, whose narrow sides with their transparent verandas opened onto the square.[7] Only the narrowest space remained between the residences, suggesting the appearance of a row of townhouses. A public path, slightly sunken and covered with stone slabs, ran through the middle of the village street. The areas between the houses and this path were the private property of each respective family. They were used as drying areas for laundry and rice, as well as for other work. Windows and openly designed front walls ensured that the residents could observe and participate in the village's daily social activities.

In contrast, the houses in Central Nias tended to be separated from one another, their frontal façades facing the village street. Structurally these houses were halfway between those of the south and the oval dwellings of the north, where the natural terrain affected their design. No special type of fortification seems to have been used in the north.

No closed villages were found in the north. The northern village was not an independent, largely self-governing political unit; instead it was always part of a territorial confederation (öri), which encompassed several villages that were allied to one another. In the past, the leadership of such a village confederation always fell to the ruler of the oldest village, which had founded the others over the course of time.[8] A uniformly structured village layout was unknown in the north. Here, there tended to be small, scattered settlements, loosely grouped around the house of the village leader and adapted to the natural spatial conditions. This meant that settlements could also exist at different levels. In contrast to the other two regions, the inhabitants of northern Nias gave their residential dwellings a basic oval shape that is quite unusual in Indonesia. Their longer sides faced the village street, while their entrances were located in one of the two rounded narrow sides. The communal room of a house was also aligned toward the village street, and, just as in the south, an open, "windowed front" facilitated participation in village life.

The use of immense tree trunks as house posts, which supported the living quarters, and sometimes also a high slanted roof, was common to all three architectural styles. The spaces underneath these raised houses served as holding pens for the ubiquitous pigs and chickens. Their massive diagonal pillars, which were placed in front of the regular vertical posts in the south (fig. 30) and behind them in the central and northern regions, were unique to Nias. They were intended to better distribute the weight

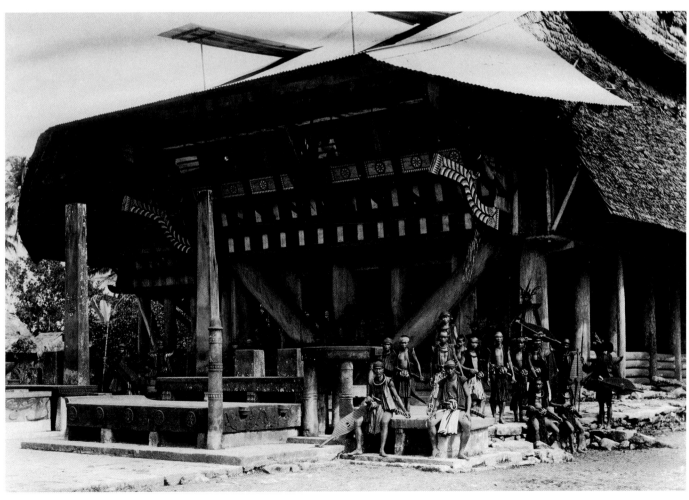

FIG 30 House in Bawömataluo, South Nias, 1892–1916. KIT Tropenmuseum, Amsterdam 10016887.

of the house and to increase its stability in case of earthquakes.[9] The largest houses of all (*omo sebua*) were built by village leaders in the south as magnificent physical manifestations of their claim to power.

Stone monuments were constructed and consecrated in the context of celebrations dedicated to the achievement of higher rank or status for a family member. Often very complex and diverse, they stood directly before the residential dwellings. The goal of every noble and free adult male was to rise in rank above his peers. At these celebrations (*owasa*), not only were many pigs slaughtered and served among the guests, but new gold jewelry also had to be made for both the host and his wife, and then publicly shown to the guests.[10] The right to bear certain honorary titles was contingent on the hosting of such celebrations. Thus the stones in front of a house symbolized the conspicuous power, wealth, and rank of a house's owner. New stones were placed next to those of the preceding generations, and consequently the number of stone monuments in front of a house also documented a family's history. The DMA's stone seat (*osa-osa*) from Central Nias (cat. 10) is a splendid example of Ono Niha stone sculpture.

The ancestor and protective figures made of wood, which can readily be distinguished from the sculptures of many other Indonesian ethnicities, are of special importance in the art of Nias. There are numerous stylistic differences in the woodcarvings of North, Central, and South Nias, but also just as many features that can be described as typical of the island as a whole. For instance, the figures are mostly nude or have a piece of cloth wrapped around the hips. Their gender is usually very clear. They wear traditional jewelry, whose distinctive forms are not common in other regions of Indonesia.[11] These include high-pointed gold crowns (*tuwu*), long pendant earrings (*si'alu*), bracelets (*töla gasa*), and a splendid necklace (*kalabubu*) (see. cat. 8).

Depending on their intended purpose, these figurative sculptures range between eight and eighty inches in height; a few are even taller. In the past, large numbers of wooden figures were kept in the house in specified places. According to Andrew Beatty, "The missionary Noll (1930) claims that he once removed over 2,000 'idols' from a house of a Christian convert in the north. Kramer (1890) saw houses collapse under their weight."[12] Aside from the ancestor figures, which were supposed to ensure fertility for the family, livestock, and fields, a large number of various protective figures were also produced. With the help of these *adu* figures, the Ono Niha could heal every sort of illness—one individual *adu* for each illness.[13] Depending on their special purpose, these *adu* figures varied in size, form, material, and in style. This variation could be said to reflect "the social status and wealth of the dead person whom the figure represents, or the person for whom it is designated. Finally, the individual images indicate the specific nature of

FIG 31 Group of assembled warriors, Hilisimaetano, South Nias, c. 1909. KIT Tropenmuseum, Amsterdam 60009097.

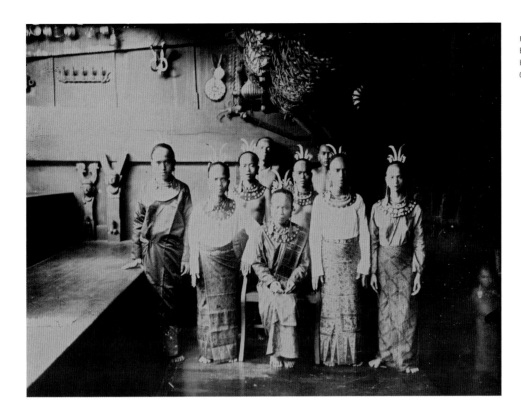

FIG 32 Group of aristocratic women, Bawömataluo, South Nias, 1905–15. KIT Tropenmuseum, Amsterdam 60043140.

a carver's individual aesthetics."[14] Of course the aesthetic quality of a wooden sculpture also very much depended on the artistic capabilities of the carver. Professional carvers who regularly produced sculptures for various customers ultimately gained a higher level of aesthetic skill than those who occasionally carved figures for their personal use. But for the Ono Niha, an effective religious sculpture did not necessarily need to be beautifully carved. Its intended purpose as a protective figure was always more important than its aesthetic qualities.

The large ancestor figures from North Nias (adu siraha salawa) and those from Central and South Nias (adu zatua) were cared for and propitiated most devoutly. They received regular sacrificial offerings and a place of honor on the right wall of the front communal room.[15] Often a wall panel with a carved altar platform was found here (daro-daro ndra ama), on which the ancestor figure stood, sometimes being inserted into it with a peg. Other figures stood on beams, hung from the timberwork of the roof, or stood on the floor in groups, in front of the left wall.

The art of woodcarving was more richly varied in Central Nias, but more widespread in the north. In addition to figures that were worked relatively superficially and fleetingly—frequently carved as protective figures against illnesses or as ancestral portraits of less important persons—many sculptures are now recognized as impressive works of art because of their modes of representation, styles, surface designs, and expressiveness. Every region of Nias is characterized by special stylistic features according to which sculptures can be locally attributed. Sculptures in a squatting posture in South Nias hold a cup or a betel nut cracker in their hands resting on their knees. In the north, such a figure holds a cup in both hands in front of its chest. Sculptural representations of dual

gender (hermaphroditic sculptures) were carved only in Central Nias.[16] Moreover, the figures in Central Nias are mostly represented standing, not sitting as in the south and the north. The more abstract representations are from Central Nias; the rather naturalistically designed sculptures are from the south. While some have a relaxed, closed posture, other standing figures are represented with outstretched or raised arms. There are ancestor figures without arms, primarily in the south and on the Batu Islands. Sculptures, adu hörö, that wear a high, forklike headdress, come chiefly from Central Nias, but also sometimes from South Nias. Here, too, the arms are missing and the body is reduced to what is most essential. The body is usually very flat and boardlike, although there are also three-dimensional adu hörö.[17] Unfortunately, to this day, there is still not a comprehensive description of the iconographic features in the various arts and stylistic regions of Nias.

5

Sword (*telögu*) in sheath

Indonesia, South Nias
Late 19th to early 20th century
Iron, wood, tiger teeth, European glass or crystal
25 × 10 × 8¾ in. (63.5 × 25.4 × 22.2 cm)
Promised gift of Sarah Elizabeth Alpert to the
Dallas Museum of Art, PG.2013.6

Affixed to the sheath of this warrior's sword (*telögu*) is a *rago balatu*, an amulet containing magical ingredients. These bundles were meant to protect the sword's owner from danger in war or on a headhunting expedition. A *rago balatu* usually consists of a woven rattan ball surrounded by crocodile teeth, boar tusks, fossilized shark teeth, small shells, talismans of stone, bits of bone or sheet metal, and occasionally the teeth of headhunting victims. The magical power of these amulets was sometimes further enhanced by small wooden figures, *adu nori*, or even by the addition of small porcelain figurines from Europe or East Asia.

The intimidating and uniquely constructed magic bundle on this sword represents the head of a mythological creature. Instead of the usual rattan ball, this emblem is fashioned from two carved pieces of wood secured to a tightly fitting bezel, which in turn is held in place by twisted wires and pins pegged to the sword's sheath. The entire visage is framed by teeth; some are the actual fangs of tigers while others are wooden imitations sheathed in silver. The animal's mouth is also lined with beaten silver to more clearly delineate its lips and smaller teeth. Especially striking are the two crystal or glass stoppers from European bottles or decanters used to represent its bulging eyes.

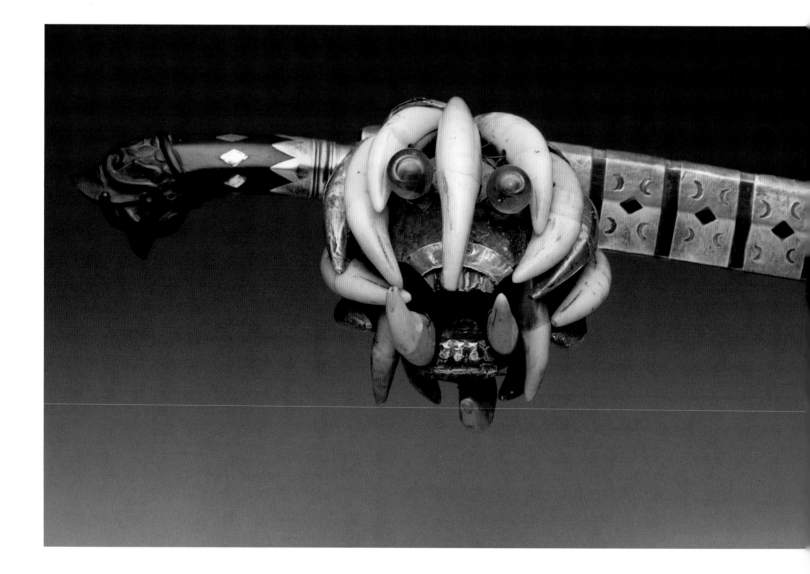

The handles of *telögu* swords are always ornamented with the dragonlike creature called *lasara*, either alone or with a monkey depicted on the back of its head. As an apotropaic animal, the *lasara* is also found near the front ends of the two lateral beams of house façades, on stone monuments and seats, and on the sides of the large staircases that lead up to villages in South Nias. This wooden handle has a fine patina (some are made from horn) and is unusual due to the silvery metal inlays and the sleeve at the base of the grip. The sword's sheath is further ornamented with fifteen bands of silver, each with a cutout of a rhombus and four slender crescents. These attributes combine to give the weapon a sumptuous look, while the amulet's basket suggests a fierce beast capable of warding off evil and subduing enemies.

Only the swords of village chieftains could be decorated with tiger teeth, and their presence here, along with the rich ornamentation in silver, reinforces the notion that this sword—at once both spectacularly lavish and entirely unique—once belonged to a personage of great distinction.

A.S.

FIG 33 Studio portrait of a chief clutching a sword, South Nias, 1892–1922. KIT Tropenmuseum, Amsterdam 60046761.

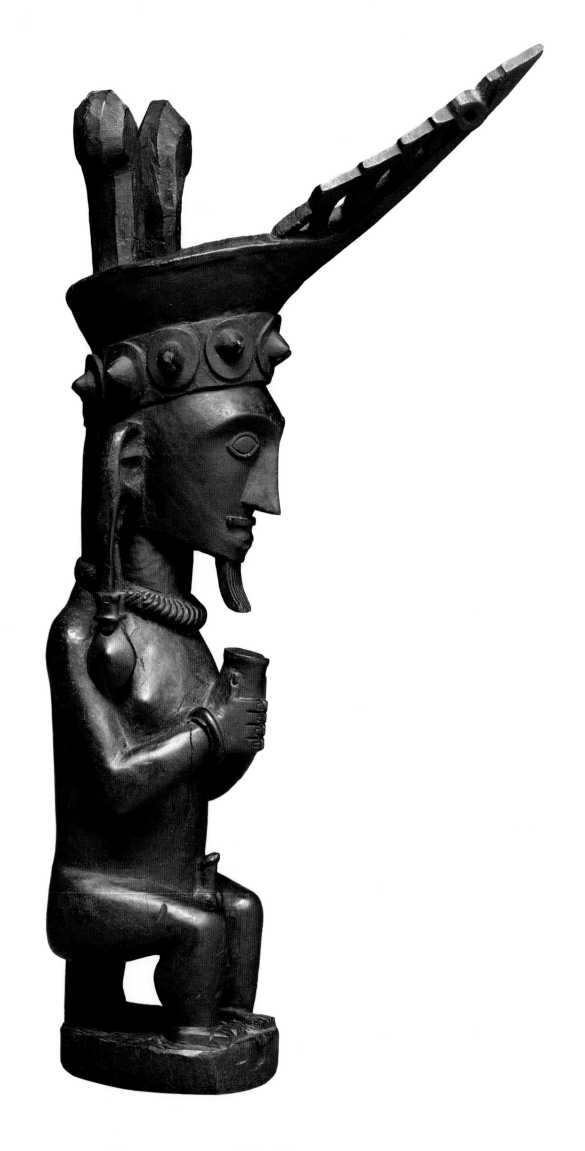

6

Seated figure (*adu siraha salawa*)

Indonesia, North Nias
Early 19th century
Palmwood
25 × 12½ × 6 in. (63.5 × 31.8 × 15.2 cm)
Promised gift of Steven G. Alpert and Family, PG.2013.11

FIG 34 Photograph of the village chief of Tabeloho, North Nias, 1890. The chief is wearing the high head-dress reserved for hereditary noble-men. A similar headdress is worn by the hardwood statue.

In addition to their splendid stone sculptures, the Ono Niha also produced outstanding figural wooden sculptures (*adu*). They acknowledged a multitude of magically effective effigies, whose propitious help and support they believed they could secure for themselves through sacrificial offerings. At the end of the nine-teenth century, the world traveler Joachim von Brenner-Felsach listed more than sixty different kinds of rather crudely carved *adu* portraits,[1] which were meant either to help against specific ill-nesses or to fulfill general apotropaic functions for the protection of the village and its inhabitants. Among the prolifically carved *adu* portraits also belong many of the *adu zatua* sculptures. As ances-tor figures, *adu zatua* serve the souls of the deceased as places of residence, without actually showing individual, portraitlike facial features. Members of the noble class, the wealthy and the power-ful, in particular, often possessed a great number of such "helpers."

In North Nias, the largest protective shrine figures, *adu siraha salawa*, which represent an outstanding village founder or the old-est known ancestor of a group of relatives, were given a place of honor on a wallboard or altar throne (*daro-daro*). The smaller, less important ancestor figures (*adu zatua*) were bound together in a horizontal row with rattan and carved fastening pegs, which were then mounted onto a decorative board attached to the wall in a house's main front room. Another class of large protective figures, *adu hörö*, stood on the ground and/or leaned against the walls.[2] During the pre-Christian era, all of these figural representations were to be found in every noble dwelling and were also passed down to subsequent generations. The greater part of what had pre-viously been innumerable figural representations in the houses of the Ono Niha were destroyed (often burned) in the course of Christian proselytizing activities during the end of the nineteenth and beginning of the twentieth centuries. The majority of the sur-viving examples now reside in public institutions and mission collections, with a much smaller number in private collections, mainly outside of Indonesia.

A case in point is the DMA's superb *adu siraha salawa*, which was originally collected by the Rheinische Mission (Rhenish Mission) before 1885. This figure depicts a man of noble descent sitting upright on a stool of honor. His fine mustache and goatee, in a culture that lacks much facial hair, are symbols of the venerable respect accorded to important ancestors. He holds a small partially raised cup in both hands and is naked except for his jewelry and adornments. These include a massive teardrop-shaped earring in his right earlobe (whose local name unfortunately was never recorded), a choker necklace woven from gold wire (*nifatali-tali*), a thin bracelet (*töla gasa*), which formerly would have been carved from the shell of a giant clam (*Tridacna gigas*) or cast from various metals, and most notably a towering crownlike headdress (similar to the one pictured in fig. 34). Here the headdress (*tandrulo, tuwu,* or *saemba ana'a*), while typical of those found on the finest *adu siraha salawa*, possesses a tapered frontal point whose incline is extended at a particularly rakish angle. Such crowns, the property of wealthy noblemen, were made with a mainframe created from wood and woven rattan. The mainframe was then covered and wrapped in yellow and red cloth and embellished with various ornamentation. The band encircling the headdress was decorated with round disks with raised cones and covered with thin sheet gold or gold leaf.[3]

This figure's arching browline emphasizes its raised, almond-shaped eyes. These mirror each other in such a way that the clearly incised eyelids convey both a fixed stare and the impression of a distant, "empty" look. As is the case with many of these figures carved from red palmwood, its smoothly finished surface over the years has become polished to a dark, brilliant patina.[4]

All these features distinguish the Dallas *adu siraha salawa* from the simpler and smaller *adu zatua* ancestor figures, while simultane-ously attesting to the great esteem that was shown to this ancestor in former times.

A.S.

7

Lid with human hands

Indonesia, North or Central Nias
Late 19th to early 20th century
Palmwood
11¾ × 14½ × 4 in. (29.5 × 36.8 × 10.2 cm)
Promised gift of Hannah Allene Alpert to the
Dallas Museum of Art, PG.2013.1

Most wooden storage containers (*bari*) from Nias are unremarkable everyday objects. They were often overlooked by Western collectors, who were usually more focused on the island's figural wood or stone sculptures. However, there are a few surviving containers, said to be from the Gomo area, that embody an exceptional level of craftsmanship and artistry.[1] This particular lid is from one of these embellished, partly conical containers (fig. 35)—where form, function, and humor are combined in a pleasing and skillful way.

In cat. 7, two hands reach up as though to grip the top of a well-formed lid, pressing down with all five fingers to secure the lid to the container below. Adorning each wrist is a bracelet (*töla gasa*) resembling those fashioned from the type of giant clam shell (*Tridacna gigas*) that was worn by nobles. Along the container's sides run two rounded parallel contours that match up perfectly with the hands on the *bari*'s lid to form a pair of arms. Here, an inspired carver has managed with only a few special touches to transform a commonplace lid and cylindrical box into a memorable work of art.

Why hands appear repeatedly in the art of the Ono Niha is an open question. They are occasionally found on spoons (*haru*) and wooden troughs (*lahu*) used to feed the family pigs,[2] and also on the ends of the beams in large scales used to weigh the flesh of sacrificed pigs at great *owasa* festivals, and can be said to appear frequently on objects that tend to be handled daily. The motif does seem highly appropriate for the lid of a prized container, as these boxes were used to store ceremonial textiles and jewelry.[3] The idea that the container should be tightly sealed to protect its precious contents from exposure to vermin such as moths and rats—as well as from any prying persons—makes sense. To achieve this, two loopholes were carved on each of the box's sides to facilitate the tight syncing of the lid to the container's body with cordage. These boxes were kept in the private quarters of traditional dwellings. Only a few *bari* of this type are known, and with the exception of this lid from the Dallas Museum of Art, they all still remain in private collections.

A.S.

FIG 35 The Dallas lid with its accompanying *bari*, from a private collection.

8

Man's necklace (*kalabubu*)

Indonesia, Central or South Nias
19th century
Wood, gold, gold leaf, and brass (?)
9¾ × 9¼ × 1¼ in. (24.8 × 23.5 × 3.2 cm)
Gift of The Nasher Foundation in honor of
Patsy R. and Raymond D. Nasher, 2008.58

The Ono Niha are known for two different kinds of necklaces, which are somewhat structurally alike: both types have a largely invisible inner wire core consisting of iron, brass, bronze, or even gold wires. The most well known are the so-called headhunter's necklaces, *kalabubu*, typically embellished with pieces of polished coconut shell strung over the wire core. The diameter of these perfectly fitted, disklike pieces gradually increases toward the center, so that the thickest section of the necklace always hangs above the chest of its wearer. The *kalabubu* typically did not have a clasp, but was made large enough in diameter so that its owner could effortlessly pull it over his head.

This one-of-a-kind *kalabubu* necklace is an especially beautiful object.[1] An inner core made of brass is wound with two interwoven brass wires. Only two small sections of this substructure are exposed next to a round clasp of solid gold. Thirteen thin casings made of wood, which are sheathed in beaten sheet gold, are strung over the core of the necklace. The gold surface is decorated with a densely embossed leaf pattern. Seven of the casings have an embossed surface, into which four to six nearly equal-sized rhombuses are cut. The dark wood of the casings contrasts strikingly with the gold as the raised wooden shapes emerge from these incisions.

Very few such necklaces with wooden and gold casings are represented in collections or found in historical photographs.[2] Even if the *kalabubu* looks more like a badge of rank (*nifatali-tali*) from its construction and mode of production, it must nevertheless be viewed as an emblem for a successful headhunter. The aesthetic charm of this unique *kalabubu* consists in the finely embossed leaf patterns and the alternation between the dark wood and the exceptionally rich patina of its gold decoration.

In many societies, wearing special jewelry was associated with extensive rules and regulations. Wearing a *kalabubu* was also subject to such rules of tradition and common law, also known as *adat*. In the pre-Christian era, a young nobleman of the Ono Niha could acquire the right to wear a *kalabubu* once he had taken part in a successful headhunting raid. Only then did he become a recognized member of the adult world and only then was he marriageable.

The second type of necklace, *nifatali-tali*, was worn equally by men and women. Wearing these woven necklaces was reserved for members of the noble class, or *si'ulu*. The thickness and workmanship of the woven wire and the composition of metals in these necklaces reflected a family's wealth. *Nifatali-tali* necklaces can be made of iron, bronze, silver, and gold. This kind of necklace has a considerably smaller diameter and therefore a clasp at the narrowest ends. Sometimes this clasp is only a hook, or it may also take the form of a pyramid-shaped button, or a specifically produced concave button with a central breastlike elevation. The Dallas necklace is shaped like a common *kalabubu*, but it has a clasp like a *nifatali-tali*. The lustrous gold emphasizes its noble pedigree.
A.S.

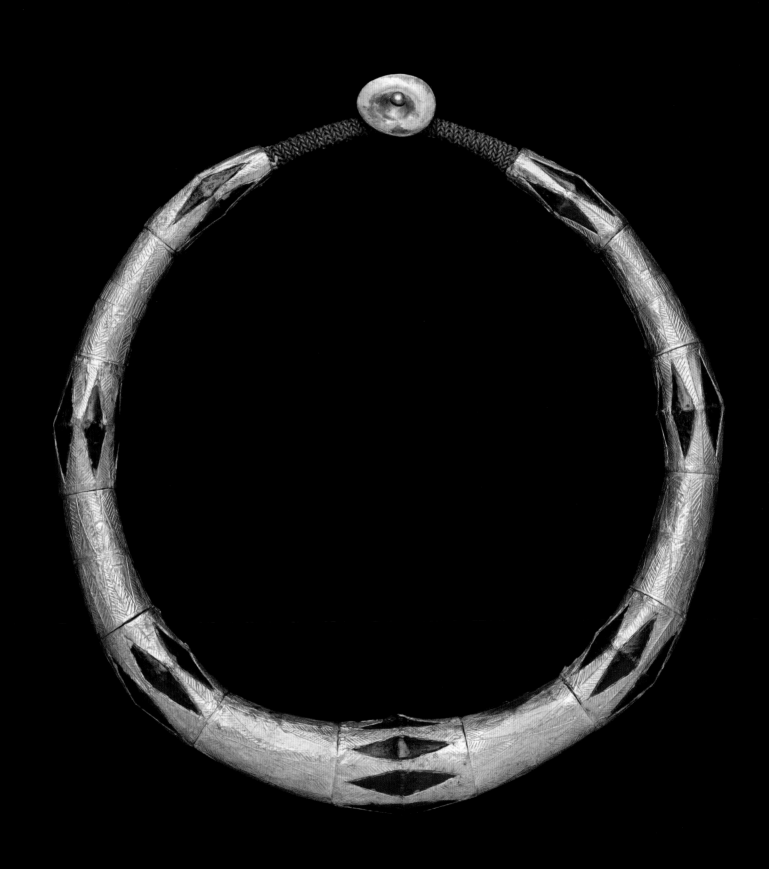

9

Architectural sculpture depicting a monkey (*ba'e*)

Indonesia, Central or South Nias
Late 19th to 20th century
Wood
19¾ × 5¼ × 20½ in. (50.2 × 13.3 × 52.1 cm)
The Eugene and Margaret McDermott Art Fund, Inc.,
1999.182.McD

In the past, the great clan houses of the Ono Niha were adorned both inside and outside with richly figural ornamentation. These figures on wall panels, beams, and posts made reference to the lives of the residents both as part of this world and in the afterlife. Like the Batak of North Sumatra, the Ono Niha created residential dwellings that reflected their religious and cultural ideas about the cosmos and their place in it. The upper world and underworld were clearly defined and distinguished from each other by their respective flora and fauna. Fish and crocodiles, for example, as inhabitants of the underworld, abound as decorations on the large stone tables

that were set up in front of a house. In contrast, portraits of birds and monkeys, animals that tend to settle in the upper regions of the trees and are thus associated with the sky or the upper world, can be found in the roof section of a house.[1]

This unusual sculpture shows a monkey with a raised tail. Although it stands on its four limbs, the monkey was not conceived by its woodcarver as a freestanding sculpture, but rather served as a figural adornment on a house post. Collection documents reveal that the monkey was separated from a wooden beam or post in the 1960s. Whether it was attached standing on a beam or looking down at a post below remains uncertain. The downward-focused gaze allows for both possibilities.

The artist has carved the monkey—including its extremities—from one large block of wood. The body of the monkey is not depicted in naturalistic detail, but is reduced to its most essential form. It was produced with a relatively broad woodcarver's knife. The parallel knife marks reveal the woodcarver's exacting self-assurance and skill, emphasizing the physical tenseness of a watchful animal ready to fight or take flight at any moment. This impression of vigilance is enhanced by the wide-open eyes, bristling fur, jaws with bared teeth, inflated genitalia, and the posture of the monkey's head and long, raised tail, both turned slightly toward the left. All these details argue against the sculpture's being an apotropaic protective figure, but instead suggest that it was intended, like a good watchdog, to warn against approaching harm or calamity.

Aesthetically, this guardian monkey stands out in its powerful sense of movement, dynamic form, and expressive carving technique. It is a distinctly individualistic work of art that differs from other known similar wood sculptures of the Ono Niha with their generally smoother and more polished surfaces.
A.S.

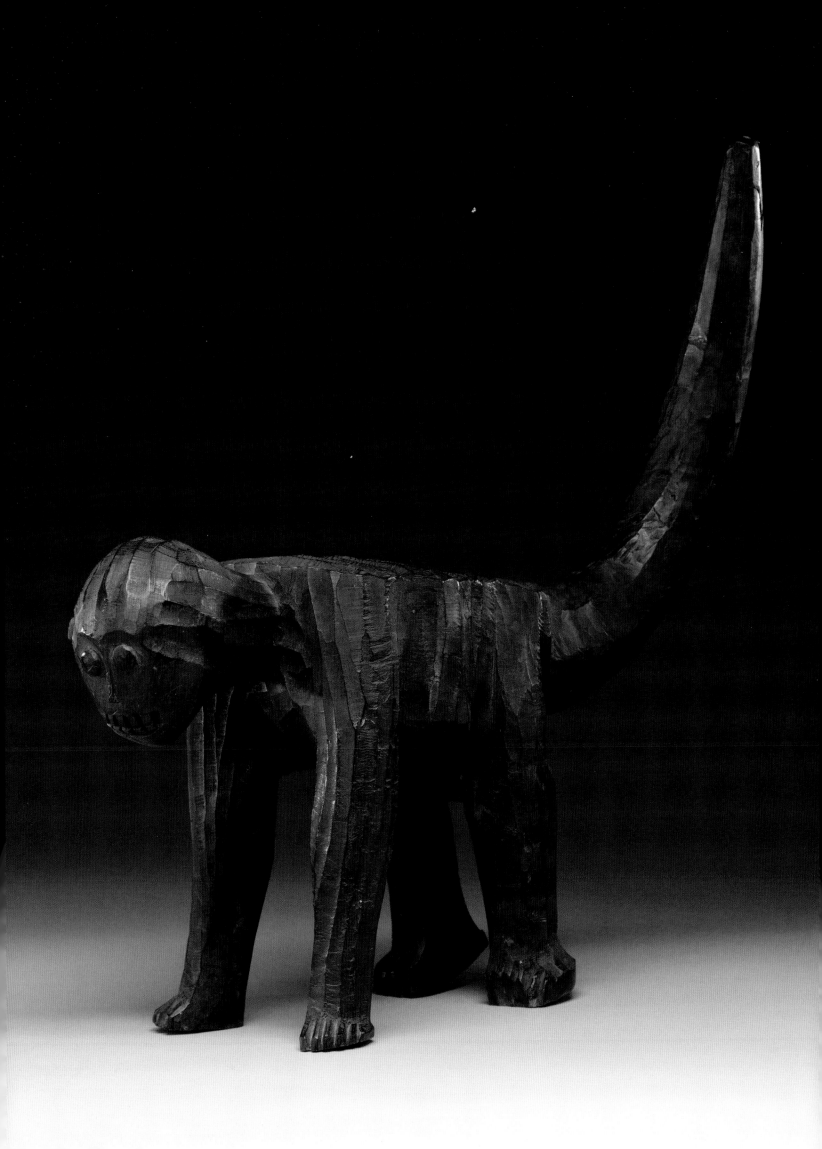

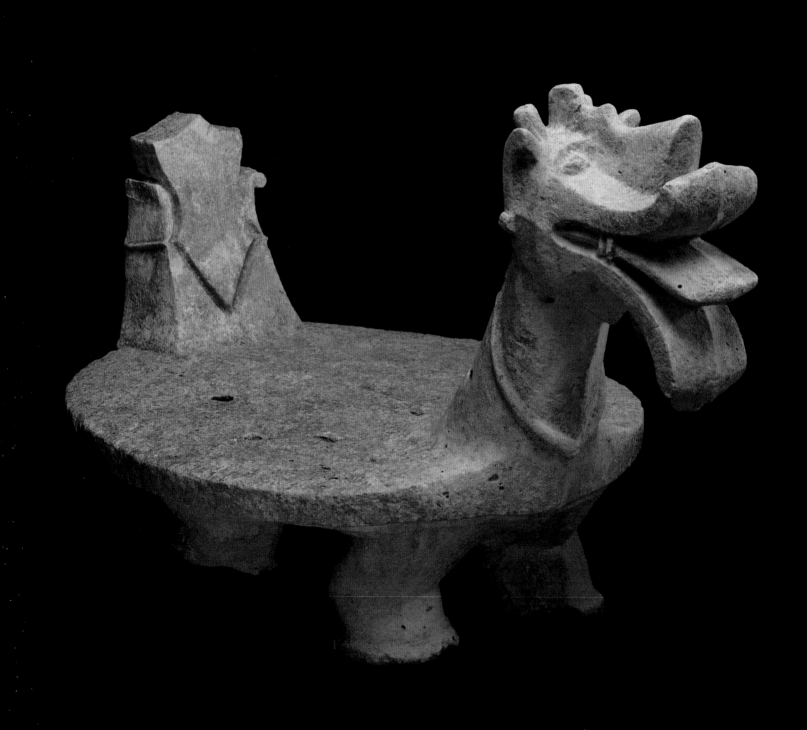

10

Commemorative stone seat with a mythical animal head
(*osa-osa si sara mbagi*)

Indonesia, Central Nias
19th century
Stone
36 × 47 × 43 in. (91 × 119.3 × 109.2 cm)
Promised gift of Sally R. and William C. Estes to the
Dallas Museum of Art, PG.2013.4

FIG 36 A man next to a three-headed *osa-osa*, a stone seat in honor of chiefs and ancestors, Central Nias, early 20th century. KIT Tropenmuseum, Amsterdam 10004911.

Impressive evidence of the traditional stonework of the Ono Niha abounds on Nias and is particularly distinctive in Central and South Nias.[1] A remarkable array exists in all shapes and sizes: large stone staircases, paved village streets, walled bathing locations, mighty soaring obelisks, and countless flagstones, tables, standing columns, and sculptures. In addition to undecorated stonework, the artistically designed megaliths of the Ono Niha deserve particular attention. Among these may be counted vertical columns with or without tops in animal form (*behu*), anthropomorphically shaped male figures or stones showing characteristics of both sexes (in North Nias: *gowe*), flatly aligned, decorated, but also undecorated slabs (*daro-daro*), tables (*niogaji*), and benches decorated with the heads of mythical animals (*osa-osa*).

Such stones commemorated great celebrations and were erected before the host's house. Differences between the noble class (*si'ulu*) and common people (*sato*) manifested themselves in the lavishness of the celebrations and in the number, as well as the size, of a household's stone monuments. The great celebrations (*owasa*) served to increase the host's own rank in society, whereupon he earned the right to assume corresponding titles of honor. The stones in front of a house were the visible evidence of the power, wealth, and prestige of its residents.

In the case of the DMA's *osa-osa*, the round stone slab rests on four feet and depicts a mythological animal (*lasara*) warding off disaster. According to the cosmogonic myths of the Ono Niha, the *lasara* represents the dragon of the underworld, who wears the Earth on its back.[2] Its neck, head, and tail jut out of the flat stone slab. Some of these *osa-osa* had an oval stone slab that rested on a single column or two rectangular blocks of building stone. Other animals depicted include stags and hornbills. Such *osa-osa* were erected in front of a house for both the male and female hosts of a celebration. Before the *osa-osa* was installed at its final location, it was repeatedly paraded through the entire village, during which time the host of the celebration sat or stood on it. At the great ceremonies and celebrations themselves, the owner would sit on his or her *osa-osa*.

In these stone sculptures, the animal is always adorned with a *kalabubu* necklace (see cat. 8). If the animal head wore two pendant earrings (*saro dalinga* and also *fondulu*), it was intended for a woman; with only one pendant earring in the right ear, it was made for a man. Female breasts on the bottom edge or on the front cutting edge of the slab were further indications that the sculpture had been made for a woman. Female breasts in combination with male sex organs beneath the tail may occur in the *osa-osa* for men. In many *osa-osa*, this tail is adorned with a decoration reminiscent of tail feathers. The underside of the Dallas stone is dominated by a central V-line ridge that runs the length of its body and through the rear legs to subtly indicate its female sex.

The *lasara* seems to be a hybrid creature that unites features of different animals. Antlerlike outgrowths on the animal's head are combined with a wide-open, fleshy animal mouth and the powerful canine teeth of a boar. From the side, the hump between the jaws and eyes is reminiscent of a hornbill.[3] The long tongue hanging out is a widespread apotropaic motif in many regions of Indonesia.

If we consider the simple tools that the sculptors on Nias used to carve such animal figures out of full blocks of stone, the artists' skills can only be marveled at. With its head raised in proud dignity and with its wide-open mouth, this *osa-osa* radiates a magical power, which is intended to be passed on to its owner.

A.S.

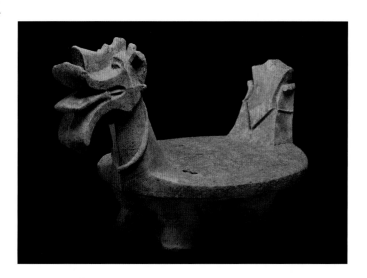

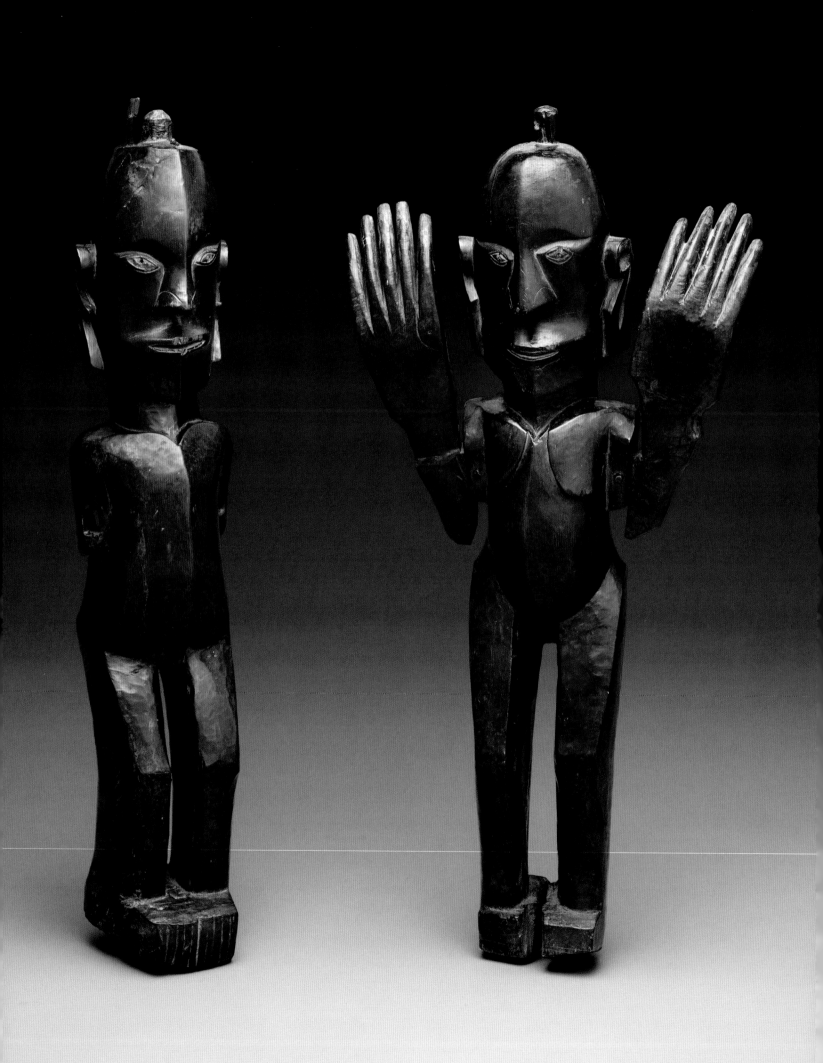

CHAPTER THREE
THE ART OF THE BATAK OF SUMATRA

Achim Sibeth

The Batak live mainly in the mountainous region of north- ern Sumatra, the largest of Indonesia's roughly 17,000 islands. Estimated as numbering around 6 million, they constitute one of the largest ethnic minorities in this multiethnic nation, with its now almost 250 million inhabitants. The true home of the Batak, as described in orally transmitted traditional myths about the creation of the world and the people's primeval ancestors, is the area around the vast Lake Toba. The lake—created after a powerful volcanic explosion—lies in a huge caldera at an altitude of roughly 3,300 feet above sea level, and measures some 2,300 feet in depth at its deepest spot.

The Batak highlands form a part of the Bukit Barisan mountain chain that extends across all of Sumatra. In pre-European times, Batak were already living outside this region in hilly border areas and nearer the coast. The coastal strips themselves were settled many centuries ago by Muslim Malays who maintained diverse trading relationships with Arab and Asian seafaring nations. In contrast to these cosmopolitan coastlines, the mountain pre- serve of the Batak remained closed to outsiders until the middle of the nineteenth century. To keep unwanted visitors away from sacred Lake Toba, the Batak kept trails and passes garrisoned. As a result, the Batak region came to be thought of as wholly inac- cessible and impenetrable. Today, Batak also live in Sumatra's western and eastern coastal regions north of the equator and west of the 100th meridian. In addition, after the Batak homeland was opened up in the nineteenth century, hundreds of thousands of Batak have emigrated to other islands, so that sizable popula- tion groups are found there as well, especially in commercial and trading centers.

The Batak are not a homogeneous people, and their culture is by no means uniform. Six ethnic groups are included under the umbrella term "Batak." Their grouping into the Toba, Pakpak/ Dairi, Simalungun, Karo, Angkola, and Mandailing does not reflect arbitrary regional divisions. These categories are based on a large number of cultural differences[1] that have evolved over the course of centuries and are clearly apparent in their varied dialects, religious concepts, social structures, notions of justice, economic organiza- tion, and written characters. Contrasts are also found among the various groups in political systems, village layouts, and types and styles of architecture and arts and crafts. Common to all is social organization in patrilineal and exogamous clans. At one time among the various Batak groups, their practices of ancestor wor- ship and their religious ideas regarding the properties of living and dead souls shared common features as well. Of course, over time many of these early beliefs have changed dramatically, so that today the differences among Batak cultures are more appar- ent than the similarities. Indeed, members of several of the ethnic groups mentioned above deny any affiliation with the Batak and wish to see that name applied only to the Toba. Since the Batak art objects at the DMA come exclusively from the Toba, the general remarks about Batak culture and art that follow apply primarily to the Toba Batak.

The arts and crafts of the Batak became extremely popular as souvenirs among European travelers, colonial officials, mission- aries, plantation employees, collectors, and tourists beginning in the mid-nineteenth century. They served as visible proof of a dan- gerous journey made to the land of alleged man-eaters and exotic "savages."[2] Magic staffs, ancestor figures, and amulets testified to the "primitiveness of the heathens" and therefore to the perceived necessity to comprehensively "civilize" them. The Batak came under the authority of the Dutch colonial administration, and the majority were Christianized between 1860 and 1908. During this period, Europeans placed more emphasis on quantity than on qual- ity when collecting ethnographica, and they did not consider the products of wood-carvers, brass casters, goldsmiths, and weavers to be works of fine art.

Rapid change has taken place in the Batak culture since the beginning of the twentieth century. Indigenous religious beliefs were forsaken in favor of Christianity and Islam, and ritual objects lost their importance. Sacred heirlooms (pusaka) became increas- ingly superfluous. Many objects were heedlessly abandoned or were sold. In the present day, authentic and artistically valuable objects

are scarcely available any longer among the Batak. Aesthetically unique artifacts are sold at high prices on the international art market because of their rarity and their extraordinary beauty.

In the pre-Christian era, priest-magicians (*datu*) produced three-dimensional sculptures made of wood, or occasionally of stone, on behalf of villages, families, or individuals. The function of these sculptures was always magical and religious, never decorative. A *datu* carved the cult objects in his own style, according to his own abilities, and based on his level of knowledge. Among the Batak, all ancestor figures, ritual objects, and representations of primeval mythological creatures were fashioned exclusively by the *datu*. The importance of these objects came not so much from their artistry as from their magical-religious potency. Even so, figural representations could also be highly valued for their beauty; such objects were preserved as sacred heirlooms in long-since Christianized families for many generations. In contrast, household furnishings such as chests, wooden boxes, containers for provisions, and so on were either made by the head of the house himself or commissioned from skilled carvers who were not *datu*. Such utilitarian carvings included ornaments wholly unrelated to religious concepts.

The great stylistic variety characteristic of Batak works of art is based not only on the individual skill of their creators, but also on geographic and ethnic factors. In addition to the resident *datu* in the villages, there were also traveling *datu* in Batakland, who plied their trade in the regions of other Batak groups. Circumstances such as the search for temporary work, permanent migration into neighboring regions, interethnic marriages, and cultural mingling in border regions attest to a permeability of the cultural boundaries between the individual Batak groups and their neighbors that should not be underestimated. During the period when the old religion was still intact and the cult objects of the *datu* still had ritual functions to fulfill, religious sculptures were certainly more resistant to this cultural permeability than was the case with everyday objects and, in terms of their artistic design and style, were subject to a stronger standardization, at least in the pre-Christian era. For example, there was relatively little deviation in the design of medicine containers (*naga morsarang*).[3] They were always made from a water buffalo horn fitted with a wooden stopper that was generally figural in form. And although there are clearly two different types of ritual staffs and variations in the number of figures and animals depicted on them, the basic

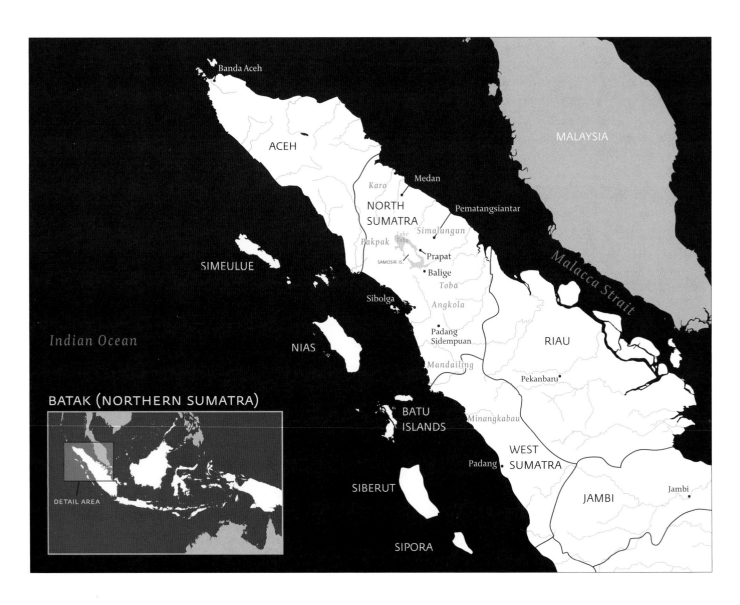

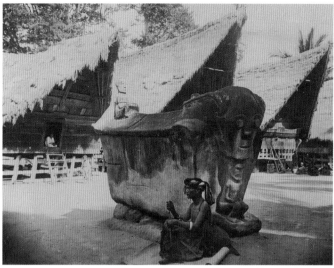

FIG 37 Woman wearing heavy silver ornaments (*padung*), Karo Batak, North Sumatra, c. 1920. Courtesy of KITLV/Royal Netherlands Institute of Southeast Asian and Caribbean Studies 6482.

FIG 38 A large stone sarcophagus in the center of a Toba Batak village on Samosir in North Sumatra, c. 1928. Courtesy of KITLV/Royal Netherlands Institute of Southeast Asian and Caribbean Studies 78570.

structural concept changed very little within a given ethnic group (cat. 15).

What fascinates us about the art of the Batak now, in our own time? What makes a sculpture into a work of art? The aesthetic impact of a particular object can be very different for people from different cultures. Time and geographic location also affect how an object is perceived. Subsequent generations certainly judge the artistic value of an object that was used by a long-deceased ancestor differently than he himself would have judged it. Members of other, foreign, cultures also view and interpret such an object differently than did its original creator. This may reflect different aesthetic values, but also perhaps insufficient knowledge about the intention and function of an object. Prejudices and a lack of respect for the products of other cultures are also a factor and can lead to misinterpretations.

It is often the unknown, the strange, and the exotic that fascinate a Western art lover about the art of the Batak. Indonesia is far away. Few Westerners know Batakland from their own travels; most people obtain their knowledge only from books, film, or travelogues. And precisely in these "sources," primarily from the nineteenth and the beginning of the twentieth century, we find reports about cannibalism, headhunting, and continual fighting among villages. The mountainous world of Lake Toba, which remained inaccessible to foreigners into the nineteenth century, was shrouded in mystery and was the subject of adventure stories. The veneration of ancestors included an elaborate funeral cult that practiced secondary burials, which were of great interest to

Westerners.[4] Ancestor figures, which could still be found throughout the region in the nineteenth century, first came to the attention of art connoisseurs during the twentieth century. Around the beginning of the twentieth century, perceptions of "the art of primitive peoples" began to change in the Western world as many forms of non-Western art were embraced and championed by Western artists. Western attitudes toward the art of the Batak also slowly began to change. Nonnaturalistic sculptures, in particular, were from then on viewed through different eyes.

In their figural sculpture, the Batak embraced unusual rules of proportion with an emphasis on the head at the expense of the legs and feet. The often squared, vigorously protruding chin, especially evident in the art of the Toba Batak, resonated with the style of the times in early twentieth-century Europe, particularly in fascist Germany. Something mysterious seemed to imbue the facial expressions of the sculptures of the Toba Batak. The sculptures gaze calmly, almost contemplatively, straight ahead. Figures with eyes often lacking pupils seem to gaze vacantly into an emptiness. The figures generally sit, kneel, stand, or ride in a closed, static posture. Only a few known sculptures depict figures in a state of motion.

The unusual patina of a sculpture's surface also frequently elicited great admiration on the part of Westerners. An aesthetic appreciation for its shimmering, partially glossy surface was heightened by a sense of awe at the thought of how the owner—of a magic staff for example—could very possibly have created this patina with his own hands.[5] During his ritualistic practices, a *datu*

FIG 39 Northward view from the southeast coast of Samosir, Lake Toba, 1989.
© Christine Schreiber from *Sidihoni: Perle im Herzen Sumatras I.*

would rub a sacrifice of food and beverages (rice, meat, vegetal matter, or blood) onto the surface of his staff. This regular application and rubbing by hand, over the course of many years, resulted in a lustrous patina, which has been described by some as a "blood patina."[6] Other objects that were kept in the house over open fireplaces have a patina that is crusty and smells of smoke. This patina is usually covered with fat and the tarnish of house dust—provided that it was not polished by later Western owners.

The most important cult objects of the Batak were richly carved magic staffs (*tunggal panaluan* or *tongkat malehat*) and medicine containers (*naga morsarang*). The *datu* produced these objects for his own personal use.[7] If a *datu* carved objects for other customers, such as figures to counteract illness (*porsili*) or protective figures (*pagar* and *pohung*), then he alone was the one who guaranteed the effectiveness of the figures through his incantations, ritual actions, sacrifices, and offerings of prescribed food and beverages. Moreover, it was at his sole discretion to determine when certain aids, such as amulets, magically effective figures, or remedies intended to cure a sick person, were to be administered. In this way, the *datu* themselves were able to control the demand for their services. They earned a large portion of their income through performing the ritual aspects of their profession. Their training took a

long time and was expensive; the collecting of medicinal herbs and magically effective ingredients and the production and application of various aids and cult objects were time-consuming.

The external appearance of figures created by the *datu* had no influence on their function or value. The worth of a sculpture was measured by its proven effectiveness against anything negative, including adverse interactions with ancestors, malevolent spirits, or personal enemies. If a sculpture had accomplished its task, it was left to rot, rather than being cared for as an heirloom with an ongoing purpose. For the majority of the Batak, the aesthetic quality of a ritual sculpture was less important than its magic-religious efficacy.

Three-dimensional human representations depict figures of both sexes in standing, squatting, or kneeling postures, as well as male equestrian figures. Standing sculptures in human form represent spirit beings or ancestors. They are frequently described as "ancestor figures," although only in the rarest cases do they depict specific forebears known by name. Representations of the founding ancestor couple (*debata idup*), which were kept in the oldest residential building, known as the house of the founding family of a clan (*marga*), were regarded as a temporary physical residence for the ancestors during rituals. In contrast, protective spirits (*pangulubalang*) are permanently connected to the figures representing them

thanks to certain magic ingredients, known as *pupuk*.[8] A *pangulubalang* is a permanently animated sculpture and not just a casing for a temporarily present spirit.

Among the Batak, two stylistic features are characteristic of sculptural representations of the human form. The first is the oversized representation of the head, mentioned above. In accordance with Batak ideas of proportion, the head, trunk, and legs of a standing figure were almost always equal in length. An explanation for these proportions, which appear unusual from the Western viewpoint, relates to the old religious beliefs pertaining to the soul or life force (*tondi*), which was understood to be especially present in the brain, blood, and liver—but not in the legs. Moreover, a *datu* applied the magically effective ingredients for the "vivification" of the sculpture precisely to these regions of the body.

The second stylistic feature is a closed-leg posture with slightly bent knees. This posture is widespread in the traditional arts of Southeast Asia and Oceania. In the Batak version of the motif, the legs are pressed closely together. Only rarely is the shape of the feet naturalistic in appearance; the legs often end in a closed block. In many cases, the lower bodies and legs of the figures were dressed with a hip cloth, which made a detailed fashioning of the legs and feet unnecessary from a practical point of view.

Artistically designed objects are found in all areas of Batak life. However, a family's possessions were modest in pre-Christian times. Everything was produced from materials that were collected or traded. Clothing was made of spun and woven cotton; household objects and tools were made of wood, bamboo, clay, and different metals; various pieces of wickerwork were made of palm leaves or rattan; jewelry was made of bronze, brass, silver, and gold.[9] Furthermore, various specialized craftsmen, including goldsmiths, silversmiths, blacksmiths, and woodcarvers, designed numerous utilitarian objects, from house façades to sword hilts. Batak produced their own weapons, swapped them with neighboring groups, or brought them back as trophies from raids. Chinese and Thai ceramics, as well as earthenware, woven bags, and betel boxes made by northern and southern neighbors, were of foreign origin. These products found their way into Batakland through traditional trade routes, adding to the diversity of styles and materials in the region. Other finished products from the coastal regions or other parts of the world first came into Batakland with the advent of Christian missionaries and Dutch colonial rulers toward the end of the nineteenth century.

The art of woodcarving was profoundly changed as a result of growing Christianization, integration into the Dutch colonial empire, and the increasing number of travelers to this region. Not only did much of the indigenous paraphernalia in the possession of the *datu* become superfluous, since this material was not compatible with Christian beliefs, but the introduction of the colonial monetary economy also destroyed the traditional exchange structures. Numerous figural objects fell victim to Christian and Western innovations, and many of the utensils used for curing the sick were eventually replaced by Western medicine. The *datu* increasingly lost influence as custodians of the beliefs, history, and traditions of their society. Frequent commissions for the artistic design of house façades to fend off disaster decreased in direct proportion to the Batak giving up their traditional architectural styles. The spread of Christianity destroyed the foundations of the old Batak religion, making the further production of cult objects superfluous. Christianization had advanced so much in just a few generations that researchers and travelers in the 1920s and 1930s already had difficulty obtaining authentic information about precolonial traditions and practices during their trips to Batakland. For the *datu*, this process meant the loss of their once highly regarded position in society.

Today, the lifestyle of the Batak can hardly be distinguished from that of their neighbors. Industrially manufactured products from Australia, Asia, and Europe have displaced the traditional objects of daily life. The specialized knowledge of brass casting and wood carving has largely disappeared as a consequence. Only certain forms of jewelry, along with a broad range of woven textiles, have survived. Today the numerous products of modern tourist art as well as the proliferation of blatant fakes have come to play an increasingly important role in the local marketplace. At the same time, objects preserved in museum collections since the beginning of the twentieth century are only very rarely recognized by young Batak as a part of their own culture, because knowledge about their original functions and their cultural meaning is no longer passed down from generation to generation.

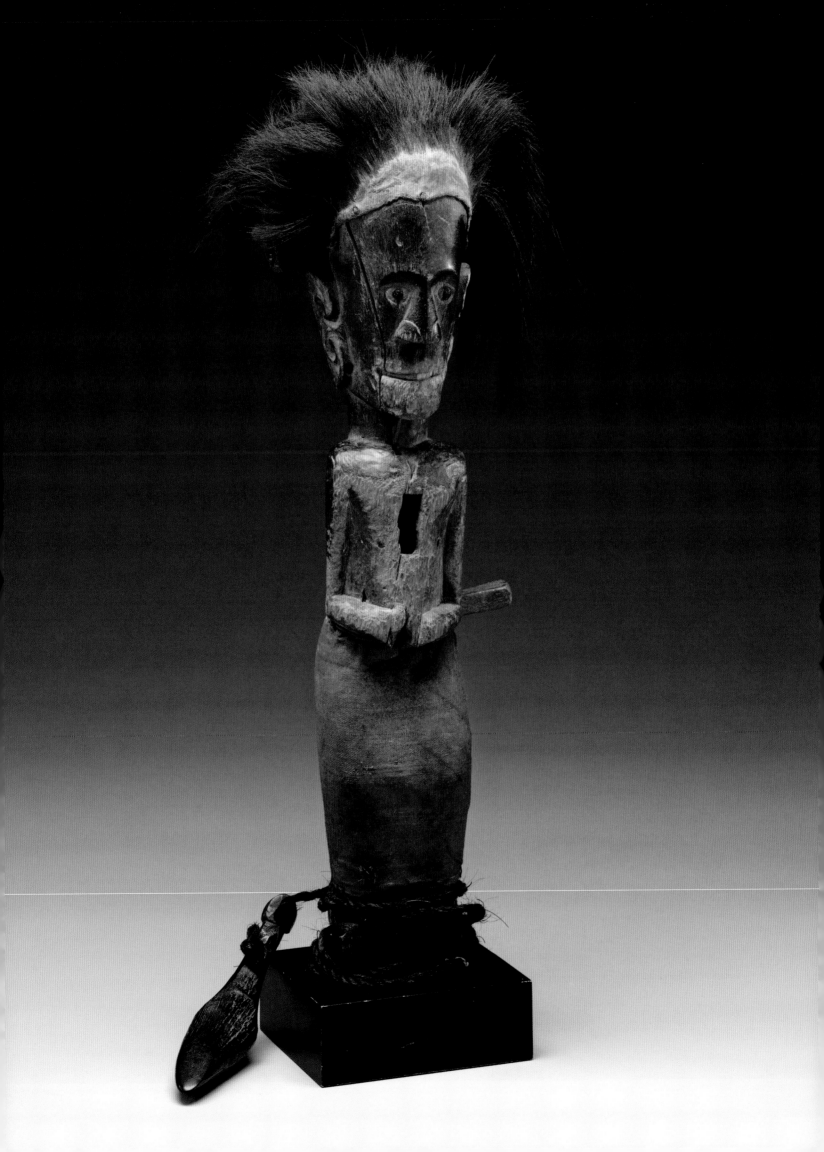

11

Guardian sentinel

Indonesia, North Sumatra, Lake Toba region,
Toba Batak people
Late 19th century
Wood, metal, horsehide, and fabric
20¼ × 9¼ × 6½ in. (51.8 × 23.5 × 16.5 cm)
Gift of Honu Frankel, Ethel S. Frankfurt, Ebby Halliday,
Jean Pogue, Rita Rasansky, and Judy Tycher, 1982.31

In contrast to the ancestor figures (*debata idup*), guardian sentinels were provided with a magically effective ingredient (*pupuk*), which was inserted into square or rectangular cavities in the chest or liver areas. These cavities were closed with a covering made of wood or metal, which was glued or nailed to them. In many cases, a dollop of tree resin served the purpose, or an angular wooden peg was used, from which a piece jutted out. The offering of food and beverage sacrifices was thought to assure the lasting efficacy and power of these sculptures.

The figure illustrated here has a cord attached to its legs made of fibrous material (*ijuk*) from the sugar palm, to which a spoon used for feeding the sculpture is tied. Traces of abrasion to the mouth and chest gradually resulted from this ritual feeding and show that the figure enjoyed great attention and esteem over a long period of time.

A clapper was attached to the wooden peg on some guardian figures, from which warning signals could be sounded by striking it against the thighs. This type of guardian figure often hung upside down somewhere in the house. In general, guardian sentinels share certain features in common with the protective figures called *pagar* (the literal meaning of which, in English, is "fence").

This standing figure—probably male—has a direct, frontal gaze. The eyes are wide open and feature inserted pupils fashioned from buffalo horn. They lie beneath arched and protruding eyebrows. The skull is covered with a long-haired, black horse mane or hide. The broad nose with its indication of nostrils, the squared, slightly prognathous chin, and the wide mouth with its bulging lips are all typical of Tobanese sculpture. A crack traverses the right half of the face. A wooden peg seals an opening for the magically effective *pupuk* in the region of the temple over the right ear. Another wooden peg is embedded in the left abdominal area.

The figure has an oblong skull. The lower jaw and the chin are noticeably narrow. The large ears are shaped as spirals; the earlobes have been pierced for the attaching of jewelry. It is possible that the figure wore such jewelry only for ceremonies.

In the head, upper body, and legs, this sculpture exhibits proportions typical of the art of the Batak. The upper body is cylindrically round; the bent arms pressed against the body are fully differentiated from it. The hands show substantial traces of wear. A grayish-brown hip cloth covers the lower body and legs. In the past, many guardian and protective figures were dressed in this way. However, these garments have often been damaged or lost; in these cases, figures often display considerably lighter areas of the body that were originally clothed. In the case of the Dallas figure, the hip cloth seems to be original.[1] The base area, which indicates the feet, was drilled through at the side to attach the spoon with an *ijuk* cord. The back of the figure is not angular, but instead is carved naturalistically. The fact that the hair is still to a large extent intact is especially gratifying. In most of the objects that have been adorned with or produced from leather and hair (such as the bags used by *datu*), much of the hair has been lost due to damage from mites.

Even if the traces of abrasion around the mouth and upper body seem to detract from the aesthetic value of the sculpture at first glance, this figure nevertheless radiates a unique expressiveness and "wildness," strengthened by a penetratingly rigid gaze.
A.S.

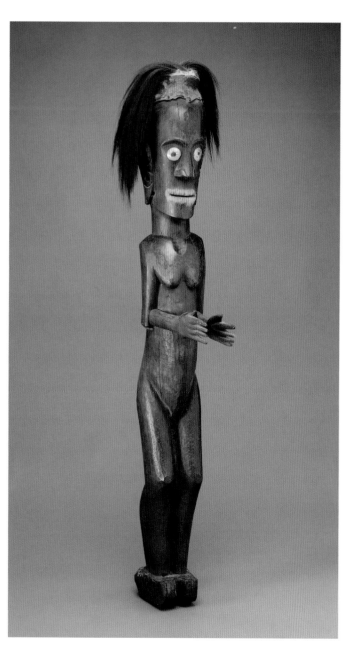

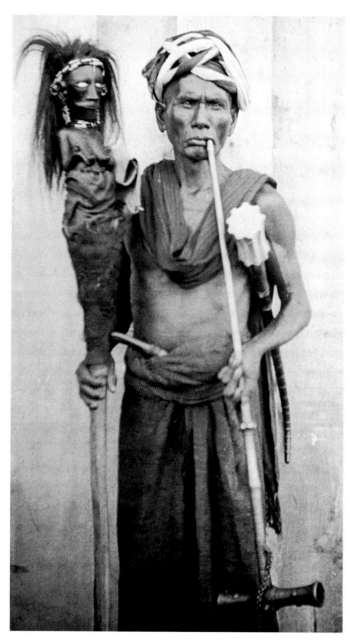

FIG 40 Protective statue, *pagar*, 19th century. Wood, metal, hide, hair (horse), 45 × 5 × 10 in. (114.3 × 12.7 × 25.4 cm). Fine Arts Museums of San Francisco, Gift of George and Marie Hecksher, 2005.140.1. This *pagar* was collected by Steven G. Alpert from the same house as were cats. 11 and 12.

FIG 41 Priest-magician (*datu*) with a long pipe (*tulpang*), a sword (*piso gading*), and a magic staff with a large *pagar* on top. Toba Batak, North Sumatra, 1920s–1930s.

12

Male protective figure (*pagar*)

Indonesia, North Sumatra, Lake Toba region,
Toba Batak people
Late 19th century
Wood, fiber, metal
23 × 2 × 2 in. (58.4 × 5.1 × 5.1 cm)
Gift of Mr. and Mrs. Fred M. Richman, 1984.82

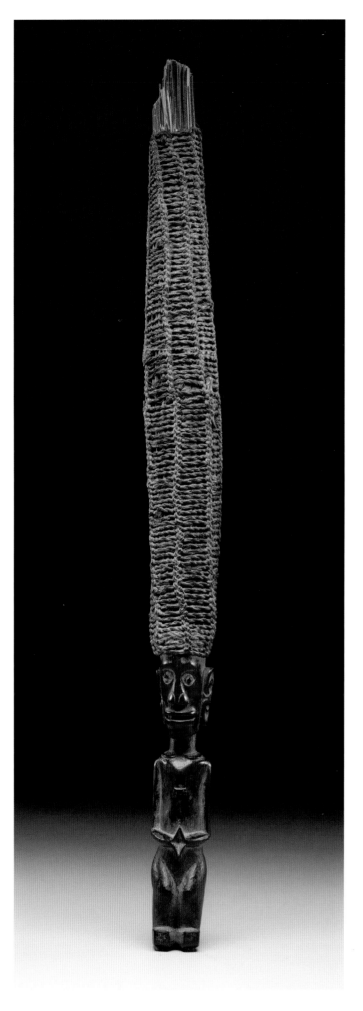

This figure belongs to the group of protective figures categorized as *pagar*, although its basic construction differs from that of the freestanding male and female protective figures illustrated on pages 76 and 79 (see cats. 16 and 17). The comparatively small figure is characterized by an extraordinarily high crown or headdress. This structure is wound tightly with wrapped fiber cord (*ijuk*) around a wooden core. Only a small portion at the top of this wrapping has been lost. The headdress functioned as a container for certain organic materials (often including leaves and animal bones) that were inserted into it as magically effective ingredients.[1]

Pagar figures of this type were mostly depicted in a squatting posture above the container for the magic ingredients. The Dallas *pagar*, however, is a rare standing figure and is underneath its container. The legs are slightly bent at the knees. The kneecaps are clearly emphasized, but the feet are not developed. The legs are a bit short compared to the upper body, and yet the proportions of the figure largely match those of cats. 16 and 17. The head shows typical Batak features; however, the ears are not pierced and a necklace seems to be indicated. The arms are bent against the body, and the upper arms are considerably elongated. The hands are formed into a diamond shape on the belly. This position of the hands appears quite frequently in Batak woodcarvings—mostly in the case of ancestor figures (*debata idup*). A square hole in the chest is for the insertion of further magical ingredients (*pupuk*). The strong hips, legs, and the thin arms are depicted with smoothly rounded forms.

This figure was purchased from the same family as was the guardian sentinel (cat. 11).[2] In addition to the clear parallels in the design of the head and face, the disproportional, elongated upper arms and general deep-reddish patina also seem to confirm a common provenance. A third *pagar* was originally associated with these two figures;[3] it is presently found in the Indonesian collection of the Fine Arts Museums of San Francisco (fig. 40).
A.S.

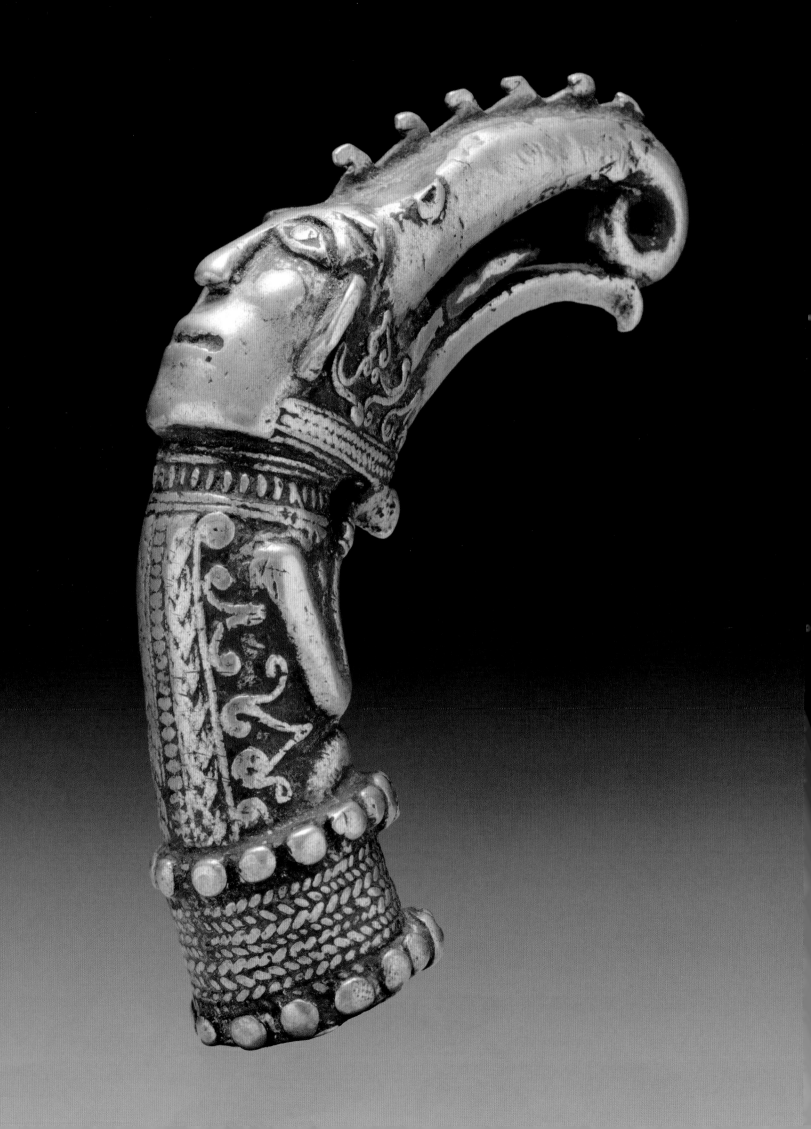

13

Knife hilt

Indonesia, North Sumatra, Lake Toba region,
Toba Batak people
17th to 19th century
Brass
3⅝ × ⅞ × 2⅝ in. (9.2 × 2.4 × 6.7 cm)
The Roberta Coke Camp Fund, 1994.252

This knife hilt is genuinely one of a kind in its design. Looking from the front, a large human face wearing an immense headdress dominates the composition. From the side, the figure's thin and disproportionally small arms and legs that are arched to the back are seen. This rather unnatural depiction of the human body indicates that a priest or magician (*datu*) is represented. The *datu* were quite feared in pre-Christian times. For example, the fear of their magic powers was so great that their bodies were buried in a squatting position away from regular cemeteries. Bodies were placed to ensure that under no circumstances could the *datu* see in the direction of their villages. Moreover, their hands and feet were bound to prevent any possibility of physical return to their villages.

Looking at this object from its side makes it clear that the long headdress of the *datu* represents the stylized head and beak of a hornbill. Comparable double views can be found in bullet cases (*baba ni onggang*) among the Karo and Toba Batak.

Knife hilts depicting a bird's head, its beak, or the point of the beak rolled inward were common in many regions of Indonesia. Among the Batak, the idea existed that the soul of a newly deceased person began its journey to the kingdom of the dead on the back of a bird. Birds also had an important function during the creation of the Earth in Batak legends, according to which divine messengers, in the shape of birds, brought soil down into the primeval waters. Si Deak Parujar, a goddess who fled from the sky, was able to use this soil to create a habitable world for mankind.

In the DMA knife hilt, the figure of a *datu* arching backward squats on a base depicting a woven ornament, which is defined at each end by a band of flat balls. Such "pedestals" are seen chiefly on the long swords, *piso halasan*, made by the Toba. The body displays a central pattern of horizontal lines in front, flanked by a narrow woven band on each side. Batak rules of proportion are also recognizable in this object, according to which the head—the most important part of the body—is oversized, while the torso and extremities recede in contrast.

The face of the *datu* is characterized primarily by his prominent mouth and strong chin. The lips are formed in a slightly raised straight line, while the pupils are clearly delineated in their oval sockets. Zygomatic arches emphasize the face's rigid gaze, which is focused upward in an otherworldly direction.

A pendant earring in the form of the Karo Batak ear spirals (*padung-padung*; see fig. 37, p. 63) can be seen on each side. This is quite unusual for the work of a Toba Batak brass caster. It is possibly an indication that the object was created in the border area adjacent to the Karo or was produced for a *datu* of the Karo people. Purely functional considerations certainly did not lead to this design for a knife hilt. The most likely explanation is that the depiction of a *datu* was intended to transfer some of his personal magic powers to the knife.

The Toba were renowned for their skill in brass casting. Through casts made by using the lost wax technique, they produced pieces of jewelry, metal fittings for bags, brass necklaces, and tobacco pipes and boxes, as well as containers and equipment for betel consumption. In addition to figurative knife and sword hilts, they also produced human figures, standing or riding on horses, as top pieces for a simpler form of magic staff (*tongkat malehat*). Tobanese objects cast in brass frequently stand out for their richly varied floral decorations, which were either predefined in wax or subsequently embossed or carved out after their initial casting.

The piece's surface polish and wear are the result of long use and considerable age. The Dallas knife hilt is a masterpiece of brass casting. It embodies all of the aesthetic and imaginative qualities of the art.

A.S.

Sword with a Janus-faced hilt in an undecorated sheath

Indonesia, North Sumatra, Lake Toba region,
Toba Batak people
c. 1800–1850
Iron, wood, and horn
27½ × 5 × ⅞ in. (69.9 × 12.7 × 2.2 cm)
Gift of Steven G. Alpert and Family, 2001.354.A–B

In the basic form of its sheath, this sword is reminiscent of the *piso sanalenggam* sword of the Simalungun Batak; however, it is longer than the Simalungun type. The sheath gleams with an extraordinary patina reflecting black, brown, and red hues. While the sheath is not carved with any ornamentation, its basic form adds to the anthropomorphic sense of the entire object: the handle suggests a head, and the sheath a body. On the upper part of the sheath are three cleverly placed knobs. In functional terms, these projections helped to hold the sword's carrying cord or sash firmly in place. This rare type of sword with its unusual hilt is actually a Toba Batak sword known as a *piso halasan*. The sword hilt was cut from water-buffalo horn and features three small, curved pins of differing lengths made of iron.

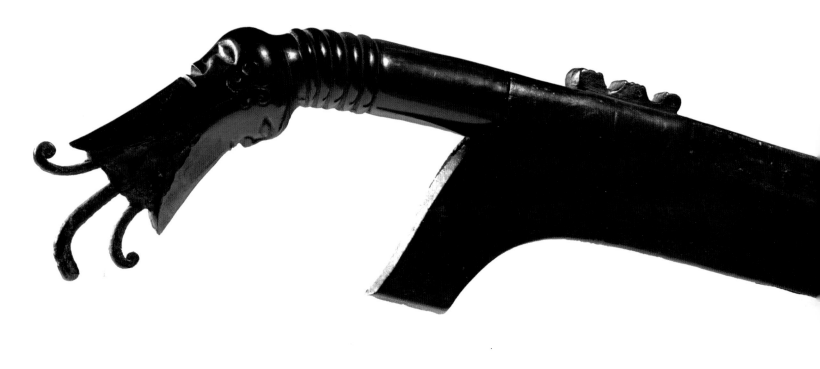

This type of sword was more likely to have been a status symbol than a combat weapon, because the Batak preferred to fight with weapons made for distance, such as spears and guns, as opposed to engaging in hand-to-hand combat.

The design of the hilt on this sword is particularly striking. Above five simply engraved rings are two identical carved faces, which are facing in opposite directions.[1] Unfortunately, it has not come down to us what the Batak traditionally saw in this configuration.

The two projecting points on the lower corners of the hilt can be viewed as the oversized chins of the two Janus faces; they also repeatedly occur as a stylistic feature in the large helmet masks of the Batak mask cult. The three iron pins are inserted into the opened lower edge and can be interpreted as furled lips with tongues protruding—a motif to which the Batak assigned the power of fending off disaster. The pins can also be interpreted as a flower with leaves and pistils.

Few comparable specimens of this sword type are preserved in any worldwide public or private collection.[2] Here, the overall shape has been redacted to its simplest, most powerful form, which makes this an outstanding example.

A.S.

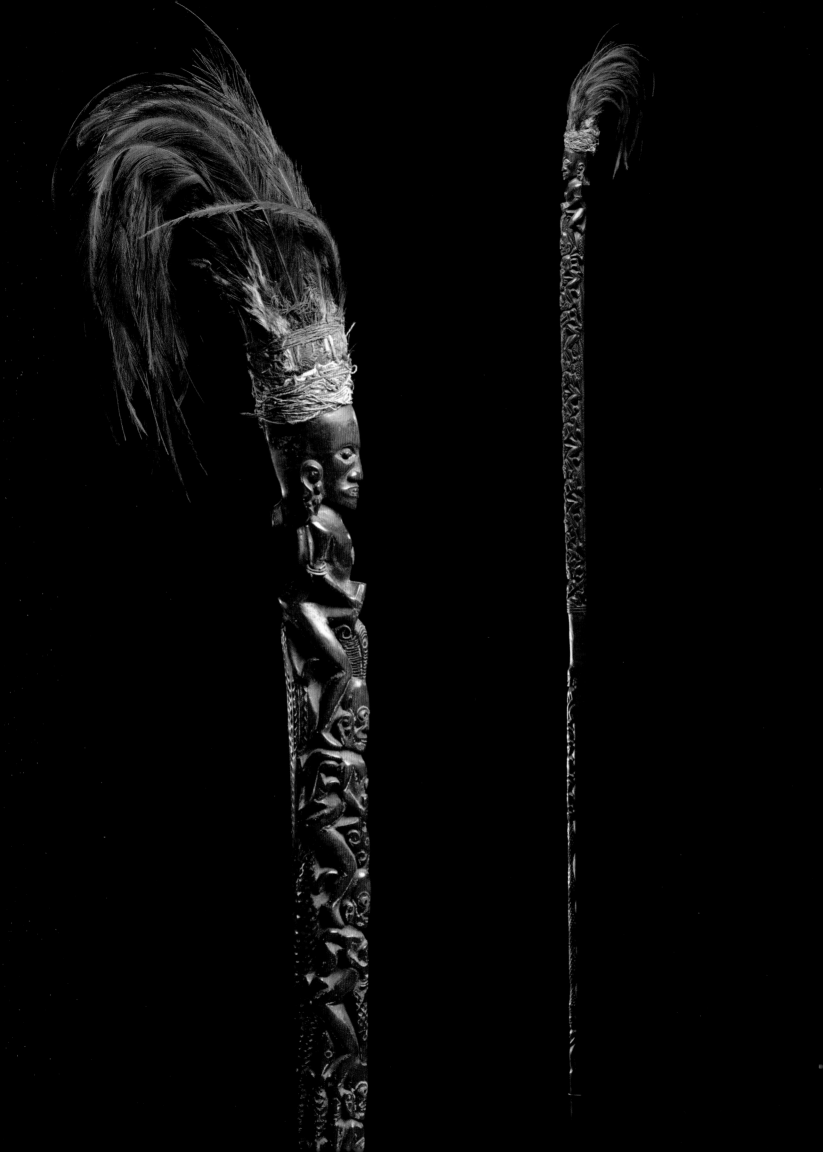

15

Priest's staff (*tunggal panaluan*)

Indonesia, North Sumatra, Toba Batak people
19th century or earlier
Wood, lead, buffalo horn, brass wire, chicken feathers,
and cotton yarn
72 × 6 × 8 in. (182.9 × 15.2 × 20.3 cm)
The Eugene and Margaret McDermott Art Fund Inc.,
2001.266.McD

The magic staff of a priest-magician (*datu*) is undeniably the most impressive ritual object of the Batak. At least two types of staffs are known: the *tongkat malehat* and the *tunggal panaluan*. At their very finest, the carved staffs with numerous figures (*tunggal panaluan*) are exceptional examples of the creativity and artistry to be found in Batak woodcarvings.

According to pre-Christian ideas, a magic staff protected the house of its owner from fire, warned against enemies, and served as a magic weapon in combat. A *datu* could make rain, drive away storms, visit illness or death on enemies, or cure illness, all with a magic staff. Moreover, the staff safeguarded the fertility of fields, people, and animals.

The mythological background behind the magic staff, held in common by all Batak subgroups, concerns the incest between a pair of twins. As is the case with many ethnic groups, among the Batak incest was considered to be a serious offense against the overarching importance of exogamy. The myths of the Toba record that after committing incest the boy and the girl tried to pick fruit from a tree but, as punishment, became intertwined with it and could no longer disentangle themselves. Their parents made efforts to rescue them, engaging five *datu*, one after another, to try to release the children through sacrificial offerings and ceremonies. However, none of these *datu* were strong enough to undo the spell. Ever since, a carved staff depicting this mythical event has been regarded as the most effective and singularly powerful instrument of the *datu*. The staffs were considered so dangerous to normal people that the *datu* had to keep them outside the village.

Great differences exist in the iconography of the staffs, but basic features are also found in common. The staffs vary in length between 50 and 100 inches and in thickness between 1 and 3 inches. Even the number of persons and animals carved into the wood varies significantly. However, the order of the seated and standing figures, one on top of the other and almost always unclothed, is the same in all staffs. The two topmost figures are always of different gender.

The *datu* consecrated the staffs with magical ingredients (*pupuk*). They inserted a magic mash into the cavities of the chest, belly, and liver areas of the figures and closed the holes with resin, lead, or a wooden peg. Thus, the staff was regarded as being "in-souled" or animated. During ceremonies, the *datu* danced with the staff and rubbed it with betel juice, finely chewed rice, and the blood of sacrificed animals. Through these practices, a magic staff would receive an unmistakable and often remarkable patina over the course of long years of use.

The Dallas staff, carved of a reddish-brown wood, displays the residue of a crusty patina in the cavities above and below the haft. The surface itself has been brightly polished through the constant rubbing of food and beverage sacrifices by the *datu*, or also by later owners, so that the wood emits a brilliant reddish gleam. Such a surface shows the intensive and long-standing use that distinguishes a very old magic staff.

Seven human figures can be recognized above the haft, and two more beneath it. Of these, six of the figures above stand on or sit astride scaly, serpentine riding mounts. The uppermost figure depicts the mythical hero Si Adji Donda Hatahutan, who rides the underworld dragon *naga padoha*, here appearing in the form of a scaled snake. Each of the other smaller serpentine mounts carries one of the other five figures. In the religious belief system of the Toba Batak, the autochthonous underworld dragon and the snake goddess (*naga*), taken from Hinduism, are combined to form a mythical creature, called a *singa* by the Toba today.

The head of the topmost figure is decorated with a large feather headdress, which is attached to a peg with a white, red, and black cord called *bonang manalu* that is concealed by the feather headdress. The figure shows a particularly fine attention to facial and bodily detail. Lead inlay has been preserved as a pupil in the left eye. The figure wears metal bracelets on his upper arms. Below the rider, we see his sister Si Tapi Na Uasan, who, like the four other figures, stands on a *singa*. The figures below the twin couple represent the unsuccessful *datu* called on for help by the parents in the mythological story. As in many other magic staffs—but not, by any means, in all of them—the fourth figure carries a chicken in its hands as a sacrificial offering. The figure above the haft sits cross-legged. Two smaller standing figures can be recognized below the haft, between whom three dogs and a snake are represented. All the figures above the haft, and the lowest figure as well, have round lead inlays over the *pupuk* holes in their chests. Even the snake below the haft formerly had an insertion hole in its head.

When the staff is viewed from the side, smaller animals can be discerned in a fluid array on the back of each of the standing figures, including what may be dogs, pigs, or water buffalo.

With its nearly perfect preservation, extremely detailed stylistic features, and outstanding patina, this magic staff can be counted among the masterpieces of Batak woodcarving.
A.S.

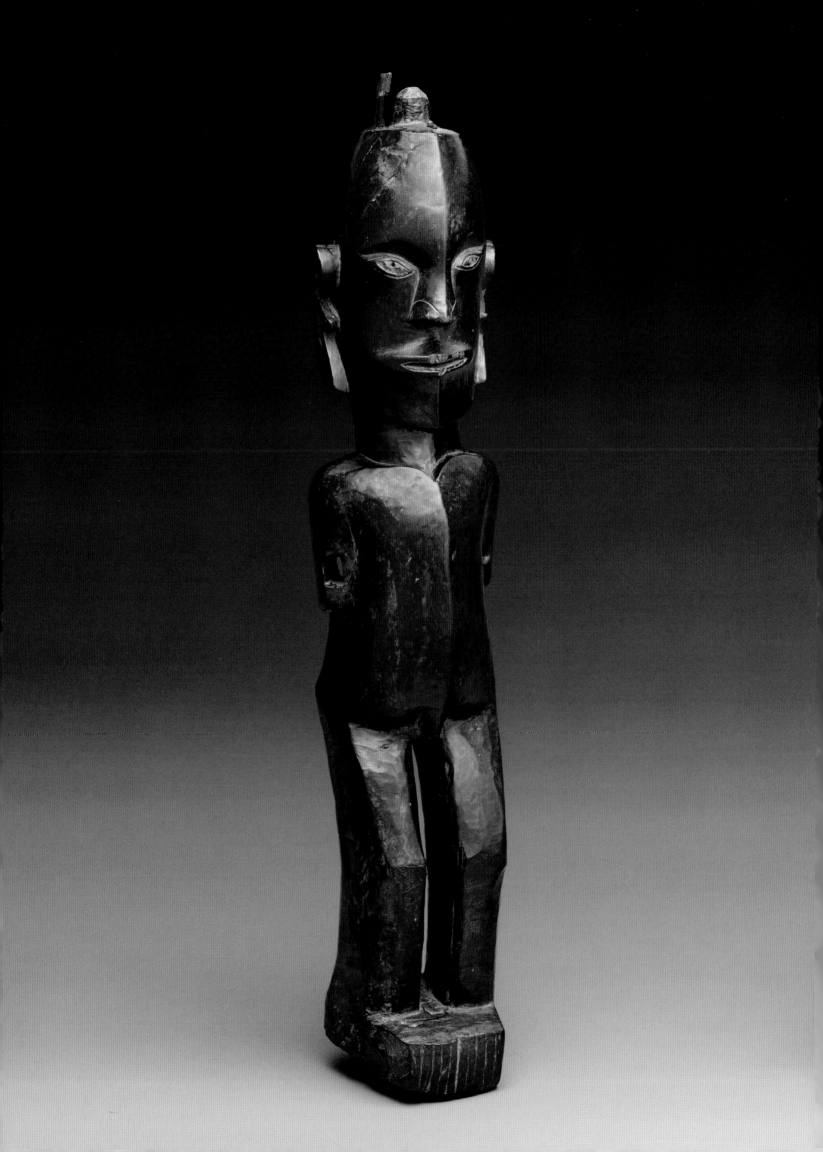

16

Male protective figure (*pagar*)

Indonesia, North Sumatra, Lake Toba region,
Toba Batak people
19th century or earlier
Wood
21 × 4¾ × 4½ in. (53.3 × 11.8 × 11.4 cm)
The Eugene and Margaret McDermott Art Fund, Inc.,
1995.33.McD

This protective figure is one of a pair; the Dallas Museum of Art also owns the female counterpart to this male figure (see cat. 17). A third figure is said to have originally accompanied this pair, which the previous owner could neither see nor buy.[1] Masterworks of beauty and stylistic fidelity, both exceptional figures were acquired in 1970 from descendants of the last Batak priest-king, Sisingamangaraja XII.[2]

Protective figures of this type were set up mostly in front of residential buildings and in the fields, but also inside private dwellings. The peg beneath the base proves that this figure most likely stood on the cross-girder of a roof construction. The residue of old smoke in the patina, which rose up from the open fireplaces over the course of many years, also suggests this. What had formerly been a rather dull patina was transformed into a shiny dark reddish-brown surface through intense use, and perhaps through polishing by previous owners. Like many other Batak cult objects, *pagar* figures received regular sacrificial offerings in order to maintain or intensify their effectiveness against disastrous influences. Food and beverage sacrifices—mostly eggs and rice, as well as palm wine and the blood of sacrificial animals—were ritually smeared onto such figures.

Both the male and female figures previously wore headdresses, which in each case were fastened to a small peg on the skull. As with magic staffs (see cat. 15), this decoration consisted of human hair or horsehair, which was attached by means of a woven cotton ribbon or a tricolor band of thread (*bonang manalu*). Feathers and the fibrous material (*ijuk*) of the sugar palm were also sometimes used as a hair substitute. In the case of statues, a section of an animal's skin or scalp with its remaining hair, usually a horse's mane, was attached. The headdress must have originally been far larger in the case of the male figure, since its skull featured additional pegs, of which only one survives.

This figure's gaze is trained straight ahead; the facial expression projects a mixture of outward calm and inner forcefulness. The head, upper body, and legs are all about the same size respectively. The broadly angled nose with its indication of nostrils, the

square chin, and the wide mouth with bulging lips are all typical stylistic details used in sculptural art in the regions around Lake Toba. The deeply cut, wide-set eyes, whose pupils were formerly emphasized by insertions of lead, are still lively and penetrating. The ears are adorned with an inner pattern, which is more extensive on the left one. The short, strong neck is set on a narrow upper body with clearly defined collarbones. A discernible ridge characterizes the vertical center of the body. The upper arms lie against the body and have square holes at the lower ends, into which forearms with hands originally stretched out toward the front at a ninety-degree angle. These no longer exist. The posture of the hands, however, would likely have corresponded more or less to that of the female figure (see cat. 17).

The unclothed figure stands in an open-leg posture, the hips narrower than in the female figure and the squarely carved legs slightly bent. The feet are not represented; instead the toes are merely suggested by vertical striations engraved into the front edge of the base, as is typical of Toba Batak statuary.

A.S.

Female protective figure
(*pagar*)

Indonesia, North Sumatra, Lake Toba region,
Toba Batak people
19th century or earlier
Wood
20¼ × 11 × 4 in. (51.4 × 27.9 × 10.2 cm)
The Eugene and Margaret McDermott Art Fund, Inc.,
2000.354.McD

This female protective figure was most likely created by the same expert woodcarver who—according to its former owner—made the male figure (see cat. 16).[1] The features, body proportions, posture, shape of the legs, absence of feet, sexual characteristics that are only hinted at, and the treatment of the surface all correspond to the Dallas male figure. These parallels are certainly the reason some scholars believe that the two figures must have been representations of an ancestor couple, *debata idup*.[2] Several aspects contradict this interpretation, however. The *debata idup* are normally represented with their arms against their sides and in a closed-leg posture. Their hands emphasize either their bellies or their genitals. Unlike protective figures, which are intended to repel harm and misfortune through the posture of their hands and arms, the *debata idup* figures serve to protect the continued existence of the family. They may be ritually deployed in cases of the absence of offspring, for example, to promote the fertility of a man and woman.

Compared to the slightly taller male figure, the head of this sculpture is a little broader and the eyebrows are emphasized more strongly. As a result, the eyes seem to be cut more deeply. The ears are also different in their design. They hardly show an interior structure and are unadorned by jewelry or ornamentation. The outstretched forearms of the figure with their gigantic hands are inserted into the side openings of the closed upper arms, each by a wooden peg. The forearms and palms point to the front. The fingers are close together, the thumbs not differentiated or rendered naturalistically, but the same length as the other fingers. The breasts lie flat on the body. The hips of this figure are considerably broader than those of the male figure so that the hips and leg joints are typically feminine. The vulva is merely suggested through light incisions.

The backs of both figures are angularly formed. Observed from the side, a curved line leads from the head and back to the horizontally sharp-edged, somewhat abstracted buttocks. Compared to the male figure, the legs of this figure are a little longer in relation to the upper body.

In both figures, we observe an aesthetic interplay between angularly shaped outer limbs and round, fully three-dimensional heads and upper bodies. The slightly bent legs and the curved backs enhance the physical balance of the figures; they are in fact reminiscent of the monumental style of stone or wooden figures that were produced primarily for ancestor cults by many Indonesian ethnic groups.

The smooth surfaces with their gleaming patinas give both figures a remarkable brilliance. In comparison, the surfaces on the majority of Batak sculptures tend to be dull and encrusted. The patina on this pair resembles that of the finest, most well-handled staffs. Both figures may be counted among the exceptional woodcarvings of the Lake Toba region.

A.S.

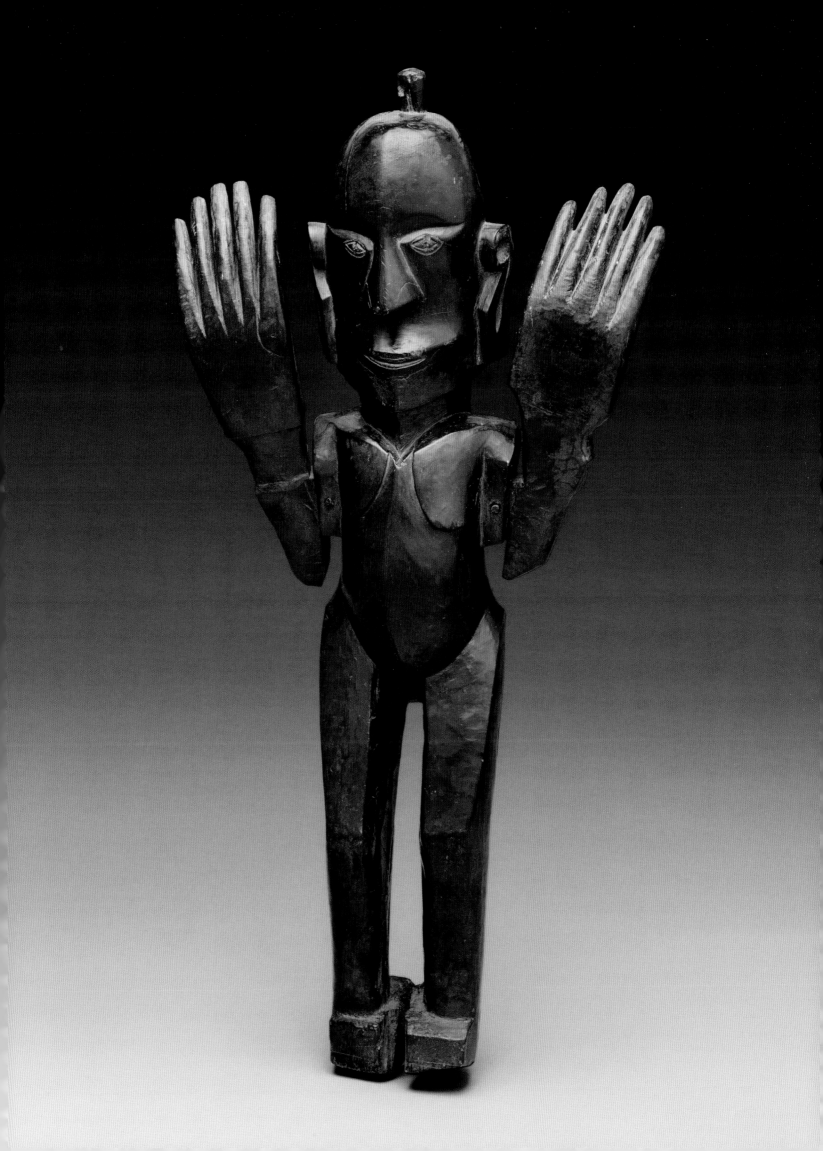

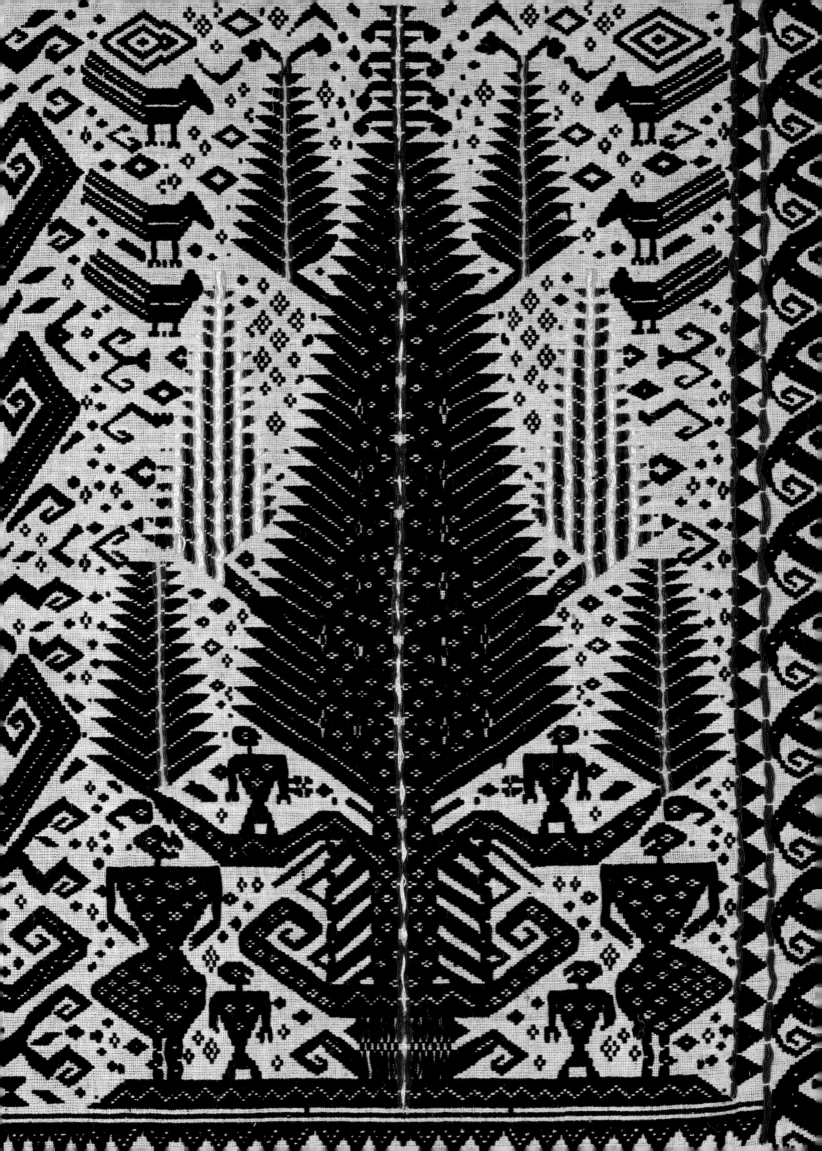

LAMPUNG SHIP CLOTHS: ANCIENT SYMBOLISM AND CULTURAL ADAPTATION IN SOUTH SUMATRAN ART

Nico de Jonge

Lampung province in southern Sumatra is known today as one of the most densely populated and also one of the poorest parts of Indonesia. This current poverty forms a dramatic contrast to its recent past. Travelers who visited the region in the nineteenth century, for example, would often be awestruck by the impressive display of beauty and splendor. English biologist Henry Forbes gives an apt testimony to this in his writings of 1880 upon encountering splendidly adorned young girls in some villages: "Every girl is arrayed in sinkels or necklets, of various shapes of heavy silver, few or many, according to the wealth or position of her parents; on their arms rows and rows of bracelets, and in their ears large buttonlike earrings."[1] It was with good reason that the region's inhabitants were renowned in this period for their "persistent vanity and ostentation."[2]

This former wealth was closely linked to the lucrative trade in pepper.[3] Large shipments of pepper grown in South Sumatra would enter the world market via Java. When this trade market collapsed in the course of the nineteenth century, Lampung was plunged into poverty.[4] This downturn in fortune was exacerbated by the devastating effect of the 1883 eruption of the Krakatoa volcano, which caused a colossal tsunami that ravaged coastal villages and claimed thousands of lives. The downturn continued into the twentieth century, and worsened after the Lampung area was designated as the primary immigration destination for poor migrants coming from overpopulated Java.[5]

It was not just the material wealth of the region that was special; the character of Lampung culture was also remarkable. It reflected the archipelago's long history in a way that was seen in very few other Indonesian cultures. Each of the grand cultural traditions that had reached Indonesia over the past 4,000 years found expression among the inhabitants of Lampung society, and their traces remained particularly evident in the region's artworks.

Here, we briefly examine these historical roots and discuss how they were expressed during the apogee of Lampung culture. Remarkably, new influences continued to infuse older traditions so that existing cultural concepts remained virtually unchanged. We are primarily concerned here with art, devoting special attention to the ship cloths. Particularly because of these unique textiles, the rich past of the Lampung is still very much alive today.

Cultural origins

The term "Lampung" is actually a generic term and refers to three ethnic groups: the Abung, a people that inhabited the mountains in the north of the province; the Pubian, from the eastern lowlands; and the Paminggir, who lived along the southern coasts.[6] The three groups consider themselves related to one another. They share a mythical founding father, Si Lampung, and a history that describes the migrations from the land of origin, Sekala Barak (to the south of Lake Ranau).[7] Family groups that left that region formed endogamous units (buwei), whose territories were called marga (or mega). This name is also used in many literary sources to specify the buwei themselves. A marga would consist of several villages named tiyuh, and each tiyuh would in turn comprise various suku, or patrilineal clans. The eldest male descendants of the founder of each buwei, tiyuh, and suku were held in high regard and bore the title of penyimbang. This term was derived from the word simbang, which means "to replace," referring to their role as representatives of the founding fathers.[8] The three separate penyimbang occupied themselves—each at his own level—mainly with the administration of adat justice.[9] Conventional political leaders were unknown to the peoples of Lampung.[10]

It is possible to recognize various elements in the traditions of the marga—as described in scarce nineteenth-century sources—that can be traced back to prehistoric roots. As is the case for all Indonesian peoples, the foundations of Lampung culture were laid down in the late Stone Age as speakers of Austronesian languages spread across the archipelago. Ancestor worship can be linked to these ancient roots, as can the practice of headhunting and ideas about cosmology. The traditions of the Dong Son culture subsequently developed on Sumatra in the Bronze and Iron Ages. Occupational diversification enabled a more hierarchical society to come into being, in which the struggle for higher social status—with elaborate feasts of merit—became a feature of Lampung culture.

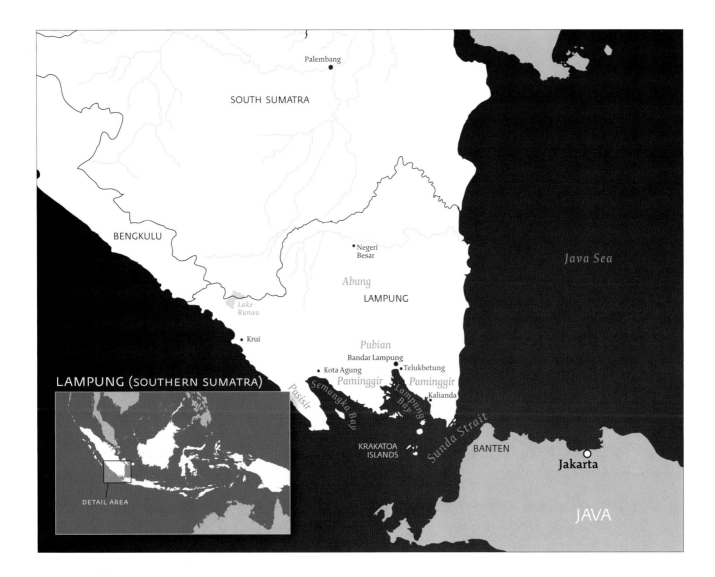

Presumably not long after the start of the common era, Indian merchants brought Hinduism and Buddhism to Sumatra, and in the thirteenth century Arabian tradesmen introduced Islam. After the Europeans arrived in the archipelago in the sixteenth century, the Lampung were confronted with Christian ideology and other Western influences.

In the nineteenth century, cultural intermingling was present in nearly all aspects of daily life within the tiny village communities surrounded by pepper and rice gardens, resulting in a multitude of extraordinary interchanges. Lampung art forms show a great deal of this intermingling of cultural traditions. To properly interpret and understand these traditions, we must delve more deeply into the nature of this "amalgamation." We will do so by looking at some brief examples arising from the exposure of Lampung culture to Hindu-Buddhism and Islam.

Hindu-Buddhism and Islam

Receptiveness to foreign influences is sometimes considered one of the characteristic traits of Indonesian cultures. The new was never shut out, but was instead invited in, causing old traditions to be transformed over and over again.[11] Elements from Hindu-Buddhism and Islam became enmeshed over time with prehistoric traditions.

The peoples of Lampung began to assimilate Hindu-Buddhist traditions probably during the first centuries of the common era. It is certain that from the middle of the seventh century onward, South Sumatra (including Lampung) was a part of the Buddhist kingdom of Srivijaya; the city currently known as Palembang was once one of Srivijaya's principal court centers.[12] As this realm weakened and finally disappeared altogether in the fourteenth century, Hindu-Buddhist influences gradually infiltrated the Lampung area from West Javan Bantam (nowadays known as Banten). Lampung pepper had great appeal to Bantam—which was a center of commerce—and thus Bantam steadily increased its interests in the area. In the mid-sixteenth century, Bantam was the source of a change that had enormous consequences. Around 1550, the local ruler converted to Islam (he would henceforth be known as the Sultan).[13] From then on, the influence of the new religion slowly spread via the coastal regions across all of South Sumatra.

It is fascinating to observe the integration of Hindu-Buddhism and Islam into the Lampung culture of the nineteenth century. A striking phenomenon in this respect is the great difference between the inland *marga* and the coastal *marga*. For example, the influence of Islam—which by that time had been present in South Sumatra for a couple of centuries—had remained limited to the

coastal Paminggir. The local *adat* of the Pubian, who inhabited more inland-lying regions, and the Abung, who lived in the mountains, remained virtually unchanged during that entire period.[14]

It is very clear that the veneration of ancestors and earth spirits, both essential strands of the Austronesian inheritance, was still the central point of focus everywhere. Even though elements of Hindu-Buddhism and Islam had been incorporated into the religion, ancestors and spirits connected to the environment continued to control daily life. It appears that the religious integration was largely a matter of applying new names to old ideas. For example, Hindu-Buddhism was acknowledged in a seemingly minimal way by designating an indigenous creator god with a Sanskrit name. In the case of the earth spirits, Islam essentially manifested itself in a similar way.

Hindu-Buddhism found expression in local mythology. The only known creation myth deals with the origin of the island of Sumatra (it contains the remarkable detail of the Lampung area deriving from a ship) and culminates in the creation of the first ancestor, founding father Si Lampung. In this case, the entire story, fully in accordance with prehistoric traditions, glorifies the worship of ancestors. The impact of Hindu-Buddhism is marginal and occurs mainly at the divine level. The creator of all earthly things was given a thin Hindu-Buddhist veneer and is referred to in the myth as *dewa*.[15]

As stated above, Islam was incorporated into the veneration of earth spirits in a comparable way. In the Austronesian traditions, surroundings were often associated with spirits who asserted themselves as the true owners of the land and who acted as sources of fertility. In the Islamized coastal *marga* of Lampung, such ancient spirits were often referred to by the Arabic term *jin*.[16] Offerings were made to them at sacred places in the environment—mountaintops in particular—in order to procure a good harvest, and to safeguard the continued existence of *marga* and *suku*. Thus, ancient mythology and religious beliefs endured with some minor refinements.

The integration of Islam into the social sphere is also revealing. Nineteenth-century reports from Dutch civil servants suggest that the imported religion was often hardly taken seriously. This is illustrated by the performances of marriageable girls at the village community center, the *sesat*. There, the young girls would dance provocatively and with their hair loose, circumstances "that would spark disgust and controversy in a truly Muhammadan society."[17]

In a notable contrast, the essential Muslim practice of going on a pilgrimage to Mecca was extraordinarily popular. Provided that the necessary means were available, every adult male Muslim was expected to make such a journey (the Haj) at least once in his lifetime, and Lampung men appeared very eager to do this. Upon closer examination, however, one sees that this motivation to travel was not entirely religious. Completing the Haj was in fact a way to climb the social ladder. The Haj was regarded as an activity that could increase social status, and consequently became a link in the so-called *papadon* complex, the system of ranks and titles that dominated traditional social life in Lampung in any number of ways.[18]

Traditionally, the institution of the *papadon* was linked to the inheritable position of *penyimbang marga*.[19] In the event of the succession of an *adat* chief, each novice had to seat himself on a sort of throne, a seat of dignity that was called *papadon*, which in addition to a higher status granted many other privileges.[20] The major feature of the ascent to the throne was the enormous feast that had to be organized. In nearly all cases, this would practically ruin the new *penyimbang marga*, as he would have to expend most of his resources in butchering a substantial part of his livestock. This custom most likely originated in prehistoric times, when comparable "feasts of merit" were celebrated.[21]

This ancient system was revitalized among the Lampung as a result of political policies enacted by the Sultans of Bantam. These Muslim rulers recognized the Lampung "predilection for splendor and social distinction" and introduced a number of universally purchasable ranks (*pangkat*) that included the festive and highly expensive *papadon* ascension. This caused the exclusive, aristocratic character of the *papadon* complex to disappear, allowing the common man—if he grew sufficient amounts of pepper and then sold it to Bantam—to also rise on the status ladder. Even though the *papadon adat* (the inheritable *papadon* ascension) was held in higher regard, the *papadon pangkat* was tremendously popular and, moreover, allowed room for the introduction of "modern" activities like the Haj into the system.[22]

These examples illustrate what nineteenth-century Lampung syncretism looked like in practice. The traditional cultural pillars, including worship of ancestors and earth spirits as well as the struggle for status, had remained intact in spite of outside influences that had been present for centuries. Precisely by being pliable and by incorporating alien traditions into those that were already present, the familiar Lampung *adat* could persist.

Ascending the *papadon*

The resilience of local *adat*, as discussed above, could be observed in Lampung material culture as well. Here, however, it was not the centuries-old traditions that were reshaped, but rather the traditional forms of art that were connected to these cultural pillars. We will demonstrate this by discussing several artifacts that played a role in the *papadon* complex. Its central position in society connected practically every major art form of Lampung to this institution.

As mentioned earlier, nineteenth-century Lampung life mainly revolved around attaining as high a social status as possible. All other matters were set aside in favor of the struggle for prestige, which culminated in the ascension to the *papadon* for the most successful men. Each rung of the social ladder had its own titles and privileges.[23] These could vary depending on the area, but the similarities were plentiful.[24] For example, as the status of a man became elevated, so did the bride price he could ask for the hand of his daughter: a "value" that would be amply visible in the amount of jewelry she would wear.[25]

The *papadon* itself, the throne that represented ultimate prestige, had a lengthy and remarkable history. Its appearance changed

frequently, owing to external influences; at the same time, the essence of the object, as a seat of dignity, never varied. The adaptations were wide-ranging; in part they concerned the design, and partly the symbolism expressed through decorative motifs.

Most conspicuous of all were the modifications that took place in the Lampung lowlands. In contrast to the mountain regions—where the traditional *papadon batus* (the original stone version of the chair, with its prehistoric roots) endured—the Pubian and Paminggir had a wooden throne type that was more amenable to adornment and stylistic modification.[26] This type was commonly used in the early years of contact with Islam. Many of the *papadon* from the coastal regions were modeled on the state thrones at the court of Bantam. For instance, backrests (*sesako*) appeared with meticulously copied floral patterns that were done in Javanese court style.[27] In the course of the nineteenth century, comparable Western influences manifested themselves in that same region. Various honorary seats were adorned with theriomorphic legs culminating in feet with dramatic claws, which were almost certainly based on seventeenth- and eighteenth-century European chairs. Time and again, a design that was associated with power and prestige would be adopted this way. The resulting dignity that the *papadon* emanated was associated with these external or foreign symbols of glory.[28]

The theriomorphic aspect was not an isolated phenomenon. Older *papadon* frequently had chair legs shaped like an animal's foot (an elephant's, for example), and the backrests of the traditional honorary seats regularly had carved animal figures on them.[29] These carvings had symbolic meanings and almost certainly expressed the original function of the piece of furniture: the elevation in status of the *papadon* ascender.

Before examining this more closely, we should first look briefly at the animals that were depicted in nineteenth-century Lampung.

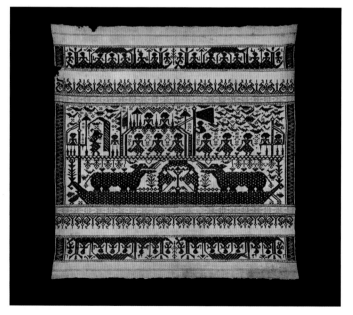

FIG 42 Ceremonial cloth (*tampan*), Indonesia, Sumatra, Lampung region, late 19th to early 20th century. Homespun cotton. The Steven G. Alpert Collection of Indonesian Textiles, gift of The Eugene McDermott Foundation, 1983.74.

The endemic water buffalo, hornbill, and elephant (fig. 42) are seen most frequently, together with the mythical bird *garuda* and a Chinese-style, dragonlike serpent, typically called a *naga*, which as a rule had a crowned head.[30] These animals can likewise be found (occasionally even together, as in fig. 43) on the honorary chairs that have been preserved in museum collections, and also on the state carriages that were used by the *papadon* owners as a means of transport to the *sesat*, the village community center where the thrones were kept.

What did these animals symbolize? The indigenous species are of particular interest in this respect. They represented a type of animal symbolism that was deeply rooted in Lampung society and probably had its origins in the tradition of headhunting. At the end of the seventeenth century, headhunting had already fallen into disuse in the coastal areas, but among the Abung it continued well into the nineteenth century.[31]

Several researchers have proved that the ascension of the *papadon* was traditionally a rite of passage for young men. Before a man was allowed to sit on the *papadon batus*, an honorary stone seat, he had to sever one or more heads; sometimes slaves would be beheaded for this purpose.[32] A young man acquired social prestige through killing and consequently obtained the enhanced status necessary for taking a wife. This was an essential social transition that would be demonstrated by ascending the *papadon*.

In the nineteenth century, there were still reminders of this ancient custom. Before each *papadon* ascension, for instance, it was obligatory to stage a mock fight (the so-called *menigel*) in the square in front of the *sesat*, at which a headhunter's blade was one of the vital attributes.[33] Moreover, the term *papadon* itself is related to headhunting. The name for the honorary chair was derived from the root word *adu*, which means "battle" or "quarrel," and appears in *pa-adu-an*, "place where one does battle," or *padon*. This latter term subsequently became *papadon*.[34]

The animal symbolism displayed on the honorary seats served to emanate the prestige that had been acquired through violence. Each of the three endemic animal species can be connected to it. In South Sumatra (as in other parts of Indonesia), the elephant was known as the mount of a great warrior.[35] Many of the megalithic monuments of the area dating from the prehistoric era confirm this.[36] The hornbill was widely associated with headhunting as well.[37] An old report about headhunts among the Abung compares them to those of the Dayak, and among the latter the hornbill was the preeminent symbol of headhunting.[38] Finally, water buffalo horns functioned as traditional trophies in Lampung culture. Until well into the nineteenth century, for example, they would be attached to the roof of the *sesat* in order to promote the prestige of a village.[39]

As time went on, the mythical *garuda* and *naga* must have been added to this indigenous trio. The adaptation most probably dates to the era of Hindu-Buddhist influences. As early as the seventh century, Sumatra (and especially the kingdom of Srivijaya) was already a key player in the trade between India and China.[40] The Indian *garuda*, mount of the Hindu deity Vishnu, originates in

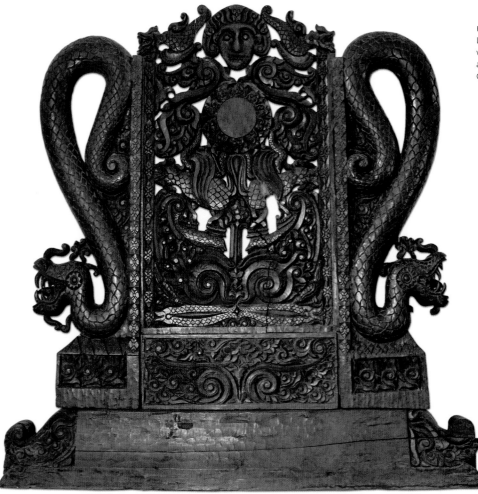

FIG 43 Backrest or *sesako* of a *papadon* seat, made before 1868, decorated with *naga* figures (left and right), what are probably hornbill figures (top and middle left and right), and fish figures (bottom left and right). Courtesy Museum Nasional Indonesia, Jakarta, 610.

India, and the dragon-*naga* is a revered creature in China, with complex symbolic associations, among them fertility.

Exactly why these foreign mythical animals became important in Lampung culture is difficult to determine. An important reason may very well have been their frequent presence as decorative patterns on trade items exported to Sumatra.[41] Moreover, the *garuda*, a bird, could naturally be associated with the hornbill, already a popular symbol; the same phenomenon seems to have occurred with the peacock. As they were incorporated into Lampung symbolism, however, both creatures lost their original meanings and gained new ones. We have to bear this in mind when analyzing the preeminent art form of Lampung, the renowned ship cloths.

Ship cloths

Extravagantly decorated ship cloths from Lampung have been of great interest to the outside world since the early twentieth century, but many of their motifs remain a mystery. The designs—often depicting numerous animals—sometimes resemble a veritable melting pot of Asian traditions. Along with indigenous Lampung patterns, for example, we see Javanese *wayang*-style motifs, Chinese-style dragons and birds, and also Hindu-Buddhist elements. The ship is present as a dominant motif on virtually all of the cloths; the textiles are indeed named after them.

Nonetheless, the character of these cloths—in spite of their similarities—is rather variable. They are habitually divided into two main categories, *tampan* and *palepai*, based on shape and use. Cloths belonging to the first category tend to be relatively small in size, and are square, with sides that rarely exceed three feet in length (see cat. 18). A *palepai* has a more elongated shape. Usually they are about ten feet long, with an average width of around twenty inches (see cat. 24). As is the case with many traditional Lampung forms of art, the production of ship cloths came to a standstill at the end of the nineteenth century, after which the fabrics gradually disappeared from society. With the passage of time, the complicated techniques used to create these textiles have also faded from memory.[42]

Decorative and symbolic motifs also vary considerably. In contrast to *tampan*, which are usually adorned with very delicate and in some cases abstract patterns, *palepai* are decorated with rather robust, plainly recognizable subjects. The figural language of the ancient Dong Son culture can be recognized in the decoration of both types of cloths.[43] The filling of the entire cloth with images and the tendency toward symmetry are both typical, as are the decorations of the edges: stylized double spirals, meanders, and hook and key patterns. At the same time, regional differences in style can be distinguished. *Tampan* that have been produced in the coastal regions often feature maritime themes.[44]

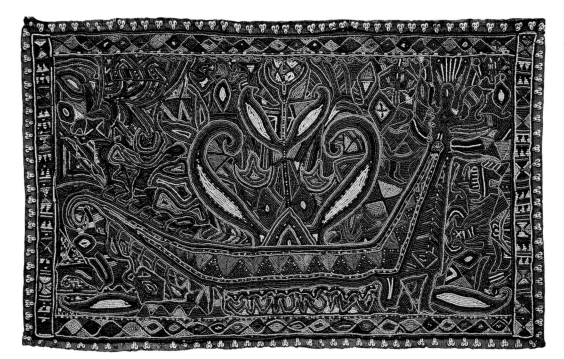

FIG 44 Beaded *tampan maju*, or ceremonial cloth, showing a symbolic boat of matrimony, made before 1878, Lampung. Cloth, beads, shells, rattan. Collection Museum Nasional Indonesia, Jakarta, 577.

Paminggir women were known to produce both *tampan* and *palepai*, whereas Pubian and Abung women made only *tampan*. All Lampung peoples used the latter type of textile, while *palepai* were used exclusively by the Paminggir. In the southern coastal regions, however, other types of ship cloths were present in addition to these two major categories. Rare textiles called *tatibin*, for example, appear to be scaled-down versions of *palepai*. Similar in size to these were very unique and valuable ship cloths called *tampan maju* that were beautifully decorated with beadwork and shells (fig. 44). Besides these fabrics, the Lampung created woven mats (*lampit*) and embroidered *sarong* (*tapis*) embellished with many decorative patterns akin to those on the ship cloths.

Since the early twentieth century, the iconography of *tampan* and *palepai* in particular has fascinated researchers and collectors, most of whose attention was, unsurprisingly, devoted to the meaning of the predominant ship motif. Because it was observed that the cloths were used during Lampung death rituals, the ships were initially viewed as ships for the soul.[45] Later, when it was discovered that the textiles were related to all life-cycle rites, the motif was seen as symbolizing transition and movement.[46] However, the rather general character of this interpretation has always been somewhat problematic. Furthermore, many other motifs—such as the numerous animals depicted aboard the ships—were left unexplained.

Several closely linked reasons appear to underlie these challenges in interpretation. Very significant, for example, is the fact that the animal representations have scarcely been investigated in terms of their indigenous cultural meanings. Hindu-Buddhist motifs, such as the *garuda*, have repeatedly been identified as traditional religious symbols (often with a Hindu-Javanese character). In other cases, particular images, and in some cases complete designs, were interpreted in terms of other Indonesian local cultures that were better documented.[47] Other kinds of meaning,

expressing concepts specific to Lampung, have apparently never been considered.

Moreover, little thought seems to have been given to the most relevant, deeply rooted pillar of Lampung culture: its boat symbolism. The major cause of this neglect seems to have been a lack of appropriate sources. Although it has been well understood for years that boat symbolism was an important concept in Lampung culture, detailed information concerning its meaning and significance appears not to have been available.

In spite of these gaps, a partial reconstruction is possible. Aided by recent studies on boat symbolism in other parts of Indonesia, a clearer understanding has emerged of what is most probably a very ancient phenomenon. Although it manifests differently in each area, this symbolism expresses equivalent, recurring messages, which can also be found in traditional Lampung culture.

Correct interpretation of animal imagery, along with increased knowledge of boat symbolism, leads to a series of surprising discoveries. On *tampan* as well as on *palepai*, we discern subjects that we can immediately connect to the use of these textiles in nineteenth-century society.

Lampung boat symbolism

In Indonesia, traditional boat symbolism was predominantly found in areas where Hindu-Buddhism, Islam, and Christianity had not made their appearance or had arrived relatively late, as was the case in the Moluccas. On many of the smaller islands of Maluku Tenggara, such as Kai, Tanimbar, and Babar, this symbolism has been well documented, and it consistently appears to have functioned in two ways. Most conspicuous is the ship's function as a model of society. Houses and villages were often portrayed as boats, with their inhabitants the symbolic crewmen (see also chapter 9). A more "hidden" form of nautical symbolism underlay this,

however, focusing on the creation of society; this symbolism represented the marriage of the first ancestors. In rituals, this wedding was expressed by means of the metaphorical "boat of matrimony" setting sail. In this metaphor, the woman was regarded as a boat, lying on the beach, waiting for a man who wanted to go sailing. Only when the man—the helmsman or captain—boarded the boat could it set sail, that is, could society come into being. All subsequent marriages were regarded as a reenactment of this primordial marriage and made use of similar symbolism.[48]

It is relevant to this discussion that the image of the boat of matrimony was conveyed in many ways in material culture. For example, the association between a woman and a boat was marvelously conveyed in ancestor statues (particularly in the position of the arms; see cat. 105). Marriage itself was similarly represented in sculptural metaphor: in the shape of a boat with a helmsman in it (see fig. 120, p. 280). As a result of Christian influences, these forms of art have disappeared over the course of the previous century.

Likewise, such symbolism is superbly evident in the decorations of ships. Splendidly adorned prows and/or sterns often show aggressive animal figures such as snakes, roosters, and hunting dogs (see fig. 115, p. 277). These creatures were more than mere decoration; they were part of a physical construction in which the bond between man and woman—or, in other words, the founding of the family—was portrayed. Although there were considerable regional variations, one part of the boat construction was marked as a feminine "hull" or "keel," whereas other parts—usually the prow and/or stern—were marked as a masculine "captain" or "helmsman." The union of these parts brought the family together in the same way that a real boat can sail because of an assembly of components.

At the same time, these references showed the traditional division of tasks in society. The female parts of the boat were associated with a vagina or uterus and suggested that giving birth to and caring for children were typically feminine preserves, while the male prow and/or stern showed that protecting the family and its reputation, especially by way of warfare, was viewed as a male's domain. By attaching symbols to these male parts—usually the animal figures mentioned above—the groom was portrayed as a great headhunter, famed for his capacity to kill.

Ongoing studies suggest that this form of boat symbolism was not restricted to eastern Indonesia but in fact was much more widespread and most likely included the islands in the western regions as well. Research concerning Bali, Madura, and Java is compelling in this respect. Here, too, as in Maluku Tenggara, a marriage between male and female components is enacted in traditional boat-building rituals.[49] At the same time, there is significant evidence regarding the age of the symbolism. We are dealing with an ancient, prehistoric tradition, which must have been present on the islands before they obtained their current Hindu (Bali) and Islamic (Madura and Java) characters.

Everything seems to indicate that South Sumatra must have been within the range of this type of boat symbolism. The boat was a significant model of society among the peoples of Lampung and served as a structuring principle for houses and ceremonial processions.[50] This was not an isolated phenomenon but was instead linked to a broader type of nautical imagery in which the boat of matrimony also played a role.

Although they have been only briefly studied, nineteenth-century love songs from Lampung also clearly imply that the nautical Southeast Moluccan metaphor was present in South Sumatra. According to linguists, sentences such as "the vessel will not sail, unless you will be captain" signified an implicit marriage proposal.[51] This naturally inspires curiosity about traditional

FIG 45 A two-couple wedding in Lampung, late 19th century. To the left is a so-called *kayu ara*, the artificial tree full of presents (called *buah*, "fruits") meant for the family of the groom. The color of the canopies over the bridal couples corresponded to the groom's newly obtained *papadon* rank (white, yellow, or reddish brown; see also note 71). Courtesy of KITLV/Royal Netherlands Institute of Southeast Asian and Caribbean Studies 3896.

Lampung boatbuilding, but unfortunately concrete facts—to our knowledge—have not been recorded anywhere. Similarly, boat models in museums do not provide much information in this regard. This dearth is probably explained by the fact that Lampung society lacked a genuine maritime character. Contrary to what some sources would have us believe, shipping was of minor importance to its traditional culture.[52] The inhabitants of Lampung were farmers whose focus was on the cultivation of pepper. They were scarcely involved in the overseas trade of this product. Those boats that they did possess were meant to be used primarily on rivers, to transport the pepper harvests to the coast.[53]

Still, the association of nautical symbolism with romantic love was deep-rooted in Lampung culture. This can be deduced from the ritual that each Lampung male hoped to experience at least once in his life (despite the enormous costs): his ascension to the aforementioned *papadon* seat.

As discussed earlier, attaining this highest status was part of an ancient initiation rite. The ascension to the "throne" once had a very specific function: it marked the fulfillment of a successful headhunting campaign, which allowed marriages to take place. The extent to which the *papadon* was linked to marriage is exemplified particularly by accounts from the very traditional Abung. Until well into the twentieth century, every unmarried Abung man who wanted to ascend the throne also had to get married on the same day. Both events were part of the same lengthy ritual, which was focused mainly on the "outer world." No expenses were spared to make as big an impression on the other villagers as possible. The matrimonial ceremony (which, among other things, featured roaring cannons) was especially dramatic and was used to maximum effect in terms of public relations. In the event that the *papadon* candidate was already married, the original wedding—elaborate ritual clothing included—was simply reenacted.[54]

A spectacular phase in the ceremony was a bridal trip through the village in a stately carriage to the *sesat*, the community center, where the *papadon* was kept and where the wedding would take place. This carriage, which rather resembled a float and was called a *rata*, was designed in a most remarkable style and displayed the bride and groom on a symbolic ship: the *rata* was actually a matrimonial boat. The carriage was also used after the *papadon* ceremony to transport the proud new Lampung "emperor" and his family (in many areas when an individual ascended to the *papadon*, the title of *sunan*, or "emperor," was bestowed). After the "emperor" died, his remains, clad in full regalia, were plunged into a deep gorge with the *rata*.[55]

The stately carriages were created in different styles throughout the Lampung area. Models in museums show that some examples (called *perahu andak*) were made in a rather crude fashion out of wood and canvas. Others (such as the so-called *perahu garuda*) were very artistic, colorful constructions shaped like animals. Yet others were no more than a relatively simple wooden dish with a bird's head.[56] In the middle of these vessels was usually a type of canopy to shelter the happy couple; in all cases, great wooden disks were used as wheels.

Can we recognize a union of male and female parts in the construction of the *rata*, even though it wasn't an actual ship? In other words, did these floatlike conveyances contain the same type of nautical marriage symbolism that was formerly known on the other, more easterly islands? Everything seems to suggest that this was indeed the case. The boat symbolism as we know it from the Southeast Moluccas had a cultural range that stretched all the way to Sumatra. The nautical metaphors in the old Lampung love songs are not an isolated example.

Among nearly all *rata*, two things stood out: the prow (and in some cases, the entire boat) was always shaped like an animal or had an animal's head attached to it. Furthermore, a towering "tree" (and sometimes even several) with "fruit" would rise from the hull of these boats.[57] Both characteristics are telling. The animals depicted were usually the elephant, hornbill, water buffalo, *garuda*, or *naga*, precisely those animals—as we have seen before—that were often used in the decoration of the *papadon* and that signified male prestige. Without a doubt, they were referring to the groom: after all, the public marriage display accompanied his *papadon* ascension. At the same time, the "tree" with "fruit" symbolized the bride's fertility. It was called *kayu ara*, one of the most important fertility symbols in Lampung culture, as is revealed below. In this way, the *rata*'s male and female parts precisely resembled their East Indonesian counterparts. The hull of the boat represented the bride and the tree that sprouted from it her fertility, while the stunning prow(s), adorned with carved animal figures, symbolized the groom.

With this knowledge, it is possible to expand on the symbolism connected to marriage. In this regard, two other traditional Lampung objects, the artfully shaped containers that held material used to blacken teeth (*sihung*) and the aforementioned *tampan maju*, the rare ship cloths adorned with beads and shells, deserve our attention.

Reflecting customs practiced until the beginning of the twentieth century, blackening containers held soot that was used to blacken boys' and girls' teeth after the teeth were filed. This was an important social rite, which indicated that the individual had reached marriageable age. There were male and female examples, each with its own telling design: the male ones were fashioned in animal forms, with great diversity in subject and style, while the female containers had a boat shape. The male and female types were originally linked together as a pair.[58] Indeed, they probably represented—as we now understand—a bridal couple.

The patterns of the *tampan maju* show the bridal couple in an even more splendid manner. These fabrics, of which only a few are found in museum collections worldwide, were presumably offered by the groom at the wedding ceremony as a gift to the bride.[59] The designs in these textiles are quite consistent: a boat shaped like an animal or with animals on the prows, with the representation of a tree more or less in the middle of the boat with branches that fan out widely (again, see fig. 44). In fact these are the essential components—observed from a symbolic point of view—of the *rata*: we are looking at a majestically sailing bridal ship. This view is

supported by the name of this type of *tampan*: through her marriage, a Lampung girl is granted the status of *maju*, which means "married woman."[60]

Fertility and status

In many cases, the designs of other types of ship cloths similarly reflected the use of these fabrics in society. We shall demonstrate this by focusing on ancient Lampung rites of passage. An analysis of *tampan* and *palepai* by category—a popular approach—has its limitations. A significant group of *tampan* was used in a manner that was comparable to the function of *palepai*, which could usually be deduced, at least by insiders, from the depictions on the cloths.

The *tampan* and *palepai* played a role in practically all rites of passage. The *tampan*, on the one hand, were often used as sitting rugs for the initiate(s), often in combination with decorated mats (*lampit*). The *palepai*, on the other hand, were usually hung on a wall of the house where the ritual was performed. The textiles were connected in a more intrinsic way to the two rituals we have already discusssed: the celebration of marriage and the *papadon* ascension. Many *tampan* and *palepai* appear to have been produced especially for these occasions. Marriage was all about fertility, while the *papadon* ascension obviously revolved around prestige. These social values were expressed in the designs of many of the fabrics that were used during the rituals.

Fertility is the main theme in the ornamentation of many smaller *tampan*; as a whole, these *tampan*—displaying a wide array of design elements—make up a dominant category of ship cloths.[61] These mainly served a role at weddings, the occasions where a union between two *suku* was forged. Before the wedding ceremony—during the marriage negotiations—substantial amounts of ceremonial gifts or food, wrapped in these *tampan*, were exchanged between the wife-giving and wife-taking *suku*. The cloths played an important role during the actual wedding and were most likely part of the bride's dowry.[62]

Their role in the wedding ceremony reveals a great deal about the character of these cloths. During the ritual, the *tampan* symbolized the bride and her role within the *suku*: taking care of progeny. Weaponry or animal figures, in contrast, represented the groom and his duty: upholding the clan's reputation. This was a typically Indonesian pattern. On many islands of the archipelago, textiles were associated with new life, because they were produced by women and were made of cotton, which is a product of the earth, the ultimate source of fertility. Likewise, weaponry was widely associated with male tastes and pursuits. In Lampung society, this symbolism could be observed during the wedding ritual in the sticking of a spear, with a *tampan* attached to its shaft, into the ground next to the bridal couple; in other cases, a yarn reel and a spear would be used.[63]

Fertility symbolism was also marvelously evident in the *kayu ara*, a tall pole, decorated like a tree, which in addition to featuring in the *rata* would also be planted in the ground where the festivities were held. Hanging from the branches of the *kayu ara* were mats,

beads, shells, little pots, pouches, coins, delicacies, and also textiles that originated from the grandparents of the bride and were meant for the family of the groom (fig. 45, p. 87).[64] The small presents, represented as vegetation (and called *buah*, "fruits"), symbolized the fertility that—with the bride—became available to the wife-takers. Moreover, another reference to the bridal couple and its social tasks could often be found at the top of the *kayu ara*. Bound together here were usually a *garuda* figure (representing the groom and his duty in matters of prestige) and a *tampan* (portraying the bride and her role in reproduction).

The ornamentation of many *tampan* can be related directly to traditional Lampung marriage. The motifs often refer in a symbolic way to the bride and groom, with a prominent role for nautical love symbolism, the metaphoric language of love songs. We repeatedly see an animal (the captain/bridegroom) in a sailing boat (the bride). In many cases, the depiction of a highly stylized hornbill is found, but the peacock, originating from the Asian mainland (China and/or India), also occurs remarkably often. This bird was probably adopted into traditional Lampung animal symbolism in a way similar to the incorporation of the *garuda*. The peacock feathers and crests that are present in other animal motifs also suggest this.[65]

In many designs, another primary motif besides the boat of matrimony is visible: a tree sprouting from a boat. The motif recalls the *tampan maju* and *rata*: a boat (the woman) that, through the imagery of vegetation, is presented as a source of fertility. The significance of the boat/tree motif was also visible in another way in nineteenth-century Lampung society. At parties and at their weddings, the marriageable girls (*muli*) from the highest social class (fig. 46, p. 90) traditionally wore shiplike head decorations (called *siger*) made of gold leaf and sporting a floral motif. In this way, *siger* symbolized female fertility, just like the boat/tree portrayals on the *tampan*.[66]

Although our analyses of the boat of matrimony and the tree/boat combination may leave many designs unexplained, we clearly see what the smaller *tampan* were all about: fertility. The use of these fabrics for various rites of passage, including birth, circumcision, and death (fig. 47, p. 90), stemmed from the bond that two *suku* had entered into through marriage.[67] This relationship was reaffirmed and strengthened on these occasions through the exchange of textiles.

The *palepai* of the coastal Paminggir functioned completely differently from the aforementioned *tampan*. These textiles, up to ten feet in length, did not circulate through the community, but were the exclusive property of the traditional Lampung aristocracy: the *penyimbang* families who had inheritable rights to the *papadon* ascension (*papadon adat*). For them, these cloths were like regalia; owning a *palepai* played a major part in legitimizing the distinguished position of an aristocratic *suku* in Lampung society. This was expressed in the motifs on the fabrics: above all else, they had to communicate status.

There are strong indications that a *palepai* was made especially for a *papadon* ascension. As mentioned, a highlight of the ritual surrounding the celebration of marriage and *papadon* ascension was

the ride in the *rata* to the *sesat*, where the thrones of the *suku* were kept.[68] The float was part of a larger procession that featured a variety of things: dancing *muli* wearing *siger* on their heads, musicians, masked clowns, people waving streamers, carrying umbrellas and other insignia, and so on.[69] At the head of the parade were often several women arrayed in the shape of a crescent moon and carrying a narrow band of cloth between them. The cloth was usually a piece of white textile, but according to a credible source, this could just as well be a *palepai*.[70] Both types of textiles advertised the main purpose of the procession: the *papadon* ascension. White was the color of the highest Lampung rank, and a *palepai* was also closely tied to the throne.[71]

Traditionally, the white cloth and *palepai* seem to have been used for decorating the *papadon* seat during the ascension ceremony. The textiles were draped around the bottom of the seat, which might well explain their unusual extended shape.[72] With subsequent use in society, a *palepai* would represent the *papadon* seat to which the fabric had been ritually connected; as such, the cloth would, as it were, be the literal proof of the *papadon* ascension.

As noted, *palepai* were hung from a wall of the house during rites of passage, and sometimes during meetings and festivities as well. They acted as the "visiting cards" of the various aristocratic *suku* who were present at the ceremony, and this simultaneously reflected the internal balance of power between individuals and groups. Within a *marga*, "weak" and "strong" *suku* were traditionally distinguished, a classification in which many criteria (such as age, wealth, and number of members) were taken into account, and one that was visible to all in the traditional placement of *papadon* in the *sesat*. In this community center, the most eminent *suku* had their thrones in the middle, flanked to the right and left—and extending to the sides of the communal space—by the seats of the lower-ranked clans. This *papadon* pattern was mirrored during rites of passage in the arrangement (at a man's height) of the *palepai* on the wall of the house.[73]

It goes without saying that status was also the dominant theme in the designs of many *palepai*.[74] The majority of the cloths seem to portray a ship's deck with realistic, festive scenes, and at its center two mounted animals facing each other, a symbolic representation of the *papadon* ascension. Here, elephants and water buffalo appear most frequently. As we have observed, these animals were strongly associated with prestige in traditional Lampung society; this also explains their appearance in the form of decorations on the ancient thrones. However, other symbols unrelated to ritual festivities are often visible on *palepai* as well, such as stacked buffalo horns attached to a stake. These were obviously included to advertise the prestige of a *suku* through the display of valuable trophies (see note 39 as well).

How then do we interpret the boat motif, associated with fertility, displayed on these cloths? If the *palepai* are associated primarily with status, then what do the depicted boats imply? Surprisingly, we are probably dealing with the *rata* again, the float also found on the *tampan maju*. This time, however, it is portrayed frontally, with a specific focus on prestige symbolism. To the left and right, rather than the boat's stern and prow, are the wings of the animal making up the "boat on wheels" (a *garuda* or hornbill). And between these wings of the *rata*—on the ship's deck—the *papadon* ascension is taking place.[75]

Informing this interpretation are several details, each of which concerns the spot on the symbolic boat of matrimony where the bridal couple was seated. This was usually a kind of throne, which was covered by a canopy, or baldachin. *Rata* models in museums show that this chair was adorned as though it were a *papadon* seat

FIG 46 Young women from Gunungsugih-Besar, Lampung, 1901. Courtesy of KITLV/ Royal Netherlands Institute of Southeast Asian and Caribbean Studies 3897.

FIG 47 Funeral ceremony in honor of a descendant of the founder of a *marga*, late 19th century. Underneath the baldachin, or canopy, lies the body of the deceased. His widow is seated in the middle of the front row of female mourners. Groningen University Museum.

and included animal decorations.[76] Thus, the float clearly suggested how the entire event, including the festive wedding ceremony, had to be viewed. Indeed, the *rata* was also denoted by the term *perahu papadon* in some regions.[77]

A portrayal of the *papadon* seat of the stately carriage seems to be found in the middle of many *palepai*. A typical feature of various baldachins was their specific shape (slightly bulky and flattened out, with sloping sides), which can be readily recognized in many cloths (see cat. 24). Beneath the baldachin, we often notice two animals, each carrying a human figure. These probably represent the bridal couple, who were the central focus. Both would later, after their arrival in the *sesat*, also mount the actual *papadon* together. The representations on various *palepai*, carried at the head of the procession, would thus reveal to onlookers the essence of what was ceremonially yet to come.[78]

This design did not appear only on *palepai*. A large group of *tampan*—also made by coastal Paminggir women—was decorated with highly similar designs (see, for example, cat. 23). The slightly larger examples (with sides sometimes reaching up to three feet in length) are of particular interest; many of them originated from the area surrounding Lampung Bay (particularly Kalianda). Here, these *tampan* functioned in a similar manner as *palepai* did: owning them was associated with the *papadon* ascension, and local *suku* considered these cloths to be part of their regalia.[79]

Research suggests that the democratization of the *papadon* complex, initiated by the sultans of Bantam, most likely played a role in this. As mentioned, the sultans introduced a series of ranks (*papadon pangkat*) that were purchasable by anyone. This system operated alongside the old aristocratic *papadon* institution (*papadon adat*). Precise regulations existed regarding which type of cloth belonged to which rank and title, and the *palepai*-like *tampan* (along with the previously mentioned *tatibin*, the scaled-down version of the *palepai*) most likely belonged to the common *papadon pangkat* complex.[80]

The design of the *palepai* that were made in Kalianda (the so-called red ship style) was copied onto these *tampan* in a basic way.[81] Here, however, the image was projected onto a square instead of a rectangular area: this limitation of space often caused the *papadon* ascension (sometimes displayed multiple times on a cloth) to be surrounded by rather stocky *rata* wings extending high into the composition. In the western part of the Lampung Bay region, the *papadon* ascension could also be depicted on the somewhat larger *tampan*. In these examples, the subject can often be recognized in the depiction of two opposing, mounted animals, surrounded by many festive details.[82] It is doubtful, though, that the textiles—formerly known in the Lampung Bay area as *tampan jung galuh*, "great junk cloths"—would also be displayed in processions with a *rata*.[83]

In the previous discussion, we hope to have demonstrated that the boat motif on ship cloths symbolized more than just movement and transition. Traditional Lampung animal and boat symbolism offers clues leading to new insights. The symbols were combined in a unique way in the stately carriage, or *rata*. As a part of the joint marriage and *papadon* ritual, both fertility (the wedding ceremony) and prestige (the *papadon* ascension) were displayed by means of this float.

This is probably not the last word on the symbolic significance of the ship cloths. Various layers of meaning may once have existed, expressed through cosmic symbols, about which we know little. Research in South Sumatra will probably not increase our understanding. Over the course of the nineteenth and twentieth centuries, the *papadon* system was abolished everywhere as a result of increasing pressure from the Dutch colonial administration; simultaneously Islam expanded tremendously.[84] Today, all Lampung are Muslim, and there are few reminders of the old symbolic system in which boys were given animal names such as Gajah (elephant) and girls were customarily named after components of the loom.[85]

18

Ceremonial cloth (*tampan*)

Indonesia, South Sumatra, Lampung region,
Paminggir people
19th century
Homespun cotton and natural dyes
34½ × 29¾ in. (87.6 × 75.6 cm)
The Steven G. Alpert Collection of Indonesian Textiles,
gift of The Eugene McDermott Foundation. 1983.71

The *tampan* chosen for this catalogue can roughly be divided into two basic types: *tampan darat* and *tampan pasisir*. *Tampan darat* are said to come from inland areas, and their compositions are less courtly and less Indianized than those of their coastal counterparts (*tampan pasisir*). Many *tampan pasisir* feature a single large ship laden with an array of animals, embellished with various architectural forms, and crewed by numerous figures often rendered in Javanese style. The narratives on *tampan darat* tend to depict more modest boats, one along the bottom edge, which is often mirrored by an inverted ship at the top of the cloth, as is the case here.[1] Between these "borders" of boats, a lone animal, or a dominant subset of creatures, is generally depicted, along with more archaically stylized figures, symbolic trees, pavilions, and shrine houses.

The various motifs on this *tampan darat*'s dragon-shaped boat include five jellyfish, a nascent tree, and a figure next to a ritual house shaped like a parasol, a *rumah pojang*, that was once associated with deities, ancestors, and a *marga*'s treasures.[2] Dominating the boat is a looming composite mythological creature whose oversized head, hunkered body, and arms or tails with fingerlike or featherlike appendages are typical of those associated with protective, supernatural animals. Similar to a Batak *singa*, it has a long, triangular face with a sharp, V-shaped chin, an open mouth with exposed teeth, flared nostrils, and accentuated eyes.[3] The frontal rendering of a creature is atypical on *tampan*.[4] However, when the components that create the beast's limbs and its face are seen as individual motifs, they resemble other smaller animals depicted in profile.[5]

Such an archaic-looking composition was most likely the result of a weaver's ability either to faithfully copy older cloths or to continue to reinterpret their existing vocabulary in novel ways. The depiction of mythological and sacrificial animals is deeply rooted in South Sumatra's ancient artistic traditions. On the nearby Pasemah plateau, they appear on prehistoric boulders, megaliths, and cist tombs, one of which is famous for its frontal depiction of a buffalo (see fig. 19, p. 25). The inspiration for this *tampan*'s zoomorphic vocabulary undoubtedly reflects an amalgamation of indigenous motifs from the region's Bronze Age cultures with imagery from Indianized Buddhist and Hindu areas and from elsewhere throughout Southeast Asia and China over a very long period of time. For example, Chinese ceramics featuring another version of a monstrous protective face (*t'ao tieh*) have been found in southern Sumatra on the lugs of earthenware storage jars dating as far back as the Han dynasty (206 BCE–220 CE).[6] Export jars and Chinese blue-and-white porcelain from the Ming dynasty (1368–1644) often depict mythical creatures such as dragons, kylins, and phoenixes. These were once widely circulated in Lampung, and more than likely influenced the contours and character of some of the fantastic creatures found on Lampung textiles.

As an integral component in rites of passage, and as currency within an intricate system of ceremonial reciprocity, *tampan* were exchanged and displayed during status-raising rituals and rite-of-passage or life-crisis ceremonies (for example, birth, circumcision, marriage, and death). In the case of many larger-sized cloths (*tampan penedung*), it is unclear whether they reflect the high status of their owner or a cloth's specific ceremonial function.[7] Among their many uses, larger *tampan* served as the outer wrappers for other smaller, bundled *tampan* containing food or symbolic tokens. *Tampan* were displayed, used as covers and pillows, and stacked or clustered near important elders during ceremonies. They were also reported to have been laid over bowls that were presented at funeral feasts.[8]

S.G.A.

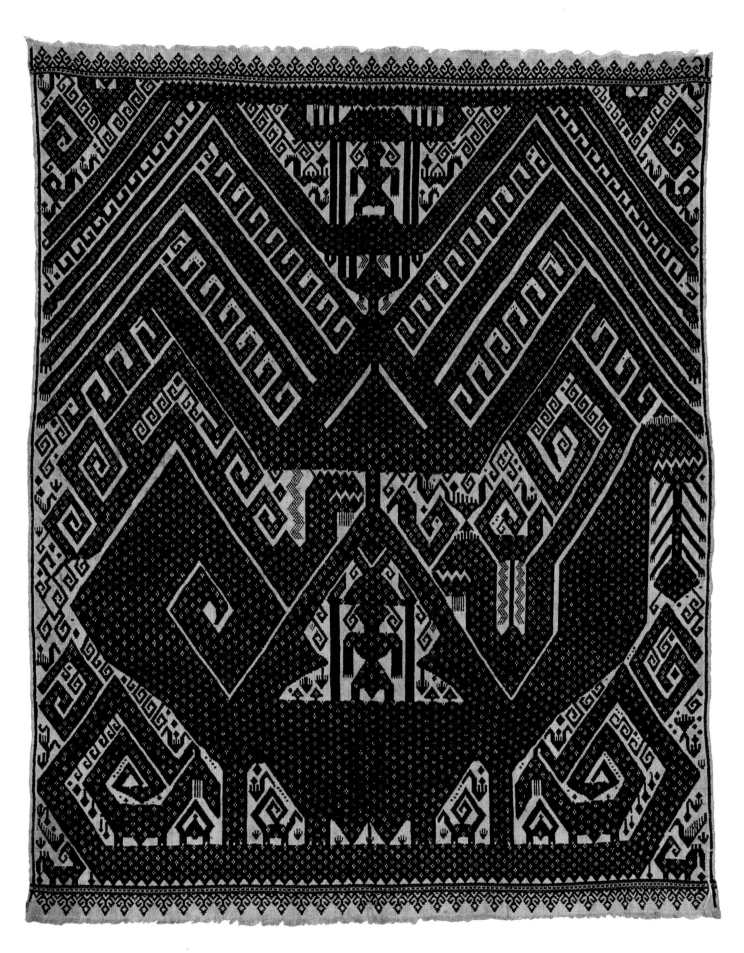

Ceremonial cloth (*tampan*)

Indonesia, South Sumatra, Lampung region,
Paminggir people
19th century
Homespun cotton and natural dyes
35 × 28¾ in. (88.9 × 73.0)
The Steven G. Alpert Collection of Indonesian Textiles,
gift of The Eugene McDermott Foundation, 1983.72

As late as 1905, on the island of Nias off the coast of West Sumatra, the missionary H. Sundermann photographed a chief being carried atop a mythological creature during a feast of merit in his honor. F. M. Schnitger wrote that human heads were required for these feasts, and that carved underneath ceremonial conveyances was often an image of a sacrificed slave.[1] In the past, Lampung aristocrats were also carried on large animal floats (*rata*), or rode in wheeled boats that were pulled during ritual processions. While there are no published images of similarly purposed Lampung floats (only models remain), a few wooden finials in the form of hornbills, serpentine dragons, and composite creatures have survived. These were placed on a float's "prow," or on a baldachin, a canopy covering a sacred structure or altar.[2]

Among the aristocratic classes in Lampung and Nias, and among the Batak in Sumatra—and in many other islands of the Indonesian archipelago—the dead were traditionally placed in wooden coffins and shrines. Like the ceremonial floats, these, too, were carved to resemble elaborate ships, mythological birds, and fantastic creatures. In this context, *tampan* were used to cushion the deceased's head prior to burial and are said to have been tied or attached to a coffin's grips.[3] For the living, *tampan* helped to sanctify all life-cycle ceremonies. When the traditional *marga* system still flourished, these cloths were displayed and circulated at feasts of honor (*papadon*).

Many larger *tampan* are dominated by an image of a single fanciful creature. In the 1930s, A. Steinmann suggested: "It is possible that they [the varied creatures seen in profile on *tampan*] represent the seats of honor with the carved animals, which were formerly used in South Sumatra and in Nias."[4] It would appear that the bottom section of this *tampan* as a ship form represents a "concrete symbol of conveyance used when the state of transition is most abstract."[5] Looking closely, one sees an elite person or an ancestor surrounded by an animal-like structure, or sitting on a seat of honor, centered on a shiplike conveyance. Emerging from the apex of the central creature's spine, and flanked by two *naga* or serpents, is a triangular form on a pole. This resembles a uniquely shaped Lampung construction, a communal sacred house (*rumah pojang*) erected on a single stout central pillar. Ritual paraphernalia was stored under its umbrella-like roof. In lieu of gable ornaments, a profusion of forms appears to sprout from the *rumah pojang*. Like bent limbs, branches, or inverted V-shaped wings, these "arms" culminate in fingerlike digits, or buds that may indicate renewal and new growth. Nesting on the tree's exalted crown is another figure standing in a shrine (*rumah dewa*) or beneath a ceremonial gate (*lawang kori*).

The orientation of these stacked designs is forcefully vertical and strictly symmetrical. At the same time, viewed horizontally, the boats, beast, *naga*, birds, and the tree's branches, juxtaposing symmetrical with asymmetrical elements, imbue this *tampan* with a vibrant sense of movement and aesthetic tension. This is the work of an imaginative master weaver, who was able to tell a story that equaled her weaving skills. Its bold designs and exquisite flourishes, the effective use of negative space, and above all the crisp execution—augmented and enriched by a deep maroon color—are attributes that would have been as much admired in their original context as they are today. Further adding to this textile's uniqueness are its pristine condition and relatively large size.[6]

S.G.A.

Ceremonial cloth (*tampan*)

Indonesia, South Sumatra, Lampung region,
Paminggir people
19th century
Homespun cotton and natural dyes
30 × 27¼ in. (76.2 × 69.2)
The Steven G. Alpert Collection of Indonesian Textiles,
gift of The Eugene McDermott Foundation, 1990.201

Given its perfect condition, deep colors, excellent use of negative space, and unusual pictorial qualities, this *tampan* is an exceptional example of the genre. In contrast to cat. 19, here the primary designs, except for the topmost center motif, are symmetrically aligned. Within these designs are carefully placed argyle patterns, smaller diamond shapes, rosettes, and dots. The background teems with lines set at various angles, along with chevrons, coils, keys, and additional dots. As a whole, these elements create an impression of charged movement and a depth of field. The cloth's optical effects are further sharply enhanced through the use of alternating supplementary weft bands in indigo blue and natural red dye.

The composition is anchored by a lone ship whose zigzagging bow and stern ornaments resemble a pair of elongated serpents. It is dominated by four large composite mythological creatures. Despite having four legs, these birdlike animals with their fanning tails and curved beaks most likely draw their inspiration from hornbills (*Bucerotidae*).[1] Between these birdlike animals stand a prominent couple. The smaller figure is enshrined in a structure whose walls double as part of the elongated legs of the larger figure standing above and wearing an elaborate headdress.[2] With raised, bent arms, this figure seems to be presenting six ovoid forms, possibly trophy heads. These are mounted on a V-shaped crown that doubles as either the lintel of a gate or the inverted roof gable of a ritual structure.

Headhunting was practiced in Lampung[3] but eventually ceased after the area's conversion to Islam. At least four human heads are said to have traditionally been required during the unveiling of a *papadon* seat and its attendant feast.[4] As in other traditional Indonesian cultures, trophy heads represented a male component that once enhanced fertility, and were often likened to fruit, seeds, or the jewels of a crown.

Above these figures and their surrounding structure is a treelike motif that can also be imagined as a splayed anthropomorphic figure whose lower "limbs" extend in such a way as to resemble boat shapes. Alighting on this symbolic tree's lower limbs are two large creatures reminiscent of birds, along with a cast of other avian and anthropomorphic forms. Between the tree's upper branches atop a polelike, knobbed edifice is a pair of hornbills. The larger of the two birds is preening its head backwards toward the smaller baby hornbill perched on its back.

Hornbills not only were omen birds and revered upper-world symbols, but also allegorically reflected the cult of the warrior. While Lampung's only known creation myth[5] does not mention their presence, hornbills are closely associated with creation myths in many other parts of Indonesia.[6] In terms of material culture, the hornbill is perhaps best known from the artwork of the Ngaju Dayak of Borneo: drawings, painted panels, mortuary carvings, and engraved bamboo containers (see fig. 51, p. 119). There are remarkable similarities between the cosmic orientation and depiction of serpentine *naga*, symbolic trees, and hornbills in Ngaju Dayak art and those occasionally depicted in Lampung textiles. Despite the weakening of the *marga* system occasioned both by Dutch colonization and the area's conversion to Islam from the sixteenth to nineteenth centuries, the sensibility of this particular *tampan* is remarkably conservative, and a testament to the lasting power of mythic memory.

S.G.A.

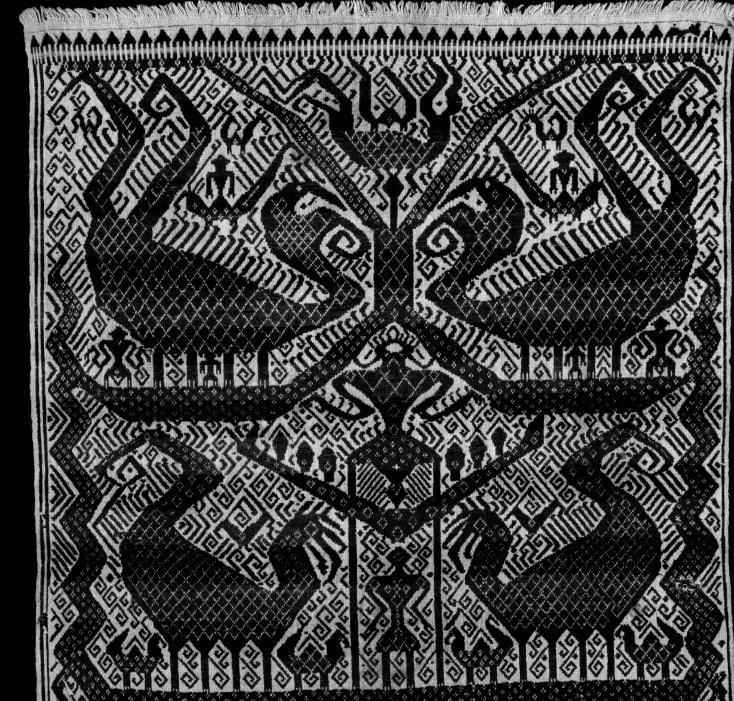

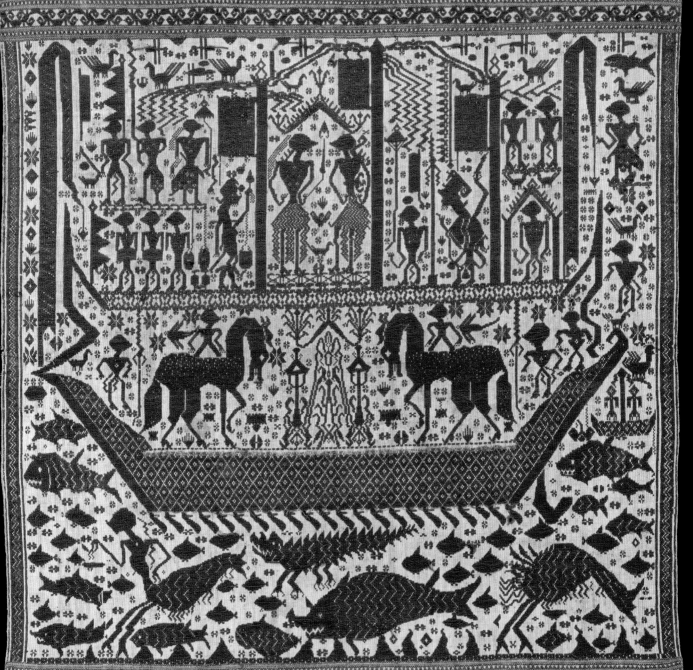

Ceremonial cloth (*tampan*)

Indonesia, South Sumatra, Lampung region,
Pasisir people
19th century
Homespun cotton and natural dyes
36¼ × 30½ in. (92.1 × 77.5 cm)
Textile Purchase Fund, 2000.357

This *tampan* is from an area east of Semangka Bay on the south coast of Lampung. Its large size reflects both its importance and its ceremonial function.[1] The overall story line may refer to an event of mythic or even historical origin, or may simply allude to status-raising ceremonies, alliances, or marriage. No doubt the pictorial content of this *tampan* reflects the sensibilities of a local aristocracy that borrowed much from the refined courtly cultures of Java. Mixed with these courtly and mythic elements are icons of worldly wealth set amid an ancient cosmology of time-honored symbols.

At the heart of the upper tier of motifs are a man and a woman facing each other on a platform that resembles a barge. They are further united by a gabled roof or the lintel of a ceremonial gate (*lawang kori*) that floats above them. The female is on the left and the male on the right. Each wears a long flowing ceremonial *sarong* (*kain dodot*) similar to those worn by Javanese elites. The male carries a *keris*, or ceremonial dagger in the Javanese style, which is tucked in the rear waistline of his garment.

To their left and right are two comical figures. To the Javanese, these *punakawan* embody the virtues of both guardian knights and court jesters, and are considered to be reincarnations of deities in an outrageous mortal form. They serve humanity and their lords with selflessness and integrity.[2] In Lampung, masked comical figures accompanied their chiefs as the latter were being pulled or carried in boats during ritual processions. Their role in these ceremonies was figuratively and literally to turn things upside down, create chaos by hindering the ship, and engage in outlandish antics. This was done to clear the way and sanctify the path of the elites.[3]

On the far left are musicians: two holding drums at their waists and a third positioned next to two suspended gongs. A profusion of masts, flags, pennants, banners, and streamers that surrounds the couple, courtiers, and entertainers adds to the celebratory and festive mood.

Below this *tampan*'s centrally placed motif is a large ship propelled by many oars. Its cargo, two poised horses that face each other, elegantly mimics the couple. Horses and elephants rarely appear on *tampan*, but when they do, it is as symbols of power and wealth. The suggestion of rare and costly imported goods is also echoed in the structure of the central pavilion or "tree" between the horses, which is flanked by a pair of tall standing objects resembling lamps. Their Continental-style feet reflect those produced in Holland in the seventeenth century.

This *tampan*'s narrative is essentially informed by pan-Indonesian notions of a tripartite cosmos. Befitting a coastal culture's maritime outlook, the sea (the underworld) is depicted at the bottom of the *tampan* with an imaginative plethora of fish and aquatic creatures. The most interesting of these denizens is to the left below the prow of the central ship. A human torso, long, slender arms in *wayang* style, two pincer claws of a crab, and the lower body of a serpentine sea creature together form a compelling figure. She is most likely modeled on Dewi Urang Ayu, a sea goddess and the wife of the god Bima, who represents good in the struggle against evil in the great Hindu epic the *Mahabharata* (fig. 48).[4] As though magically assembled, the goddess and her entourage are also "guests," whose presence, in conjunction with this textile's upper-world imagery of birds and dragonflies, serves as a visual reminder that balance in all things is essential to ensuring harmony, vitality, and abundance during important ceremonial proceedings.

S.G.A.

FIG 48 Detail of skirt cloth (*kain panjang*) depicting the goddess Dewi Urang Ayu, Cirebon, Java, 19th century. Homespun cotton, natural dyes, hand-drawn batik. 38¾ × 86¾ in. (98 × 220 cm). Conserved with the assistance of the Maxwell family in memory of Anthony Forge, National Gallery of Australia, Canberra, 1989.2246.

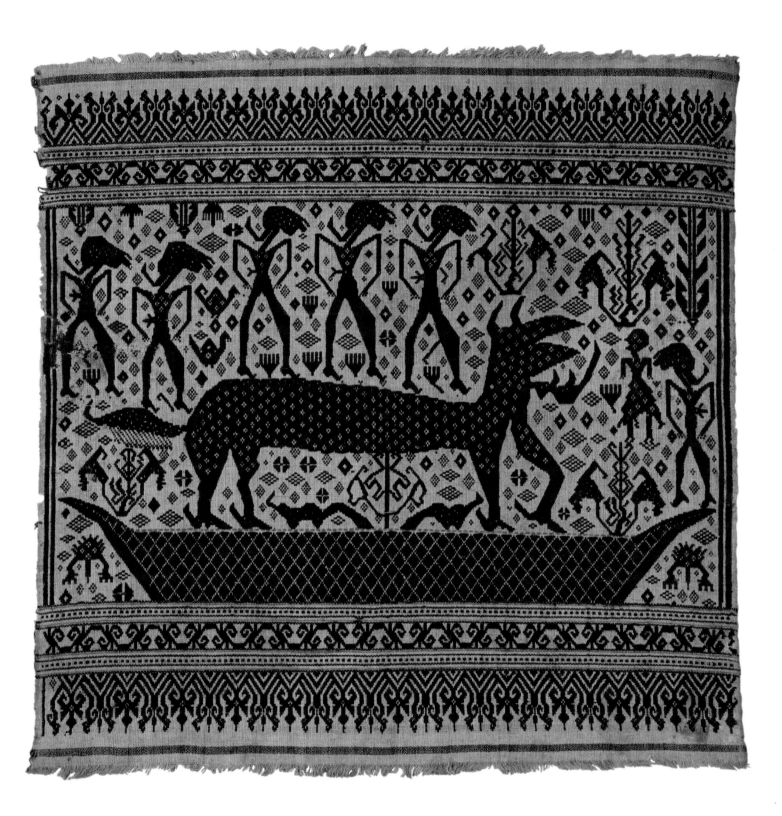

Ceremonial cloth (*tampan*)

Indonesia, South Sumatra, Lampung region,
Pasisir or Paminggir people
19th century
Homespun cotton and natural dyes
17½ × 17¾ in. (44.5 × 45.1)
The Steven G. Alpert Collection of Indonesian Textiles,
gift of The Eugene McDermott Foundation, 1983.75

Nearly all the *tampan* in the Museum's collection are of a large size. In contrast, the scale of this cloth is comparatively small. Perhaps this reflects its specific function, or the skill level of the weaver, as there are a number of anomalies in the *tampan*'s design and execution. The outer frame and inner bands of indigo blue are composed of repetitive patterns that are precisely spaced and well executed. Between these upper and lower registers, the pictorial center contains a riotous array of barely decipherable symbols, geometric conventions, and the bold rendering of otherwise familiar motifs.

The unconventional arrangement of these motifs, and the fact that some of the secondary designs and minor animal forms are not fully realized, could suggest that this *tampan* was created by an inexperienced weaver still learning her craft. However, the overall result may also simply represent the mindset of a singularly original artist, more intent on conveying the main elements of her story than overly concerned with its surrounding details.

Placed on a simplified boat with diamond-shaped lozenges is a lively beast. With splayed feet, seemingly neighing mouth, ears bent slightly forward, and a raised fluffy tail, it is vaguely equine but also utterly fantastic. The beast is dappled with diamond-shaped spots. Above, as though floating through this composition on arched feet, are five male figures. Each carries a *keris* and wears a turbaned head wrap (*blangkon*).

This is most likely a coastal *tampan*, and the human forms and their attributes are depicted in a manner that reflects Javanese aesthetics. The *wayang*-style figures underscore the interaction, trade, alliances, and the long suzerainty of the West Javanese Sultanate of Bantam over the elites of the South Sumatran coast. There, local rulers competed for and depended on the revenue and goods reaped primarily from the spice trade, especially from black pepper.

Meeting the boat, its beast, and retainers is, presumably, an aristocratic couple. He is the larger figure on the far right. The female is skirted and her mouth is wide open as though she is staring in astonishment into the beast's gaping mouth. The delivery of such a fanciful creature recalls the immense costs associated with life-cycle and status-raising ceremonies. Depending on the status of the person being honored, these ceremonies required the distribution of great quantities of food and goods, presumably even including exotic gifts, to obtain and hold onto prestigious titles and coveted privileges.

While its exact function and narrative have been forgotten, the imagery on this *tampan* remains fresh and vibrant. Its central creature, the human figures, and several of the more enigmatic details seem more animated than those found on most other *tampan*. Normally, the execution of motifs similar to these is more mathematically precise, sharper edged, seemingly stiffer, and more predictable. This is in part due to the physical properties of the supplementary weft technique, which makes it inherently difficult to convey a perfectly curving line or a sense of flowing movement. In this case, the textile's main figures approximate, to some degree, the graphic spontaneity of the pyrographically drawn designs on Lampung rattan mats (cat. 25) or those painted on Toraja textiles (see, for example, cats. 58, 59, 61, and 62). It is the figures' combined sense of immediacy and motion, in tandem with their quirky, and not quite linear placement, that gives this *tampan* an endearingly eccentric and naive charm.[1]

S.G.A.

23

Ceremonial cloth (*tampan*)

Indonesia, South Sumatra, Lampung region,
Kalianda area, Paminggir people
19th century
Homespun cotton and natural dyes
34½ × 29½ in. (87.6 × 74.9)
The Steven G. Alpert Collection of Indonesian Textiles,
gift of The Eugene McDermott Foundation, 1983.76

Among the most distinctive of all Lampung textiles are the large multicolored *tampan* and longer ship cloths depicting boats (*palepai*) from the area around Kalianda. Numerous examples of *tampan* from Kalianda have survived. Often they combine varying hues of maroon-red, indigo, tan, and white dyed yarns on a neutral ground. In skillful hands, such a rich palette of natural colors could be combined to create a sumptuous and regal-looking product.

As early as the sixteenth century, following the first Muslim ruler of Bantam, people from Kalianda began to convert to Islam. Many of the most aristocratic families there trace their ancestral ties to this kingdom. The Sultans of Bantam dispensed titles and privileges in exchange for Lampung's valuable pepper crop.[1] The effect of these titles "was to introduce an increasingly stratified and rigid social pattern."[2]

A well-developed titular hierarchy is reflected in the symbolism of the great ship, which is always the most prominent feature appearing on Kalianda *tampan*. Not only does a great ship signify transition and pedigree, but as a conveyance, it is also a bringer of wealth and prosperity. The hulls on these emblematic boats are characterized by multiple prows or wings whose flanges end in curling key designs. Attached to these prows and to the bottoms of the ships are numerous other decorative hook motifs that may represent oars. They may also be a vestigial reminder of the outriggers that were once attached to Southeast Asian seagoing vessels, the type memorialized on the bas-reliefs of Java's eighth-century Borobudur temple.[3]

This ship's top deck is also densely packed with forms that recall communal houses and ancestral shrines. Above these buildings is another construction that further suggests transitioning from one state to another. It most likely represents a ceremonial entryway (*lawang kori*) that was used to honor bridal couples and the recipients of titles.[4] Supporting its archway are the bows of two ships, each carrying two pairs of figures, one of which is holding hands in a dwelling, the other standing atop an elephant. Above these, the *lawang kori* is flanked by two smaller boats transporting peacocks surrounded by avian figures, rising tendrils, and triangular pennants.

Separated by the narrow Sunda Strait, Kalianda lies strategically close to Java, and not far from Palembang, the capital of Sumatra's Buddhist kingdom of Srivijaya. At its height in the eighth century, Srivijaya's empire stretched from Thailand to Java and included much of Lampung. In recent years, increasing parallels have been drawn between certain characteristics of *tampan* and the shared techniques, forms, design motifs, and functions of the textiles of various T'ai peoples including the Shan of Burma, the Lao Neua of northeast Thailand and Laos, and the Dai of China. Kalianda *tampan* have also been compared to the soul ships and tiered temple architecture on Shan Buddhist temple banners erected for the dead.[5]

Most likely these connections were established during the ascendancy of Srivijaya. In 687, after studying for eleven years at Nalanda, a renowned monastic and academic center of Buddhism in India, the Chinese monk Yijing (I Tsing) came to Srivijaya, where he translated Buddhist texts into Chinese. He wrote that monks should include Srivijaya in their intellectual and spiritual pilgrimages. The ongoing transformation of prehistoric imagery and its intermingling with Buddhist, Indian, and Javanese sources are perhaps what lend the textiles of Lampung their unique syncretism and fascinating allure. Mattiebelle Gittinger's hypothesis that *tampan* "may have arisen in the service of Buddhism," but their use persisted because of their intricate involvement in a "complex web of alliances and reciprocal relationships" widens the understanding of the evolution of *tampan*, while reaffirming the enduring role that ceremonial cloth plays in Indonesian society.[6]

S.G.A.

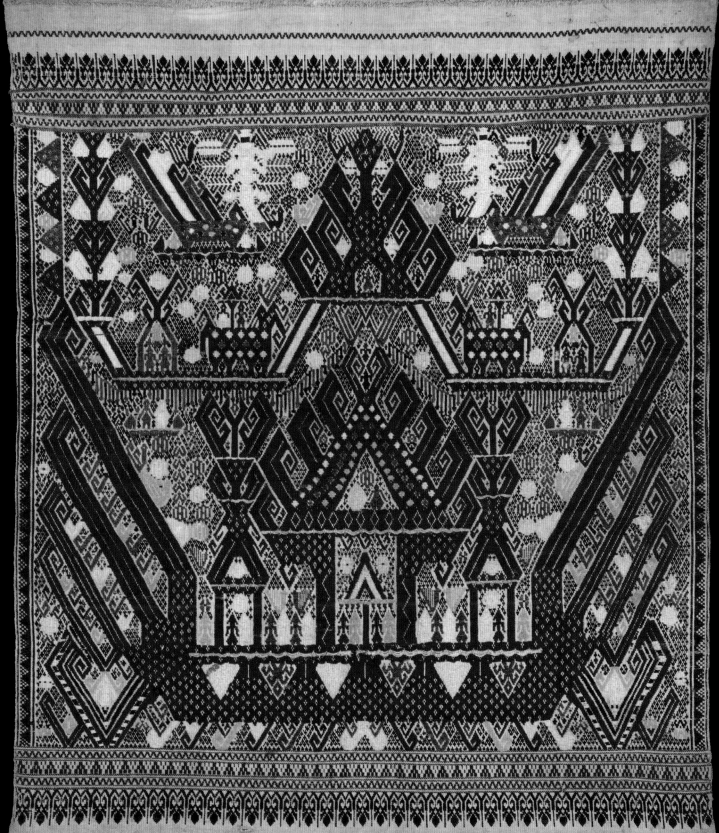

Ceremonial banner cloth (*palepai*)

Indonesia, South Sumatra, Lampung region,
Paminggir people
19th century
Homespun cotton, gold-wrapped thread, and
natural dyes
24¼ × 95¾ in. (24¼ cm × 2 m 43.2 cm)
The Steven G. Alpert Collection of Indonesian Textiles,
gift of The Eugene McDermott Foundation, 1983.79

While *tampan* were used by all levels of society, the use of long horizontal cloths (*palepai*) was the prerogative of the eldest representatives of the aristocratic *penyimbang* rank, the head of a *marga*, and leaders of a patrilineal clan (*suku*).[1] Among the people of southeastern Lampung, the ship is the primary symbol of ritual conveyance that connotes a participant's passage from one state to another. To affirm and witness an important event, *palepai* were hung in the inner central portion of a house along its right side wall as the backdrop for an honoree during ceremonies.[2] They were displayed at weddings and other life-cycle ceremonies, at formal meetings, and during the establishment of a new *suku*, or at feasts of merit, when titles and privileges were bestowed and dispensed.

Palepai containing a single blue ship have been described as an older conceptual form whose context is earthbound,[3] whereas red ships, which are depicted singly or mirrored in pairs, are said to be more associated with the sacred realm.[4] In the final phases of a marriage ceremony in Kalianda, a single-ship *palepai* is also said to replace a double-ship cloth "to signify the merger of family clans or the joining of male and female."[5] Generally, *palepai* with lone blue ships are not as elaborate or as aesthetically complex as those with single or double red ships. However, a few very rare exceptions to this broad model of classification are found that utilize elements occurring in both red-ship and blue-ship iconographies. Mattiebelle Gittinger writes that "these might be dismissed as

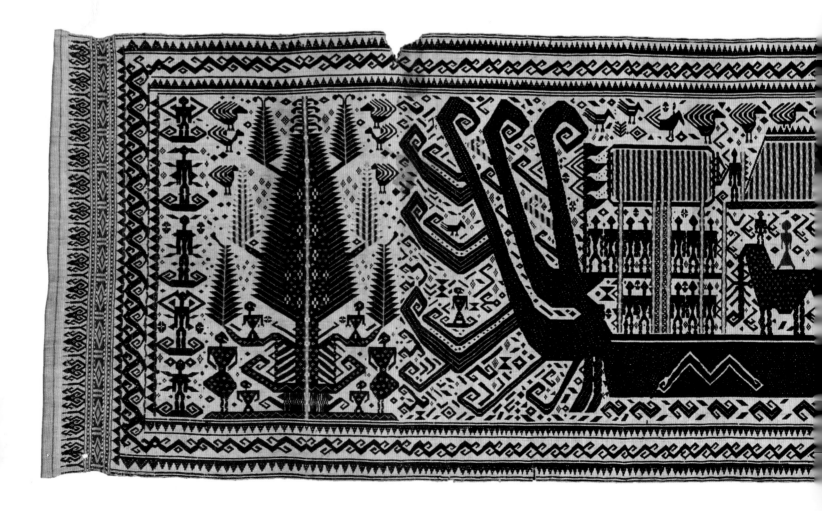

aberrations, but their consistently superb craftsmanship suggests that they were important textiles."[6] This cloth is one of those elite blue-ship *palepai*.

The only other published example similar to the DMA's blue-ship cloth is a slightly larger and more embellished one in the Tropenmuseum, Amsterdam.[7] Stylistically, these textiles share so much in common that they are certainly from the same weaving tradition. Between two converging flocks of birds and two schools of stylized sea creatures is a primeval ship with great oars and prows or wings that rise up as immense tendrils. Under its central pavilion, woven of continuous supplementary weft and gold-wrapped thread, are two creatures that resemble buffalo, each supporting a couple atop its back and haunches. To the right and left are additional structures, woven in the same manner, containing a tiered audience of participatory figures.

Of particular note are the masterfully conceived trees that add a sense of symmetry and balance to the entire composition. Each is floating on a platform that could be said to represent a boat, along with pairs of passengers standing underneath their boughs. The forms of these symbolic trees could be said to hark back to the sacred Hindu *kalpataru*, or wish-fulfilling tree, or the mountainlike tree of life (*kayon*) that is always placed at the center of an array of Javanese puppets before a performance. Their extended branches, the lowest supporting two childlike human figures, also recall another construction resembling a tree (*kayu ara*) that was festooned with gifts for the young attendees at major life-cycle ceremonies (see fig. 45, p. 87). The trunks of both the Tropenmuseum and the Dallas trees are anthropomorphically rendered; the lowest branches extend like arms supporting both a child and another more miniaturized tree. The upper branches also support diminutive trees. What appear to be curling legs and a rib cage are possibly stacked buffalo horns that are repeated again at the top of the tree.[8] As prestige animals, buffalo play an important part in ritual sacrifice and the subsequent distribution of food parts. Together, these motifs, along with hovering upper-world birds and the presence of the great ship, perpetuated notions of rank, continuity, and the consolidation through marriage of lineages among nobles and their descendants.

S.G.A.

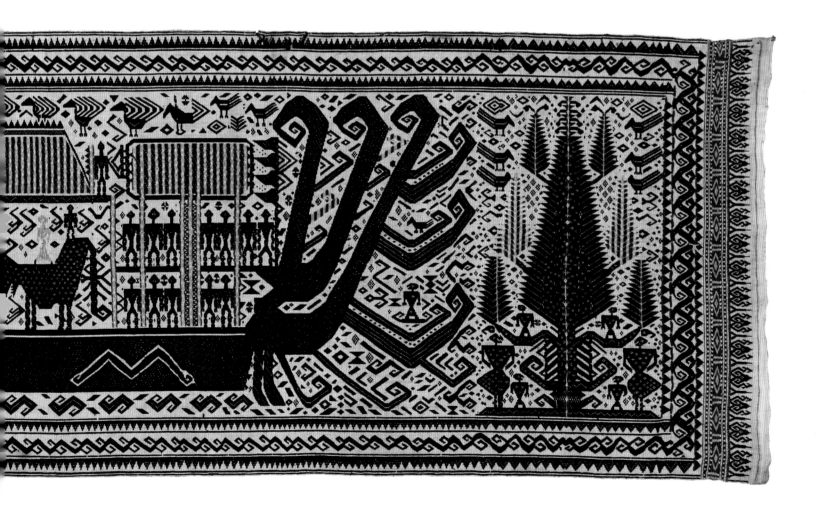

25

Ceremonial mat (*lampit*)

Indonesia, South Sumatra, Lampung region,
Paminggir people
19th century.
Split rattan and bast fiber with pyrographic drawing
36½ × 39¼ in. (92.7 × 99.7 cm)
The Steven G. Alpert Collection of Indonesian Textiles,
gift of The Eugene McDermott Foundation, 1983.81

Traditionally throughout the archipelago, well-made and often beautifully decorated mats (*tikar*) are unfurled to seat visitors, as well as laid out for use during communal functions. In addition to the customary *tikar*, Paminggir aristocrats had the exclusive right to use a special squarish or rectangular-shaped rattan mat called a *lampit*. *Lampit* were made from finely split sections of rattan cane that were then pierced, threaded, and lashed together. A heated stylus was used to draw or outline designs, and a hot ember to darken the surface. This pyrographic technique was traditionally done by men and is unique to Lampung mats.

Although their usage varied from area to area and knowledge regarding these mats is fragmentary, the pairing of *lampit* and *tampan* seems to have once been widespread and to have played an important symbolic role in both ritual exchange and display during rite-of-passage ceremonies. In marriage processions, a rolled mat placed on a *tampan*, or a *tampan* wrapped around a mat, was carried on *pahar*, or high-stemmed platters.[1] *Lampit* were also used by a bride for a ritual bath by a riverbank, and again as her seat during the marriage ceremony.[2] Similar to the tying of a *tampan* to a spear or the wrapping of one around a staff, the binding or placement of *lampit* and *tampan* together symbolizes, in simple but profound form, the principles of male and female duality. Their relationship can also be likened to that of a pillow and a sleeping mat. Together, they signify a change of state, an affirmation of ties, and the transition into another state of being. In death, *lampit* were placed under the body of the deceased during burial preparations, and relatives were required to provide them to the bereaved.[3]

One of the other uses of *lampit*, again as described by Mattiebelle Gittinger, occurred during an annual meeting of village leaders (*raja*) within a *marga*. This meeting was held to promulgate laws, discuss the dispensation of titles, and address any problems that might be affecting the entire community. In the Liwa area, the *raja* who was selected as the gathering's leader sat on a *lampit* and a *tampan*. In Kalianda, the local ruler (*ratu*) and his four princes (*pangeran*) met in the community house (*sesat*), where a *lampit* and a *tampan* along with a betel nut box and wall hanging were displayed during

their discussions.[4] The most complex and most commonly published *lampit* depict a celestial center surrounded by four orbs or crescent moons at each of their cardinal corners.[5] These compositions may reflect a long-standing hierarchical order between kings and princes expressed in cosmological imagery. On the Pasemah plateau, one court was named *lampik empat*, which literally means "four mats."[6]

The DMA's *lampit* is one of the finest known examples of the genre. Its sunburst center is surrounded by eight birds and four ships whose prows curl in classic Kalianda-area style. Each boat carries passengers and has a symbolic tree arising from the center of its hull. Added to this *lampit*'s solar-lunar arrangement is a swirling galaxy of stars and rosettes that include upper- and lower-world animals. The positioning of these designs and the significance of their repetition in quantities of four or eight correspond to Buddhist numerology within a mandala, the sacred circular symbol of the universe.[7] The mat's decorative border of tendrils and corner rosettes also serves to contain its potent designs. Far more than just a mat or seat, the *lampit* reflected order and supernatural protection, the presence of the ancestors, and an aristocrat's alignment within the universe.

S.G.A.

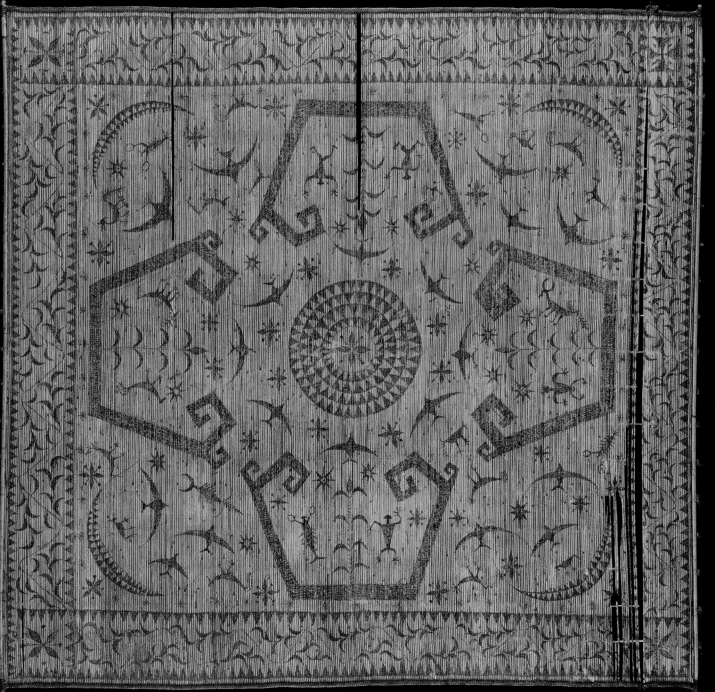

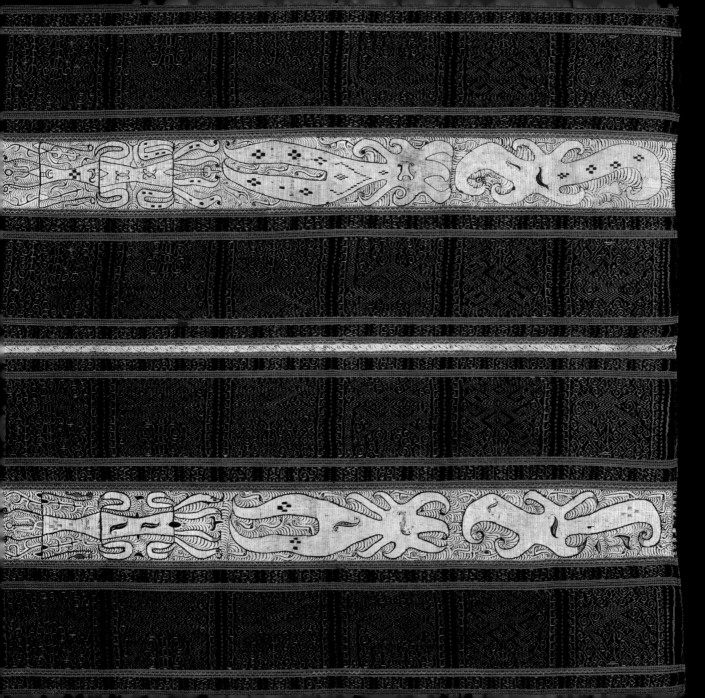

26

Woman's ceremonial skirt
(*kain inu*)

Indonesia, South Sumatra, Lampung region,
Paminggir people
19th century
Homespun cotton, natural dyes, and silk thread
49⅛ × 50¼ in. (124.8 × 127.3 cm)
Textile Purchase Fund with support from the
DFW Indonesian Community Association, 1996.182

FIG **49** Bronze Age vessel found at Kerinci, southwest Sumatra.

FIG **50** Detail from the tympanum of a Bronze Age drum of the Pèjeng type, Tanurejo, central Java.

Many of Indonesia's oldest artistic conventions were perpetuated by peoples living in the interior or more inaccessible areas of an island, as opposed to relatively more accessible coastal areas. This ceremonial heirloom skirt was created by women living in the remote mountainous highlands surrounding Lake Ranau. Reflecting their conservatism, the embroidered panels on the DMA's Paminggir *sarong* celebrate ideas and imagery that are deeply rooted in the region's remote past. One might compare this skirt's creatures with the curling motifs on a Bronze Age ritual vessel found in nearby Kerinci (fig. 49). A distant but shared aesthetic kinship can be observed between them. Their linkage goes beyond the primary design element to include the vessel's tight secondary patterning, which is reminiscent of stitched cloth or plaited basketry.[1]

Among the Bronze Age drums found in Indonesia, some appear indigenously made, or created for Indonesian sensibilities,[2] with tympana consisting of a central sunburst-type motif surrounded by organically flowing whorls with raised knoblike eyes (fig. 50).[3] The anthropomorphic creatures on the DMA's embroidered Lampung skirt with their S-curve bodies and arcing tendrils possess similar qualities. A penchant for the curvilinear was once part of a grand Asian tradition typified by intertwining forms and complex compositions that spanned a vast area from the far western steppes to ancient China, to the island of Borneo and beyond.

The writhing animals on these *sarong* are often described as being "amoebalike."[4] Other scholars have suggested that these motifs may be related to the "imaginative monsters found on Paminggir *tampan*," or may have evolved from a human figure "that was radically stylized and changed over time."[5] In modern parlance, these designs are sometimes referred to as *cumi-cumi*—squid or cuttlefish—but in actuality this may be "a label of convenience without supporting field work."[6] The local name for this specific type of textile is *kain inu*, but the etymology and original meaning of this appellation are both conjectural. Curiously, while the first skirts of this type appear in Dutch museum collections by the early twentieth century, there are no known photographs of women wearing *sarong* with this pattern.

In spite of their age and scarcity, there are actually a fair number of surviving examples of *kain inu* in Dutch museums, in the National Museum in Jakarta, and in other institutions such as the National Gallery of Australia[7] and the Metropolitan Museum of Art,[8] as well as in private collections. The finest skirts combine impeccable condition and precise *ikat* patterning with very tightly embroidered panels in fine silk floss.[9] Surrounding and energizing this skirt's well-developed sequence of creatures are repeated flourishes. These patterns are reminiscent of a powerful churning wave or the quaking of the earth, created as these animals move through what is perhaps a watery realm or a subterranean world that is pictured on a deep indigo blue ground. The most highly developed skirt panels feature a variety of animals, not a repetition of the same creature. Floating within their "stomachs" or interior parts are often smaller motifs that recall either embryonic forms or other miniature creatures, including on very rare occasions a human figure.[10] The combination of this particular *sarong*'s earthy *ikat* tones with its depiction of varied underworld creatures suggests the fecundity and potency that rites of passage—particularly marriage—embody. Whatever their symbolic intent, the embroidered panels of a *kain inu* display some of Indonesia's most enigmatic and memorable designs.

S.G.A.

27

Woman's ceremonial skirt (*tapis*)

Indonesia, South Sumatra, Lampung region,
Paminggir people
19th century
Homespun cotton, natural dyes, silk, gold foil, and
reflective mica or lead glass
27¼ × 46¼ in. (69.2 × 117.5 cm)
The Steven G. Alpert Collection of Indonesian Textiles,
gift of The Eugene McDermott Foundation, 1983.69

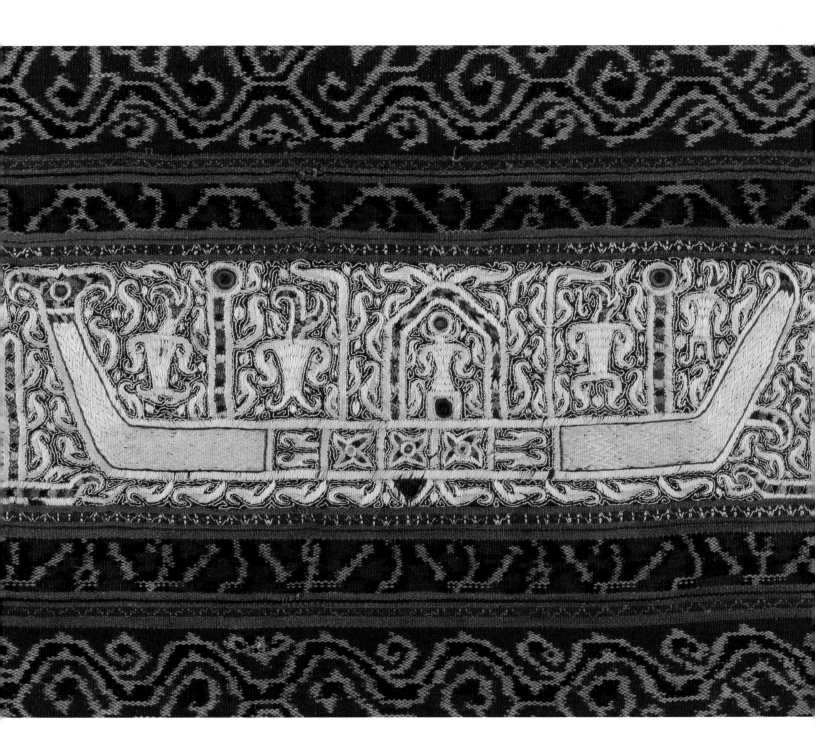

Boats are a ubiquitous and seminal symbol in the textile arts of Lampung. Renderings of fanciful ships were based on a weaver's skill and the imagination of the men who reportedly drew the storyboards that portrayed vessels. Elements from more than 2,000 years of seafaring history appear on Lampung textiles, including the depiction of watercraft that have affinities with Austronesian and Dong Son vessels, early Javanese boats, and two-masted Makassarese proa (*pinisi*). Added to this group are also design elements derived from various European ships including carracks, galleons, men-of-war, and various ships of the line—commercial East Indiamen, barques, fly-boats, and nineteenth-century steam-powered paddle wheelers (see cat. 29).

Throughout Indonesia, ancestral boats are associated with stories of origin and ancient burial customs. As Indonesia is the world's largest island nation, the boat is naturally an iconic artistic symbol often laden with deep meaning. The ships on this skirt's panels, with their single-canopied superstructures and the figures sporting feathered headdresses, are rooted in antiquity. They share a remarkable similarity to Dong Son–era sea vessels and their crews depicted on bronze ceremonial objects and large kettle drums (see fig. 15, p. 20). When comparing the iconography of ship imagery from South Sumatra with that of Dong Son bronzes, the scholar A. J. Bernet Kempers commented that their representation on Lampung cloths went beyond being solely "ships of the dead" to more broadly encompassing concepts of life's "totality," and the bringing together of a sacred whole.[1]

A relatively large number of skirts have survived that depict archaic-looking boats. Yet only a few published examples feature graceful ships with curving bows and sterns displayed on richly dyed, tricolored *ikat* panels.[2] The *ikat* on this *sarong* is exceptional. Its design was probably influenced by those found on Indian export textiles known as *patola*. At their very best, master Lampung weavers managed to transform these designs into an organic series of sinuous forms. Here a combination of the natural hue of oxidized homespun cotton and a brownish-black dye, surrounded by a deep blood-red field tinged with burgundy, is particularly effective.[3] Bands of plain weave, in deep tan to turmeric color, also separate and help to distinctively frame each panel.

The weaver's use of natural cotton shaded by dark bordering in the narrowest panels is reversed in the larger *ikat* areas, where the darkest lines are in part highlighted by lighter banding. In Indonesia, everything has an opposite value, or a "shadow soul." However it may have been intended—as a subtle psychological twist or an artistic flourish—such a juxtaposition of color, along with the addition of costly silk threads, mirrors, and gold foil, give this skirt a shimmering radiance that would have made it an object of admiration even from afar. Overall, this mixture of colors suggests traditional female qualities, such as purity, earthiness, and fertility. The panels' subject matter not only speaks to one's lineage and noble position in society, but also underscores the importance that females play as "vessels" in perpetuating the survival of a clan. Part haute couture, part embodiment of Bernet Kempers's notions of the "sacred whole"—a state that must be brought to balance during all rites of transition—this superb example of the Lampung weaver's art combines in equal measure impeccable condition, bold and clear *ikat*, and finely embroidered panels.

S.G.A.

28

Woman's ceremonial skirt
(*tapis*)

Indonesia, South Sumatra, Lampung region,
Paminggir people
19th century
Cotton, silk, natural dyes, silk embroidery,
gold-wrapped threads, cut lead-glass mirrors,
appliqué pieces of felt and trade cloth, sequins,
and metallic trim
50¾ × 48 in. (128.9 × 121.9 cm)
The Steven G. Alpert Collection of Indonesian Textiles,
gift of The Eugene McDermott Foundation, 1983.67

This opened tubular skirt, with its remarkable embroidered center panel, is a singular piece. Its rich mixture of local and sought-after foreign materials, its palette of golden colors, and its shimmering opulence convey the aesthetics associated with status. Most likely it was initially worn as a wedding skirt by a high-ranking woman, or donned during dances and important ceremonial functions.

It was made in three sections. The outer areas of matching plain weave juxtapose undecorated bands of earthy yellow ocher and colorfast turmeric tones with smaller widths, whose ground colors shift from russet red to steel gray–blue hues. Tacked and sewn on the darker, smaller bands are designs outlined with gold-wrapped threads that are encased in or complemented by sequins, lead-glass fragments, metallic lacework (*passementerie*), and bits of trade cloth. The arrangement of these carefully choreographed materials creates a visual contrast and a dialogue between the skirt's undecorated areas, ornamental bands, and silk-embroidered pictorial panel. The center panel's imagery is enlivened by muted yet vibrant silken tones of aubergine, deep blue, steel gray–blue, cinnamon, and tan, tastefully combined with red and green appliqué trade cloth, and sewn bits of mirrored glass set on a plain white weave.

When the skirt is wrapped around the wearer, the center panel is divided into four separate squared tableaux, two in front and two in the rear. Each tableau is centered around a symbolic tree. Anchoring the trees on one pair of matching squares are serpentine dragons (*naga*) of the underworld.[1] Balanced on their backs are trees filled with avian and simian creatures of the upper world cavorting in its branches. Dominating the tree's crest is a hornbill. The trees on the other two matching squares depict a solid root structure replete with shoots of vigorous new growth. Placed between their taproots is a lone human figure. An identical pair of figures is perched on the upper boughs of the tree, sharing the space with birds, luxuriant growth, and ripened fruit.

Symbolic trees can be seen on nearly every Lampung piece in this catalogue. They appear as minor devices on *tampan pasisir* and as fantastic forms on *tampan darat*, as upright saplings on the pyrographic rattan mat, and as anthropomorphic Indianized structures on the collection's long ship cloth. Their range of expression is astounding, but also a sad reminder that in the passing of old customs, ancestral images, and shrine houses, far more has been lost of the past than has been retained. There are a number of unique Lampung textiles whose composition "hints at a repertoire formerly much wider than the surviving corpus" of material.[2] Forty years ago, Mattiebelle Gittinger wrote that there was a serious reluctance in Lampung to speak about pre-Islamic customs and their meanings.[3] At that time, the last vestige of the customary uses of treelike structures (*kayu ara*) still accompanied marriage and circumcision ceremonies in a few areas.[4]

While this skirt may have been worn at such events, its designs hark back to an earlier ethos. Trees set on the backs of underworld creatures and topped by hornbills choreograph the regenerative cycle of life. The human figures below the alternating trees' taproots may well refer to a time long ago when a marriage between elite personages, the building of an important structure, or the setting up of a new *marga* necessitated human sacrifice (*irau*). As in other parts of the archipelago, the dispatched were often placed below a newly planted tree or a house post to stabilize an important ceremonial event.[5] As a motif linking the forces of the upper and lower worlds, a symbolic tree powerfully idealizes and enshrines Indonesian notions of fertility, generational continuity, and the blessings of the ancestors. Their archaic rendering on this unique skirt is essential to appreciating the genre, yet compellingly fresh and lively as a work of art for a contemporary audience.
S.G.A.

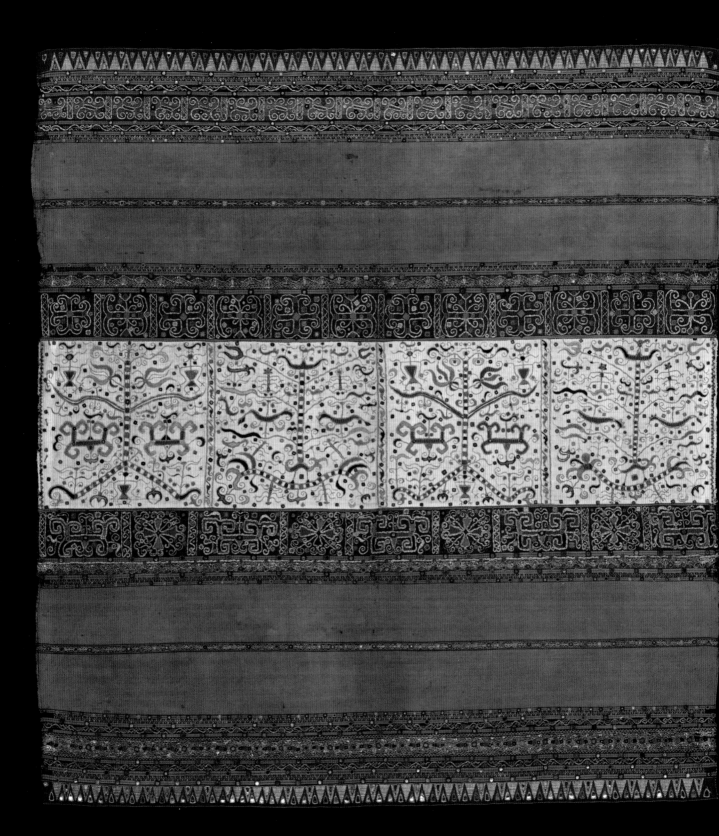

29

Woman's ceremonial skirt
(*tapis*)

Indonesia, South Sumatra, Lampung region,
Abung people
Late 19th century
Cotton, silk, natural dyes, gold thread, trade felt,
sequins, couching, and embroidery
46 × 54¼ in. (116.8 × 137.8 cm)
The Steven G. Alpert Collection of Indonesian Textiles,
gift of The Eugene McDermott Foundation, 1983.68

Reflecting one's rank and purpose, the majority of ceremonial skirts of the Abung consist of horizontal stripes of plain weave of varying widths. Couched gold thread is used to create raised designs that range from decorating only a few narrow bands on a skirt to covering nearly its entire surface. The most common compositions are composed of abstract blossoms, fruits, flowers, stars, diamond patterns, triangular lozenges, and a variety of other geometric forms. Their sumptuous sheen and raised textures are enhanced by a subset of designs within each motif. These are the result of the varying tacking patterns (*sasab*) used to sew down the thickly wrapped gold thread. For the most part, the designs on these skirts articulate the Abung's embrace of Islam. Reflecting Islam's devotion to the word of God, some skirts are embroidered with Arabic phrases or sayings in the Abung language.

In some instances, the antiquated use of upper-world and lower-world animals, birds, buffalo, and dragons is retained in these skirts. Rarer still are those skirts that depict human figures, called *tapis raja medali*, or "king's medallion skirts." These textiles often depict scenes that are reminiscent of the great *papadon* feasts, at which animal floats or shiplike conveyances carrying honorees were pulled by attendants.[1] The rarest and most imaginative gold-couched figurative skirts used the exoticism of alien objects and the powerful engines of what was then cutting-edge technology to reinterpret and renew time-honored symbols with modern imagery.[2]

One can readily imagine that the resplendent lexicon of imagery on this skirt increased its potency and merit. It would have been worn by either a new bride or a matron of standing from a prominent aristocratic family. The dark colors for the warp-faced plain weave background, dominated by navy blue and black panels braced by narrower bands of yellow and dark red, create a dynamic contrast with lustrous gold thread. The blue bands, particularly the more completely rendered lower one, depict two symbolic trees. On its upper branches are birds, and tethered to its trunk are two remarkable creatures. One resembles a traditional dragon or buffalo, although it has the unusual characteristic of three humps.[3] The other depicts a rider sitting astride a beast that resembles a tiger.[4] The festive atmosphere is enlivened by two gesticulating figures in profile wearing Dutch caps of authority. Seats of honor have been supplanted by a European rocking chair and its straight-back counterpart. The table is set with flowers in a vase along with a pair of drinking cups. A similar scene is repeated with two figures holding their cups and staring directly at the viewer. Behind them are smaller childlike figures. Uncharacteristically, the heads of the elders, the birds, tree roots, and four of the camel-like creatures break the planes of their gold-banded borders.

From the vestigial memory of ancient vessels to ships with many sails, the inspiration for the rendering of symbolic boats reaches its apogee with the paddle wheelers depicted on this skirt. Steam-powered boats could defy the vagaries of the monsoon season and were seen as a great manifestation of European power. Rather than masts that might double as *kayu ara* or earlier Hindu-inspired trees of good fortune, between each of the ships is an elaborate set of harbor lights. Suggesting a magic talisman, its golden ladder and red lanterns, which hang like enticing fruit, beckon and guide oceangoing vessels. The ships are oriented in opposite directions: one is leaving the harbor presumably laden with valuable cargoes of Sumatran produce; the other is arriving with trade goods that would have furthered the distinction and prosperity of ruling elites.

Since the 1970s, the golden couched skirts of the Abung have become symbols of modern wealth and fashionable dress. Abung skirts have also become popular and synonymous with Lampung culture outside of Sumatra. Opened, stretched, and framed to fully expose their decorative qualities, they are also frequently displayed in office buildings and private collections in Jakarta and abroad. Today, the great ships, the underworld creatures and fantastic animals of the past, and pre-Islamic pictorial imagery in general are no longer part of the Lampung weaver's repertoire. While the palette of plain weave colors and the quality and content of metallic thread are not the same as in former times, the craft of weaving this type of *tapis* is alive and well in a culture that still takes pride in their creation.

S.G.A.

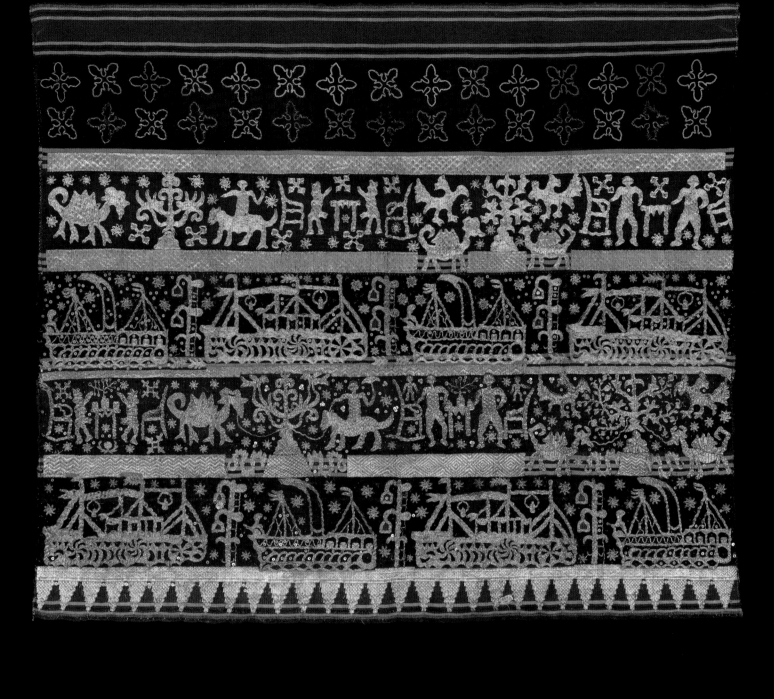

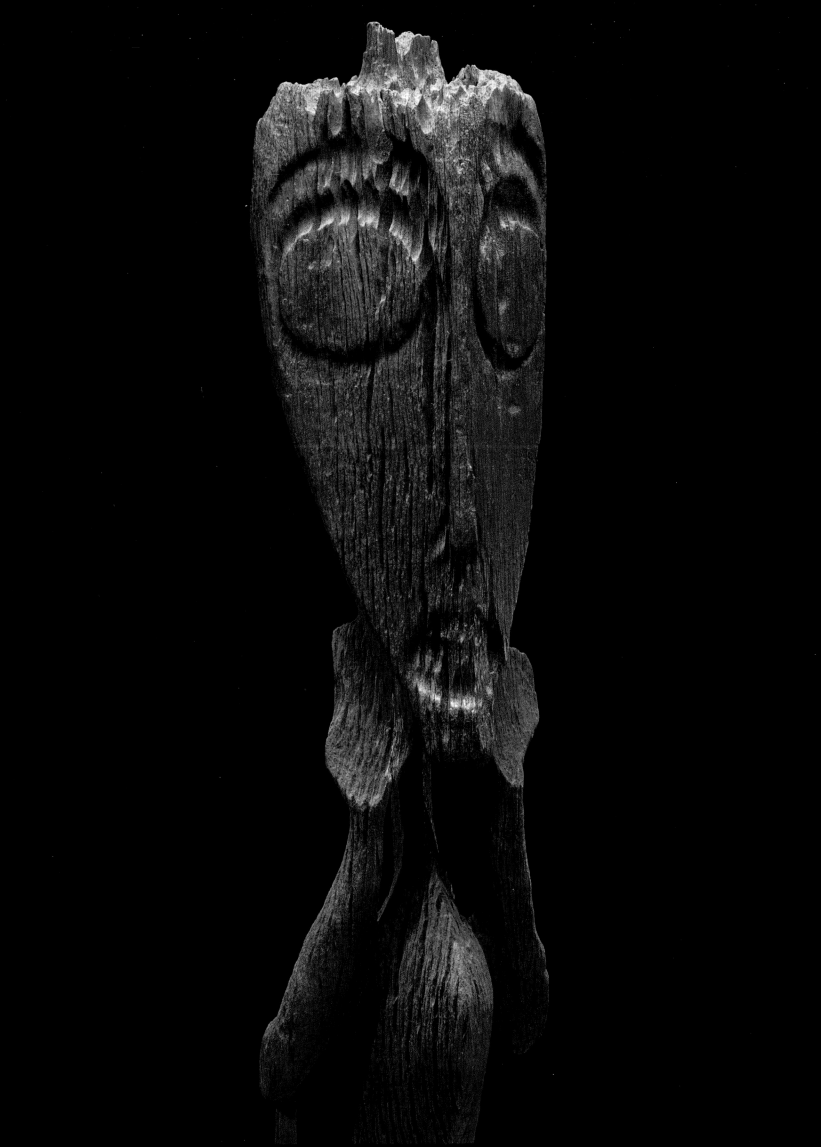

CHAPTER FIVE
BORNEO: THE ISLAND—ITS PEOPLES

Steven G. Alpert

For anyone who has paddled its rivers, or known both the silence and cacophony of its ancient tropical forests, Borneo leaves an indelible impression. Bigger than the state of Texas and more than seventeen times larger than the Netherlands, Borneo is the world's third-largest island. It is one of the most biodiverse locations on earth, a place that Charles Darwin was said to have described as "one great wild, untidy luxuriant hothouse."[1] Since 1963, it has been divided among East Malaysia (Sarawak and Sabah), the oil-rich Sultanate of Brunei, and Indonesia (Kalimantan). In a vast nation of more than 17,000 islands, Kalimantan accounts not only for 73 percent of Borneo's territory but also 28 percent of Indonesia's entire landmass.

Borneo's indigenous peoples are collectively known as the Dayak. This term was already in use among the island's inhabitants when first noted by Europeans in the eighteenth century. It is most likely derived from the Austronesian term "daya," which means "toward the interior."[2] The name "Dayak" was further popularized in the nineteenth century as a colonial convenience, and today is still generally used to refer collectively to the island's indigenous, non-Muslim peoples. Not including numerous dialects, seventy-four individual language groups are ascribed to Borneo.[3] Indigenous Dayak communities range in size from the very last bands of nomadic Penan hunters and gatherers, variably estimated at 300–500 persons, to the most populous entity, the Ngaju, with an estimated population of 890,000 persons (2003).[4]

While many Dayak groups share similarities, each has its own distinct language, social norms, and material culture. Before the 1950s, the majority of Dayak lived in dwellings that accommodated an extended family or in longhouses, and practiced shifting agricultural techniques. Until the late nineteenth and early twentieth centuries, many groups also engaged in headhunting.[5] The passing down of oral traditions and leitmotifs in elaborate creation myths, heroic legends, and stories is essential to each group's identity and is honored in its artwork.

Long before the arrival of Europeans in 1521, the forebearers of present-day Indonesians, Malaysians, Chinese, South Asians, and Arabs came to Borneo's coasts in search of valuable forest products such as camphor, rare woods, hornbill ivory, and beeswax, as well as gold and alluvial diamonds. In return, trade goods from coastal settlements, Buddhist and Hindu kingdoms, and later Islamic sultanates were transported into the remote interior by intrepid natives and traders using Borneo's extensive river systems. Over time, the most coveted and prestigious imports—Asian ceramics, beads, textiles, tools, and metalwork—were often ascribed magical properties. These same items also became important ritual and heirloom objects. Whether acquired through trade, exchange, or conquest, such goods can still be seen in modern-day dwellings or longhouses. The creation of art was influenced by trade goods and the assimilation of forms and motifs from other indigenous groups. These exchanges enlivened the traditional arts of Borneo by making them materially rich and stylistically diverse.

The Dayak pieces at the Dallas Museum of Art are drawn largely from Kayanic peoples and their related subgroups, the Modang and Bahau of eastern Kalimantan, and the Iban of Sarawak. The objects illustrated in this catalogue reflect the highest level of their artistic achievements. Many such objects are no longer produced, and most were created before the Dayak peoples were exposed to colonialism, the creation of twentieth-century nation-states, conversion to outside religions, and other manifestations of modernity.

A Dayak worldview, the tree of life, and dyadic pairing

In the Ngaju creation story, the supreme being of the upper world, Mahatala, is the creator of the first tree of life (sanggaran). From its buds, Mahatala's sister, Jata, goddess of the underworld, proceeds to create a parallel tree where she places a female hornbill to eat its fruit—the first rice. Mahatala reacts by changing his sword into a male hornbill that alights on this tree. A terrible conflict ensues in competition over its fruit. Driven by their hunger, both birds relentlessly tear at the tree's riches until it is completely decimated. In the process, they also destroy each other. The tree's detritus and the birds' deaths figure in a series of transformational events that

eventually results in the formation of the upper, lower, and middle worlds and the creation of the first ancestors. The birds' bones also form another tree of life that guarantees eternal happiness in the land of departed souls.[6] In drawings and on bamboo containers, the upper world of the dead is often depicted under the tree's boughs, and amid its branches is an idealized land of the living filled with earthly abundance (fig. 51).

For the Ngaju, a stratified upper world is the home of the higher gods, the heroic, and the elite. Its symbols include the sun, soulships, birds, trophy heads, and all that is jewel-like in life. Potency, maleness, and heat also belong to this realm. These particular qualities are associated with carved images, iron weaponry, and ceremonial metal objects. In contrast, the tiers of the underworld possess their own deities and spirits. The lower realm is the final resting place of slaves and lesser beings, a shadowy region where watery serpents, crocodiles, and powerful underworld beasts dwell. Its attributes can be described as regenerative, cooling, fecund,

and female. Material goods often associated with these qualities include mats, basketry, beadwork, and woven cloth.

In Dayak art, upper-world animals such as the hornbill are often depicted together or in conjunction with their complementary opposite, a serpent or dragon from the underworld. Upper- and underworld animals can also be fused with one another to represent a composite creature, or they can be depicted naturalistically in the order of their cosmic alignment. One of the Ngaju's most impressive creations is a tall mortuary pole known as a *sengkaran* (fig. 52).[7] At its apex there is often a carved hornbill, while at its midpoint, skewered to the pole, is an heirloom ceramic trade jar that is said to contain primeval water. Placed just above this primordial essence is the depiction of an underworld serpent or dragon, surmounted with a fanning arc of spearlike projections. Older drawings show that the pole's side mounts were once enhanced with bits of cloth. These embellishments, spears for Mahatala and cloth for Jata, fuse the upper and lower worlds

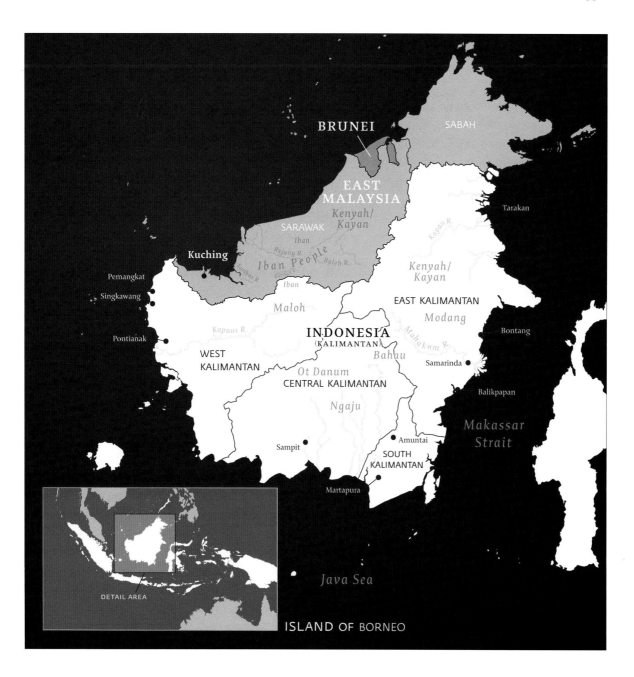

FIG 51 Drawing of the incised work from an Ngaju carved bamboo container by the German missionary Father Zimmermann, between 1904 and 1914.

FIG 52 A funerary pole or *sengkaran* with a Chinese export jar, figurative sacrificial post, and a mausoleum, Central Kalimantan, prior to 1989.

together and in their union reaffirm that in death there is renewal and continuity.

The metaphors associated with the upper and lower worlds, as well as their inverse meanings, are often complex and poetic. For example, trophy heads, which are treasured upper-world objects, are sometimes depicted as fruit hanging from the boughs of the *sanggaran*. Among the Iban, virile heads are said to emit potent "seeds."[8] When referred to in this manner, the metaphysical seeds from a trophy head are complementary to the underworld as they assist in promoting fertility, sustenance, and good fortune. In the Dayak's *Weltanschauung*, every important state possesses its opposite or inverse complement: upper world/underworld, living/dead, male/female, high/low, upriver/downriver, hot/cold, and so on. These states or forces must be in harmony with each other in order to maintain a proper balance in life and death. During important rituals and rite-of-passage ceremonies, verbal constructs, objects, and artistic creations are often paired with their complementary opposites to represent the dualistic nature of life. For traditional peoples in Borneo and throughout Indonesia, ceremonial renewal is expressed not only through dyadic presentations but also in the differences between ordinary speech and ritual language.[9]

Creations of purpose and pleasure

The languages of Dayak peoples have no traditional words for art or the making of art. Since the Age of Enlightenment in Western societies, defining art as opposed to craft, and understanding their differences, have been elusive and philosophically charged exercises.[10] Non-Western cultures are not as concerned with such differences and view objects in perhaps a more unified sense, in which art and craft are seen as one and the same. Dayak artists created inspired carvings, weavings, plaited fine mats and baskets, decorated bark cloth and beaded garments, crafted jewelry, and a wide array of ornaments. They also excelled in tattooing, metalwork, and the creation of architectural embellishments.

The Dayak were exceptionally skilled at forging swords. High-quality iron ore deposits were known to have been found on the

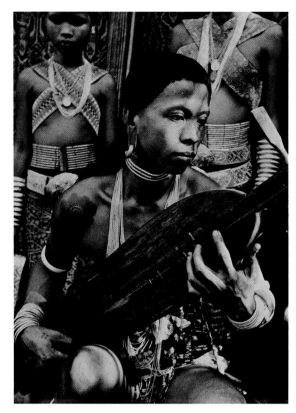

FIG 53 A young Iban in traditional bracelets, earrings, and beads plays the *sape*, 1950s.

Mantikai, Tayan, Apo Kayan, and Montalat Rivers.[11] Groups that controlled a source, or the flow, of ore and had the ability to make fine-edged weapons presumably possessed a competitive advantage over their neighbors in terms of both warfare and commerce. The tempered metal and the overall quality of Dayak swords (*mandau, parang ilang,* etc.) surpass those of the other traditional peoples represented in this catalogue. Their blades were forged at high temperatures and then immersed in cold water. The Ngaju have a poetic description for such tempered swords, *suluh ambun panyulak andau,* "a torch of the dew announcing the new day."[12] Heirloom blades rarely rust and retain a sharp edge. Often they are beautifully worked, the flattened surface etched or inlaid with brass, before being fitted with an elaborately carved handle and ornamented sheath.

Iban textiles (*pua kumbu, pua sungkit,* and *kain kebat*) are notable, too, for their intricate patterning. In addition to displaying technical virtuosity, the designs on the finest, most highly valued cloths were inspired and countenanced by dreams. While a weaver's basic repertoire of motifs was actually fairly limited, individual design elements could always be slightly altered and then recombined into limitless variations. The resulting patterns, as well as the praise-names attached to individual cloths, are drawn from both the natural and supernatural worlds, and their mythical heroes reflect the ethos of a warrior people. To ensure the inner potency of certain cloths, only its weaver and persons privy to her knowledge were fully apprised of their deepest meanings. Even so, beyond any hidden or esoteric content, there was a general familiarity with most patterns, as they were publicly displayed during ceremonies. Hung, folded, or draped over ceremonial constructions or laid on the floor during important rituals, *pua* assist in demarcating sacred space as they afford protection and invite the blessings of the ancestors.

Unlike ancestors or deities, who were considered remote, spirits (*antu*) inhabited the nearby forests. They could take on many forms and easily traveled along Borneo's rivers. *Antu* were said to be able to enter anything, including longhouses.[13] At times, these spirits could be benign, or made useful, but mostly they were ominous. Certain places or activities (often associated with the idea of transition) created potential openings for them. As a result, one's sense of vulnerability was heightened when approaching a shift in the landscape, at intersections, in and around doorways, or while deeply concentrating on a task. Consequently, Dayak artistic creations and their intricate overlay of designs are often associated with some form of personal protection. In addition, an item's embellishment often reveals its owner's rank, level of prestige, or a specialization of knowledge. For the highly stratified Kayan-Kenyah peoples, many commonly encountered designs, like the curvilinear *aso*, or dragon-dog, were originally reserved for aristocratic individuals. This sinuous creature appears on a variety of their utilitarian objects, implements, architectural ornaments, and statues (cat. 33).

In Dayak societies, ritually consecrated carvings also served as intermediaries between the living, the ancestors, and the supernatural. Among the most evocative creations are those effigies and magical charms that combine figural and powerful animal-like traits. Much of what we now consider works of art were originally used in conjunction with healing the sick, perpetuating healthy crop cycles, going to war, receiving blessings from the ancestors or deities, or assisting the dead on their souls' journey. From personal items to ritual creations—whatever their purpose or level of importance—objects and textiles that affirmed a group's notion of having been "correctly and expertly" made engendered stability. In the spirit of duality that permeates everything Dayak, beauty was not only desirable but also purposeful and essential. Something well done or well made assisted in influencing positive outcomes, both with other people and with the spirit world.

Then and now

The open inner veranda that spanned the length of a traditional Iban Dayak longhouse (*ruai*) was a gathering place for neighbors and a setting for many social activities. It was also an area of creative interaction or friendly competition which, according to such ethnographers as Derek Freeman and Michael Heppell, could at times reflect an almost palpable tension. In one sense, the communal area of a longhouse also provided a stage where others could see what was being made, observe techniques, and judge finished products. Creative tension and flirtatious behavior alike began at a young age; for example, boys might have carved a bamboo or created ornaments to express their youthful ardor, while girls learned how to weave short skirts (*kain kebat*) that would elicit comments

like *buah gantung sengayuh*, "men stop paddling (so a man will look at you)."[14] In this, and in many other youthful activities, competitive instincts were sharpened, and a hierarchy of the able would begin to unfold. Socially, the Iban have always been considered relatively egalitarian (as opposed to the more stratified Ngaju, Kayan, and Kenyah peoples). Still, young persons would naturally tend to gravitate toward mates whose proven abilities and status equaled their own.

For Iban women, the highest accolades revolved around weaving and the secrets of properly applying dyes and fixatives. The term *kayu indu*, or "women's war," refers to ritual actions performed during the *gaar* or dyeing ceremony that were complementary to headhunting. Textiles used in conjunction with headhunting ceremonies aided and protected warriors. Certain designs championed by women for this purpose were employed to praise, encourage, and even goad their menfolk to greater valor and victory. In the 1970s, one could still encounter a few old men and women sporting tattooed hands. Formerly, this was a sign of prowess reserved for successful Iban headhunters and their counterparts, the most gifted weavers.

The articles and rituals surrounding headhunting were associated with a highly charged activity, one that engenders an extreme state of competitive tension that can be described as "agonal."[15] In Greek, the words *agon* and *agones* refer to honoring the gods in contests that involve death. As a modern medical term, "agonal" is applied to surgeries that teeter on the cusp of life or death. Here, the term "agonal" is used to describe an intense state of codified rivalry between peers that includes the production of artwork that is associated with headhunting or death. Of the Dayak art illustrated in this catalogue, fourteen of the following twenty-three items have some association with either headhunting or the soul journey of an ancestor. Working under agonal circumstances provided master Dayak artisans with a heightened purpose—to create items for the protection of themselves and their community. In contemporary parlance, we might say that this can happen when someone is "in a zone"—an alpha state in which heroic actions occur, artists produce their greatest work, or athletes excel beyond their competition.

Once, young Iban men went on an adventurous journey to amass wealth and prestige by acquiring gongs, Asian trade jars, and above all else, human trophy heads. This drive is still embodied in the modern meaning of *bejalai*: a time when young men routinely leave their longhouses to seek work in towns, in the timber industry, or in mono-agriculture, or when students or adults journey far away from their homes to further their educations or seek self-advancement in politics, business, and in all walks of life.

In 1981, Dr. J. B. Avé wrote about Dayak art in the catalogue *Art of the Archaic Indonesians*, which accompanied the exhibition of the same name that was shown in Dallas. He ended his introduction by commenting on the sad destruction of Borneo's forests (in central and eastern Kalimantan) and the stripping away of a "once so fresh and harmonious culture," while posing the question: "What will remain of his (Dayak) artistic expressions?"[16] Between 1985 and 2005, deforestation increased there by 23 percent.[17] Despite the current government's moderate policies toward indigenous groups and its genuine interest in the environment, there is still pressure

FIG 54 Repository for magic stones with a guardian figure in the foreground, Kayan people, undated. KIT Tropenmuseum, Amsterdam, 10000842.

FIG 55 *Salong* mausoleum photographed by Dorothy Pelzer near Rumah Laseh, Kejaman, Sarawak, in 1968. Courtesy of ISEAS Library, Institute of Southeast Asian Studies, Singapore, and Dorothy Pelzer Collection.

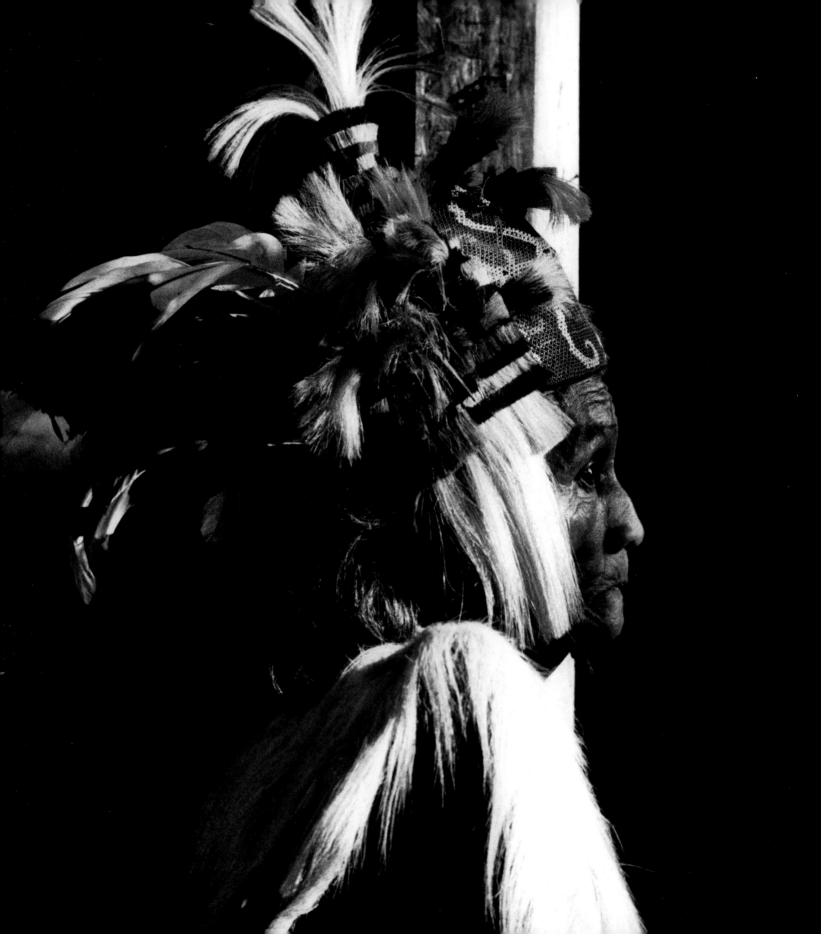

to commercially mine gold and to extract East Kalimantan's massive coal deposits. By some estimates, two-thirds of the island's forests will cease to exist by 2020.[18] Such radical changes in the landscape will continue to have negative effects, not only on the environment, but on many aspects of life ranging from traditional agricultural practices to the creation of art. The replacement of many longhouses and other traditional dwellings with more individualized forms of habitation, first by colonial authorities and later by Indonesia's President Sukarno in the 1950s, has over time slowly affected notions of communal responsibilities, reciprocity, and traditional relationships.

The recent choking of a 150-mile stretch of the Baleh and Rejang Rivers in Sarawak, as a result of overlogging, reflects these challenges. Over time, silt, surface debris, and logs have become so thick that the rivers' aquatic life is vanishing due to the water's reduced oxygen content. Distraught locals believe that the gods and spirits, disturbed by noise, loud machinery, and carelessness, are shaking the forest, resulting in its devastation and loss of animal life.[19] To assist in correcting this damage, the Iban there took a very traditional approach to an acutely modern problem. In November 2010, a rarely invoked ritual, a *Muja Menua miring*, was performed on the Malatai River. This ceremony had not been enacted since 1924 when it was last used to validate the end of hostilities and the cessation of headhunting among the Iban, Kayan, and Kenyah peoples.

As a symbolic event, it brought together the local population and high government officials. Given the gravity of the crisis, traditionalists sought to appease the gods and spirits, and to seek forgiveness for what they perceive as sins committed against both humanity and nature.[20] The elder who conducted the intercessory rituals, Nabau Tutong, asked the gods to replenish the land and the spirits to offer guidance. His prayers also included a riposte for better forest management. A local reporter wryly noted that the last *Muja Menua miring* resulted in a rapprochement between peoples, and asked whether its current counterpart could successfully encourage peace between man and nature.[21] Some estimates conclude that as many as 90 percent of Borneo's indigenous population have now adopted an outside religion. Yet, as this vignette illustrates, there is still a reverential embrace of tradition and time-tested concepts.

While the impetus and the agonal tensions involved in creating ceremonial objects have abated in modern times, beadwork and carving still continue to be created in sometimes innovative, albeit more contemporary forms. Among all the traditional arts, the famed weaving skills of the Iban are particularly enduring and still flourish. Today Dayak visual culture, with its anthropomorphic creatures and their bold curvilinear designs, is actually best known to outsiders as a component in the lexicon of "New Tribalism." Since the 1980s, this moniker has been associated with a creative explosion that celebrates a fusion of traditional Dayak and Pacific tattooing motifs. Its immense worldwide popularity has also sparked a revival of tattooing, which forty years ago was rapidly disappearing and seemed doomed to extinction. This phenomenon, along with eco-tourism, is inspiring in younger people a new interest in Borneo and its indigenous cultures.

Since Avé's prediction that the Dayak would become an "uprooted trans-migrant" and "a coolie of lumber firms," change and environmental loss have accelerated at an exponential rate.[22] While the Dayak art in the Dallas Museum of Art stands as a remarkable testament to a way of life that no longer exists, the groups that produced it continue to thrive as vital living cultures. The Dayak, echoing the story of the destruction of the *sanggaran*, or mythic tree, are ably adapting, reseeding, and perpetuating themselves to accommodate modern challenges. Where will their artistic expressions take them? Wellem Ingan, a master Kenyah craftsman, not only carves commissions for foreigners, but still carves for traditional Dayak purposes with the talent, verve, and imagination of his ancestors. Recently, when asked his thoughts regarding the Dayak sculpture and metalwork illustrated in this catalogue, he replied: "These items are well kept in Dallas, which I appreciate and respect. That's good. [As a carver] I would like to have images of these pieces so as to better understand, envision, and be further inspired by objects that I have never seen."[23]

FIG 56 Portrait of Tedong anak Barieng, who had just cut a ceremonial red thread (*benang merah*) with his sword. This was done to clear the way during a ceremonial event. Rumah Unyat, Sungai Merirai, Sarawak, 1979.

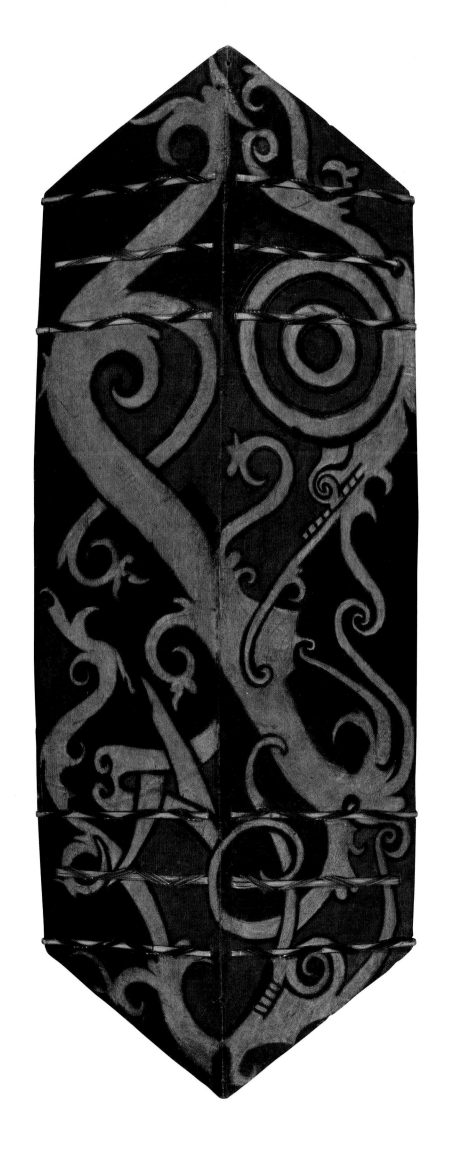

30
Warrior's shield (kelbit/ kelempit/kliau/talawang)

Malaysia, Sarawak, Upper Rejang River,
Kayan people
19th century
Wood, rattan, and pigments
50 × 20½ × ½ in. (127 × 52.1 × 1.3 cm)
Promised gift of Steven G. Alpert and Family,
PG.2013.8

While most likely of Kayan or Kenyah origin, the form and weight of this shield type proved so practical that it was adopted by other peoples in Sarawak including the Klemantan, Muruts, and the warlike Iban.[1] Crafted from a strong but light wood (julutong), its elongated rectangular shape with triangular ends made this a particularly efficient shield at close quarters. A raised spine running down its center served to deflect any glancing blows, while six horizontal bands of laced rattan reinforcements prevented these shields from splitting or shattering during engagements.

The outer surface on the majority of surviving shields depicts a single monstrous face surrounded by plugs of victims' hair. This was intended to give an already fierce composition an even more menacing appearance (kelempit buk). Protective imagery on shields included an array of beasts, birds, serpents, or giant warrior spirits. Usually, these symbols were painted as repeating designs in a direct, literal manner

Here, a supernatural being's face (hudo') and the overall design are presented in a fractured, asymmetrical fashion. The shield's composition is dominated by a mesmerizing targetlike "eye" in the upper right-hand corner. Toward the lower left, in corresponding juxtaposition to its one eye, one-half of the beast's parted mouth bristles with two oversized fanglike teeth. Embedded in the design are also the mouths of several other mythical creatures (aso) set amid a tendril pattern (kalung kelawit).[2] As part of a larger composition, these designs create a sense of continuous movement. Are the beast's floating parts coming together, or are they changing into a new, unknown, and perhaps even more ominous form?

To an opponent, such shape-shifting imagery was meant to be intimidating and visually disconcerting while at the same time conferring protection upon its aristocratic owners. Trumping or neutralizing an enemy's powers by projecting one's own protective talismans deprived opponents of any means of supernatural support—thereby encouraging their defeat and subjugation. Most likely this was a ceremonial shield used in headhunting rites.[3] When either danced with or displayed, this type of shield was used to reaffirm the courage and audacity of its handler, owner, and tribal group.

Shields painted in this style are said to have been made along a stretch of the upper Rejang River from Belaga to the Baram River in Sarawak. They are exceedingly rare and are usually found only in old European museum collections. Antique shields painted with singular or unusual patterns, like this one, are generally associated with the period just before or soon after the cessation of headhunting. They most likely ceased to be made not long after Western contact during the second half of the nineteenth century.
S.G.A.

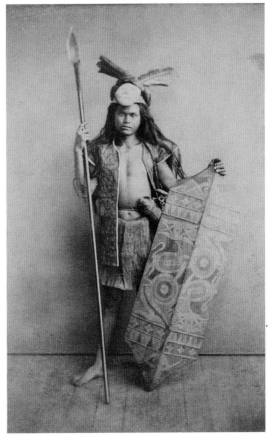

FIG 57 Dayak warrior from the east coast of Borneo with asymmetrical shield, c. 1867. Courtesy of KITLV/Royal Netherlands Institute of Southeast Asian and Caribbean Studies 4543.

31

Headhunter's or ritual ceremonial sword

Indonesia, Kalimantan, or Malaysia, Sarawak,
Bidayuh, Kantu' Mualang, or Kendayan peoples
19th to early 20th century
Iron, wood, deer horn, trade beads, silver coins,
fiber, and rattan
46 × 7 in. (116.8 × 17.8 cm)
Promised gift of Hannah Allene Alpert to the
Dallas Museum of Art, PG.2013.2.A–B

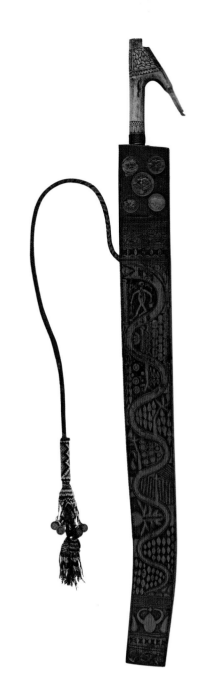

Among the Dayak, the greatest glory belonged to successful head-hunters. With this sword's fearsome size and remarkable pictorial sheath, it would have been worn by a person of importance such as a battle commander (*patinggi*) or, more likely, a ceremonial leader for ritual purposes (*temanggung*). A similarly shaped sword (*penepoh andai*) in the Sarawak Museum is recorded as being of Bidayuh origin.[1] *Penepoh andai* were made around the Sadong River and across the border in West Kalimantan.[2] Such swords have also been seen in the Badau area that straddles the border of Kalimantan and Sarawak, among the Kantu' Mualang, and the Kendayan and Ahe living from Ngabang to the Ambawang River.[3]

This blade's carved sheath addresses various themes: victory, prestige, the acquisition of wealth, and fertility. Here, an alle-gorical landscape of abundance includes rice in various phases of its growth. Lording it over this domain is the body of a gigantic underworld serpent. In many Indonesian traditional cultures, such creatures are guardians of the land of the dead and a fertile force in nature's cyclical process of renewal and regeneration. They can empower and enrich, or potentially harm. In the mythic realm, menacing underworld creatures are hungry and must be fed. To help sate, respectfully manage, and perhaps to expropriate the beast's powers, its gaping mouth has been fed a tasty offering.[4]

Leeches (*lintah*) are also depicted on several parts of the sword's scabbard, as well as being clustered on its deer horn handle. Their presence symbolically unites the sword's handler, its blade, and the scabbard's dreamscape through a potent metaphor and a binding promise. Just as leeches require blood for their sustenance, a ven-erable blade is thirsty, too, and requires the "harvested" heads of enemies to succor its soul. Clusters of leeches are also depicted in the fields, tying together themes of headhunting, planting, and, most auspiciously, the harvesting of rice. At the sheath's base, two engorged leeches flank an enigmatic design that has been described by informants as a headless corpse.[5]

Below the creature's head, a figure is triumphantly carrying a basket. In Iban mythology, the hero and model warrior Kling, who

was able to transform himself into five creatures including a giant python, boasts in response to his wife Kumang's exhortations:

> *Indah keba aku meti*
> *Nda kala aku pulai sablau*
> *Makau slabit ladong penyariang.*

> When I have gone on the warpath
> Never did I return unsuccessful
> Bringing a basketful of heads.[6]

As an especially honored blade, and as a symbol of authority, this sword would have been invoked in rituals related to headhunt-ing and as a virile complement in rice cycle ceremonies.[7] The finely carved sheath, its trade beads, and its silver Dutch coins are offer-ings of beauty that pay homage both to this blade's efficacy and to the ethos of the Dayaks' formidable warrior tradition.[8]

S.G.A.

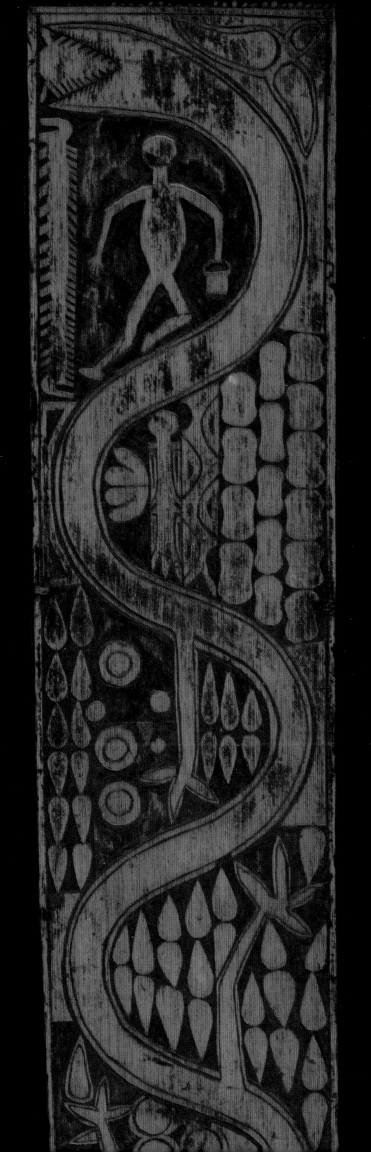

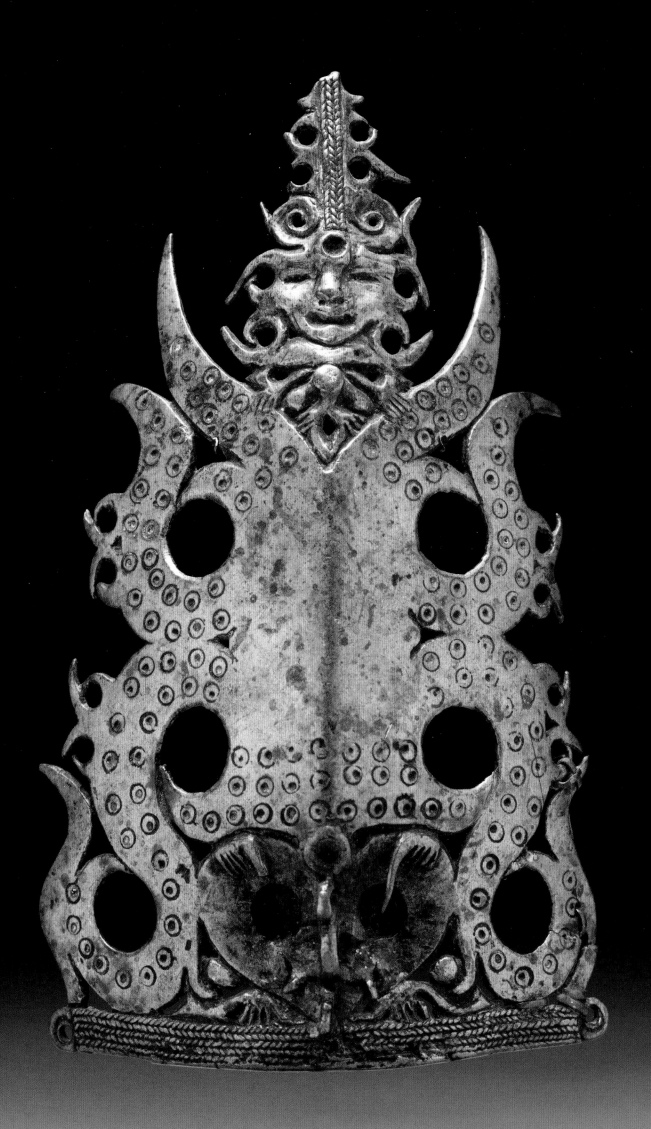

Warrior's headdress ornament: frontal figure
(*tap lavong kayo*)

Indonesia, East Kalimantan, Mahakam River region,
Kayanic peoples
19th century or earlier
Brass
6½ × 3¾ × ⅞ in. (16.5 × 9.8 × 2.2 cm)
The Roberta Coke Camp Fund, 1994.248

In addition to a warrior's sword, shield, blow pipe or javelin, a complement of armor often included a heavy skin jacket or a thick quilted bodkin and a decorated helmet.[1] Metal fittings were sometimes used to reinforce these war helmets.[2]

The most prominent type of attachment was a vertical, slightly convex metal frontlet. The oldest ones were finely cast with each frontlet having its own distinctive appearance and personality. Later or contemporary examples are often clumsily cast or cut from a sheet of thin brass.

The iconography portrayed on this remarkable frontlet is unique to the genre. At its base is the heart-shaped face of a powerful and protective underworld spirit with a protruding tongue and large riveting eyes. Framing its head are four handlike appendages that are neither human hands nor animal paws.[3] Each appendage is composed of humanlike fingers and a long, sharply tapered thumb. The curling protrusions emerging from both sides of the frontlet represent a spirit being's writhing limbs, with the emblem's midsection as the back of its body.

Grasping, riding, and seemingly controlling this powerful beast by its V-shaped, flukelike tail is a warrior, who most likely represents either a mythical hero or the embodiment of the wearer's own strength. The bond between this figure and the supernatural spirit is further indicated by the circular spaces created by the beast's curving outer limbs, which also appear on the right and left sides of the warrior's face and are then repeated once again on his headdress. As a design element, these curvilinear motifs not only beautify the object but also imbue it with a sense of unity, energy, and movement. As a potent symbol, this frontlet's composition projects the expropriation or merging of the beast's protective powers with a warrior's prowess.

The repeated dotted circles on the beast's limbs, tail, and torso also cleverly accentuate its ferociousness by imitating spots or scales. Whether in a ritual guise or in battle, these markings may have also served to further coordinate and identify this warrior's frontlet with his upper-body armor or ceremonial attire. To make Dayak warriors of note appear more menacing, war jackets were sometimes covered with the pelts and skins of various animals that included the tortoise-shell leopard (*Felis macrocelis*) or the sewn scales of the scaroid fish (*Pseudoscarus marine*).[4]

Given its visual qualities, theatricality, and archetypal message, this frontlet is reminiscent of the finest emblematic crests of other notable warrior societies, such as the samurai of Japan, the knights of medieval Europe, or the epic warriors memorialized by Homer in classical Greek literature.[5]

An emblem such as this one would have been worn only by a paramount chief—a dangerous warrior with a strong persona—who would have been the heroic leader of many men. The image of such a fearsome supernatural beast projected the wearer's ability not only to communicate with the spirit world but also to channel and make use of its protective power. Judging from its considerable wear, old breaks, and native repairs, this frontlet was once a carefully kept heirloom that was handed down from generation to generation.

S.G.A.

33

Pair of mythical *aso*

Malaysia, Sarawak, middle Rejang River region,
Kayan people
19th century
Wood (*kayu tapang* or Koompassia: *Excelsa*)
30½ × 8 × 10 in. (77.5 × 20.3 × 25.4 cm) (each)
The Roberta Coke Camp Fund and the Museum
League Purchase Fund, 1995.34.1–2

An *aso* (dragon-dog) combines the traits of a powerful dragon with the awareness, speed, and fierce loyalty of a dog.[1] Aside from their depiction on doors, wall panels, eaves, and the occasional figure, *aso* are most frequently seen on handheld items that were touched or grasped such as sword handles and their accompanying wooden scabbards, or on tools, utensils, bowls, ornamented work boards, and baby carriers. As supernatural guardians, *aso* provided protection against potentially meddlesome spirits, and in so doing ensured the safety of their owners.

Finely decorated possessions and architectural elements with *aso* also glorified the status of the elite. Among the inherited prerogatives of Kayan chiefs and high aristocrats (*hipuy aya'*) was the right to own beautifully decorated stools and low tables. This pair of stout mythical beasts once served as two of the four legs (*jihe' ladung*) from an aristocrat's table or bench (*ladung aya' litt*).[2] In former times, such benches were used primarily as chiefly seats, but are said to have also been used to receive ritual offerings while commemorating wars in which the Kayan had been victorious.[3]

While used only by a select few, ceremonial tables, seats, and ritual paraphernalia were decorated in such a way that they could be seen and admired at a distance. The scale of these *aso* is indicative of their importance. In its complete form, this table-seat must have been a truly impressive sight. Like a carved European throne replete with protective animals, it advertised the owner's ability to claim or dominate space according to his social standing and birthright.

Here, artistry and craftsmanship work together in equal measure. The upper section of the better-preserved of the *aso*'s tails reveals a deep ninety-degree horizontal notch that was intended to help support and distribute the weight of a single heavy slab of wood. To further secure the legs, peg-and-doweled construction was employed. That the animals face outward and that the *aso*'s fangs are bared, their bodies tensed for action, not only reaffirmed the nobility of its owner, but implied that whoever was sitting on,

or whatever was being conducted on, this seat or table did so in a protected zone.[4]

Most likely we will never know the detailed history of these *aso* aside from the fact that they were rediscovered in 1980 in Nottingham, England. Like the Kayan shield from the same area in Sarawak (cat. 30), these items were collected during the colonial era. They are rare survivors of the ravages of time, and each epitomizes Kayan artistry at its highest level of achievement.
S.G.A.

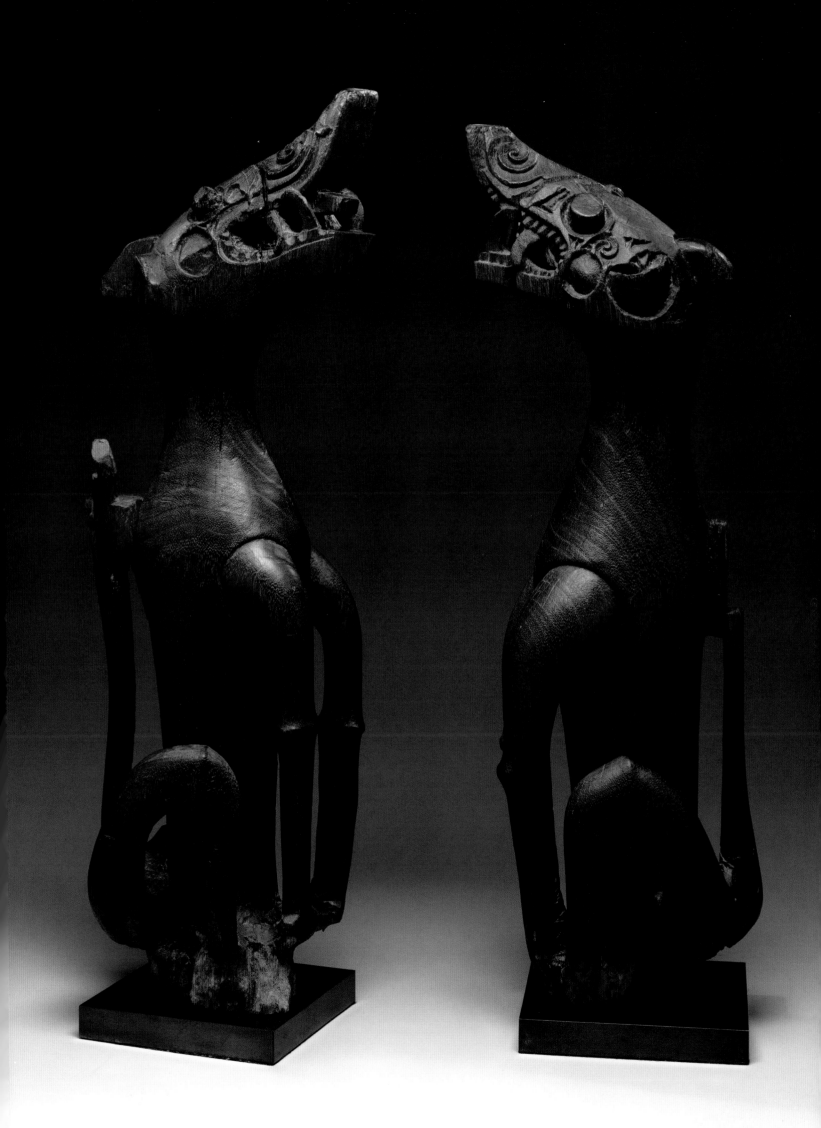

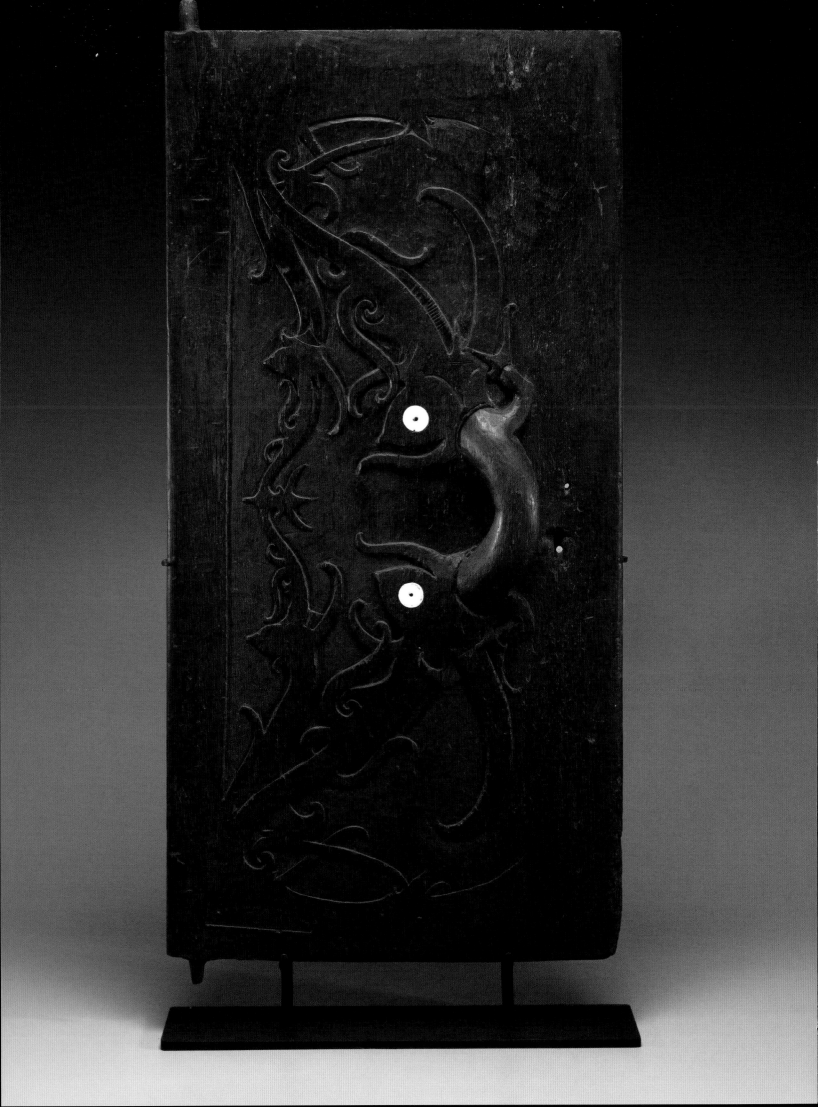

34

Door with protective symbols
(*baa betamen*)

Indonesia, East Kalimantan, Kayan people
Early 20th century
Wood, brass inserts, and shell disks
44 × 20½ × 3 in. (111.8 × 52.1 × 7.6 cm)
The Roberta Coke Camp Fund, 1997.111

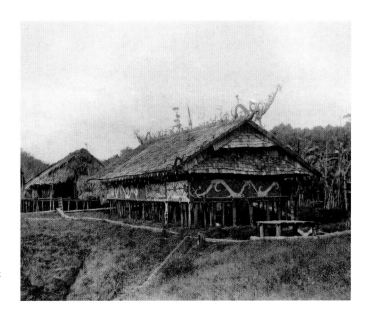

FIG 59 The Kubu longhouse of Pingan Sorong at Long Nawang, Kayan River, East Kalimantan, that was built in six days to house the expedition of A.W. Nieuwenhuis.

While they vary greatly in size and architecture, the most impressive traditional Dayak houses consisted of a long row of contiguous apartments (fig. 58).[1] Each family unit was connected to an unimpeded veranda that stretched the entire length of the longhouse. In precolonial times, these structures were sometimes raised on tall pylons, and in times of strife sometimes surrounded by stout stockades. Among Kayanic peoples, the entrances to the living quarters of aristocrats (*amin aya'*), particularly those at each end of the longhouse, and that of the paramount chief residing in its center, were often decorated with elaborately carved panels, posts, lintels, and doors (fig. 59).[2]

FIG 58 Carved door to Kayan or Kenyah chief's quarters. Photograph by A.W. Nieuwenhuis, 1904.

This door depicts a stylized dog-tiger (*aso' lejau*), a motif that was reserved exclusively for aristocrats.[3] Mythical tigers were considered the protectors of both a chief's mortal body and his soul. Antonio Guerreiro has observed that from a stylistic point of view, this door is characteristic of "Kayaan people, either from the Mendalam River, Daa' Kayaan [West Kalimantan] or the upper Mahakam [East Kalimantan]." He further suggests that it most likely originates from the "Uma' Suling subgroup or the Apo Lallang Kayaan in Long Kuling [formerly Long Paka']. In the latter region, the Uma' Suling are known also as Busang, or *deha' Busang*."[4]

Originating in the mythic realm, the composite animals emerging from doors and house panels are above all else protective guardians. According to Wellem Ingan, a master carver who has created numerous doors and panels, a composition with complex and conjoined mythical animals is infused with spiritual heat, is powerful, and is highly attuned to the spirit world. Such imagery not only glorified the owner's status, but also underscored the constant need to maintain a harmonious relationship between a temporal longhouse and the spirit world. Here, two *aso lejau* share one body that serves as the door's handle and symbolizes the transition from a chief's apartment to the outside world.[5] The placement of smaller, less defined *aso*, orbital dependents or "children" to the handle's larger figures, alludes to the complementary relationship between a leader and his people. Seen in this manner, the designs not only prayerfully beseech protection, but also acknowledge the cosmic order and linkage of all things.[6]

Generally, older doors from the era before the end of headhunting were designed to be smaller than are modern ones. In times of strife, invaders, in order to gain entry, would have had to momentarily lower their heads and bend their bodies. House defenders could thus make use of smaller doorways to slow an enemy's advance, while simultaneously using them to form a defensive position from which to launch their own counterattack. In times of peace, visitors would have had to briefly pause and slightly genuflect before crossing the threshold into an aristocratic family's apartment.

S.G.A.

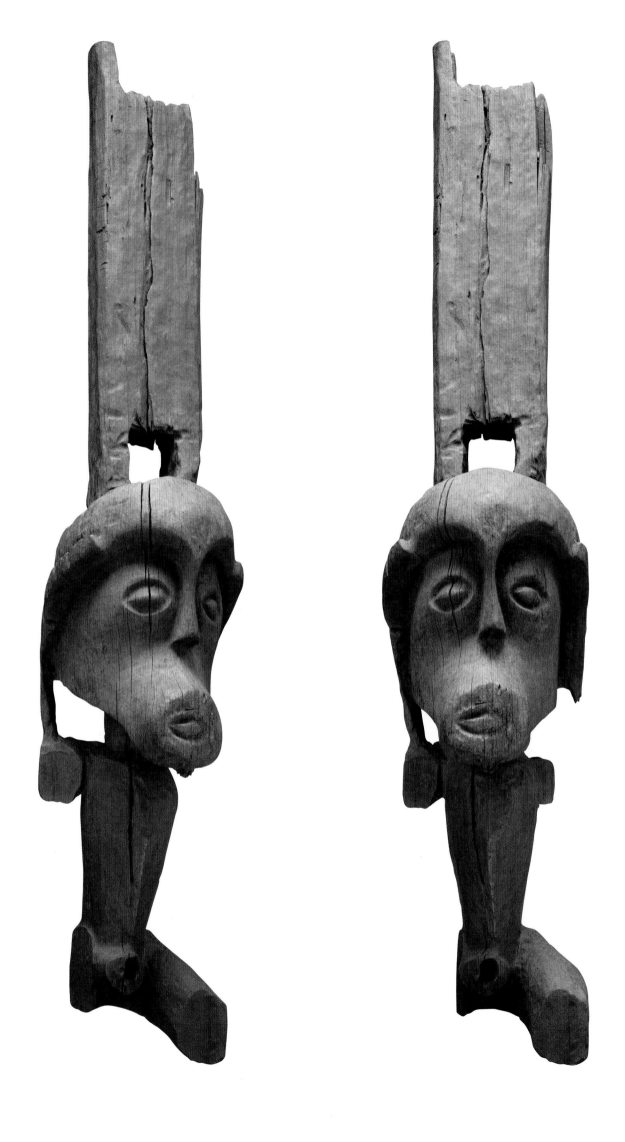

35

Tutelary figure

Indonesia, East Kalimantan, Sungai Telen,
Wehea Modang or Pre-Modang peoples
17th century or later
Ironwood (Koompassia: *Leguminosae*)
60 × 12½ × 13 in. (1 m 66.4 cm × 25.4 cm × 15.2 cm)
The Eugene and Margaret McDermott Art Fund, Inc.
2001.267.McD

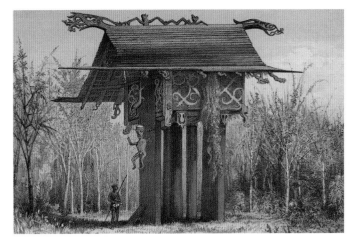

FIG 60 Raja Dinda's elaborately carved family sepulchre near Long Wai. Courtesy of KITLV/Royal Netherlands Institute of Southeast Asian and Caribbean Studies 36C121.

On rare occasions unusual carvings have been found in exposed riverbeds or along the muddy banks of the Wahao River and its adjacent tributaries. Usually, this occurs during periods of drought or when the courses of rivers shift. This particular figure was accidentally discovered by two Kenyah when a portion of it became snagged in their fishing nets on a small unnamed tributary off of the upper Telen River.[1] Since around 1810 to 1815, this territory has belonged to the Wehea Modang people.[2] Executed in an archaic style, this carving was created either by the Wehea Modang, or perhaps as its carbon date suggests by earlier occupants of the area.[3]

Among the Modang, statues of protective spirits (*meta*) were incorporated into both chiefly houses (*msow pwun*) and common houses (*eweang*).[4] In 1879, Carl Bock visited East Kalimantan and after laborious negotiations was allowed to see and draw the family mausoleum of Raja Dinda of Long Wai (fig. 60). This structure once housed the bones of a long line of paramount Modang chiefs. Now lost, it was already quite old when Bock encountered it. He noted that it was well made and composed of heavy ironwood.[5]

Among the mausoleum's ornate decorations is a prominent figure that shares certain affinities with the Dallas statue. Judging from the height of the person standing under it, the singular effigy on the building's left side would have been approximately twelve to fourteen feet off the ground. The exaggerated brow and elongated jawline of the Dallas figure indicate that it, too, was meant to be seen at a height well above eye level.[6] Both statues were clearly attached to or suspended from an architectural structure. The post protruding from the effigy's head has two large rectangular holes. This indicates that an interlocking mortise-and-tenon technique was used that evenly displaced the figure's weight using two longitudinal beams to secure it tightly to the main structure. Suspended, such a free-floating figure's gestures would have been especially animated.

Indonesia's finest traditional sculptors were masters at using angle, incidence, and natural lighting to heighten the psychological drama surrounding their creations. In its plasticity and complementary volumes, this statue reflects a deep understanding of how to use these attributes to the best advantage. Much like someone flexing his or her muscles to lift a heavy weight, the torso's expansive chest, arching back, and compressed and squared-backed shoulders strain and interact in perfect unison to successfully balance a massive head on a much smaller body. Even in its current fragmentary form, minus most of both its arms, lower legs, and male sex organ, it remains a compelling work of art. This figure's combination of dynamism and elegant simplicity is the hallmark of a master carver. Just as geological time gradually sculpts features within a landscape, the wear of river currents has added to this figure's undeniable mystery by softly caressing and subtly altering its surfaces.

S.G.A.

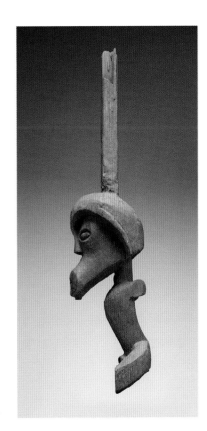

36

Standing guardian figure
(*tepatung*)

Indonesia, East Kalimantan, Wahau River,
Bahau people or Pre-Bahau people
c. 16th to 19th century
Ironwood (Koompassia: *Leguminosae*)
65½ × 10 × 6 in. (1 m 66.4 cm × 25.4 cm × 15.2 cm)
The Eugene and Margaret McDermott Art Fund, Inc.,
2001.268.McD

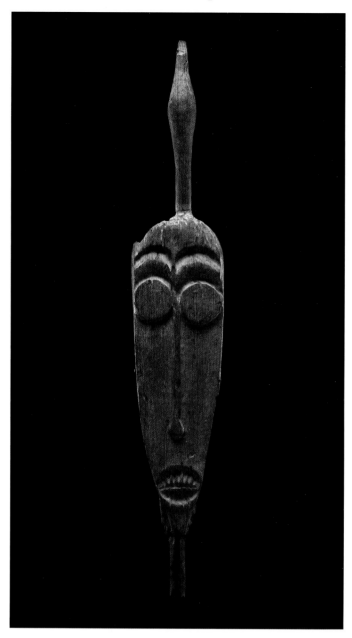

FIG 61 A large Dayak head carved in the style of cat. 36, Wahau River,
East Kalimantan, 16th to 19th century, private collection, Dallas.

This statue's surface tells the story of two lives. Before it was toppled, the erosive wear on its crown, shoulders, and hips was caused by exposure to the elements. Its finely polished and abraded surfaces are consistent with its having reportedly been found protruding from a riverbank.[1] Stylistically, this statue's bold face is related to only one other documented piece, an elongated head attached to a hand grip or pole (fig. 61).[2] While these two carvings belong to the area's general artistic tradition, their salient features—long faces, pronounced double brow, and raised disklike eyes—are stylistic elements that no longer exist within the region's aesthetic repertoire.[3]

The peripatetic patterns of Dayak peoples, including their disappearance or assimilation into other tribal groups, often make the identification of older substyles problematic. These two carvings, and a few architectural remnants that depict single or repeated animals, appear to be all that remain of a once vigorous, but now extinct, Dayak substyle. This statue does not belong to the Kayan, Lun Wehea, or other Modang peoples currently residing in the area where it was discovered.[4] However, the oral history of the Lun Wehea of Nihas Liah Bing does mention a Bahau ethnic group, the Lun Kalgak, who lived there before the Lun Weheas' arrival. Through intermarriage, they were absorbed by the more numerous Lun Wehea around 200 years ago.[5]

Being able to invoke and harness the aid of one's ancestors or other powerful beings is a persistent theme and impetus behind many Dayak creations. In former times, tutelary figures were placed along riverbanks adjacent to villages or mortuary sites. Imposing figures were also created in conjunction with rituals pertaining to prestige, fertility, or headhunting. Protective figural carvings were architecturally incorporated into aristocratic dwellings, men's houses, and mausoleums. Images were also sometimes erected as temporary repositories for the spirits of departed elites. These carvings represented a physical form to which the journeying souls of ancestors could return and where they could be consulted regarding important omens or customary law.[6]

The exact function of this life-sized statue remains unknown. Its raised cupped hands may be those of a supplicant (or represent keen hearing abilities), but the saucerlike eyes, bared teeth, erect posture, and inflated and powerfully flexed limbs more likely suggest an alert sentinel poised to repel malevolent spirits or unwanted intruders. Here, the exaggerated muscularity of powerful animals—with their feral traits—has been brilliantly combined with the human form.[7] The result is a riveting presence, an otherworldly being, who in some capacity was used to reconcile and bridge the world of the living and that of the supernatural.
S.G.A.

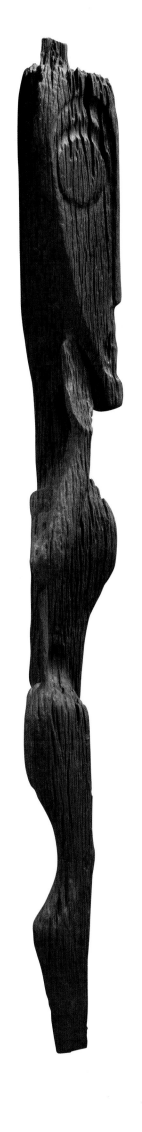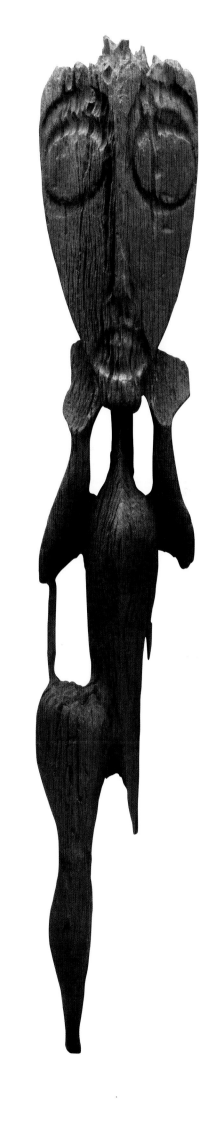

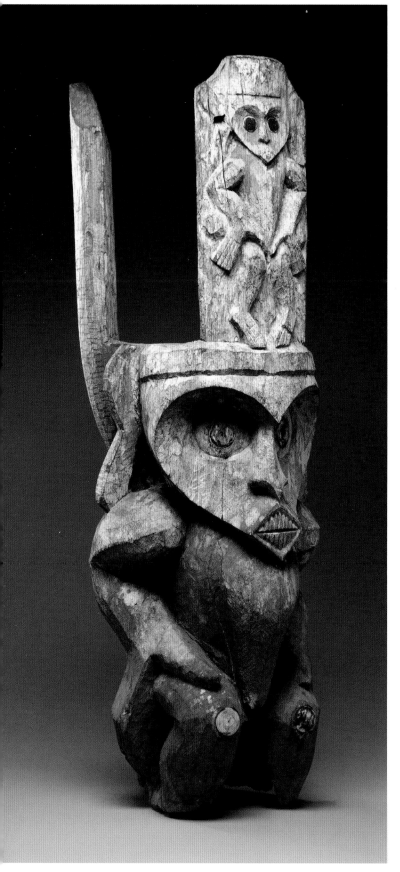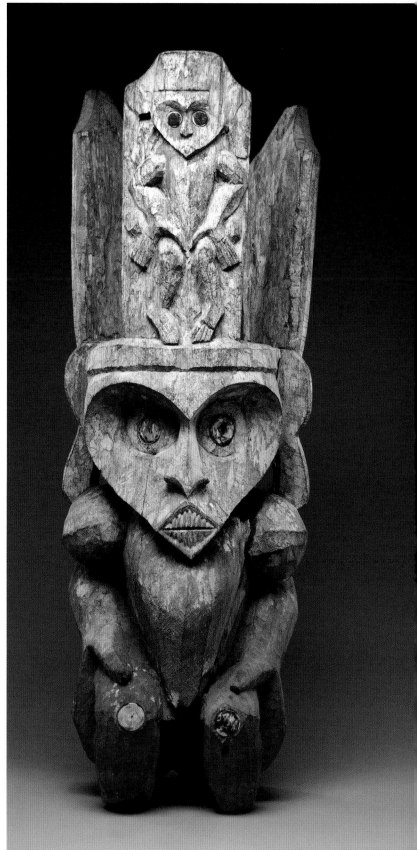

37

Figure from the top of a funerary post (*jihe*)

Indonesia, East Kalimantan, Mahakam River region,
Bahau Saa' or Bahau-Busang peoples
18th–19th century
Ironwood (*belien* or *taha*) with conus shell insets
46 × 14 × 15 in. (116.8 × 35.6 × 38.0 cm)
Gift of Tootsie and Peter Fonberg, Linda and
Charlie Jackson, Mr. and Mrs. John Ridings Lee,
Jan and Jack McDonald, Carol and George Poston,
and Mr. and Mrs. Martin Tycher, 1984.11

Throughout Southeast Asia, indigenous tribes have always honored the dead, and their ancestors, in elaborate ceremonies. In the case of the most exalted aristocrats, structures were often erected to glorify their memory and hold their remains. Arguably, the most impressive funeral monuments in Borneo are the ornately carved burial poles said to have originated with the Punan (Punan Bah') of Sarawak and later adopted by other tribes including the Kayan, Lahanan, and Kejaman (fig. 62).

Known in Sarawak as *kelirieng*, these poles often supported small houselike structures or were topped with large slabs of stone. The largest known surviving *kelirieng* is a majestic thirty-two feet tall with an impressive width of approximately six feet.[1] Such monuments were costly in terms of manpower, feasting, and ritual payments so that only the very wealthy could afford them.[2] Their erection necessitated the sacrifice of slaves both to stabilize the structure, which straddled both upper and lower worlds, and to provide "helpers" for the deceased.

Before the early nineteenth century, the Bahau Saa' also used impressive secondary burial poles. Over time, their primary burial practices changed, and like other neighboring groups in the Mahakam Basin they began to place their dead in coffins housed in elaborate mausoleums (*bilah*).[3] Resting on the top of these poles were the carefully cleaned and prepared bones of an illustrious chief or high-ranking aristocrat (*hipuy aya'*).[4] In the case of the Dallas figure, the bones were placed in a ceramic jar of Chinese or Southeast Asian origin (now lost) that was once snugly nestled and pinned within the three prongs protruding from this figure's head. The human figure carved in relief on the central prong represents the deceased individual.[5]

Supporting the jar with its remains is the protective spirit being Panlih. His distinctive heart-shaped face is reminiscent of the one found on Dallas's headdress ornament (cat. 32). This type of facial treatment is of ancient origin, and is perhaps best known from its depiction on the "Moon of Bali," the world's largest Bronze Age drum, which is thought to be about 2,000 to 2,300 years old (fig. 16, p. 21). The historical persistence of the heart-shaped face on

statues and other traditional objects from Borneo and throughout Indonesia continued into the twentieth century.[6] In the Dallas figure, Panlih's engaged and ever-watchful stance reminded the living of the exalted status of the deceased, while his taut muscularity and superhuman strength assured a safe journey for the aristocratic class to the land of the departed souls.

S.G.A.

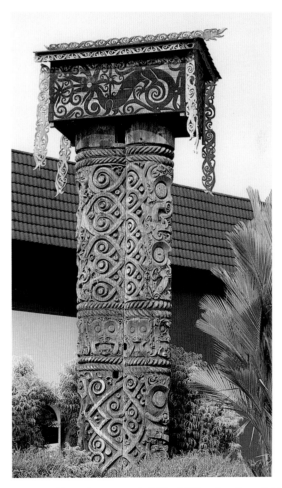

FIG 62 Double-trunk mortuary pole (*kelirieng*), 19th century, Punan Bah', Long Segaham, Ulu Belaga. Now reinstalled at the Sarawak Museum, Kuching, East Malaysia.

38

Roof-ridge panel with crouching human figures

Indonesia, East or Central Kalimantan,
Mahakam River region
18th to 19th century or earlier
Ironwood (Koompassia: *Leguminosae*)
17 × 34½ × 3½ in. (43.2 × 87.6 × 8.9 cm)
The Roberta Coke Camp Fund, 1996.181

The function of this architectural panel is not clear, but its scale and tapered shape, when compared to more modern forms, suggest that this carving is most likely the central panel from a small mausoleum or shrine house. Elaborately decorated mortuary structures glorified the ruling classes of a number of Dayak groups and, befitting their upper-world status, ensured that their bones did not mix with either animals or the earth.[1]

Architecturally, this finely tapered panel was ingeniously stacked like a Lego block on two other sections of a structure. Above, an additional tier was neatly fitted to the "male" flange running along the top of the panel. Below, to soundly anchor it to the main structure, there is also a "female" recess underneath this panel's base, which is not visible. Side pins indicate that there were at least two other attached elements. There is no way of knowing what these attachments once looked like. However, lateral extensions composed of mythical animals, curling arabesques, and complex tendrils are commonly seen in both early drawings and latter-day photographs of secondary burial houses.

Among some Dayak groups, the upper classes owned slaves, who were occasionally sacrificed.[2] The repeated figures on this panel most likely refer to sacrificed slaves, or helpers of the dead.[3] It was once common practice to take human life at the end of a funeral cycle. Important structures belonging to the ruling classes in many parts of Indonesia were sanctified by the bodies of sacrificial victims that were placed under key posts or at cardinal points. This was done to solicit the blessings of the spirit-souls of the ancestors, and to properly settle or stabilize structures.

The squatting figure is an ancient motif that can be found throughout Southeast Asia. As a design element, a sequence of such figures is now rarely found in the region's carving repertoire, but it does survive in beadwork, which can be seen on compositions that were attached to baby carriers (fig. 63).[4] It is most likely that this piece originates from the northern part of East Kalimantan, the Bulusu'/Tingalan region, or remote upriver areas of Central Kalimantan that border West Kalimantan.[5]

Carved from ironwood, this panel was fashioned from one of the world's hardest woods (as the name implies). It miraculously survived by being buried in a riverbed. One side was face down in the mud where it would have been protected from exposure and the force of rushing water. The other side is more eroded as a result of being washed over by a river's current before also being buried beneath mud and other debris. This item's wear patterns and the figures' lyrical simplicity suggest that it belongs to a category of extremely rare archaic-styled carvings that have been found mostly along the upper reaches of the Mahakam River and its tributaries.
S.G.A.

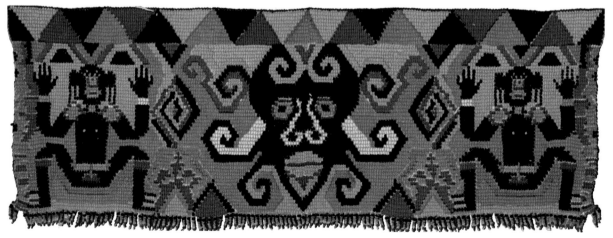

FIG 63 Color drawing by A. W. Nieuwenhuis of a protective beaded panel for a baby carrier, Upper Mahakam River, Kalimantan, 1904.

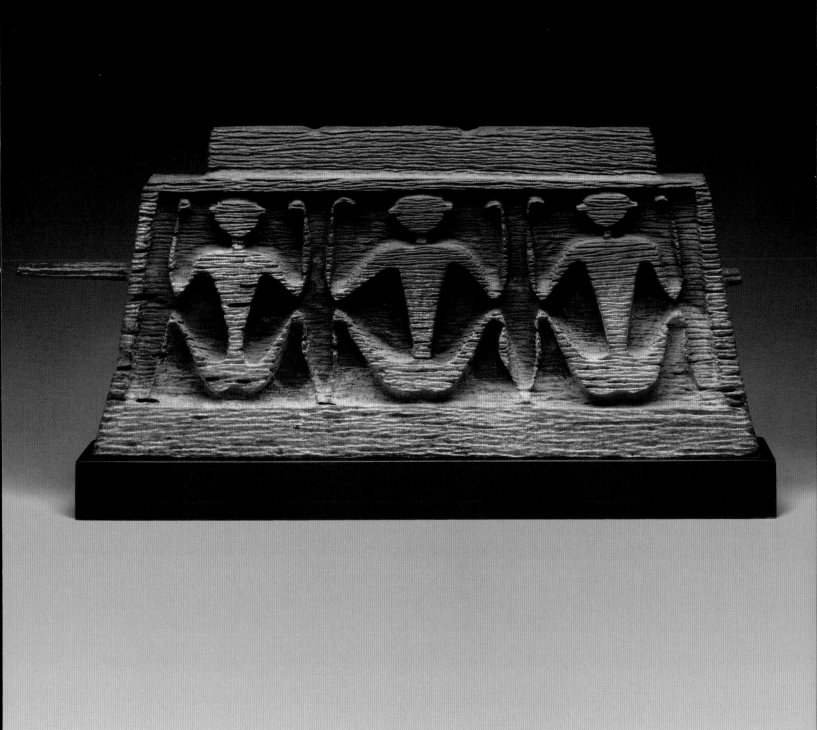

39

Shrine object with figure atop a dwelling flanked by two mythological animals

Indonesia, Kalimantan
19th century or earlier
Bronze
4 × 2⅞ × 1¾ in. (10.2 × 7.3 × 4.4 cm)
Gift of The Nasher Foundation in honor of Patsy R. and Raymond D. Nasher, 2008.60

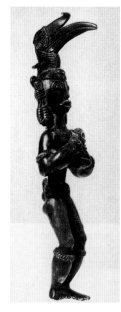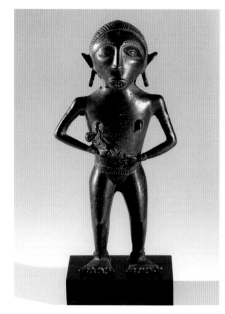

FIG 64 Prehistoric bronze figure (*Imun-ajo'*) whose headgear features a hornbill, Kayan people, Sarawak. (Formerly in the collection of Tom Harrisson, current whereabouts unknown.)

FIG 65 Late Bronze Age maternity figure said to have been collected on the upper Wahau River, East Kalimantan, c. 4th to 6th century. Bronze. Honolulu Academy of Arts, Hawaii, gift of the Christensen Fund 2001.

On occasion, unusual metal objects have been found that came from the interior of Borneo. Among the most notable of these are a well-cast Kayan-style figure crowned with a hornbill, from Sarawak, and a mother and child said to have been found in the Wahao area off the Mahakam River (figs. 64 and 65). Such figures, along with the Dallas piece, are unique examples of "Dayak" metalwork. However, it remains an open question as to who actually made these objects, and whether they are actually of native or outside manufacture.

On Borneo's north coast, Brunei has long been associated with metalwork. In 1225, a visiting Chinese official, Chou Ju Kua, noted that Bruneians wore metal armor and carried swords made of bronze when attending funerals.[1] Magellan's chronicler, Pigafetta, described the Sultan's bronze and iron cannons during his brief stay there in 1521.[2] Bruneian trade items including elaborately decorated gongs and their suspension chains, miniature cannons, and ornamented kettles were also prized by native peoples of Sarawak. An eighteenth-to-nineteenth-century Brunei kettle in the Museum's collection is decorated with warriors, a theme that would have certainly appealed to the warlike Iban who once owned it (fig. 66).

According to the scholar Antonio Guerreiro, this piece most likely hails from "the now upland people of the Apad Duad range." During the fifteenth to sixteenth centuries, some of these people were living close to Brunei Bay, where they could have attained the technological knowledge necessary to make such a bronze.[3] Southward expansion of northern groups toward the upper Bahau and beyond possibly explains why this bronze was reportedly found in Indonesia's southeastern province of Kutai Kartanegara.[4]

Many informants also insisted that this bronze was used during healing ceremonies. Describing such, Carl Lumholtz makes particular mention of a bronze Hindu deity who was long venerated by local Dayaks of the Temang district.[5] This statuette was washed in lemon juice prior to being displayed on a brass dish containing rice. After the statuette was "fed" and rewashed, the residual water was used as an eye remedy.[6] The well-worn and velvety smooth surface of Dallas's bronze indicates that it, too, was handled over many generations and may also have been ritually washed in a similar manner.

This item is composed of three elements. The first is a central hunkered figure that most likely represents a priest, healer, or even a fabled ancestor—an intermediary who in some capacity can straddle and navigate the worlds of men, gods, and spirits. The object between the figure's legs is either a bamboo container, a sword, or perhaps a small drum, as each of these items has associations with the spirit world. While the building's architectural style cannot, based on the available scholarship, be ascribed to any particular group, the use of winged water snakes and other mythical animals as roof finials is a common feature on traditional Dayak structures. Two rectangular side lugs on this object's base suggest that at one time it may have been the top of a container or a shrine-like object that was raised on two stiltlike struts. The origin and purpose of this venerable object, which has been transformed by time, extensive handling, and physical movement, are enigmas that remain to be solved.

S.G.A.

FIG 66 Kettle decorated with armed warriors, Brunei, 18th to early 19th century. Bronze. The Roberta Coke Camp Fund, 1994.249.

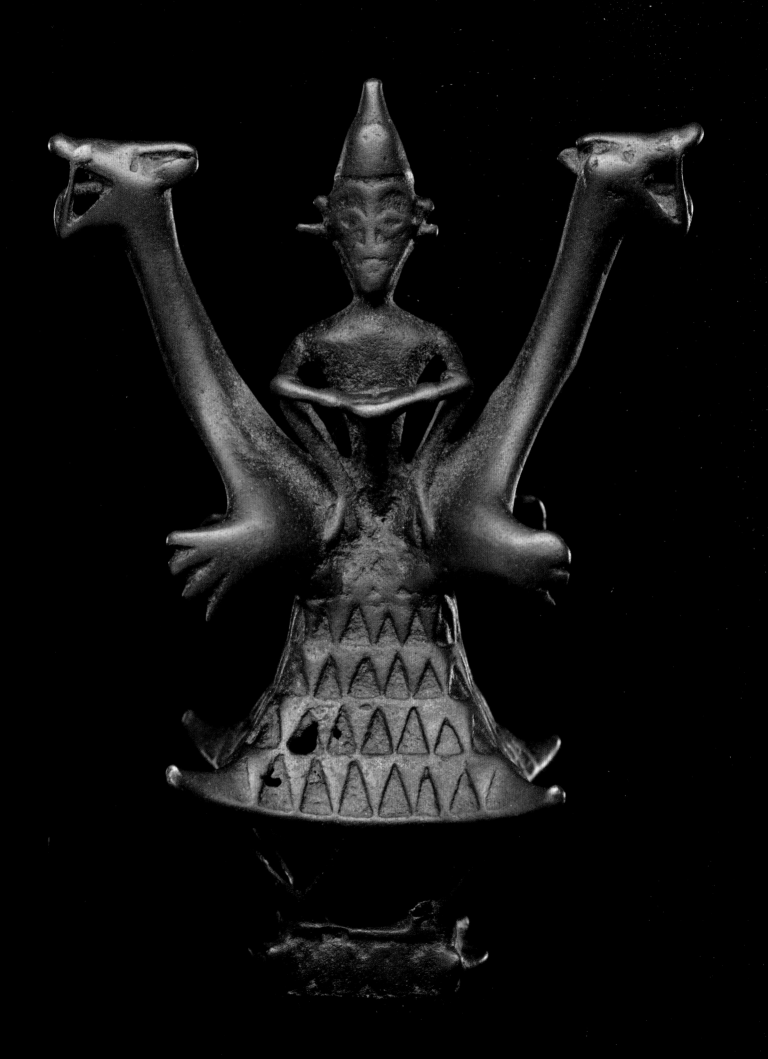

40

Mask

Malaysia, Sarawak, Iban people
Late 19th to early 20th century
Wood, dammar resin, lime, and black pigment
10¾ × 7 × 4½ in. (27.0 × 17.8 × 11.4 cm)
Gift of Albert and Elissa Yellin, 2003.38

Masking traditions were once found in many parts of Borneo. The fanged, hook-nosed masks of the Ngaju worn during death rituals (*tiwah*), the elaborate curvilinear deity masks of the Apo Kayan, and the famous composite animal masks (*hudoq*) of the Bahau used during agrarian festivals all attest to the quality and variety of Dayak masks.

Among the Iban, the use of masks has traditionally been less ambitious and is associated either with protecting crops or with entertainment. Though they generally have played a minor role within longhouse life, indoor masked performances often exhibit the prankish humor of the Iban. Indai guru' is a spirit who lurks in lofts and along the far reaches and edges of the longhouse. An older female impersonates her, and with skillfully performed theatrical gestures, attempts to scare children, who, terrified, run shrieking into the protective arms of their waiting parents.[1]

As late as the 1970s, the arrival of a guest from far away, or the ending of a ceremonial cycle (*berbuti*), often called for tension-releasing dances that made use of these masks. Once again, older females wearing sacklike clothing would perform to the tremulous beat of gongs. In my day, the most proven men (as well as male guests) were playfully accosted and teased by Indai guru', who was allowed to harangue their masculinity, often with ribald gestures.[2] It was a classic play on role reversal. At first seemingly tense, the entire affair quickly turned into a comedic farce. Chaos was created and balance within the longhouse was temporarily threatened, only to be righted and cleansed by doses of human folly amid peals of laughter.

In general, Iban masks often seem to have been hastily worked. Perhaps this is because they were made more for pleasure than actually being the focus of a ceremony with agonal consequences.[3] In addition, Iban masks were not made solely by a class of experts. Crude execution may also have been intentional so as to accentuate a mask's ghostly qualities in an era before kerosene lamps and incandescent light.

Antique masks usually have a natural surface or are painted black with areas highlighted in white.[4] Generally, they display abraded areas, and, depending on the hardness of the wood, concentrations of patina develop with use and age. Qualitatively, this older Indai guru' mask is exceptional, as it was carved by a very skilled hand. While balanced and even stately, its parted mouth, bared teeth, long sallow face, and jutting chin effectively combine to evoke a sly and menacing persona.

S.G.A.

FIG 67 Female masquerader wearing a mask depicting the face of Indai guru', 1950s.

41

Granary charm (*agom*)

Malaysia, Sarawak, Iban people
19th to 20th century
Wood (*kayu tapang* or Koompassia: *Excelsa*)
6½ × 2½ × 3 in. (16.5 × 6.4 × 7.6 cm)
Promised gift of Sarah Elizabeth Alpert and
Hannah Allene Alpert, PG.2013.5

Rice is the staple food of the Iban, as well as the source of their wine and distilled spirits. It is present in some form at nearly every Iban ritual and is ceremonially honored in each of its phases: from seed to planting, from growth to harvest, and in various forms of storage within an Iban longhouse. *Agom* are carved wooden sentinels that are indispensable to this cycle. They are all-seeing, vigilant, and able to communicate with their owners to ensure that a family's rice supply will not be adversely affected during its production or storage.[1]

Just before the rice seedlings are planted, *agom* images are carved at the ends of tapered stakes. These are then inserted into the ground, marking an area of cultivation, and are activated during the *pemali umai* ceremony. These figures guard the fields against both natural and supernatural predators. *Agom* are sometimes also found along trails, on the peripheries of cultivated areas, and along paths that run from waterways and rivers to the fields.[2] Another category of *agom* are those that are placed near or inside a family's rice storage bins within the longhouse. When this carving was collected, the seller stated that it had been wrapped in cloth and placed within the rice bin itself.[3] Besides the danger from those insects and animals that might eat the rice, there is also the fear that a household's food supply will be coveted by jealous people or by a class of spirits described as withered crones (*antu buyu*). Those that would covet rice are both wily and voracious, and those with an "evil eye" are said to be able to detach their heads, gain entry to rice bins, and greedily devour its contents.[4]

Some Dayak groups carved protective charms depicting maternity themes because it was felt that women, particularly those giving birth or nursing children, were more vigilant and aware than menfolk.[5] The image of a mother nursing a child not only connotes attentiveness, but also conveys the essence of feminine beauty. Old photographs often show young women in their ceremonial finery sitting in this fashion with straight backs, their legs akimbo, as they greet guests and sing their praises during festivals (fig. 68).

The bodies and faces of the mother and child are carved in a reductive and tender manner. That the child is both suckling and looking upward into the mother's face increases the intensity of both their gazes while reaffirming their inseparable bond. Rice is like a human child, as it entails great effort and sacrifice to produce and even greater vigilance to protect. As a female, this figure is associated with fecundity and plenty. As a guardian, she ensures that there is no waste (*jediau*) and that one's rice supply never becomes exhausted.[6]

S.G.A.

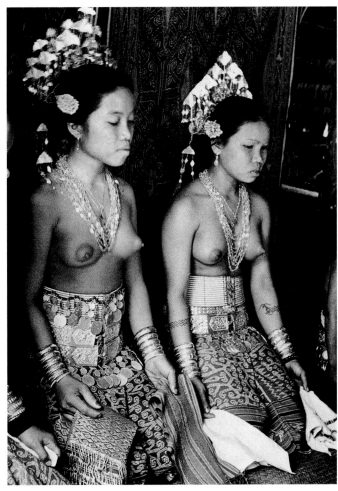

FIG 68 Girls singing a song of welcome to a guest in the longhouse, 1950s.

42

Ceremonial jacket (*sape buri*)

Indonesia, West Kalimantan, Upper Kapuas River area,
Maloh people
Early 20th century
Commercial cotton, wool trade cloth, Nassarius shells,
buttons, sequins, coins, leaf fiber, and beads
22 × 18½ in. (55.9 × 47.0 cm)
The Steven G. Alpert Collection of Indonesian Textiles,
gift of The Eugene McDermott Foundation, 1983.140

The Maloh populate the upper Kapuas River basin of West Kalimantan.[1] They are known for their skill as silversmiths, and for their decorated skirts (*kain manik* or *kain lekok*) and sleeveless jackets (*sape manik* or *sape buri*) that women don on important ceremonial occasions. The beaded geometric patterns and figurative imagery on these garments—dragons, serpents, dragon-dogs, crocodiles, and squatting humanlike figures—are shared by Ibanic and Kayanic groups.[2] Among the hierarchical Maloh, the depiction of both supernatural animals and stylized figures (*kakale'tau*) were formally associated with funerary rites. The latter, squatting beings with upraised arms and splayed legs (fig. 69), were once linked to the ritual killing of slaves. As helpful spirits, *kakale'tau* accompanied and served aristocrats on their souls' journeys in the hereafter.

The Maloh also decorated their ceremonial clothing with Nassarius shells (*parus* or *nassa*). Unlike beaded patterns, each shell was stitched directly onto an outer cloth of indigo blue or black whose underside was padded with additional layers of fabric or bark cloth. The use of these shells, along with cowries (*uang kulit kerang*) and polished disks made from the ends of conus shells, points to an ancient affinity for shells among the Dayak that predates the introduction of small European glass trade beads.[3]

In the tradition of investing something distant and foreign with prestige, this vest displays materials that were sought after by indigenous peoples during the colonial period. Set amid the stitched shells are swatches of red, yellow, and green trade felt, metallic sequins, and strips of multicolored trade cloth. This jacket's composition is enclosed in a rectangular frame of shells and further embellished on each side with European buttons. Along the bottom border, Dutch silver coins dating back to 1701 dangle from a single strand of tacked glass beads. Here, an array of materials, colors, and textures has been tastefully laid down by this jacket's maker to create a vibrant, powerful composition.

These embellishments also reflect a conscious effort to fill open space with an interlocking mesh of protective designs. Turned on their side and viewed horizontally, two serpentine, dragonlike creatures (*naga* or *binawa*) mirror each other, their profiled bodies,

tendrils, bared teeth, and curling tongues clearly visible. Looking at this jacket as it was worn, the reverse side is anchored by a central spine of shells. When the jacket's two complementary halves are viewed together as one, they coalesce into the faces of supernatural creatures. This design (*kungkasak*) is said to be a combination of a dragonlike creature and a scorpion (whose pincers double as the *naga*'s jaws). Their eyes are highlighted by circles of red felt, which along with their ovoid mouths and flaring nostrils are also composed of Nassarius shells.[4] These garments had many ceremonial uses. According to some informants, this particular type of jacket was commonly worn by high-ranking women during the ritual naming of a child (*manyauti*).[5]

S.G.A.

FIG 69 Detail of a beaded panel depicting *kakale'tau* from a ceremonial skirt (*kain manik*), Kalimantan, Upper Kapuas River region, Maloh people, late 19th century. Cotton cloth, wool cloth, glass beads, metal sequins, shells, cotton yarn, and leaf fiber. Textile Purchase Fund, 1998.192.

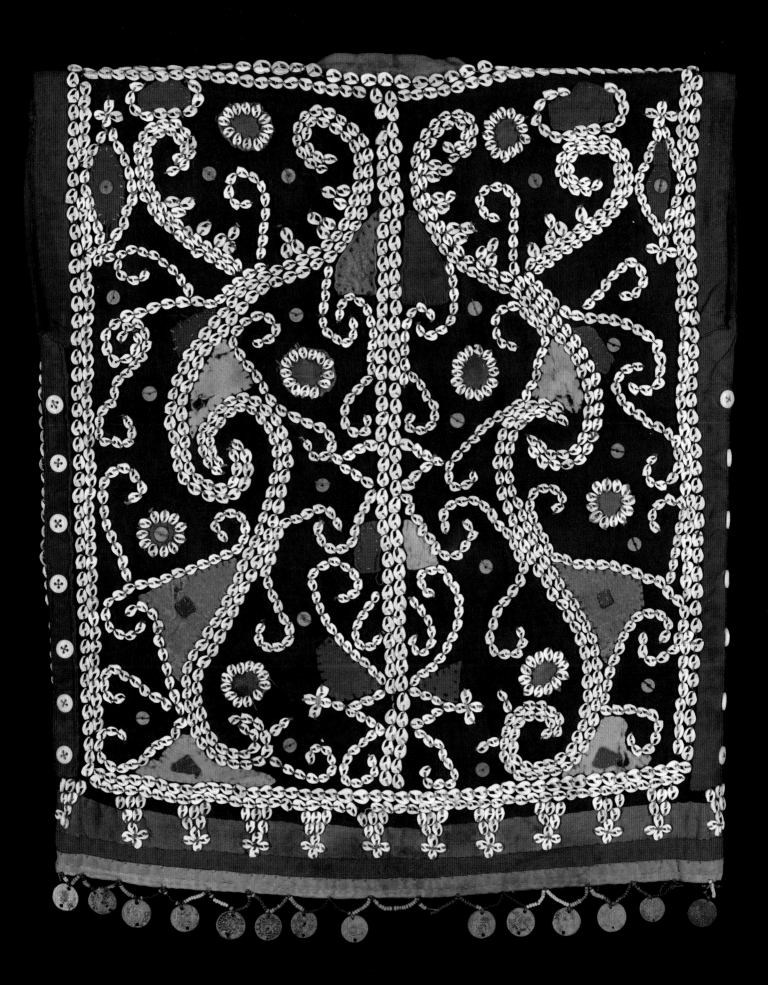

43

Woman's skirt (*kain kebat*) with moon rat design
(*bebuah aji bulan*)

Malaysia, Sarawak, Baleh region, Iban people
Early 20th century
Homespun cotton
40¾ × 19¼ in. (103.5 × 48.6 cm)
The Steven G. Alpert Collection of Indonesian Textiles,
gift of The Eugene McDermott Foundation, 1983.135

44

Woman's skirt (*kain kebat*) with brahminy kite design
(*bebuah lang*)

Malaysia, Sarawak, Saribas region, Iban people
20th century
Homespun cotton
44¼ × 21¾ in. (112.4 × 55.2 cm)
The Steven G. Alpert Collection of Indonesian Textiles,
gift of The Eugene McDermott Foundation, 1983.137

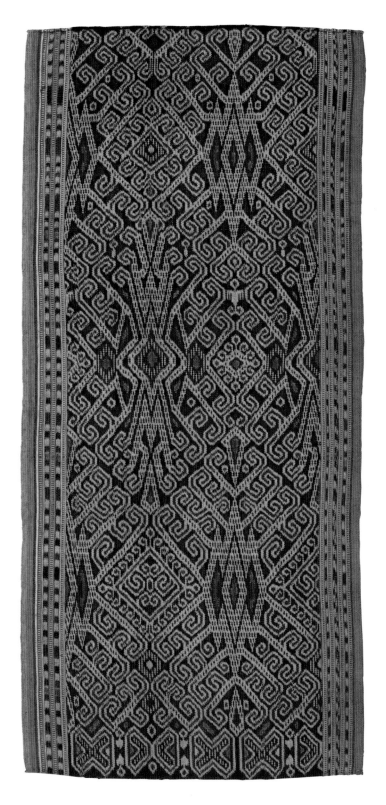

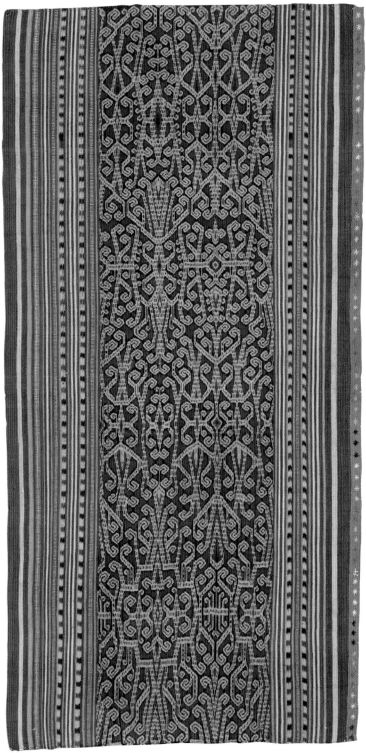

In the Baleh, where cat. 43 originates, the central motif of the cloth's design is known as the *Aji Bulan* or Moon Rat.[1] Anthony J. N. Richards defines the moon rat as "*Echinosorex gymnurus Rames* (and *candidus*). It is a pugnacious nocturnal burrowing insectivore living near water, a survivor from prehistoric times."[2] The motif is heavily stylized, and is not supposed to be a naturalistic representation of a rodent. Its abstracted design is emphasized, with very few accompanying supplementary motifs surrounding it.[3] Weavers today remember how to construct the motif, a very ancient one, but cannot explain what each curl or projection might mean.

Discreetly tucked in between curls is a tiny anthropomorphic form, rare on skirts. It has a head, limbs, and upturned feet. Only the weaver would have known what it represents and why she wove it on her skirt. It is most definitely not a food offering for the rodent. Food offerings are for spirits, the depiction of whom on textiles outranks, by leaps and bounds, stylized representations of animals, especially innocuous ones like the moon rat.

Liberal splashes of indigo blue accentuate the lozenges and chevrons of the entire design, which makes this Iban skirt an exceptionally beautiful one.

In the Saribas, where cat. 44 is most likely to have originated, this textile design is known as Lang, though a Baleh weaver would immediately see the *Aji Bulan* (Moon Rat) instead. Here we have a classic case of essentially the same basic design with a single genesis, probably developing in Kalimantan prior to the migration of the Iban into Sarawak hundreds of years ago, evolving into respective regional variants and expressions over the centuries in areas totally isolated from each other.

In the Saribas, the design evolved into a more stylized motif and has the name Lang, shortened from Sengalang Burong, the Iban god of war. Why the god of war found himself woven onto skirts is a mystery lost in time. Saribas weavers recognize the motif but cannot explain why it is called Lang. However, they can tell you that it is always surrounded by the constellation Pleiades, known to the Iban as *Bintang Banyak* (Seven Sisters). Seven motifs, each comprising a diamond-shaped rhomboid with four extensions bending into curls, surround Lang. This motif is also found on *pua kumbu* (ritual blanket) and is known as *buah bintang* or the star motif.

To emphasize this point, the weaver, probably at a later stage when she had access to new threads, stitched onto the skirt a strip of cloth decorated with multicolored embroidery designs of stars that were additionally sewn into it. This skirt is a beautifully executed Lang design and a good representation of fine Saribas workmanship.

Iban women in the nineteenth century wore two types of skirts: the *kain jugam* or plain indigo skirt for daily wear, and the *kain kebat* or tie-dyed (*ikat*) skirt for special occasions and festivals, especially for participating in rites. In the published material, little mention is made of the ritual significance of the tie-dyed skirt. Contrary to popular belief, it is not simply a garment of beauty worn to attract attention or advertise a weaver's skill; it is also used as ritual payment and, in some cases, acts as currency for fines. For this very reason, skirts do not remain the personal property of the weaver, as is often mistakenly put forth in academic literature, but are the property of the *bilek* or family unit in the longhouse. The *bilek* is paramount, and daughters and granddaughters proudly wear heirloom skirts woven by their foremothers.

In healing rites called *pelian*, the *manang*, or shaman, would always ask for a *kain kebat* as ritual payment. The same skirt would also be used in the healing ritual when the shaman went into a trance to seek the lost soul of the sick patient. His feet would be touching the skirt, acting almost like a homing device, so that his soul might return to the present.

Female *lemambang*, or bards, would also ask for tie-dyed skirts as payment when they chanted the *sabak* or ritual dirge at the wakes of deceased persons.

However, the most significant yet seldom acknowledged purpose of the skirt is well documented by Michael Heppell;[4] women rip off their skirts and toss them at their men to shame them into action. The practice still occurs today, especially in domestic disputes, when a wife wants to make a very public point. It is her way of saying, "You are only fit to wear my skirt!" The tie-dyed skirt, suffice it to say, is not only a woman's pride but also her most damning armament.

V.K.

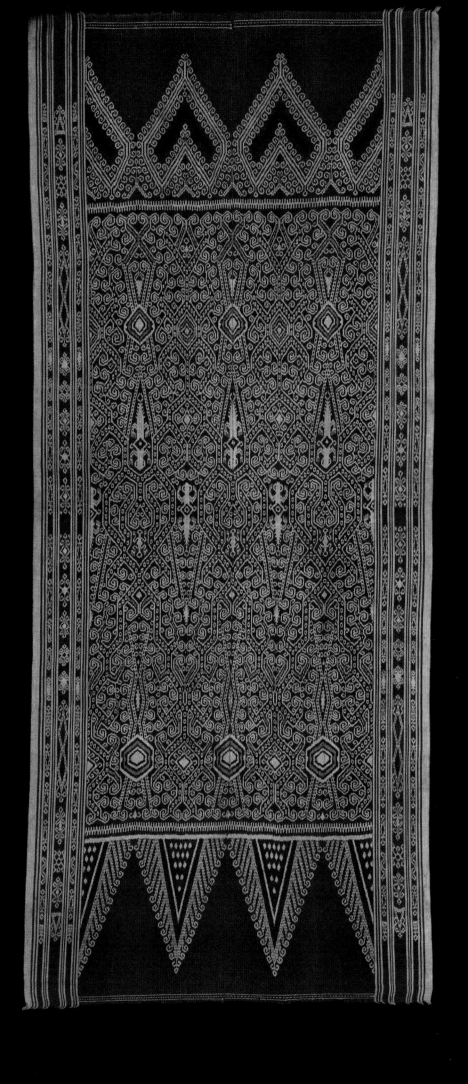

45

Ceremonial cloth (*pua kumbu*)

Malaysia, Sarawak, Iban people
19th century
Homespun cotton
82 × 35¼ in. (208.3 × 89.5 cm)
The Steven G. Alpert Collection of Indonesian Textiles,
gift of The Eugene McDermott Foundation, 1983.127

Quintessentially Saribas in style, this pristine nineteenth-century *pua kumbu* or ritual blanket from the Iban people of Sarawak (Northwest Borneo) represents one of the best works to come from the Layar, a tributary of the Saribas River in the south of Sarawak. The Saribas region is known for its fine weave and matchless designs of intricately intertwining coils and fronds imitating foliage and forming dense and compact motifs replete with esoteric symbolism.

Pua kumbu are used to create sacred space at ceremonies and festivals because they are believed to be imbued with spiritual energy harnessed by the weavers when they "capture" the spirits of designs and "trap" them in these blankets. These ritual blankets are hung to create a perimeter of sacred space where gods and prominent ancestors are invited to be present as honored guests at festivals. They are also draped over offerings or wrapped around ritual objects used in various rites to infuse the accoutrements with spiritual energy.

All *pua kumbu* display a main central design, and all designs have their own names. The main design that makes up most of this blanket is known as *Bali Bugau Kantu*,[1] or "That Which Metamorphosed into the Enemy's Cloth, the *Kantu*," reinterpreted from a looted *pua kumbu* by its progenitor Mengan Tuai,[2] and then imitated by competent weavers throughout the Saribas in furious competition to execute the finest rendition. Additionally, ritual blankets are given secret praise-names by their respective weavers, which are passed down only from mother to daughter. One such praise-name, given by its weaver to her *Bali Bugau Kantu*, was translated into English:

> Oh! I am torn with grief and sorrow for my elder brother Chundau who was slain and is lost forever; he will turn into a giant slithering sea serpent, whose back is striped with scales white and black!
>
> Oh! I am torn with grief and sorrow for my elder brother Sempaok who was slain, whose legs had sunk in the mud; he will take the form of a huge ferocious screaming gibbon!

> Oh! I am torn with grief and sorrow for my brother Bada' who was slain; he will become a terrifying monster crocodile which opens its jaws wide!

The anthropomorphic figures in the central design of this *pua kumbu* correspond to the fantastic creatures mentioned in the translated text above. Here, the weaver tells a story, decipherable only by those privy to the allegorical devices employed in the lexicon of Iban ritual textile designs, motifs, and repeated patterns.

The startling and unexpected splashes of indigo blue to accentuate circular lozenges at the top and bottom of the central design are curious, as the use of indigo blue in a central design is ritually restricted in the Saribas, being the color of mourning. The weaver of this *pua kumbu* probably wanted to interpret the lozenges as representing trophy heads taken in war. Hence, she used the color blue, which is associated with death.

The central design is visually complemented by chevronlike upper edge motifs (fig. 71) known as the *Sepit Api* (fire tong), while the lower edge motifs (fig. 72) are very well-embellished pyramid-shaped *Pucuk Tubu* (bamboo shoots). The central design is also flanked by identical vertical bands displaying omen birds. Hot fire tongs and sharp bamboo shoots with minuscule fibers that cause the skin to itch are pictorial devices used by the weaver to contain the imprisoned "spirit" of the central design. Omen birds calm the spirit with their singing. It is believed that should the spirit of a design break free from a ritual blanket, it would wreak havoc in the community and bring misfortune—or even death—to the weaver and her immediate family.[3]

It would be a grave misunderstanding to underestimate a weaver's worldview and limit her lexicon of motifs, patterns, and designs to just that of innocuous flora and fauna, especially in the case of master weavers who have deep knowledge of the full range of Iban mythology—and the cryptic names of the entire cosmology of Iban deities, literally, at their fingertips.[4] When a weaver creates a frog motif and calls it a frog in public, her Iban audience would

immediately discern that she most definitely means it to represent something other than just an amphibian, and they would instantly relate it to a deity of the Iban pantheon. To accurately read an Iban textile design, one must always contextualize it and have an almost encyclopedic knowledge of Iban folklore and oral wisdom, remembering always that a weaver ultimately weaves to enhance her own status within her community—a female prestige system paralleling that of her menfolk, who base theirs on headhunting with its associated values of valor and bravery.[5] By enhancing her own status, she is also adding to the spiritual strength of her *bilek*, or family living quarters, in the longhouse. All *pua kumbu* woven by the women of a *bilek* become the property of the *bilek* and are passed down as heirlooms.

The selvedges of this *pua kumbu* appear to be colored white but in fact have been left uncolored and undyed—the mark of excellence in the Saribas. In Iban society, women are ranked according to their aptitudes, and in the Saribas region specifically, birth is also an important factor in determining a woman's social status.[6] The lowest rank is the *indu paku indu tubu* (she who gathers ferns and shoots), someone who does not know how to weave. Above her is the *indu lawai indu temuai* (she who is a good wife and hostess), who has little leisure time to weave, being a full-time wife and mother. The next rank is the first echelon of weavers, the *indu tau sikat tau kebat* (she who knows how to comb the threads and tie designs), who is affluent and can afford servants to care for the family or, conversely, industrious, finding time to weave after executing her familial duties. Most weavers remain at this level, their skill average, their spiritual strength sufficient to weave designs posing little danger to them. However, a serious weaver would aspire to attain the next rank, the *indu tau muntang tau tengkebang* (she who knows how to fold the threads and create new designs). To qualify, a weaver must weave nine *pua kumbu* (with ascending respective spiritual weights), thus completing her first cycle in the attainment of spiritual prowess. She is allowed to leave the selvedges of her tenth *pua kumbu* uncolored. In other words, she has become a master weaver, and all her subsequent *pua kumbu* may have the distinctive uncolored white selvedges. The highest rank a woman could attain is the *indu tau takar tau gaar* (she who knows how to measure the mordant and treat the threads), and she would reign supreme in her community, leading all the rites and ceremonies. As a grandmaster weaver, she would exercise the privilege of conferring praise-names on the designs woven by other weavers and master weavers, *if* she so wished. Grandmasters, who are very few and far between, achieve their status only by being recognized as such by the entire community once they have woven whole repertoires of the most powerful designs and are able to "tame" the mordant bath, which, it is believed, requires great spiritual strength. These grandmasters are also believed to enjoy special protection from weaving deities from whom they learn the secret measurements of various mordant and dye solutions through dream encounters. Grandmasters also leave the selvedges of their *pua kumbu* uncolored.

FIG 70 Weaver practicing her craft on the verandah of a communal longhouse, Baleh River region, Sarawak, 1970s.

Other important *Bali Bugau Kantu* in public collections include one at the British Museum, London,[7] and one at the Fowler Museum of Cultural History, Los Angeles.[8]

The Dallas Museum of Art's brilliantly executed *Bali Bugau Kantu* with its deep burgundy maroon background wash and near-perfect symmetry was certainly woven by a master weaver, if not a grandmaster, and by Saribas Iban standards, owing to its distinctive uncolored selvedges, outranks all other *pua kumbu* in the DMA's collection.

V.K.

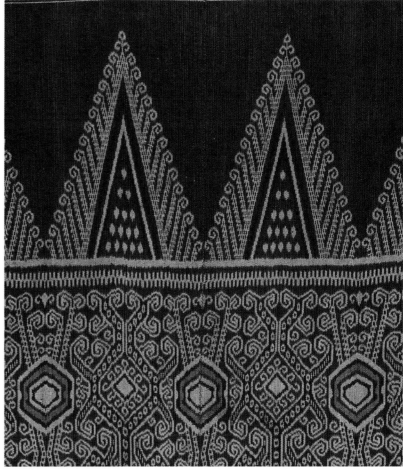

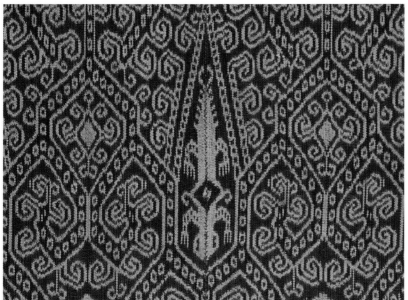

FIG 71 Detail of cat. 45. Chevronlike upper edge motif known as the *Sepit Api* (fire tong).

FIG 72 Detail of cat. 45. Stylized trophy heads encircled in blue. The border depicts the motif known as *Pucuk Tubu* (bamboo shoots).

FIG 73 Detail of cat. 45 depicting an animal motif in the central design.

Ceremonial cloth (*pua*) with shields aslant (*simbang terabai*)

Malaysia, Sarawak, Iban people
Probably late 19th century
Homespun cotton
86½ × 38½ in. (219.7 × 97.8 cm)
The Steven G. Alpert Collection of Indonesian Textiles,
gift of The Eugene McDermott Foundation, 1983.129

The *Simbang Terabai*, or Shields Aslant, motif is one of the first designs a young apprentice weaver creates. On a technical level, it is a study in learning to tie and form straight lines and negotiate curves, bends, and various shapes that make up complex elements and forms in the vast repertoire of *pua kumbu* designs. On a higher level, the weaver is creating a kind of mystical armor that will clothe and protect her as she begins to advance in the art of weaving, a journey that can take an entire lifetime. Once a novice weaver completes such a design correctly, she has succeeded in grasping both the technical and spiritual skills required to weave more potent designs incorporating anthropomorphic elements or high-ranking motifs bearing supernaturally powerful names.

It is common practice for a mother or more spiritually mature female relative to begin tying the knots of a young apprentice's cloth before she is allowed to continue it. This is clearly evident in the case of this textile, where the *pun*, or foundation, of the central motif is preceded by a *selaku*, or lower band, consisting of the twin *buah belum*, fruit of the belum tree. (The *selaku* cannot be woven by novice weavers.) *Belum* in archaic Iban also means "not yet." The fruit of the belum tree is thus an analogical device used by mature weavers to depict unripe trophy heads waiting to be "plucked," suggesting that the young weaver is now beginning her journey to the day when she can successfully "pluck trophy heads" of her own by weaving them herself. It is analogous to the mother or older relative extending a challenge to the novice to complete her design with care and daring.

The collector of cat. 46 mentions in his notes that this textile was collected from the Ngemah region and was used in a sacrificial rite in which a pig was covered with this cloth before being slaughtered.[1] Ritual blankets with designs of weaponry and armor (blades and shields) are often used for ceremonies wherein spiritual protection is sought from Iban deities against malevolent spirits.

The *Simbang Terabai* design is found in all Iban weaving traditions regardless of region. This cloth is a fine illustration of the Ngemah variant of the design. It shows not only the shield aslant but also the handle of the shield intertwining with the handle of another shield. The uncolored chevron-shaped motifs in the center contrast beautifully with the study of maroon burgundy straight lines and interlocking angles, sprouting into very well-executed tendrils. Indeed, it represents an almost perfectly symmetrical work revealing great potential that must have made its novice weaver and her female kin very proud.

V.K.

47

Ceremonial cloth (*pua*) with monitor lizards slumbering on watchtowers (*bandau bepadung*)

Malaysia, Sarawak, Iban people
19th century
Homespun cotton
87½ × 40¾ in. (222.3 × 103.5 cm)
The Steven G. Alpert Collection of Indonesian Textiles,
gift of The Eugene McDermott Foundation, 1983.130

Reptiles such as monitor lizards, crocodiles, pythons, and water serpents on Iban ritual textiles always suggest two things to the Iban eye. First, the beholder would perceive *tua*, or spirit familiars of warriors—guardian spirits who take the form of reptiles or certain other animals to help, protect, advise, and warn men through dream encounters when they go to war. On a second, more mystical level, the beholder—especially another weaver—would appreciate that whoever wove these representations had successfully captured the spirits of such beings. If she wove monitor lizards with leathery scales, it would indicate that the weaver had magically taken on such scales as further protection for herself from malevolent spirits. This design is known as the *Bandau Bepadung*, or "Monitor Lizards Slumbering on Watchtowers," and it recalls the days of headhunting when warriors would often sit atop high platforms to survey and keep watch over their territory.

The Dallas *Bandau Bepadung* shows six monitor lizards confronting six others. Monitor lizards are easily distinguished from crocodiles by their conspicuously elongated and curled tails, which almost always form a circular pattern. Designs of crocodiles, creatures that stalk on land as well as in water, are reserved for more mature weavers, while the less lethal monitor lizards are the first reptiles a maturing weaver would attempt to depict.

At first glance, one is almost deceived into thinking that the weaver folded her warp threads during the knotting process in order to create a mirror image, leaving a small line gap where the fold would have been. Upon closer inspection, however, it is clear that the weaver has flawlessly created twelve monitor lizards from the *pun*, or foundation, of the design at the bottom to the *pengabis*, or conclusion, of the design at the top without folding the warp threads in half. This is a major and painstaking technical achievement, and one that entailed a fierce battle between her spirit and that of the monitor lizard. Technically, this design constitutes a further exercise or study for maturing weavers to attempt to display their skill at knotting minuscule patterns, as demonstrated in the evenly spaced leathery scales of the lizards—a laborious but essential exercise in positioning, spacing, and duplication.

The lizards are hedged in with upper and lower bands of *selaku*, or borders, which contain a variant of the trophy head motif as spiritual nourishment for the reptiles so that they do not break free and devour the weaver and her family instead. Edge motifs of the *Bali Mabuk*, or "Drunken Decapitated Corpse," complete the cloth and ensure that there is plenty of decaying flesh for fodder. The line or gap is the "spiritual chasm" that separates the lizards and keeps them from attacking one another, which would bring about unending chaos in the weaver's life.[1]

The DMA's outstanding *Bandau Bepadung* is a prime example of a very old ritual blanket from Bangkit[2] in the Saribas, most likely woven in the middle of the nineteenth century. The deep maroon background of the cloth accentuates the uncolored lizards and their sharp claws. When a weaver weaves the *kukut*, or claws, she impresses upon her audience that she is ready to progress to the next level of maturity as a weaver and "claw" her way through the spiritual realm. This *Bandau Bepadung* is a magnificent display of both womanly courage and ferocious guardian spirits captured in cloth.

V.K.

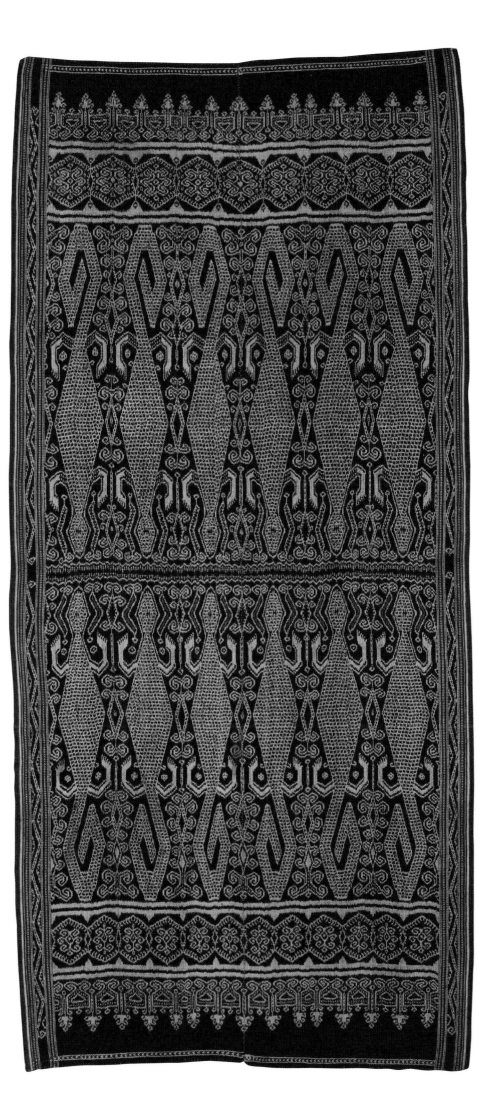

48

Ceremonial textile (*pua*) with brooding giant (*gajah meram*)

Malaysia, Sarawak, Kapit area, Iban people
Late 19th to early 20th century
Homespun cotton
92¾ × 55½ in. (235.6 × 141.0 cm)
The Steven G. Alpert Collection of Indonesian Textiles,
gift of The Eugene and Margaret McDermott Art Fund,
Inc., 1988.125.McD

When an Iban weaver has distinguished herself by weaving animal forms, her next ambition is to weave the ultimate: spirit representations. This is when she enters the final stage of her maturation as a weaver with the technical skill not only to create fearsome images of creatures of the mind on cloth—but above all to capture such spirits, subdue them, and imprison them in a ritual blanket, thus imbuing the textile with great spiritual potency. As she has never actually seen the mythological spirits recalled in oral literature and wisdom, the only way she can be inspired to create them on cloth is through dream encounters. One such spirit figure is the *Gajah Meram*, or Brooding Giant.

Gajah translates as "elephant," but in esoteric language it means a creature of gigantic proportions.[1] In the Baleh, the *Gajah Meram* is given a supersized rendering, taking up the entire central design of a cloth. Margaret Linggi gives a Baleh version of the praise-name of the *Gajah Meram* as "*Gajah meram nyawa dederam merembam tansang*" or "The brooding giant growls in its nest," and intimates that the hidden meaning "symbolizes a warrior who, upon taking an enemy's head, stays put, guarding his precious trophy head."[2] The cloth Linggi refers to shows the torso of the giant with a stylized head of two *Mayau Tindok*, or Sleeping Cat, motifs conjoined and facing each other.[3] The sleeping cat, a pictorial device depicting a curled-up cat, is employed by weavers to indicate the presence of trophy heads above the fireplace of a communal longhouse (see the entry for cat. 49). So the brooding giant becomes an extension

of the trophy head itself. The logic is simple yet profound: the warrior has taken a head, and he is now as potent as the head, for it empowers and becomes him.[4]

The DMA's *Gajah Meram*, from Nanga Stapang, Sungai Gaat,[5] does not characterize the trophy head in human terms but instead boldly exaggerates it with bulging eyes, a gaping mouth, and distended nostrils. The bulbous trophy head, almost dwarfing the torso of the giant, is the weaver's way of emphasizing its primacy. Two rows of brooding giants sit in wait, and are carefully appeased with singing omen birds in the shape of chevrons on either selvedge. They are enclosed at the top and bottom with the pattern of the *Tugang Ruai Langgai Tinggang*, or Fallen Plumes of the Argus Pheasant, in the shape of uncolored chevron motifs. These feathers decorate the headdresses of warriors, and in offering such feathers to the brooding giant, the weaver is assuaging its ravenous spirit.

In the Saribas, where strict conventions dictate the size of spirit figures, the *Gajah Meram* is more restrained in its proportions and is also known as *Gerasi Nabor Menoa*, or Giant That Sows the Earth (with seeds), and "under its arms are seeds which it guards jealously, a covert reference to a victorious warrior who proudly clutches his trophy heads under his arms after a battle."[6] Instead of exaggerating the head of the brooding giant, Saribas weavers place the trophy heads under the outstretched arms (fig. 74).[7]

V.K.

FIG 74 Detail of *Gajah Meram* woven by grandmaster weaver Sendi Ketit, Saribas River region, Sarawak, early 20th century. Stylized trophy heads are depicted under the outstretched arms of the anthropomorphic figures.

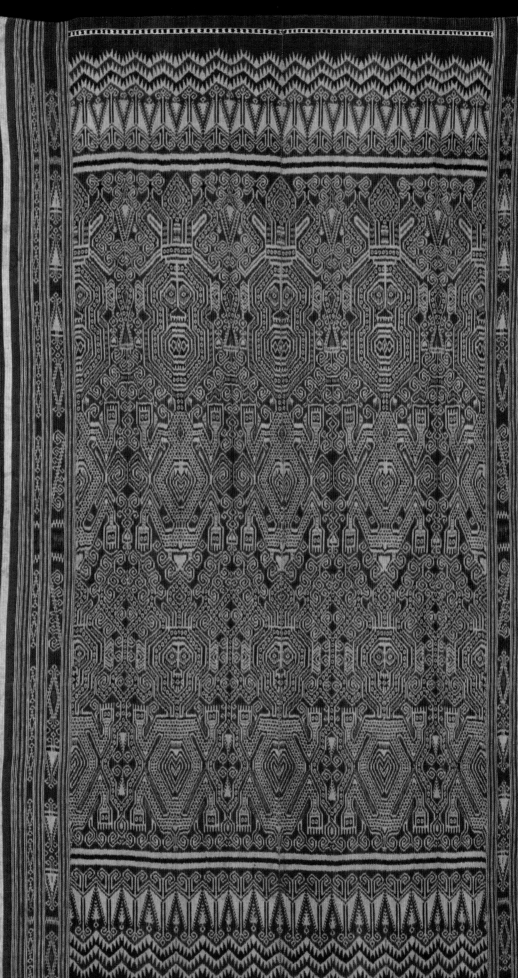

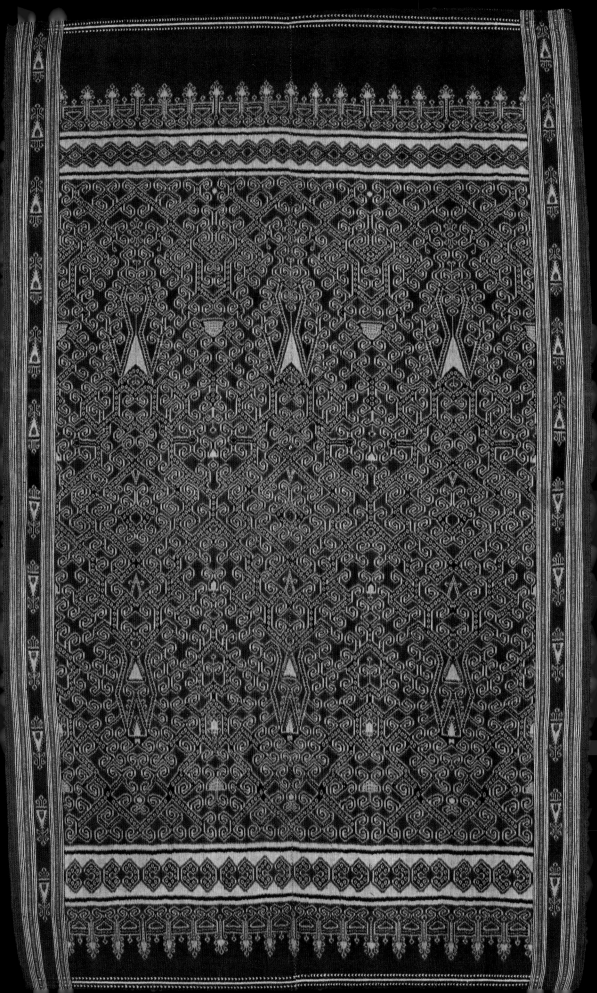

49

Ceremonial cloth (*pua*) with Jugah's jawbone (*rang Jugah*)

Malaysia, Sarawak, Iban people
Probably late 19th century
Homespun cotton
84¾ × 52¼ in. (215.3 × 134.0 cm)
The Steven G. Alpert Collection of Indonesian Textiles,
gift of The Eugene McDermott Foundation, 1983.128

Celebrated throughout the Baleh region of central Sarawak, the enigmatic design of this *pua kumbu*, known as the *Rang Jugah* or Jugah's Jawbone, has been much discussed by students of Iban ritual textiles, collectors, and anthropologists alike. To the Baleh weaver, it is one of the most terrifying designs she could attempt to weave, second only to the *Lebur Api*, or White Heat (see cats. 51 and 52), which reigns supreme in the Baleh as the monarch of all *pua kumbu*.

No weaver in the Baleh now remembers who the Jugah named in the design's title was, but all Baleh weavers know that the Jugah's jawbone design is a synonym for a trophy head taken in battle. Interestingly, no weaver today, not even a grandmaster, would be able to decipher all the enigmatic motifs that make up this distinguished design. The *Rang Jugah* is definitely one of the oldest designs known to Baleh weavers and in all likelihood had its genesis centuries ago, before the migration of the Iban into Sarawak from Kalimantan, so much so that the meanings of most of the motifs that constitute the design have been lost.

To understand why this design is so revered among Baleh weavers is to understand its *julok*, the secret praise-name given by the weaver to her work. One such praise-name was recorded by Michael Heppell,[1] "*Rang Jugah, ngawa ngempuan, bau sinang*," and translated as "Jugah's Jaw [the severed head he has taken], mouth bellowing, pungent smell [of game]." Margaret Linggi gives an extensive variation of another style of praise-name for the *Rang Jugah*:

> *Kandung nibung berayah tangkai besembah, Bujang Berani Kempang berapa kali' iya udah matahka dilah nukangka rang atas bedilang.*

> Behold the Palm, heavy with ripened fruit, and its swaying fronds bowing in obeisance; Behold the Brave and Fearless Warrior; countless times has he dashed in pieces men's tongues and prised opened jawbones upon *my* hearth![2]

In this recorded example, a weaver has created the *Rang Jugah* design and given it a praise-name with allegories of ripened fruit representing trophy heads and mutilated body parts smoking above her fireplace. She clearly means to boast of her menfolk's heroism, or even incite them to feats of greater daring. To the Iban mind, such words conjure fantastical images and simultaneously enhance the prestige enjoyed by head-takers valiant in war. For a weaver to replicate such a design is also an indication of her spiritual maturity, her ascent into the ranks of master weavers.[3]

The *Rang Jugah* at the Dallas Museum of Art is, in the words of its collector, a "strong, good example of this design in perfect condition with strong borders."[4] Along with its vivid color, very precise knotting, and excellent control of backstrap pressure to ensure symmetry of both left and right warps, it is also a classic example of how Baleh master weavers employed weaving conventions in the overall design of a ritual cloth of high rank. The cloth has four major parts to it:

1. The central design depicting the majestic *rang Jugah*.

2. A lower band between the edge motif and the central design that weavers call *selaku* (literally, "a rope") consisting of the *Mayau Tindok*, or Sleeping Cat, design (in the shape of a curled-up letter C). Sleeping cats are innocuous. But every Iban would know that cats always sleep in the communal area in a longhouse, near the warmth of a hearth with embers, and beneath a cache of trophy heads. It is ritual practice to smoke trophy heads to keep them "warm." The weaver is therefore using a cryptic device to indicate that trophy heads are present, though not depicted.

3. An upper band of *selaku* displaying the *Leku Sawa*, or Path of the Python. No pythons or motifs resembling snakes are shown, but two trails left behind by two pythons record their presence.

4. Edge motifs of a very old pattern known as the *Bali Mabuk*, or Drunken Decapitated Corpse. The weaver was not implying that the corpse was drunk; rather, she was describing the victim's wobbly gait immediately after he was decapitated.

The Dallas textile is an excellent work displaying the *Rang Jugah* both in all its ferocity but also securely contained. The weaver was careful to use not just the requisite edge motifs composed of decapitated bodies offered as food for the devouring jawbone of the spirit of the design but also woven-in ropes as added safeguards. Unseen trophy heads hanging above sleeping cats appease the spirit of the central design at one end, while two pythons guard the other. Omen birds on either side calm the spirit with their singing. To Iban eyes, this *pua kumbu* is a magnificent demonstration of fine Baleh weaving conventions impeccably executed.

V.K.

50

Headhunter's jacket (*baju kirai*)

Malaysia, Sarawak, Rejang River area, Iban people
c. 1825–75
Homespun cotton
24½ × 19¼ in. (62.2 × 48.9 cm)
The Steven G. Alpert Collection of Indonesian Textiles,
gift of The Eugene McDermott Foundation, 1983.134

Known in the literature as *kelambi sungkit*, or *sungkit* jacket, this type of war vest is called *baju kirai* by the Saribas Iban. It has often been mistakenly referred to as *baju taya*, which is a war vest containing rough cotton padding between two layers of fabric.

The *baju kirai* was worn by all Iban warriors when they went into battle, and it was also handed down through the generations, often passed on to the eldest male in the family, not only as an heirloom but as a real and practical war vest to be worn with pride. Such vests would see constant repair and alteration as the years took their toll.

The Dallas example is a fine specimen of a war vest tailored out of two sets of fabrics woven from homespun and homegrown cotton. The inner lining was left undyed, while the outer garment was dyed in *engkudu* (*Morinda citrifolia*) and then embroidered (by means of the supplementary weft technique) with various motifs. Once the motifs were completed, the dyed fabric with the embroidered motifs was sewn onto a lining of woven homespun cotton.

Three upper rows of floral motifs decorate the front, while two lower bands comprising fruitlike motifs complete the frontispiece. The front of the vest is typically sparsely embellished, as a warrior did not appear in battle with loud and bold patterns that would attract his enemies' attention. The back of the vest, however, is a veritable masterpiece. The deity Indu Dara Tinchin Temaga (in the Saribas) or Dara Meni (in the Batang Ai) is paired with a partner. In the Saribas, the partner could be either her son Sera Gunting (who taught the Iban the rules of war) or her husband, Ketupong (the principal omen bird and most senior son-in-law of the god of war). Either way, the principal deity here is Indu Dara Tinchin Temaga (or Dara Meni), the eldest daughter of Sengalang Burong (the god of war), and, as suggested by being prominently displayed on the back of a warrior's jacket, the tutelary spirit or familiar of the wearer. She advises and assists supernaturally through dream encounters with the wearer and in some oral histories of the Saribas even causes the wearer to be invincible to all manner of weapons (blades, spears, and even darts). Interestingly, this depiction of Indu Dara Tinchin Temaga and her paired partner has the all-important "dangling

prize" (in the shape of a pendant with a cross inside) hanging between them—the much-coveted trophy head.

Below the two rows of Indu Dara Tinchin Temaga (or Dara Meni) and her male partner are more rows of well-embellished representations of trophy heads, taking the innocuous forms of fruit and droplets of seeds. In battle, the Iban warrior's back is the most vulnerable, which is why his back must always be supernaturally shielded with powerful motifs of deities, and offerings of trophy heads to appease them.

Despite its great age, this *baju kirai* (recorded as being six generations old in the 1970s[1]) is in relatively good condition, its vegetable dye colors still vivid and the weave tight, an amazingly impeccable example of an old war vest of the Iban nation.

V.K.

CAT 50 *front view*

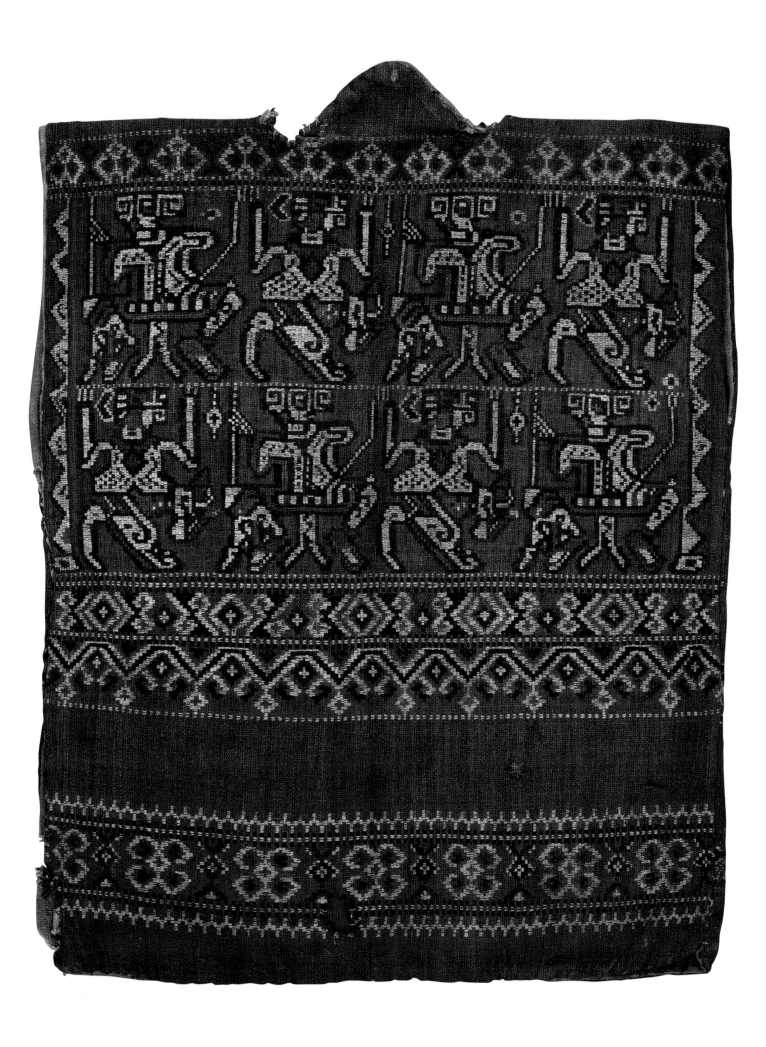

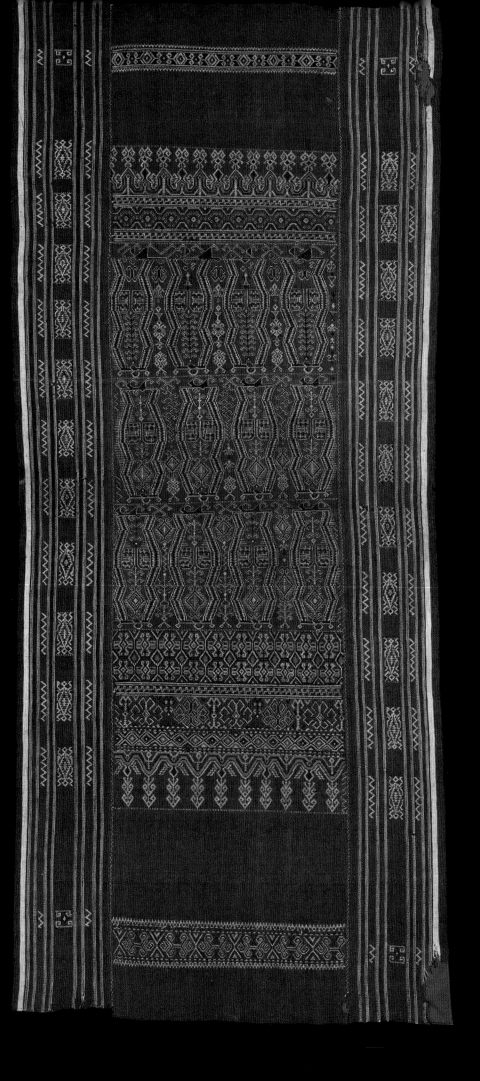

51

Ceremonial cloth (*pua sungkit*)

Malaysia, Sarawak, Iban people
19th century
Homespun cotton
84 × 37½ in. (2 m 13.4 cm × 95.3 cm)
The Steven G. Alpert Collection of Indonesian Textiles,
gift of The Eugene and Margaret McDermott Art Fund,
Inc., 1988.124. McD

Cats. 51 and 52 are a type of textile known as *pua sungkit*, a term that refers to their production technique, that of weft wrapping. *Pua* means "blanket" and *sungkit* is a verb meaning "to raise it up," thus the phrase might be translated "blanket whose design is raised." The ritual name for such a blanket in the Saribas[1] is *Lebur Api*, best translated as "White Heat."[2] This design name has multiple levels of meaning. First, it describes the distinctive composition: a predominantly undyed white supplementary weft accompanied by concentrated indigo supplementary weft highlights on a rich maroon warp background, dyed repeatedly with *engkudu* and left out in the sun to oxidize. The name also refers explicitly to the blanket's supernatural ability to incinerate negative energy.

The *Lebur Api* was reserved for use in a critically important religious festival celebrating the introduction of a new trophy head into the longhouse, known formally as the *Gawai Enchaboh Arong* (Festival of Clearing the Path). The event is also referred to as *Sekali ke Tanju* (Once at the Open Terrace), referring to its limited practice of calling the gods to attend just once during the day, or *Gawai Mata* (Fledgling Festival), referring to the festival being celebrated only within one day. Although the festival was short in duration, it was absolutely imperative that the rites were carried out correctly in order to keep the cosmological balance undisturbed; otherwise it would have been catastrophic for the entire longhouse. Severed heads had to be welcomed appropriately so as not to turn them against their new owners. This welcoming ceremony was critical for a warrior who had taken his first trophy head. The pivotal moment in the *Gawai Enchaboh Arong* in the Saribas was when the trophy head was placed by its possessor in the *Lebur Api* held by a woman of high rank, almost always a master or grandmaster weaver, who stooped on her knees to receive it like a midwife delivering a newborn baby. She would then cloak the trophy head completely in this blanket, place it in a ceramic bowl called a *jalong*, and then cradle it in her arms, singing to the head as though singing a lullaby to a child. Other senior women would join her in a procession and respond in chorus. The procession would traverse the entire length of the longhouse. This highly dramatic ritual was known as *Nyangkah* (in

the Saribas, from the noun *sangkah* which is the name of the chant for receiving trophy heads) and *Naku' Pala* (in other Iban regions). Anthropologist Michael Heppell notes that in the Batang Ai region, the women yelled jubilantly,[3] in stark contrast to the Saribas, where the women sang soothingly to the trophy head. It was believed that the intense spiritual force of the blanket, coupled with the hypnotic, magical chanting, would transform the head from an object of potential malevolence to one of goodwill imbued with potency and fecundity.

Only nineteenth-century master weavers who possessed great spiritual maturity would weave the *Lebur Api*, regarded at the time as the highest-ranked Iban textile because of its supernatural ability to render harmless an enemy's decapitated head.[4] By the twentieth century, the activity of head-taking considerably diminished in the Saribas, and the need for the *Lebur Api* became uncertain. Instead of the *Gawai Enchaboh Arong*, attention transferred to the *Gawai Burong* (Festival of the Gods), which was hosted and celebrated by prominent warriors, successful war leaders, and men of high rank as an ostentatious affirmation of their advanced status. Within the lexicography of Saribas textiles, by the end of the nineteenth century, the *pua sungkit* came to be eclipsed in rank by *ikat* cloths displaying designs reflecting the nine ascending stages of the *Gawai Burong*.[5] These designs depict the *tiang chandi* (ceremonial pole) of the *ranyai* (shrine created by draping *pua kumbu* around the ceremonial pole), the two described interchangeably by Heppell as a Tree of Life.[6]

These two *Lebur Api* in the collection of the Dallas Museum of Art are fine examples of the best *sungkit* work. They were provenanced to the Baleh region by their collector.[7] That they were used in the ceremony of receiving trophy heads is more than probable, but not

FIG 75 Staged photograph of Iban women displaying trophy heads. They wear *kain kebat*, *kain anyam* and *kain sungkit* skirts. Around their waists are rattan hoops lined with metal rings. The men in the rear wear costumes appropriate to headhunting.

in the Baleh, as Derek Freeman's field notes indicate that by the time the Iban entered the Baleh, they used *pua kumbu* for receiving newly taken heads.[8] While cat. 51 is aesthetically pleasing and demonstrates the near-perfect symmetrical work of a very skilled weaver (notoriously difficult in *sungkit*), cat. 52 terrifies yet dazzles the Saribas Iban beholder with its use of powerful *mali*, or taboo motifs, that only the most daring master weaver would attempt. Both textiles have a central panel, each with side borders stitched onto it. Each central panel displays tableaux depicting deities, spirit familiars, and fallen victims with their decapitated heads. The added side borders accentuate the visceral theme of head-taking while maintaining subthemes of their own.

The central panel of cat. 51 shows twelve *naga* or dragons, each of their bellies filled with a trophy head. This display honors the guardian familiars of the weaver's immediate male kin and also loudly hints, on another level, at goading the same menfolk to be as ferocious as their spirit familiars in battle. Heppell also identifies this motif as the *naga*,[9] although he suggests that it is "a new arrival because the original Dayak dragon is the *nabau*, which is an ancient word used by a number of other Dayak groups," further proposing a Chinese origin.[10] Margaret Linggi, on the other hand, calls the Baleh *naga* motif the *nyelipan*, or millipede (though her translation of it in parentheses as a "symbolical motif" suggests she was more likely concealing the real meaning of the motif, as is also the wont of many weavers), an interpretation that an Iban audience would thoroughly appreciate as meaning something quite different.[11]

At the top and bottom of this central panel, the weaver has placed *sungkit* variations of the *Leku Sawa* (Path of the Python) and the *Buah Bunut* (the Horse Mango Fruit as a pictorial euphemism representing a trophy head) with aesthetic embellishments. The sewn-on side borders display omen birds and grass snakes. Omen birds feed on grass snakes and in turn sing to the dragons, to keep them tranquil.

Truly a sumptuous work of art, the DMA's cat. 51 is a finely woven *Lebur Api Naga* that demonstrates great Iban weaving at its absolute best.

Cat. 52 is surely the crowning jewel in the Museum's entire collection of Iban textiles for three reasons: its age (as indicated by a looser weave as compared to the much tighter weave found in cat. 51), the dexterous skill that went into its creation, and the designs it bears. Both side borders have only the one colored selvedge, a prime indicator of old cloths before the advent of imported threads. The weaver's great skill in the *sungkit* method is evident from the exacting level of detail, the composition of the intricate flourishes embellishing the main motifs in the central panel, and the elongated *nabau*, or water serpent, on both stitched-on side borders. The *nabau* is a ferocious giant serpent, and when it is placed on the side borders of a *pua sungkit* or *pua kumbu* (which is rare), the weaver is incorporating a very powerful image meant to contain the spirits in the main body of the cloth. The *nabau* in turn would be

52

Ceremonial cloth (*pua sungkit*)

Malaysia, Sarawak, Katibas River area, Iban people
Probably late 19th century
Homespun cotton
78 × 48¾ in. (198.1 × 123.8 cm)
The Steven G. Alpert Collection of Indonesian Textiles, gift of The Eugene McDermott Foundation, 1983.131

"fed" smaller creatures that would inhabit narrow bands on either side of it.

When "reading" a *pua kumbu* or a *pua sungkit*, the Iban would begin at the *pun buah*, or "beginning of the main design" (at the bottom), and make his or her way through the design to the *pengabis buah* or "end of the main design" (at the top). To read cat. 52, the Iban would start with the tableau of figures at the bottom of the central panel.

This tableau displays the celebrated "dancing figure" that has excited, confused, and confounded collectors of and commentators on Iban textiles for some time. Upon closer inspection, it is clear that the dancing figure depicted on this textile is not just one generic image but actually represents three very different figures, each with its own name and visual characteristics.[12]

It is important to note that in the Saribas, the dancing figure (which Gittinger plausibly suggests was copied[13] by Iban weavers who had come into contact with Indian trade cloths[14]) is not perceived as dancing at all but rather is clearly understood by Saribas weavers to be "kneeling" or "stooping" with arms outstretched in anticipation of receiving an object. This figure is further faceless (with no distinguishable eyes, mouth, nostrils, or ears), but the bun of hair indicates female gender. Iban deities, especially of the upper world, are hardly ever woven as themselves onto cloth, whether on *ikat* or *sungkit*, but when they are, they are always portrayed without distinguishable faces.

Further, whenever this particular deity is portrayed in the kneeling position with arms outstretched, she is often paired with either a fellow deity or a demigod. In cat. 52, she is paired with a demigod wearing a loincloth, his sword belt decorated with charms, amulets, and, dangling in exaggerated fashion, a rattan basket containing a freshly taken trophy head. The demigod has a face with distinguishable eyes, mouth, and ears (fig. 76).

In the Saribas, the kneeling figure is not Dara Meni, the goddess of dyeing, but rather Indu Dara Tinchin Temaga, the eldest daughter of the god of war, Sengalang Burong. Indu Dara Tinchin Temaga

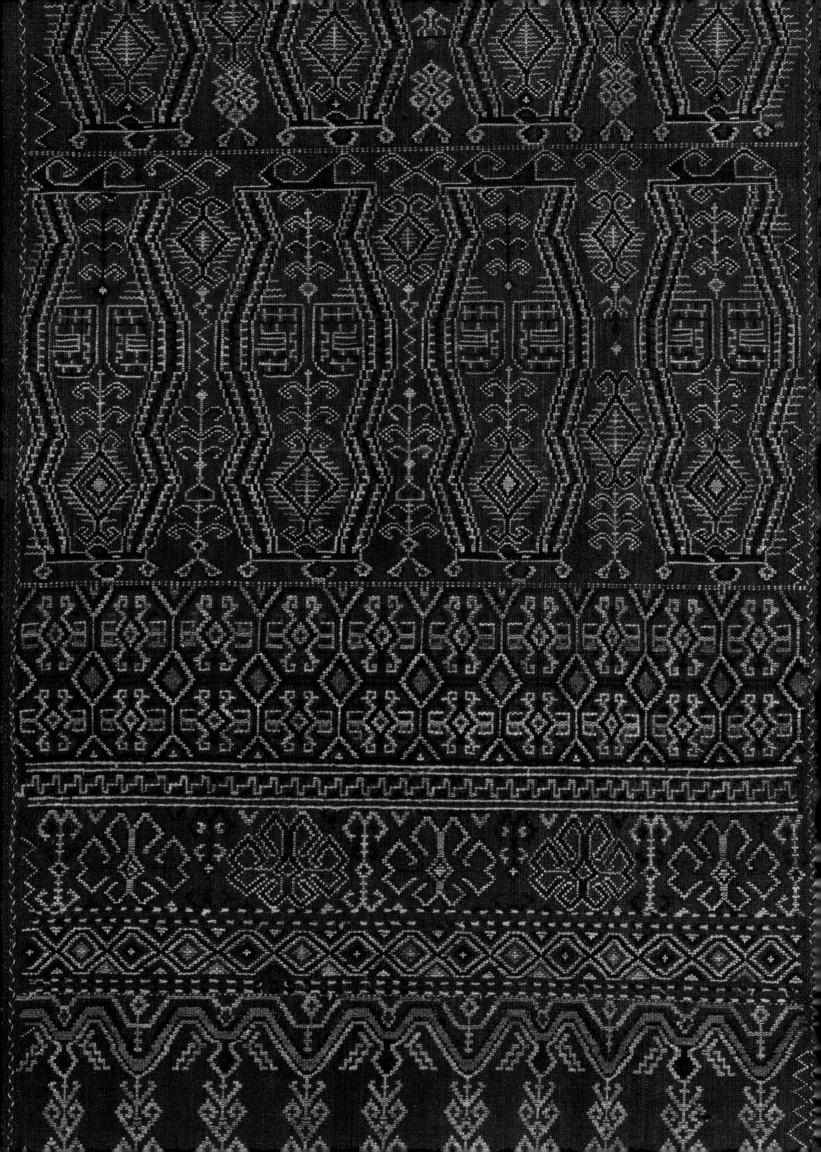

lives in the heavens at Tansang Kenyalang (Sengalang Burong's longhouse) and is married to Ketupong, the most senior son-in-law of Sengalang Burong, who takes the earthly form of the principal omen bird, called *ketupong* in Iban (Rufous Piculet). Ketupong, a god himself, is never given a face by weavers. A particularly complex series of bird calls (interspersed with the calls of the other sons-in-law of Sengalang Burong) is also known as the *Lebur Api*,[15] and is the most auspicious omen sought in warfare. The probability of getting this omen in its perfect order is so remote that in augury it is given the highest rank, *Lebur Api*, the name also given to these cloths, and to the baskets reserved for war leaders and grandmaster weavers.

Indu Dara Tinchin Temaga, however, had a son with an Iban generally known as Menggin, but called Ming in the Saribas, and named him Sera Gunting, who was then brought back to the upper world and taught the rules of warfare, augury, and the laws against incest by his grandfather, the god of war, Sengalang Burong. Sera Gunting, at the command of his grandfather, accompanied Ketupong on raids to learn the craft of warfare. He then returned to earth to teach this divine lore to the Iban and became known as both the archetypal war leader and lawgiver. When Sera Gunting is paired with his mother, Indu Dara Tinchin Temaga, the connection is apparent. The son returns from a successful war with his trophy head; the mother prepares to receive it, albeit depicted without a *Lebur Api* in hand—why that is so remains a mystery lost in time.

How do all these figures in the tableau tell a story? Reading the weaver's unspoken "prayer" from the bottom of the textile, Saribas fashion, first she invokes Ketupong, the principal omen bird of war, and begs for his assistance in dispensing good omens for a favorable outcome in battle. She then calls on her patroness Indu Dara Tinchin Temaga[16] to protect her menfolk and to bring them home safe and triumphant, like Sera Gunting. In tribute to Indu Dara Tinchin Temaga, the weaver delicately depicts the pivotal scene of the son handing over a trophy head to his mother. And as she reaches the end of the central panel, she weaves three rows of six humanlike figures that look deceptively like the *Bong Midang*, or "War Boats on a Journey,"[17] except that the true *Bong Midang* figure is characterized squarely by a cross-piece extending from its waist, which the figures on the Dallas *Lebur Api* (cat. 52) are conspicuously lacking. Could the weaver, who so accurately executed the deities of the upper world, have intended these figures to mean something completely different (deliberately leaving out the cross-pieces), and therefore have had no intention of weaving war boats on a journey? Might not a Saribas eye most likely interpret these grotesque caricatures as representing enemies, slain, with limbs twisted, jaws gaping, and eyes bulging out of their rotting skulls, the weaver cursing her menfolk's enemy with every prayerful stitch and pull of the thread? In this case, the cloth becomes not just a potent prayer for protection, but also a damning curse—a stroke of genius where the pièce de résistance becomes not the so-called dancing figures but rather the soon-to-be-dead enemy.

Nevertheless, this interpretation of the kneeling figure as the goddess Indu Dara Tinchin Temaga attending her son, or possibly her husband, is strictly a Saribas interpretation[18] and does not explain why the Ulu Ai and later the Baleh interpret it as Dara Meni. Neither of the goddesses is a principal protagonist in warfare, yet both find themselves on the ritual textile woven to soothe and console the "crying severed head" of the enemy. Could it be Indu Dara Tinchin Temaga's protective motherly qualities, or Dara Meni's ability to control the elements, that the weaver is secretly invoking when she finally uses the *Lebur Api* to swathe her first trophy head? Then again, could the weaver simply have meant to depict very potent motifs so as to imbue her *Lebur Api* with as much spiritual efficacy as possible, but with no particular story to tell? We will never know, as only the weaver and her family would possess the answer. Nevertheless, one point held in universal agreement across the Iban weaving diaspora is that the motifs do represent named figures in the Iban belief system. The female figure has a name, and depending on whether it is a Saribas Iban or Batang Ai/Baleh Iban beholding the cloth, she is either Indu Dara Tinchin Temaga or Dara Meni, respectively, and never just an anonymous and speculative dancing figure copied from an ancient Indian trade cloth.

The *pua sungkit* designated as cat. 52, dyed the deepest burgundy with images of deities bursting forth like flames of white fire devouring rotting corpses, is called *Menyeti Lebur Api Mansau Tisi Dilah Kendawang*, or "the Beautiful White Heat with Deep Red Edges like the Tongue of the Krait." It is arguably one of the most sought-after Iban cloths in existence and will remain the pride of the Dallas Museum of Art for a very long time.

V.K.

FIG 76 Detail of cat. 52. Kneeling figures in the act of receiving trophy heads.

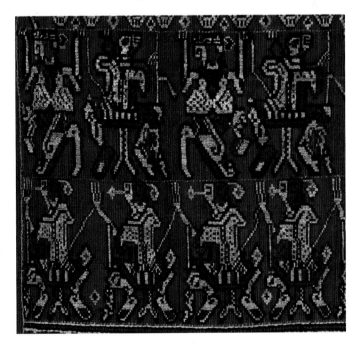

THE ART OF SULAWESI

Roxana Waterson

Sulawesi's strange, spread-eagled shape is the result of a geological collision between its eastern and western halves, originally separate landmasses, which occurred between 13 and 19 million years ago. Sulawesi remains one of the most geologically complex regions of the world, with eleven active volcanoes along the northernmost peninsula and its outlying islands, and seismic activity giving rise to frequent earth tremors. It is also, as the great naturalist Alfred Russell Wallace first established, biologically remarkable in being the home of numerous unique species of flora and fauna, found here and nowhere else.[1]

Though it is the fourth largest island in Indonesia's vast archipelago, Sulawesi remained largely unexplored by Europeans until the late nineteenth century. Sixteenth-century Portuguese voyagers landed at opposite ends, visiting both Minahasa in the north and the kingdom of Makassar in the south, without realizing that the regions were connected in a single landmass.

All European maps until 1546 showed the peninsulae as separate islands, which gradually became known by the apparently plural name "Celebes." The origins of this name itself are obscure. The Dutch conquered the Makassarese kingdom of Gowa in 1667, establishing a fort at Makassar, and were at that time using the name "Selebessi" for the region. The term is conceivably a corruption of an indigenous name, *sula besi*, meaning "iron dagger."

The name is apt because Central Sulawesi is indeed the site of rich deposits of iron ore and nickelous iron (*pamor*), which provided raw material for the swordsmiths of the Toraja highlands. This valuable iron ore was one of the items upon which the wealth of the early Buginese kingdom of Luwu', formed in the second half of the fourteenth century, was based. Iron ore was traded throughout the archipelago, being especially sought after by Javanese sword makers, since iron ore was never extracted on Java.[2] Since the 1940s, the old appellation "Celebes" has given way to the island's modern name, Sulawesi.

The whole of the Indonesian archipelago is characterized by an astounding cultural diversity, and Sulawesi, whose peoples speak sixty-two distinct languages, is no exception. Those of South Sulawesi, with whom we are mainly concerned here, are broadly divisible into three groups, the Bugis and Makassar of the lowland areas and the Toraja of the mountainous north. Most of the items in the DMA collection come from the Toraja regions or from neighboring areas immediately to the north, such as Seko, Rongkong, and Kalumpang. The collection includes some of the finest known examples of sacred cloths locally produced by the Sa'dan Toraja. These textiles were the precious heirlooms of noble houses, carefully stored in attics inside tightly woven baskets, and taken out only to be displayed during major rituals. There are also some splendid examples of *ikat* weaving from Kalumpang.

The Toraja occupy the northern highlands of South Sulawesi, a distance of around 185 miles from the provincial capital, Makassar, on the southwest coast. Numbering around 450,000, they are mostly subsistence farmers, growing rice in rain-fed or irrigated hill terraces, along with cassava, maize, and a variety of vegetables, as well as cash crops of coffee (for which they are justly famous), chocolate, cloves, and vanilla. Nowadays most families also hope to have members working outside the homeland, whose remittances provide an important source of extra cash.

The name "Toraja" derives from the Bugis *to ri aja*, or "people of the mountains" (as opposed to *to luu'*, "people of the coast," from which the name "Luwu'" derives). Dutch linguists and missionaries applied the name "Toraja" to several groups in Central Sulawesi as well, but it is only among the Toraja of South Sulawesi that the name has stuck. These people are sometimes called the Sa'dan Toraja (after the Sa'dan River that flows through their lands from north to south). Their territory became known only in the 1930s as Tana Toraja (Land of the Toraja). Since 2008, the Kabupaten, or Regency of Tana Toraja, has been split into two parts. The name now refers to the southern part, with its main town of Ma'kale, while the north, centered around the town of Rantepao, has taken the name "Toraja Utara" (North Toraja). But most Toraja will insist that, in spite of minor variations, both halves still share the same culture. Immediately to the west live the Mamasa Toraja, whose language and culture are closely related, though with some variations.

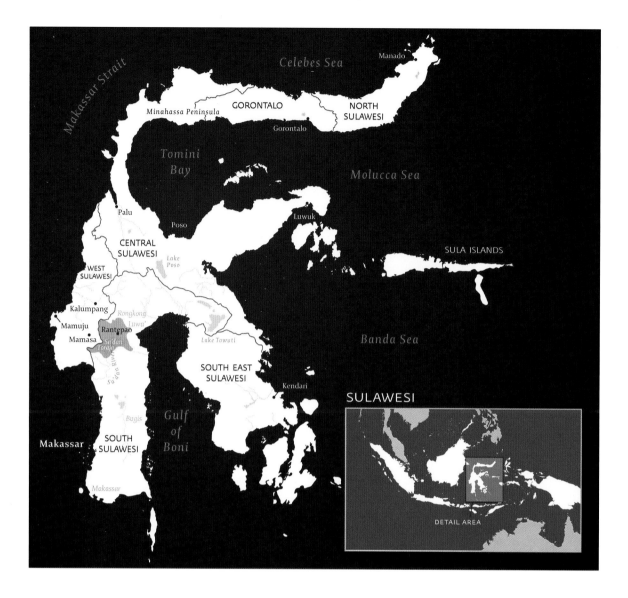

All of the peoples of South Sulawesi are Muslim, except the Toraja. Islam was introduced here in the early seventeenth century, by which time the lowland Bugis and Makassar peoples had become divided into a number of small centralized polities. These kingdoms became Muslim in the seventeenth century. In the rugged territories of the Toraja highlands, however, people continued to live in scattered autonomous settlements under their local chiefs. They had successfully resisted the formation of any centralized state and remained unreceptive to Islam. In the precolonial era, Toraja nobles picked their own quarrels and competed among themselves for power and influence. Local feuds were common, in pursuit of which the warriors (to barani) of either side would wage pitched battles with limited casualties. War dances (pa'randing) are still a feature of some high-ranking funerals today. To this context belongs the beautifully painted ceremonial shield (balulang) in this collection (cat. 53).

In the late nineteenth century, several powerful chiefs formed alliances with Bugis mercenaries who were competing to control the Toraja coffee trade, and who also traded in slaves. There was an escalation of warfare as the Bugis supplied rifles to some headmen who cooperated with them in raiding weaker villages, seizing lands,

and capturing people to be sold as slaves in the lowlands. These predations devastated some outlying regions, while the most powerful chiefs became locked in a struggle to expand their own territories, a process abruptly halted by Dutch colonization in 1905. The fact that the Dutch imposed peace after such a chaotic period in Toraja history is perhaps one reason the colonial period is not remembered here with as much bitterness as in many other parts of the archipelago.[3]

The Toraja had their own religion, which until recent times was so much a part of the everyday rhythms of life and cultivation in their mountain valleys that it needed no name of its own. Since the 1950s, this religion has become known as Aluk To Dolo (Way of the Ancestors), or simply Alukta (Our Way). Ironically, however, this Way is acknowledged by fewer and fewer Toraja, as the vast majority have by now chosen to convert to Christianity. Calvinist Christianity was first introduced by the Dutch, in the form of the Dutch Reformed Church Mission, in 1913. South and Central Sulawesi were among the last parts of Indonesia to be incorporated into the Dutch colonial empire; hence the period of colonial rule for the Toraja was a short one, lasting a mere thirty-seven years, until the Japanese Occupation of 1942. At the time of Dutch

intervention, some of the Toraja nobility, having had long historical contacts with lowland courts, were considering becoming Muslim. Concerned to check any such expansion of Islam, the Dutch sought (as elsewhere in the archipelago) to convert this highland region to Christianity. The pace of conversion during the decades of Dutch rule was exceedingly slow; by 1930, only about 1 percent of Toraja had accepted the new religion, and the figure was still only 10 percent in 1950.

The impact of the Christian Mission took a long time to be felt, but its pioneering contributions to education and the provision of health services in the region had an impact far beyond what these meager statistics would suggest. Today, in addition to the Toraja Church (Gereja Toraja), long independent of the Mission, there is also a minority of Catholics, and as many as twenty or so more recently established Pentecostal churches. Nearly all schoolteachers are Christian, while the indigenous religion, Alukta, has no place in the school curriculum. As a result, children are very much influenced in favor of Christianity, and conversions have accelerated tremendously in the past few decades. From its first introduction by the Dutch in the early twentieth century, Christianity has been aligned with modernity, such that most young people today perceive their indigenous beliefs as old-fashioned, if indeed they still know anything about them. However, it is within this context of the Way of the Ancestors that we must make sense of the wonderfully vibrant objects in the DMA collection, because that is the world in which they were created and used, and within which they had meaning.

The indigenous Toraja cosmology envisioned the world as divided into three main layers—the earth, underworld, and upper world—all of them inhabited by the immanent powers of the deities (deata). When sky and earth first separated out of chaos, the deities of these three layers came into being: Puang Banggairante (Lord of the Broad Plain) ruled the middle world, and Pong Tulakpadang (Lord Who Supports the Earth) dwelt at first in the sky but later descended to become the deity of the underworld, while Gaun Tikembong (Cloud That Expands by Itself) was the deity of the air.[4]

There is no consistent pantheon or dogma associated with the Aluk To Dolo; every area had its own particular pattern of beliefs giving greater or lesser importance to these beings, their wives, and a multitude of other deities. One deity in particular was widely recognized and gained much greater prominence when the Christian Bible was translated into Toraja, for his name was chosen as the translation of "God." This is Puang Matua, the Old Lord of the heavens, who according to myth created humans and many other things in his forge in the sky and lowered them down to earth.

The dramatic and complex rituals of Alukta are broadly divided into two categories, those of the East and the West. Rites of the East (also referred to as Aluk Rambu Tuka', Smoke of the Rising [Sun]) encompass all those connected with the enhancement of life and fertility, including celebrations for the building or rebuilding of ancestral origin houses (tongkonan), agricultural rites, and rituals to ward off sickness, which customarily involved trancing.

Greatest of all these was the ma'bua', now very rarely performed. Rites of the West (Aluk Rambu Solo', Smoke of the Setting [Sun]) are mortuary rituals, of many levels of complexity depending on the rank and wealth of the deceased. Ancestors are associated with the West, deities with the East. On the one hand, the Christian Church has been particularly opposed to the Rites of the East, and a large part of these have now all but disappeared, except for house ceremonies. Mortuary rites, on the other hand, continue to be vigorously performed, albeit in Christianized form, and have even become more and more elaborate and expensive. The prices of livestock (buffalo and pigs) required for funeral sacrifice have undergone staggering inflation over the past few decades, fed by ever spiraling demand and the wealth transmitted to the homeland by those who have made successful careers in Jakarta, and remittances from the many Toraja who are now earning their living in other parts of Indonesia.

The focal point of Toraja kinship organization and social life is the ancestral origin house. These houses are remarkable pile-built structures, with characteristically curved and extended roofs, so cantilevered that the eaves must be supported on special freestanding posts at the front and the rear. Those of the nobility are especially imposing, being covered with elaborate carved designs painted in black, white, red, and yellow. The house comes to have a life history of its own, as special ornaments are added to it in recognition of high-ranking ceremonies that have been performed there. Most typically, a sculpted buffalo head with horns (kabongo') in the center of the façade indicates that the highest-ranking form of funeral rite has been carried out for one of its members; if this is surmounted by the katik (a long-necked bird representing a hornbill or mythical cock), it means that the highest level in the Rites of the East has also been achieved (see fig. 18, p. 24). Occasionally the bird appears transformed into the head of a naga or underworld dragon. All these motifs, and their combination, have a wide distribution in Southeast Asia, indicative of their great antiquity. While generally associated with rank and prestige (and also in many instances with headhunting), they have at the same time acquired quite specific meanings among the Toraja.[5]

Among the Mamasa Toraja to the west, houses were built in a massive style, often with very fine carving. While the roof is given less upward curve and the eaves are less pointed, the extensions to the roof can be so huge as to require not one but two freestanding posts for their support.[6] The imposing figure of an aristocrat riding a buffalo in this collection represents a distinctive and unusual example of the Mamasa woodcarvers' art (cat. 57). It is one of a pair that originally graced the façade of a Mamasa house from the village of Osango.[7] One of the buffalo sacrificed at high-ranking funerals is said to become the deceased's mode of transport on his or her journey to the afterlife; the figures thus commemorate the holding of this prestigious rite and, at the same time, serve as ancestral guardians, protecting their descendants.

Genealogies always begin from a married couple who founded a house. Most people cannot trace their family trees very far back, but

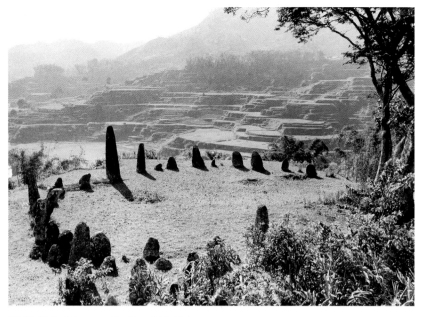
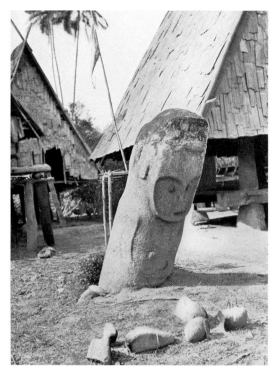

FIG 77 Circle of stone menhirs, Pangala' district.

FIG 78 A female stone megalith called "Golden Anklets" (*Langke Bulawa*), near Bomba village, Bada', Central Sulawesi, c. 1913. Megalithic traditions, which are widespread in the Indonesian islands, have taken distinctive expression in different parts of Sulawesi as well.

those who are descendants of politically important noble houses may be able to recount their genealogy to a depth of thirty generations or so. The founding ancestors of these houses are often mythical beings, the "descended ones," or *to manurun*, or, to give them their full name, "ones who descended from the sky, ones who rose up out of a pool," since of these couples, the man is said to have descended from the sky and the woman, equally mysteriously, to have risen out of a deep river pool before meeting to found their house on the earth.

The former ruling houses of the aristocracy are fixed in number, but even a more ordinary house may over time acquire the status of "origin house" for its descendants. This happens with the birth of many children, whose placentae are buried on the east side of the house, and also with repeated rebuilding, which, if the family can afford it, is undertaken every twenty years or so, even if the house is still in livable condition.[8] Completion of rebuilding is marked by the celebration of a ritual called *mangrara banua*; this is one important Rite of the East that continues to be celebrated today, often in Christianized form. Toraja trace their descent bilaterally from both parents, and all children have equal rights of inheritance. A man most commonly moves to live with his wife at marriage, which means that, as well as inheriting land, a woman often has rights over the house, which is built on her family's land. If there is a divorce, the husband is then the one who has to leave, though he may be permitted to take the rice barn as his share.

People maintain ties to the houses that were the birthplaces of their parents and grandparents, and potentially to numerous other houses where more distant ancestors were born. These ties entail ritual responsibilities, especially to give help at funerals and to contribute to the costs of periodic rebuilding, with its accompanying sacrifices and final celebration. When a man and woman marry,

they are enjoined to maintain a balance in their contributions to the rituals of both sides of the family.

Houses are closely linked to land and to the rock-cut family tombs called *liang*, which form another remarkable feature in the Toraja landscape. Some are cut into cliffs, while others have been chiseled out of egg-shaped granite boulders. Beside these tomb chambers are balconies in which the *tau-tau*, or effigies of the deceased, are placed. Only those whose funerals are celebrated at the highest level are entitled to have such an effigy. At the present time, *liang* are increasingly being replaced by tombs cut in the earth (*patane*), topped with a miniature house in concrete. In some cases, this is because the *liang* has become full after generations of use, and this latter type is cheaper to make; in others, it is because some Christian Toraja now declare themselves uncomfortable at the thought of interment alongside their pagan ancestors. Outstanding items illustrated here include a diminutive and much weathered *tau-tau* in archaic style, and a finely carved tomb door with its bas-relief guardian figure with hands upraised (cats. 66 and 67).

The Toraja highlands were for at least 600 years an end destination in the long networks of trade that stretched from India and China across Island Southeast Asia. Indian textiles were very highly sought after all over the archipelago and were used as a currency in the spice trade. Their superior workmanship and bright, fast colors were as much admired here as they were in Europe and the Middle East. Toraja was not itself a spice-growing area, but cloths must have reached here originally through the Buginese kingdom of Luwu', which rose to prominence in the fourteenth and fifteenth centuries and was engaged in long-distance trade. Later, large quantities of textiles passed through Makassar, which became a major port of the spice trade starting in the sixteenth century. Remarkably, Toraja is the area where the greatest numbers of very

old Indian cloths have survived, testament to the enormous care with which they have been preserved as sacred heirlooms over the centuries. Some are now in museum collections, where since the 1990s they have been tested with newly refined radiocarbon dating techniques, revealing that they are of much greater antiquity than previously thought. The oldest examples have been dated to the fourteenth century, and a few even to the late thirteenth century.[9]

These rare and exotic textiles were incorporated into a category of sacred cloths called *mawa'* (also pronounced *maa'* in some dialects). *Mawa'* include both imported and locally made cloths, and are used for display especially in the life-enhancing Rites of the East. Gujarat was the source of most of the earliest Indian examples, while from the seventeenth century onward, painted and printed cottons from the southeastern Coromandel coast predominated. Especially highly prized throughout the archipelago were the famed double-*ikat* silk *patola* cloths from Gujarat that were widely traded from at least the fourteenth century, and whose designs were incorporated into indigenous *ikat* weaving in many places. *Palampore* are large block-printed and painted cotton hangings from Coromandel (also known to Europeans as chintz), which typically bear the image of a flowering tree and were produced mainly in the seventeenth and eighteenth centuries.[10] There are also large and long hand-painted cotton cloths depicting a climactic battle scene from the Hindu epic the *Ramayana*, in which Rama, aided by Hanuman and his monkey warriors, does battle with the demon king Ravana of Lanka. *Ramayana* cloths have been found not only in Toraja but also in several other islands including Bali, Sumbawa, and Sumba. Narrative textiles of this sort were traditionally made by groups of *chitrakattis*, a caste of singers, musicians, and painters who toured the villages of Andhra Pradesh making a living as storytellers. They used the cloths as backdrops in their recounting of the epics. However, the *Ramayana* textiles that have been found in Island Southeast Asia, while related to this tradition, have no close parallels in south India and may have been made especially for the Indonesian market.[11] This is especially intriguing since some of the areas where they ended up are outside the zone of familiarity for the *Ramayana* story; the narrative is well known in Java and Bali, but not in Toraja or the more eastern islands. We know little about how the peoples of the latter places may have reinterpreted these cloths.

The aristocracy of the southern districts of Toraja claim genealogical connections with Luwu' royalty, and it is possible that some textiles might have been gifts presented to Toraja chiefs by the rulers of Luwu' in an effort to establish tributary relationships with them. However, this political use of textiles for cementing alliances does not seem to have existed here on the scale that accounts from some other regions, such as Sumatra, suggest.[12] Most cloths were probably brought into the Toraja highlands by Bugis traders. The Toraja aristocracy may have paid for them in horses, buffalo, or

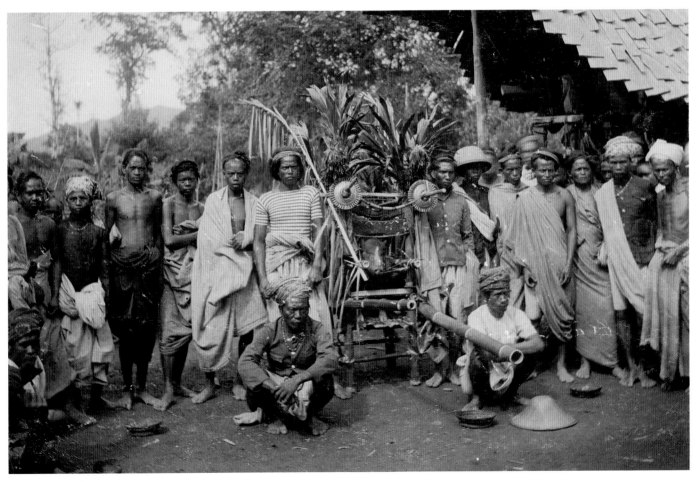

FIG 79 A sacrificial boar in a palanquin during a ceremony in Toraja, 1910–1916. KIT Tropenmuseum, Amsterdam 60040828.

valued forest products such as camphor and dammar resin. From the late nineteenth century, when coffee began to be more intensively cultivated, local headmen had a valuable new product to exchange for luxury goods. Only the nobility could afford such items; mawa' could be worth as many as ten or twenty buffalo.[13] Textiles thus lent an aura of sacred power and prestige to the houses that owned them, and served as impressive markers of status on the rare occasions when they were brought out for public display.

Throughout history, elites have sought out luxury objects from distant places as a means of expressing their superior status. The more remote the origins of such goods, the more likely that they will come to be viewed as having supernatural power.[14] Thus it is not surprising that Indian textiles (whose quality and craftsmanship were for centuries the envy of Europe as well as much of Southeast Asia) are often attributed mythical or divine origins by the Toraja. The same claims are made, however, about their own indigenous cloths. Who exactly produced the latter, whether men or women, and from what precise areas, is difficult to establish, for their creators have remained anonymous, and by now they are generally declared to be of divine origin. These pieces, while occasionally finding inspiration in motifs borrowed from the Indian repertoire (such as a tree growing out of a mound),[15] have a strongly indigenous flavor, giving ebullient and poetic expression to homely images of everyday life and subsistence activities. These scenes overflow with signs of nature's fertility and abundance, depicting both the actual bounty of the Toraja landscape and the desired outcome of rituals. Every inch of the field is deliberately filled, an intensification of design that in the ritual context is part of what gives these cloths their power. Their unfolding is in itself a kind of prayer, or in Toraja terms, pelambean: a term of great salience in indigenous ritual, meaning "hope" or "expectation," which is the driving force behind all Rites of the East.[16]

A second type of indigenously made cloth consists of the long narrow banners called sarita, sometimes reaching up to twenty feet in length. They were often dyed using a unique, locally evolved batik (wax-resist) technique, in which beeswax was applied with a bamboo stick. The patterns were hand-drawn in either indigo blue (Toraja: lallodo; Indigofera tinctora) or a brown made from sandalwood sap (Toraja: lite sendana). Sometimes ferrous mud was also used as a dyestuff.

Of those sarita that are indigo blue in color, not all are indigenous productions. In the 1880s, more than two decades before Dutch colonization of South and Central Sulawesi, a simpler, mostly nonfigurative, block-printed version was mass produced in Holland to cater to the Toraja market.[17] Some sarita were also traded in the highlands of Central Sulawesi, where old photographs show the cloth being worn on festive occasions by individuals of both sexes, sometimes fashioned by the women into voluminous skirts. These mass-produced items were a late and crude imitation of the originals, however. The authentic tradition is exemplified by the DMA's sarita and mawa', which are of superlative indigenous workmanship.

Sarita are used especially in the life-enhancing ceremonies of the East. They may be worn, displayed as banners, or included in the tall triangular structure called bate, made for certain Rites of the East. The bate symbolizes the cosmic tree, decked with valuable heirloom textiles, beaded ornaments, and ancestral swords. It resembles the kayu bilandek of myth, a huge tree that joins the layers of the cosmos with its roots in the underworld and its branches in the heavens, its leaves being formed of different kinds of textiles and other valuables. At the merok ritual, too, sarita cloths are twisted together with rattans to form a long rope, which is tied at one end to the interior central post of the house (petuo) and stretched through an upper window to a sandalwood trunk that is planted in the courtyard, to which the sacrificial buffalo is tethered. It thus serves as a ritual conduit linking together house and tree, both of which represent the pa'rapuan, the kinship grouping of the house descendants. A traditional priest (to minaa) then sanctifies the buffalo and requests its consent to be sacrificed by performing an all-night chant in which the myth of the creation of the world is recounted. At the ma'bua' pare, greatest of all the Rites of the East, the priest chants the praises of the nobility (massinggi') while they sit on a platform, linked to him by ropes of cloth. It is as though the sarita serves to channel the energies of the ritual, ensuring that the blessings desired from the deities reach the right recipients.

It was within this extraordinarily rich and imaginative context of myth, ritual, and poetry that Toraja textiles performed their sacred functions. Ikat weavings from areas farther north in Seko, Rongkong, and Kalumpang were also drawn into the world of ritual. Cats. 64 and 65 are two fine large woven shrouds or ceremonial hangings from Kalumpang. These cloths were traded both to the Sa'dan Toraja to the south, and to neighboring peoples farther north in Central Sulawesi. In the latter region, women sometimes wore the cloths as festive garb, gathered into many-layered skirts in imitation of the style of barkcloth skirts formerly worn in that area.

Altered and reduced though it may be, Toraja ceremonial life today in many respects still maintains a surprising vigor. Treasured textiles are still displayed and worn on ritual occasions. In the ikat weaving areas of Rongkong and Kalumpang to the north, traditions are being revived, albeit with commercial dyes and threads, to cater to an international market of tourists and collectors. But the worldview that informed the creation of these masterpieces has largely lost its plausibility for a younger generation. For that reason alone, the DMA collection is exceptionally valuable as a cultural and artistic record.

FIG 80 Toraja village, Tikala district, 1988.

6 THE ART OF SULAWESI

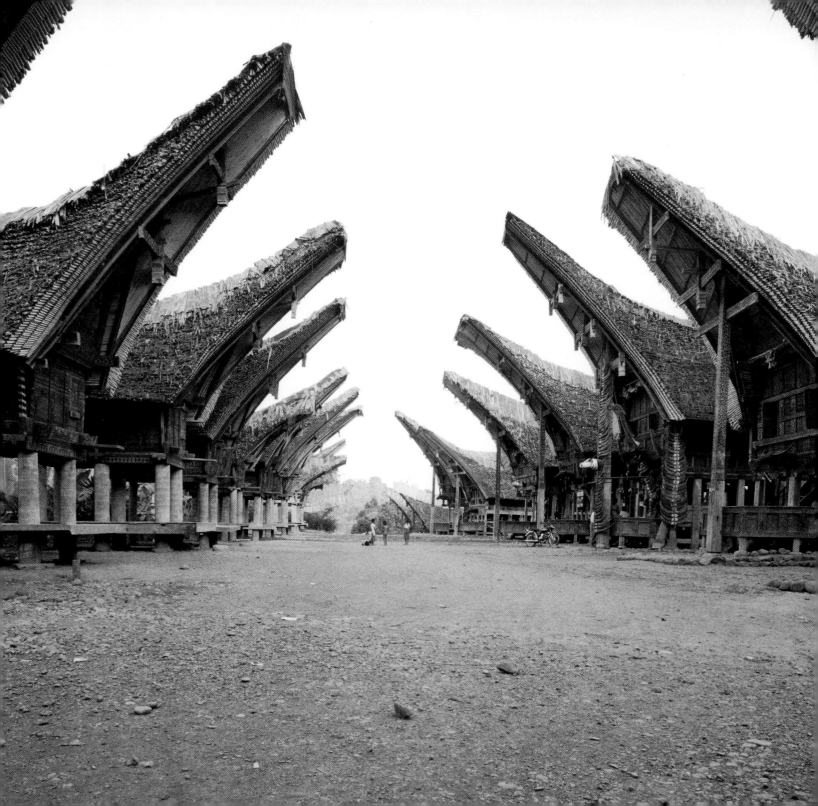

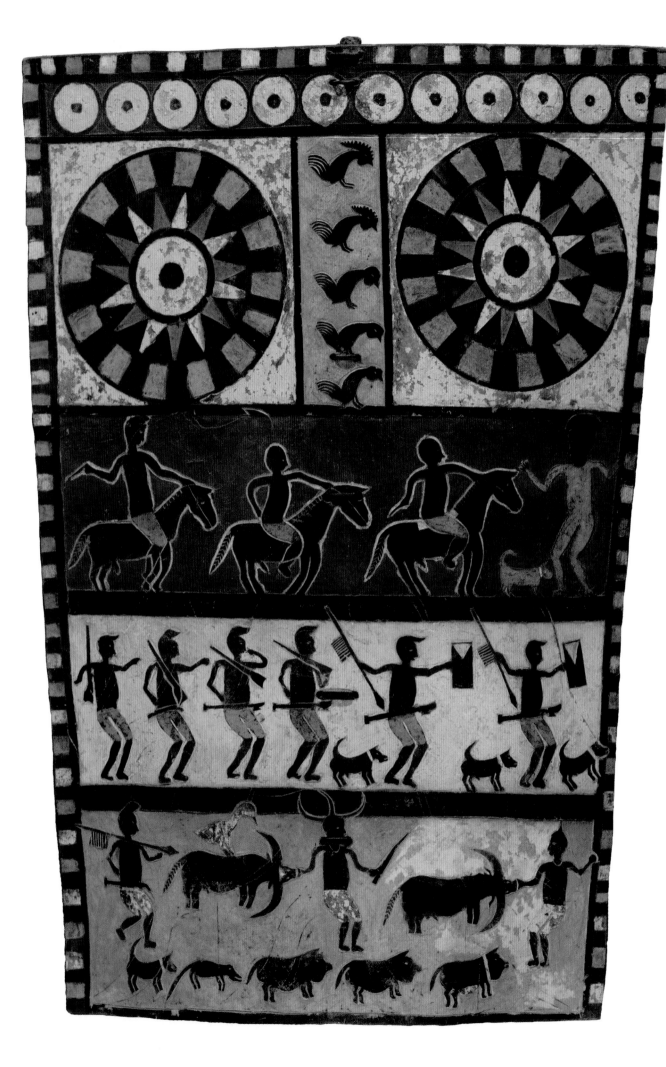

53

Shield (*balulang*)

Indonesia, South Sulawesi, Sa'dan Toraja people
Late 19th century
Buffalo hide, pigment, and wood
26¼ × 16 × 4 in. (68.0 × 40.6 × 10.2 cm)
The Otis and Velma Davis Dozier Fund and
The Roberta Coke Camp Fund, 2006.4

The peoples of Indonesia traditionally made shields in a wide variety of shapes, usually elongated, and quite different from European examples.[1] Some were used in warfare or raids, while others, more decorative, were intended for display in mock combat or in war dances.

This buffalo-hide shield (*balulang*) is so beautifully painted that it must have been used for ceremonial purposes rather than for actual warfare, no doubt as part of the costume worn by performers of the *pa'randing* warriors' dance that serves as a mark of status at high-ranking funerals. It glows with rich red and yellow ocher, balanced by charcoal black and lime white. These four elemental colors, which in the traditional Toraja worldview have cosmic associations with the cardinal points, are the same ones used in house carvings. White and yellow are associated with the north and east, the directions of the creator god Puang Matua and the deities and with the life-enhancing Rites of the East. The colors red and black, on the other hand, are associated with the ancestors, whose directions are the south and west, and they are the colors used in the mortuary Rites of the West. Here, they combine to create a vibrant harmony, adding to the sense of motion conveyed by the figures in the scenes depicted in the shield's four horizontal panels.

The upper edge of the shield is bordered by a row of large white circles on red, representing the thick shell disks (*mata kara*) that used to be sewn onto war jackets as a form of armor or attached to shields. The broad uppermost panel contains two sunbursts (*pa'barre allo*), animating the shield with an impression of fierce, hypnotically glaring eyes. They are separated by a panel of yellow containing a vertical row of black roosters (with prominent combs) and hens. Both these motifs are associated with the heavens. A sunburst surmounted by a cock is the design almost universally seen in the upper triangle of the façade of carved origin houses, the *tongkonan*.[2]

Below are three horizontal panels filled with figures on contrasting backgrounds of red, white, and yellow. In the first, three horsemen, riding bareback, take orders from their leader, painted all in yellow and wearing a curious semicircular hat. He

is accompanied by a small yellow dog. Dogs were formerly taken along on war parties to help sniff out the enemy. Next comes a row of warriors, their bent knees lending the impression that they are dancing, or at least in motion. They all carry swords at their waists and are accompanied by three dogs, one of whom breaks the frame as he jumps up. The first two warriors are armed with spears decorated with fringes of human hair or horsehair to make them look more frightening, while their companions carry rifles over their shoulders. Their long hair is bound up on top of their heads in warriors' topknots (*patondon*).

In the bottom panel is a ritual scene, suggestive of funeral sacrifice: two men lead buffalo with fine large horns; the central figure wears a pair of buffalo horns, with his hair knot sticking up in the middle like an extra horn. The second buffalo appears to have an egret on its back, an everyday detail more commonly observed in the fields than at a ceremony because buffalo will sometimes allow these birds to land on their backs to rid them of ticks. Its appearance here is something of a puzzle, although warriors used to wear an egret's wing in their headdresses as a mark of bravery, and men still wear them when performing the songs of the *ma'bua'* feast (*manimbong*). Alongside the buffalo marches a procession of three pigs, a curious-looking creature with a long snout and tail, and a dog.

The shield's imagery has a strongly narrative quality that suggests it might even record some real events, the details of which are no longer recoverable. On the other hand, it may simply be the product of the artist's lively imagination. In any case, this shield certainly reflects the warlike environment in which most Toraja communities found themselves in the closing decades of the nineteenth century, which was a violent and troubled time in the Toraja highlands.

R.W.

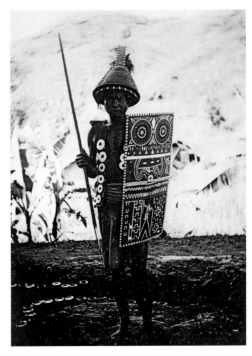

FIG 81 Toraja warrior with an elaborately decorated shield, 1910–16. KIT Tropenmuseum, Amsterdam 60039254.

54

Serpent-form head ornament[1] (*sanggori*) with human figure (detail)

Indonesia, Central Sulawesi, Palu/Kulawi area, Kulawi people
19th century
Copper alloy[2]
6¾ × 8¼ × 1⁄16 in. (17.1 × 21.0 × 0.2 cm)
Gift of The Nasher Foundation in honor of Patsy R. and Raymond D. Nasher, 2008.56

55

Serpent-form head ornament (*sanggori*)

Indonesia, Central Sulawesi, Palu/Kulawi area, Palu or Kulawi people
19th century
Copper alloy
5½ × 7¾ × 1⁄16 in. (14.0 × 19.7 × 0.2 cm)
Gift of The Nasher Foundation in honor of Patsy R. and Raymond D. Nasher, 2008.55

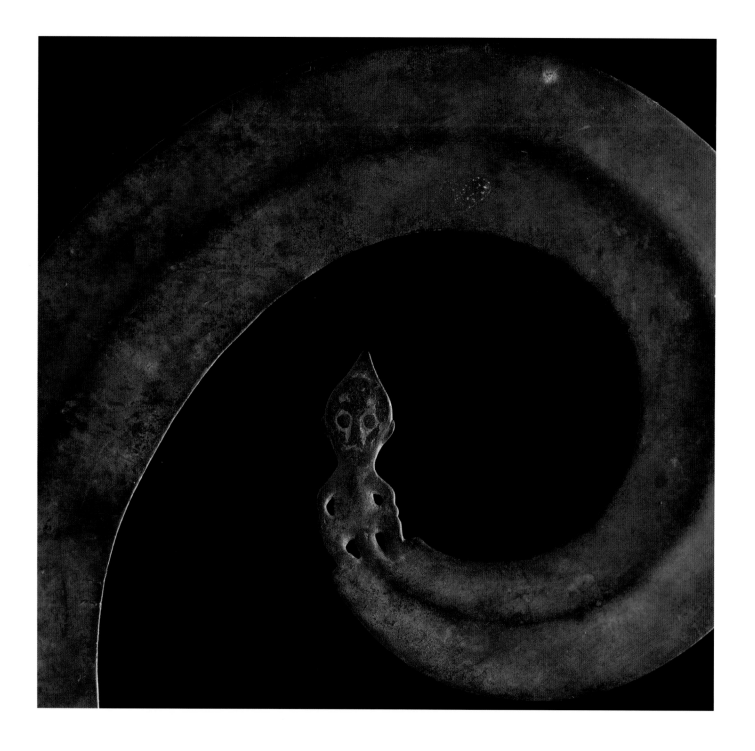

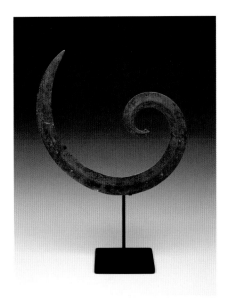

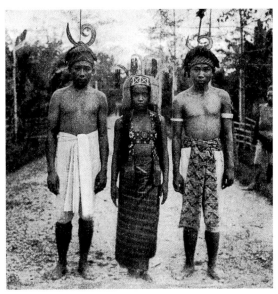

The western region of Central Sulawesi was historically a center for local coppersmithing. *Sanggori* is one of the names given to a spiral ornament fashioned of copper alloy, a type of adornment that was widespread among the peoples of Central and North Sulawesi and may be ancient in design. The metal is beaten flat, but is ridged. In both the examples seen here, there is a single ridge, though in others there may be two or three. In three-ridged examples, the central ridge is slightly higher than the others. The overall shape is suggestive of a serpent, having at the inner tip of the spiral a small pointed head, seen as though from above. The eyes are often very small, sometimes inset with stones, though in other examples, they take the form of circular disks set on the sides of the head. In rare instances, a tiny human face may be seen. Cat. 54 is still more unusual in depicting an entire human figure, with staring eyes and arms akimbo. The significance, either of the serpent or of its combination with a human face or form, is unknown. Walter Kaudern, a Swede who made a lengthy expedition through Central Sulawesi from 1917 to 1920, writes at some length about the *sanggori*. He records that such spiral ornaments were in use all over Central Sulawesi and were also to be found in Loinang in Northeast Sulawesi and in Minahasa in the north. An alternative name for them in Kulawi and Palu is *balalunki*, or variants thereof, while in North and Northeast Sulawesi they are known as *sualang*.[3]

The *sualang* as used in Loinang was not of copper alloy but was made from two conjoined tusks of the *babirusa*, a species of wild pig. Because the tusk in the upper jaw has a more pronounced curve than that in the lower jaw, when two of them are joined together at the base, they take the form of a slightly coiling spiral, very like the *sanggori*. This type of ornament was worn in a bark-cloth turban by the leader of a headhunting expedition. Walter Kaudern records that the exact manner of wearing the ornament varied from group to group, "but always it is a head ornament solely worn by men."[4] Susan Rodgers, who made inquiries in Kulawi in 1983, was told that it could be worn by both men and women, but only those of aristocratic status.[5] The Sarasin brothers, Swiss explorers who made pioneering journeys through Sulawesi from 1893 to 1896 and 1902 to 1903, described the *sanggori* as a warrior's head ornament, worn fastened in the hair (men in precolonial times typically wore their hair long in most parts of Indonesia). Being shiny, it was meant to confuse and terrify the enemy by flashing in the sun. The *sanggori* was also believed to repel sickness or evil forces. At Palu, the Sarasins attended a healing ritual at which the male shamans all wore such ornaments on the left side of the head, with the tip pointing forward.[6] In Kulawi, Kaudern witnessed a ritual for a sick chieftain, in which the *balalunki* spiral was fastened in his hair in a horizontal position. At Tomata, in east Central Sulawesi, he encountered two young men and a woman on their way to a ceremony in honor of the dead (fig. 82). The young men were wearing *sanggori* ornaments fastened into their headcloths, arranged so as to stand up vertically, with the tail pointing to the right. The woman, for her part, was decked out in a headdress with dangling brass ornaments called *tali pampa*.[7]

A further use of the *sanggori* is described by Nikolaus Adriani and Albert C. Kruyt in their monumental work on the peoples of east Central Sulawesi, around Lake Tentena.[8] The To Pamona (as they call themselves today) and their easterly neighbors, the To Mori, both held elaborate secondary rituals for the dead. A great festival would be held at which they made a packet of the bones of the deceased, topped with a wooden funerary mask on a stick, called a *pemia*. The mask, which was shaped like a human face, might have a *sanggori* fastened on top of it; an example is illustrated in Grubauer.[9] In the To Mori village of Sampalowo, Kaudern also encountered the tomb of a chief, which contained a life-sized effigy with a *pemia*-mask as its head, topped by a *sanggori*.[10]

R.W.

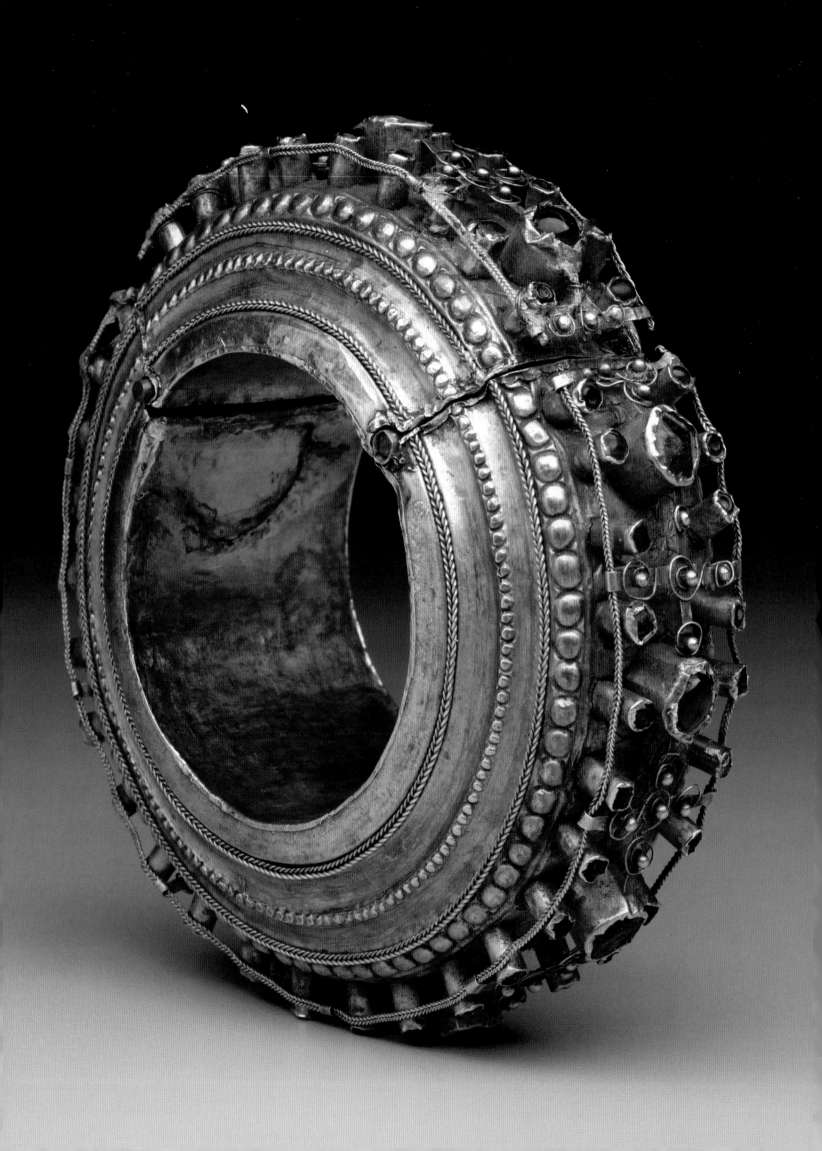

56

Bracelet (*komba lola'*)

Indonesia, South Sulawesi highlands,
Sa'dan Toraja people
19th century or earlier
Gold, garnets(?), Burmese rubies, red and
blue glass, pastes, wood core
1¾ × 4⅝ in. (diam.) (4.5 × 11.8 cm)
Gift of Mrs. Eugene D. McDermott, 1988.55

This massive gold bracelet is a particularly finely worked example of a Toraja heirloom ornament called *komba lola'*. *Komba* means "bracelet"; the name *lola'* is also applied to larger examples of this type of ornament, made for display at rituals rather than to be worn (see fig. 79, p. 177). In larger *lola'*, the gold is usually layered around a wooden core; these are sometimes referred to as *komba dikatik*, a name that suggests their association with the highest-ranking Rites of the East, or life-enhancing rituals. In practice, though, they are used at rituals of both the East and the West. Both larger and smaller variants of the *lola'* are associated with high status, being regarded as a mark of aristocratic rank and a source of pride for the family or house that owns them. On ritual occasions, they may often be seen in association with gold-sheathed *keris* or daggers (Toraja: *gayang*), either displayed together or worn by the house descendants.[1] In ritual costumes, both sexes typically wear the *keris* as a mark of nobility, though *komba lola'* are worn exclusively by women. There are also silver versions, called *ponto lebu*, which in some areas may be worn by nobility of the second rank.

The bracelet is ornamented with delicate rings of repoussé work around the rim, and a complex array of radiating spikes or columns projecting from the outer surface, some of which are set with garnets, Burmese rubies, and transparent beads of red and blue glass. Some examples are linked with spirals of fine gold wire, encircling small clusters of granulated gold bosses that seem to float between the stones. A filigree gold chain encircles the spikes on either side. This is a mark of the superior workmanship of this piece, since in lesser examples a colored thread is used in place of such a chain.

For Toraja, the buffalo has always been a supreme measure of wealth, and other things such as land, houses, and tombs have always been valued in buffalo. *Lola'*, too, have traditionally been paid for this way, each commanding a price of four or five buffalo.[2]

The quality of this particular bracelet suggests the possibility of its having been influenced or crafted by Bugis goldsmiths. They were masters of filigree work, a technique learned from the Minangkabau smiths of West Sumatra. A smaller kind of ornate gold bangle is typical of the work of Bugis smiths. It is somewhat similar in design, having a single ring of projecting bosses around the rim, offset by granular and filigree decorations. The Bugis being highly mobile and entrepreneurial, some of their smiths migrated from the lowlands to other parts of Sulawesi, including Palu, Central Sulawesi. These bracelets became popular with women in the Palu and Kulawi regions of Central Sulawesi.[3] The Toraja *komba lola'* might be seen as a sort of expanded version of this design. Bugis traders and others also settled in parts of Toraja during the last two decades of the nineteenth century. Whether Bugis jewelers had any part in the manufacture of this example is difficult to say for sure; it is certainly possible that local Toraja goldsmiths have found inspiration in their work.

R.W.

FIG 83 Aristocratic woman sporting ceremonial bracelets, c. 1913.

57

Male figure and water buffalo head from a house façade

Indonesia, South Sulawesi, Mamasa area,
Mamasa Toraja people
Early 20th century
Wood and pigment
50½ × 52½ × 21 in. (128.3 × 133.4 × 53.3 cm)
The Eugene and Margaret McDermott Art Fund, Inc.,
2001.269.McD

This hardwood carving is one of a pair that came from the façade of an aristocratic ancestor house (*tongkonan*) in Osango, Mamasa Toraja. It was positioned on the left-hand corner post below the gable triangle. The figure's stern facial features are rendered with an abstract economy, the recessed plane of the eyes cast into sharp shadow when lit from above, while his air of authority is accentuated by the upward sweep of his headgear. The proportions are top-heavy, the statuesque upper body with its vertical accents giving way to an undeniably spindly pair of legs as he sits astride his buffalo with its magnificent upward-sweeping horns. The whole is boldly painted in red and black; the figure appears to be wearing on his upper chest a beaded collar or heirloom ornament (*kandaure*), while the disk-shaped object pendant from his waist represents his betel-bag (*sepu'*).[1] The zigzag patterns on the legs suggest that he is also wearing *seppa*, traditional knee-length trousers.[2]

The matching figure from the right-hand post is now in the Fine Arts Museums of San Francisco.[3] Between the two figures, in the center of the façade, was a third figure astride a ship's prow that rested on the back of a *naga* or water serpent, the latter a widespread symbol of the underworld in Southeast Asian cosmologies.[4]

The sculpting of three-dimensional human figures on the façades of houses is not found among the Sa'dan Toraja, but is a feature unique to Mamasa.[5] One of the buffalo sacrificed at high-ranking funerals (those divided into two stages, called *rapasan sundun*) is designated to become the deceased's mode of transport on his or her journey to the afterlife; therefore these figures are a way of indicating that the house descendants have succeeded in celebrating a funeral at this level. In this sense, the figures are comparable in function to the three-dimensional buffalo head called *kabongo'*, mounted in the center of the *tongkonan* façade, which marks the same achievement among the Sa'dan Toraja. They may at the same time be read as ancestor figures, guarding the corners of the house and protecting the present-day inhabitants.

R.W.

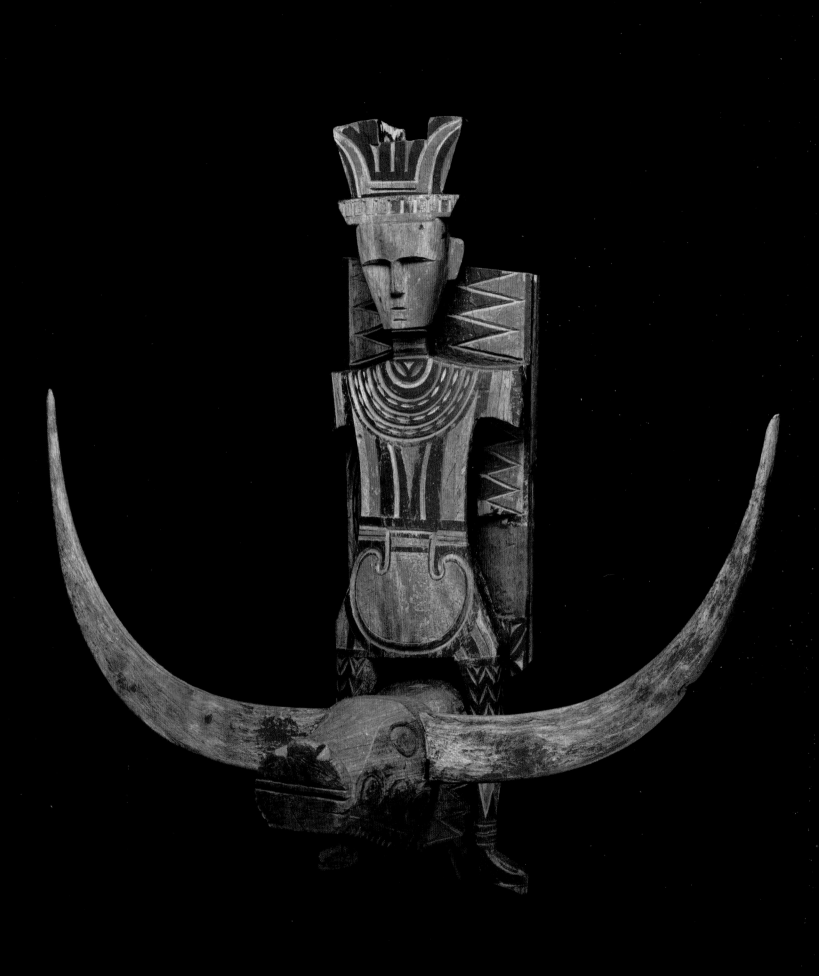

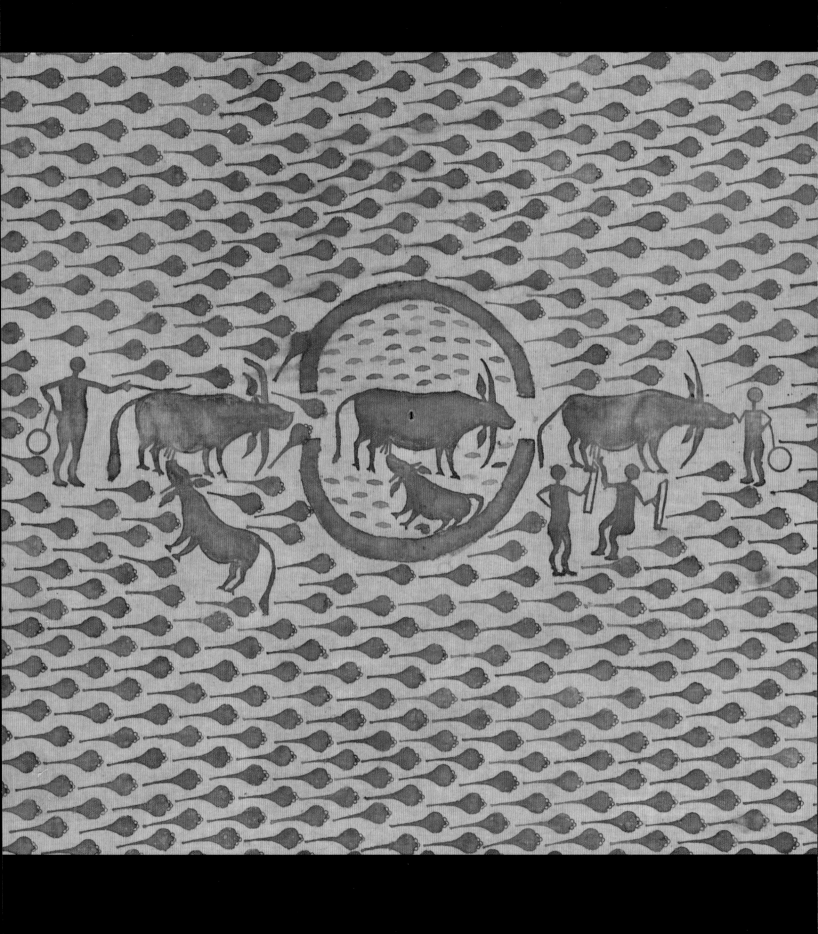

58

Sacred textile (*mawa'*) depicting tadpoles and water buffalo

Indonesia, South Sulawesi, Ma'kale area,
Sa'dan Toraja people
Probably early 20th century
Homespun or commercial cotton, stamped
and painted
80¼ × 35 in. (2 m 3.8 cm × 88.9 cm)
The Steven G. Alpert Collection of Indonesian Textiles,
gift of The Eugene McDermott Foundation, 1983.116

The simple and bold conception of this *mawa'*, painted in indigo on homespun cotton, results in an inspired work of art from the humblest of motifs—the tadpole (*bulintong*). For all its apparent ordinariness, or even because of it, this is a classically Toraja motif—one that draws from the smallest details of nature and everyday life to create a powerful symbol of abundance and reproductive success. Like the trailing plants in cat. 59, tadpoles flourish in the flooded rice fields that lie fallow in the months between harvest and the planting season. A stylized tadpole design may also be found in house carvings, along with associated patterns representing trailing water weeds and "water boatmen," those gravity-defying long-legged insects that skim here and there across the surface of the water without sinking.

In the central panel of this cloth, the density of tadpoles, swimming from left to right, creates a vivid sense of movement, especially at the right-hand border, where they seem to bump against the edge of the rice field and swerve to the left as though unable to stop. The panel is bounded by a row of closely set, stamped concentric circles, here representing the end of a bamboo tube used for collecting buffalo milk (*pa'pollo' songkang*).

The central roundel in this cloth represents a buffalo corral, an image of fertility and wealth. Three stately buffalo are led in a line through the corral by their herdsmen. The leading animal is being milked, while the other two are suckling their calves. Two slightly smaller figures, perhaps boys, hold bamboo containers in which to collect the milk. In typical Toraja style, the buffalo are depicted with their heads tilted to the side, the better to display their long horns. Buffalo are greatly desired and are the ultimate measure of wealth in Toraja society. Even today, the value of a rice field or the cost of building a house or stone tomb is measured in buffalo. In traditional Toraja religion, the Rites of the East were intended to enhance a community's wealth, and also its fertility and reproductive success, not only for human beings but also for their buffalo, pigs, and chickens. So the images of buffalo on *mawa'* may be interpreted as a powerful wish or prayer for such results.

Where figures are depicted in Toraja cloths, as here, they are invariably shown moving from left to right. For the Toraja as well as for a number of other eastern Indonesian peoples, movement from left to right (or clockwise, in the case of things that must be turned in a circle) is a preferred direction and is called *liling deata* (movement of the deities). The opposite is called *liling bombo* (movement of the spirits of the dead) and is regarded as inauspicious. Such rules are even applied in everyday contexts—for instance, in the arrangement of the trunk and tip ends of beams in a house or the rotation of a cooking pot over the fire. Such a movement is in tune with the sun's passage from east to west, which is also echoed by the individual's life course, rising to full strength before declining in old age, and the division of ritual life into spheres of the rising and the setting sun.

R.W.

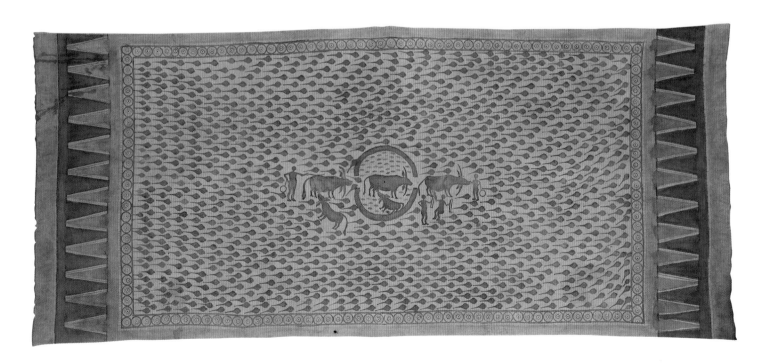

59

Sacred textile (*mawa'*) with fish pond and leafy plants

Indonesia, South Sulawesi, Ma'kale area,
Sa'dan Toraja people
Probably early 20th century
Commercial cotton, stamped and painted
133 × 29¾ in. (3 m 37.8 cm × 75.26 cm)
The Steven G. Alpert Collection of Indonesian Textiles,
gift of The Eugene McDermott Foundation, 1983.114

This exceptionally beautiful *mawa'* is also of local Toraja manufacture, stamped and painted on a long cotton cloth. It reflects the influence of Indian textiles from the Coromandel coast in its overall reddish hue (here actually more of a delicate pink, suffusing the cloth with a warm glow), and possibly also in the circular motif at the center, a typical feature of *mawa'* textiles. This motif, while it echoes the central medallion of some Indian cloths, becomes transformed in the Toraja context into something entirely local, in this instance, a depiction of a fish pond or buffalo's wallowing-hole (*tombang*) at the center of a rice field.

The long center panel is literally bursting with life, being filled with a design of trailing water plants (*tangke lumu'*), such as flourish in fallow flooded rice fields after the harvest. Cloths with this motif form a particular genre of *mawa'*, called *mawa' tangke lumu'*.[1] Their finely drawn stems create a serpentine rhythm from which the triangular leaves sprout in a closely set yet free-flowing pattern, surging densely around the central roundel and up to the very rim of the panel at the top. The overall impression is one of shimmering movement. Such images, associated with water and rapid growth, are characteristically Toraja.

All across the ground, in between the leaves, are tiny stamped cross-shaped motifs (*pa'doti*). The *pa'doti* motif, which appears in a number of variants, is a particularly salient one for the Toraja; sometimes it is said to represent the stars or the white spots on the coats of highly valued piebald buffalo, and it always signifies the desire for blessings and prosperity. *Pelambean* ("expectation," or desire for well-being) is a leitmotif of Toraja religion, which finds many forms of expression in rituals, as well as in these textiles. The filling of the entire ground with detail and ornament is itself described as a form of *pelambean*, intensifying the wish for well-being, and the unfolding of the cloth on ritual occasions carries a similar significance.

At the panel's lower edge, where the roots of the plants can be seen, are a few stalks of rice left by the harvesters, among which ducks forage. In the middle of this border is a diminutive rice barn, alongside which a tiny figure of a harvester holds aloft a stalk of rice. More ducks parade around the rim of the central pond, which is

full of fish, interspersed with more cross motifs. On the rim, among the ducks, stands a human figure holding aloft in one hand a fish that he has evidently just caught with his long fish-trap (*tagalak*), which is clutched in the other hand.[2]

On the long edges of the cloth, in the outer border, are rows of small stamped circles called *pa'bua padang*, or "fruits of the earth." *Passora* (fence) is the Toraja name given to the row of triangles forming a border at either end.[3]

R.W.

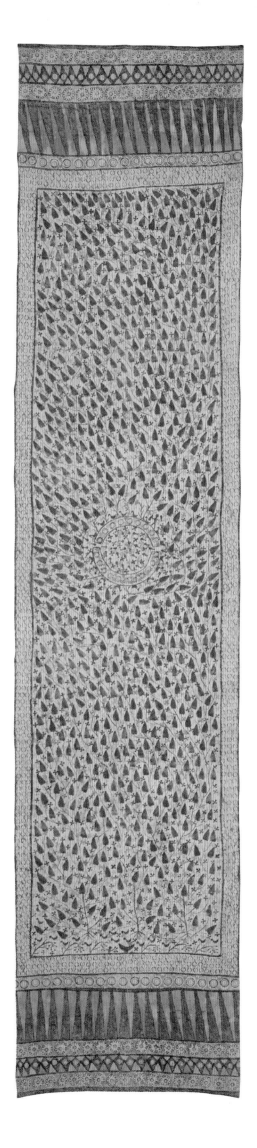

60

Sacred textile (*mawa'*) (detail)

Indonesia, South Sulawesi, Sa'dan Toraja people
19th century or early 20th century
Homespun cotton, stamped and painted
154½ × 26¼ in. (392.4 × 66.7 cm)
The Steven G. Alpert Collection of Indonesian Textiles,
gift of The Eugene McDermott Foundation, 1983.117

This *mawa'* is executed in dark brown with a rose blush on hand-made cotton fabric. Its central roundel depicts the goddess Indo' Samadenna (Mother All There Is) with her golden spinning wheel. Also known as the mythical lady of the moon, she is accompanied by a cockerel and surrounded by constellations. The artist has expressively captured her movements as she guides the wheel and pulls at the thread, while the companionable rooster takes up his position alertly beside her. Over her head are the seven stars of *Bunga'* (the Pleiades), whose place in the sky is traditionally observed in order to time the beginning of the agricultural cycle. A row of three stars beneath her spinning wheel represents Orion's Belt, known to the Toraja as *Lemba*, the Rice-bearer. *Lemba* is the term for a bamboo carrying-pole that is balanced across the shoulder and used to carry home the sheaves of newly cut rice from the fields at harvest.

According to myth, Indo' Samadenna and her sister, Indo' Pare'-pare' (Mother Little Rice), were two of the eight children born of an original marriage between deities in the sky-world. They quarreled over which of them should inherit from their parents a golden spinning wheel. Indo' Samadenna chose water as her weapon, while Indo' Pare'-pare' chose fire. Water quenches fire, so Indo' Samadenna won and took the spinning wheel with her up to the moon. Indo' Pare'-pare' went into the sun; that is why the sun is hot and the moon is cold.

The presence of the cock in this scene has led previous commentators to identify the woman as Tulang Didi', another mythical figure. She was weaving one day when her father's dog soiled her work, and in anger she hit him with her wooden shuttle stick and killed him. Her father then determined to kill her in revenge and took her into the forest, where they wandered far upstream before she instructed her father to cut her in half. Her mother had given her a chicken egg for the journey, which hatched into a cock and crowed her bones back to life. Then, by his crowing, he brought into being a beautiful house and all kinds of wealth for her. She and her rooster eventually went up into the sky, where the rooster is said to have been transformed into the Pleiades. As the constellations proceed across the sky, the rooster (*Bunga'*, the Pleiades) follows after the Rice-bearer (*Lemba*), so that he can peck at any grains that fall from Lemba's burden of rice.

The regenerative power of the cock's crowing, which features in a number of related Toraja myths, reflects the everyday experience of its association with the sunrise. The cock thus is closely associated with themes of vitality, friendship, wealth, the upper world, maleness, and rice cultivation, as well as standing in other contexts for bravery and high rank. How exactly these two well-known stories connect is not entirely clear, but in a version collected by Hetty Nooy-Palm,[1] after going up to the moon, Tulang Didi' was known as Indo' Samadenna thereafter. Thus the two women sometimes become identified and conflated.

As in many other examples of Toraja textiles, the cloth's field is divided in two long halves by two parallel lines forming a narrow channel, or *kalo'*, resembling the irrigation channels that bring water to the rice fields. The remainder of the cloth is covered with a pattern of crosses, called *pa'doti langi'*, around a central circle. Each cross is expanded into lozenges by the addition of a stepped pattern of L- and T-shaped motifs around it and diagonal rows of small squares with a central dot. This pattern is widely interpreted as deriving from Indian textiles in which similar motifs are said to be based on the plans of Buddhist stupas.[2] The Toraja, however, have developed their own interpretation of the motif: *doti* means "spotted," "star," "blessing," or "auspicious" and can also refer to a spotted or piebald buffalo, the rare variety most highly prized for funeral sacrifices.

Pa'doti langi' (*langi'* means "sky") is described as looking like "stars in the sky," and this is sometimes used as a general term for *mawa'* that carry this design. It appears to be a motif of special importance, capable of bringing good fortune or blessing (*pas-sampa' doti*), and is also particularly associated with women, which perhaps explains its presence here.[3] House carvings, too, are said to be incomplete unless this design is included.

This particular cloth came from somewhere in the southern region of Toraja, the so-called Tallu Lembangna, or "Three Domains" of Ma'kale, Sangalla', and Mengkendek. The cotton has been handwoven with paired wefts, the warp threads grouped in sets of three or four. A cloth with a strikingly similar design, but also suggesting the phases of the moon, is illustrated in an essay by Nooy-Palm.[4]

R.W.

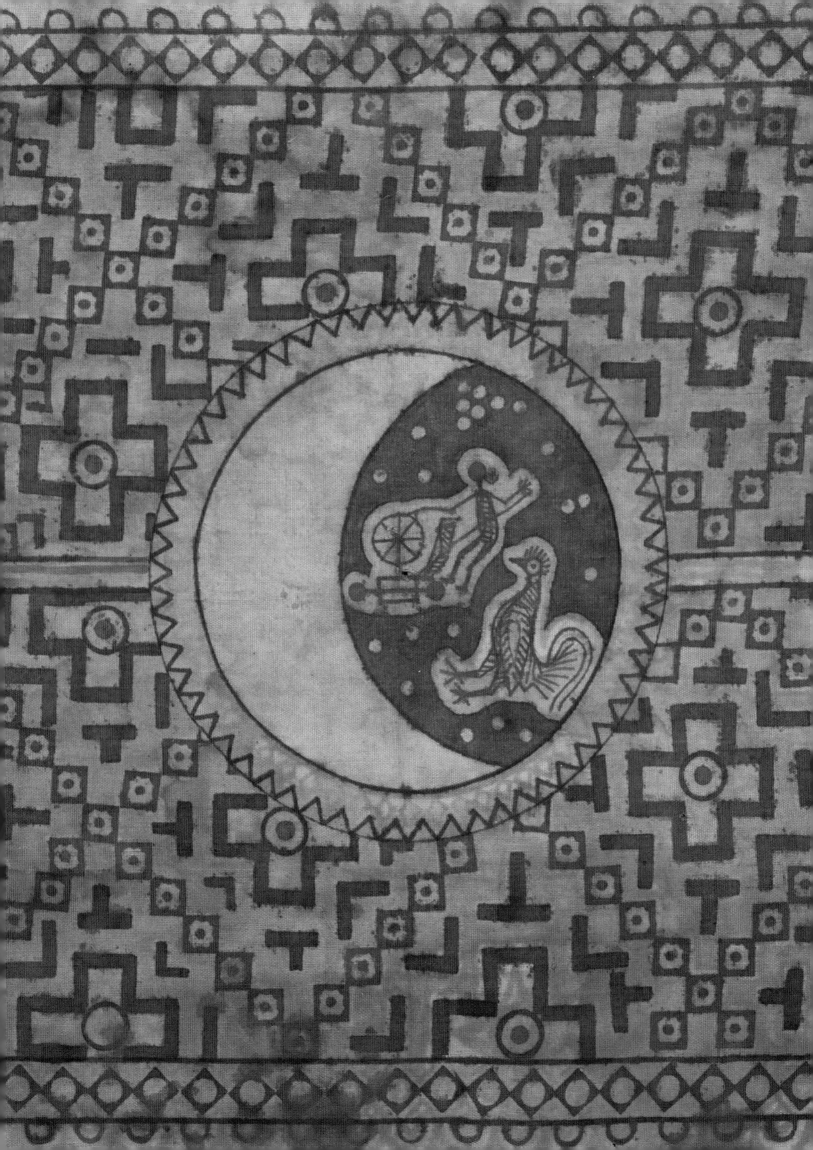

61

Double tubular sacred textile (*mawa'*)

Indonesia, South Sulawesi, Sa'dan Toraja people
Late 19th to early 20th century
Homespun cotton, painted
46 × 24 in. (116.8 × 61.0 cm) (framed)
Textile Purchase Fund, 2007.47

This *mawa'* is curiously folded and stitched to form a double loop, shorter at the top and longer at the bottom, such that a central panel is displayed in the middle of the bottom portion. Sometimes *mawa'* were sewn like this in order to facilitate their being worn at Rites of the East, those concerned with the promotion of fertility and prosperity. The positioning of the figurative panel here suggests that this one may have been made expressly for this purpose. The upper loop, with the lozenge design, was worn across the top of the head as a headband, allowing the lower part to hang down the wearer's back. The lower portion bears the *pa'doti langi'* motif (see cat. 60), hand-painted in muted tones of red and brown, the maker having stretched the pattern to make it extend all the way up to the border on the left-hand side, in order not to leave any empty space in the field. A red dye was obtained from the *bangkudu* plant (*Morinda citrifolia*), while browns were obtained from sandalwood sap (*lite sendana*) or by boiling the leaves of *bilante* (*Homolanthus populneus*) and dipping the cloths in mud to fix them.

The central panel depicts a lively little scene around a fishpond in the middle of a rice field. The pond is surrounded by ducks, buffalo, their human herders, and a dog. In the middle of the pond, two ducks fight over a worm, while another pair do likewise on the rim. To the right and left are two large buffalo cows, each with a suckling calf, its tail held happily aloft as it feeds. The herdsmen hold them by ropes attached to rings in their noses. The herder on the left has his betel-bag (*sepu'*) dangling from his upper arm; a boy comes holding a bamboo flask (*panganduran*) in which to collect milk. Right of center, another herder squats, holding the animal's rope in one hand, and in the other a circular object, which one Toraja viewer suggested might represent a large pomelo fruit such as herd boys in the old days often liked to play ball with. On the far right, another man, perhaps the owner of the buffalo, holds aloft an umbrella or sunshade (*ta'dung*), an item formerly used only by the aristocracy.

In spite of the small scale, the painter has succeeded in evoking with spontaneity and tender expressiveness an everyday scene of farming life that at the same time is full of deeper significance. The flooded, fallow rice field holds the promise of future growth. This is the time of year when fish are reared in the rice field ponds and the ducks are allowed into the fields, where they aerate the soil as they forage with their beaks in the mud, at the same time contributing their droppings as fertilizer. The buffalo in milk, with their calves, are also a potent image of fertility and well-being—expressing the hopes, desires, and expectations (*pelambean*) embodied in the Rites of the East. The association explains why this type of cloth is sometimes referred to as *mawa' deata*, or *mawa'* of the deities, whose immanent presence in nature is such a fundamental part of the traditional Toraja worldview, and who are the focus of attention in Rites of the East.

R.W.

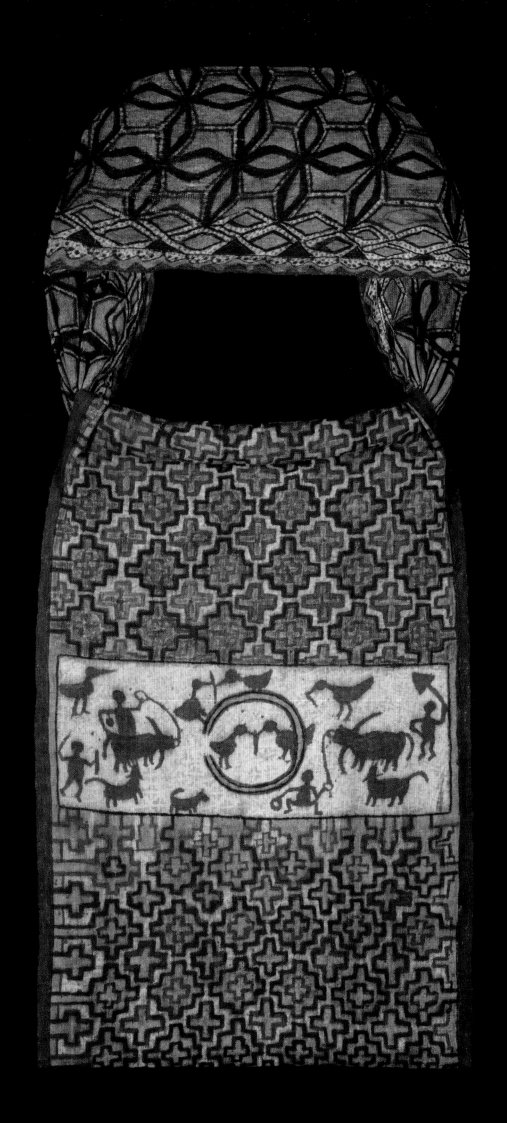

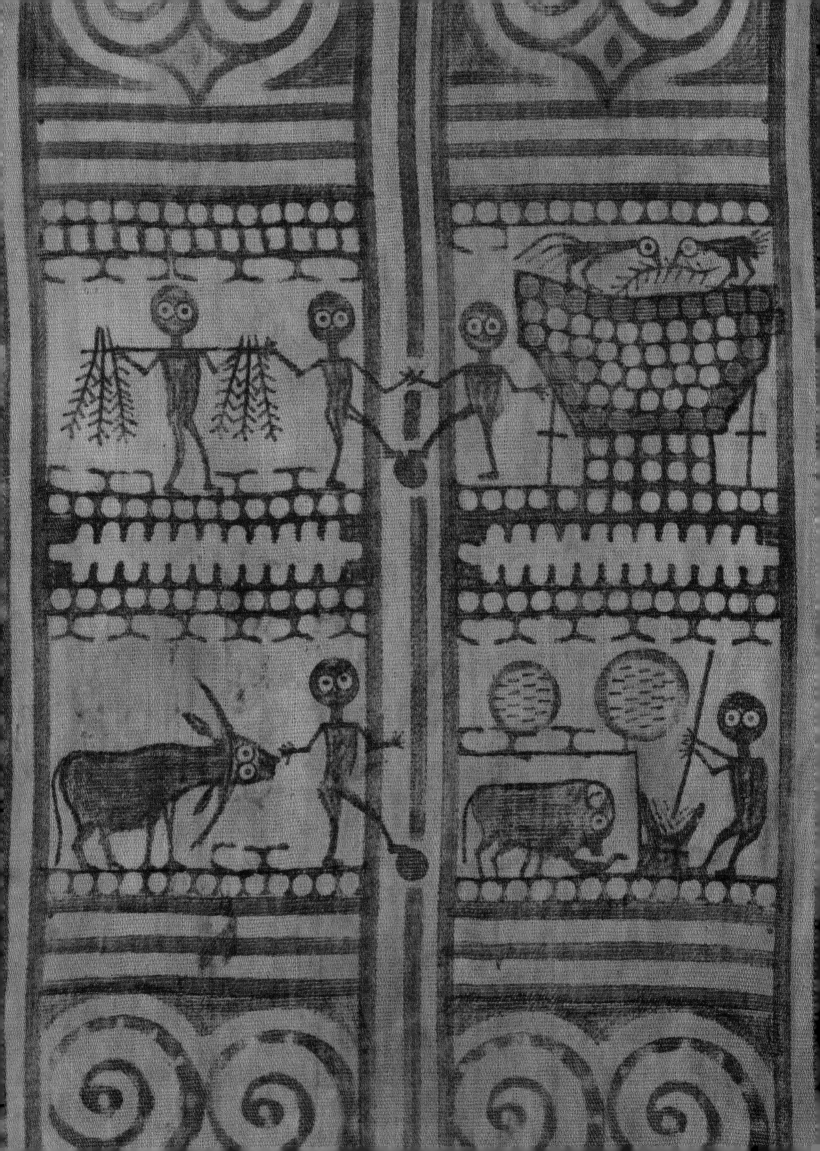

62

Sacred textile (*sarita*) (detail)

Indonesia, South Sulawesi, Sa'dan Toraja people
Late 19th to early 20th century
Homespun or commercial cotton
198 × 9 in. (502.9 × 22.9 cm)
The Steven G. Alpert Collection of Indonesian Textiles,
gift of The Eugene McDermott Foundation, 1983.120

FIG 84 *Sarita* were frequently worn by men and women as articles of festive clothing. Kulawi, about 1920.

Sarita are very long, narrow cloths, sometimes as much as twenty feet in length, in which multiple paired rectangular panels are filled with motifs executed in either deep indigo blue or brown. These are typically interspersed with small stylized scenes of everyday life and human activities. They were indigenous Toraja products, sometimes painted as in this example, and sometimes worked in a local batik technique in which wax was applied with a bamboo stick to areas that were not to take the dye. Some of the designs closely resemble motifs used in house carvings, though on textiles they are often given different names. *Sarita* are used most especially in Rites of the East, which the Toraja call "Smoke of the Rising [Sun]" (*Aluk Rambu Tuka'*). This group of rituals emphasizes the enhancement of life and fertility.

Sarita may be worn, hung from poles as banners, included in the tall triangular structure called *bate*, a symbolic world tree, or used to tie together two points in a ritual (as described in more detail on p. 178).

This remarkable *sarita* is rather freely painted in gray-brown on natural-colored cotton. The brown was obtained from boiling the leaves of *bilante* and fixing the dye by immersion in mineralized mud. It is bisected along its length by parallel lines indicating a stream or irrigation channel (*kalo'*). Across this channel, figures can be seen helping each other to cross by means of stepping-stones from one side to the other. This specific textile design is known as *sarita to lamban*, "*sarita* with people crossing a stream." Not only is water essential to life, but the idea of blessings as being like flowing water that can be channeled by ritual activity and verbal performance is a fundamental one for the Toraja and lends this image a deeper resonance. The figures holding hands as they cross evoke profound cooperation and harmony.

Decorative sections of the cloth are filled with variations on spiral motifs, signifying bowed ears of rice (*pa'tukku pare*) and fern fronds (*pa'lulun paku*). The latter are another emblem of fertility, since ferns grow quickly. These are interspersed with panels containing rows of birds drawn in a lively and individual manner. Some of these resemble herons and egrets, the species often seen in rice fields, especially when they are flooded or being plowed in preparation for planting. In ritual verse, these birds have a special association with the plowing season. Others are hens and roosters, pecking at stalks of grain. In another panel, two men, one of them leading a buffalo, hold hands as they each rest one foot on the stepping-stone in the middle of the stream.

A similar arrangement features again in a larger figurative panel in which a man bears bunches of harvested rice on a pole (*ma'lemba*), roosters peck at stalks of rice on the roof of a house, a buffalo is led across the stream, and a woman pounds rice in a mortar next to a pen in which a pig is eating from its trough. On top of the pig pen are two winnowing trays used to sift the chaff from the grain after the rice is pounded. The smaller one may represent a tray of woven bamboo (*bingka'*) used for making offerings to the deities in agricultural rites.

R.W.

Sacred textile (*sarita*) (details)

Indonesia, South Sulawesi, Sa'dan Toraja people
Late 19th to early 20th century
Batik on homespun or commercial cotton
199 × 11 in. (5 m 5.5 cm × 27.9 cm)
The Steven G. Alpert Collection of Indonesian Textiles,
gift of The Eugene McDermott Foundation, 1983.122

This *sarita* is a truly spectacular example in which the paired panels display an unusual variety of finely executed motifs, creating a sense of vibrant rhythm. It has been crisply executed in the local *batik* technique and dyed with indigo. Asymmetry lends an additional dynamism: here and there, contrasting motifs are placed in opposite panels. The ends, as is very typical, are finished with rows of long triangular motifs (*passora*), here executed in tiny dots. The row (a double row on the opposite end) of larger dots above the *passora* is called "coins" (*pa'katte'katte'*) and represents the desire for wealth. The crenellated band above that is called *pa'pollo' dodo* ("hem of a woman's *sarong*," a reference to the appliquéd patterns on the borders of locally woven *sarong* once worn on festive occasions, which can be seen in some old photographs).

A figurative panel (at the bottom of the section farthest to the right) shows two men plowing with a pair of water buffalo, a tadpole swimming away from them on either side. Above this we see a four-lobed design depicting leaves of the water hyacinth (*pa'daun ambollong*). This design is sometimes alternatively named after the fruit of a tree (*pa'bua tina'*). Rows of ribbed, fishbonelike patterns are called "backbones of eels" (*pa'buku masapi*), a symbol of strength. They surround a man in one panel who holds in one hand a bird and in the other a small animal, possibly a dog. The crisscross pattern above this is known as "chiles" (*pa'bua pana'*), while a pattern of concentric rings (*pa'lola*) depicts circular gold heirloom ornaments and closely resembles a house-carving motif called *pa'barre allo*, or "sunburst."

Above this, the sinuous spiral design on one side represents "tadpoles swimming here and there" (*pa'bulintong siteba'*), while the other panel contains stars (*bintoen*) in the bottom half and a circular pattern above called *pa'pollo' songkang* (ends of bamboo tubes). Next on one side is the powerfully auspicious *pa'doti* design of stepped lozenges, together with a group of daggers (*gayang*), a mark of nobility, and knives. Most unusual is the organic and asymmetrical pattern of twisting lines in one of the next long panels, the name of which has not been identified. On the other side is a variant of the bitter gourd motif (*pa'buku paria*). At the foot of each of these panels is an animal, a dog or horse on one side and a buffalo on the other.

A little more than halfway down the middle section, a small square panel is filled with birds pecking, probably hens. Above it, an interlocking key pattern is named after the typical hooked motifs found on beaded heirloom ornaments (*pa'sekong kandaure*); the design next to it is said to be a variant of buffalo ears distinctive of the Pangala region. Next come two tightly packed figurative panels. On one side is a man on horseback, while on the other we see a man armed with sword and shield, accompanied by two small horned animals probably representing the anoa (*Bubalus depressicornis*), a dwarf buffalo species unique to Sulawesi.

Toward the upper end of the leftmost section, we see a pair of square designs with radiating spirals called *pa'kapu' baka* (bindings of a lidded heirloom basket), a motif also common in house carvings and a symbol of prosperity.[1]

A man in one of the next panels carries a bamboo tube, perhaps for palm wine, and a small bird. Above the man's head is the design called *pa'talinga* (buffalo ears), generally said to represent the hope for many buffalo, and on the other side, the ribbed patterns of eels' backbones and a motif (looking somewhat like a Union Jack) that is called *pa'isi santung*, or clappers of small brass bells shaken in the climactic procession at the greatest Rite of the East, the *ma'bua' pare*. Two horses or dogs can be seen at the bottom of the panel. Below the radiating leaves of water hyacinth comes a narrow band of small squares with tiny white dots, identified as *pa'batan-batan* ("gold beads," which are sometimes worked with just such a granulated pattern). The final figurative panel again depicts men plowing among the tadpoles. Below it is a spiral motif with a comblike array of vertical lines, a variant of the *pa'tangke lumu'* or water weeds pattern. The entire cloth is dense with symbolism expressing the hope for wealth and abundance.[2]

R.W.

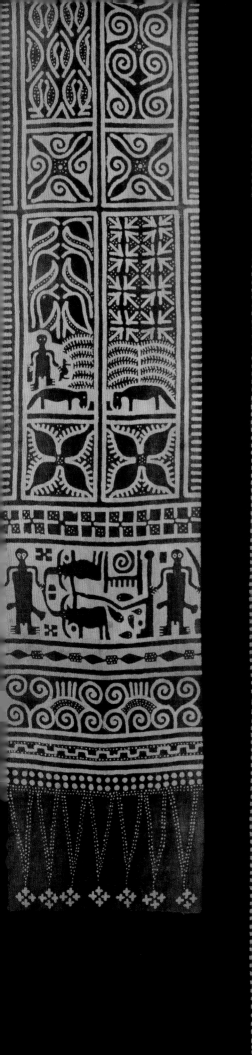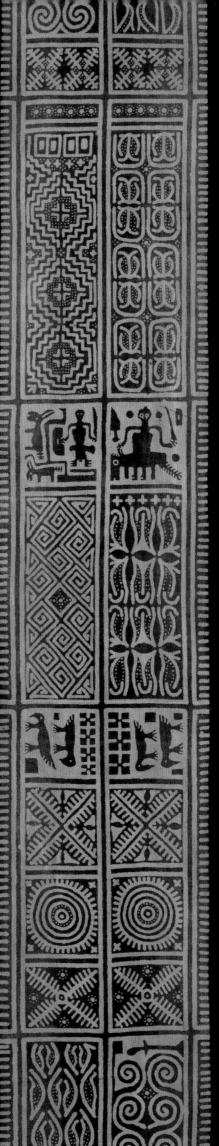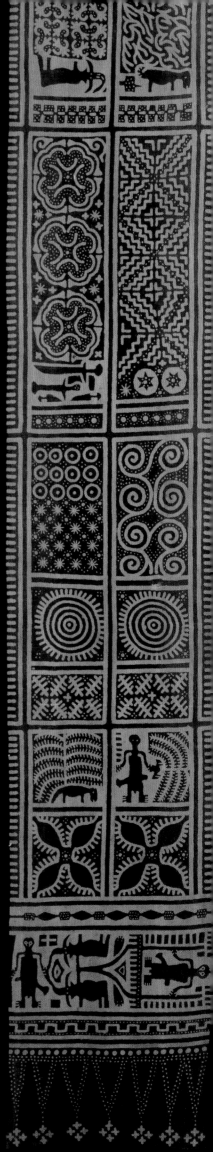

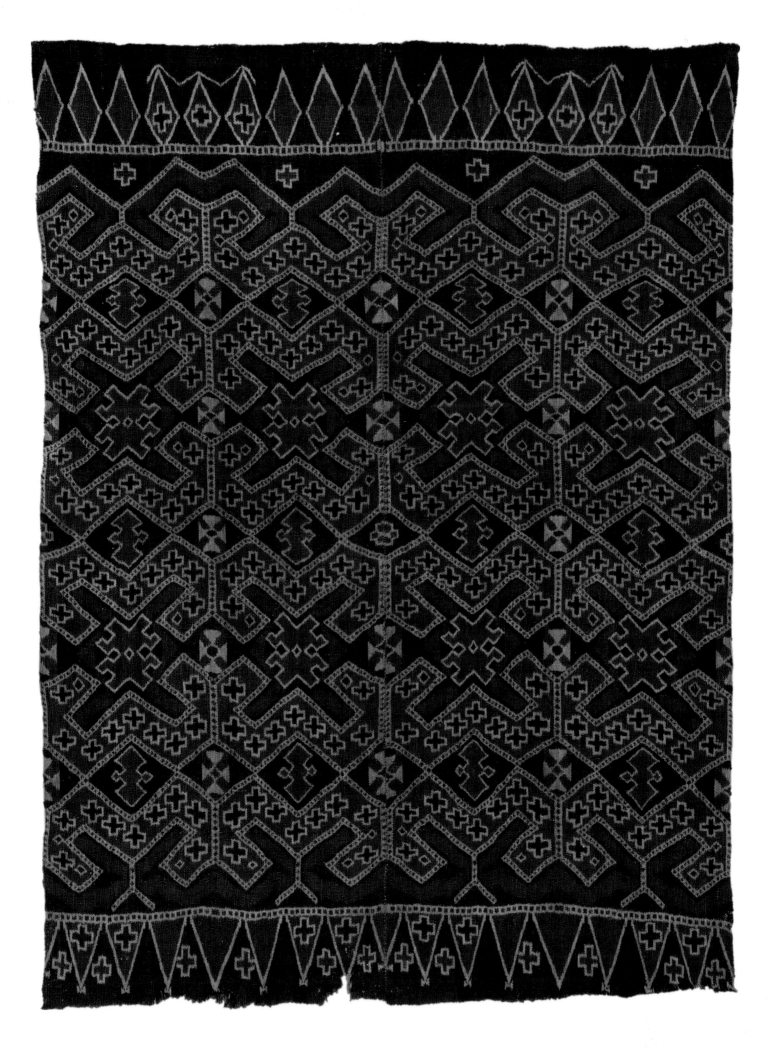

64

Shroud or ceremonial hanging (*Papori to Noling*)

Indonesia, West Sulawesi highlands, Kalumpang
19th century
Homespun cotton
65½ × 48¾ in. (1 m 66.4 cm × 123.8 cm)
The Steven G. Alpert Collection of Indonesian Textiles,
gift of The Eugene McDermott Foundation, 1983.125

The people of Kalumpang, in the region of the Sa'dan highlands to the northwest of Tana Toraja, are famed for their production of *ikat* textiles, which were used for ceremonial display or as shrouds. *Papori* means "wrapped" or "tied," a reference to the *ikat* process; Noling is the name of a place in Kalumpang that was a center for the weaving of this style of cloth. Thus, the name *Papori to Noling* means "*ikat* weaving of the Noling people."

Kalumpang weavers produced cloths with double the density of warp threads compared to those of Rongkong, their neighbors to the east, whose textiles are rather loosely woven. This density of warp makes their textiles exceptionally durable. The Kalumpang weavers were also highly skilled in dyeing, as well as in the process of tying the warp for dyeing, resulting in designs of impressive crispness. In the best examples, repeated steeping of the threads in the dyes produces, as seen here, a wonderful saturation and richness of color. This process may extend over weeks or months. The main colors used are blue from the indigo plant (*Indigofera tinctora*) and red from the roots and bark of *Morinda citrifolia*, or Indian mulberry (known as *bangkudu* to the Toraja). Blacks and browns of varying hues are produced by overlaying red and blue. The complex angular patterns of this textile, with their four red projections, look almost like abstractions of the human figure in a line dance, tightly interlocked with red bands featuring a small brown cross motif. The result is exceptionally rhythmic, vibrant, and vigorous, a masterpiece of women's artistic creativity.

Very little modern ethnographic research has been done in this region of Sulawesi, and today it is difficult to provide in-depth accounts of these cloths and their production. Both Kalumpang and neighboring Rongkong suffered devastation during the 1950s as a result of attacks by Buginese Muslim guerrillas of the Darul Islam/Tentara Islam Indonesia (DI/TII) movement led by Kahar Muzakkar. Many large old houses were burned, and weaving almost stopped; some fine cloths from this area have survived precisely because they had been traded to neighboring peoples who have carefully treasured them as heirlooms. Today, some women have returned to weaving for the tourist market, with cloths being traded south to souvenir shops in Tana Toraja. Few of these new cloths are made with homespun cotton or natural dyes. But the members of a recently formed cooperative, with the support of an Indonesian fair-trade organization, Threads of Life, are reviving traditional dyeing techniques and regenerating the weaving heritage of their mothers and grandmothers.

R.W.

65
Shroud or ceremonial hanging (*sekomandi*)

Indonesia, West Sulawesi highlands, Kalumpang
Probably late 19th or early 20th century
Homespun cotton
57 × 98½ in. (144.8 cm × 2 m 50.2 cm)
The Steven G. Alpert Collection of Indonesian Textiles,
gift of The Eugene McDermott Foundation, 1983.126

The term *sekomandi* appears to refer to a group of villages in the Kalumpang area where this style of warp *ikat* weaving originates. Working on the backstrap loom restricts the width of the cloth that can be woven; the larger textiles from this region are therefore assembled from multiple parts. This impressive example is composed of four separate pieces. It is dominated by a central panel (made from two sections stitched together) of complex interlocking hooked motifs (*sekong*), very crisply executed in red, blue, brown, and natural colors. A small row of triangles borders the upper and lower edges of this center field, which is framed on either side by sections in which broad bands of red are punctuated by fine vertical stripes in shades of blue and brown.

These cloths were traded both south to the Sa'dan and Mamasa Toraja, and north to peoples in Central Sulawesi. They were valued as ceremonial hangings, and also as shrouds. Steven Alpert recounts the following story about how he came to collect this piece:

In 1976, I was guided by a man of Mamasa to a marvellous, remote, and unusually "original" Toraja *tondok* (or village of just a few houses) on a mountain overlooking the town of Mamasa. I mention the originality of this *tondok* because there was so little evidence of contact with the modern world. The house where I stayed was ancient, carved, and surrounded by a low stockade. In fact, the only obvious bit of Western culture gave me a bit of a shock. On the wall a hook had been fashioned from the lower jaw of a wild pig. Hanging from the hook was a bucket of bright blue plastic—shockingly blue—a sight you did not easily forget. I awoke one morning in this setting facing the old nobleman, who patiently waited for me. He pointed to an old *lado-lado*, a beautiful (wooden) container, that held this particular blanket. The old man explained that with all his traditional wealth of land and buffalo, he still could not pay his taxes. It would be against his *adat* or custom to sell either of them. The blanket he had wished to use as a burial shroud for himself, but because of his situation he was willing to sell the piece to me. Early in

(the twentieth) century, as a young bachelor, he had traveled to Kalumpang and had exchanged among other items a white horse for this blanket.[1]

R.W.

FIG 85 The elderly Mamasa couple to whom the *sekomandi* shroud had formerly belonged in 1976.

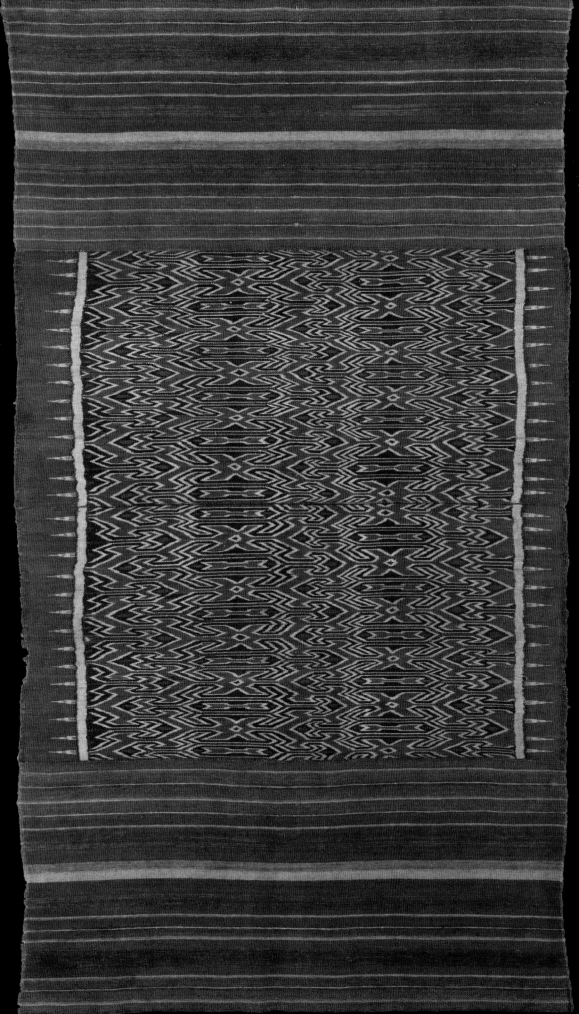

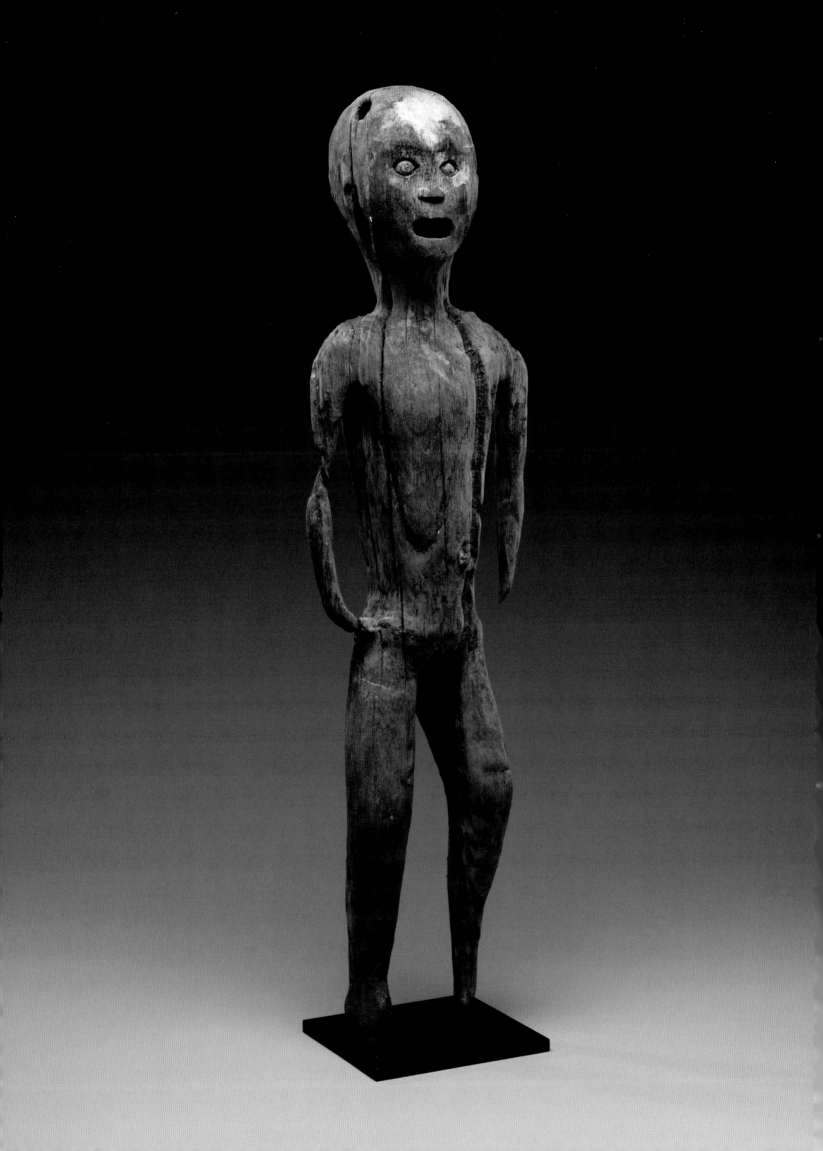

66

Funerary figure (*tau-tau*)

Indonesia, South Sulawesi, Sa'dan Toraja people
19th century or earlier
Wood
32¹¹⁄₁₆ × 9⅜ × 6¾ in. (83.0 × 23.8 × 17.2 cm)
The Eugene and Margaret McDermott Art Fund, Inc.,
1980.2.McD

Tau-tau is the name given to the funeral effigy, smaller than life-size, that is made to commemorate the deceased when a very high-ranking funeral is held, accompanied by the sacrifice of many water buffalo. Only members of the highest-ranking aristocracy (the so-called *tana' bulaan*, or "golden stake") are permitted to have permanent *tau-tau*. Nobles of the second rank (*tana' bassi*, or "iron stake") are permitted temporary effigies made from bamboo and dressed in cloths, which are discarded after the rituals are completed.

A permanent *tau-tau* was traditionally made of jackfruit wood (*nangka*), which is very hard and long-lasting, with a rich slightly yellowish tone. Offerings traditionally accompanied every stage of its making, and the spirit of the deceased was thought to linger around it until the mortuary rites had been completed. At night, when the *ma'badong* circle dance and chants for the deceased were performed, the *tau-tau* would be placed in the center of the circle, so that the spirit might enjoy the songs performed in its honor. Furthermore, it was believed that the singing itself had the power to assist the spirit to depart on its long journey to the afterlife, Puya, far away in the southwest. To this day, the effigy, at the conclusion of the rites, accompanies the corpse to its final resting place, being installed in a balcony alongside the tomb, from where it can survey the landscape with its familiar rice fields.

This *tau-tau* is archaic in style and appears to predate even the oldest effigies seen beside Toraja tombs today. It is unusually small (most surviving older *tau-tau* are about two-thirds life-size) and still more powerfully abstracted in its execution. The bun or hair knot at the back of the head tells us that this is the figure of a woman. In precolonial Toraja society, both men and women wore their hair long, men binding theirs up in a knot on top of the head, while women favored a chignon. The solidity of this figure's head contrasts with the effacement of the limbs, weathered by the passage of time. This erosion of the arms lends the figure a sense of arrested motion, almost levitation. The open mouth, curiously reminiscent for modern viewers of Edvard Munch's *The Scream*, creates a heightened sense of drama.

It is tempting to think that the statue's mouth might have been intended to receive offerings of betel, since it was customary when seeking the ancestors' advice or blessing to visit the tomb in order to commune with them through the effigies. More recent surviving *tau-tau* often have one hand extended to receive the betel quid, the other raised in blessing. However, we cannot verify this explanation for the figure's open mouth, and there is no other extant example known that has this feature. This portrayal of the mouth may have been meant to capture the bearing of an aristocratic woman of authority, accustomed during her lifetime to public speaking and the giving of orders, as she appears to be doing here. In Toraja society, eloquence in public speaking is termed *ma'kada muane*, "to speak like a man," but it is not a trait exclusive to men. More important are the rank and personal character of the person concerned.

R.W.

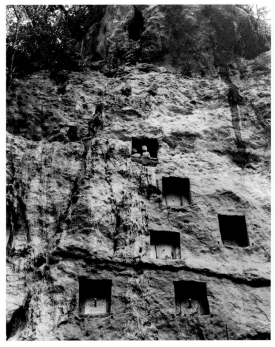

FIG 86 Rock tombs with *tau-tau* and wooden doors, Tikala district, 1988.

67

Door of a tomb (*tutu' liang*) with human figure

Indonesia, South Sulawesi, Sa'dan Toraja people
18th or 19th century
Wood
21¾ × 16½ × 4½ in. (55.2 × 41.9 × 11.4 cm)
Gift of The Eugene McDermott Foundation, 1991.362

The Sa'dan Toraja are renowned for their family tomb chambers (*liang*), cut into the living rock and sealed with an almost square wooden door. Particularly famous is the dramatic cliff face full of such tombs, with their balconies of attendant funeral effigies (*tau-tau*) at Lemo, a village some miles to the north of Ma'kale, but there are many other such sites, often in egg-shaped granite boulders, dotted around the Toraja landscape. The tombs take months to cut out of the rock with chisels, and the stonemasons take payment in buffalo; at least six or seven large buffalo with well-developed horns are still the going rate today. At an earlier historical period before the making of *liang*, the Toraja placed the bones of their dead in boat-shaped wooden ossuaries decorated with carvings, called *erong*, some examples of which still survive. Beginning in the seventeenth century, the neighboring Bugis sometimes made incursions into Toraja territory. It is said that stone tombs were developed as an alternative to the *erong*, to deter the Bugis from stealing the gold ornaments that might be buried with the high-ranking dead or sewn into the many layers of cloth in which the corpse is wrapped.

The carving on this door, which originates from the western district of Saluputti, is exceptionally fine. The guardian figure with his warrior's topknot and raised hands bars the way as if to ward off entrance by intruders. The protruding eyes, carved in strong relief, cast shadows beneath them, lending the stylized, masterfully simplified face an ethereal expression of watchfulness. The whole figure and its surround are embellished with sinuous carving, much more fluid in execution than is the tightly symmetrical, geometric style that dominates in house carvings today. The motifs include, in the upper part, trailing water weeds (*pa'tangke lumu'*), while a close variant of this in the lower part is a protective motif called *pa'suletong* (fence). The design on the figure's chest could be a form of *pa'talinga* (buffalo ears, perhaps suggesting his alertness), while that on his arms is called *pa'sulan sirendeng* (threads knitted together). On his hips is a band of *pa'bombo uai* (water boatmen). Water weeds are associated with fertility and well-being, while the long-legged insects called water boatmen that skim across the surface of the water without sinking evoke an association with rice

fields and are also said to symbolize diligence. Most significantly, the interwoven coils of the other motifs, covering the entire surface of the door, are intended to serve a protective function, just like the forbidding stance of the guardian warrior himself. Since the Toraja believe that the ancestors in the tomb bring blessings to the living, this figure serves the dual function of ensuring not only that the dead rest undisturbed but that the living should enjoy peace and long life, too.[1]

R.W.

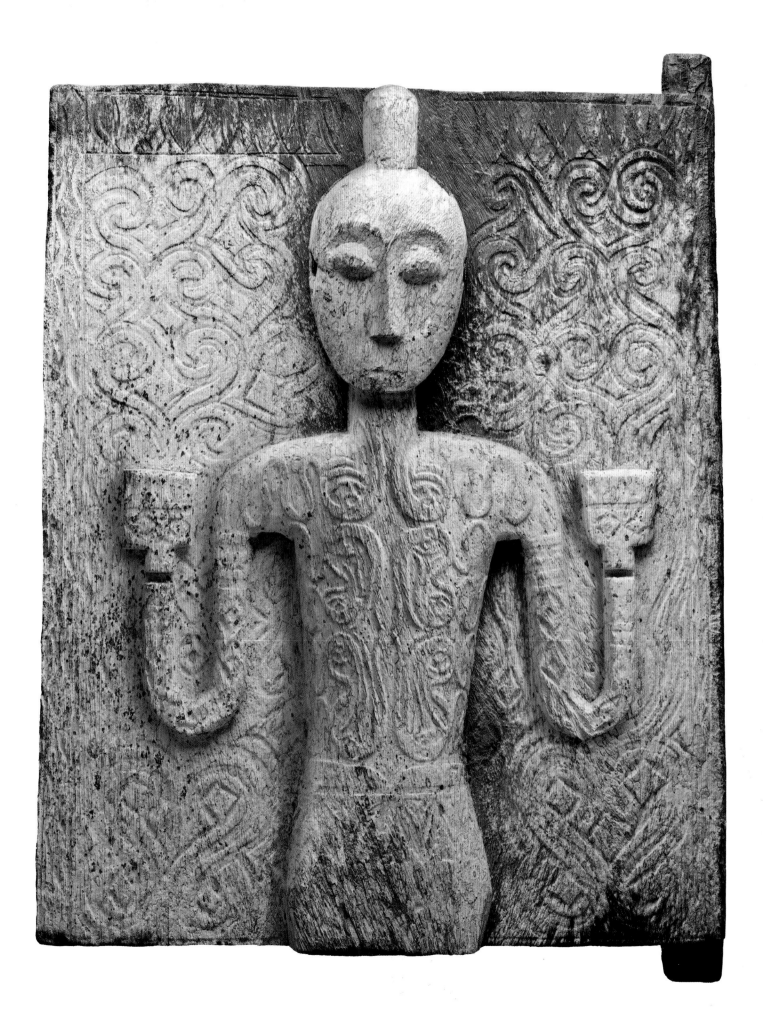

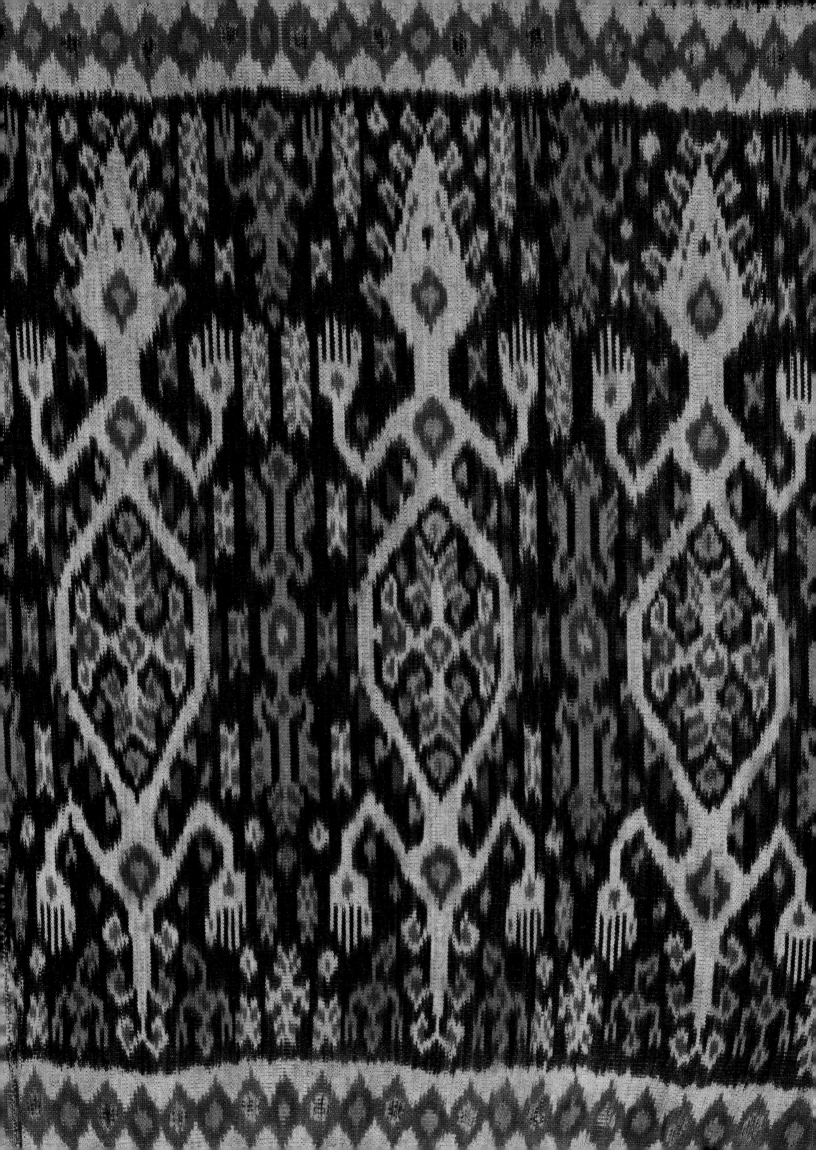

THE ART OF EAST NUSA TENGGARA: SUMBA AND FLORES

George Ellis

Modern Indonesia is an island nation of almost a quarter of a billion people and hundreds of different languages stretching from Sumatra in the west to western New Guinea (Papua) in a sweeping arc of more than 3,000 miles. In size it is the eighth-largest and in population the fourth-largest country in the world. More than 17,000 islands of striking beauty and geographic complexity encompass lush lowlands and high volcanic mountains, rain forests and grasslands subject to periods of monsoon and drought. Today's population is equally striking, and a rich tapestry of diversity reflects its complex history.

Located in the east central portion of this shimmering string of islands is the modern province of East Nusa Tenggara, consisting of more than 500 islands. The largest are Timor, Flores, and Sumba, and the combined population of the province in 2008 was roughly four and a half million. The capital is Kupang in West Timor. In contrast to the majority of Indonesia's people, who are Muslim, the people of East Nusa Tenggara are nominally Christian, but many continue to practice their traditional religion.

As outlined in the introduction to this catalogue, our knowledge of how and when the ancestors of today's population reached these islands remains problematic and shrouded in mystery. Scholars, however, theorize that intrepid immigrants began to move from south China around 4000 BCE, eventually arriving in eastern Indonesia and East Nusa Tenggara around 2000 BCE. Physical evidence of their presence is now available. Archaeological investigations have uncovered stone implements and beads, and excavations at Melolo,[1] East Sumba, yielded a rich array of goods found in urns containing human remains. Rare ceramic vessels decorated with human and animal figures were also found there. These burials have been dated by some researchers to the Southeast Asian Neolithic period (1000 BCE) and by others to the early Metal Age (500 BCE–1000 CE). Today's Sumbanese have no memory of this type of burial, stating that their ancestors were buried in stone tombs, which was indeed the case in the nineteenth century and continues today.

Stone monuments, including tombs, sculpture, platforms, and assemblages of vertical rough-hewn columns, have been found throughout Indonesia. Many of these works most likely date to the Dutch colonial period, including those present on Sumba and Flores. Early scholars proposed rather fanciful and Eurocentric origins for these sculptural works, postulating that they were the work of Indian and Mediterranean artisans.[2] The stone tombs of Sumba are now well published in academic literature and heavily frequented by tourists. They were first brought to the attention of Westerners by scholars such as Dr. H. ten Kate[3] in his late nineteenth-century descriptions and drawings. Illustrated are tombs from east Sumba, including carved upright slabs called *penji*. Since World War II, many of these carvings have been removed from their original locations and are now in private and museum collections worldwide, including two that were gifted to the Dallas Museum of Art (cats. 78 and 79). How long this sculptural and burial practice was followed before the nineteenth century is uncertain; the *penji* bear no resemblance to the early burial urns of Melolo.

Small numbers of beautiful and unique bronze drums, drum fragments, and other bronze ceremonial objects have been found throughout Indonesia, including in East Nusa Tenggara. Strangely, however, none have yet been discovered on Sumba or Flores. These striking objects have been attributed to the Dong Son culture of Vietnam (500 BCE–500 CE), possibly indicating widespread regional trade at that time, but some may also have been cast in the islands. A handful differ stylistically from the best-known pieces. Two represent females suckling their children, one standing and the other seated and in the act of weaving.[4] Recent analysis dates them to the sixth century CE and suggests that they were possibly crafted in a regional casting center on Borneo or Sulawesi.[5] The standing figure was reportedly found on Borneo, but the metal image of "the weaver" was discovered and documented on Flores, although it may have been cast on Borneo. This bronze also suggests one early date for weaving, if the information concerning its age is correct.

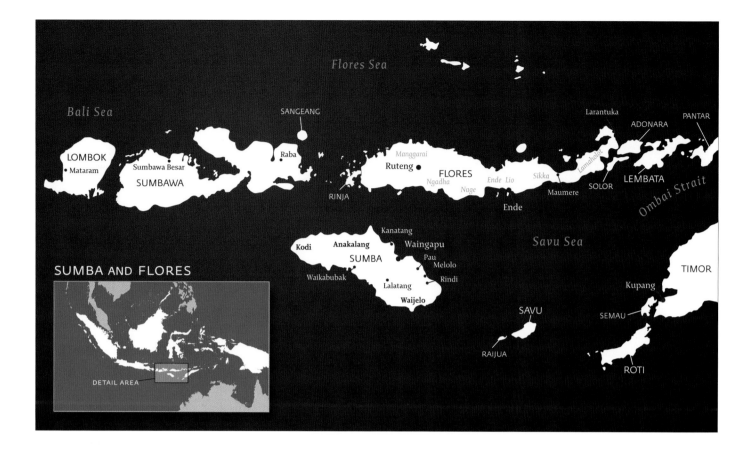

Around 500 CE, traders, scholars, and religious leaders began to arrive from India, and a period of profound societal change in the western islands followed. Buddhism and Hinduism were introduced, and large Indianized civilizations developed, particularly on Sumatra, Java, and Bali, where wealth and power were centered. By 900, monumental stone religious structures had been built, including Java's Borobudur, the largest such construction in the world.

Little archaeological work has been done that sheds light on the early history of East Nusa Tenggara, and written accounts are scant. A Chinese description from 1349 mentions trade in silver, iron, porcelain, and cloth, all exchanged for sandalwood in the Flores area, although Flores itself was not a major source of sandalwood. Other accounts refer to the influence of the East Javanese kingdom of Majapahit in the fourteenth century. It is not clear, however, what the full impact of Majapahit influence was at the time. Political and religious influences do not seem to have automatically resulted in profound change, and traditional religion and customs were largely maintained. Islamic trade centers slowly grew in power, and by the fifteenth century, they exercised considerable influence, especially in the coastal areas.

Europeans began to arrive in the early sixteenth century[6] in search of both spices and opportunities for Christian proselytizing. Their primary attention was directed to the lucrative spice trade and focused on the larger islands in the west, as well as on the Moluccas (the Spice Islands) in the east. The Dutch eventually prevailed, and their commercial interests continued to be concentrated in these areas. The people living in remote mountainous regions and the smaller islands to the east remained largely relegated to splendid isolation and benign neglect, considered as they were to inhabit backwaters of limited economic interest. Dutch military action brought Flores under the colonial umbrella only in 1846, and Sumba in 1907.

But contact did certainly occur between the peoples of these far-flung islands, linked by seafaring traders, pirates, and slavers. Island products of the forest and sea made their way to distant ports for distribution throughout the archipelago and beyond. Trade in textiles was especially active, Indian cloths being particularly desired. Widespread textile trade was conducted throughout Southeast Asia, but one type of double *ikat* (*patola*) had a major impact on the textile designs of many indigenous Indonesian peoples. On Sumba and in certain areas of Flores, talented and creative weavers drew inspiration from *patola* designs, making changes and modifications that reflect local circumstances and preferences. Trade in sandalwood and horses from Sumba and other islands was of special importance to the colonial government, resulting in the decimation of sandalwood forests in the region, as was also the case in distant Hawaii.[7]

Dutch policy toward the indigenous population was extremely pragmatic and effective. Prominent leaders of Sumba and Flores were identified, empowered, and given titles and rank by the colonial authorities. Significant gifts and payments by the Dutch assured their allegiance, at the same time enhancing their existing prestige and power. The majority of all trade was conducted under local auspices, and the trade and sale of sandalwood, horses, cattle, textiles, and slaves resulted in the accumulation of substantial wealth in the hands of a relatively small number of aristocrats.

Wealth provided the opportunity for noble families to acquire items considered prestigious and exotic. Precious metals, beads, valuable textiles, ceramics, and jewelry in gold and silver were obtained. Royal treasuries expanded, the family heirlooms (*pusaka*) of the nobility were augmented, and the fame of their owners grew. Ceremonies and rites became more elaborate and expensive as resources multiplied. The funerals of the nobility, previously ostentatious, became even more so, displays of power and prestige befitting the noble status of the deceased in this world while assuring a similarly exalted status in the next.

In many areas of East Nusa Tenggara, a dualistic supreme being was recognized. Ancestor sculptures were carved in pairs including a male and female, and female and male shrines were erected together. Opposing forces were believed to balance each other; for example, evil was balanced by good, cold by heat, and so on. Unless balance between opposite forces was maintained, chaos and calamity would follow. Governed by traditional religion, *adat* law provided guidelines that pointed the way toward tribal harmony and well-being. The arts of Sumba and Flores reinforced *adat* and had prescribed functions and forms as dictated by the customs, laws, beliefs, and ethics of the original ancestors.

On Sumba and many areas of Flores, society was divided into three classes: aristocrats, commoners, and slaves. Not surprisingly, the power and wealth of the aristocracy assured that the rarest, most beautiful, and most spectacular works of art were reserved specifically for its members' use. Beautiful textiles and jewelry connoted royal status, and certain materials used in their creation were restricted to royalty. On Sumba, the dead were sometimes wrapped in hundreds of valuable textiles, the number and quality dependent on status. With the slow demise of traditional culture, many of these works lost their meaning and value.

Sumba

Sumba, once called Sandalwood Island, lies to the southeast of Sumbawa and southwest of Flores. Its population of 600,000 is primarily Christian, though a sizable but diminishing percentage continue to follow traditional religious practices (*marapu*) and *adat* law. Its natural resources are limited, and topography and weather have created a landscape of stark contrasts. Rain is more abundant in the west, which is forested and mountainous. The east is far drier, and grassy savannahs and rolling hills once covered with sandalwood are home to herds of cattle and horses but are agriculturally far less productive.

The people of West Sumba are more diverse than are their eastern neighbors. Ten language groups are recognized. In contrast, a single language, Kambera, is spoken in East Sumba. However, the arts of East Sumba are more varied and spectacular than those to the west. This generalization is especially true with respect to textiles. A single style of *ikat* textile serves the needs of the nobility in the west, while a spectacular array of figurative *ikat* blankets and ceremonial *sarong* (*lao*) produced for both male and female members of the nobility are woven in the east. These textiles have been internationally acclaimed and collected since the late nineteenth century, and modern demand from collectors, tourists, and museums has resulted in increased production, but uneven quality. Beautiful gold and silver jewelry is found in both the west and east.

Today, the impressive stone tombs of Sumba are tourist destinations. These continue to be commissioned, but cost has resulted in many being constructed in concrete. Stone sculpture is not common. Traditionally, freestanding works sometimes embellished tombs, while others were placed at particular shrines. Figural woodcarving is rare, but game boards, musical instruments, and other utilitarian items were sometimes decorated, particularly in West Sumba.

Flores

Flores, a Portuguese word for "flower," is the second-largest island in East Nusa Tenggara, stretching for twenty-five miles from west to east. Sumba lies to the southwest, Timor to the southeast, and Sulawesi to the north. This island's topography is varied, encompassing coastal lowlands and rugged volcanic mountains that rise to over 7,000 feet. Most Westerners are familiar with the fearsome and sometimes man-eating Komodo dragons found on the west coast of Flores and on the nearby island of Komodo. By contrast, the one and a half million inhabitants of Flores are little known outside the region.

The population of Flores is divided roughly into five major ethnic groups, based primarily on language. From west to east, they are the Manggarai, Ngadha, Ende-Lio, Sikka, and Lamaholot, who today live in the five regencies (political divisions) of Manggarai, Ngada, Ende, Sikka, and East Flores. Traditionally the Florenese

FIG 87 Ancestral tomb in a kampung on West Sumba, 1910. Courtesy of KITLV/Royal Netherlands Institute of Southeast Asian and Caribbean Studies 8765.

were primarily farmers, growing cotton and indigo, dryland rice, and cassava, along with maize introduced from the West. A large percentage of today's population are Christian, but Islam has a strong presence in some areas, and aspects of traditional religious beliefs still survive in more remote and conservative enclaves.

For hundreds of years, Flores has been subject to external forces and interests that have included foreign invasions, sizable migrations of people, outside political control, and Christian and Islamic influences, all of which have served to shape the arts, particularly textiles. The full range and variety of textile styles is remarkable. Arguably, the most striking are those woven by the Ngadha noble-women of Ngada Regency, two of which are found in the collection of the Dallas Museum of Art (cats. 81 and 82).

The Ngadha draw their name from their largest clan. Society is generally composed of aristocrats, commoners, and slaves, as is the case on Sumba. The highest class, the *gae meze*, traces its ancestry to the ancient past, constituting an aristocracy based on descent. Traditionally the *gae meze* largely controlled all aspects of clan life, and specific textiles could be woven, owned, used, and worn only by its members.

In contrast to Sumba, three-dimensional figurative sculpture in wood was an important part of the artistic repertoire of the island. The Nage people, members of the Ende-Lio-Nage language group living to the east in the Ngada Regency, are particularly known for their sculpture. Figural carving may have been present in many other areas at one time, but the majority of reports and photographic evidence available during the Dutch colonial period points to this area as a center of the art, perhaps in part due to its conservative religious views.

A pair of ancestor figures in the Dallas collection (cat. 80) is exceptional and certainly among the finest sculptures created by Indonesia's indigenous peoples. While carving is still practiced in the region today, its presence is on the wane. Stone sculpture is present but rare.

Beautiful jewelry crafted from precious metals is striking, some forms echoing those of Sumba. This similarity may be explained by the fact that metalsmiths from Savu and Roti were responsible for the creation of many pieces, traveling to both Sumba and Flores to fulfill commissions for noble families.

The arts of the indigenous peoples of Sumba and Flores were shaped by thousands of years of internal and external influences, but most existing works can be dated only to the late nineteenth and twentieth centuries. It might be tempting to say that artworks present in the early twentieth century are mirror images of those created hundreds of years earlier. We know, however, that this is not the case. One can only marvel at what has survived, while regretting the loss of what once existed. Foreign influences and intervention certainly hastened the demise of arts tied directly to traditional religion, but for a limited period of time, the production and diversity of jewelry and textiles were actually energized and increased by the economic stimulus that followed, particularly among the wealthiest strata of local cultures, the nobility. The breakdown of *adat* law that had dictated the production of Sumbanese and Florenese arts, as well as the continuing growth of Islam and Christianity, have severely compromised the need for these art forms in traditional contexts as well as their function and use.

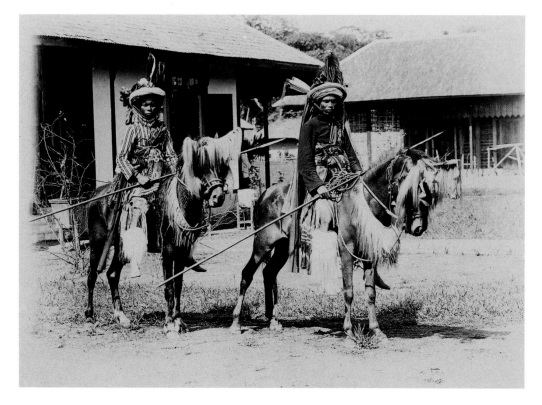

FIG 88 Two mounted warriors, East Sumba, c. 1915. Courtesy of KITLV/Royal Netherlands Institute of Southeast Asian and Caribbean Studies 4457.

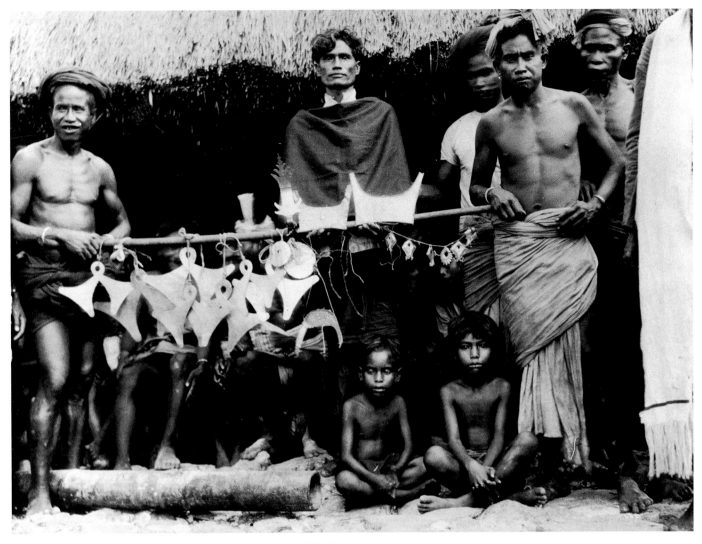

FIG 89 Jewelry and other valuables, shown by the Raja of Anakalang, Sumba, 1930–40. KIT Tropenmuseum, Amsterdam 60002196.

In Jakarta on Java, and in Denpasar on Bali, huge quantities of work that stylistically resemble traditional arts from throughout the islands can be found today. Sculpture, textiles, and jewelry are stylistically similar to those previously produced for local use, but their quality is often marginal at best. Others blend styles from different islands, and some purported to be genuine are in fact new creations that bear little resemblance to traditional art. Some newly manufactured sculpture and jewelry are intentionally "aged" in order to bring higher prices. All of this merchandise, however, lacks the intrinsic power and "soul" of the original artifacts, and is purely decorative.

Nevertheless, some artists—especially weavers—continue to serve limited local demand with exceptional textiles while also working for an international clientele.[8] Their special talents and creativity have also led to new art forms, based on traditional styles, but demonstrating departures and innovations that are very exciting and promising. Beautiful jewelry is also produced, including excellent fakes, reproductions, and new styles. One can only hope that the gifted artists of these islands will find new outlets, patronage, and audiences in the international marketplace. The role of the arts in Sumba and Flores has changed, but the creative potential of their peoples has not.

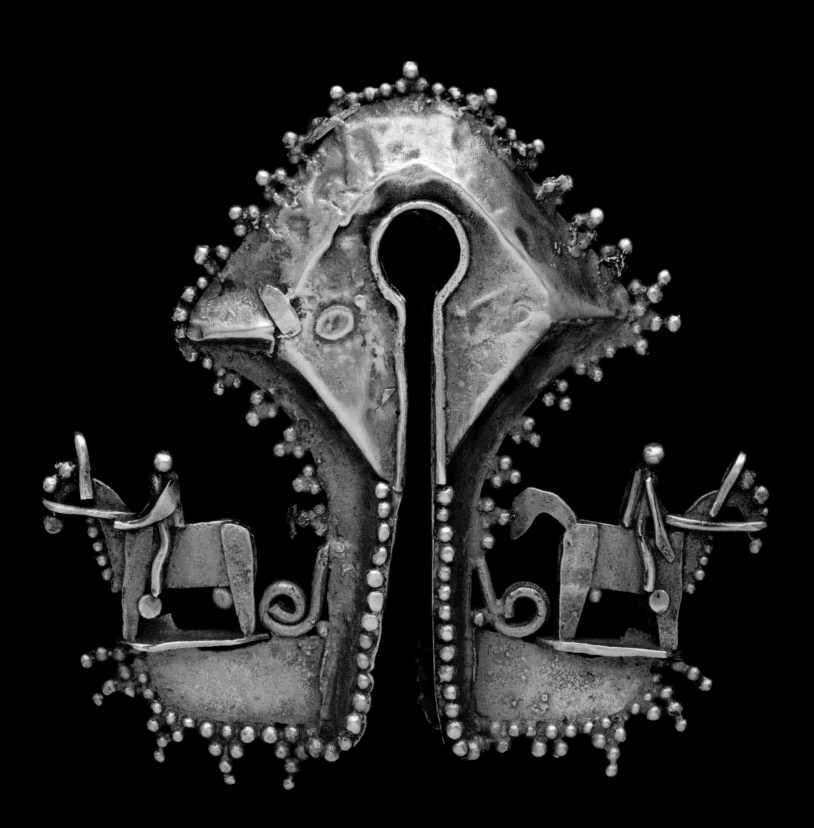

68

Ear ornament or pendant
(*mamuli*)

Indonesia, Lesser Sunda Islands, West Sumba, Kodi
19th century
Gold
2½ × 2½ × ½ in. (6.4 × 6.4 × 1.3 cm)
Gift of The Nasher Foundation in honor of Patsy R.
and Raymond D. Nasher, 2008.66

Avidly sought by museums and private collectors, gold and silver earrings (*mamuli*) from Sumba are perhaps the most widely admired type of jewelry from eastern Indonesia. The antecedents of today's *mamuli* can be traced to Southeast Asia, and ancient examples in metal and greenstone have been found in archaeological contexts in Vietnam, Taiwan, Indonesia, and the Philippines.[1] Related *mamuli* forms and shapes are found today on many Indonesian islands, but the shimmering gold and silver earrings of Sumba are unsurpassed.

Mamuli are considered either male or female, their overall shape being similar to the uppercase Greek letter omega.[2] Male *mamuli* are more lavishly decorated with beadwork and braid work, and have bases (feet) on which stand a variety of human, animal, and bird figures, and narrative tableaux depicting warriors and equestrians. Female *mamuli* are simpler and do not have "legs." Contemporary informants state that whether male or female, Sumbanese *mamuli* represent the female vulva and, thus, fertility.[3]

Although similar in appearance, *mamuli* are not of equal value and importance, and factors such as age, size, quality, and historical significance serve to determine their specific context and use. The most valuable were worn and displayed only on important ceremonial occasions. They also played an especially important role in marriage exchanges[4] and funerals, and served as sacred altar objects employed by priests to contact the spirits (*marapu*). Some especially valued and sacred *mamuli* from East Sumba could be taken down from their special storage areas in the attic of clan houses only after one had taken careful ritual precautions; these sacred items were charged with the "heat" of intense spiritual power. Fewer restrictions were imposed on the use and function of West Sumbanese *mamuli*. During special *adat* ceremonies, large numbers of gold and silver ornaments, including *mamuli*, are today worn by young girls in ostentatious displays of wealth and social position.[5]

This simple, bold, and powerful *mamuli* is from West Sumba, differing from others found in East Sumba that are more delicate, elaborate, and Baroque in feeling. The patina and wear of this extraordinary ornament indicate considerable age. On its unusually wide "legs" stand opposing horsemen who sit astride their sturdy mounts with assurance and pride. Horses are always depicted on *mamuli* with tails held high; over time the horse's tail at the left has been lost, although without any diminution of its regal posture.[6] Equestrian figures represent the exalted status of noblemen. In this particularly fine example, valued gold has been transformed into a strikingly lustrous statement of wealth, status, and privilege.

Many *mamuli* and other gold ornaments were apparently not made by local Sumbanese. The literature seems to indicate that the majority are the work of itinerant specialists from the nearby islands of Savu and Ndao, of Savunese settlers on Sumba, or of Chinese metalsmiths. In recent years, the Sumbanese have also employed Balinese or Chinese-Indonesian goldsmiths to fabricate new pieces or repair older examples.[7] These unnamed metalsmiths have created works of lasting beauty that are integral to all aspects of Sumbanese life.

G.E.

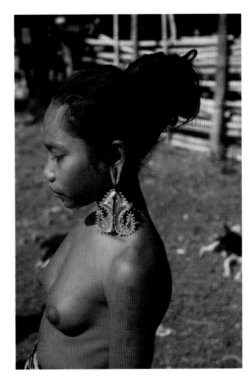

FIG 90 Woman of Paronambaroru village, Kodi region, West Sumba, wearing a *mamuli* ear pendant, 1949. Museum der Kulturen. Basel, Switzerland.

69

Crescent-shaped ornament
(*tabelo*)

Indonesia, Lesser Sunda Islands, West Sumba,
Anakalang
19th century
Gold with rattan (*rotan*) binding
10¾ × 10¼ × ¼ in. (27.3 × 26.0 × 0.6 cm)
Gift of The Nasher Foundation in honor of
Patsy R. and Raymond D. Nasher, 2008.65

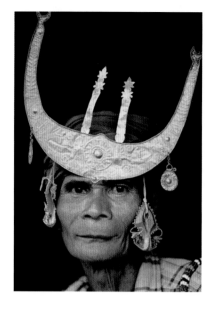

FIG 91 Retainer wearing
royal jewelry at the funeral
of T. U. Windi Tananggoendjoe,
Pau village, East Sumba, 1983.

During the colonial period, Sumba horses were in great demand by the Dutch for use as cavalry mounts. Sturdy steeds brought a high price, and payment was frequently made in gold and silver coins. In addition, gifts of precious goods, including gold and silver staffs of office, were made in order to gain the support and loyalty of important noble clans. Such transactions resulted in the accumulation of great wealth by these families, especially during the nineteenth and early twentieth centuries—wealth demonstrated in part through the amassing of spectacular ornaments and jewelry. Gold and silver coins were often worn without alteration, but many were melted down by metalsmiths, who created a wide variety of jewelry that served as symbols of aristocratic power and prerogatives. Among the most elegant and impressive of these superbly executed pieces are crescent-shaped ornaments. This ornamental form is found not only in Sumba, but also in Nias and Sumatra in the west, and to the farthest eastern reaches of the archipelago.[1]

Contemporary examples are thought to date from the nineteenth to the early twentieth centuries, but similar forms that are considerably older have been unearthed in archaeological contexts on Java.[2] Exceptional works from the eastern islands evidence a similarity of workmanship and design that often includes a central boss, possibly representing the sun. Its overall shape could be said to represent buffalo horns[3] or ships with impressive prows.

On Sumba, these ornaments are included in clan treasuries[4] and are among the most sacred possessions of a noble family. In East Sumba, they are called *lamba* and on very rare occasions are worn as a man's forehead decoration. They are kept in special storage areas in a house attic and used during important ceremonies and rituals. They require special handling and extraordinary care lest great misfortune befall their owners. Specific heirloom pieces represent sacred relics, imbued with special powers, sometimes serving as a spiritual conduit between the living and the world of the spirits.[5]

In West Sumba, *lamba* are called *tabelo* or *tobelu*. As with *lamba* from East Sumba, they are stored in secure areas of the house and are considered sacred possessions of the spirits (*marapu*). *Tabelo* are worn by the sons of aristocratic families as regalia for dancing during important ceremonies.[6] During high-status weddings, the bride, in addition to other finery, may also wear a *tabelo*.[7]

Without specific provenance, it is difficult to determine the precise geographic origin of *tabelo*; the Dallas nineteenth-century *tabelo* appears to be from Anakalang, West Sumba, or a nearby village. Fabricated from a thin sheet of richly patinated gold, this ornament's repoussé decoration includes a central boss surrounded by what appear to be references to heirloom earrings (*mamuli*), two riders who sit astride mythical horned mounts, and writhing serpents from the world of spirits. The rider to the left (riding a female horse) is male, complemented by the female (riding a male horse) to the right. Serpents are underworld creatures that give rise to upperworld potency and fecundity. Sprouting from their tails are the repeated tendrils of plant life, which, like growth seeking the sun, rise vertically to the upper world. In style this ornament is similar to other *lamba* from East Sumba,[8] some of which may have been executed by the same itinerant artists.[9] Whether from east or west, their beauty and presence make them remarkable examples of the talent and skill of indigenous metalsmiths.

G. F.

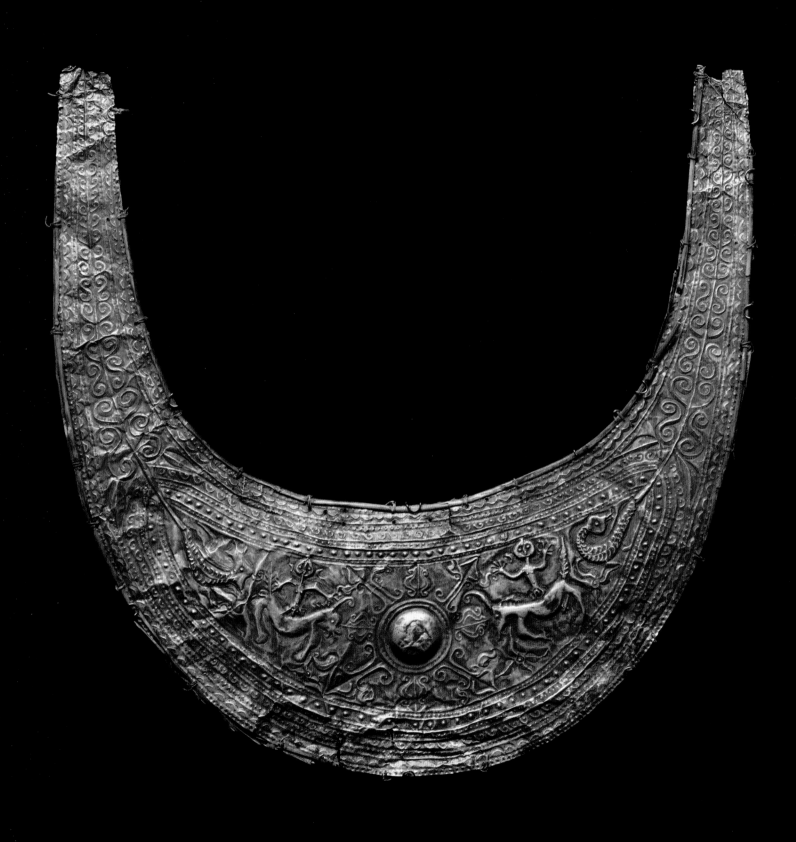

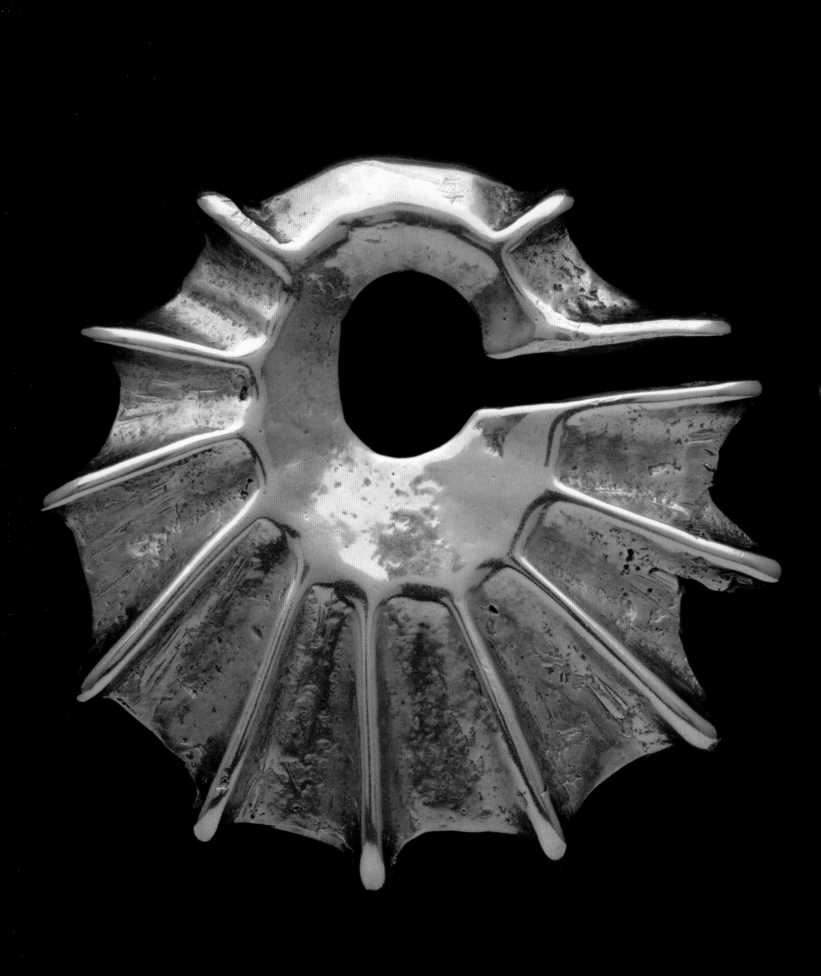

Ceremonial pendant (*mendaka*)

Indonesia, Lesser Sunda Islands, West Sumba,
Lamboya, Bogar Kahale
19th century or earlier (possibly 14th to 16th century)
Gold alloy
2½ (diam.) × ¼ in. (6.4 × 0.6 cm)
Intended gift of Steven G. Alpert and Family to the
Dallas Museum of Art, PG.2013.10

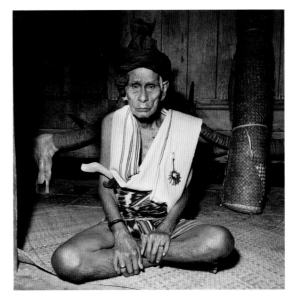

FIG 92 Amawau, Bogar Kahale, Lamboya,
West Sumba, 1989.

Authentic *mendaka* are extremely rare.[1] Unlike large earrings or crowns, *mendaka* are not found in East Sumba. Their ownership is largely localized to the area around Anakalang in West Sumba. In *Power and Gold*, Susan Rodgers has described this type of pendant as "apparently an uncommon and perhaps idiosyncratic ornament."[2] According to Umbu Sangera, a former village headman of Anakalang, *mendaka* are ancient ornaments whose origin is shrouded in mystery.[3] Such an ornament was worn only by aristocrats as a chest piece or jacket pin, or was displayed when an important person died. They were also worn by the paramount war chiefs as an emblem of their rank and prowess.[4]

This large and truly exceptional *mendaka* comes from the kampung of Bogar Kahale, a traditional village perched on the summit of an imposing hill in Lamboya. It was once owned by an aristocrat there named Amawau (figs. 92 and 93). Amawau did not inherit this pendant from his father. One evening, nearly seventy-five years ago, he was awakened by the voice of a hornbill, a *burung badak*.[5] The bird's song was so strange, so eerie, that Amawau took its presence as an omen. The next day, he journeyed to Kampung Winituna in Wonokaka, where he went to visit the widow of his great-uncle, Rato Muna Nganga. It was there, after promising a prescribed

number of buffalo and cattle, and after completing other ceremonial requirements, that Amawau received this precious pendant from his great-aunt.

Amawau never intended to part with his pendant, but one night, the omen bird returned, and a sequence of events that had occurred nearly fifty years ago repeated itself.

> It was late as I looked out of the window. There, exactly as had happened many years before, the *burung badak* reappeared and sang to me. It was that same strange song. I never wanted to part with my *mendaka*. The *mendaka*'s container began to shake—the *mendaka* began to awaken and move. It then began to walk. I tried to prevent this from happening, and in clutching the box became feverish while attempting to prevent the inevitable. I knew then that it was time for the *mendaka* to pass to its new and rightful owner.[6]

Legend has it that forty-eight of these pendants were brought to Sumba and given to "big men" there. They range in size from much smaller examples to the size of this pendant. Cornelis Kadobo, the son of Amawau's elder brother, stated that *mendaka* were originally presentation pieces given by emissaries of the Majapahit empire of East Java to those who may have been Amawau's remote ancestors.[7]

According to Amawau, this *mendaka* is an object of tremendous power. He described the elongated finial as the head of a winged snake-dragon or serpent (*ular galar*), which guards a sacred cave. This cave contained both material riches and the knowledge necessary for personal illumination. A *mendaka* in the hands of a strong man is a key that allows access into this sacred cave. Its ten distinctive prongs are considered to be "male" and represent "the perpetual turning of the cosmos."[8]

S.G.A.

FIG 93 Amawau and sons, Bogar Kahale, Lamboya, West Sumba, c. 1960.

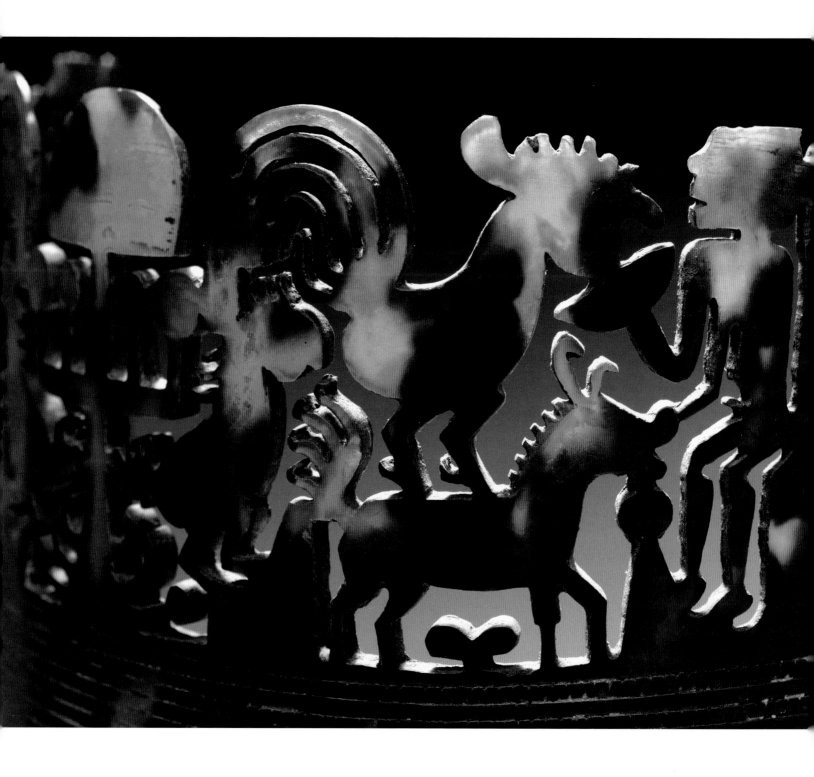

71

Comb (hai kara jangga)

Indonesia, Lesser Sunda Islands, East Sumba,
Melolo
Late 19th century
Turtle shell
6¾ × 6 × 2¼ in. (17.1 × 15.2 × 5.7 cm)
Gift of The Nasher Foundation in honor of
Patsy R. and Raymond D. Nasher, 2008.63

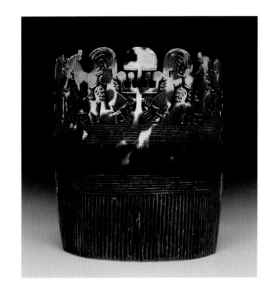

In the Lesser Sunda Islands, the use of turtle shell for crafting items of personal adornment is not common.[1] On the island of Sumba, however, striking women's combs were fashioned from this precious and beautiful material. Combs fabricated from turtle shell (hai kara jangga) were worn by adult upper-class women on important ceremonial occasions, and fathers gave them to their teenage daughters when the girls reached puberty and were of a marriageable age.[2] They were worn at the back of the head as a symbol of sexual maturity and availability.[3] These valued and handsome combs were included in the inventory of goods forming royal treasuries, along with ivory bracelets, ornaments of gold, silver, and other metals, textiles, and important porcelains.[4]

Sumba artists took maximum advantage of the natural shape of a turtle's curved back to create combs that follow the curve of a woman's head. Their upper section is fenestrated to reveal simple abstract designs, birds, horses, aquatic creatures, skull-trees (andung), and occasionally humans, motifs that refer to wealth and important aspects of the secular and religious life of the community.

The Dallas comb, collected in Melolo, East Sumba, is populated with cocks, cockatoos, and horses flanking a skull-tree, with human figures at each end. Roosters are sacrificial animals associated with the upper world, and horses are symbols of upper-class wealth and prestige. A leafless skull-tree (andung) occupies a prominent location in the center of a village. The Sumbanese were once headhunters, and after a successful raid the skulls of the vanquished were displayed on the branches of such a tree. Severed heads not only declared the prowess of warriors, but also proclaimed the good luck and prosperity that would surely follow their successful hunt.

The use of turtle shell as a material for crafting noblewomen's combs is appropriate, since turtles (tanoma) are symbols of noble lineage. Turtles are carved on memorial stones (penji)[5] and are also motifs on the clothing of the aristocracy, both male and female. Considered one of the oldest creatures in the sea, they are associated with seniority, wisdom, and diplomacy and in myth act as guides for heroes "undertaking epic journeys."[6]

The natural beauty of the variegated translucent shell combined with the technical virtuosity of the comb's maker together result in a superlative example of Sumbanese art.[7]

G.E.

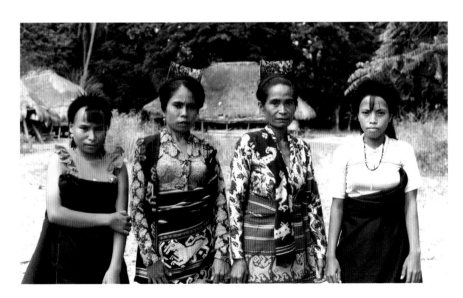

FIG 94 Two girls flanking two aristocratic matrons wearing combs in their hair as a sign of their married status, Pau village, East Sumba, 1976.

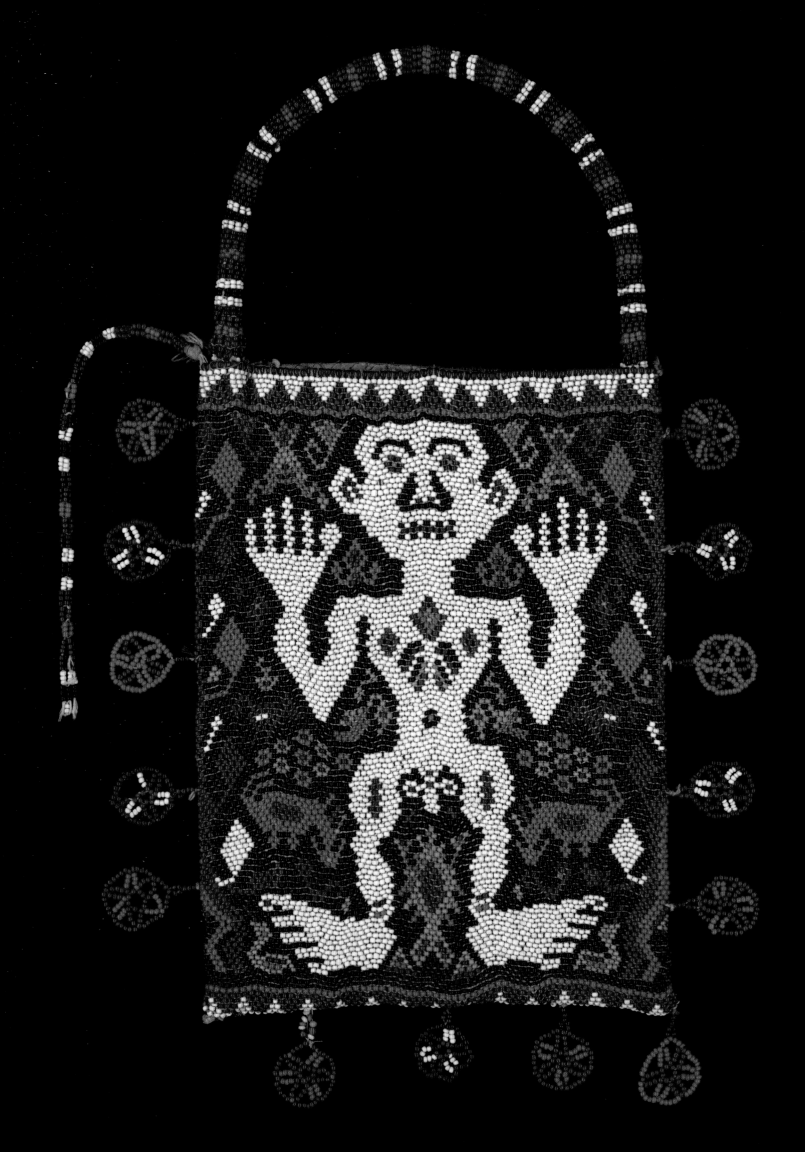

Betel nut bag (kalimbut hada)

Indonesia, Lesser Sunda Islands, East Sumba, Rindi (?)
Late 19th or early 20th century
Plant fiber, beads
21¾ × 14¼ in. (55.2 × 36.2 cm)
The Steven G. Alpert Collection of Indonesian Textiles,
gift of The Eugene McDermott Foundation, 1983.99

Betel nut chewing is practiced from India to New Guinea and north-ward to the Philippines. Its origins are not known, but it is assumed that the practice began thousands of years ago.[1] The ingredients for a chew consist of a betel (areca) nut, the leaf of a pepper vine, and a touch of lime. Chewing acts as a mild stimulant, somewhat similar to a cup of coffee. In addition to its physiological attraction, betel nut chewing is firmly embedded in the social and religious fabric of Indonesia. Betel nut is offered as a sign of hospitality and friendship throughout the region and to the spirits during rituals and ceremonies.

Betel nut containers are made from diverse materials, reflect-ing culture, class, and region. Those composed of plant materials, wood, and cloth are often decorated with valuable and precious beads and shells. Metalsmiths fashioned skillful designs in gold and silver that were sometimes embellished with precious gems.

Gold and silver containers for betel nut, pepper leaves, and lime, as well as their accompanying spittoons, are beautiful examples of technical virtuosity and aesthetic genius, but few complete betel nut sets have survived.[2] Honored guests of the royal courts of Java were served betel nut as a gesture of friendship and welcome at rites of passage including marriage, circumcisions, ritual tooth-filings,[3] death, and burial.

In the more remote regions of the country, indigenous island-ers carried the ingredients for a betel chew in less ostentatious containers that were especially made for this purpose. While their function was similar, their decoration and ritual use varied.

Men's beaded betel nut bags (kalimbut hada) from East Sumba are among the most striking and ornate. These exceptional ceremonial bags were highly valued and imbued with symbolism associated with status and power. Heirloom bags were included in the sacred treasuries of noble families,[4] and were displayed at important ceremonies including funerals for men of the nobility. During the mourning period, they were brought daily to the grave site.

Bags were completely covered with beaded designs and motifs associated with the ruling nobility and could be made only by women of noble lineage. Beads were said to be gifts of the ancestors, indicating their sacred nature and value. Most seem to be of European origin, and colors include white, pink, green, blue, orange (gold), and rust. Birds form the primary motif on many bags, but examples also feature deer, chickens, and a Dutch coat of arms. Similar beaded images and configurations were also worn around the neck as part of traditional funerary finery[5] and as headbands.[6]

The royal, beautiful, and rare Dallas piece, acquired in the 1970s in East Sumba, features a large white male figure with raised arms that dominates the bag. On either side of the neck is an omega-shaped form (mamuli). Triangular shapes form the border at each end of the bag. The background is filled with various abstract forms and figural elements that represent birds, possibly deer and horses, and other anthropomorphic creatures. Attached to both sides and the bottom of the bag are openwork circular pendants. A handle and strap hangs at one side. This exceptional example is a bold aesthetic statement that proclaims the exalted status of its owner and the prominent role that betel nut chewing played among the Sumbanese people.

G.E.

73

Woman's skirt (*lau pahudu*) (detail)

Indonesia, Lesser Sunda Islands, East Sumba, Pau
19th century
Homespun cotton
26½ × 61 in. (67.3 × 154.9 cm)
The Steven G. Alpert Collection of Indonesian Textiles,
gift of The Eugene McDermott Foundation, 1983.94

The name *lau pahudu* is derived from the verb *hudu*, which means "to land, to fish, to catch in a dip net," and *pahudu*, meaning something that has been "landed or caught."[1] Appropriately, the dominant motif of this supplementary warp[2] skirt is an extraordinary, large, and bold fish.

It is difficult to determine the specific type of fish appearing on *lau pahudu*, since no examples exactly mimic the characteristics of a particular species. It has been suggested that this fish is a ray.[3] Rays have a horizontally flat body, both eyes on the upper surface, and a slender whiplike tail. While this fish does exhibit a horizontally flat body with both eyes on the upper surface, its tail is not that of a ray. Plaice (flatfish) also have a horizontally flat body with both eyes on the upper surface, but they do not have a forked tail.[4] The lines shown inside this fish possibly represent bones, a device also used regularly in the depiction of human figures. Fish and other aquatic creatures are associated with the underworld. Revered ancestors manifest themselves in fish, including plaice, which are not a species eaten by the Sumbanese.

In this case, the large fish is accompanied by two female consorts wearing *mamuli* and two horses with riders. The fish is not perfectly centered in the composition; five alternating brown and white lizards (*kumbu*) form a vertical band to its left. Scorpions complete the tableau. The fringed band above contains alternating rows of white and brown horses, symbols of wealth and prestige.

This remarkable nineteenth-century textile is not only technically superb, but aesthetically compelling. Among the few pieces with credible documentation concerning provenance, this skirt belonged to the grandmother of Windi Tananggoendjoe, the Raja of Pau.[5]

G.E.

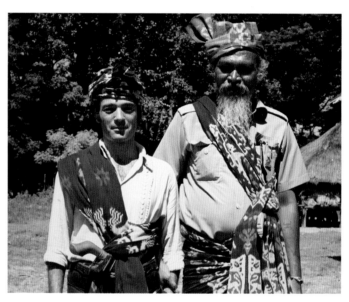

FIG 95 Raja Tananggoendjoe of Pau with Steven G. Alpert, 1976.

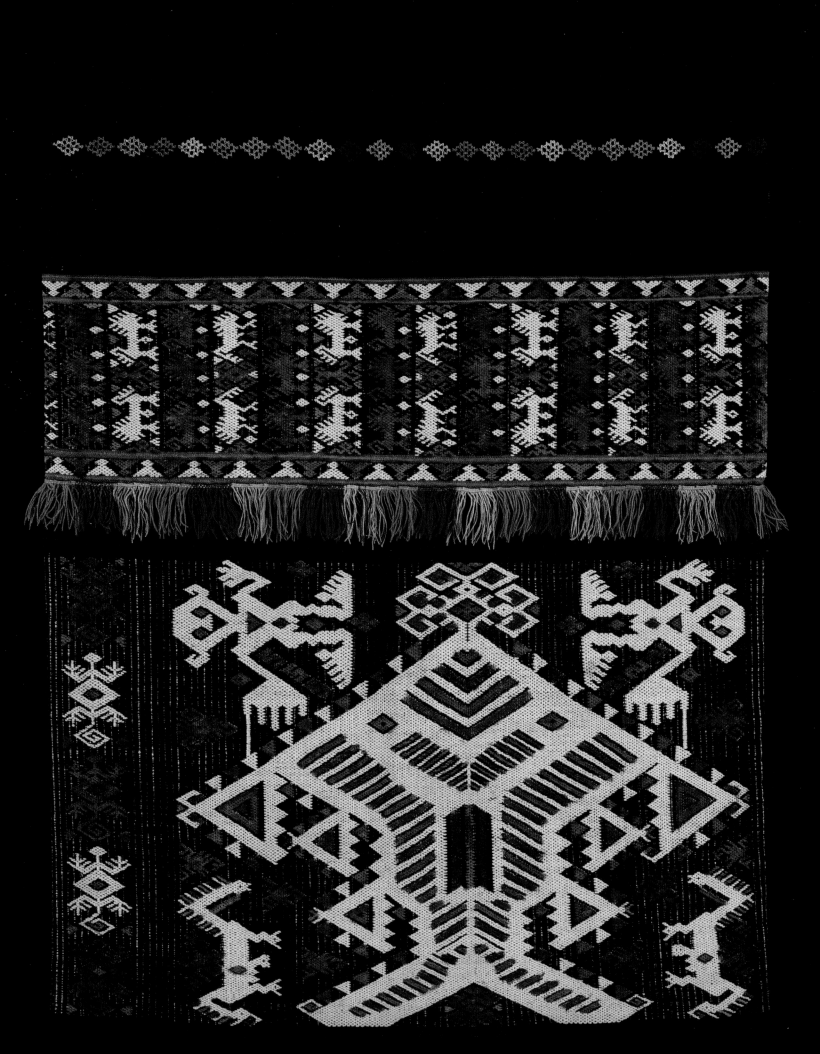

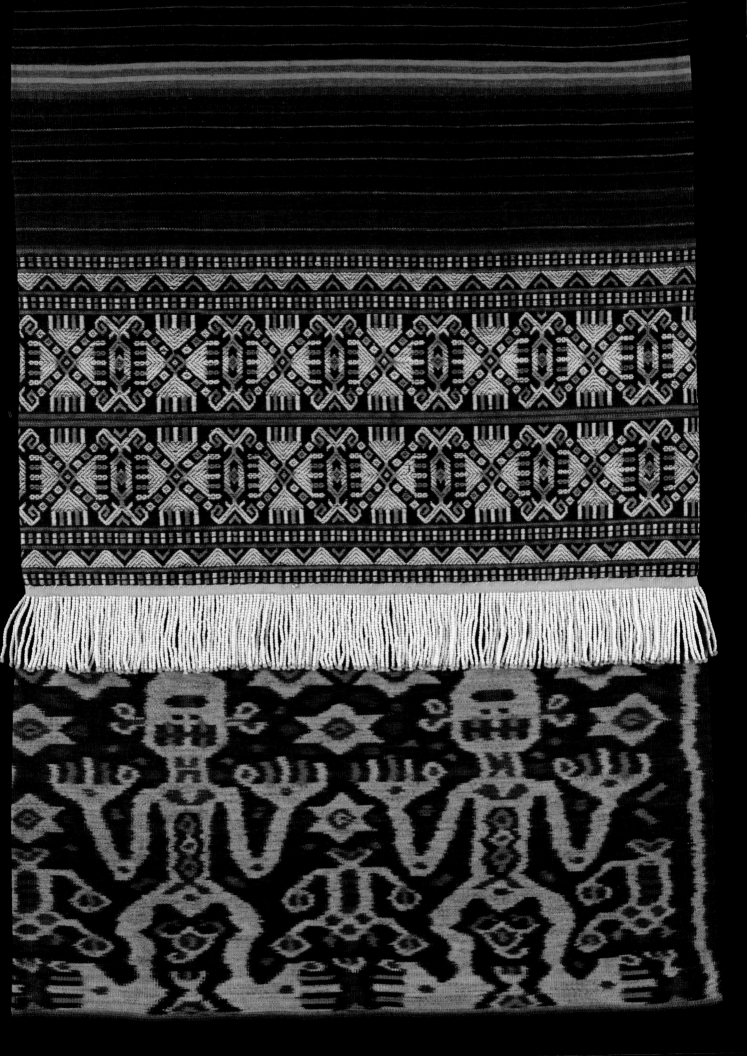

74

Woman's skirt (*lau pahudu*)
(detail)

Indonesia, Lesser Sunda Islands, East Sumba,
Rindi area
Late 19th to early 20th century
Homespun cotton and beads
55½ × 23¾ in. (141.0 × 60.3 cm)
The Steven G. Alpert Collection of Indonesian Textiles,
gift of The Eugene McDermott Foundation, 1983.95

Supplementary warp weaving, although rare in Indonesia, is practiced in East Nusa Tenggara (Lesser Sunda Islands) and on the islands of Bali, Timor, and Ternate, and on Tidore in the Moluccas.[1] Best known, however, are women's skirts (*lau pahudu*) from Sumba. Here, these valuable cloths are woven by women of the nobility and worn by them only on important ceremonial occasions. Paired with *hinggi*, men's ceremonial hip cloths, they also serve as an important category of objects transferred during marriage exchanges. Superior weavers are held in high esteem, and their expertise and value are recognized both before and after marriage.

Supplementary warp weaving is extremely difficult to master and execute.[2] In contrast to the production of *hinggi*, in order to create *lau pahudu*, weavers use pattern guides, following established motifs and styles, some of which have possibly been passed down through the generations with only minor changes.

Only the bottom portions of *lau pahudu* are decorated with figurative and geometric motifs. The upper half (which is not seen when the skirt is worn) consists of a solid dark ground with horizontal stripes in various colors. The bottom band of this rare and beautiful piece is *ikat*-dyed.[3] Two female figures with their arms raised (and perhaps wearing *mamuli*) dominate the space, while scorpions are placed underneath the genitalia. Alternating with these large figures are three smaller anthropomorphic forms and geometric star-shaped designs. The wide fringed band above contains two rows of geometric motifs, reflecting the influence of Indian *patola*, executed in supplementary warp. The combination of these two techniques produces an exceptionally powerful and compelling visual effect, the sharply rigid imagery of the supplementary warp band playing against the narrative and softer quality of the *ikat*-dyed section.

G.E.

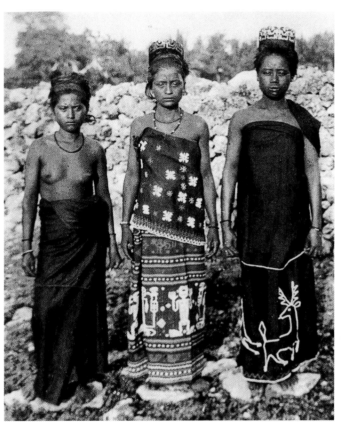

FIG 96 Women of East Sumba, 1930. KIT Tropenmuseum, Amsterdam 10002786.

75

Man's shoulder or hip cloth
(*hinggi*)

Indonesia, Lesser Sunda Islands, East Sumba
19th century
Homespun cotton
109 × 33¼ in. (2 m 78.9 cm × 84.5 cm)
Textile Purchase Fund, 1995.94

Traditionally, Sumbanese men's *ikat* cloths,[1] called *hinggi*, could be woven only by upper-class women. Women planted and harvested the cotton, carded and spun it, prepared the dyes, applied the motifs, wove, and completed the fabrication of these remarkable textiles. Great care was taken with the finishing of a superior piece, including precise joining stitches, and the addition of corded fringes and terminal borders (*kabakil*). The finest examples also include an added yellow/tan color that was daubed on the textile after weaving was completed. The yellow stain is perhaps Sumba's answer to the gilding of cloth that one finds in Bali, Java, and Sumatra.

The two primary colors of a *hinggi* are blue (*wora*) and a rust-colored red. The most highly prized color, this rusty shade of red, is obtained from the roots of the kombu tree, while blue can be extracted from both wild and cultivated indigo. The intensity of these colors is determined by the number of times the thread is dyed before weaving. The application of one color over another results in still greater variation. Yellowish tan daubed over blue, for instance, results in a green.

The range and variety of motifs depicted on *hinggi* are exceptional. In addition to their decorative quality, *hinggi* reflect the social and religious life of the community, while validating and confirming royal wealth, privilege, and power. Indigenous motifs include ancestor figures, jewelry, horses, stags, lizards, crocodiles, turtles, cockatoos, lobsters, and shrimp. Various combinations of this imagery can also appear on other royal prestige goods. Foreign symbols of authority and power—such as elephants, Dutch heraldic figures taken from coinage, and dragons copied from highly valued Chinese jars—are also frequently incorporated.

The colors of this *hinggi* are darker, and its design far bolder and less dense than in its companion piece (cat. 76). Both are examples of nineteenth-century *hinggi* created by exceptionally skilled weavers for local use rather than trade. The primary motif of this striking piece is the skull-tree (*andung*). In addition, male ancestor figures in the orant position, along with anthropomorphic figures and birds,

occupy the large bands at each extremity. Smaller bands that frame these end registers depict what seem to be dragons.

Headhunting was a widespread practice in Indonesia—including in Sumba—before its suppression by colonial officials. The taking of heads signified male bravery and guaranteed good fortune as well as fertility for both land and people. Skull-trees were erected in the center of the village, the dead trees stripped of leaves and bark and enclosed in a base of stones. The skulls and mandibles of defeated warriors hung from them, symbolizing the future well-being of the community. *Hinggi* that depict skull-trees became popular with tourists who were attracted to the more sensational and exotic aspects of Sumbanese culture. Although the motif remains popular, current commercial examples are of highly inferior quality.[2]
G.E.

FIG 97 East Sumbanese weaver tying the *andung* (or skull tree) pattern into warp threads of a man's mantle, 1978.

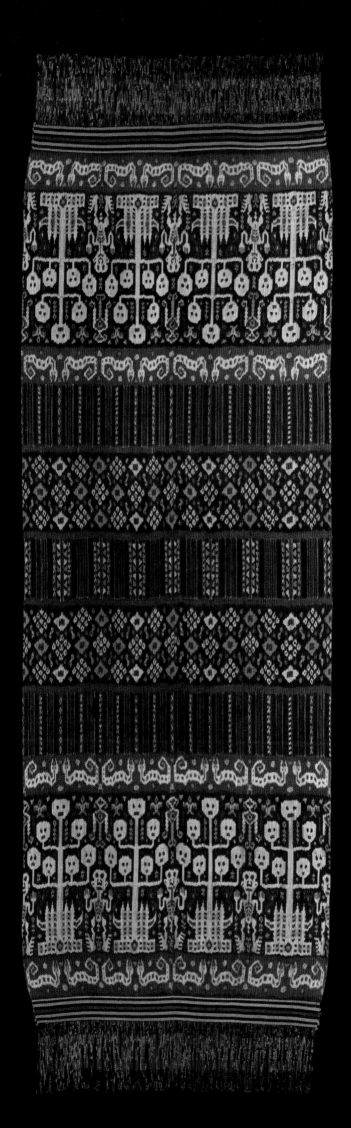

76

Man's shoulder or hip cloth (*hinggi*)

Indonesia, Lesser Sunda Islands, East Sumba, Kanatang village
19th century
Homespun cotton
104 × 43¾ in. (2 m 64.2 cm × 111.1 cm)
The Steven G. Alpert Collection of Indonesian Textiles,
gift of The Eugene McDermott Foundation, 1983.91

Sumba is internationally known for the beauty, originality, and power of men's *ikat* cloths, called *hinggi*. These impressive textiles were avidly collected by the Dutch and other Europeans beginning in the early twentieth century. In Europe, exhibitions were mounted, scholars published important articles, and homes featured *hinggi* as decoration. More recent scholarship has added to the understanding of their complex uses and functions, further enhancing their appreciation in the West.

While most *hinggi* were woven for trade purposes, the finest examples were reserved for indigenous use. To own *hinggi* was the right and privilege of noblemen, and the number and quality of colors, the materials, and the technical virtuosity of the weaving and motifs pictured were important factors that denoted superior textiles, along with the status and power of their owners. *Hinggi* are worn in identical pairs; one cloth is wrapped around the waist and the other draped over the shoulders. Only donned during important ceremonial occasions, they were carefully stored in specific areas of a house's attic and constituted an important part of the house treasury of noble families. *Hinggi* also served as marriage exchange gifts and as presentations on other occasions associated with both secular and religious life. Perhaps their most important function involved their role in funerary activities, when the corpse of an important nobleman was sometimes wrapped in hundreds of *hinggi* and could lie in state for many years before being buried.

Dating to the nineteenth century, this exceptionally beautiful and technically superior *hinggi* is colored with red, rust, blue, green, and yellow/gold dyes whose interactions result in a rich tapestry of sparkling yet subdued design elements. Revealing the hand of an outstanding textile artist, this work was once the property of the kings of Kanatang.

The wide bands at each extremity feature eight[1] large lizards or crocodiles[2] along with smaller anthropomorphic and crocodilian figures that are used as filler. A large center field is inspired by *patola* designs.[3] In some areas of East Sumba, it is believed that crocodilian creatures represent one of the original ancestors (*marapu*), and they are never killed or eaten. According to local belief, they cause no harm to people unless some offense against a clan descended from the crocodile ancestor has been committed. Young noblemen are called "children of the crocodile." Crocodilian creatures are said to live in human form in a village beneath the sea.[4] Their depiction on this *hinggi* links its owner to the distant past and verifies and validates his regal status.

G.E.

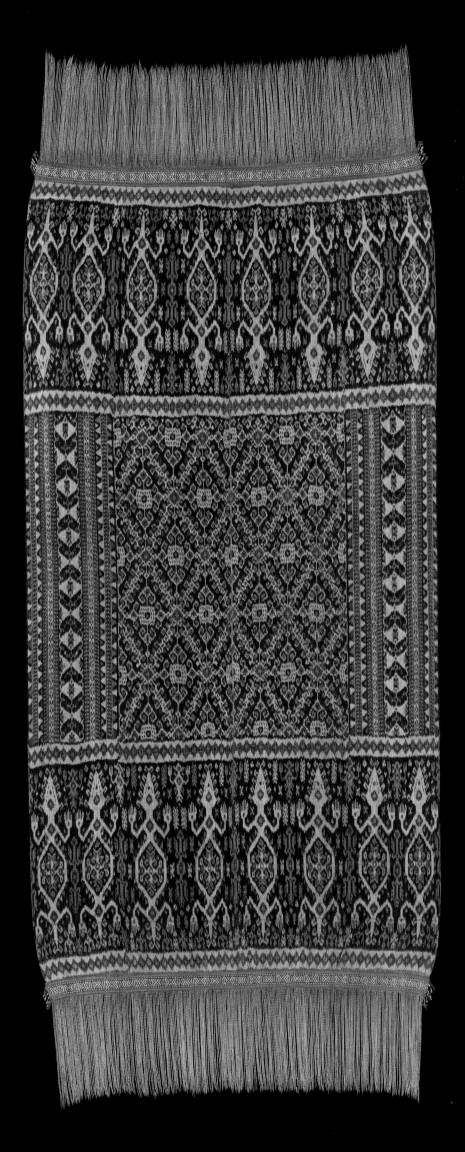

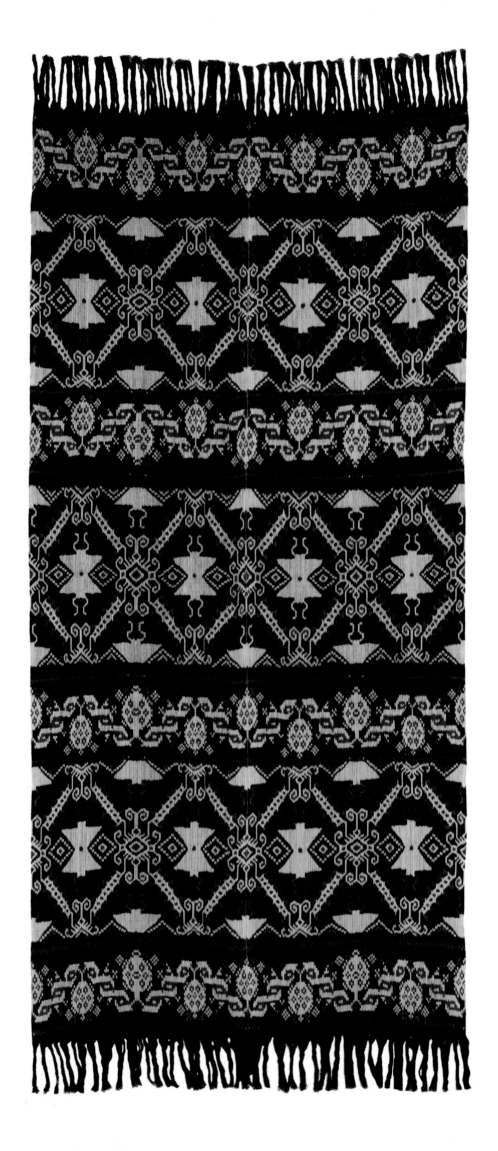

77

Man's shoulder or hip cloth
(*hinggi*)

Indonesia, Lesser Sunda Islands, East Sumba, Melolo
Early 20th century
Homespun cotton
104¼ × 45¼ in. (2 m 64.8 cm × 114.9 cm)
The Steven G. Alpert Collection of Indonesian Textiles,
gift of The Eugene McDermott Foundation, 1983.93

This striking and unusual textile differs significantly from the other two examples of men's cloths (*hinggi*) illustrated in this catalogue (cats. 75 and 76). It is divided into seven horizontal bands, and its motifs and coloration produce a bold overall abstraction of aquatic life. Three larger bands are filled with designs that were identified by the weaver as rays "jumping or skipping over the surface of the water at sundown," while the four smaller bands depict "turtles breaking waves" and emerging from the surf to lay their eggs.[1] The ground is a deep indigo, the yarn having been dipped in the dye numerous times to produce a rich blue-black hue. The turtles, rays, waves, surf, and other more abstract forms appear to swim on a velvet blue sea in contrasting colors of rust, the natural off-white of the yarn, and light blue accents.

Aquatic animals such as lobsters, fish, octopuses, and shrimp occur with some regularity on *hinggi*, but rays (*rumput laut*) and turtles (*tanoma*) are rare. Symbolizing personal attributes such as wisdom, the latter are often carved on memorial stones (*penji*) and are associated with royalty.[2] *Hinggi* motifs include designs that refer to social status, royal prerogatives, mythology, history, and religion, each of these being individual and discreet declarations of position and power. This example, however, could be interpreted as a highly abstract narrative, a story of the sea and man's relationship to this mysterious and religiously charged realm, filled with creatures associated with the ancient ancestry of today's Sumbanese. Skirting the boundaries of traditional *hinggi* design and composition, this unique cloth was woven by a highly creative weaver who dared to push accepted artistic conventions. *Hinggi* design was never static, but rather always responsive to changing internal and external influences and circumstances as necessary.

While this striking cloth does not seem to have substantially influenced *hinggi* design and composition in the years immediately following its creation, its innovative configuration is echoed and magnified by narrative cloths first woven for tourists in the 1980s. These cloths are far more literal and realistic, but aspects of Sumbanese thought and history are embodied in both the Dallas cloth and these later ones. The Dallas cloth was intended for traditional use, but these later "*hinggi*" are directed to the tourist market and new purposes, uses, and patrons.[3]

In contrast to the majority of *hinggi* in Western collections, this textile was acquired directly from the weaver, a Savunese woman married to an East Sumbanese nobleman (*kabisu*). It was woven at some time during World War I or slightly later.[4] Savu lies midway between Sumba and Timor. Many Savunese migrated to East Sumba during the nineteenth century, and significant Savunese contacts presumably date to an even earlier period, along with a history of intermarriage between royal families on the two islands.[5]

G.E.

78

Memorial stone or grave marker (penji reti)

Indonesia, Lesser Sunda Islands, Southeast Sumba,
Waijelo, Mangili area
Late 19th or early 20th century
Stone
H. 170 in. (4 m 31.8 cm)
Fractional gift of Sally R. and William C. Estes, 2004.57

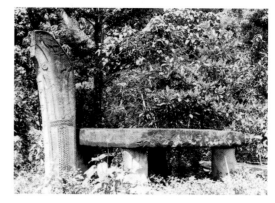

FIG 98 Commemorative monument (penji) with stone tomb, Waijelo, East Sumba, 1976.

Megaliths,[1] dolmens, and menhirs are found in locations throughout the islands of Indonesia. There is insufficient evidence to determine the exact age of these imposing stone monuments, but some could date to as early as 1000 BCE, while others, like this penji, are far more recent in date.

Among the Batak of North Sumatra and the Sa'dan Toraja of South Sulawesi, and on the islands of Nias and Sumba, stone monuments and sculpture continued to be produced well into the Dutch colonial period.[2] On Sumba, the practice exists to this day, although the erection of stone tombs is slowly being replaced by the construction of cement structures.[3]

On both East and West Sumba, monumental stone tombs are placed at the ceremonial center of traditional villages. These impressive tombs are the final resting place of noblemen who commanded extraordinary reverence and respect both in life and in death.[4] In the west, these tombs were commissioned by the owner during his lifetime, but in East Sumba, this responsibility fell to the son after his father's death, including shouldering the considerable expense.

The construction of these tombs involved the marshaling of considerable resources. First the stone had to be acquired from the owners of quarries along the coast. The stone, weighing from ten to thirty tons, then had to be transported, a task that sometimes involved movement over both water and land. This task necessitated the labor of hundreds and sometimes thousands of people. Following the arrival of the stone at the entrance of the ceremonial village, prescribed rituals were conducted, followed by feasting. Afterward, the stone was carved with finishing motifs and designs appropriate to its geographic location and as dictated by the family.

In West Sumba, four-sided tomb chambers are topped by a massive "male stone" (kamone), and decorative carving features buffalo heads and horns, sometimes capped by human figures. Buffalo are symbols of wealth and status and are valued sacrificial animals used in wet rice cultivation.[5] Vertical upright slabs resembling the branches of a tree sometimes stand alongside.

In East Sumba,[6] the tomb (reti) consists of a monumental slab, sometimes resting on stone supports (fig. 98). Placed at one end is an upright stone called a penji (banner of the tomb),[7] a reference to its general shape of a ship's prow board. At the other end of the tomb stands another upright stone called a kiku. Together the penji, the tomb itself, and the rudderlike kiku can be thought of as a ship that transports the deceased to the next world.[8] Penji are decorated with three-dimensional and low-relief carvings of sea creatures (turtles and fish), ornaments, horses, standing and equestrian human figures, and geometric and botanical motifs that relate to the status and achievements of the deceased.

This exceptional and bold sculpture is one of two penji in the Dallas collection (see cat. 79).[9] It is decorated with motifs that include metal gongs, a fish, a horse, a scorpion, three penji, and geometric patterns, possibly representing young growing plants.[10] Horses and metal gongs are indicators of wealth, and the fish, a sea creature, represents wild outside spirits that can enter into partnerships and alliances with humans. They can be dangerous but can also become generous patrons and benefactors,[11] and refer to mythical sources of ancestral power.[12]

Although some penji remain on Sumba, many have been sold and transferred to museums and collections outside the country. The technical achievement and aesthetic appeal of these exceptional sculptures are acknowledged by a global audience.
G.E.

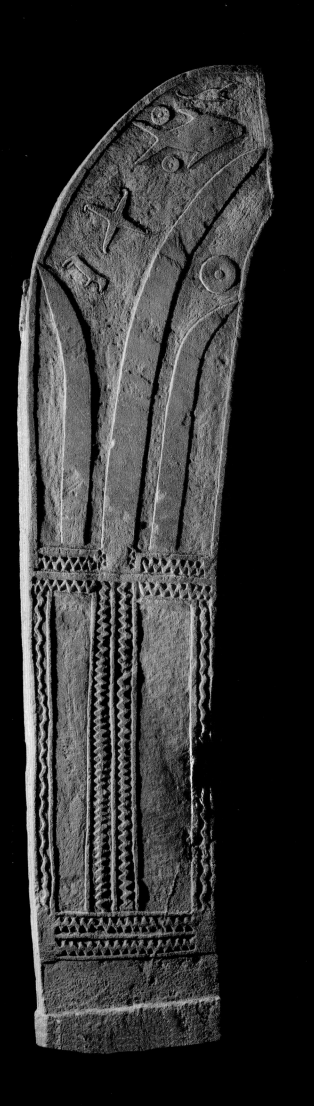
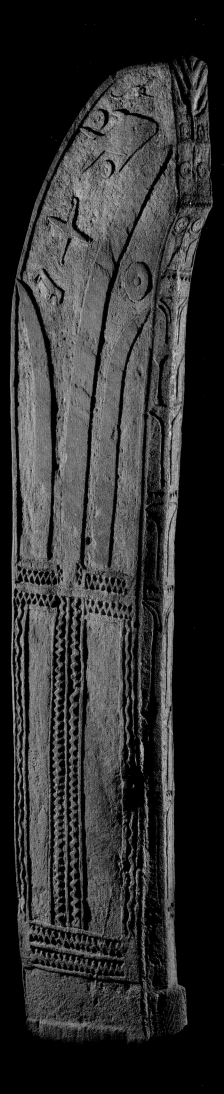

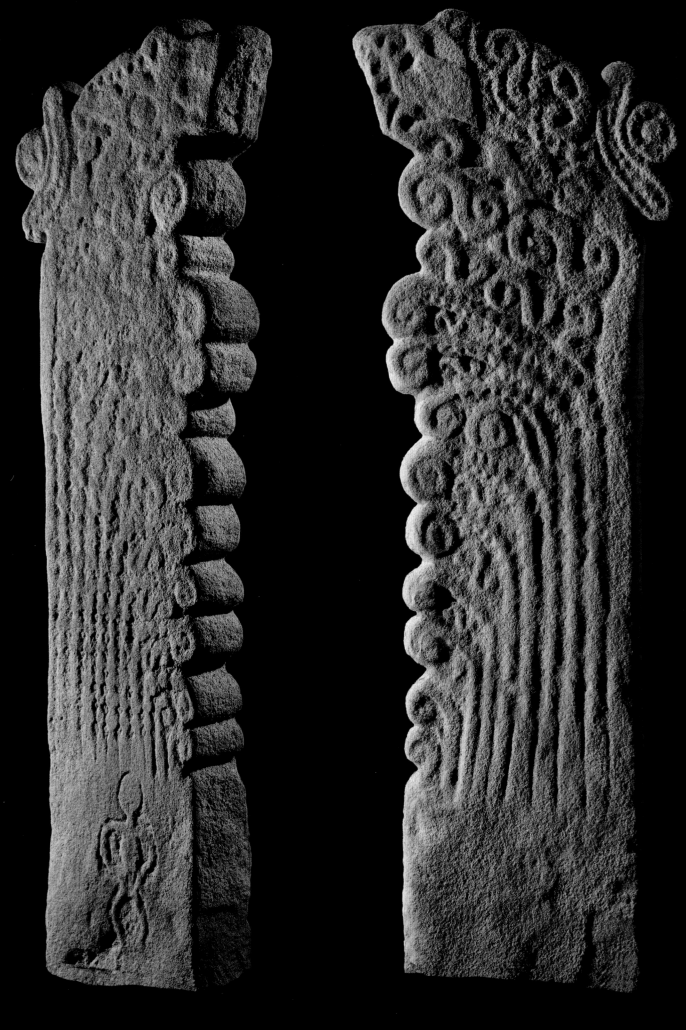

FRONT BACK

79

Memorial stone or grave marker (*penji reti*)

Indonesia, Lesser Sunda Islands, East Sumba, Lalatang
19th century
Stone
H. 162 in. (4 m 11.5 cm)
Fractional gift of Sally R. and William C. Estes, 2004.58

This second *penji* in the DMA collection is one of the finest surviving stones outside of Sumba. Although weathered, its beautiful and sensitive use of line and form clearly indicates the hand of a master sculptor. In contrast to many *penji*, this exceptional sculpture is less angular and rigid, its design rippling over the entire surface of the stone in a sinuous tribute to a revered ancestor. In addition, the design elements are not rigidly confined to distinct registers, as is the case with most other *penji*, and there are fewer such registers. As a sculptural work, the piece is aesthetically understated rather than excessive or overly demonstrative.

Here, the dominant motif consists of ferns nestled together in a spoon-shaped formation, the leaves increasing in size as they move upward from the base. The characteristic coils or spirals of fern imagery occur in the art of many societies worldwide, where they represent fecundity, growth, death, and, above all, regeneration, as well as the transfer of knowledge between generations. In this piece, the stems are carved within the sculptural frame, but their heads appear to burst beyond it, seeming to escape from the hard lifeless stone. The result is an irregular outer edge and an aesthetically compelling sculptural form.

Above the ferns are bands of curvilinear elements that are probably more abstract references to ferns or tendriled plant life. At the top right there seems to be a "compressed" unfurling fern, which is closer to the sun's warmth and power than any of the other subjects depicted on the stone. In juxtaposition to this upper-world symbolism, at the top left is a fish, an image related to the underworld and death. At its base is a single standing male figure, possibly representing an ancestor, that does not appear on the verso.[1]

To the Sumbanese, the ceremonial dragging of such enormously heavy stones represents the height of human obligation and reward that traditionally exists among extended kinsmen. Lende Mbatu, the patriarch of the Weyewa people, said of the time during a ritual when a stone is erected: "My corrals are all empty but my wealth is all around me."[2] Or as another Weyewa elder put it, "I am not a rich man according to most human reckonings, but I am rich in ability and I am rich in knowledge, I am rich in favors, and I am rich in cooperation with others."[3]

This *penji* is from Lalatang, a village that the famous Dutch artist and explorer W. O. J. Nieuwenkamp visited on August 14, 1918. There, he made several pen-and-ink drawings of the village's megalithic monuments. The one reproduced below (fig. 99) depicts two *penji* set amid a group of raised memorial slabs, which were used to honor and remember the deeds of great ancestors. The Dallas *penji* is the one on the left, and Nieuwenkamp's drawing memorializes a scene that was once typical in many Sumbanese villages.
G.E.

FIG 99 Drawing of stone monuments, Lalatang, Sumba, by W. O. J. Nieuwenkamp, 1918.

Pair of male and female ancestor figures (*ana deo*)

Indonesia, Lesser Sunda Islands, Central Flores,
Ngada, Nage people
Late 19th to early 20th century
Wood, horsehair, and glass
Male: 25¼ × 9½ × 11½ in. (64.1 × 24.1 × 29.2 cm)
Female: 28 × 10½ × 10 in. (71.1 × 26.7 × 25.4 cm)
The Eugene and Margaret McDermott Art Fund, Inc.,
2001.270.1–2.MCD

In central Flores, two powerful creator gods are recognized and revered. The god of the heavens is called Deva or Mori Meze, and his female companion is Nitu, the goddess of the earth. Perhaps of greater everyday relevance is the power of the ancestors, since they are more closely associated with the daily lives of all living descendants. Both gods and ancestors must be respected and honored, for failure to do so would result in chaos and disorder.[1] Ancestor sculptures play significant roles in the religious life of the community, serving as points of contact between the living and the dead.

The Nage people of central Flores are known for their wood sculptures, collectively called *ana deo*. These ancestor figures take the form of freestanding paired male and female figures, figures carved atop posts, and sometimes a male-female couple sitting astride horses. Post figures stood on either side of the entrance to houses belonging to important and powerful clan leaders. While serving a protective function, their presence also proclaimed that the owner had erected a shrine in the village to honor his clan ancestors.[2] Equestrian sculptures (*jara heda*) were supposedly placed near female ancestral shrines (*sao heda*),[3] although other sources claim that they were placed near male ceremonial houses in addition to more distant, and smaller, female shrines featuring riderless horses.[4] The literature is less helpful regarding the specific location and context of freestanding male and female figures, but all are declared to be ancestors.[5]

Most surviving male and female figures from Flores tend to be somewhat stiff and carved in a rather rudimentary fashion. This was not, however, the result when an exceptionally talented artist was the sculptor. Arguably the finest example of freestanding sculpture from Flores, the Nage *ana deo* pair from the collection of the Dallas Museum of Art was clearly created by just such a master sculptor. Although they were most likely once clothed, the loss of apparel in this instance is serendipitous, for the remarkable and sensitive carving of these extraordinary figures is fully revealed. Their anatomically correct, smooth, and rounded naturalistic bodies are beautifully sculpted, including carefully observed and detailed clavicles, nipples, breasts, ankles, sexual organs, hands

(although damaged), and toenails (rarely depicted). Kneecaps are indicated by flat circles, much like those appearing in certain sculptures from Nias and from the Batak regions of Sumatra. Horsehair was once pegged into the heads, lip (in the case of the male), and genital areas of the couple. With the exception of remnants on the head, this hair has been lost. Separately carved arms bent at the elbows extend forward, with the palms of the hands facing upward. The meaning of this gesture is not known. It could indicate the couple's request for veneration, possibly an offer of protection and beneficence, or a gesture of supplication. Other Flores figures also show the hands in a palms-up position.[6]

The artistic genius of these sculptures is intensified by the tension and charged energy created by their posture. They appear caught in mid-action, legs sharply bent at the knees, while seeming about to spring upward. The movement communicated by this posture is extremely unusual in the art of Indonesia, and this exceptional couple offers impressive testimony to the talent of the unknown artist who created them.

G.E.

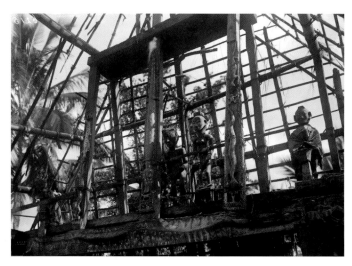

FIG 100 Interior of a spirit house with *ana deo* figures, Central Flores.
KIT Tropenmuseum, Amsterdam 10001080.

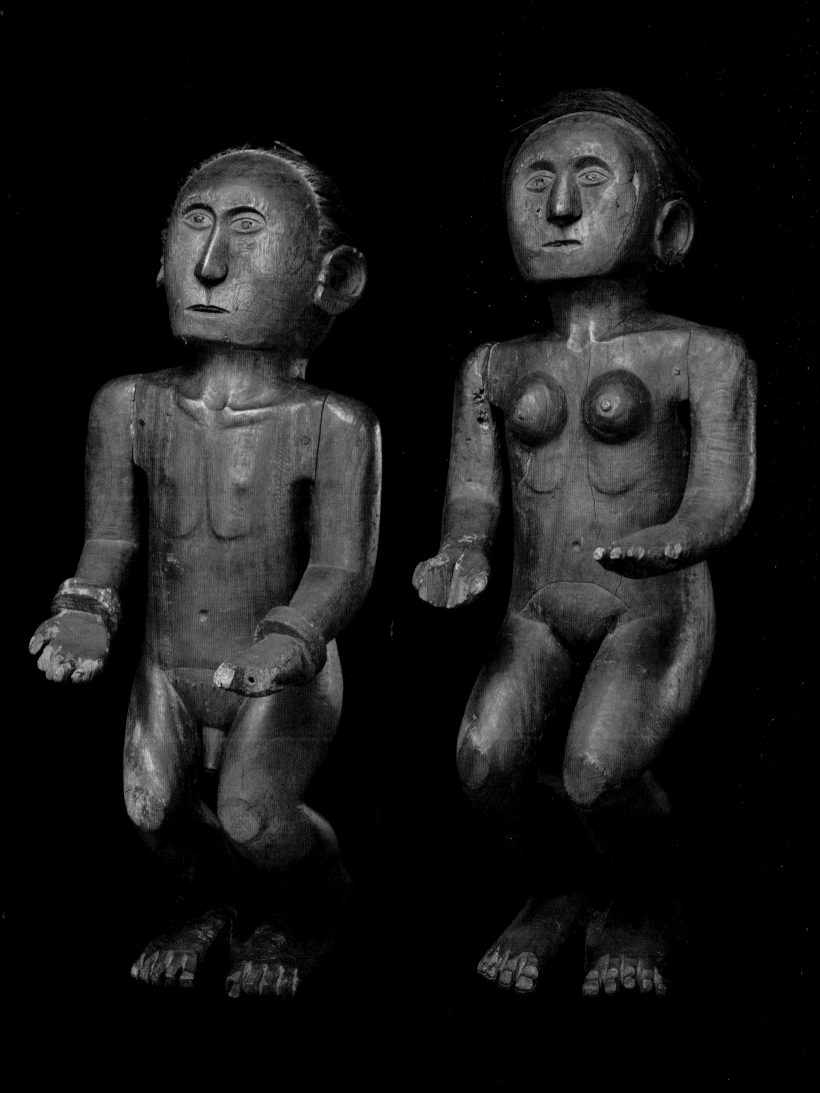

81

Skirt (*lawo butu*)

Indonesia, Lesser Sunda Islands, Central Flores,
Ngada, Ngadha people, Bomari village
19th or early 20th century
Homespun cotton, glass beads, shell, and metal
68½ × 31¼ in. (1 m 74.0 cm × 79.4 cm)
The Steven G. Alpert Collection of Indonesian Textiles,
gift of The Eugene McDermott Foundation, 1990.205

FIG 101 Ngada woman wearing a fine example of a *lawo butu* with a large beaded ship motif, n.d.

Talented artists of Flores created sculpture, beautiful jewelry and items of personal adornment, and exquisite textiles. These textiles were not, however, universally admired from an early Western point of view. While cloths from Sumba were avidly collected by Dutch colonial officials, missionaries, scholars, and travelers who were impressed by their bold, eye-catching, and colorful imagery, those from Flores went largely unappreciated. Flores cloths are far subtler and more discreet. Bold figural motifs dominate Sumba textiles, while smaller, more abstract and highly stylized figures and patterns define those from Flores. It was not until more recent decades that their exceptional designs and technical virtuosity attracted the attention of the Western world.[1]

Flores textiles were named, ranked, and valued according to the status of their owners, whether nobility, commoners, or slaves. Individual textiles are symbolic of local customs, values, and beliefs (*adat*). They were not merely garments, but played important roles in ceremonies and rituals. The revered and valued cloths of the nobility were passed down through the generations as family heirlooms and formed a part of clan treasuries. Some possessed spiritual powers that could be harnessed for the welfare of the entire community. Conversely, these sacred and highly charged textiles could also cause harm if not properly handled and respected.

For the Ngadha people of Ngada Regency, the most highly regarded textiles (*lawo butu*) could be dyed, woven, and worn only by noble women of the highest class (*gae meze*). Exceptional beadwork patterns and designs, the work of men, were attached to these cloths after the textile had been woven.[2] *Lawo butu* were commissioned by high-status clan leaders before their death and named after them at death. *Lawo butu*, as a result, were also referred to as "named skirts" (*lawo ngaza*). They were created to be clan heirlooms and were worn by women of noble lineage only on the most important ceremonial occasions such as the building of important religious structures.[3] They were also used in connection with the birth of noble children to ceremonially receive them during their introduction to the community. The skirts were secured with a belt, the beaded section facing forward or tied at the shoulder by threads (*kodo*) woven into the fabric (fig. 101).

The textile ground for this exceptional example consists of *ikat*-dyed designs enclosed in narrow bands at each end of a large central field of abstract patterns. Tied to the textile are beaded, circular, diamond-shaped designs with strings of beads and shells trailing from them. Also present are five human figures whose arms and legs are similarly delineated by strings of beads and shells terminating in Nautilus-shell chips. Looming over these motifs is a large ship. Their meaning is no longer known, but the human figures likely represent ancestors. The ship is possibly a reference to trading vessels that transported the valuable beads used in the creation of this skirt, as well as other precious cargo that generated the great wealth enjoyed by the owners of *lawo butu*. This mysterious vessel silently sails across mythical seas accompanied by magical designs and animated human figures, a haunting scene that pleases the eye and stimulates the imagination.

Despite careful conservation of these rare and important textiles, many have suffered damage over the decades. For cases in which the integrity of the textile was compromised, beaded designs were repaired or sometimes transferred to new grounds without any loss of prestige or value. Only small numbers of *lawo butu* were commissioned, and few survived into the twentieth century.
G.E.

82

Skirt (*lawo butu*) (detail)

Indonesia, Lesser Sunda Islands, Central Flores, Ngada,
Ngadha people
19th or early 20th century
Homespun cotton, beads, and shell
61¾ × 29 in. (1 m 56.8 cm × 73.7 cm)
The Steven G. Alpert Collection of Indonesian Textiles,
gift of The Eugene McDermott Foundation, 1983.100

While the basic form and use of this textile (*lawo butu*) are equivalent to those of cat. 81, its overall composition differs. Contrasting with the asymmetric placement of beadwork motifs in the previous catalogue entry, here the decoration is more rigid and balanced. In this case, the hexagons, human figures, and birds (chickens?) all exist in splendid isolation, while beads and shells form an elegant terminating border. Further, the textile ground with human figures and horses rendered in *ikat* contributes to the overall impact of the piece. Although the precise meaning of *lawo butu* motifs is no longer known, chickens are used in ritual sacrifice, horses were highly valued possessions of the nobility, and the human figures most likely represent ancestors.

Beads were extremely valued throughout Indonesia, and their presence was indicative of wealth and prestige. Less elaborate beaded textiles are found among other ethnic groups in central Flores. The Lio and Sikka people used beads similar to those seen here to form a single motif. The rhomb beaded motifs with flowing tendrils attached were placed in rows at the lower end of women's skirts.[1] Elder Lio and Sikka informants recall that at one time beadwork depicting horses, chickens, and human figures was also placed on their skirts.[2]

Lio *lawo butu* are worn by young unmarried women during the *mure* rain dance ceremony, and also by high-ranking married women during the ritual for the roof renewal of the most important houses.[3]

The heirloom skirts (*utang beke*)[4] of the Sikka people display a series of beaded rhomb designs in colors that echo Lio and Ngada examples. Their meaning is no longer known, but *beke* refers to long hunger, the period of famine often experienced before harvest. It is possible that this skirt also played a role connected with famine and harvest.[5]

G.E.

FIG 102 Three women wearing *lawo butu*, red blouses, and gold jewelry during the ritual of the renewal of an important *adat* house, Nggela, Flores, 1988.

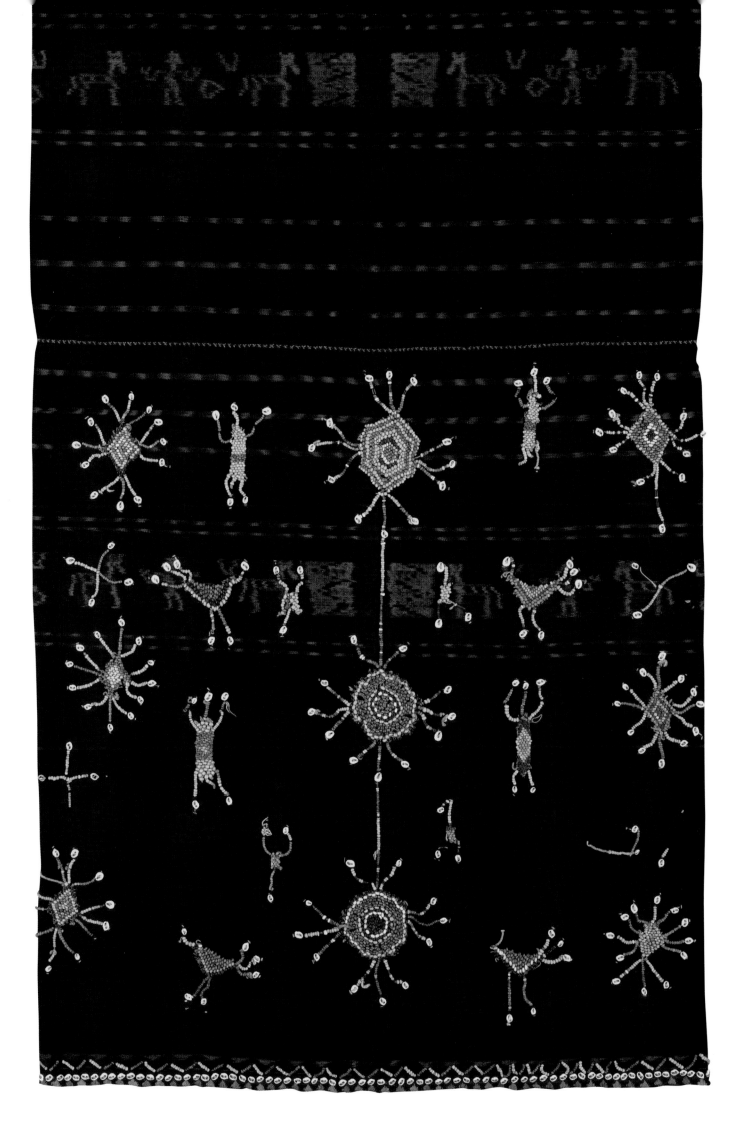

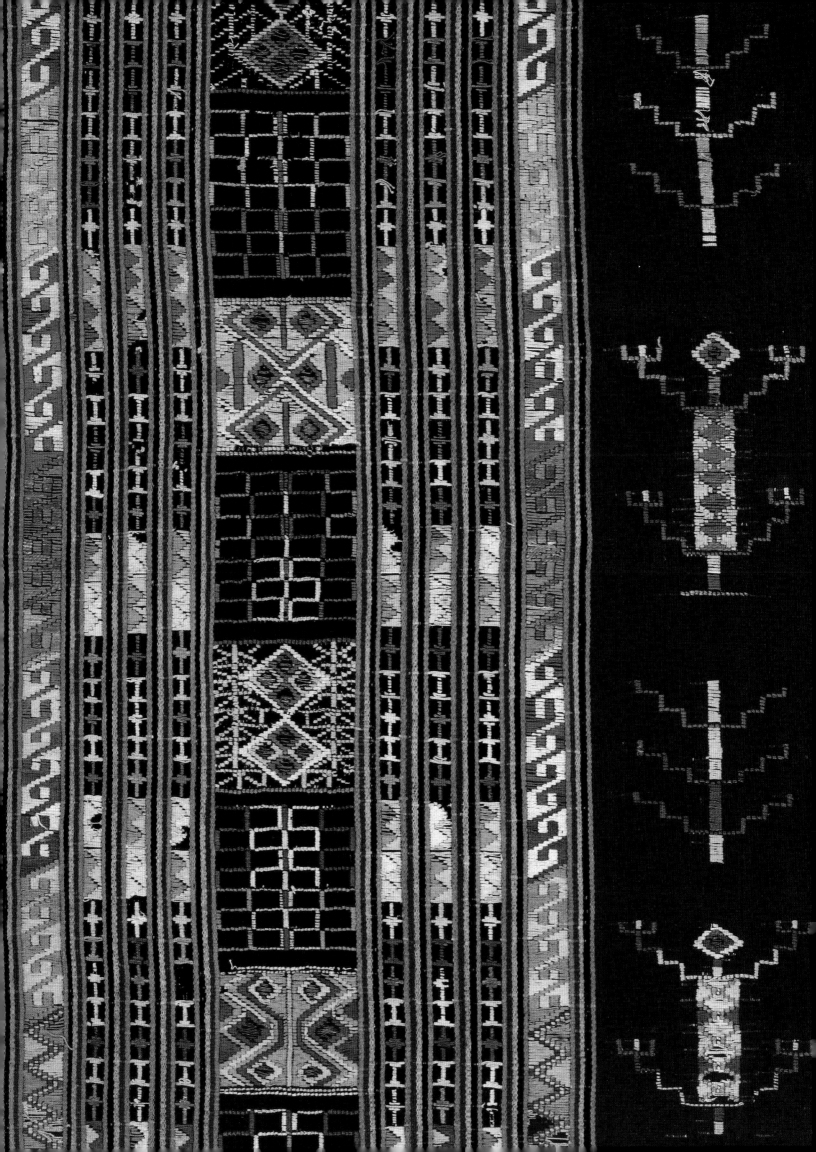

CHAPTER EIGHT
TRADITIONAL ART IN TIMORESE PRINCEDOMS

Nico de Jonge

Timor, with its eastern location in the Indonesian archipelago, has a unique position among the Lesser Sundas—not only because it is the largest of the islands, but also because of its political situation. The island consists of two parts virtually identical in size: West Timor (Timor Barat), a former Dutch colonial territory that is currently part of the modern nation of Indonesia, and East Timor (Timor-Leste), an independent state that used to be a Portuguese colony.[1] The Ambeno enclave at the northern coast of West Timor, as well as the islands of Atauro and Jaro, are also now part of East Timor (see map).

The cause of this remarkable division was the centuries-long conflict over the stocks of sandalwood (*Santalum album*) that were present on Timor. This rare and aromatic wood initially drew a variety of Asian (particularly Chinese) and Arabian merchants to the island. Sandalwood used to be in high demand for ritual and medicinal purposes in many Eastern cultures and was considered a very valuable commodity.[2]

The first Europeans landed on Timor's shores at the beginning of the sixteenth century. The Portuguese arrived in 1515, followed by the Dutch midway through the seventeenth century. Subsequently, a fierce battle between these two colonial superpowers ensued over who would gain a monopoly in the sandalwood trade. In the course of this struggle, all sorts of deals were made with the local Timorese rulers, as the island was divided into dozens of small sovereign princedoms. From the mid-nineteenth century onward, both the Portuguese and the Dutch attempted to demarcate their respective areas of influence on a permanent basis. In the end, both governments settled on a division of the island, followed by a definitive agreement on the borders in 1916 in The Hague.

The Timorese

When the island was being divided, ethnic and linguistic characteristics were, unfortunately, largely overlooked. The border between West and East Timor runs straight through the Belu region, which is home to two major ethnic groups who both speak the Tetun language. On both sides of the northern border lives a group that, based on this language, is classified as Northern Tetun. The Southern Tetun are likewise spread over the two countries in the southern area of Belu.[3] Similar labeling of the inhabitants on an ethnolinguistic basis also occurs elsewhere on the island.

The cultural diversity is most pronounced on East Timor. Here, besides the Northern and Southern Tetun, at least ten different groups can be identified. Of these, the Mambai, Kemak, Fataluku, Galoli, and Makassae are best known. In addition, a third Tetun-speaking community known as the Eastern Tetun resides in the southeast. The situation in West Timor is somewhat simpler. Alongside the Tetun groups of the Belu region, the Atoni are dominant here. Numbering around 750,000 people, they represent about half of the population of West Timor.[4]

Besides language, a considerable number of differences exist among the various groups. Until recently, this was most noticeable in regional architecture. The dwellings of the Atoni, for example, historically resembled a kind of beehive with earthen floors, while the houses made by the Northern Tetun were built on poles and had an oblong shape. In other aspects, such as kinship, the differences still persist today. Basic contrasts between the Northern and Southern Tetun clearly reveal this: the Northern Tetun are characterized by patrilineal descent and patrilocal settlement after marriage, whereas the Southern Tetun are governed by matrilineal descent and matrilocality.

Despite these differences, cultural similarities have always played a key role in the way Timor is regarded by the outside world. For instance, the tradition of a sovereign princedom, governed by a ruler who resided in a ritual center, was historically a very prominent characteristic. This feature, together with ethnolinguistic boundaries, was a decisive factor in shaping the social environment of most Timorese.[5] Additionally, a strict division in classes characterized many Timorese societies; a community typically consisted of aristocracy as well as commoners and slaves.

Important similarities also existed among various groups on the spiritual level and in worldview. Until the arrival of Western missionaries, many basic shared beliefs were widespread in Timor.

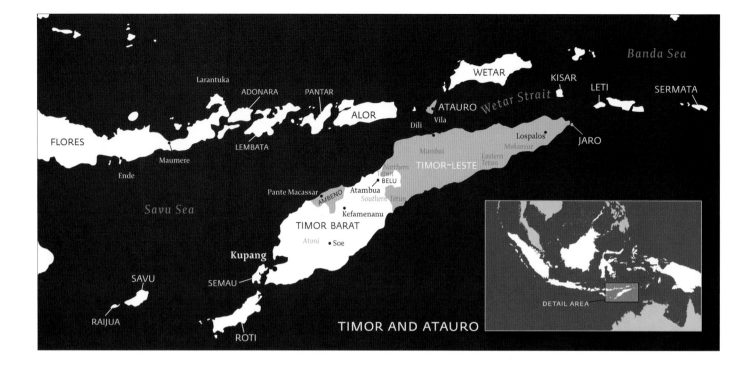

For example, it was generally believed that a cosmic dichotomy existed between heaven and earth. Heaven was associated with a male deity, while the earth was linked to a female counterpart. Alongside belief in these gods, great reverence for ancestors and spirits (associated with the landscape) was traditionally common-place everywhere, as were various kinds of totemism.[6] Many families or clans, until recently, sustained a bond with a particular type of animal that had a protective role.

The extent to which the art forms of Timorese cultures are similar or different has never been properly researched. To date, only fragmented examinations have been undertaken regarding traditional Timorese art, the development of which has not previously been recorded in a systematic way.

Traditional arts

In the past, ethnological fieldwork on Timor has been carried out only on a very small scale, and field research into the material culture has been extremely scarce. Earliest information comes from colonial civil servants in Dutch territory,[7] and also from Dutch missionary workers.[8] Missionary and ethnologist Dr. B.A.G. Vroklage made the first outstanding contributions in his fieldwork and publications. In the service of the Catholic Church, he worked among the Tetun in the Belu region and, in the midst of his other interests, studied the arts.[9]

Considering all of the available fieldwork and research information, and keeping in mind the limited studies of some regions,[10] one interesting conclusion becomes clear: no single art form appears to characterize traditional Timorese art, in contrast to some of the neighboring islands. For instance, sculptural wood-carving developed only sparsely on Timor, even though it is amply represented on the western islands of Maluku Tenggara in the form of ancestor statues. Similarly, a megalith culture, although

magnificently present on nearby Sumba, was altogether absent on Timor.

Still, Timorese cultures are justifiably celebrated for their distinguished achievements in the visual arts. Here, to a far greater degree than on the surrounding islands, distinctive, impressive decorative and fine art forms have developed. Women excelled at the manufacture of cotton *ikat* fabrics with ingenious, attractive patterns, while men were responsible for making, among other masterworks, beautifully decorated horn spoons and containers of bone and bamboo. Indeed, these finely crafted artworks can be found in relatively large quantities in the collections of ethnological museums.

Examining these art forms reveals the close ties among the cultures of the island. A remarkable uniformity of style and design elements is found, which supersedes Timor's ethnolinguistic diversity. This is most noticeable in the recurring images of certain animals (lizardlike figures, birds, crocodiles) and standing anthropomorphic figures, as well as in the way many geometric patterns (such as diamond shapes and decorative bands) have been rendered. Within this unity, we can observe local aesthetic characteristics throughout the island, reflecting both specific ethnic identity and the degree of interaction of Timorese groups with the outside world.

Women's art making

This unity in diversity is displayed at its fullest in Timor's most splendid art tradition, the making of textiles. As early as the nineteenth century, Dutch colonial civil servants spoke highly of the beauty of the fabrics, and since that era an increasing number of researchers have examined them. Both the technical aspects of weaving and decorating, as well as the symbolic meanings of the design and use of the cloths in society, are thus documented fairly extensively.

Textile production on Timor—along with pottery and basketry (often combined with beading)—was preeminently a female occupation. From an early age, girls would start weaving textiles that were used for all sorts of purposes. The principal textiles were the woman's tubular skirt (best known by its Indonesian name *sarong*), and the man's rectangular hip and shoulder cloth (*selimut* in Indonesian). Special headwraps were produced for headhunters, and certain fabrics were used, for example, in men's belts and shoulder bags and in the horse cloths favored by the nobility.

Women grew the required cotton themselves, and the homespun yarns were subsequently dyed using pigments derived from local plants. At the end of the nineteenth century, weavers also started using machine-spun yarns that became available through trade. As a result, it became possible to add extra color variations to the fabrics, which was done particularly in the lateral stripes.

The often intricately patterned designs were worked in many techniques: warp *ikat*, warp-faced alternating float weave, two types of supplementary weft, tapestry weave, twining, and warp stripe patterning.[11] These techniques were not used in all princedoms, however; in some regions, certain techniques were even banned.[12] The leading decorative techniques were warp *ikat* and warp *ikat* patterning, for which a backstrap tension loom was usually employed.[13]

From an aesthetic viewpoint, three types of textiles stand out: the woman's *sarong*, the man's *selimut*, and the warrior's headwrap (*pilu saluf*), which was used by the Atoni in the western part of the island. Together with the often exuberantly decorated man's shoulder bags, these can be regarded as the highlights of Timorese textile tradition.

To the Timorese, the local *sarong* and *selimut* clearly indicated identity, revealing an individual's area of birth (princedom) and traditional allegiance (clan). The use of colors or color combinations, specific motifs, and pattern arrangements specified precisely to which political community someone belonged. Furthermore, they revealed a person's social status, whether noble or commoner. The exact meanings of certain frequently appearing figures and motifs are a source of much speculation, but unfortunately little is known for sure. It is commonly assumed, for instance, that zoomorphic motifs refer to the totems of families and consequently played a protective role and warded off evil.

The bird motif, which appears often, is also associated with local ideas about death. Among the Atoni, for instance, it is known that after a person passes away, his or her soul transforms into a bird, which then travels to the realm of the dead.[14] In aristocratic circles, the deceased is bid farewell during an elaborate funerary ritual, in which the body is wrapped in many precious *selimut*, and a ceremonial farewell meal with special spoons is held. Both cloths and spoons are decorated with beautiful bird figures. The birds on the spoons certainly refer to the soul of the deceased. The same is probably true of the birds depicted on the cloths.[15]

Another art form associated with animals is the splendid Atoni headwrap, or *pilu saluf*. These pieces—insignia for men who had severed a head—consist of a rectangular body with many "ribbons" on one side that commonly have (often white) beads decorating their ends. The name of these garments appears to reflect this design: *pilu* refers to headcloth, and *saluf* means "to tear into rags." These "rags" probably represented the tails of cats (*meo*) and dogs (*asu*), both animals to which a headhunter was compared in ceremonial language.[16] Pieter Middelkoop explicitly refers to the association of these rags with dog tails, but since *meo* was the most common honorary title for a headhunter, we can assume that the association could be extended to include cats as well.[17]

After the Dutch eradicated the practice of headhunting at the beginning of the twentieth century, many *pilu saluf* became sacred heirlooms (*pusaka*). To this day, these remarkable garments are meticulously preserved as eternal mementos of brave ancestors, and they are brought out only for staged performances. Similarly, ancient *sarong* and *selimut* that have been produced in the traditional way have now also become family heirlooms. For the past fifty years, nearly all weaving has been done with industrially spun yarns, and synthetic dyes are used on a large scale. Recent decorative patterns show a fascinating mix of ancestral forms and modern influences. Although many of the ancient clan motifs have persisted, now they are portrayed side by side with motifs derived from Christianity.

Men's art making

Aesthetically comparable to the most accomplished textiles are the beautifully decorated containers used for storing stimulants, and also ritual spoons.[18] The majority of these containers (made from wood, gourd, bone, and bamboo) were crafted by men, and the cutting of spoons from water-buffalo horn, wood, or coconut shell was also a typical male endeavor.[19] These were produced in a traditional and usually very skillful fashion until about the mid-twentieth century.

As early as 1903, a study was published on the containers. It showed that the most fascinating examples originated from West Timor.[20] Besides various geometrical forms, two decorative designs were emphasized here: the "blossom" motif (usually consisting of a three-pronged leaf) and the "morning star" pattern (often depicted as a kind of spiderweb).[21]

The splendidly decorated ritual spoons were found over a much larger area than West Timor. The most impressive specimens, often adorned with beautiful openwork carving, are probably those of the Tetun in Central Timor. An interesting feature of their decoration is the frequent use of human figures, as well as the bird motif. Both subjects are sometimes rendered in high relief, and in some rare cases the human figures are even partially three-dimensional. These human shapes probably had a meaning comparable to that of the birds, signifying that the deceased had said his farewells to the community and was now a part of the realm of the ancestors.

Other important ritual tableware was typically decorated with bird and human patterns as well. Ritual ladles, water pitchers, and beakers often have bowls fashioned from plain coconut shell, while their wooden handles are elaborately decorated. These handles

frequently take the form of a single large stylized bird or ances-tor figure, in some cases adorned with striking tattoos. In fact, the result often looked less like a decorative handle than an artful statuette that was also used as a handle.

Typical of Timorese art is the way in which the surface of a motif was filled in, as is the case with many spoons (whether large or small, horn or wood). Within the contours of a bird shape, for example, decorative bands composed of double lines and rows of small dots filled in the form, all carved in relief. Comparable deco-rative patterns were found all over the island, on both large and small objects. These patterns are also noticeable as architectural or decorative flourishes on residences and granaries.

These houses and their immediate architectural environs, although quite different in size and scale from the smaller objects, provided a third, very important category of artwork created by men. Houses that were spiritually connected with the founding ancestors of a clan or lineage—the so-called houses of origin—were generally beautifully decorated. Within a clan, these named dwellings were ordered in a hierarchical way and were of great significance to its members. They represented the visible symbol of a group and, more important, functioned as the connection between the living and their ancestors; they and their annexes were ritual centers.[22]

Throughout Timor, the architecture and decoration of a house of origin had its own specific character. The decoration would often be aimed at propagating the status of an individual group. An example of this can be found in gable finials in the shape of buffalo horns; owning buffalo was an essential indicator of status on Timor. Furthermore, the main posts, joists, and walls of a house were fre-quently adorned with depictions of totemic animals and various geometric forms. The splendidly ornamented door panels found in the Tetun residences of North Belu have become highly renowned (see cat. 86). In 1937, Vroklage collected various doors with magnifi-cently stylized female figures, in some cases depicted as nothing more than a head ornament, breasts, and a sarong, consisting of highly characteristic spiral patterns.[23] Upon his return to Europe, Vroklage donated the doors to the National Museum of Ethnology in Leiden.

In precolonial times, a house of origin was often part of a "village of origin," a cluster of family residences. These hamlets were usu-ally located on a hilltop that was easy to defend; conflicts between princedoms—especially over (alleged) cattle theft and claims on sandalwood trees and trees with beehives—were once common-place. In the vicinity of an important house of origin (such as the eldest house of a clan), there would often be a connected small sac-rificial temple, where the graves of esteemed ancestors, including stone platforms with altars and pole sculptures of the clan found-ers (ai tos) were located. These ai tos, in fact, constituted the only category of ancestor statues on Timor. The tradition of producing a statue for each deceased individual, as on the Moluccan islands off the east coast (such as Leti and Kisar) and also farther to the west on Wetar and Atauro, was not practiced on Timor.

It is interesting to note that the style of many ai tos statues is also found on Wetar. Even though this island technically belongs to Maluku Tenggara, the dominant squatting position of figural sculpture is not found here, and its ancestor figures have the typi-cal characteristics of those on islands in the Lesser Sundas. These ancestors are generally portrayed in a standing position, often with arms stretched along the body, and there is almost always a hair knot present. In his expedition report of 1911, the German explorer Johannes Elbert included a picture of the statues that he encoun-tered on Wetar in which these stylistic features are clearly visible.[24] More specifically, however, the art of Wetar appears to incorpo-rate the styles of its direct neighbors: Atauro with its distinctive squared-off figures, and Timor with its sober ai tos statues.

The term ai tos literally means "hardwood," and most of the clan founder statues, both male and female, were traditionally made of such wood. These pole sculptures were usually approximately forty inches tall, with only a rather rudimentarily carved head topped with a stone like a hat. More detailed, but rarer, examples were made of white limestone. The best-documented ones are those of the Northern Tetun in Central Timor.[25] Particularly notice-able in this area, besides geometric decorations with many double spirals, are the representations of head ornaments. Moreover, there were examples with a so-called Janus head; in such cases, the faces of the first male and female ancestor would adorn opposite sides of the same pole.

Just like a house of origin, the sacrificial temple connected to it had a particular architectural style that varied by area. For example, Henry Forbes noted that there were rectangular types constructed on poles in East Timor, while a lower, round model with a beehive roof was recorded by Pieter Middelkoop among the Atoni and by B. A. G. Vroklage among the Northern Tetun.[26] The sacrificial temples were known as uma lulik, "sacred house," in East Timor and in West Timor primarily as ume le'u. The sacred aspect mainly concerned the ancestral heirlooms stored or hanging inside of them and believed to be dangerous, related, as they were, to war and headhunting, and endowed with the spiritual potency to kill enemies. The pos-session of such dangerous and volatile attributes—known as le'u musuh among the Atoni—was considered of profound and grave importance. They would traditionally be propitiated with offer-ings in times of war (often by sprinkling them with the blood of sacrificial animals) in the hopes of ensuring a successful battle or headhunting raid.

Among these heirlooms were the old weaponry that legendary headhunters had used in victorious battles (swords and shields, for example) and also objects connected to the rituals of war, such as dancing masks and drums. The latter were used for victory celebra-tions and other dances.

Abolished by colonial authorities, all villages of origin have by now been abandoned, and most Timorese have moved to modern settlements. Often a social group would build itself a new house of origin in the new settlement, regularly accompanied by a new sacrificial temple to store the ancestral heirlooms. Often, however,

FIG 103 Figurative house panel, Asumanu, Belu, 1953.

these were situated in a special room in the new house of origin. At the same time, many of the *ai tos* statues have not been moved, since these were believed to be too thoroughly connected to the soil of the village of origin. Until the mid-twentieth century, they could be found in the location of the old villages, overgrown by tropical vegetation.

Objects of trade

In addition to locally produced forms of art, Timorese princedoms also contained remarkable quantities of beautiful objects from other regions.

Primary among these imported items were gold and silver jewelry, weaponry, and bead necklaces. Examination of such items is desirable, not only to advance our understanding of local material culture but also because of larger symbolic and religious associations. On Timor, diverse works of art, both homemade and imported, usually had "hidden" meanings that superseded their practical uses. They reflected the core values of Timorese society and as such acted on a symbolic as well as a practical level. Only by examining the multiple meanings in relation to one another can one fully appreciate the symbolism of these objects. In this regard, the intriguing role of the rulers of the princedoms must be further discussed.

Those who look at antique "official portraits" of Timorese rulers and their retinues are often impressed by the richness of their traditional attire (figs. 104 and 105). Besides the exquisite textiles, the jewelry, in particular, is remarkable. The rulers' heads are adorned with silver finery and round, gold disks; strings of beads are frequently visible on their chests, while splendidly worked weapons complete many a costume.

Even though the scholarly sources are not in agreement, it is reasonably certain that many of these ornaments, made of precious metals, originated outside of Timor. H. G. Schulte Nordholt, who worked in West Timor around the time of the Second World War, was of the opinion that no indigenously made jewelry existed

within the entire Atoni region. In his view, all of the objects came from either Roti Island or the Belu region (in Central Timor).[27] The ethnologist Vroklage, on the other hand, who did fieldwork in the latter region in 1937 and studied material culture, reports that all jewelry in the Belu region was of Rotinese origin.[28] It is therefore safe to assume that there were no indigenous silversmiths active in West and Central Timor, and that Roti—or more precisely, the nearby island of Ndao—played a leading role in this trade and exchange. Even today, there are many silversmiths living on Ndao who move to Timor at the beginning of the dry season to make jewelry and then, after taking orders for the next season, return home.[29]

The most impressive pieces of art were undoubtedly the silver jewelry that was worn on the forehead. Here, two main motifs appear to be combined: at the base was usually a crescent shape, which resembled water buffalo horns, from which a number of "leaf fingers" arose.[30] Schulte Nordholt points out that in the jewelry of the Atoni there were typically three of these "fingers."[31] This suggests a close connection to the aforementioned blossom motif present on many antique bamboo containers from West Timor.

The headdresses were quite often adorned with old Dutch silver or Mexican coins, the latter brought to Timor by the Portuguese. Similar coins (or comparable disks) were also attached to male garments and accessories. Their sparkling, decorative effects were especially popular on headbands. Many ammunition belts (used to transport gun powder and bullets for the imported rifles) were also decorated with them.

The peoples of East Timor probably actively imported this sort of jewelry as well. Although there is mention of local silversmiths (who produced hair ornaments and bracelets), it is known that until around 1900 the area was a vital market for the goldsmiths of the small island of Kisar.[32] Among their specialties were the large, gold pectoral plates made from Dutch ten-guilder pieces (*gouden tientjes*) and English sovereigns, and it was precisely these pieces of jewelry that abounded in East Timor.

Beads, which were popular throughout the island, were entirely imported. A convincing study done in 1899 demonstrates that there were two kinds of beads present on Timor: the very precious so-called *mutisalah*, made from natural quartz and opal rock, and industrial-made glass beads. The *mutisalah* were found in two colors, a dim yellow and a reddish orange, and both originated from the region of Cambay (Gujarat) in India. Until the arrival of the Portuguese, they were exported via Malacca to Timor within the framework of the trade in sandalwood. After approximately 1600, they were gradually replaced by assorted glass beads from Europe or China.[33]

The impressive bladed weapons of Timor were undoubtedly imported as well. They were shipped in from Malacca, together with the *mutisalah*, before the arrival of any Europeans. During the colonial era, this import trade was mainly conducted by the Dutch United East India Company (VOC). The quantities involved are truly astonishing. For instance, VOC statistics from the seventeenth century show that Timorese rulers of 1625 received approximately 730,000 swords over a seven-year period in exchange for their

FIG 104 Atoni *meo*, as portrayed around 1820, showing his sword and sheath, furnished with a decorated shoulder brace.

sandalwood.[34] After the downfall of the VOC, the Makassarese from South Sulawesi dominated the trade in weaponry.

Only the blades of the swords were imported. The local people themselves produced the handles, sheaths, and other decorations. A handle was customarily made of water buffalo horn; it had a triangular shape and was decorated with horsehair, which was sometimes dyed red. In the middle of the triangle was often a rosette, which in some cases was meant to depict the eye of an animal (possibly there was a form of totemism involved here). The occasionally extravagant decorations applied to the shoulder braces of Atoni weapons were again probably the work of the silversmiths of Ndao. This can be deduced from the quality, style, and design of the motifs. They would often closely resemble the crescent-shaped head ornaments mentioned above.

Finally, there existed a rare, but nonetheless significant fourth category of import goods on Timor. This category consisted of wares that were ironically referred to as "jewelry of state" by the Dutch civil servant H. J. Grijzen in his report on Central Timor.[35] Even so, these objects played a major role on the island.

Rulers and objects

The objects mentioned by Grijzen can be understood as state regalia—extraordinary wares that embodied political power—and they were heavily used throughout the Indonesian archipelago. The positions of the early rulers of Java and South Sulawesi provide striking examples: their power was legitimized because they owned specific heirlooms—which could even transform them into the earthly personifications of deities.

For centuries, a similar situation prevailed on Timor. Traditional rulers throughout the region inherited and passed on sacred objects, which were believed to yield both fertility and victory in war. Sources record that such objects were usually kept in one of two places: the items ensuring fertility hung within the walls of the royal palace, and objects with potency to kill were stored outside, in sacrificial temples built especially for that purpose, reminiscent of the aforementioned *uma lulik* or *ume le'u*.

Many of the sacred objects were imported goods. Apparently it was the powers inherent in these objects that were considered to be supernatural. Aside from their religious significance, they also played a major role at strategic and political levels: the functional efficacy of the objects determined the balance of power to a great extent between the princedoms.

The ruler who owned the strongest or most formidable objects was in the dominant position, which explains why the princedom of Wehali (located in the Southern Tetun area in Central Timor) was the most powerful realm on the island for a long period of time, its influence culminating in the sixteenth and seventeenth centuries. The ruler of this princedom possessed, among other heirlooms, elephant tusks, a gong, and three cannons. All of these objects had been brought from overseas by the mythical founders of the realm, and they conferred unsurpassed, supernatural power.[36] Because of these items, the ruler of Wehali commanded rain, drought, good or bad harvests, and victory or defeat in wars. Furthermore, he had the power to cause deadly epidemics or to end them. It was no coincidence that his title was *Meromak O'an*, literally, "God's son."[37]

Arts and values

The presence of these acquired objects affords us an opportunity to discuss the symbolic meaning of Timor's material culture. The royal court not only performed a role on the religious and political levels but also was an important model of society, to which it is possible to connect the deeper meaning of many pieces of art. The basic principle was that the Timorese ruler was the primary representative of the community enclosed within the boundaries of his princedom. The ruler was the ultimate symbol of his people, and through his person and actions, society was united. For good reason he would therefore be called the "father and mother" of the community.

What exactly this meant is made clear by the organization of power in the traditional princedoms. Although the ruler had absolute power, in practice, authority was divided between two people. The ruler himself primarily performed a role as the spiritual leader. He was depicted in various ways as a feminine, introverted, inactive person who, by making sacrifices, concerned himself with the fertility of the land. As "son of God," he was supposed to ensure the arrival of enough rain. He was the "bringer of coolness"; through him a good harvest was assured.

Simultaneously, however, a worldly leader operated in his name. This leader was active as an executive power in times of "heat," meaning war. This was why in some areas he was referred to by the title of *kolnel* (derived from the Dutch word for "colonel").

During a war, he was assisted by, among others, the *meo*, men who had decapitated enemies, and who in Atoni society were allowed to wear a *pilu saluf* headdress. Furthermore, the *kolnel* took care of all matters of government, administered justice, and collected taxes. He was regarded as the male, active, and extroverted counterpart to the spiritual leader.[38]

Both aspects of the ruler make it perfectly clear what Timorese society was all about: fertility and battle, the latter aimed at maintaining the reputation of a princedom. Both of these core values were united in the person of the ruler, the symbol of society. In fact, the royal model encompassed the social roles of men and women. As complementary aspects, both were necessary to preserve a princedom.

A characteristic of East Indonesian cultures, including that of Timor, is the importance of the material culture in reflecting these social values. The overall model of society would typically be expressed in the architecture and layout of the houses of origin, whereas the various constituent values were usually related to smaller, specific works of art.[39] Consequently, many of the items described above possessed symbolic meanings, associated either with "masculine" heat (the struggle for status) or "feminine" coolness (fertility).

The nature or materials of the objects regularly played a role in these associations. Textiles, for example, were habitually regarded as feminine because they were produced by women and were made

FIG 105 Portrait of the ruler of the Wehali princedom, 1937. Photo taken by the missionary ethnologist B. A. G. Vroklage.

of cotton, which is a product of the earth, a great source of fertility. However, associations could also have an entirely different framework. This was the case with some jewelry that was recognized as masculine. The large, golden pectoral plates, for example, are known to be associated with headhunting in East Timor. Such plates were actually regarded as honorary tokens, which a warrior would receive as a reward for each severed head. In fact, the jewelry represented headhunting trophies.[40]

The symbolic meaning of objects mattered particularly in a ritual context. Through the use of ceremonial language and the application of specific goods, messages were relayed in a metaphorical way. A splendid reflection of this can be found in the traditional wedding ceremony, in which both status and fertility, presented as material items, played a prominent part.

In Timorese cultures that admitted the bride to the clan of her husband, the family of the groom (the wife-takers) usually presented the family of the bride (the wife-givers) with a bride price. This gift was always answered with a counter-presentation. On Timor, the bride price could consist of a variety of things. Especially in aristocratic circles, buffalo were a main component; as discussed earlier, these animals were traditionally the foremost indicators of status on the island. In addition, "masculine" swords could be included (in the case of the Makassae), "masculine" gold and silver disks (with the Northern Tetun), and old, valuable *mutisalah* strings of beads (in the case of the Atoni). In many places, the counter-presentation consisted of "feminine" cloths (*sarong* as well as *selimut*) and pigs tended by women, sometimes supplemented with jewelry and rice that were considered feminine.[41]

Through the presentation of the feminine goods—and the bride—the wife-givers handed over fertility to the wife-takers. To the latter group, the family of the bride represented a source of life on which they felt dependent for the survival of their own group. This subsidiary position was also reflected in the bride price. Through the donation of indicators of status and weaponry to the wife-givers, the wife-takers essentially placed their masculine forces in the service of the woman's family. This was no trivial gesture. As Forbes (in the case of East Timor) and Schulte Nordholt (regarding West Timor) have noted, the wife-takers were the first to be called upon in case of war.[42] Because permanent relations often developed between wife-givers and wife-takers, these ties into which the families had entered were cherished and repeatedly reaffirmed. For instance, when births or deaths occurred, they would ritually exchange, once again, masculine and feminine works of art.

Even today this exchange of objects with symbolic connotations still occurs, but the modern age also makes itself felt on Timor. In the case of the bride price, money often replaces the traditional objects as an indicator of status, while nowadays the counter-presentation is increasingly made up of, besides textiles, kitchen utensils that are considered feminine.[43] This shows that the symbolic system of the old princedoms has in fact endured. With the disappearance of traditional pieces of art on the island, however, this centuries-old system has become much less typically Timorese.

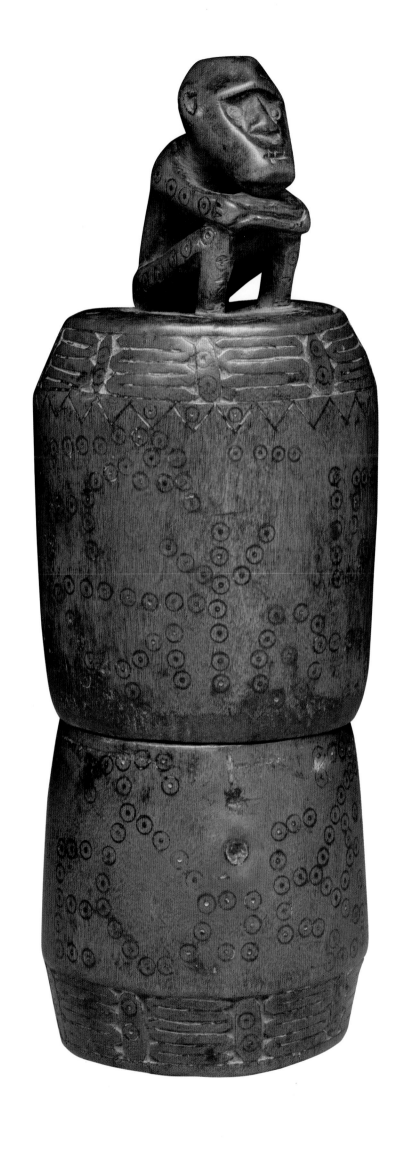

83

Ceremonial lime container (*ahumama*)

Indonesia, Lesser Sunda Islands, West Timor,
Belu region, Tetun people
19th or early 20th century
Sandalwood
7¼ × 2⅝ in. (diam.) (18.4 × 6.7 cm)
The Roberta Coke Camp Fund, 1996.205.A–B

In Indonesia, the chewing of betel nut was once a ubiquitous tradition.[1] Betel can be consumed in many ways, including in conjunction with tobacco to heighten its effects. In Indonesia, a quid commonly consists of a quartered section of an Areca palm seed, mixed with a pinch of gambir (*Uncariae ramulus et uncus*) and then smeared with just the right amount of slacked lime paste to make it more palatable. These ingredients are wrapped in betel leaf, which is from a vine related to the kava plant and pepper family (*Piperaceae*). This mixture contains alkaloids, and its mild psychoactive properties provide users with a sense of general well-being. Old-timers often say that among its many efficacious effects, chewing betel nut made them healthier, allowed them to work harder, and fended off hunger. It is also used as an astringent and is said to kill parasites.[2]

Beautifully carved, woven, and beaded containers and paraphernalia associated with the ceremonial chewing of betel reflect one's identity, social standing, and level of refinement.[3] The components in betel chewing, particularly the Areca nut and the betel leaf (*bua* and *malus*, respectively, in Tetun), are of deep ritual and philosophical significance to Tetun-speaking peoples. As in other areas, these components are part of the ritual exchanges associated with both marriage and offerings to the ancestors.

Generally, lime containers were crafted from bone, horn, bamboo, or light wood. This particular container was fashioned from white sandalwood. For many centuries, a primary place from which to obtain the wood of this slow-growing tree was the island of Timor. Its aromatic wood has long been prized and figures in the religious practices of the East, in medicines, and in artful creations. During the Age of Discovery, one of the first European visitors to Timor, Duarte Barbosa, wrote in 1518 that "there's an abundance of sandalwood (white) to which Muslims in India and Persia give great value and where much of it is used."[4]

The choice of sandalwood for this container is unusual. Normally, lime containers in this shape are of bamboo or other woods and are adorned with geometric designs, not a hunkered figure. For traditional peoples, this is a common stance, even a

respectful posture, but as a carving convention, a hunkered figure normally connotes an ancestor or a deity. This squatting figure, with its powerful gaze and well-articulated limbs, epitomizes this prototypical form in miniature. It remains unclear whether this well-handled lime container was used daily by its owner, or whether it was a ceremonial item belonging to a ruling family or an heirloom used in some ritual form.

S.G.A.

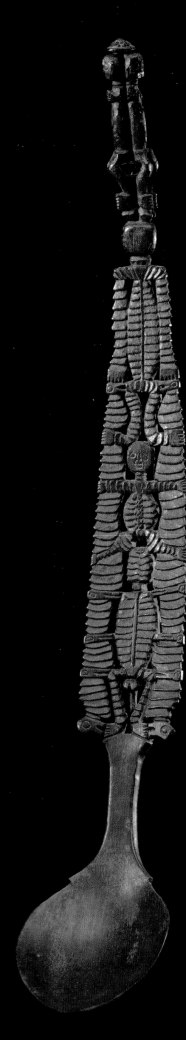

FRONT

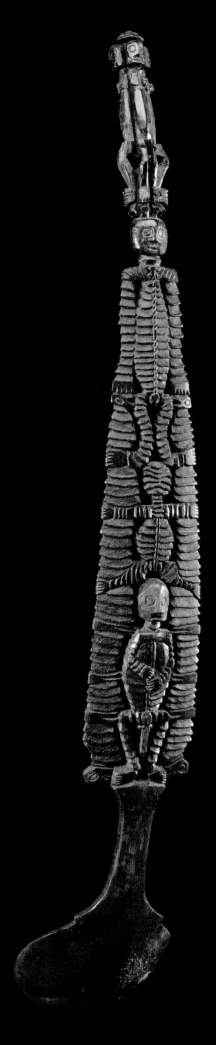

BACK

84
Ceremonial spoon (*nura dikun*)

Indonesia, Lesser Sunda Islands, West Timor, Belu,
Tetun people
19th century
Buffalo horn
16 in. (40.6 cm)
Promised gift of Sally R. and William C. Estes to the
Dallas Museum of Art, PG.2013.9

FIG 106 An Atoni
man clutching two
ceremonial spoons,
Central Timor, 1918.
Drawing by W. O. J.
Nieuwenkamp.

Ceremonial spoons are among the most notable creations of the Tetun- and Atoni-speaking peoples. They exist in large numbers, and had already begun to enter European museums by the mid-nineteenth century. These spoons are mostly fashioned from Asiatic buffalo horn (*Bubalus arnee*), which is boiled and sometimes treated with hot oil to make it easier to embellish and more pliant in forming the spoon's overall shape. Durable and textured, buffalo horn ranges in color from a polished jet black to tones of warm reddish brown to translucent shades of amber.

Tremendous variety is found in the patterns and overall shapes of these utensils. The most frequently encountered design consists of variously stacked geometric patterns interspersed with profiles of pairs of birds, whose curvilinear execution aesthetically harks back to Indonesia's distant Bronze Age. The philologist and missionary Pieter Middelkoop wrote that these spoons "were used exclusively during a farewell meal for the deceased."[1] Spoons associated with these feasts served as a reminder to mourners that the deceased's soul had assumed the form of a bird and, in successfully achieving this metamorphosis, had permanently separated itself from the living and their communities.[2] Among the Atoni, the name for a spoon in their ritual language, *kol kotin*, means "backbone of birds."[3]

The grandest old Timor spoons are characterized by their elongated handles and stately length, which generally ranges from approximately six to sixteen inches. Nearly all the available space on a handle's flat surface is intricately carved. Occasionally crocodiles, lizards, and other totemic animals—as well as human figures—are included in these compositions. Some of the most interesting spoons depict large birds perched and twisted at a ninety-degree angle on the handle's end, or human figures that are either three-dimensional or raised in relief. The most elegant handles are also perforated with variously sized pinholes, cutout sections, or designs in silhouette. Given the density and complexity of these compositions, the selective use of negative space greatly adds to their visual impact.

This particular spoon is remarkable in every respect. A kingly piece, it once belonged to the rajas of Mandeu, a Tetun area in Belu.[4] In Mandeu, much as in Middelkoop's description, spoons were used during mortuary feasts (*kenduri*) that took place three days after someone was buried.[5] This spoon was also used during state occasions, and again during feasts when ceremonial heirloom objects, which were kept in a special house, the *uma lulik*, were taken out, displayed, and blessed.[6]

The handle's tapered end sports three back-to-back, bent-kneed figures forming a circle that recalls the line dances connecting the Tetun to their ancestors and the spirit world. Along the central length of the spoon, figures of both sexes are depicted flanked by stacked birds. The top and bottom figures' frontal views are on the reverse of the spoon, while their backs are aligned to the spoon's bowl. The middle figure's orientation is reversed. This ingenious alternation of bodies, one flat, two raised in relief, adds to the character of this spoon's unique composition. On the handle's flattened section is a distinctive shinglelike pattern covering both the human and avian figures. This surface treatment, suggesting layers of feathers, inextricably and seamlessly binds man and bird together in a transforming and poetic composition.

S.G.A.

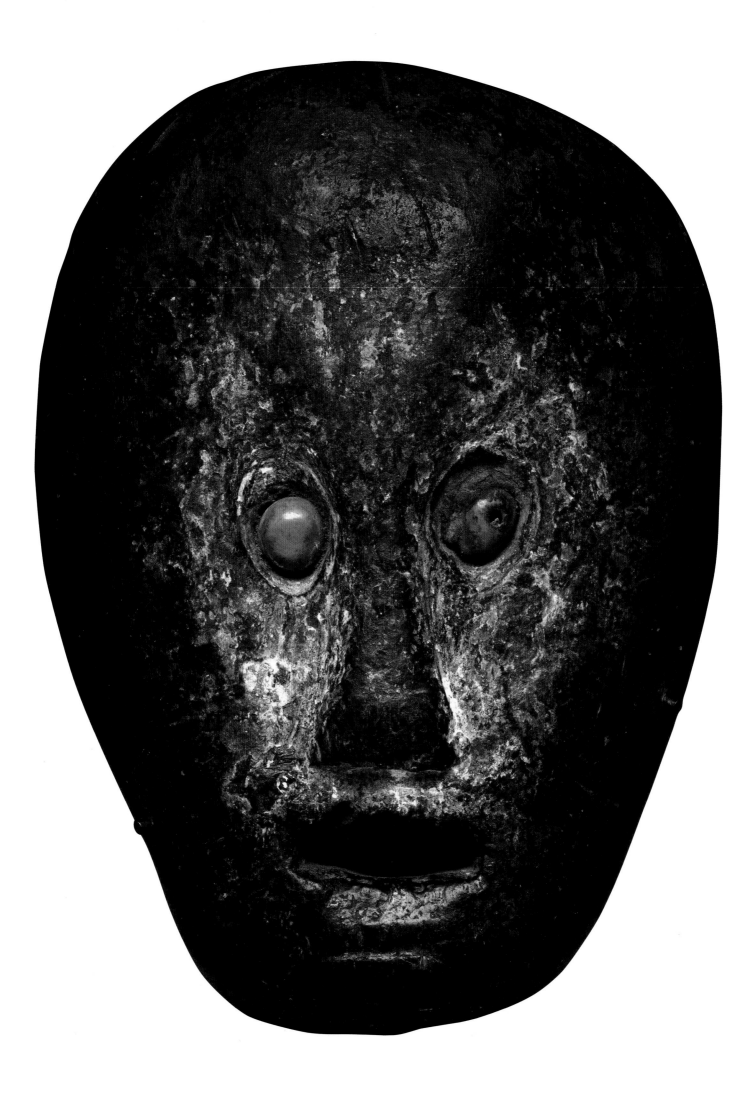

85
Ceremonial mask (*biola*)

Indonesia, Lesser Sunda Islands, West Timor, Belu,
Tetun people
19th century
Wood, chalk lime, resin, nails, and shell inset for eyes
9¼ × 6¾ × 2¾ in. (23.5 × 17.3 × 7.0 cm)
The Roberta Coke Camp Fund, 1994.254

A small group of similar but also highly individualized masks from Timor is noteworthy for the masks' great age and their simple, sometimes raw, but always evocative facial features. Given the long period of time over which they were used, these masks always display varied surface areas. Usually, they consist of hardened layers that are partly granulated, in combination with areas that exhibit a glossy black patina.[1] Such rich and complex surfaces can be naturally created only by a combination of handling and extended contact with the smoky interior of a traditional house. It is said that *biola* were worn during ceremonial dances and used for traditional practices revolving around a village's ceremonial house (*uma lulik*). Otherwise, they were stored in the attic or among the rafters of the *uma lulik*.

At some point, masking traditions in Belu, as well as in other areas, seem to have fallen into disuse. While a few latter-day photographs depict dancers wearing masks,[2] the names of older masks, their origins, and detailed knowledge surrounding their functions are now little understood. This may result from the transformation of their meaning within the culture, the reappraisal of their use and

value after the region's pacification by the Dutch, the cessation of headhunting, and the introduction of Christianity. The masks were worn in conjunction with a number of ceremonial dances, including the *loro'sae*. Originally a war dance, this celebrated ritual, with its entrancing rhythms and intense crescendo, culminated in the decapitation of prisoners at sunrise. When Margaret King saw this dance performed in 1960, she wrote that an event that had once been tied to headhunting had now become a vibrant celebration of village life.[3] Today, dances such as the *loro'sae*, the *likurai*, and the *tebedai* are still strongly bound to local identity, as well as having become cultural attractions. Since independence, *loro'sae*, which means "rising sun" in Tetun, is that community's name for modern East Timor (Timor-Leste).

The Museum Volkenkunde in Leiden has a mask from western Timor described as "named *Le'u musuh* that was worn by a priest during the ritual dance performed with warriors after a victorious military expedition."[4] An intriguing vintage photograph that seems to confirm this description shows a diminutive figure holding a walking stick and wearing a mask that is distinctly different from those of his compatriots (fig. 107).[5] This central figure is surrounded by virile, bearded masked men wearing outfits of shredded fibers. Each carries or grips a sword or machete in the stance of a warrior. Old nails and indentations for wooden pegs on the Dallas mask are signs that it, too, was once crowned with hair and adorned with a beard.

Qualitatively, this Timor mask is one of the finest and most expressive examples known. Its raised furrowed brow, straining appearance, and open mouth are suggestively combative, much like a warrior's facial expressions in the midst of shouting or singing chants of aggression. This mask also possesses an extraordinary set of shell eyes, one gray, one an opaque orange, that seem to pulsate within their sockets.[6] Set in a profusion of hair and framed by a black background, the mask's whitened face would have added a final flourish to its theatrical impact.

S.G.A.

FIG 107 A group of masked figures, Timor, 1963. Photograph by Margaret King.

86

House door (*oromatan*)

Indonesia, Lesser Sunda Islands, West Timor, Belu,
Dirun, Tetun people
Early 20th century
Wood
57½ × 23¼ × 5 in. (146.1 × 59.1 × 12.7 cm)
Gift of Diane Ansberry Rahardja and Andyan Rahardja
and Family in honor of Louise Steinman Ansberry,
2013.3

FIG 108 Drawing
of figurative house
panel, Belu, 1987.

The great communal houses of Indonesia's traditional peoples reflect man's place in a tripartite cosmos, where humans live in the middle world, on earth, between heaven and the underworld. Notions of duality, portents of cardinal directions, and the dictates of the first ancestors are honored in these often elaborate buildings that are in many ways a microcosm of each group's belief system. Often the houses of aristocratic clans were beautifully embellished with carvings and painted designs. Among the Tetun of Belu, houses are notable for their interesting altars, carved panels (fig. 108), and, above all, beautifully carved doors.

While male and female symbols are complementary to each other in Tetun houses, the dwelling is a decidedly female place. Pieter Middelkoop wrote that the term *matsau ume nanan* describes the oldest form of marriage in Timor, and can be translated as "the marriage (of entering into) the interior of the house." That means that a husband stays within the house of his in-laws, and thus participates in the family magic (*nono*) of his wife.[1] Great houses are often described as being "living" things, and as such, various areas of the building are often named after parts of the human body.[2] Thus among the Tetun, who practice matrilineal descent, the largest room in the rear of the dwelling is known as "the womb of the house" (*uma ulon*).[3] Here, one finds the house's hearth, its ritual pillar, and the women's entryway, which is known as the house's "vagina" (door).[4]

Conversely, the door used solely by postpubescent boys and men is found at the front or "face" of the house and is referred to as "the eye of the house."[5] As thresholds, both doorways mark the boundary between the inner, mostly female world of the house, and a predominantly male outer world. These portals are complementary entryways that connect the Tetun to "the steps that lead to the source of life."[6] In a ritual that was once common but is now rarely performed, a baby's first exposure to the outer world occurs when the father carries the child through the vagina door to the village plaza.

Most doors are decorated solely with tightly patterned geometric designs. Others singularly depict or combine raised carvings of breasts, animals, or ceremonial jewelry, while only a few sets of doors actually depict male and female figures. Usually a figurative door consists of a single effigy with a long angular frame or a half-bodied torso. Conceptualized here in a slightly different manner, this female figure is expansive, rotund, and with her oversized breasts appears to address aspects of reproductive power—and the connectedness of many generations of women—compressed into the body of one archetypal female figure.[7] Framing her likeness is a series of meandering key- and diamond-shaped geometric patterns whose optical effects draw further attention to her fecund form. This door is said to have been the work of a master carver named Alfonsius Seran, and comes from the village of Dirun.[8] Other related doors can be found in the Museum Volkenkunde in Leiden[9] and at the Musée du quai Branly in Paris.[10]

S.G.A.

8 TRADITIONAL ART IN TIMORESE PRINCEDOMS

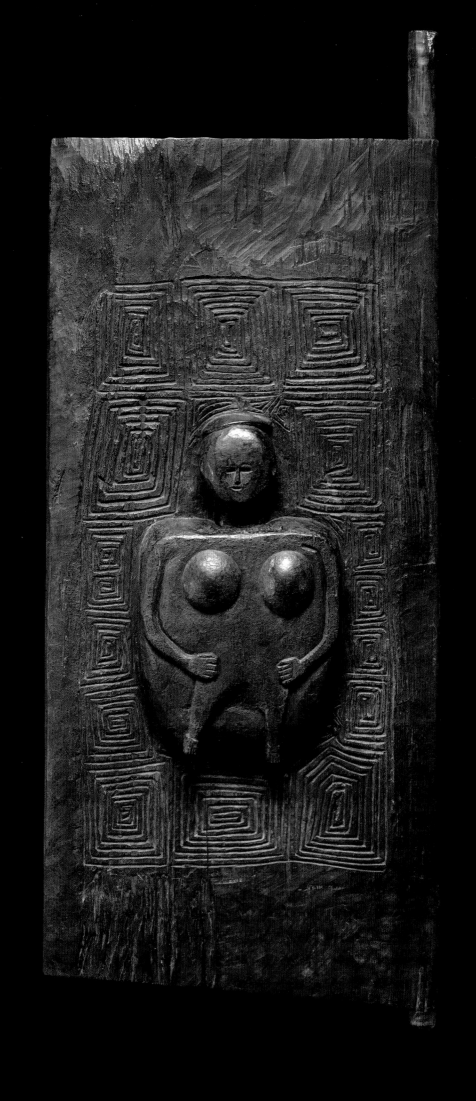

87

Woman's tubular garment
(*tais feto*) (detail)

Indonesia, Lesser Sunda Islands, West Timor,
Malaka Regency, Nurobo, Atoin Meto people
19th century
Homespun cotton and silk
67½ × 25 in. (171.5 × 63.5 cm)
The Steven G. Alpert Collection of Indonesian Textiles,
gift of The Eugene McDermott Foundation, 1983.106

The Dallas Museum of Art has three outstanding examples of tubular skirts from the Belu region of Timor. These impressive *sarong* feature supplementary weft wrapping techniques. Known as *sui* among the Tetun speakers, and *buna* among Atoni groups, the raised patterns on *sarong* are the result of a deft, painstaking process that requires supplementary weft threads to be wound around collected strands of warp yarns. The weavers do not use pattern sticks, and the intricate designs on these skirts have to be memorized and picked out by hand.[1] The most beautifully decorated *sarong* are owned and inherited by females from the warrior and aristocratic classes. These textiles are worn or displayed during important ceremonies and festivals when age-old traditions and customary laws are honored and one's social identity is reaffirmed.

Heirloom skirts from Belu are among the finest surviving examples of textiles from Timor. They are easily identified, because the *sui* sections are tightly wrapped with richly colored and costly imported silk thread (*letros*) that became rare in the twentieth century and disappeared completely with the onset of World War II.[2] Open areas of warp-faced plain weave and bands of warp *ikat* of varying width are sometimes found on these *sarong*. The most eye-pleasing ones juxtapose indigo blue with brownish-red, maroon, or purplish-burgundy hues from *mengkudu* (*Morinda citrifolia*), a tree in the coffee family. In comparison, modern skirts are dominated by the use of chemical dyes. Their more garish palettes, along with a propensity for covering most of the surface area with densely packed designs, while eye-dazzling, lack the deep dye tones and areas of elegant contrast that are the hallmark of antique *sarong*.

The most densely designed Belu skirt (cat. 89) is from the village of Nurobo in the kingdom of Mandeu in Belu. This weaving dates to the late nineteenth century. It would have been owned by a member of the local raja's or king's family there. Each side panel is populated by numerous anthropomorphic creatures in a colorful array of *letros* threads, while the center is dominated by tight geometric *ikat* designs punctuated by stripes of plain weave.

The second Belu skirt (cat. 88) is from the village of Faheluka, where this design pattern is said to originate. It can be worn by any

FIG 109 Tetun women dancing with hand drums, Belu, 1953.

88

Woman's tubular garment
(*tais feto*)

Indonesia, Lesser Sunda Islands, West Timor,
Belu region, Tetun people
Early 20th century
Homespun cotton and silk
48¼ × 57½ in. (122.6 × 146.1 cm)
Textile Purchase Fund, 2003.20

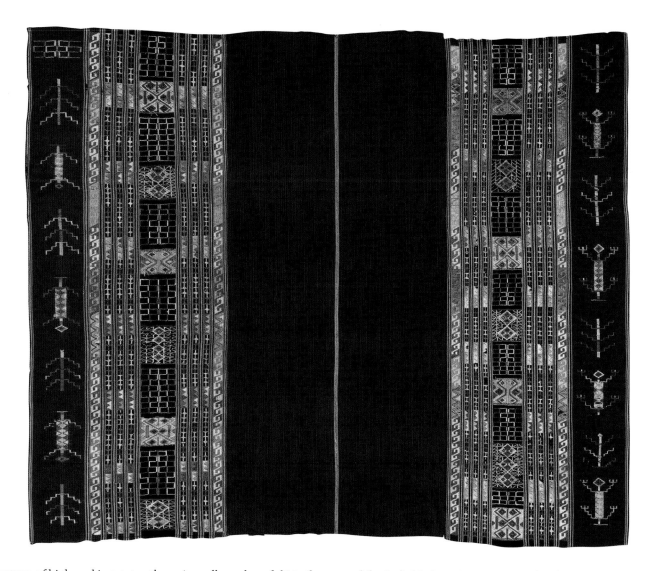

woman of high-ranking status there. A small number of skirts that depict variants of this pattern are now in museum and private collections.[3] This particular *sarong* was woven in the early twentieth century by a master weaver named Mama Maria Manek.[4] Its shifting arrangements of silken colors are vibrant, perfectly chosen, almost melodic. These visual qualities are heightened by the adept tight wrapping of the *letros*, which is punctuated by the occasional use of gold-wrapped thread.

The gem among Dallas's Belu skirts (cat. 87) is also from Nurobo. This heirloom *sarong* from the nineteenth century is reported to have been worn only by the king's wife during ritual ceremonies and festivals.[5] It is unique among Belu skirts, as its supplementary work, rich colors, and the addition of tightly woven bands of *ikat* with geometric designs are so breathtaking. Cast silver earrings (*kavata*) (not visible in the illustration) are depicted within the narrow-striped inner *ikat* bands. These are symbols of wealth reflecting the large amount of metal goods that were exchanged during the forging of matrimonial alliances.[6] On the skirt's side panels, alternating stylized skeins of thread are bounded by protective lizards (*teki*) that are depicted with an unusual verve and sense of authority.

S.G.A.

Woman's tubular garment
(*tais feto*)

Indonesia, Lesser Sunda Islands, West Timor,
Belu region, Tetun people
Late 19th century
Homespun cotton and silk
67¾ × 47 in. (172.1 × 119.4 cm)
The Steven G. Alpert Collection of Indonesian Textiles,
gift of The Eugene McDermott Foundation, 1983.105

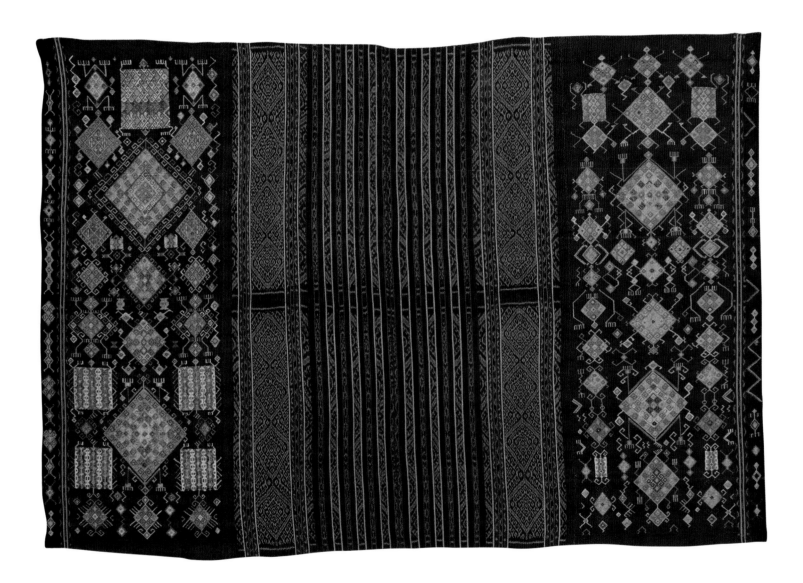

90

Ancestral statue (*ai tos*)

East Timor, possibly Lospalos region
19th or early 20th century
Wood
33½ × 7 × 6 in. (85.1 × 17.8 × 15.3 cm) (excluding base)
Promised gift of Steven G. Alpert and Family, PG.2013.13

Throughout Belu, carved images of founding ancestors are known as *ai tos*, a name that literally means "hardwood." In fact, *ai tos* are made from both stone and wood and can be found outside the entrances to villages, in and around graves, on stone platform altars, and in secluded spots in the forest where one prays to ancestors. All of life's important decisions necessitate calling upon ancestors, and offerings of betel leaf, palm nuts, tobacco, and wine are lavished on them in order to receive their blessings and advice. As Margaret King noted:

> To come unexpectedly upon the little Lulic [*ai tos*] figures in the forest is an eerie sensation. They stand so solemnly hidden in the thick jungle growth, bright pearl eyes staring. The husband has his hair in a topknot on his head, the wife, smaller beside him, has hers coiled in a chignon, both of them gaze unwinkingly, always facing the direction of the northeast, whence, so the descendants say, these ancestors first came in their long canoes.[1]

Ai tos are usually represented with carved heads and arms on postlike bodies or as fully articulated figures. This latter treatment can be seen in a pair of *ai tos* photographed standing between the roots of a venerable tree in the Lospalos region (fig. 110).[2] Stylistically, this couple is similar to the Dallas *ai tos*, which, as indicated by its prominent topknot, is the male figure from a pair of these statues.

At first glance, the sculpture may appear crude, but as King commented regarding her chance encounter, a figure like this one in a natural setting would have been a heart-stirring, even apparitional sight. This impression is fostered by a successful combination of the statue's well-conceived anatomy with a ghostly face. The piece is not static. The left shoulder is slightly raised, while the left leg is placed just a bit more forward than the right. The torso's midsection is also engagingly asymmetrical. This combination of postural details perfectly mirrors our own body mechanics in the act of walking. The sculptural subtleties give this *ai tos* a sense of taut inner energy that is in line with its active and vigilant role as an intermediary between the ancestors and their descendants.

In juxtaposition to its attractively shaped head, this figure has a flattened, masklike face. It is not clear whether this treatment suggests a deeper meaning, or whether it is simply a stylistic convention. The figure's inlaid eyes were lost long ago. Still, the depth and darkness of its eye sockets evoke a penetrating, spectral gaze. Years of slow erosion, just the right amount of wear, and partial white staining of the face (the result of a residue left by dead lichens), in tandem with a carver's skillful artistry, have enhanced this statue's qualities to such a degree that—beyond the boundaries of time and culture—it is still capable of speaking to our imaginations. S.G.A.

FIG 110 Pair of *ai tos* figures in situ, Lospalos region, 1987.

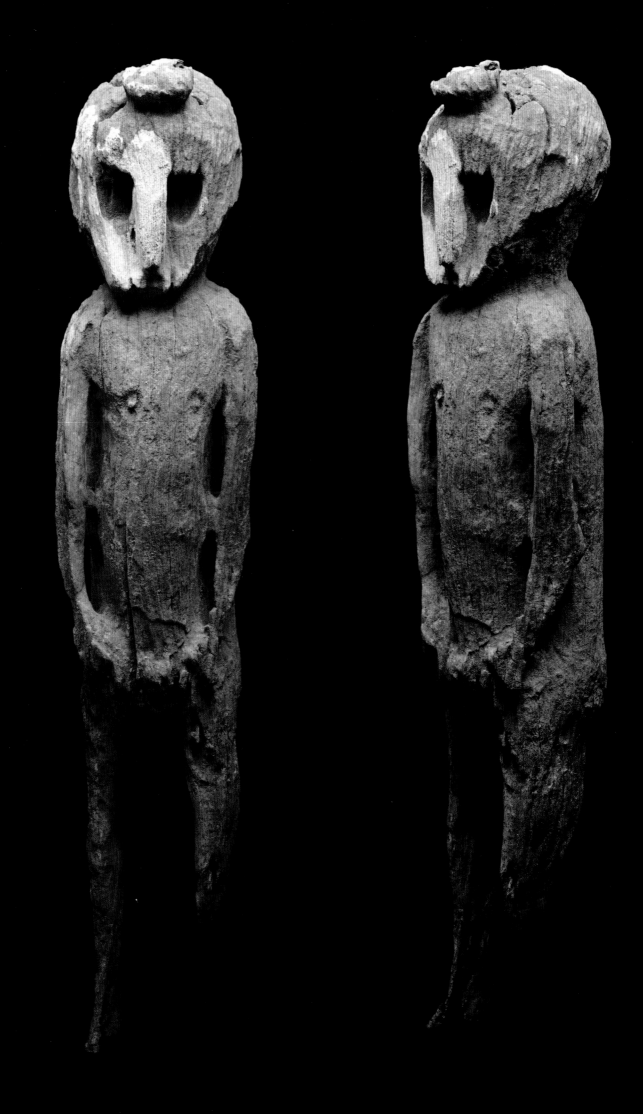

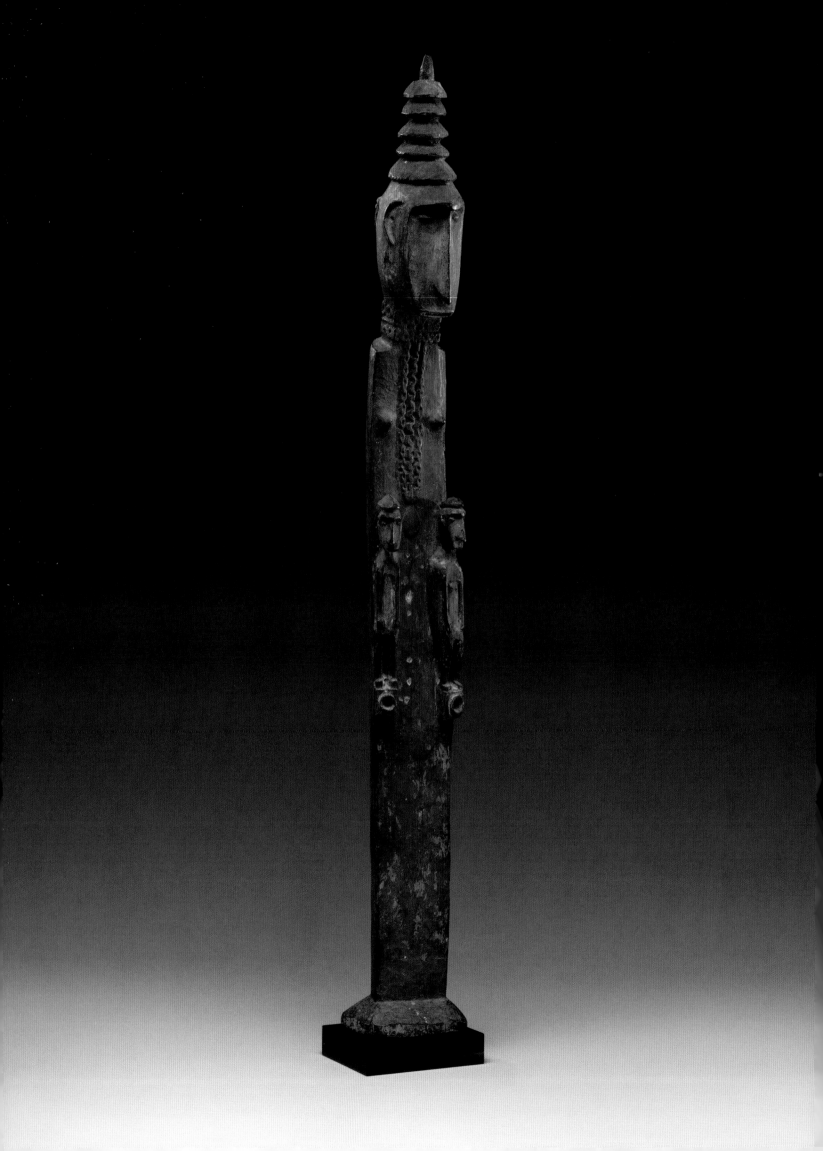

91

Shrine figure of a deity (Baku-Mau)

East Timor, Atauro Island, Makili
Late 19th or early 20th century
Wood
25¼ × 3⅛ × 3⅞ in. (69.0 × 7.7 × 9.6 cm)
Gift of Helen Bankston, Sally Brice, Ginny Eulich,
Margaret Folsom, Mary Ellen Fox, Betty Jo Hay, LaVerne
McCall, Judy Tycher, and an anonymous donor, 1983.49

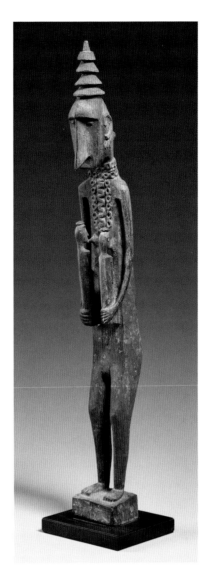

FIG 111 Female figure, Atauro, Nusa Tenggara, c. 1900. Wood. 26¼ × 3½ in. Indiana University Art Museum, 82.32.

Formerly known as Kambing or Goat Island, Atauro is a small island dominated by several extinct volcanoes that are surrounded by a mostly dry and rugged landscape. The island is less than sixteen miles from Dili and the Timor mainland. In the 1970s, carved images of deities and ancestors that were associated with both outdoor and indoor shrines, or placed in and around cemeteries or within a family's dwelling, could still be seen in a few villages. Traditionally, before the region's general conversion to Christianity, a divine couple, Baku-Mau and his female consort Lebu Hmoru, were worshipped there as important fertility deities.

The Atauroans supplicated these gods with offerings and sacrifices, imploring them to regulate the rain and enrich the earth for their crops. The couple's combined beneficence ensured the fecundity of both domestic and wild animals, guaranteed a plentiful supply of fish from the sea, and was integral to the success of any important undertaking. Baku-Mau and Lebu-Hmoru (who in local myths is capable of sporting some fifty nipples) not only promoted the fertility of all things but also looked after the male islanders' virility as well. Their maintenance was considered synonymous with good health and prosperity.[1]

The most memorable in situ photograph of a set of clan founders, or more likely of Baku-Mau and Lebu-Hmoru, was taken at an outdoor shrine near Mount Manu-Koko.[2] The couple's likenesses were carved on a pair of posts. Placed in a cairn of rocks facing each other at an angle, the figures poetically recall the stern and prow of a ship. In describing similar sculptures, Father Jorge Duarte, a Catholic priest who lived on Atauro for fifteen years, noted that Lebu-Hmoru wore a larger carved comb in the shape of an occipital trident. Her ears were often more elongated and pronounced than those of the male figure, and suspended from them was a fine pair of earrings. These figures also generally wore tiered headdresses. In some old photographs, their crowns are spiked with offerings of pierced coconuts.

Duarte also wrote that Lebu-Hmoru was depicted wearing strands of highly prized antique trade beads (mutisala). In eastern Indonesia, these deep-orange-colored beads, said to be of Indian origin, were and sometimes still are used as a ritual currency and were associated with wealth and status. Baku-Mau's bulkier choker chains of mutisala with their extended strands were longer than those worn by Lebu-Hmoru, and suspended from his necklaces was often a distinctive circular or ovoid medallion.[3]

These same features are found on the male figure belonging to the Dallas Museum of Art, and on its former mate, which is now in the collection of the Indiana University Museum at Bloomington (fig. 111). In the Bloomington piece, the female's well-defined contours contrast with the male figure's postlike body. Duarte mentions that the more elongated torso found on some depictions of Baku-Mau was intended to accentuate his "maleness."[4] The symbolic identity of these deities is further affirmed by the positioning of the children attached to each figure. The children nursing at Lebu-Hmoru's breasts are looking inward, creating an overall pose considered to be nurturing and quintessentially female. Those attached to Baku-Mau's torso are reversed to face the outside world in a statement that projects masculinity.

This pair of statues is said to come from a sanctuary house (rumalululi) in the village of Makili on the island's southeastern coast.[5]
S.G.A.

Ancestor figure (*itara*)

East Timor, Atauro Island, Kampung Makeli
Early 20th century
Wood, fiber, and cloth
19½ × 3¾ × 3¾ in. (49.5 × 9.5 × 9.5 cm)
The Art Museum League Fund, 1981.15

Itara are highly conventionalized wooden images representing a family's most prominent founding ancestors. They were bound in cordage and hung from the "branches" of a forked post (*rumah tara*) (fig. 112). *Rumah tara* were erected at the rear of the dwelling, an area that is considered to belong to the "spine of the male end of the house."[1] These figures were always paired in couples and thus honored generational continuity while also reflecting the general Atuaroan belief in the inherent duality of all things.

In Atauro, one's religious and social standing were expressed in the number of figures affixed to one's family *rumah tara*. Duarte noted that most houses had only one pair of *itara*, but that more prominent families displayed up to three pairs of figures. He wrote that this number struck him as odd when compared to the apparent number of individual ancestors mentioned by name during the Nussa-Obun and Rare-Obun ceremonies. Those rituals included more than one hundred different nominative invocations to entreat the blessings of each individual ancestor.[2]

Itara were suspended so that their feet faced the house. This placement was believed to promote vigilance, as *itara* maintained the well-being of the dwelling and its inhabitants.[3] To enlist their assistance in apprehending thieves, prayers were addressed to these figures, as were offerings that included one hundred areca nuts, betel leaves (*daun sirih*), fish, and wine. After a transgressor's capture, Jorge Duarte recorded that there followed a ritual confession. Thieves could be forced to recant before the offended *itara*, where they humbled themselves by saying: "In fact, it is preordained that I am sent back to you to look for my soul."[4] Such were the considerable powers once ascribed to *itara*.

Given its large size, this male figure must have represented an important person and belonged to a very prominent family. As ancestor figures generally hung for display, all these images are of the same basic form: slightly bent at the knees, with arms and shoulders characteristically akimbo and rolled forward. Most *itara* are more abstracted, their planes more sharply edged; one could say that they are in general rather more Cubistic in their execution (see fig. 113) than is this piece. The Dallas *itara* is exceptional for its large size, sensitively shaped head, expressive almond-shaped eyes, aquiline nose, and jutting chin, which are all in perfect harmony. The combination of these features affords the piece its singular personality. Additionally, the image's native cordage is still intact, and a traditional loincloth (*koghi*) is wrapped around the great ancestor's loins.

S.G.A.

FIG 112 Ancestor figures hung from a *rumah tara*. Photograph by Jorge Barros Duarte, 1959.

FIG 113 Statuette, probably an ancestor effigy, Atauro. © 2013 Musée du quai Branly/Photo SCALA, Florence 70.2001.27.293.

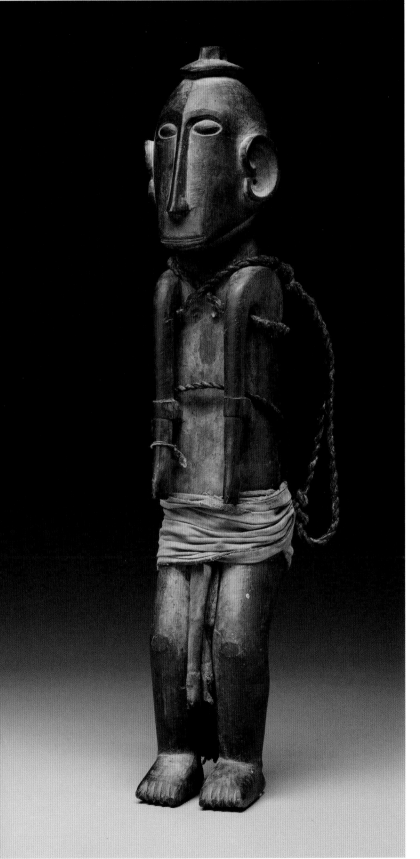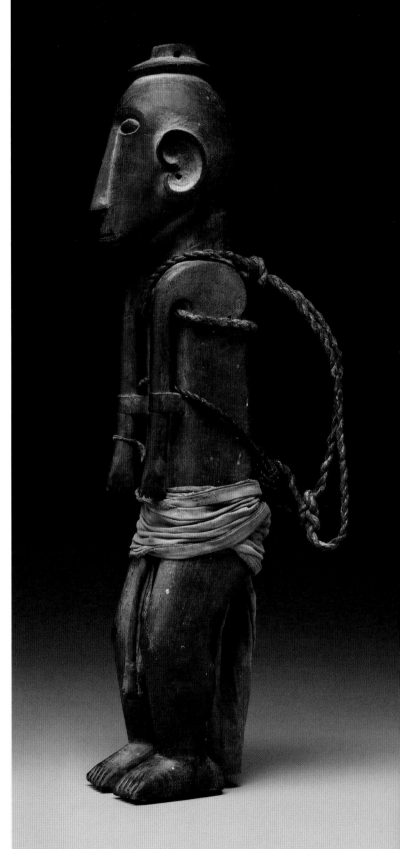

93

Standing charm figure

East Timor, Atauro Island, Macadade (Anartutu)
19th century
Dugong tooth
2 × 1⅝ × 1 in. (5.1 × 4.1 × 2.5 cm)
Gift of Steven G. Alpert and Family, 2001.355

Throughout Indonesia, traditional peoples created a wide variety of protective charms to ensure well-being and prosperity. Images of animals, ancestors, and spirit beings were cast in various metals and carved from wood, bone, and, in some rare instances, ivory.

A small number of amulets crafted from either wood or buffalo horn are known to exist from Atauro. One such miniature figure is a splayed-legged male charm of buffalo horn (fig. 114) that represents a captain (*sucao*) of a ritual canoe (*beiro*).[1] Along with four oarsmen, his crew was charged with the responsibility of bringing two sometimes wrathful deities, Minetu and Lekali, back to the village in order to receive offerings in atonement for any wrongdoing or offense. This particular image of a *sucao* was said to have been found attached to the suspension cordage of an *itara*, or hanging ancestor figure (see cat. 92).[2]

While its function and meaning are not fully understood, the Dallas ivory charm would have served another purpose. Its stance is similar to those of *itara* figures, yet its detailing is also consistent with the embellishments found on older, more singular Atauro objects.[3] Those singular items include a figure carved at the top end of a unique ceremonial shield and a squatting funerary statue, one of which is illustrated in *Indonesian Primitive Art*, and the other in *Art of the Archaic Indonesians*.[4] Each of those figures has a well-delineated spinal column and protruding or engraved scapulae and shoulder blades; their eyes are either covered with thin copper or flat brass disks or inlaid with copper or brass rivets.[5] This charm exhibits all those traits. It also possesses faintly visible engraved lines over its waist, wrist, and ankles. Those markings are presumably references to jewelry, as bracelets, earrings, and pendants are depicted on some Atauro images.

This amulet's stylish bun and prominent breasts probably tie her to an important female ancestor or perhaps even to the "bearer of unripe coconuts," Lebu-Hmoru, the goddess of fertility, who ensures the fecundity and regeneration of all things.[6] First observed secreted in a small compartment within a betel nut box made from woven palm leaves, this unique charm belonged to an elderly woman who had inherited it from her father. Once a highly valued heirloom, it was said to possess protective powers that ensured the prosperity and good health of its owner.[7] Its steady gaze and engaged posture are both captivating and communicative. That this charm was crafted from a precious material accords well with its diminutive size and tactile appeal. Years of handling have given it a fine surface and lustrous patina.

S.G.A.

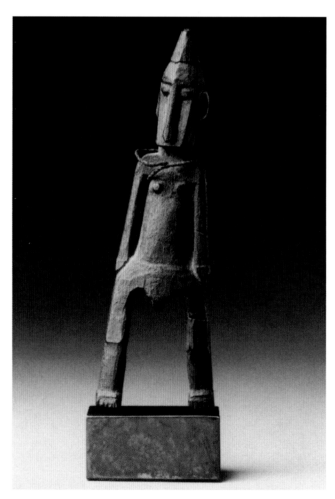

FIG 114 Figurine, Atauro. © 2013 Musée du quai Branly/Photo SCALA, Florence 70.2001.27.357.

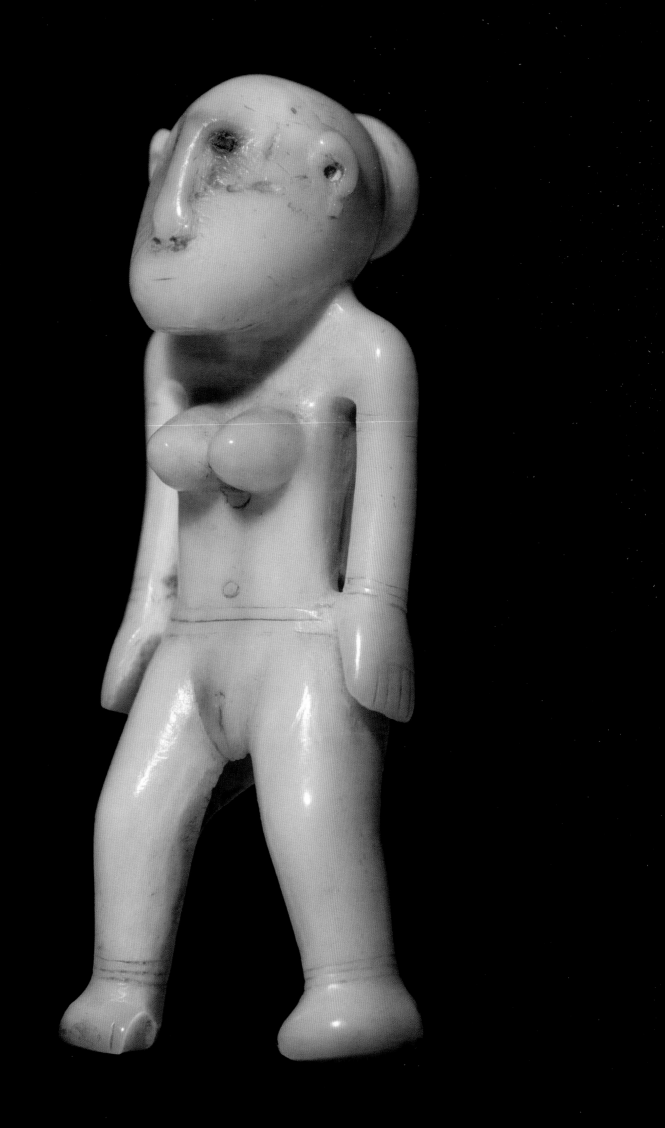

94

Ceremonial spoon

Eastern Indonesia, group unknown
c. 17th century
Ivory
10 × 1½ × 1 in. (25.4 × 3.8 × 2.5 cm)
Promised gift of Steven G. Alpert and Family, PG.2013.7

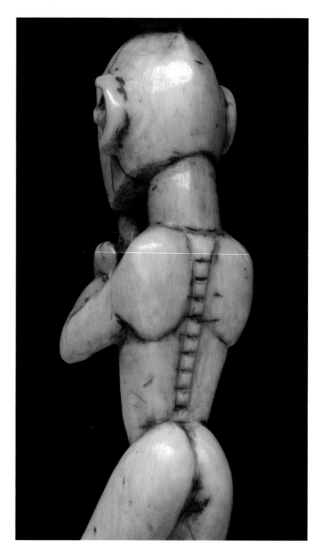

While the exact island origin of this spoon may never be known, it is now generally regarded as an early masterpiece that comes from somewhere in eastern Indonesia.[1] To begin to understand this unique spoon's provenance, one must start by comparing its salient features with those found in a subcategory of very rare items from the island of Atauro, and from other nearby islands. These features include a stacked topknot or headdress, raised or engraved scapulae, and an articulated spinal column.[2] The stance and facial qualities of the figure on the spoon can also be compared to those in certain masterworks from Timor and Tanimbar—and to other pieces from an area spanning the southern Moluccas to the northwest coast of Papua (New Guinea). Such an unusual combination of features cannot be convincingly ascribed to any other extended cultural area.[3]

In a phenomenon now largely forgotten to history, eastern Indonesia was a major impetus for Europe's Age of Discovery. After the fall of Constantinople to the Ottoman Turks in 1453, explorers such as Christopher Columbus began to conceive of sea routes that would allow Christian Europe to bypass the Muslim world in order directly to acquire the riches of the Orient. Among those riches were costly spices that were believed essential to the cuisine and the health of any who could afford them. The Portuguese discovery and dominance of Indonesia's fabled Spice Islands, at the time the world's only source of nutmeg and mace, provided a unique source of phenomenal wealth for nearly one hundred years. In *A Treatise on the Moluccas* (c. 1544), Antonio Galvao notes that payment for cloves was rendered "in the form of jewels, gold, copper gongs, ivory, porcelain, silk and cotton cloth."[4] This trade actively stimulated the importation of ivory into eastern Indonesia in partial exchange for cargoes of cloves, nutmeg, mace, and sandalwood.

Long after the departure of the Portuguese, and well into the Dutch colonial era, S.W. Earl, who first arrived in the southern Moluccas in 1838, noted that "incredulous Eastern traders" were buying up ivory tusks at any price. "So great is the demand even now for these articles that Siam and India seem scarcely to afford a sufficient supply, for I see by the latest commercial returns that the Dutch are importing African tusks from Europe for traffic in the Moluccas."[5] This explains why ivory tusks and carved ivory artifacts of many varieties appear in the small islands of eastern Indonesia.

This spoon was once owned by one of the most renowned collectors of indigenous and tribal arts, James Hooper (1897–1971). According to his grandson, Dr. Stephen Hooper, James Hooper always kept this piece in a desk drawer.[6] Calling it his "puzzle piece," he occasionally showed it to knowledgeable persons to solicit their opinions. Both James and Stephen Hooper always thought it most likely that this spoon came from Indonesia. Their assessment was made before the art world became aware of some of this area's more obscure and intriguing creations. Given the spoon's highly valued material, it certainly once belonged to a person of high status, and was perhaps used as a treasured ritual object. Most likely we will never know for certain. Ultimately, this exquisitely crafted spoon is a humbling, even daunting reminder that we have lost or destroyed far more knowledge of humankind's material past than we will ever manage to rediscover or fully understand.
S.G.A.

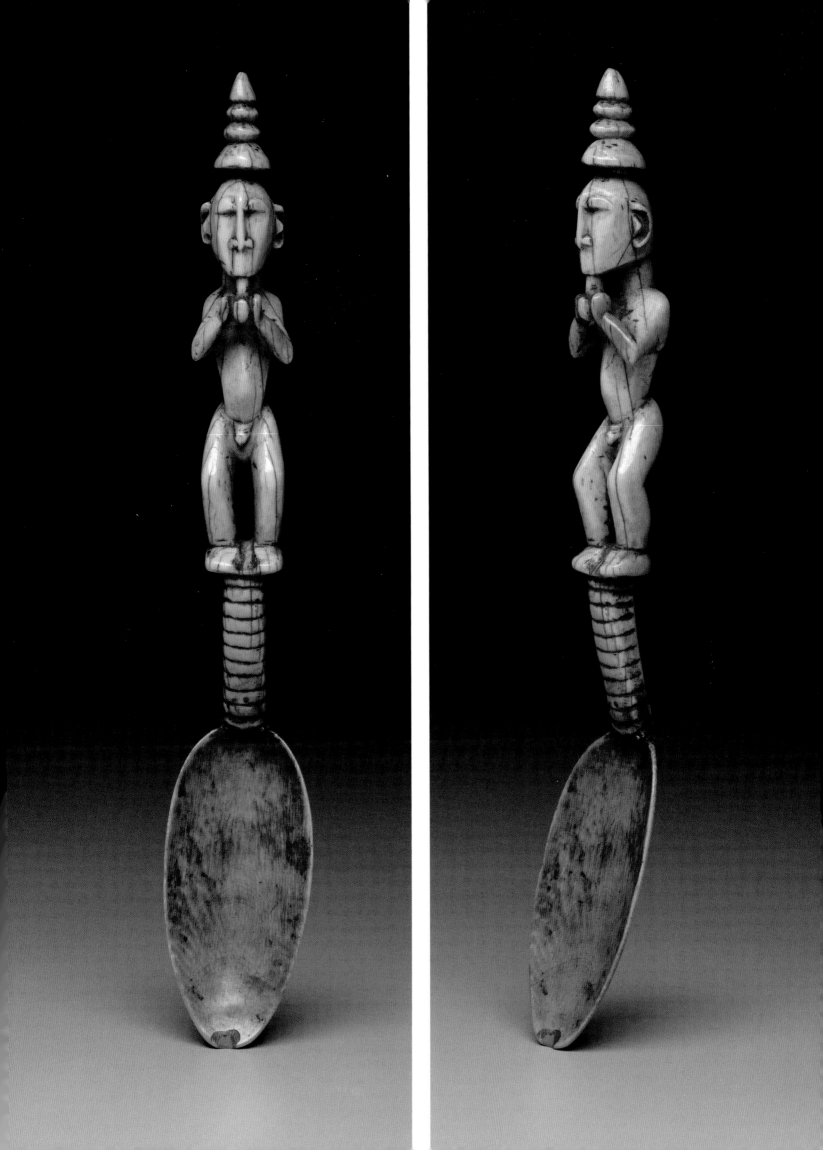

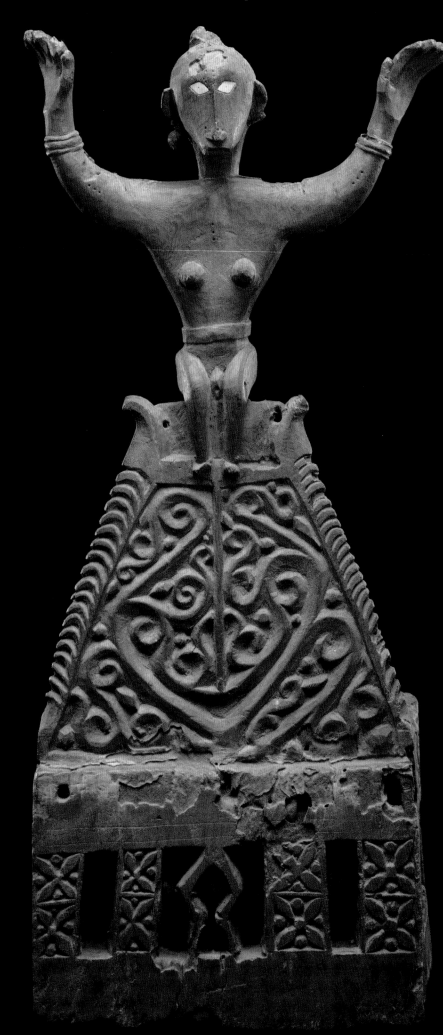

LIFE AND DEATH IN SOUTHEAST MOLUCCAN ART

Nico de Jonge

Between New Guinea and Timor, spread throughout the Banda Sea, lie the islands of Maluku Tenggara, also known as the Southeast Moluccas. Those who expect the area to be an isolated, idyllic South Sea paradise will be disappointed. For the most part it is made up of uplifted coral islands—small and barren in the west, somewhat larger and more wooded in the east—where the standard of living is low. On some of the islands famine occurs regularly due to infertile soil and a shortage of rainwater.

Despite their challenging environment, the inhabitants of Maluku Tenggara have produced works of art of impressive beauty and profound meaning. Consequently, the ancestor statues of Leti and Tanimbar, as well as the jewelry and fabrics of Kisar (fig. 122, p. 281) and Tanimbar, have been highly desired by collectors for many years.[1]

Regrettably, the production of most of these objects ceased nearly a century ago. This resulted primarily from the increasing influence of the Dutch colonizers at the beginning of the twentieth century, as well as the related efforts of Christian missionaries. In areas prone to constant fighting, the Dutch relocated remote villages situated like eyries on cliff tops to coastal places that were easier to control.

As a result of colonial and Christianizing inroads, the ancient customs and habits known as adat—together with the indigenous religions—came under immense pressure. The islands where Protestant missionaries were active were hardest hit. With the tacit and sometimes active backing of the colonial administration, the mostly Amboinese clerics trained by the missionaries converted the island inhabitants in an often coercive way, forcing them, among other things, to abandon their "open idolatry." Many statues of gods and ancestors were thrown into the sea or ostentatiously burnt.[2]

Because of these substantial losses, it might seem that the only information available for understanding the cultural context of traditional works of art from this region are colonial records and early Western sources. However, this is not entirely the case. In fact, when traveling around the islands, it quickly becomes apparent that a number of traditional cultural practices, particularly ancestor

worship, are still very much alive. Traditional beliefs function, albeit adapted and without the original statues, side by side with Christianity and, to a lesser extent, with Islam. In addition, some traditional goldsmiths can still be found, and on some islands the art of weaving has been maintained. Moreover, in many places, one comes across remnants of a form of nautical symbolism that was important in pre-Christian times. This symbolism dominated the former island cultures to a large extent and found its expression in various kinds of art forms.

The boat as a model

On most Maluku Tenggara islands, the boat not only served as a means of transport; it was also considered an important model of society. In the Kai, Tanimbar, and Babar archipelagos, as well as on the islands of Luang, Sermata, Leti, and Damar, the occupants of houses and villages saw themselves as a ship's crew, a view that was expressed in various ways. The Tanimbarese, for example, considered their houses to be large ships with their prows pointing toward the sea. The beautifully horn-shaped ridgepole decorations on both the sea side and the land side were indicated with the term kore, which was also a word used for the artistic prow boards of the actual proas (fig. 115).[3]

Similarly, on some Babar islands, large traditional houses were associated with sailing boats that followed the orbit of the sun, from east to west. Inside the house, this symbolic course was reflected in the names of the living spaces. For example, the eastern rooms were part of the helmsman's area and the western rooms were part of the pilot's area. The boat concept was also incorporated in the architecture of the house. On the eastern and western sides of the ridgepole, upwardly curving gable ends were applied, providing the ridgeline with the basic shape of a ship.

Just as with houses, many villages in Maluku Tenggara were also thought of in terms of boats with crews. This association was easy to make, because many large family houses or compounds originally formed independent units and could operate as small, walled villages. Even when different descent groups started living

together at a later stage, the proa model was usually maintained. We can again find good examples of this phenomenon in the Babar archipelago. On some islands, large villages were built in which one family identified itself as a symbolic helmsman, another as a bailer, and a third as a pilot. This "village boat"—just like the local family house—was oriented in terms of the sun's orbit in the sky, with the helmsman living in the east, the pilot living in the west, and the bailer living in between.

Ship of marriage

In addition to its use as an architectural and spatial model, the boat image functioned in another way in Maluku Tenggara. With the aid of this symbolism, rituals recounted the creation of society. The representatives of the mythical first ancestors played a primary role in these rituals. Thus, a magnificent blueprint of island life was reflected in nautical terms that reaffirmed the most important social values and the division of labor between men and women.

The rituals were based on a type of metaphor for marriage frequently found on the western islands, but most likely illustrative for a much larger region. In this metaphor, the woman was regarded as a boat, lying on the beach, waiting for a man who wanted to go sailing. Only when the man—the helmsman or captain—boarded

the boat could it set sail, that is, could a family (or society) come into being.

This imagery featured in various ceremonies, for example in the construction ritual of a traditional boat and also, on various islands, in the building ritual of the family house, the symbolic boat. Despite considerable regional variations, this type of ritual usually reflected the marriage ceremony of the founding ancestors. One part of the construction was marked as a feminine "hull" or "keel," whereas another part—for example the main post—was marked as a masculine "captain" or "helmsman." The union of these parts brought the family (or social unit) into being, just as one would launch a ship after its completion.[4]

These rituals simultaneously displayed core social values. The construction of the feminine parts took place in an atmosphere of "coolness," aimed at growth and fertility, while the masculine parts were applied in an atmosphere of "heat," referring to lethal danger. Through all kinds of symbols, the founding father was portrayed as a "great (head)hunter," who had acquired his reputation because of his capacity to kill. At the same time, these references showed the traditional division of tasks in the region: the care of children and crops (all things concerning new life) was a typical feminine affair, while protecting the family reputation, especially by means

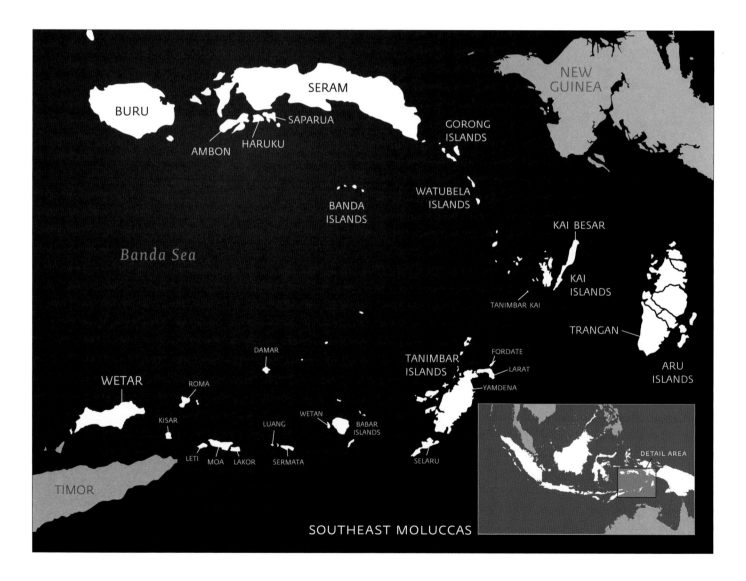

9 LIFE AND DEATH IN SOUTHEAST MOLUCCAN ART

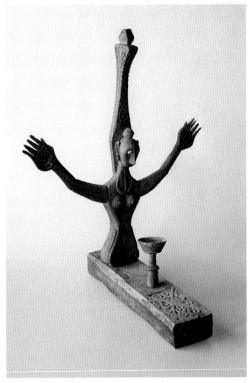

FIG 115 Children on the prow of a Tanimbarese proa, c. 1930. The *faniak* figure, a stylized dog catching a fish, is visible on the underside of the scrollwork of the open carving on the prow board. Courtesy of KITLV/Royal Netherlands Institute of Southeast Asian and Caribbean Studies 404633.

FIG 116 Realistic *luli* statue from the island of Lakor. Museum Volkenkunde, Leiden, 1476-11.

of warfare, was viewed as the male's domain. On some islands (as in the Babar archipelago, for example), the saying "women look inward, whereas men look outward" was common.

With this understanding of ritual and symbolism, a whole new world is revealed when we consider the material culture of Maluku Tenggara. Society on all the islands revolved around fertility and status, with clear roles for men and women, and this was reflected in the traditional arts. All important objects—whether ancestor statues, gold jewelry, or fabrics—related directly to these values. The statues were part of an all-encompassing religious system that always informed traditional tasks. Through these sculptures, gods, spirits, and ancestors could be provided with offerings and properly supplicated. Jewelry and fabrics mostly played a role in a group's social life. As gifts, they symbolized status and fertility, defining relations between individuals and families.

Trunk and top

The most familiar aspect of the ancestor worship of Maluku Tenggara is its use of human figurines, often carved in a characteristic squatting pose (cat. 95). Much less known, however, is the fact that ancestors are sometimes also depicted in the form of animals. In this guise, they usually were understood to belong to a group of mythological creatures that inhabited the area before the first human beings. The creation of *adat* (as well as language) is mostly ascribed to these creatures, for they are its guardian spirits. On various islands the founding ancestors are believed to have originated from them.

The deceased were called upon for help in all kinds of matters, yet two themes predominate. When fertility was relevant, the female ancestors were indispensable, as were the male ancestors in matters regarding prestige. These themes were based on the notion that whether a woman would conceive or not was partly determined by the female ancestors, whereas the male ancestors had to assist a man so that he could kill and acquire status. This dependence on, and alliance with, the ancestors was often expressed in botanical terms. The ancestors were regarded as the trunk of a tree, while the living descendants represented its top branches. The development of new shoots is dependent on the root system at the base of a tree, just as the fate of the clan or larger society was in the hands of the ancestors.

As the founders of family groups, the first ancestors were naturally worshipped the most. To their descendants, they represented the ultimate sources of both fertility and the capacity to kill. The most imposing ancestor statues in Maluku Tenggara, therefore, were related to these first ancestors. On the islands whose society had a matrilineal character, a primary role was reserved for the founding mother. On islands where the male line took precedence, that role was reserved for the founding father.

Boat and tree

The most impressive statues of founding mothers were found in the western part of the region. On islands such as Luang, Sermata, Leti, Lakor, and Kisar, so-called *luli* (a word meaning "sacred") represented the female founders of noble matrilineal families (fig. 116). Because of their extraordinary decoration and expressive design (together with the *aitiehra* from the same region and the Tanimbarese *tavu*, both described below), they are celebrated among the masterworks of Southeast Moluccan art.

Interestingly, *luli*, which traditionally stood in special sanctuaries, were designed in a variety of different and creative ways. The

female figure could be depicted realistically, with some characteristic decorative motifs, or it could be completely dominated by these motifs to such an extent that the female figure became abstracted and was barely recognizable, if at all. Moreover, all sorts of transitional forms were found between these two extremes. Surprisingly, however, this multitude of appearances reveals the founding mother's essence. Comparison of the most important *luli* categories suggests that she was associated above all with a life-giving force.

When a founding mother is depicted realistically, she generally holds her arms raised and sideways (cat. 105). Usually, there are decorations on fixed parts of her body. Often her stomach or abdomen is decorated with a highly stylized boat motif, fitted with prow and stern posts curling powerfully inward. The upper body (for example, the shoulders and the head) is often decorated with floral motifs. Sometimes the upper body and the surrounding foliage even seem to have become indistinguishable from each other.

The decorations can be explained by examining the abstract *luli*. There, the female figure is only implied, whereas the boat motif and the vegetation—as elements of a combined decorative pattern—are much more prominent. From the middle of the stylized boat, a tree-like pole (sometimes with "leaves") rises—a preeminent symbol of fertility on most islands. The tree—often symmetrically carved—represents new life, with the boat representing the source of life, analogous to the marriage metaphor. In this interpretation, the boat is essentially compared to the womb, an association that also explains the positioning of this motif on the realistic *luli*, namely, on the abdomen. This association is also found on the eastern islands of Maluku Tenggara. On Tanimbar, for example, a pregnant woman was explicitly compared to the hull of a boat. It was said of a woman in labor that "the proa had landed" and "the cargo was being carried ashore."[5]

The position of the arms in the realistic *luli* is as remarkable as it is intriguing. To interpret this positioning, the "mixed *luli* forms" are especially important. Quite often, these show a boat motif from which the founding mother, sometimes as part of a floral motif, is rising. The female figure is thus part of the motif as found on abstract *luli* and splendidly represents new, burgeoning life. We may assume that the arms of a realistic *luli* refer to the same pattern. These raised arms, stretching out sideways, can be understood as the shape of a boat from which the founding mother emerges. This might also explain the great emphasis on the upper part of the body at the expense of the legs. Whatever the design of the *luli*, the symbolism is evident; through the association of the boat with a womb, the founding mother represented a sacred source of fertility.

Hunter and prey

Characteristic statues of founding fathers can generally be found on the eastern islands. On Aru, Kai, and Tanimbar, the history of many patrilineal descent groups goes back to a glorious, mythical past in which the first male ancestors still act in the guise of animals. This is beautifully reflected in material culture.[6]

FIG 117 Boy at the stern of an Aruese boat, with the clan emblem, in the image of a fish, c. 1983.

On the island of Aru, for example, totemlike figures of founding fathers were placed on boats before they set out to sea. Most examples of this imagery depict a seabird, dog, rooster, or snake (fig. 115, p. 277). The three-dimensional figures, called *semai* or *mitmosim* (both terms meaning "sacred"), were attached to the prow and stern.[7] Furthermore, a two-dimensional version in which double images mirrored each other was often placed on a stern board; in special cases, human beings were depicted. Remarkably, these traditions continued to be practiced until quite recently. These animal figures received offerings on a regular basis, as Western missionaries did not regard them as ancestors and were therefore not threatened by their presence.

In villages on Tanimbar, and to a lesser extent on Kai, the founding fathers were portrayed in a comparable way. Here, the animal figures were carved on "houses of origin" of descent groups, village stairs and doorways, and stern boards of proas as clan emblems.[8] As on Aru, roosters, dogs, and snakes were favored. Moreover, ancestors sometimes appeared as animals inside the houses of origin. The remote island of Tanimbar-Kai offers well-documented examples. Around 1980, images of founding fathers in the shape of animal figures were documented in the attics of two houses. The statues were fitted with the heads of roosters; the bodies resembled those of a human being and a bird (fig. 118).[9]

Evidence collected on the islands of Kai and Tanimbar reveals, however, that not all animal figures connected to a descent group concerned the genealogical founding fathers. A clan or village could

9 LIFE AND DEATH IN SOUTHEAST MOLUCCAN ART

also be represented by an animal with which a mythical bond had been made. Through this bond, the animal joined the group, and its image seems to have replaced or symbolized the first male ancestor. These types of bonds are known to have existed primarily on Tanimbar. In various cases, no kinship relation existed with the animals that made up the clan emblems (faniak).[10]

The animals chosen to be depicted in these kinds of sculptures were closely linked to the role of the founding fathers in society. Roosters, as well as dogs and snakes, were associated with virtues such as bravery and aggression, both necessary for the ability to kill and thus build a reputation. To the descendants, therefore, the animal figures referred to a founding father as a man of highly impressive standing: an invincible headhunter and an ultimate source of power.

Illustrative of his "heroic deeds" was the decorative design depicting a hunter and his prey: a rooster or a dog with a fish or turtle in his beak or paws. Sometimes this motif was used to decorate a house or village doorway, but more often it was incorporated in a prow board (see fig. 115). The latter could also be decorated with other "prey," such as shells that represented severed heads. The shell decorations (usually Ovula ovum shells strung together) were widely used within the region (see also cats. 97 and 98). For countless generations, these were the preferred means of advertising one's standing as a headhunter in the Moluccas.[11]

A special version of the design could be found in some of Tanimbar's founding houses. Here, lavishly embellished plank statues proclaimed the fame and glory of the noble families concerned. The plank statues (mostly known as tavu, meaning "source" or "trunk," a good illustration of the botanical symbolism) functioned as a sort of family shrine where the ancestral power available within the group could be called upon.

The tavu decorated with the "hunter and his prey" motif were most common on Selaru, the southernmost island of the Tanimbar archipelago. There, the ancient totemic culture was probably best preserved.[12] Generally, the Selaru tavu had the shape of a standing, very stylized human figure with its arms spread wide. At the top there was often a symmetrical carving of two roosters or two dogs, quite similar to the Aru stern boards. This faniak image was accompanied by carvings (often directly below it) that depicted seized treasures in various forms, such as gold valuables and shells probably symbolizing severed heads.[13] However, in contrast to the prow boards, here often beautifully stylized Nautilus species could be observed.[14]

While the statues of founding mothers in Maluku Tenggara—in accordance with symbolism of the "ship of marriage"—explicitly referred to fertility, the male family founders were—in accordance with the same concept—usually depicted as "great hunters."

Heaven and earth

The ancestors were not the sole determinants of events on the islands. In many cases, they were called upon together with one or more gods. Sometimes this was a creator god, who lived somewhere far away—in or above the firmament (for example, Langit Ombak on Tanimbar or It Matromna in western Maluku Tenggara). More often, however, they were deities related to the structure of the universe. Generally, a specific dependency relationship existed with these gods.

In pre-Christian times on almost all of the islands, the cosmos was conceived of as a system of two entities, which were usually called "above" or "heaven" and "below" or "earth." Although the cosmic divide was interpreted differently on different islands, "above" and "below" were generally thought of as persons. "Above" was a man, in the person of a heavenly deity; "below" was a woman, in the person of an earth goddess. Both parties were linked in a cosmic marriage, on which everyday life was directly dependent.

Although no clear information about eastern Maluku Tenggara is available, it seems that throughout the region people communicated with their deities by means of symbols. Most villages had a ritual center, including a "holy" stake or pole statue and a "sacred" stone or shell. Only for the western islands (Babar to Kisar) has it been possible to get some idea of what these objects represented and which roles they played in society. For the moment, we will therefore limit ourselves to this region.

Holy marriage

In nearly all the villages in the area, the earth goddess was worshipped in the shape of a round, flat stone or a large Tridacna gigas shell. In many places, she was addressed by the name Rivnoha:

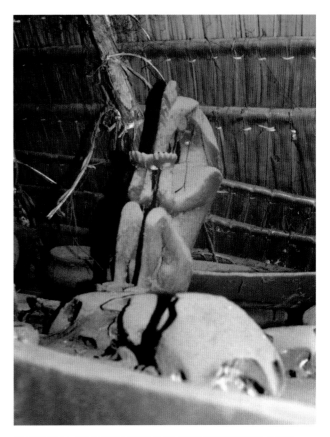

FIG 118 Statue of a founding father on the island of Tanimbar-Kai, c. 1980. The statue has the body of a human being and the head of a rooster.

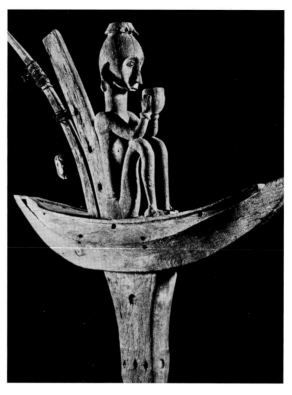

FIG 119 The person who makes the sacrifices calls on the deity. She is adorned in locally made *sarong*, with a gold pendant on her forehead, *kmwene* ear pendants, and bracelets of conus shells. Tanimbar, c. 1930.

FIG 120 Statue of the heavenly deity Lamiaha, until 1913 situated in the ritual center of the village of Emroing on Babar. Collected by German ethnologist W. Müller-Wismer in 1913. Rautenstrauch-Joest-Museum, Cologne 36532.

"(the person) who carries the island (the earth)." Everywhere, earthquakes were attributed to her. To stop these, she was invariably called upon with a lot of noise.

Next to the female stone or shell, one could find the symbol of the heavenly deity. In large parts of the Babar archipelago, this would be a wooden stake, which, in some villages, had weaponry (a bow or fishing spear) attached to it. More to the west, for instance on Luang and Leti, the male god was represented mostly as a male human figure sitting in a boat or a boat-shaped construction that usually had a beautifully worked "stern," which was placed on top of a pole (fig. 120).[15] In many villages, it would have attributes hanging from it, such as *Ovula ovum* shells, and wooden figurines in the shape of fish and weapons, objects reminiscent of the Tanimbarese prow boards that showed the *faniak* figures and their prey. From this we may deduce that the heavenly deity, just like the founding fathers, had the attributes of a feared headhunter. The names given to the deity (for example, "Great Spear") also suggest this, as does the fact that the pole statues were called *aitiehra*. This term literally means "hard wood," and hardness is considered to be an important symbol of strength on the islands.

In the way they functioned, the gods also showed remarkable similarities to the ancestors. Again, fertility and status were of key importance, with the distinction that here the dealings were at the highest, divine level. Rivnoha was regarded as the "owner" of the earth and, in this capacity, was worshipped as the source of all earthly life. Before going into battle, warriors requested divine power and protection at the wooden stakes and pole statues. To that end, splinters of the wood were sometimes even incorporated in the warriors' clothes.

The fact that the heavenly deity was depicted as a great hunter sitting in a boat can probably be traced back to a great fertility feast that, until the end of the nineteenth century, was celebrated primarily when a disaster such as a crop failure or fatal epidemic occurred. The aim of the ritual, usually known as *porka*, was similar everywhere: people wanted to formally acknowledge the end of a bad period and to make a new start; they wanted creation to be renewed. We have good reason to assume that this ritual applied nautical symbolism on a wider scale, to embrace the whole cosmos.

During the *porka* feast, the "holy marriage" between heaven and earth was ritually reenacted. The stake or statue of the heavenly deity was renewed and stuck into the ground next to the stone or shell that represented the earth goddess. Their bond seems to have been symbolically expressed by the concept of the "ship of marriage": just as in the building ritual, the groom was depicted as a helmsman or a pilot. Through the union of the two cosmic halves during the *porka* ritual (see the entry for cat. 96), creation came back "on course" once again.

Hot and cool

The aforementioned examples beautifully illustrate how the most important social values of Maluku Tenggara were reflected in religious rituals and artifacts. Various supernatural powers were worshipped as sources of fertility and status. Without the gods and ancestors, traditional life was in fact impossible. In conjunction with such sacred sources, however, society itself also contained "suppliers" of fertility and strength: descent groups with whom marital relations were established. Even nowadays, this is still referred to through the ritual exchange of valuables.

On various islands, for example on Kai and Tanimbar, the *adat* traditionally obliges a man to look for a wife outside of his own group. Consequently, a family always depends on other groups for its survival. Usually these marriage alliances are one-sided: a bride may never be given to a group from whom a bride was once taken. Because of this, various groups have developed permanent wife-giver–wife-taker relationships, alliances that are repeatedly reaffirmed through the public exchange of ritual presents.[16] Of these, beautiful *ikat* fabrics and fascinating gold jewelry are the most prized; both categories of gift are symbolically important.

The *ikat* fabrics are meant for the wife-takers. The cloths are referred to as "cool" and symbolize the fertility that—through the bride—will "flow" from the wife-givers (and their female ancestors) to the wife-takers. The "coolness" derives from the nature of the materials: the fabrics are made of cotton, which is a product of the "feminine" earth. Conversely, the wife-givers often receive—as the major part of the bride price—"hot" golden jewelry, and these items convey a message as well. Though the fact is generally forgotten nowadays, on many islands these valuables are associated with slain enemies (see also cats. 99–101).

By offering these "headhunting trophies," the wife-takers place their own capacity to kill, so to speak, at the service of the wife-givers: if aggression occurs, they (and their male ancestors) can be counted on for aid and protection. On many Moluccan islands, weapons used to be a part of the bride price as well (cat. 97), which of course contributed to the symbolism.[17] At the same time, receiving jewelry increased the social status of the wife-givers: their

prestige—as the new owners of additional "hot" items—was given added weight within the community (fig. 121).

On many islands, the presenting of the bride price also involves the boat symbolism discussed earlier: during the ceremony, the valuable objects are traded for a symbolic proa, that is, the woman. On Tanimbar, for instance, gold and elephant tusks are given in exchange for the "mainsail" and the "rudder," and on the Kai islands, a cannon and a gong are donated in exchange for the "keel" and the "oars." In return, the wife-givers make sure "the boat is rigged up nicely," which means the bride will be handed over to the wife-takers all dressed up and provided with a handsome trousseau.[18]

Even though their numbers have decreased, valuables of this type are still to this day being exchanged on numerous occasions (primarily rites of passage). The social roles of both men and women are symbolically highlighted by these exchanges, while at the same time they emphasize the mutual interdependence of the clans: only through cooperation will society endure. This raises the question of how long this practice can last. Increasingly, the islands of Maluku Tenggara are becoming part of modern Indonesia, and many traditions, such as the production of gold jewelry, are dying out or indeed have already disappeared. Like the statues of gods and ancestors, soon the textiles and jewelry that are visible symbols of the fertility and status they confer on society will also have disappeared from the villages.

FIG 121 Tanimbarese boy from the island of Yamdena wearing a gold chest pendant, 1982.

FIG 122 Shoulder cloth (detail), Southeastern Moluccas, Kisar, late 19th century. Homespun cotton. The Steven G. Alpert Collection of Indonesian Textiles, gift of The Eugene and Margaret McDermott Art Fund, Inc., 1988.121.McD.

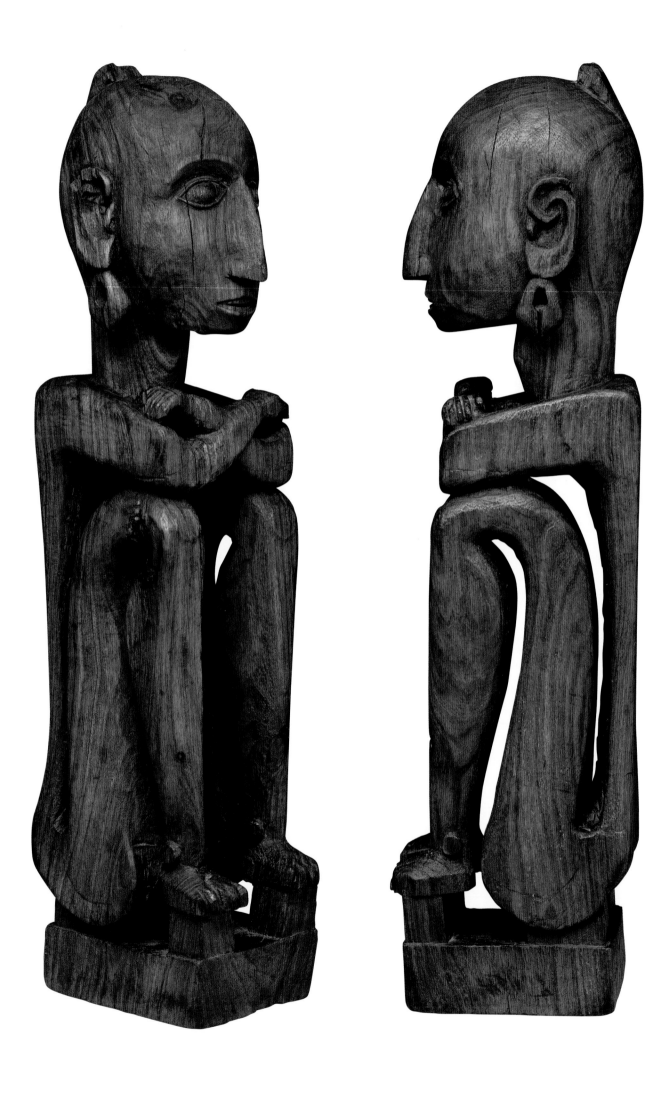

95

Seated male ancestor figure

Indonesia, Southeast Moluccas, Leti
Late 19th century
Wood
20¾ × 4¾ × 6 in. (52.7 × 12.1 × 15.2 cm)
The Otis and Velma Davis Dozier Fund and
General Acquisitions Fund, 2003.31

One of the most noticeable basic forms in the traditional arts of Island Southeast Asia is the squatting position of carved anthropomorphic figures: the knees are raised in front of or to the right and left of the body. At one time, this sculptural form was widespread and could be found in Taiwan, the Philippines, parts of Borneo and Sulawesi, and—very prominently—in the Southeast Moluccas. This artistic form is associated with the so-called Austronesian cultural complex. There exists both linguistic and archaeological evidence to suggest that this complex, which originated in southern China, spread from Taiwan and the Philippines to Indonesia in the third millennium BCE (see also the introduction to this catalogue).

The object shown here is a beautiful example of such a squatting figure. It was collected on the island of Leti, in western Maluku Tenggara, at the end of the nineteenth century and represents an ancestor. Traditionally ancestors have been of great importance to the islanders. In the southern Moluccas, fertility and status are the most important social values, and these cannot be obtained without ancestral help.

The creation of these ancestor figures was strongly connected to ideas about the nature of mankind. In general terms, a person is regarded as a being in whom two elements have merged: first, a sort of anonymous "vital force" that expresses itself in the physical growth and movement of the body; second, something that can be described as a person's "self," an element that, by earlier missionaries, was compared to the "soul" or "spirit." "Self" refers to personal characteristics and is thus associated with a person's name, facial features, voice, bodily shape, and even reflection or shadow. The islanders describe the self as a person's "shadow image."

In contrast to someone's vital force, this shadow image is considered immortal. After death, it continues to be socially active, while the vital force ebbs away as the body decays. Until the mid-twentieth century—a period in which Christianity gained ground—wooden figures were carved to serve as a point of contact with the deceased. The shadow image could take up residence in such a figure, allowing descendants to communicate with him

or her. Female ancestors were addressed mainly on matters concerning fertility, whereas the male ancestors were called upon for status issues.

In many instances, the carved statue reflected the individual characteristics of the deceased. In the case of this Leti statue, for instance, the gender has been portrayed very prominently (the amputation of the penis is a "souvenir" of Protestant influence). The ear ornament identifies this figure as a member of the local nobility. Finally, the sheer size of the figure signifies an important person; statues of ordinary ancestors were usually only a couple of inches tall.

Leti statues were usually kept in a house's attic. An activation ritual with a ceremonial meal was performed here for each newly carved statue. To "lure" the shadow image of the deceased into the statue (as its new seat, or home), the statue was first placed on a golden disk (mas bulan; see cat. 101). Next, the statue, which now possessed the "shadow image," was taken up to the attic, where the deceased was fed by placing food in front of the statue and rubbing palm wine on its lips. The ceremony was rounded off with a meal for the family.[1]

Because of their striking craftsmanship and aesthetic design, squatting statues from Maluku Tenggara became collectors' items early on, and they often appear in Western museum collections. In the twentieth century, several experts attempted to assign them to clearly defined style groups.[2] Looking comprehensively, however, an analysis of style can be made only very broadly. Shortages of drinking water, along with a state of enduring warfare in the area, resulted in what was essentially a continual process of migration. Families that had their roots in Leti would, for example, move to Babar or Tanimbar and vice versa. According to some analyses, details such as a large triangular nose or tapering torso are typical for Letinese sculpture; however, given the fluidity and migrations in the region, we must be cautious in the assignment of stylistic and regional categories.

Still, it is feasible to argue that the squatting figures of eastern Maluku Tenggara are usually designed in a more rugged and less painstaking way than are the statues of the western islands. Generally, the foremost style feature distinguishing one region from the other appears to be the position of the arms. On Leti and its surrounding areas, the arms usually rest folded on the knees in a horizontal plane with the shoulders, as in the Dallas statue. Conversely, on Tanimbar, for example, it is usually the elbows that are resting on the knees while the arms are held upward, often clasping a sacrificial bowl.

In any event, because of their particular, often artistic style, nearly all sculptures from the Southeast Moluccas are endowed with their own unique appearance. Indeed, the religious art of Maluku Tenggara is justifiably considered to be among the most fascinating in Indonesia.

N.d.J.

96

Mouth mask probably depicting the head of a rooster

Indonesia, Southeast Moluccas, Leti, Luhuleli
19th century
Wood, boar tusks, clam shell, mother-of-pearl, buffalo
horn, resinous material, and pigment
5½ × 6⅜ × 5¾ in. (14.0 × 16.2 × 14.6 cm)
The Eugene and Margaret McDermott Art Fund, Inc.,
1997.141.McD

Among the rarest of the ethnographic artifacts from the Southeast Moluccas are small masklike objects depicting the head of an animal. On the back of each of these objects is a wooden tab, extending from the inside of the head, which is clamped between the teeth and serves to hold the mask on the wearer's lower face in front of the mouth. This type of object is thus sometimes referred to as a mouth mask.

As far as we know, only four of these mouth masks exist in museum collections worldwide. The oldest specimen was collected in 1888 in the village of Tombra on the island of Leti. According to the man who parted with it, the mask was very old and was the only one of its kind on the island.[1] This statement was subsequently proved to be incorrect, as in 1914 the German ethnologist Wilhelm Müller-Wismar discovered another two specimens on Leti, in the village of Tutukei. These three masks resemble one another, and they each depict a pig's head. The Tombra specimen is currently in the collection of the Amsterdam Tropenmuseum in the Netherlands; the second and third masks both belong to the Rautenstrauch-Joest-Museum in Cologne, Germany.[2]

The object shown here is the fourth mouth mask, and it comes from Leti as well; it was collected in the village of Luhuleli about forty years ago. Its design is particularly remarkable. In this case, it is not a pig that is represented, but instead a bird, presumably a rooster. The materials of this mask are in fact similar to those of the pig masks; the head, carved from wood, has round bits of shell for eyes, while a series of boar tusks gives the mask a dramatic appearance.

The collectors were not able to obtain much in the way of information when acquiring these masks. In Tutukei, Müller-Wismar was able to learn only that both masks were used as "porka tools," and the collector of the Tombra mask noted simply that the object was used for the "pig dance poreke."[3] In the case of the bird mask, no additional information was gleaned. Still, the little that is known suggests the context in which these objects functioned; they were used in dances during the so-called porka ritual.

This fertility feast, which used to be celebrated in the Babar-Kisar region, was intended to bring about a renewal of life or, as Müller-Wismar noted on Leti, the proliferation of man, cattle, and vegetation.[4] It would usually be held following some catastrophe: the burning down of a village, a fatal epidemic, crop failure caused by a drought, and so on. However, on many islands the celebration would be held at fixed intervals. Luang, for example, had a porka feast once every seven years.

The festivities, which abounded in song and dance and lasted for weeks, were disapproved of by missionaries and the Dutch colonial government due to their alleged encouragement of both headhunting and promiscuity. Beginning around 1850, the performance of the porka ritual was consequently prohibited, though it continued to be performed in remote areas over the ensuing decades. By the twentieth century, elements of the ritual gradually became intertwined with the Western celebration of the new year.

In early literature, there is no reference to the role that mouth masks played in traditional ceremonies. Nonetheless, we can link the pig masks to the porka ritual in an indirect manner. According to J.G.F. Riedel, a Dutch administrator who visited Leti several times between 1880 and 1883, there were performances of a bean dance, a goat dance, and a sea-worm dance during the festivities.[5] All the evidence implies that these dances were meant to generate an abundance of crops, livestock, and other staples. The mention of the goat dance is of particular importance, since goats, along with pigs, represent great wealth on the islands. Thus, goats and pigs were often grouped together, and they were even referred to with the same word (pipiwawi). Furthermore, goats and pigs were prime sacrificial animals for the porka ritual, which explains why there were explicit prayers for "the replacement of deceased goats and pigs, with live ones."[6] The existence of a goat dance strongly suggests the coexistence of a pig dance, and thus the information obtained with the Tombra mask appears to be correct.

The function of the bird mask seems to have been entirely different. One of the most important dances of the porka feast was a

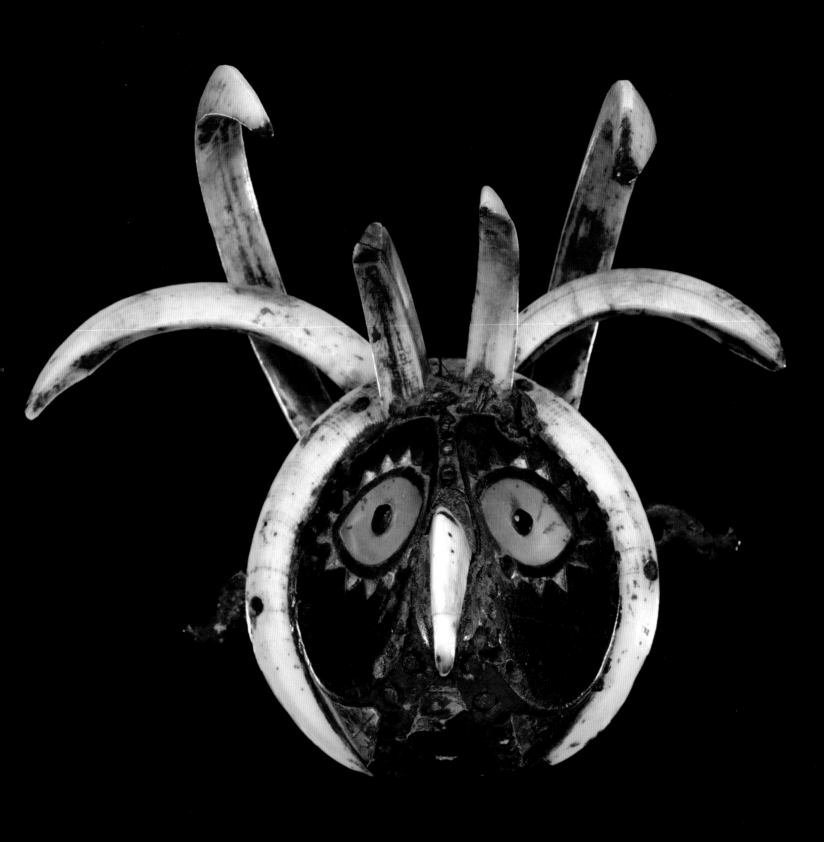

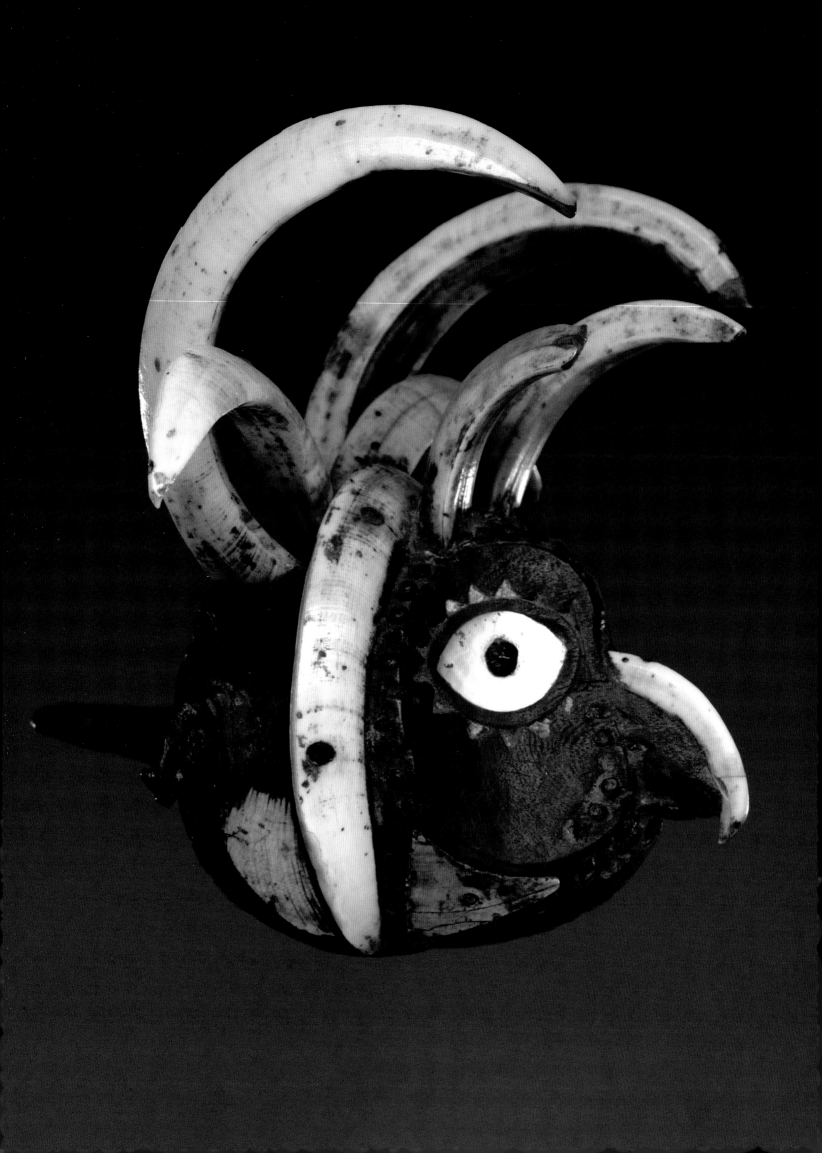

war dance performed by men, which portrayed a hunt for heads. On many islands, these dances were led by a champion who was called the "dog's tongue." During the spectacle, an imaginary dog made up of all the dancers would symbolically lacerate the enemy.

In some villages, the dancers portrayed a ruthless, aggressive rooster. This phenomenon can still be observed during the New Year's celebrations in the Babar archipelago. The dancers are adorned with rooster feathers, and they each wear a small mask on their heads that covers their eyes. On top of this mask is a red-and-white "horn" made of cotton and filled with kapok.[7] It is quite probable that the rooster mask from Luhuleli was formerly used in a similar war dance.

The rarity of the masks undoubtedly relates to the fact that the *porka* ritual was celebrated at the village level and therefore required relatively few accoutrements, as compared to objects produced for individual use. Additionally, many objects were probably lost due to colonial prohibition of these traditional celebrations. Riedel, the Dutch administrator cited above, also made a crucial observation. During his tenure, every village had its own way of performing songs and dances, which, probably on penalty of war, was not to be copied by other villages.[8] In other words, a sort of patent protected the use of the mouth masks.

N.d.J.

FIG 123 Drawing of the mouth mask from the village of Tombra, as published in the periodical *Globus* in 1892 (see Pleyte 1892a: 344).

97

Sword with handle resembling a human face in profile

Indonesia, Southeast Moluccas, Tanimbar Islands
19th century or earlier
Iron, wood, buffalo horn, bone, and rattan
31½ × 1¼ × 5½ in. (80.0 × 3.2 × 14.0 cm)
Gift of Steven G. Alpert and Family, 2007.7

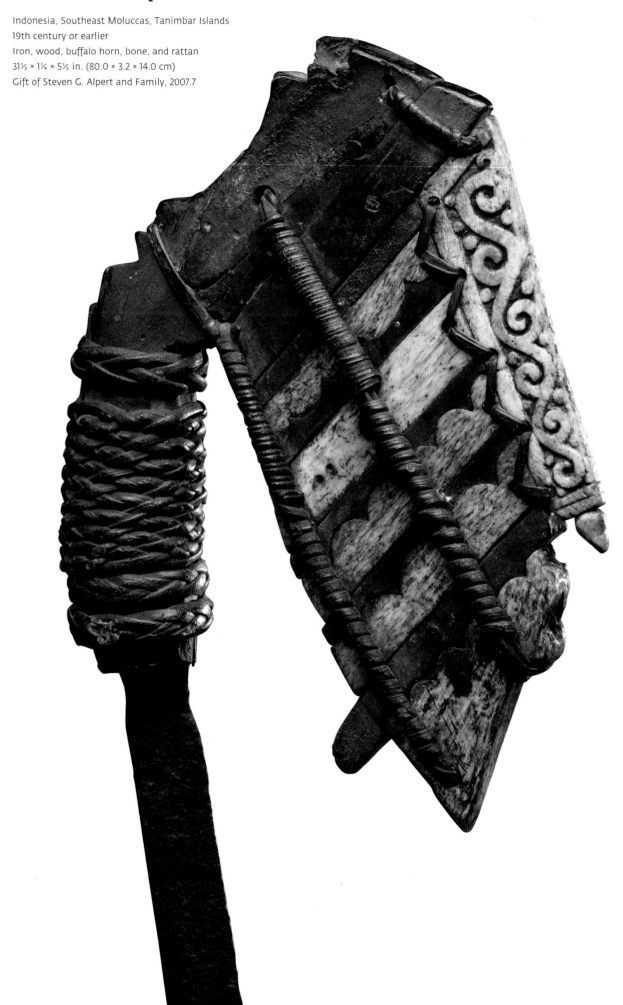

Of all weaponry in Tanimbarese culture, the *krai silai*, or "great sword," is without a doubt the most impressive.[1] Its extra-long blade and often splendidly carved hilt would inspire awe in the enemy.[2] The *krai silai* was seldom used in actual battle, nor was it meant for daily use; its function was mainly a ritual one.

Much uncertainty remains concerning the origin of these venerated swords. Most probably, the blades originated from tradesmen who visited the islands centuries ago; these blades were subsequently equipped with their hilts by the Tanimbarese.[3] In the most artistic examples, the hilts were composed of wood and bone and often—as is the case here—decorated with carved, spiral patterns. A striking aspect of these swords is the hand protector, made of tanned stingray or sharkskin, with which most swords—but not this one—were equipped. Often some *Ovula ovum* shells would be attached to the protector (fig. 124). Undoubtedly, these shells were meant to increase the sword's potential to impress: it is highly likely that the shells—as in other East Indonesian areas—represent severed heads.

As mentioned, the use of the *krai silai* was limited. Usually, the weapon, blackened with soot from cooking fires, would hang from a strip of rattan cane on one of the walls inside the house. The blade would have a small hole especially for this purpose. Only when circumstances demanded it was the weapon taken in hand. Payment of a bride price, celebration of a ritual headhunters' feast, and the fighting of a ceremonial duel were the most important occasions.

Tanimbarese society is patrilineal and patrilocal. When a marriage is contracted, a woman becomes part of the descent group of her spouse. The transition is accompanied by the presenting of a bride price that consists of several parts. Traditionally, this would include golden jewelry such as ear and chest pendants (see cat. 101), elephant tusks, and antique *krai silai*. All of these objects had a similar symbolic meaning and together conveyed the Tanimbarese view on a man's role in society.

A man strove, above all else, to maintain the prestige (the "great name") of his descent group, a goal that he achieved by obtaining—often with deadly violence—treasure (gold, ivory, or severed heads) from the outside world. In common parlance, the man was sometimes compared to a *krai*.[4] In contrast to the acquiring of a "great name," the position of the woman focused inward, and her role was associated with fertility. This manifested itself in the reciprocal gifts at the marriage ceremony, in which homemade textiles played an important role.

Besides being an instrument of the male violence necessary to a man's quest for prestige, the antique sword also played a role in the context of ritual aggression. The weapon would be used in solemn duels, in which the two factions—separated by a bamboo fence—faced each other. Furthermore, it was used in the ritual feasts celebrating the hunting of heads and held after a victory in war.

Until the beginning of the twentieth century, wars between Tanimbarese villages were commonplace. Reasons to go to war were constantly sought out, with an ultimate goal of showing off a victory. Combat would often yield casualties, and the victorious party would attempt to take the heads of the slain home as

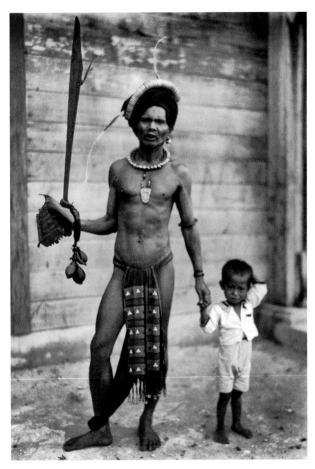

FIG 124 Tanimbarese man showing a ritual sword, c. 1930.

trophies. During a special ritual, in which the *krai silai* was ostentatiously brandished, the headhunters would extol their own valor and martial prowess, reenacting their exploits in the presence of the vanquished enemy's heads and the village community.[5]

An interesting detail that, according to the Tanimbarese, could—at least partly—influence the outcome of a battle seems to have been worked into the handle of the DMA *krai*. The edge of the hilt suggests the presence of a human face, possibly that of an ancestor who would guarantee success, along with protection, to the bearer of the sword. This symbolism was common on Tanimbar. Many Tanimbarese men would thus "hand" their instruments or weapons over to the ancestors. Arrows had ancestor figures carved into them, and tools had an ancestor figure for a handle, as did the grips of proa rudders.[6] In this way, the deceased could take up residence in the tools and help their descendants in undertaking difficult endeavors. Likewise, bags filled with ancestor figures were often carried by the Tanimbarese.

With the arrival of the modern age, as heralded by Roman Catholic missionaries, both the ancestor statues and the ancient *krai silai* have disappeared from Tanimbarese society. Sports contests have co-opted the role of wars, and the antique sword is no longer used during marriage ceremonies. The few specimens that still remain, however, as a kind of family heirloom, keep alive the memory of Tanimbar's colorful past.

N.d.J.

98

Comb

Indonesia, Southeast Moluccas, Tanimbar Islands
19th to very early 20th century
Wood, bone, and feathers
17½ × 7 × 1¾ in. (44.5 × 17.8 × 4.5 cm)
Gift of The Nasher Foundation in honor of Patsy R.
and Raymond D. Nasher, 2008.73

Exotic jewelry has always received a great deal of attention in first-contact situations (between foreign cultures). Tanimbar was no different in this respect. At the turn of the nineteenth century, during an extended period of exploration of the islands, the ornamental comb shown here (a so-called *suar silai*) was mentioned in publications unusually often, and it was even depicted several times.[1] To this we owe our relative familiarity with the background and recent history of this artifact.

Our most reliable source of information by far is the missionary Petrus Drabbe, who lived on Tanimbar from 1915 until 1935. He discusses the ornamental comb in terms of an interesting feature of traditional Tanimbarese culture: the division of men and women into various age groups through the use of external devices and signifiers. Central to this was the distinction between boys and girls who were "marriageable" and those who were "not marriageable yet." After their years of puberty, the boys would join the so-called *tabweri*, a group with several subclasses. Through marriage and reproduction, this adolescent status would slowly change to the rank of an older man: a *tabweri* would become a so-called *makene*.

At the start of the twentieth century, only the *makene* would wear the *suar silai*, or "great comb." They were not obliged to do so, but if they—as dignified elders—felt so inclined, they could wear it. The comb was carved from a single piece of wood, and the handle, which had two symmetrical halves, was usually beautifully decorated. These decorations would often consist of ingeniously carved, small bone or ivory sheets inlaid into the wood. As in the Dallas example, the sides were usually finished with this material as well. The *suar silai* was worn flat on the head with the handle toward the back. In a hole in the middle of the top of this handle, a large plume was placed, typically made of bird's feathers.

According to Drabbe, the *suar silai* was part of a somewhat more elaborate costume. Besides the great comb, many *makene* would wear two additional accessories: the *wangpar*, a type of collar made of white *Ovula ovum* shells, and a head ornament called *indar lele*. This last ornament was composed of a row of tiny rings, usually cut from the bone of a swordfish, which were attached to the forehead with a piece of string or strip of cotton. In Tanimbarese culture, the *suar silai*, *wangpar*, and *indar lele* formed a decorative triad.

Drabbe's reports describe two remarkable situations in which wearing the precious objects was more or less compulsory. They were expected to be displayed during an official duel (the *suar silai* in particular) and also when chiefs actively exercised their duties.[2] These occasions trumped everyday usage and could therefore suggest a more profound meaning attached to the jewelry. However, Drabbe, who was at a loss as to what this deeper meaning might be, did not pursue matters any further.[3]

Fortunately, early literature provides further information. Reports from nineteenth-century travelers recount that in earlier times, only a select group could wear the jewelry. To this group belonged the champion, warriors, and chiefs of the village.[4] These were all men who defended the prestige of the community through violence, which is why the adornments were part of a costume aimed at impressing the enemy.

Each of the three ornaments probably had its own fear-inspiring message. The *wangpar*, for example, was common throughout most of the Moluccas, and in 1678 Georg Eberhard Rumphius reported that the collar of shells represented a great headhunter's "proof of bravery."[5]

Similarly, at least on the island of Larat, the *suar silai* must have had a deeper significance. As can be seen in a sketch made by J. A. Jacobsen, the Larat comb had a boat's prow for its top decoration, an element that, according to the Berlin-based ethnologist, represented "the actual jewel of the comb."[6] Sometimes the comb would be crowned by the figure of a dog, fish, rooster, or snake, all animals that could often be found—as in the Dallas example—in the inlay as well.[7]

This recalls the symbolism of the Tanimbarese war proa, discussed in the introduction to this chapter. On the prow of such boats, one would typically find the emblem (*faniak*) of the clan or village: a depiction of the animal that supported and protected the seafaring warriors. Its protection was also desirable in battles on dry land. In such cases, a symbolic war proa was formed by the warriors, in which the "great comb," filled with spiritual power, would be worn—probably by the champion.

The old and the new were clearly intermingling on Tanimbar during the dynamic period described by Father Drabbe. At the start of the twentieth century, the *suar silai* had lost its exclusiveness but had gained a broader use as an ornament for an older man, the *makene*. Eventually, however, it would lose even this function. The islands of Maluku Tenggara became part of modern Indonesia, in which no place remained for "old-fashioned" jewelry.

N.d.J.

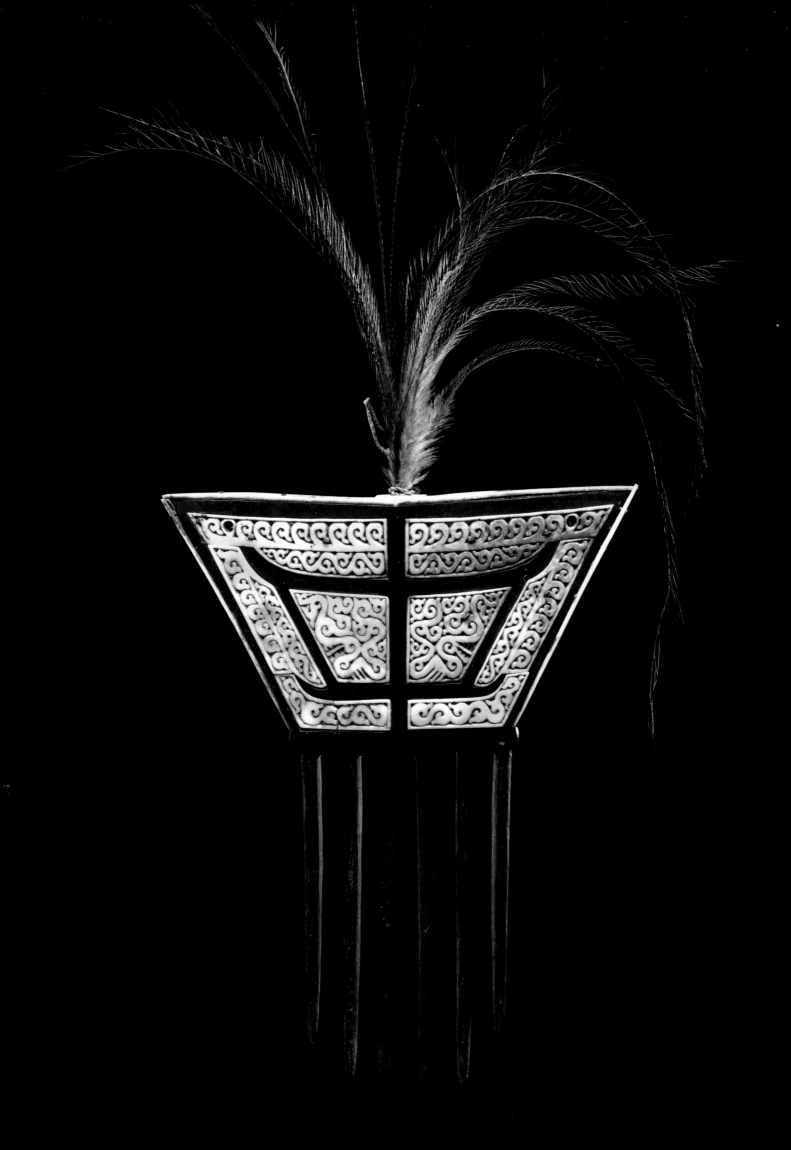

99

Hexagonal dish (*mas piring*)

Indonesia, Southeast Moluccas, Kisar
19th century
Gold
6¾ × 6¾ × ½ in. (17.2 × 17.2 × 1.3 cm)
Gift of The Nasher Foundation in honor of
Patsy R. and Raymond D. Nasher, 2008.70

100

Round dish (*mas piring*)

Indonesia, Southeast Moluccas, Kisar
19th century
Gold
9¼ × 9¾ × 3 in. (23.5 × 23.8 × 7.6 cm)
Gift of The Nasher Foundation in honor of
Patsy R. and Raymond D. Nasher, 2008.71

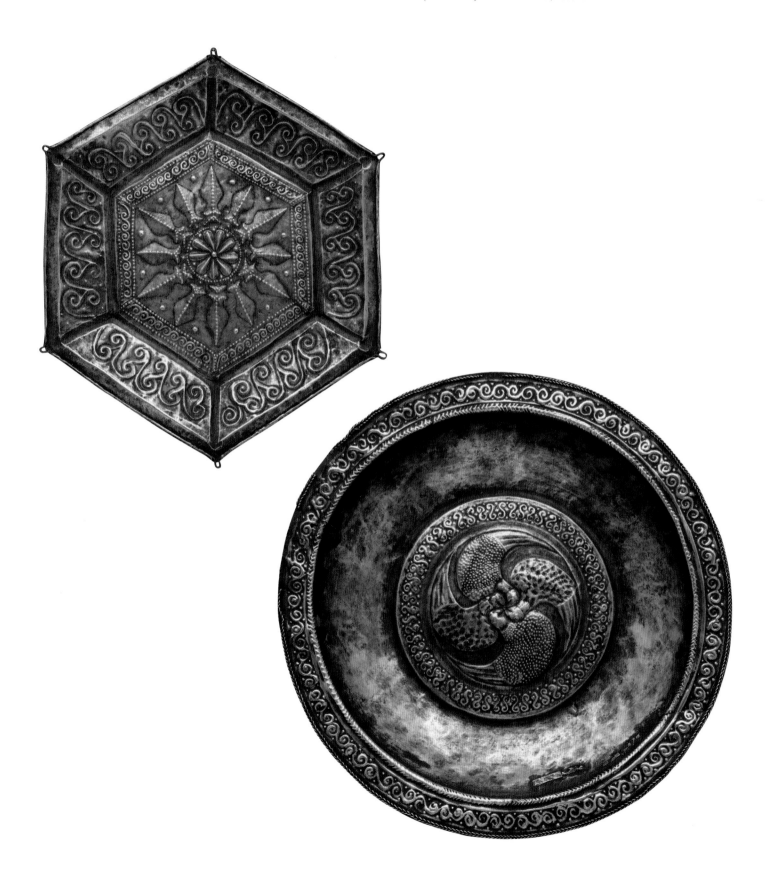

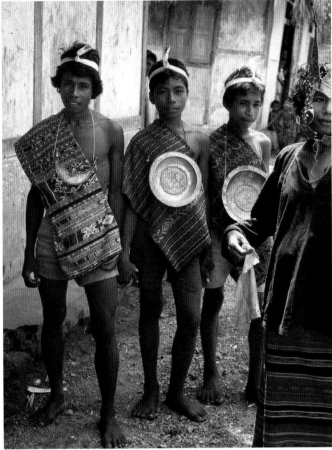

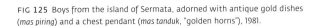

For centuries, forging gold dishes such as these was an important tradition on the small island of Kisar in western Maluku Tenggara. The first reference to these precious objects in Western literature dates to 1705. In that year, the German naturalist Rumphius, who was stationed in the seaport town of Ambon as an employee of the Dutch East India Company (VOC), warned Dutch merchants about their quality: "If one deals in gold in the Southeastern Islands, one will come across large dishes and table plates, which seem to be of gold, but which are as thin as spangle gold, and a bad alloy."[1]

From a tradesman's point of view, Rumphius's critical remarks were undoubtedly correct. The majority of the dishes were made of an inferior alloy, regardless of the fact that they had earlier had a high gold content. Usually the gold was mixed with a large quantity of silver during manufacture, and sometimes, when gold was in short supply, the dishes were made entirely of silver. However, Rumphius had not been aware that these objects were meant primarily for local use. Their importance in Maluku Tenggara (especially in the Luang-Leti-Kisar region) was derived from their symbolic significance, which made their gold content less relevant.

Although the gold dishes (known locally as *mas piring*) are often discussed together with the gold disks (*mas bulan*), the dishes have received the most attention.[2] Ordinarily, the dishes are slightly larger than a *mas bulan* (see cat. 101), and their decorations are usually more exuberant and refined. Two basic shapes of *mas piring* can be distinguished: in addition to the round model (cat. 100), there is a large group of hexagonal dishes (cat. 99).[3] The diameter of a *mas piring* is variable, but it is usually around eight inches, occasionally measuring up to sixteen inches.

The decorative patterns embossed on the dishes are certainly intriguing. The decorations appear to be highly variable at first glance, but closer inspection reveals two main themes. An important category is made up of dishes that have a star shape in the center (cat. 99). Another large group has a pattern on it that is dominated by stylized animals, usually birds (cat. 100). The finishing of the edges is often identical in both categories and consists mostly of spiral shapes.

The decorative patterns were probably closely tied to the role that the *mas piring* fulfilled in society. These dishes were important status symbols in a harsh society that revolved principally around maintaining the prestige of both family and village. Within this context, the ornaments referred to victories in war. That the dishes were "symbols of victory" is what the Dutch ethnologist J. P. B. de Josselin de Jong was told in the Babar archipelago in 1933.[4] Like other golden valuables, they were associated with slain enemies. They functioned, thus, as a kind of hunting trophy that would grant the owners, usually a descent group, significant prestige. The dishes were hung from a cord and worn around the necks of female family members at celebrations. The status of the group would improve as the number of dishes that were displayed increased.[5]

Some of the decorations on the dishes can be explained if we consider the idea of a hunting trophy. Particularly relevant is the pattern with a central star, which is probably a hunting scene. The central star-shaped design possibly represented the sun, a celestial body that, due to its scorching heat, was regionally associated with a "great warrior."[6] This association also explains why many of the sun's rays on the dishes end in arrowheads, as on the hexagonal DMA dish, with its twelve wide arrowheads. In some cases, the "victims" were also depicted on this type of dish in the form of small fish-shaped figurines attached to the small metal loops at the six corners of the dish. These figurines symbolized severed heads (see also cat. 102).[7]

It is impossible to determine exactly what is symbolized by the animals portrayed on the other category of dishes. According to many of the island's current inhabitants, the bird figures represent pigeons. This decorative pattern was perhaps derived from motifs on old Chinese porcelain (the phoenix motif, among others).[8] Unfortunately, all knowledge of a possibly more profound significance—conceivably in relation to the headhunts of old—has been lost since the art of the goldsmiths vanished from Kisar at the end of the nineteenth century.

N.d.J.

101

Disk

Indonesia, Southeast Moluccas, Kisar
19th century
Gold
7¾ (diam.) × ¼ in. (19.4 × 0.6 cm)
Gift of The Nasher Foundation in honor of
Patsy R. and Raymond D. Nasher, 2008.69

During his travels collecting artifacts for the Berlin Museum für Völkerkunde in 1888, expedition leader J. A. Jacobsen was pleasantly surprised when he came across shiny "medallions" on Kisar. He described them as round plaques of precious metal, thin as paper, which were used as chest pendants.[1] These ornaments, known as *mas bulan* or "golden moon," are seldom seen in the region nowadays. They are venerated as sacred family heirlooms (*pusaka*), which are displayed only on special occasions.[2]

Because of its typical diameter and flat design, this example would most likely be classified as a *mas bulan* by the contemporary residents of Maluku Tenggara. Considering the surface decorations, however, it is more accurately understood as a hybrid piece. The typical *mas bulan* was more sparsely decorated, and the embossed patterns were much simpler: several eyelike motifs were applied on most, either with or without some basic geometric patterns and animal figures (often birds and marine animals). In fact, this object is in the shape of a *mas bulan*, but decorated as a *mas piring*, a golden dish (see cats. 99 and 100).

Regardless of its uncharacteristic and striking decoration, this is not a unique piece, since several practically identical ornaments were documented at the end of the nineteenth and beginning of the twentieth century. Examples include a nineteenth-century golden disk from Leti in the Museum Nasional Indonesia in Jakarta, and a specimen from Luang that was photographed there by the German ethnologist Wilhelm Müller-Wismar in 1913.[3] The recurring theme is a series of horns hooked together to form a rosette. Possibly there was a goldsmith in that region who specialized in such hybrid pieces.

Directly after he mentions the encounter with the *mas bulan* in his travel log, Jacobsen discusses the importance of the jewelry. Based on observations by the English naturalist Henry Forbes, who spent some time on nearby East Timor in 1883, Jacobsen suggests a connection with the headhunting tradition. The disks possibly represented hunting trophies: warriors on Timor would, at least according to Forbes, receive such medallions for each severed head.[4]

Jacobsen was probably not that far off. Despite the lack of definitive proof, many clues support the hunting trophy hypothesis. For one thing, the gold dishes (*mas piring*), which were often mentioned in connection with the *mas bulan*, represented symbols of victory (see cats. 99 and 100). Likewise, the goldsmithing traditions of Kisar, along with some of the decorations, such as horns, that were soldered onto *mas bulan*, suggest similar symbolism (cats. 102 and 103). This would explain why these valuables (rather than just plain gold) served as status symbols: the act of killing is traditionally the basis for acquiring status in Maluku Tenggara. Finally, the moon reference is also significant. On many islands, the full moon (as well as the sun) was associated with a great warrior, and by wearing a *mas bulan*, one could promote oneself as such a warrior.[5]

The intrinsic value of the objects probably also played a part in the traditional use of the "golden moon" in society. On several islands, for example, the *mas bulan*, together with other gold ornaments, was an important part of the bride price.[6] By offering a hunting trophy at the marriage ceremony, the man's social role was emphasized. Conversely, the reciprocal gifts, which symbolized fertility and were presented by the family of the bride, emphasized the woman's role.

The *mas bulan* also figured in payment for *adat* violations. In the Luang-Kisar-Leti region, murder, arson, marriage outside of one's caste, and adultery received the largest fines. In order for the violator to reestablish his status, the injured party had to be compensated. The donation of (often dozens of) *mas bulan* and *mas piring* was the only means by which such reputation damage could be rectified.

Until recently, these ornaments also functioned as a kind of currency. Specific goods and services could be acquired only through payment of gold jewelry, including *mas bulan*, in which relatively constant exchange values applied. With the rise of cash markets in the area, both the economic and ritual uses of these valuables have substantially declined.

N.d.J.

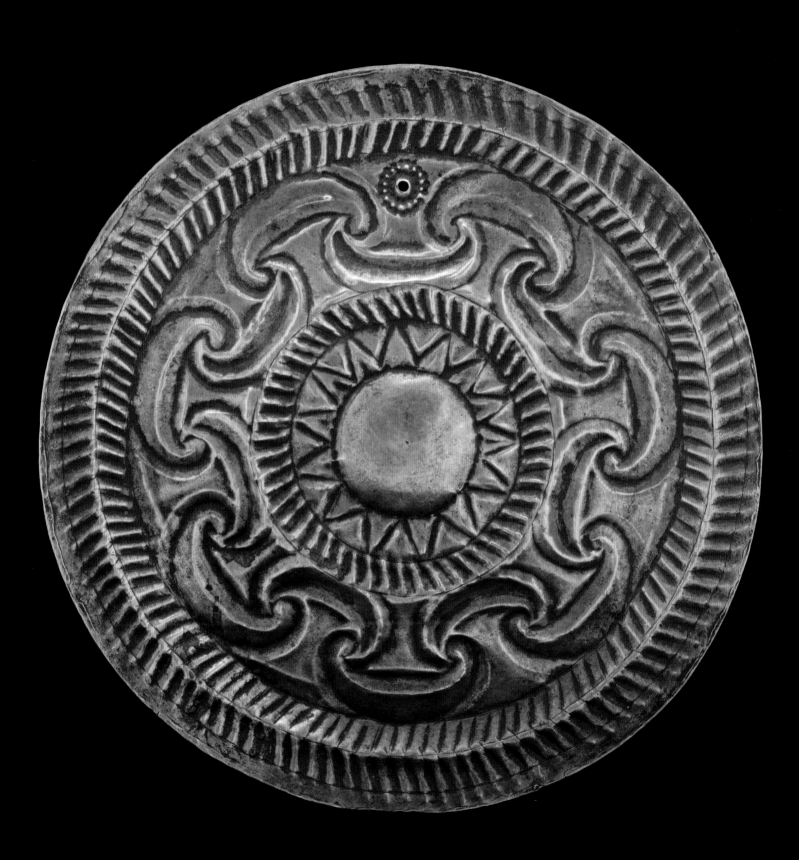

Necklace with anthropomorphic pendants

Indonesia, Southeast Moluccas, Kisar
19th century
Gold pendants, gold, and glass beads
Width (pendants): 6½ in. (16.5 cm)
Overall: 12 × 7½ × ½ in. (30.5 × 19.1 × 1.3 cm)
Gift of The Nasher Foundation in honor of
Patsy R. and Raymond D. Nasher, 2008.72

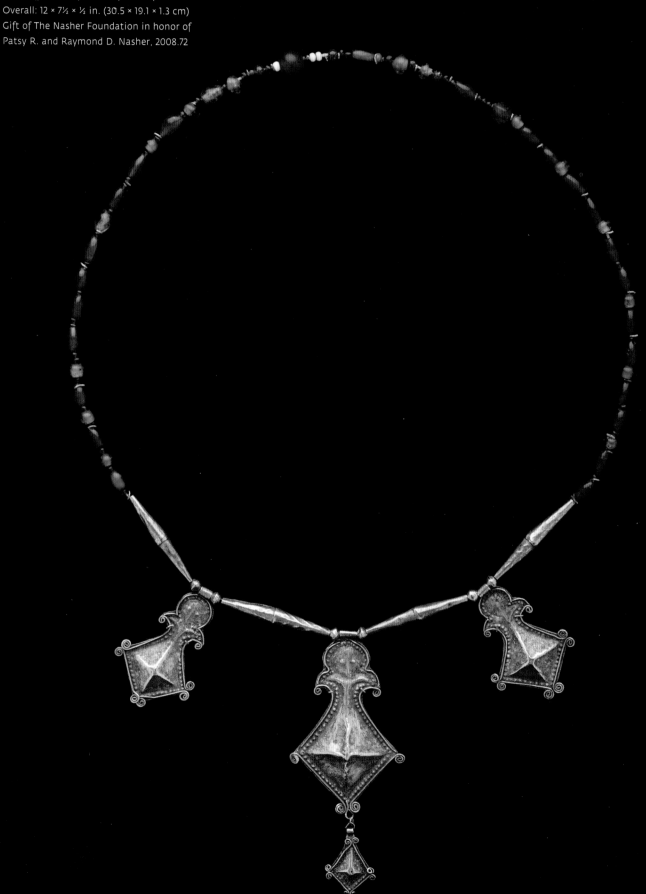

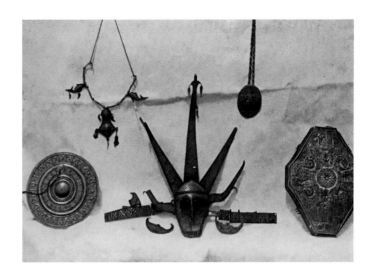

FIG 126 Field photo by Ernst Rodenwaldt, showing the gold treasure of the Raja of Kisar, 1922.

Until recently, those who traveled through Maluku Tenggara and were fortunate enough to witness the opening of a so-called *pusaka* basket (a basket filled with family heirlooms) would have been astounded.[1] Besides antique textiles, a profusion of gold jewelry would usually appear: several types of earrings, bracelets, *sirih* boxes, dishes, disks, rings, and chest and neck pendants—an astonishing array of riches that belied the local standard of living.

In 1922, the German research physician Ernst Rodenwaldt had a similar experience on the island of Kisar, when the *raja* of the island showed him the ancient family treasures. Rodenwaldt immediately realized that he was witnessing something unique and photographed a number of objects. Several of his images show a necklace (fig. 126) that could be regarded as a variation of the work illustrated here. The major difference is in the flanking pendants: in the Rodenwaldt piece, these are small fish instead of smaller humanlike shapes.[2]

Although the exact significance of the Dallas object remains uncertain, we can infer the social context in which the jewelry would have functioned. Here, Rodenwaldt's photograph is important, because the fish figurines existed elsewhere on the islands as well. For instance, they were present on hexagonal dishes (see cat. 99), and they would hang (often alongside white *Ovula ovum* shells) from house gables and prows of boats, where they represented severed heads as hunting trophies. In the ancient war rituals, this symbolism was abundant as well. From Damar to Babar, the heads of slain enemies would, in precolonial times, be brought into the community, as though they were the day's catch of fish.[3] To men—in their role as fisherman or (head)hunter—the killing of life in the outside world (the sea) was the principal means of gaining prestige for themselves and their families.

Regarding Rodenwaldt's necklace, we can safely assume that this piece of jewelry represented a headhunting trophy. By wearing the ornament, one emanated fame and status. The similarities with the Dallas object lead us to the same conclusion: this necklace also very likely functioned in such a way.

Most intriguing is the identity of the goldsmiths of Kisar. This group belonged to the so-called Mestizos, descendants of a detachment of servants working for the Dutch East India Company, who had lived on the island for centuries separated from the local inhabitants. Up until the end of such trade in gold objects, around 1900, the exclusive art of working gold was handed down from father to son within three Mestizo families.[4]

There is much to suggest that a symbolic dimension existed with regard to the status of these goldsmiths. Because of their place outside the local community, they represented a fictive outside world, from which, as in a real raid or battle, status symbols could be obtained. Information on the other goldsmiths of Maluku Tenggara shows that this was no mere coincidence; a similar "extraordinary" situation existed everywhere, to some extent.[5]

In the Babar archipelago, the smiths were either itinerant or had their separate, screened-off workshops outside the village. Some of these workshops even had a special workbench that came from beyond the borders of the islands. On Tanimbar, so-called *kukuwe*, ancestor statues that provided the goldsmith with the power to melt the gold, were associated with the outside world. On the Kai islands, the goldsmiths lived in the village of Banda Elat, which was founded by refugees from Banda. Farther north, in the Ambon region, the goldsmiths—who specialized in manufacturing golden snakes—apparently acquired their professional knowledge from Indian immigrants.[6]

Their "outside" status was reinforced by the way the goldsmiths did their work. In their screened-off workshops, they created an ornament, be it with or without the aid of ancestral powers, as if it were the loot from a raid or battle. And just as in a real headhunt, the ornament was brought into the community as a "hot," killed object.[7] All information places the necklace in a similar perspective: the ornament represented a headhunting trophy, which increased the status of its owner.

Regarding the beads that were used in this kind of jewelry, it is well known that the Mestizos of Kisar maintained close trade relations with the inhabitants of East Timor. The Mestizos traded *ikat* fabrics for coinage, which was made into jewelry.[8] Undoubtedly the beads found in the Dallas necklace originated in East Timor. Beads were traditionally an important part of Timorese material culture. N.d.J.

Chest pendant

Indonesia, Southeast Moluccas, Tanimbar Islands
19th century or earlier
Gold backed with turtle shell
4 × 5 × ⅟₁₆ in. (10.2 × 12.7 × 0.2 cm)
Gift of The Nasher Foundation in honor of
Patsy R. and Raymond D. Nasher, 2008.68

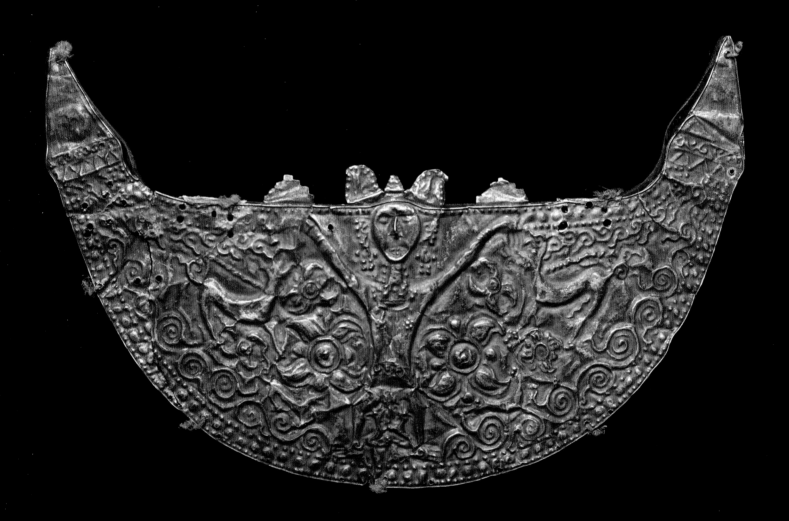

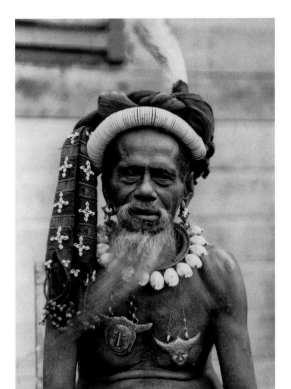

FIG 127 Old Tanimbarese man wearing two chest pendants with horn motif, c. 1930.

Around 1930, the Dutch missionary Petrus Drabbe produced a series of beautiful portraits of Tanimbarese as part of a large-scale ethnological study.[1] The persons portrayed proudly show their most valuable treasures: golden jewelry in a variety of shapes and sizes. Earrings and necklaces are among the ornaments, often in combination with large imported chest pendants, locally called *mase*.[2] The gold object illustrated here is an example of such a *mase*.

Remarkable in these photographs is the stylistic diversity of the chest pendants. The *mase* appear to originate from all over the Indonesian archipelago, and some even show decorative characteristics that recall the classical Hindu-Javanese Majapahit period (c. 1300–1500). Jewelry dominated by a face or human figure was especially prized. Unfortunately, Drabbe mentions very little about the origin of such pieces. If we examine the old trade routes, however, it is possible to imagine how these objects made their way to Tanimbar.

In the historic trade circuits, Banda merchants, on the one hand, and Makassarese and Buginese, on the other, held key positions. These traders brought chest pendants from a variety of distant lands to Tanimbar, while they simultaneously had locally produced jewelry at their disposal. It appears that a share of this last category was tailored to the Tanimbarese market.

The islands of Banda were involved in an elaborate Asian trade system long before the arrival of the Europeans. Javanese merchants, in particular, transported spices to the Asian mainland, and on their way back—along with various wares including textiles (the main commodity)—they accumulated gold jewelry. Local trading vessels transported a part of this jewelry, together with the valuables made on Banda, onward to Tanimbar. Incidentally, the gold was sometimes retrieved from Banda by the Tanimbarese themselves.[3]

Makassarese and Buginese searching for reef products created another trade channel that brought significant amounts of "exotic" jewelry to Tanimbar. On their annual journey to the Southeast Moluccas and Australia, they would customarily first visit Kisar. Here, they would have goldsmiths make their coinage into locally desirable valuables, including chest pendants; the trade value of a "worked" coin could increase up to sixfold.[4] As with the earlier trade to Banda, the Tanimbarese themselves would at times sail to Kisar (and even to Timor) to obtain valuables.[5]

The Dallas chest pendant may very well have come to Tanimbar by way of this second trade route. The shape, embossing, and details of the decoration all suggest that the jewel was made in Maluku Tenggara and that its origin is Kisar. There, particularly in the nineteenth century, the model seen here was produced in large quantities, as a variation of a so-called *mas bulan* (see cat. 101). The variation was known locally as a *mas tanduk*, or "golden horns."[6]

In his study, Drabbe elegantly reveals exactly why so many chest pendants found their way to Tanimbar. A core element in local culture was the collecting of "exotic treasure" by the men in order to gain prestige. The ultimate masculine accomplishment was severing outsiders' heads, but a great number of various objects from the "outside world"—gold chest pendants in particular—were highly appreciated as substitute headhunting trophies. They were regarded as "hot," since they were associated with killing, and in that respect they played an important role in society.[7] The often centuries-old heirlooms of the noble families illustrate this. Possession of these hot objects gave a house, that is, a descent group, added "weight."[8]

The chest pendants of the *mas tanduk* type in particular were well suited to Tanimbarese cultural beliefs. The horn motif was an important victory trophy and status symbol on the islands (as well as elsewhere in Maluku Tenggara). It could also be found mounted on family houses and even on the *tavu* shrine as a headdress to a *faniak* (or clan emblem).[9] When a man adorned himself with the *mas tanduk* chest pendant, he made it clear that he was a great hunter and a distinguished person.[10] The *mase*, which were dominated by human shapes and faces, very frequently had the horn pattern on them as well (fig. 127). These cultural associations were undoubtedly the source of the great appeal these pieces enjoyed.

The symbolic message is emphasized by the scene, portrayed in relief, on the Dallas chest pendant: two dogs flanking a successful huntsman. The man is wearing both the horn motif and ear pendants of the type made on Tanimbar, and he also has a *mas tanduk* on his chest. Two smaller dogs are between his legs, seemingly snapping at his genitals. The scene aptly corresponds to Tanimbarese cultural beliefs, and it leads us to suspect that the jewel was made especially for the purpose of trade in the archipelago.

N.d.J.

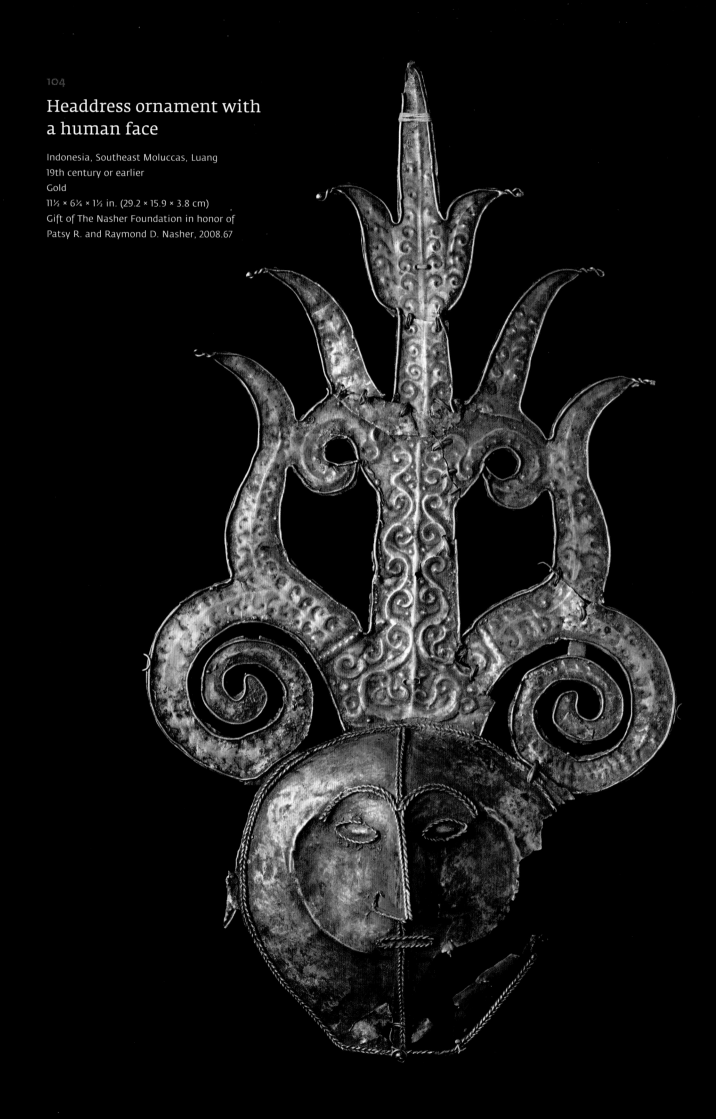

Headdress ornament with
a human face

Indonesia, Southeast Moluccas, Luang
19th century or earlier
Gold
11½ × 6¼ × 1½ in. (29.2 × 15.9 × 3.8 cm)
Gift of The Nasher Foundation in honor of
Patsy R. and Raymond D. Nasher, 2008.67

FIG 128 A field photograph made on Luang in 1913 by the German ethnologist W. Müller-Wismar shows examples of both the face-based headdress and one depicting a pair of roosters.

FIG 129 Woman from Sermata adorned with an extraordinarily striking *wutulai*, 1981. The decorations, in particular the meanders and representation of the face, suggest style influences from western Indonesia.

On the island of Luang—notwithstanding the introduction of the *Panca Sila*, the Indonesian state philosophy upholding democracy and justice—a traditional caste system endures. Historically, three classes existed on the islands: a noble elite, which produced the chiefs; a large middle class; and a caste of slaves. Though less pronounced, this social stratification is still very much alive today, particularly in matters concerning marriage. Large fines are meant to keep the nobility (*marna*) from mixing with the former slaves.

Traditionally, members of a caste were recognizable by their attire, principally the length and decoration of the female *sarong* and male loincloth. Furthermore, rules governed the wearing of jewelry. Slaves, for instance, were not allowed to adorn themselves at all.

Among the most imposing adornments for *marna* women were golden headdresses such as the one shown here. This type of jewelry, called *wutulai* in the local language, was quite rare on the islands. By around 1990 these ornaments had—as far as we know—disappeared from Maluku Tenggara altogether. Fortunately a number of them have been well documented, which has provided us with a fairly accurate picture of their traditional appearance.

The design of the majority of the headdresses was, as in the Dallas example, composed around a heart-shaped, human face.[1] Often this face was depicted in a clearly representational manner, with a sharp nose, pronounced eyebrows, and large ears (which in this case have been lost). Other headdresses depicted a pair of identical roosters confronting each other. In some cases, the roosters were clearly discernible, with or without the face-based motif, but in others they were a barely recognizable part of a highly stylized design. In fig. 128, we see two beautifully adorned *marna* women wearing both types of *wutulai*.

Regrettably, no information remains on the islands regarding the meaning of the patterns that were used, and relevant comments are also lacking in the existing literature. It appears, though, that we can interpret these patterns using other evidence. In this respect, the carved statues of the founding mothers of the local matrilineal descent groups are invaluable. As mentioned elsewhere

(see the entry for cat. 105), the design of these *luli* figures is determined by a combination of two motifs: a boat and a tree. The latter is usually more dominant and unequivocal: fertility is key.

Upon studying the face-based headdresses in more detail, we observe a prominent role for floral patterns. Every design of this group ends in "branches" or "shoots," on which small, shiny hangers (attached to small metal loops) often appear to represent hanging leaves. Also, the decoration explicitly reveals a floral theme: many of the shoots of the ornaments have been decorated as though they were part of *luli* statues. The DMA headdress provides a magnificent example. On the central stake is a relief decoration made up of a symmetrically constructed tree that has its roots in a boat with prows that curve strongly inward. Again, the predominant theme is fertility.

A second, remarkable similarity exists between these headdresses and *luli* statues. As mentioned, in order to enhance its symbolic message, the founding mother herself is regularly portrayed on the *luli* as part of the tree motif. This theme is also expressed in the *wutulai*: the "shoots" appear to grow from the human head, which is the basis of the headdress. A face-based *wutulai*, like a *luli* statue, thus probably represented a founding mother. By wearing a headdress (and identifying herself with the founding mother), a woman could present herself as a unique source of fertility.

Proof of this idea can be found in an extraordinarily striking headdress I encountered on Sermata in 1981 (fig. 129). At first glance, its style appears atypical, but the design makes perfect sense in light of its symbolism. As a variation of a face-based headdress, the goldsmith has left the face of the ornament open, which gives the impression that the shoots are sprouting from the wearer's head itself. However, the founding mother is still there; her face has been moved to the central shoot. The wearer of the headdress is thus incorporated into the floral motif, just as in some *luli* figures, which allows her to present herself unmistakably as a kind of living *luli*.

All this leads to the obvious conclusion that the wearer of a headdress could be but one woman: the eldest descendant of the founding mother of a descent group. This view is supported by certain *luli* statues, each fitted with an impressive *wutulai*, found in several museum collections. These wooden artifacts often emphasize the floral aspect at the expense of the actual headdresses.[2] The highly limited application of the headdress would also explain why so few *wutulai* have been found in the region.

Finally, I would like to comment on the rooster motif. Based on the foregoing, we can assume that the *wutulai* were considered to be entailed family heirlooms. Thus, the roosters on the headdresses may well have been family emblems. Here, as on the eastern islands, these animals were probably associated with the founding fathers. As such, they would further the prestige—and the very survival—of a descent group. This notion is supported by the design with its two "dueling" animals, which is typical of many clan emblems in Maluku Tenggara.

N.d.J.

105

Altar depicting the first female ancestor (*luli*)

Indonesia, Southeast Moluccas, possibly Luang or
Sermata
19th century
Wood, shell
21 × 8½ × 7¾ in. (53.3 × 21.6 × 19.7 cm)
The Eugene and Margaret McDermott Art Fund, Inc.,
1999.181.McD

In an 1892 publication, the Dutch missionary N. Rinnooy writes about his exploration of a pagan "sanctuary" on the small island of Kisar. The rectangular construction had an attic room, which was accessed by climbing a steep staircase and opening a hatch that divided the room in two. "The front section of the attic," according to Rinnooy, "is the place of the gods. At the front, on the floor, is a woman, carved from wood, of which the head and torso, in comparison to the legs that can hardly be seen, are very large. She has a food bowl in front of her. . . . The woman is the deity, to whom is accorded the highest honor, while proliferation of goods and family is expected of her."[1]

Rinnooy's report is the first publication to contain a description of a so-called *luli*, the statue of a "holy" founding mother of a noble, matrilineal descent group (Rinnooy erroneously calls it a deity). Up until the start of the twentieth century, *luli* figures were made in western Maluku Tenggara and were—as Rinnooy describes it—revered as an ultimate source of fertility. Due to their relative rarity, only a few of these remarkable statues have found their way into museum collections. Because of its distinctive appearance and excellent quality, this *luli* can therefore be regarded as a unique example.

It is possible to classify these statues into several basic categories, according to their design and decorations. In one aspect, such a statue may clearly represent a woman, often decorated with boat and tree motifs. On the other hand, the *luli* could be completely dominated by these symbolic motifs, showing very little of a recognizable figural form. In the latter case, a treelike stake rises up from a highly stylized boat, a composite pattern containing the most important symbol of fertility on the islands. The tree represents new life, while the boat—referring to a womb, by means of the prows that curve strongly inward—represents the source of life. A third category consists of statues that can be regarded as a combination of both realistic and abstract designs.

In terms of creativity and aesthetic appeal, the third category is particularly fascinating. Several *luli* that fall into this category show the female first ancestor *herself* rising from the boat/womb

motif. This makes the female figure a part of the pattern, as can be observed in abstract *luli*, and it represents the burgeoning of new life in a beautiful way. The DMA *luli* is a variation on this theme: it shows the female first ancestor on top of the boat/womb motif, very much like a rising tree. The image is reinforced by repetition: the arms, which are stretched out to the sides, form the shape of a boat as well, from which the founding mother rises up. It makes sense that the legs and lower body are minimal, as in the statue that Rinnooy encountered on Kisar at the end of the nineteenth century; from a symbolic perspective, they do not, in fact, matter.

Probably this founding mother would originally have had one or more valuable adornments. Many *luli* statues, for example, have a decorative comb or ornament on their heads, which may once have been the case here as well. Although it was the men who would defend the prestige of a descent group by gathering precious objects from the outside world, it was the women who would, especially at festivities, show off these items. The founding mother and her descendants would play the leading part in these events: as representatives of the group they could wear the most beautiful jewelry.[2]

The issue of status was most likely also reflected in the case of the rather large, ajour-cut ear pendant at the bottom of the statue. Items of this type were usually depicted to emphasize the "great name" of a group, a phenomenon that is also present on the so-called *tavu* of Tanimbar.[3] The jewel would most likely have had its own name, connected to a mythical origin, or to the important ancestors who had acquired it. The little dots on the founding mother's chest and arms probably did not represent jewelry, but rather tattoos.

One of the most remarkable things about this founding mother statue is the fact that it has been cut from a single block of wood. Almost all *luli* have a pedestal; usually, however, the founding mother statue and the pedestal are separate units. The decorations that have been applied here are familiar, though. On Leti in particular—where many a pedestal was made up of multiple pieces—these were given extra attention; the founding mother would be protected by ajour-cut animal figures, which closely resemble the clan emblems of eastern Maluku Tenggara. In fact, the pedestal of the Dallas *luli* was also originally made up of several parts: holes on the left and right sides betray the former presence of extensions that would have been secured from the front with wooden pegs.

As Rinnooy points out, the founding mother would traditionally receive her offerings in a special sanctuary. Usually a sacrificial bowl filled with *sirih-pinang* would be placed on the pedestal.[4] At the start of the twentieth century, however, these practices changed irrevocably. Descent groups that had up until then lived solitarily merged with larger village communities, and the *luli* statues moved to family dwellings. Not long after, many would fall victim to zealous Christian clerics.

N.d.J.

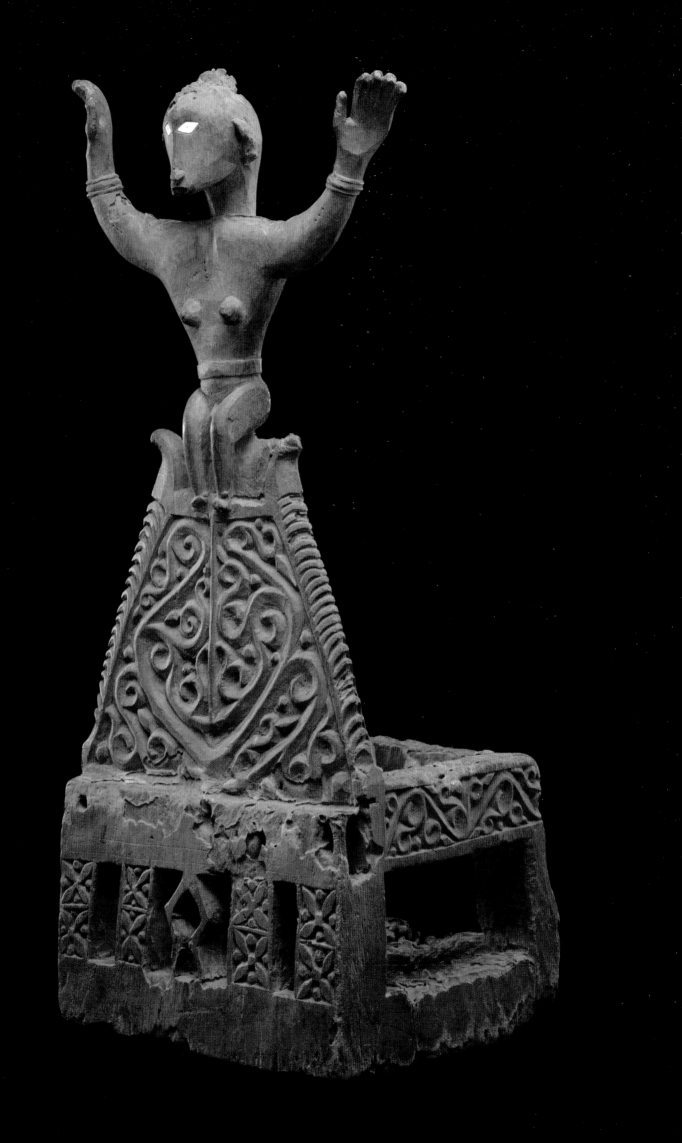

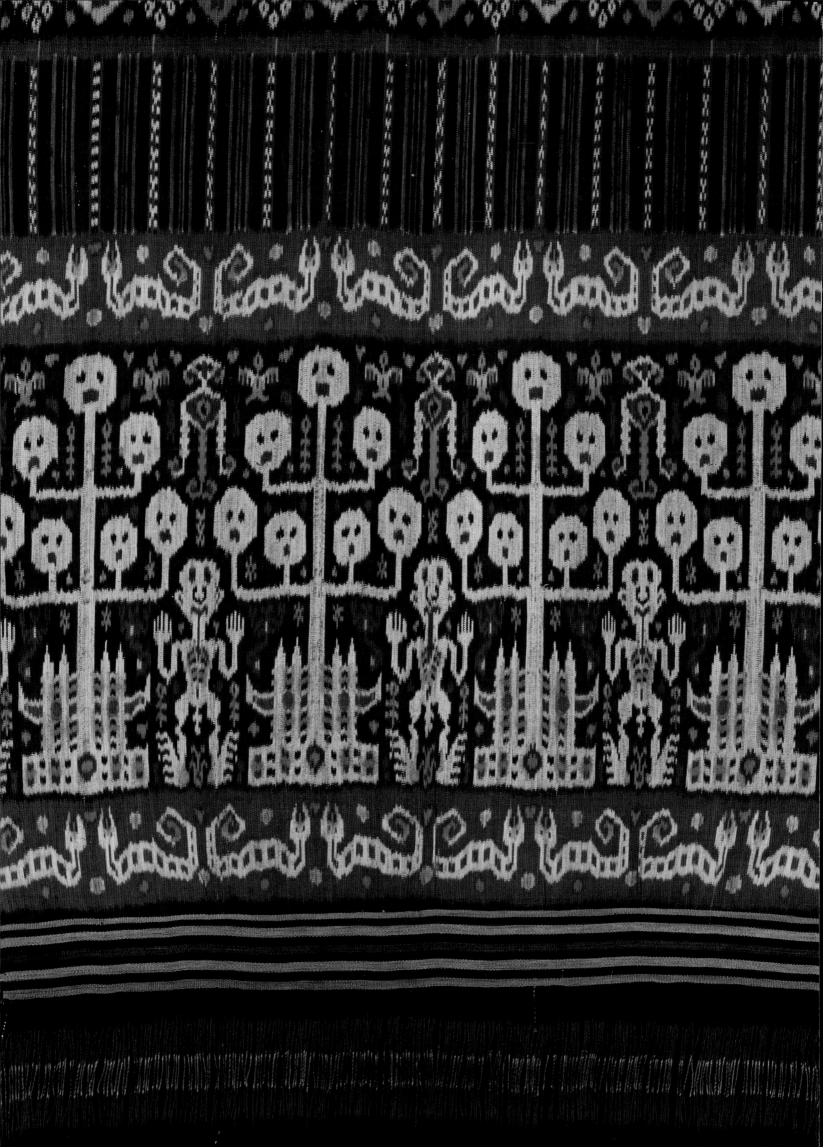

NOTES

THE ARTS OF ISLAND SOUTHEAST ASIA AT THE DALLAS MUSEUM OF ART: A BRIEF HISTORY

1. The collection history is based on text by Carol Robbins, published as "Development of the Dallas Museum of Art's Indonesian Collection," in Kosinski et al. 2003: no. 42.

2. Images of many objects from the collection, including new acquisitions, can be viewed at www.DMA.org with associated texts and technical data available for further research.

GENERAL INTRODUCTION: ART AND ITS THEMES IN INDONESIAN TRIBAL TRADITIONS

1. Van Beukering 1947: 51. This judgment is like a late echo of the general Western view of tribal art in the nineteenth century when the motto *natura artis magistra* (nature is art's teacher) still was taken as dogma, and any figural representation was judged according to how closely it resembled the original—within the limits of the particular contemporary style. "The lack of correct perception and reproduction is hidden . . . behind a fantastical-conventional stylisation . . ." is the derogatory judgment in one of the first general works in art history that gave the "art of primitive peoples" a section of its own (Woermann 1915: 18). Even at that time, anthropology examined artistic expression in material culture, but this attention focused one-sidedly on the historical evolution of art forms or their geographical distribution.

2. See Bakker 2002.

3. See Suwati Kartiwa, director of the National Museum of Indonesia, in Taylor 1994: VIII.

4. The island of New Guinea, whose westernmost provinces constitute the eastern end of Indonesia, is not treated in the present volume.

5. For the prehistory, see Bellwood 1987 and Bellwood 1997.

6. Sand and Bedford 2010: 79.

7. Schefold 2002a.

8. It would be tempting to link these mythical narratives to historical developments. It is generally assumed that the Austronesian immigrants in Indonesia absorbed or replaced an earlier Australoid human population. However, as no distinct artistic traces remain of any such original inhabitants, hypotheses concerning them lie beyond the scope of the present introduction.

9. Schefold 2001. See also the excellent introduction by Paul Taylor in Taylor and Aragon 1991.

10. Later historical foreign influences including Hindu, Islamic, and finally Western cultures lie outside the scope of the present discussion. These influences were locally more restricted, and it was mainly on Java, Sumatra, and Bali that they transformed indigenous practices.

11. Bernet Kempers 1988: 11.

12. Cf. Taylor and Aragon 1991: 67, fig. I.15.

13. Schefold 1979–80, 14 no. 11.

14. Kirch 1997: 15.

15. Ibid.: 125.

16. Sand and Bedford 2010: 119, fig. 1.

17. The same could be said of the origins of the spectacular longhouses on the Dong Son drums; see Schefold 2003: 20–41.

18. de Jonge and van Dijk 1995a: 53–57.

19. See Feldman 1985: 45–78.

20. Feldman 1994: 80.

21. Ibid.: 11; see also D. Newton in Barbier and Newton 1988: 10–23.

22. See also Waterson 1989.

23. See also Stöhr 1982: 87, no. 44.

24. Schefold 1979–80: 128–31.

25. Stöhr 1976: 73–88.

26. Marschall in Stöhr 1982: 25 and 33: fig. 5.

27. Sibeth et al. 1991: 118.

28. Schefold 2002b.

29. For a characteristic example of a modern Batak artist, see Spanjaard 1998, illus. 83.

1 TOYS FOR THE SOULS: THE ART OF MENTAWAI

INTRODUCTION

1. In this essay, I occasionally use passages from a former article, Schefold 2002a. See also Schefold 1988.

2. Cf. Indonesian *semangat*.

3. In the article mentioned in note 1, I translated this term in a slightly different way. Due to more updated information, I hereby correct the previous translation. I am grateful to Juniator Tulius for his helpful comments.

4. In this connection, as mentioned in the general introduction, it is intriguing to note that when they discovered "primitive art" at the beginning of the twentieth century, Western artists highly praised what they perceived as liberation from the straitjacket of naturalism.

5. Cf. Bakker 2002.

6. See Schefold 1979–80.

CAT. 1

1. Incised outlines of hands appear above and below the raised protrusion on the front of the shield, and a single hand outline appears at the top of the reverse side.

2. See illustrations in Maass 1906: IX, and Zweers 1988: 125.

3. See, for example, Amsterdam A 1387, 1772; Basel IIc 2631, 2632, 2633; Leiden 79,1; Rotterdam 22977. See the museums listed in cat. 2, note 2.

CAT. 2

1. After a watercolor by von Rosenberg from the 1840s in the Royal Netherlands Institute of Southeast Asian and Caribbean Studies, image code 36A 113.

2. Tropenmuseum, Amsterdam (1322/164 and A 3424), Museum der Kulturen, Basel (IIC 2644), Nationalmuseet Copenhagen (5544), Rijksmuseum voor Volkenkunde, Leiden (see Fischer 1909: 90–91), Wereldmuseum Rotterdam (3002 and 23830), and Smithsonian Institution, Washington, D.C. (Smithsonian Abbott collections, no. 22181900).

CAT. 4

1. Two of these *jaraik*, including the one shown in cat. 4, are illustrated in Schefold 1979–80: 116, pls. 128, 170, 194.

2. IIc 2683.

2 THE ART OF THE ONO NIHA

INTRODUCTION

1. Marschall 1976: 11.

2. See Marsden 1975: 474 ff.

3. Tjoa-Bonatz 2009: 119.

4. Hämmerle 1999: 380–81.

5. Ibid.

6. Ibid.: 21.

7. For a detailed description of the village layout and architecture in the different regions of Nias, see Viaro 1990.

8. Ibid.: 57.

9. Feldman 1984, Viaro 1990.

10. Beatty 1991.

11. See Feldman 1989, de Moor 1989, Richter and Carpenter 2011.

12. Beatty 1992: 19.

13. Tjoa-Bonatz 2009: 112.

14. Pospísilová, Hladká, and Jezberová 2010: 41.

15. This placement on the right wall of the front communal room is to the viewer's right, observed when one is facing the front veranda from the interior of the house.

16. Feldman 1990: 30.

17. Sibeth 2009: 160–61.

CAT. 6

1. According to Mittersakschmöller 1998: 127–31.

2. Feldman 1979.

3. Cf. Richter and Carpenter 2011: 404–5.

4. Once these impressive figures began to be sold or taken away, new examples were carved for both replacement purposes and for resale. As a result, many Nias statues have little or no patina and show no signs of usage.

CAT. 7

1. Fewer than ten complete examples exist, and they are all said to have come from the Gomo area. Personal communication: Steven G. Alpert, 2011.

2. See Volkenkundig Museum Nusantara 1990: 306 ff.

3. Ibid.: 304.

CAT. 8

1. A similar *kalabubu* of this unusual type is published in Volkenkundig Museum Nusantara 1990: 281.

2. One example is Mittersakschmöller 1998: illus. 53.

CAT. 9

1. Feldman 1979: 142–43.

CAT. 10

1. Cf. Ziegler and Viaro 1998: 70–75.

2. Stöhr 1976: 1408.

3. See Hämmerle 1984: 591 ff.

3 THE ART OF THE BATAK OF SUMATRA

INTRODUCTION

1. See Voorhoeve 1955. Barbier (2011) is a commendable study on the Kalasan, who see themselves as an independent ethnic group but who are nevertheless routinely—surely an oversimplification—assigned to the Pakpak.

2. For example, see Polo et al. 1993, vol. 2: 366, for Marco Polo's incorrect observation in 1292 that the Batak ate their parents when they were too old to work.

3. See Sibeth and Carpenter 2007: 92–119.

4. Like many traditional peoples in Indonesia, the Batak practiced secondary burials (*mangongkal holi*). Several years after first being buried, the bones were disinterred, cleaned, and mourned. This was sometimes accompanied by ceremonies that included dancing, the slaughtering of ritual animals, and feasting. Once properly prepared, the bones were stored in an elaborate "bone house," which was erected to honor a deceased ancestor and to further raise the status of living descendants. These ceremonies allowed the living to have contact with and say good-bye to the dead, and the dead to have a final lingering joy in the company of the living. To curious outsiders, secondary burials elicited great fascination, as they were quite different from European or Christian burial practices.

5. See, for example, the remarkable magic staff (*tunggal panaluan*) of the Linden-Museum, Stuttgart, inv. no. SA 32625L (Sibeth et al. 1991: illus. 151).

6. For example, Friedrich Kussmaul, Linden-Museum, Stuttgart. Personal communication, 1984.

7. Other paraphernalia necessary to his craft included sacred books (*pustaha*) and figurative and calendric charms. Storage containers for *pupuk* and other magic substances were usually put into a ceramic trade jar with a finely carved wooden stopper (*perminaken* or *guri-guri*).

8. E.g., Sibeth and Carpenter 2007: 24–25.

9. Sibeth 2012.

CAT. 11

1. A more tattered, decomposed cloth *sarong* was still attached to this figure when it was originally collected. The current covering was its undercloth. Personal communication: Steven G. Alpert, 2011.

CAT. 12

1. Feldman 1985: 94.

2. Personal communication: Steven G. Alpert, 2011.

3. Ibid.

CAT. 14

1. In Western art history, the representation of two heads that are joined at the back is known as a Janus face. The god Janus was represented with two faces by the ancient Romans, since he could see forward and backward at the same time. Later, the double-faced image came to signify that everything can have two opposing faces or sides, positive and negative.

2. See Sibeth and Carpenter 2007: 16, 236 ff.

CAT. 16

1. Undated letter from Bernard Tursch in collection files of the Dallas Museum of Art.

2. Ibid.

CAT. 17

1. Undated letter from former owner in collection files of the Dallas Museum of Art.

2. See unpublished, typewritten documentation in the collection files of the Dallas Museum of Art.

4 LAMPUNG SHIP CLOTHS: ANCIENT SYMBOLISM AND CULTURAL ADAPTATION IN SOUTH SUMATRAN ART

INTRODUCTION

1. Forbes 1885: 127.

2. Broersma 1916: 66 (see also Palm 1965: 63).

3. From around the ninth century, pepper—originally an Indian commodity—became a cash crop in Java and later developed into a major export from Sumatra, where from the fifteenth to the nineteenth centuries it was grown in Lampung, Palembang, Bengkulu, and Jambi.

4. According to Funke (1961: 113), the global pepper market collapsed around 1870; as a result, many Lampung pepper gardens gradually became overgrown.

5. Broersma 1916: 228–45. Due to the arrival of Javanese migrants, currently only one in ten inhabitants of Lampung province is a descendant of the indigenous population.

6. Paminggir people have also settled outside of Lampung province. The inhabitants of Kroë coast (Bengkulu, west coast), for example, and of the mountain area of Liwa Sukan Kenali (Bengkulu, south of Lake Ranau) belong to this ethnic group (see van Dijk and de Jonge 1980: 13). Moreover, in Anjar Kidul, situated in Banten on West Java, four Lampung villages with Paminggir people have been documented since the mid-sixteenth century (Palm 1965: 42–43).

7. Funke 1958: 3–15, 101–14. See also van Dijk and de Jonge 1980: 13. The name of the founding father Si Lampung allegedly means "floating on the water" (Broersma 1916: 17 and Palm 1965: 40).

8. Hissink 1904: 75–76, 95.

9. The term *adat* refers to local customs and habits hallowed by tradition.

10. Broersma 1916: 41, Funke 1961: 268–70, Aeckerlin 1894: 1532.

11. Schefold, Dekker, and de Jonge 1988.

12. Degroot, Chutiwongs, and Hardiati 2009: 42.

13. Funke 1958: 175–76, van der Lith, Fokkens, and Spaan 1896–1905: 118, 522.

14. Palm 1965: 42, van Dijk and de Jonge 1980: 15.

15. The creation myth was published by du Bois 1852: 330–32. In the religious and sacrificial customs, there was a strong focus on worship of ancestors as well. Their graves were regularly visited and offerings were made, especially at the grave of the founder of a *marga*, on which an umbrellalike shelter (called *rumah pojang*) was placed (Palm 1965: 62, Hissink 1904: 76, van Dijk and de Jonge 1980: 27–28). Comparatively, the veneration accorded the divine creator (to whom a small square sacrificial house, or *rumah dewa*, was devoted in some *marga*) was limited.

16. Helfrich 1889: 541.

17. Harrebomée 1885: 385.

18. Broersma 1916: 113. This system of competition for ranks and titles (and the possession of status goods) was named after the original and highest focus of achievement: a seat of honor, called *papadon*.

19. Ibid.: 67. The hereditary positions of *penyimbang tiyuh* and *penyimbang suku* were modeled after the position of *penyimbang marga*, including the associated *papadon* ascension.

20. Hissink (1904: 103–5) gives us an elaborate description of the privileges accompanying the enhanced status one gains after ascending the *papadon marga*.

21. See, for instance, Funke 1958: 78–100, 203–20, 231–60, Schnitger et al. 1939: 200–202, van der Hoop 1940: 66–67, and Palm 1965: 55–56.

22. Alongside the hereditary system of *papadon* ascension (*papadon adat*, reserved exclusively for the aristocratic *penyimbang*), it was possible to purchase the ranks (*pangkat*) of *papadon suku*, *papadon tiyuh*, and *papadon marga*, but only on condition that one celebrated it with an extravagantly lavish feast. Furthermore, there would often be several introductory ranks for sale as well, of which the *pangkat andang* (the right to be seated in the vestibule of the *sesat*) and *pangkat sesako* (the right—seated on the floor—to lean against a backrest) were the best known (see Hissink 1904: 93–100 for further details). If one had sufficient resources, it was possible to ascend from a lower *pangkat* to a higher position.

23. For titles, see, for example, Funke 1958: 218–19 and Broersma 1916: 43.

24. Contrary to what has been suggested (for example, in Guyt 1937a: 178 and Broersma 1916: 73), the *papadon* system existed throughout the entire Lampung region. There were, however, certain differences in how it was practiced between the Paminggir on the one hand and the Abung and Pubian on the other. Palm (1965: 58) reviews these similarities and differences using historical documents.

25. The status of *papadon marga* allowed the marriageable girl (*muli*) to wear twelve bracelets; the status of *papadon tiyuh* permitted six to eight, and

where the status of *papadon suku* was concerned, two to three bracelets were allowed (Hissink 1904: 105–8).

26. Funke 1958: 86–90 and 1961: 315–21, van der Hoop 1940: 66–77, Palm 1965: 55–56.

27. A widespread misunderstanding exists concerning the origin of the Lampung *papadon* complex. Some authors erroneously assume that it was copied from Banten (Aekerlin 1894: 1533, Hissink 1904: 91, Broersma 1916: 67, and Taylor and Aragon 1991: 127). It has been demonstrated, however, that the seats of honor were based on the same ancient megalithic custom practiced in the Lampung area as well as in Banten (see also note 21).

28. Another illustrative example is the design of one of the last *papadon* seats ever made (after World War II in the Abung area): the legs of this "throne" are shaped like soldier's boots (see Funke 1961: image opposite 325).

29. See ibid.: 319 and the image opposite 325 for a *papadon* seat with elephant's legs; for images of *sesako* decorated with animal figures, see, among others, Palm 1965: 54, Funke 1961: opposite 317, and R. Maxwell 2010: 150–51.

30. It should be noted here that in many cases the species of bird is rather unclear. Furthermore, some sources give the impression that, for example, the horse is also a relatively regular feature (see, for example, Hissink 1904: 104 and Schnitger 1939: 197).

31. Palm 1965: 62 and Funke 1958: 59–78.

32. Funke 1958: 60–61, Schnitger 1939: 198–202, and Broersma 1916: 74. See also notes 21 and 27.

33. Funke 1961: 323–26.

34. Here we follow Hissink (1904: 92), who also indicates that the term *papadon*—contrary to popular belief—is not a contraction of *padudukan*, derived from Malay *duduk*, "to sit."

35. See Schnitger (1939: 190–91, 201–2), who refers to the role of the elephant among the Dayak on Kalimantan and among the Batak and Lampung on Sumatra.

36. Ibid.: 202 and pl. 36.

37. See, for example, van der Hoop (1949: 170–71) about the Dayak on Kalimantan.

38. Cornets de Groot as cited in Funke 1958: 61.

39. Helfrich 1889: 609. Moreover, the amount of butchered water buffalo would customarily be an important indicator of the social status of the individual organizing the feast. Thus, the ascension to the highest *papadon* seat (*papadon marga*) was accompanied by the slaughter of thirty buffalo, which often severely depleted one's livestock (see Hissink 1904: 100–102).

40. Degroot, Chutiwongs, and Sri Hardiati 2009: 42.

41. See, for example, Sundari 2009: 100–101.

42. The *tampan* and *palepai* were woven by identical techniques: single-colored supplementary wefts were applied to a plain weave cotton foundation. The most labor-intensive and time-consuming job was to count out the threads needed for the intricate patterns before mounting them on the back tension loom. See van Dijk and de Jonge 1980: 32.

43. Ibid.: 14–15.

44. A distinction is often made between *tampan* originating from the inland parts of the Lampung area (*tampan darat*) and *tampan* from the coastal regions (*tampan pasisir*). The latter type more often than not incorporates maritime details, and West Javanese art influences can also regularly be found on these cloths (see, for example, Holmgren and Spertus 1989: pls. 30 and 32). In addition, a clear relationship in style is found between the designs of *tampan darat* and the textiles of T'ai–speaking peoples of the Southeast Asian mainland (see Gittinger 1989a: 225–39).

45. See, for example, Steinmann 1939: 252–56.

46. See Gittinger 1972: 137 and 1976: 219, Holmgren and Spertus 1989: 72, and van Dijk and de Jonge 1980: 34–36.

47. See, for example, op 't Land (1968–69: 107–10) about the designs of *tampan*, and Gittinger (1976: 225) about the compositions of *palepai*.

48. See de Jonge and van Dijk 1995a, 32–47 for a more extensive review of this nautical symbolism in the Southeast Moluccas.

49. Horridge 1986: 15–16 and 1987: 68.

50. Gittinger 1976: 219.

51. van der Tuuk as cited in Broersma 1916: 110.

52. It is a common misconception that the Lampung were a maritime people (as suggested in Taylor and Aragon 1991: 132, for example).

53. A good description of the earlier trade in Lampung pepper is given in an account by a Minangkabau tradesman, dating from the first half of the eighteenth century (published in Drewes 1961). This account demonstrates that the Lampung focused exclusively on the cultivation of pepper and did not wish to involve themselves in the trade of the product. The overseas export was controlled entirely by immigrants who had settled in the coastal regions of Lampung province (ibid.: 16).

54. Upon ascending the *papadon marga* (the highest attainable rank), an Abung man was supposed to enter into marriage. According to Funke, both events were traditionally closely interrelated. Since many were unable to afford the tremendous costs that accompanied the festivities, however, the marriage ceremony (including a ride in a special stately carriage [*rata*]) was in practice usually dealt with first. Later, after sufficient funds had once again been saved, the *papadon* ascension took place. The marriage that had been entered into before, was, so to speak, reenacted (see Funke 1958: 213 and 1961: 235).

55. Funke (1961: 223) implies that the *rata*—in certain circumstances—could also function as a *Hochzeitswagen* (or wedding car) without the *papadon* ascension. See Schnitger 1939: 198–99 for details on the use of *rata* on the occasion of the death of a Lampung "emperor." The *kayu ara* (symbols of fertility) "aboard" the *rata* were then replaced by stakes with feathers and figures of birds.

56. The peoples of Lampung distinguished between light and heavy *rata* (see Funke 1961: 223). See Palm 1965: 55 for a picture of a heavy stately carriage

decorated with canvas cloth, and van der Hoop (1940: picture 4) for an image of a light version. Aeckerlin (1894: 1541) records brightly colored *rata* made entirely of wood, which in his years within the coastal *marga*—after the abolition of the *papadon* system—could be used by every bridal couple. See inv. nos. 975-400 and 975-401 in the collection of the Dutch National Museum of Ethnology, Leiden, and Schnitger 1939, picture 38.2.

57. See Schnitger 1939: 198. It is telling that in subsequent marriage processions arranged in the shape of a ship, which came into being after the disappearance of the *rata* ritual, a tree (the *kayu ara*) would sometimes be carried along (for such processions around 1970, see, among others, Gittinger 1972).

58. Palm 1965: 71.

59. Ibid.: 65. According to Steinmann (1939: 252–53 and 1965: 25) a *tampan maju* served the purpose of decorating the (aristocratic) bridal bed. Other sources describe the valuable cloth as a ritual decoration for the seat of a bride (see, for example, Budiarti and Brinkgreve 2009: 129).

60. Hissink (1904: 144) describes a short ritual that concludes the traditional marriage festivities. The bride, dressed as a *muli* (marriageable girl), solemnly takes off her jewelry, and as a result achieves the status of *maju*: married woman.

61. Based on dominant design elements, it is possible to distinguish between various categories of smaller *tampan*. In this manner, Gittinger (1972: 95–132) classifies all *tampan* that she investigated into six categories.

62. Regarding the dowry, see Gittinger 1976: 213 and op 't Land 1968–69: 114.

63. Gittinger 1976: 214 and Hissink 1904: 144. The association of smaller *tampan* with fertility would sometimes also be splendidly visualized in another phase of the marriage ritual: across a symbolic bridge, composed of several *tampan* woven together, the bridal couple would walk to a ceremonial bedroom (see picture 165 in R. Maxwell 2003).

64. Relevant here is the *kayu ara*, as it was used in the *kawin jujur* ritual, the type of marriage that incorporated the presentation of a bride price. See Gittinger 1972: 157 and van Dijk and de Jonge 1980: 38. Schnitger (1939: 198) describes the *kayu ara* as a component of the *rata*. Hissink (1904: 105) indicates that the number of gifts in the tree (the "fruits," called *buah*) corresponded to the *papadon* rank of the families involved.

65. This is exemplified by the design as shown in fig. 44 (*tampan maju*), in which a boat's prow shaped like an animal, decorated with a peacock crest, is shown.

66. According to Funke (1961: 180–81), the floral motifs of the *siger* represented among others flower species and the "growing waringin" (a kind of Ficus tree).

67. Circumcision is relatively new in Lampung culture. Only when Islam became widespread, at the start of the twentieth century, was the ritual generally introduced.

68. Here, and in the following discussion, we refer to the ascension of the *papadon marga*, the highest Lampung rank.

69. See, for example, Hissink 1904: 106 and Schnitger 1939: 198–99.

70. Regarding the white piece of textile, see van der Lith, Fokkens, and Spaan 1896–1905: 346. Regarding the *palepai*, see Schnitger 1939: 199, 201. Although this last author does not use the term *palepai*, his description and an accompanying illustration (pl. 38.1) imply that such a cloth is concerned.

71. The three highest *papadon* ranks each had its own color: white belonged to the *papadon marga*, yellow to the *papadon tiyuh*, and reddish brown to the *papadon suku*. See, among others, Hissink 1904: 103–8; see also fig. 45.

72. See Schnitger 1939: 198, 201, and Funke 1961: 236. In relation to the *papadon* seat in Kroë, Schnitger even speaks of a *krosi bulampok*, a chair (placed on a stone) decorated with a cloth (see also Hissink 1904: 91, note 2).

73. See Forbes 1885: 145 and van der Hoop 1940: 61 for the traditional arrangement of the seats of honor in the *sesat* (which was in fact a source of constant debate and strife). The representation of the thrones by means of textiles occurred in another nineteenth-century context as well. Funke (1958: 253) describes how the weavings, which would formerly have decorated the *papadon* seats, replaced these seats of honor halfway through the nineteenth century when the Dutch colonial administration discouraged the very expensive *papadon* ascensions. Instead of sitting on the wooden thrones, participants would sit on the cloths, and in this way the ancient *papadon* tradition continued, if less conspicuously.

74. The first to note this was the archaeologist and founder and curator of the het Palembang Museum of Archeology, Friedrich Martin Schnitger (1939: 201–2). He also noted that his interpretation did not exclude the—in his years—increasingly popular opinions of Steinmann, who designated the ships on the cloths as soul ships. See also note 45.

75. Interestingly, the composition and style with which the *papadon* ascensions are depicted on these types of *palepai* are possibly derived from West Javanese forms of art. Especially the similarities with the *gunungan*, used in *wayang* presentations, are striking: here, too, center stage is often reserved for two opposing animals, and wings (as temple decoration) can be found on the sides. In her thesis (1972), Gittinger investigates this subject more thoroughly.

76. See, for example, Palm 1965: 55, Schnitger 1939: 198, and Funke 1961: image opposite 244.

77. See Schnitger 1939: 201.

78. However, we would like to take a broader perspective on this. In some cases the depictions on the *palepai* appear to be a mixture of the *rata* procession and the *papadon* ascension in the *sesat* (often readily recognizable by a roof decoration with water buffalo horns, while temporary party tents, erected beside the *sesat* might also be represented). In some southwestern Abung *marga*, the bride was

not allowed to ascend the *papadon* seat with her husband (see Funke 1961: 254).

79. Palm (1965: 65) shows a picture of a *tampan* from Wairate (Ratai, Lampung Bay), which formerly belonged to the regalia of the owner of a *papadon* rank. This cloth was collected by F. Broekmans, who spent many years working as a physician in the Lampung area after World War II. Broekmans was, according to Palm (1965: 70), a "meticulous observer."

80. Concerning a red-ship-style *palepai* originating from Kalianda, Snelleman (1910: 75–76) reports that it was used exclusively by *penyimbang marga* who bore the titles of *pangeran*, *kria*, *temenggung*, *ngahebi*, or *demang*. They would hang the cloths from the wall close to where they were seated during *adat* meetings, feasts, and marriage and circumcision rituals.

81. On the basis of the color range and the style, *palepai* are habitually categorized as either blue-ship-style or red-ship-style, in which the color of the ship is the distinguishing criterion. Rare *palepai*, with separate compositions (such as stakes with water buffalo horns for example) or with nothing but rows of human figures, make up third and fourth categories. For images, see, for example, Taylor and Aragon 1991: 126–27 and 130–31, R. Maxwell 2003: 113, and Gittinger 1976, figs. 1–6.

82. In some cases, a single mount is depicted, for example, an elephant mounted by a bride and groom. See the cloths published in Palm 1965: 65, Holmgren and Spertus 1989: 83, and Taylor and Aragon 1991: 134.

83. Palm (1965: 65) uses this term to typify a *tampan* from Wairate (see note 79), and Snelleman (1910: 76) uses it to indicate a red-ship-style *palepai* from Kalianda. It is possible that the term was employed for all types of cloth that were associated with status.

84. As far as we know, the last *papadon* ascension took place in the early 1950s (with the Abung). For a description see Funke (1961: 235–59). See also note 28.

85. See Hissink 1904: 147.

CAT. 18

1. Steinmann 1946b: 1888–89. *Darat* literally means "inland." This term has been used to describe older-style *tampan*. See Holmgren 1989, Khan Majlis 1984: 48, Barnes and Kahlenberg 2010.

2. Gittinger 1972: 138–40.

3. The *singa* most likely expresses a fusion of native concepts inspired by both Buddhist and Hindu pantheons of protective mythological animals. *Singa* is a Sanskrit word and means "lion."

4. The eyes on *singa* are usually raised and bulbous. The "eyes" on this *tampan* resemble coiled Greek keys. Like pieces of a fictive puzzle they are possibly anthropomorphic and/or the branches of a symbolic tree whose trunk and root system suggests a fanciful bridged nose with flared nostrils.

5. Heine-Geldern (1934) also remarked that this frontal/profile feature is a typical characteristic in archaic forms of a *t'ao tieh*.

6. de Flines 1975: 14–16, pl. 3, no. 3, 161.

7. Gittinger 1979: 90.

8. Steinmann 1946b: 1887. The word *tampan* also refers to ceremonial trays and shallow wooden bowls used for offerings.

CAT. 19

1. Schnitger 1939: pl. 29.

2. Ibid.: 198–99.

3. Gittinger 1979: 88.

4. Steinmann 1946b: 1888. A finely carved wooden backrest (*sesako*) from one of these seats and a complete throne seat (*papadon*) in the recent publication *Life, Death, and Magic* display similar themes to those found on *tampan* and other ceremonial cloth. National Gallery of Australia. R. Maxwell 2010: 150–51.

5. Gittinger 1972: 1.

6. These textiles have not been produced for more than 100 years, nor were great nineteenth-century Lampung weavers ever interviewed. However, one may assume that they valued similar technical and ritual expertise as in other indigenous Indonesian weaving traditions.

CAT. 20

1. Thirteen species of hornbills are found in Indonesia, including nine in Sumatra.

2. The gender of this figure is uncertain. It may represent a female with a large vulva (cf. Fraser's "heraldic woman"; see Fraser 1966: 36) wearing an elaborate crown (*siger*), or a male figure presenting trophy heads.

3. Marsden [1811].

4. Schnitger 1939: 198.

5. du Bois 1852.

6. Ibid.: 330–32.

CAT. 21

1. Gittinger 1991: 90.

2. These *punakawan* appear to be based on Javanese models. Each figure seems to carry weaponry and sports an item of clothing of foreign manufacture.

3. Schnitger 1939: 197–202.

4. A very similar example of Dewi Urang Ayu is depicted on a rare batik from Cirebon, north coast Java, from the nineteenth century; National Gallery of Australia, collection no. 1989.2246 (see fig. 48). The goddess of the South Sea, Nyi Roro Kidul, is also sometimes described as having the upper body of a beautiful woman and the lower body of a serpent or *naga*.

CAT. 22

1. This *tampan* was originally published in 1983 in the DMA's *Selections from the Steven G. Alpert Collection of Indonesian Textiles*. Because of its unique visual qualities, it was soon reproduced on Indonesian greeting cards, and appeared on newly woven *tampan*, one of which was later shown to the Dallas Museum of Art. Personal communication: Carol Robbins, 1988.

CAT. 23

1. Gittinger 1972: 8–9.

2. Ibid.

3. Miksic 1990: 69 (panel I.b86) and 88 (panel I.b108); Holmgren and Spertus 1989: 76.

4. du Bois 1852: 255.

5. Holmgren and Spertus 1989: 80.

6. Gittinger 1989a: 239.

CAT. 24

1. Gittinger 1972: 10–11.

2. Ibid.: 91.

3. Ibid.: 129–30, 153.

4. Ibid. For examples of double-red-ship cloths, see Gittinger 1979: 89, pl. 48; R. Maxwell 1990: 113, pl. 163. For examples of single-red-ship cloths, see Langewis and Wagner 1964: pl. 8; R. Maxwell 1990: 113, pl. 162; Holmgren and Spertus 1989: 88–89; Taylor and Aragon 1991: 130, fig. IV.6; Dallas Museum of Art, 1983.80, not illustrated.

5. Holmgren and Spertus 1989: 86.

6. Gittinger 1979: 90.

7. Tropenmuseum, Amsterdam (1969-4). See Langewis and Wagner 1964: 99, pl. 97; Gittinger 1979: 72–73, 89 pl. 50.

8. Gittinger 1972: 155.

CAT. 25

1. Gittinger 1972: 32–33.

2. Ibid.: 46, 68.

3. Ibid.: 58–59.

4. Ibid.: 66–67.

5. For other similarly orientated *lampit*, see R. Maxwell 1990: 172, ANG number 1984.602, and Barnes and Kahlenberg 2010: 88–89.

6. Gittinger 1972: 67.

7. In Buddhism, the journey toward enlightenment is embraced in its "eight-fold path." Prince Siddhartha Gautama was moved by "the four sights"—an old man, a sickened person, a corpse, and a holy man—before embracing a spiritual life and becoming the Buddha. In turn, he developed the "four immeasurable goals": love, compassion, joy, and equanimity. For *tampan* and Buddhist influence, see Gittinger 1989a: 225–39, and for Buddhism and *lampit*, see Barnes and Kahlenberg 2010: 88. For an exacting use of the mandala motif in Lampung textiles, see R. Maxwell 1990: 202, pls. 290 and 291, and Langewis and Wagner 1964: 203–4.

CAT. 26

1. Holmgren and Spertus 1989: 94, fig. 14; after Bernet Kempers 1988: fig. 22.11a. Related Dong Son vessels of this type have also been found in Cambodia and on the island of Madura.

2. Referred to by A. J. Bernet Kempers as "Pejeng type" drums (1988: 327–39).

3. Fluid interlocking designs such as this one are not found on the majority of imported Dong Son drums, whose tympana consists of more rigid geometric designs and recognizable pictorial motifs.

4. Holmgren and Spertus 1989: 94; Gittinger 1979: 84, fig. 41.

5. R. Maxwell 1990: 97, pl. 135; Barnes and Kahlenberg 2010: 64.

6. Solyom and Solyom 1990: 49. It is unclear when this term was first used or whether these designs, which are most likely of mythological creatures, were in part inspired by squid. In the 1970s, vendors and locals in South Sumatra often did refer to these designs as *cumi-cumi*, but when further questioned would always add something like "Well, they look like *cumi-cumi*, but we really don't know." The term *cumi-cumi* was encouraged in the resale trade, as this type of *tapis*, if in good condition, demanded a higher price than most other Lampung skirts.

7. 1980.1633.

8. 1977.19.10

9. Many of the embroidered panels on *inu* were in poor condition when they were sold. Starting in the 1970s, *inu* were reconditioned with new patterning using thread taken from old embroidery to enhance their resale value.

10. See Langewis and Wagner 1964: 193–99, 201–2; Holmgren and Spertus 1989: 94, det. 40.

CAT. 27

1. Bernet Kempers 1988, 160–61.

2. Other comparable examples can be found among the Lampung skirts in Langewis and Wagner 1964: 173, 179–85, and Holmgren and Spertus 1989: 100–101.

3. The richness and depth of color of a textile are important not only to Western connoisseurs, but also to every traditional culture in this region, and, along with technical execution, are perhaps the most important criteria on which a textile is judged by its local makers.

CAT. 28

1. On top of the serpentine dragon is a smaller *naga* or perhaps some other creature.

2. Holmgren and Spertus 1989: 102.

3. Gittinger 1972: 9.

4. Ibid.: 48–49, 156.

5. Funke 1958: vol. 1, 61, 71.

CAT. 29

1. Langewis and Wagner 1964: 173; Totton 2009: 80, 150–51.

2. The most exotic example of this type of skirt formerly owned by the author was created during the First World War. Instead of birds, the "upper world" was filled with biplanes and the "lower world" was populated with a perfectly rendered stegosaurus. The weaver somehow had pictures as models for these early engines of war and for a dinosaur.

3. The idea of including the worldly or exotic is suggested by this *tapis*'s camel-like fantasy creature. Many Abung made the pilgrimage or Haj to Mecca, where no doubt they were astounded by the sight of camels.

4. Tigers are mythical animals of the highest order and are rarely depicted in Sumatran art. While tigers are feared, it is also routinely believed that particularly powerful persons or revered ancestors can return as tiger spirits.

5 BORNEO: THE ISLAND—ITS PEOPLES

INTRODUCTION

1. This statement often appears in print as describing Borneo. The actual quote refers to Bahia on the Brazilian coast (Darwin 1909–14: ch. XXI), but reinforces the association (an accurate one) of dense jungles with the island of Borneo.

2. Adelaar 1997: 68.

3. Lewis 2009. Other sources, such as the World Wildlife Foundation, state that there are 220 native languages/dialects spoken there.

4. Personal communication: B. J. L. Sellato, 2013.

5. Headhunting and human sacrifice were practiced on a limited basis by the traditional societies discussed in this catalogue. Among the Dayak, these practices were sensationalized and sometimes even encouraged by Europeans, who sought to use them as a pretext both for extending colonial control and to further civilize these groups.

6. Heppell et al. 2005: 25–26. See also Schärer 1963: 146–54; Vredenbregt 1981: 7–12; Sellato 1989: 5–36.

7. Sellato 1989: 244–45.

8. Freeman 1979: 234–35.

9. Fox 1988: 22–23.

10. Wolheim 1980: 103–4.

11. King and Avé 1986: 16. See also V. King 1993: 113–20.

12. Avé 1982: 100.

13. Lumholtz 1920: ch. 12, 60–62.

14. Personal communication: Mme. Siah Tun Jugah, 2010. See also Linggi 2001: 14–17, 58, 61.

15. Personal communication: Reimar Schefold, 2009.

16. Avé 1982: 98.

17. Rautner et al. 2005: 7.

18. Ibid.

19. Sibon 2010: 18.

20. Ibid.

21. Ibid.

22. Avé 1982: 100.

23. Personal communication: Wellem Ingan, 2010.

CAT. 30

1. Hose and McDougall 1912, vol. 1: 165–66.

2. These can be identified by their jawlines and rows of teeth.

3. Roth 1968: vol. 2: 126.

CAT. 31

1. Personal communication: Michael Heppell, 2010, 2011.

2. Ibid.

3. Personal communication: Ruslan Nursalim, Eddy Abbas, and others, 2011, 2012.

4. Iban weaving often depicts a powerful creature consuming smaller ones.

5. Personal communication: Ruslan Nursalim and Wellem Ingan, 2011.

6. Roth 1968: 175–76.

7. Ibid.

8. Personal communication: Michael Heppell, 2010, 2011. The beaded belt is unusual for a Bidayuh, and may have been added to the scabbard, as this sword was originally discovered in an area populated by the Iban.

CAT. 32

1. Roth (1968: 130) quotes Low as follows:

> The *katapu* (*tapung*) or helmet, in general use, is a round skull cap of wickerwork, with a rush lining and occasionally a skin covering, surmounted by either a metal plate or two of fanciful pattern or the scaly armor of the *tenggolieng* [*tenggiling*: a Malaysian pangolin]. The crown is decorated with the plumage of birds, and the side [with] tufts of human hair. The Kyans [Kayans] and Kinahs [Kenyahs] wear on their headpieces the tail plumes of the helmeted hornbill—each plume signifying a dead enemy.

Early publications also display variations of this helmet type featuring, in addition to feathers, the ivory bill of a hornbill, as well as other avian parts (Roth 1968: 99; Hose and McDougall 1912: vol. 1, 162, pl. 93). These materials reflect the general Dayak belief that certain birds are givers of omens and messengers of deities. Among the Iban, this is exemplified by Lang Singalang Burong, who in the guise of a Brahminy kite is the supreme god of war and the guardian of brave men. In writing about the Kayan, Charles Hose noted that elaborately decorated headgear was worn only by men of proven valor (Hose 1988: 133).

2. A well-preserved specimen illustrated in UCLA's 1994 publication *Art of the Ancestors* (Feldman 1994: pl. 41) and an early photo of a Klemantan youth in war garb (Hose and McDougall 1912: vol. 1, 167, pl. 95) illustrate the manner in which these fittings were sometimes displayed.

3. Personal communication: Wellem Ingan, 2010. Wellem Ingan, master carver, commented that this composition represents a crossing over to the spirit world, "dua kepala, satu badan," meaning that two heads (the universe of the warrior and that of this creature) are bridged by one body (the backbone of the beast).

4. Roth 1968: 101–3.

5. Despite their sense of cultural superiority, and the period's endemic racism, early ethnographers generally admired the Iban and Kayan peoples. These authors knew the classics and at times employed Homeric references when referring to Dayak warriors and their attire (Roth 1968: 121). Coincidentally, in the *Iliad*, Homer not only identifies individual warriors and their deeds by their helmets but also uses helmets to show connections to the divine. As a literary device, a helmet's decoration establishes the wearer's salient characteristics. Thus, among the Trojans, "Hector, of the flashing helmet" is identified with nobility, courage, and self-deprecating manners, while Paris, the cause of the epic's woes, is described at a crucial moment as being "helmetless," meaning that he is confused, lacking in both courage and ability. Odysseus, the wily hero of Homer's other great work, wears a crisscrossed leather helmet topped by plates of boar's teeth. While his headgear seems simple and antiquated compared to the other leaders' glistening metal helmets, it's actually divinely blessed and of great pedigree. Odysseus's helmet reflects the man. Using stealth and superior intelligence, he triumphs precisely because others often misjudge him from his appearance and in so doing underestimate his abilities.

CAT. 33

1. Personal communication: Wellem Ingan, 2010.

2. This pair was originally purchased with a third statue. The third leg is now at Yale University (ILE2012.30.548); the fourth leg is lost. The source for these linguistic terms was a personal communication with Antonio Guerreiro in 2011. *Ladung aya' litt* translates as "big bench."

3. Personal communication: Wellem Ingan, 2010.

4. We know what a complete table of this type must have generally looked like as there are well-constructed models of them in the Sarawak Museum (No. 77/197). Its legs are also composed of four *aso* carved in a posture similar to this pair. However, their heads are turned backward at a 180-degree angle to their chests as opposed to the Dallas *aso*, whose heads face outward. According to Wellem Ingan, this was done to obscure the model's true meaning and to render its carving a harmless exercise. Personal communication: Wellem Ingan, 2010. Two other related *aso* table legs are on display at Singapore's Asian Civilisations Museum (XX11587/XX11588, W-0017/W-0249). These date to c. 1900. The *aso*'s heads are partly modeled on Chinese dragons, as evidenced by the creatures' horns and ears. Also, the *aso*'s tails would have fit into the table's top more in European fashion than in traditional style.

CAT. 34

1. The longhouses in this area were dismantled by government decree during the 1950s and 1960s and replaced with smaller single homes for housing extended families.

2. See Nieuwenhuis 1904: 28–29, 168, pls. 3 and 33, and Hose 1988: 166.

3. Another door from the same locale is on permanent display at the de Young Museum, San Francisco (2005.140.5).

4. Personal communication: Antonio Guerreiro, 2011.

5. Personal communication: Wellem Ingan, 2010.

6. Ibid.

CAT. 35

1. Personal communication: Michael Palmieri, field collector, 1981. This was the first river north and to the east of Benhes longhouse.

2. Personal communication: Antonio Guerreiro, 2011.

3. The radiocarbon date of a wood sample from this figure is CE 1040 ±40 years. The sample was tested at the Radiocarbon Laboratory of the Institute for the Study of Earth and Man, Southern Methodist University, Dallas, Texas, in February, 1986.

4. Personal communication: Antonio Guerreiro, 2011.

5. Bock 1985: 78–79.

6. This unusual treatment of a massively protruding jawline is also found on some Iban pig sticks from Sarawak.

CAT. 36

1. This statue was originally published in *Borneo and Beyond* (Heppell and Maxwell 1990: 8–9). At that time, it was said to have come from the Belayan River.

2. Personal communication: Michael Palmieri, 1981; the piece was collected at Benhes in 1981.

3. Since this piece was first published, it has served as a model for a revival industry that has been inspired by its unique style and weathered surface.

4. Personal communication: Antonio Guerreiro, 2011.

5. Ibid.

6. Personal communication: Michael Heppell, 2010.

7. Personal communication: Wellem Ingan, 2010. For example, contemporary carvers still refer to a figure's muscular, puffed-out chest as being a *burung dada*, or bird's breast.

CAT. 37

1. Chin 1980: 77.

2. Ibid.

3. Personal communication: Antonio Guerreiro, 2011.

4. Ibid.

5. Ibid.

6. This convention has entered mainstream Indonesian culture and can be seen on tourist art and advertisements.

CAT. 38

1. Personal communication: Wellem Ingan, 2010. Commoners were interred in the earth, but aristocrats were buried in accordance with their status.

2. Lumholtz 1920: ch. 34, 164.

3. Large hunkered figures with upraised arms are also found on a few surviving *keiliring*, the impressive mortuary poles of great Punan or Kayanic chiefs. These also necessitated human sacrifice before being erected (Chin 1980: 77–80).

4. This imagery does survive in the mats, basketry, and beadwork of some Dayak groups.

5. Personal communication: Antonio Guerreiro, 2011.

CAT. 39

1. "The Cannons of Brunei" in *The Brunei Times*, July 22, 2007.

2. Pigafetta 1995: 74. "There is a large brick wall in front of the kings [*sic*] house with towers like a fort, in which were mounted fifty-six bronze pieces, and six of iron."

3. Personal communication: Antonio Guerreiro, 2011.

4. Most Indonesian informants believe that this bronze is of native manufacture, but that it originated in the south of the island in an area that was influenced by, or exposed to, the suzerainty of Java's Majapahit empire.

5. Lumholtz 1920: ch. 26, 133.

6. Ibid.

CAT. 40

1. Heppell et al. 2005: 140–43.

2. I witnessed such performances on the Enkari, Batang Ai, Ngemah, and Katibas Rivers in the 1970s. In 1976, while staying at a small Chinese trading shop by the mouth of the Ngemah and Rejang Rivers, I encountered a lay Iban missionary. After proudly describing his work, he brought out a rice sack filled with *Indai guru'* masks. He called these evidence of the "devil" and told me that he was planning to destroy them. When I showed an interest in one of the masks, he softened a bit, and with a quizzical shrug gave it to me in exchange for a contribution toward his church.

3. See "Borneo: The Island—Its Peoples" in this volume, 121.

4. A more colorful palette usually indicates that a mask has been repainted.

CAT. 41

1. Heppell et al. 2005: 151–52.

2. Ibid.: 149.

3. Purchased in Sarotok, Sarawak, 1978.

4. Heppell et al. 2005: 151.

5. Lumholtz 1920: ch. 31, 150–51.

6. Personal communication: Mme. Sia Tun Jugah, November 2010.

CAT. 42

1. Maloh is a generic name that covers a number of groups.

2. The DMA has two skirts, 1989.48 and 1998.192 (fig. 69), along with a finely beaded jacket (1983.141) of this description.

3. Coincidentally, Nassarius (gibbosulus) shells are thought to be mankind's earliest form of personal adornment. Archaeological samples found in Israel and Algeria date from 90,000 to 100,000 years ago.

4. See Sellato 1989: 184–85, pl. 246, for a similar facial treatment on a beaded panel from an Aoheng baby carrier (246).

5. Personal communication: Ruslan Nursalim, Eddy Abbas, and others, 2012.

CATS. 43–44

1. Although design names customarily appear lowercased in scholarly publications, I am uppercasing the designs in these entries because they are held in such esteem and veneration by the weavers in my family—and indeed by all Saribas, Baleh, and other Iban peoples. To do otherwise, for a person of my background, would feel unnatural and even disrespectful.

2. Richards 1981: 4–5.

3. Edric Ong identifies this design as the *Buah Aji* on a skirt that also comes from the Baleh (Ong 2000: 73, fig. EO.15).

4. Heppell et al. 2005: 42–43.

CAT. 45

1. Kedit 2009: 231–34.

2. Saribas weavers remember this design as coming from the hands of the wife of the greatest nineteenth-century Saribas warlord, the Orang Kaya Pemancha Dana Bayang Apai Tiong, who looted a *pua kumbu* on one of his raids to West Kalimantan. His wife, Mengan Tuai Indai Tiong, was herself a grandmaster weaver. Not knowing the name or the meaning of the symbols on the looted piece, she wove her own expression of the design and titled it the *Bali Bugau Kantu*. To have done so and survived the resultant spiritual duel was her personal conquest over the spirit of an alien design, paralleling her husband's conquest of the enemy warriors. Over the generations, Mengan Tuai's granddaughter, Mindu Indai Selaka, began to develop the design and, in turn, Mindu Indai Selaka's granddaughter, Sendi Indai Gumbek, completed the process of enculturation by assigning names to the principal motifs in the design.

3. Other publications have also commented on the design of the *Bali Bugau Kantu*. Interestingly, Linggi (2001: 139) calls one example (no. 67, EJ016) a *Bali Bugau* (information possibly provided by the collector Datuk Paduka Puan Sri Empiang Jabu), when the design is in fact the familiar *Buah Berinjan* (correctly translated as "Steep and Jagged Pathways," rather than the misnomer of "Creeping Vine pattern" often used by non-Iban-speaking students of Iban textiles, who are not well versed in the usage of Iban idioms and esoteric terms). Gavin (2004: 188, 194) conversely identifies the design on another example, fig. 132, as the *Buah Berinjan Igi Beras* (often mistranslated by commentators as "Creeping Vine Pattern with Rice Grain Motifs"), when it is actually none other than the *Bali Bugau Kantu*. Ong (1988: 9–10, figs. 55, 56) does not attempt to name the design at all but elaborately describes the first figure in terms of flowering trees with pendant blossoms and attendant guardian spirits, and then describes the subsequent figure as depicting a slow loris climbing yet another sacred tree. Neither of these descriptions is correct, and in fact both textiles are actually very fine examples of the *Bali Bugau Kantu*. In the midst of all this confusion, one can be assured that any competent Saribas Iban weaver would not see any trees with blossoms or mounting slow lorises, nor the ubiquitous rice grain, in the celebrated design of the *Bali Bugau Kantu*, which boldly proclaims the

virtues of fearlessness and heroism through its terrifying primal motifs of lethal monsters.

4. For this reason, some master weavers tattoo the base of their thumbs with dots as ostentatious indicators of spiritual maturity and deftness at weaving.

5. See Drake 1991: 271–93.

6. See Sather 1996.

7. It was collected by Charles Hose in the Baram, northern Sarawak. Whole Saribas communities had migrated to the Baram after 1888 when slavery was outlawed by the Brookes, who then ruled Sarawak. These emigrants brought with them their textiles and the Saribas weaving conventions. British Museum AN312512001 (As1905C3.410 old CDMS number).

8. Gift of Helen and Dr. Robert Kuhn: object number X86.3239.

CAT. 46

1. Personal communication: Steven G. Alpert, 2012.

CAT. 47

1. Margaret Linggi (2001: 133) refers to a more recent *Bandau Bepadung* belonging to Datuk Paduka Puan Sri Empiang Jabu (EJ010) in her book. An old *Bandau Bepadung* from the Saribas showing monitor lizards with their tails curled around corpses of slain enemies is found in the Textile Museum in Washington, D.C. (2000.22.4), though inaccurately described as depicting crocodiles by Mattiebelle Gittinger (2005: 108). A good example of a Baleh variant of the *Bandau Bepadung* is in the Australian National Gallery (1981.1117), collected by anthropologists Derek and Monica Freeman in 1950, though they, too, erroneously describe the design as that of crocodiles (R. Maxwell 1990: 132–33). Suffice it to say, the true crocodile design is rare, and the only known published examples appear in texts authored by Jabu (1991: 89, pl. 136), Linggi (2001: 94, ML046), Heppell et al. (2005: 62, fig. 46; 68, figs. 52, 54), and Gavin (2004: 89), in which the crocodile can be recognized by its prominent jaw with accentuated razor-sharp teeth, and whose tail is not curled in circular fashion. Interestingly, Linggi names another true crocodile design the *Genali*, or the mythical Ruler of the Waters, which changes sex at whim and takes multiple forms—snake, giant turtle, and even whirlpool—but never crocodile (Linggi 2001: 80, ML009). It is not unheard of for weavers to mislead collectors and students in the field for reasons best known to the weaver, but to say that a design of lower rank is of a higher rank would be more than audacious.

2. Personal communication: Steven G. Alpert, 2012.

CAT. 48

1. Another form of the term is *gajai*, which has the same meaning.

2. Linggi 2001: 102.

3. Ibid.: ML141.

4. In his first book (1988: 64, pl. 20), Edric Ong mistakenly describes the *Gajah Meram* as *Remaung*, or "Tiger," forgivable as many commentators tend to "read" designs from an ethnocentric perspective.

5. Personal communication: Steven G. Alpert, 2012, information from Michael Palmieri.

6. Kedit 2009: 232.

7. Flying in the face of tradition, Gavin labels this design the *Buah Nising*, or Demon Ogre pattern, and then goes on to suggest that "some Iban also refer to [it] as *Gajah Meram*, irrespective of the fact that it shows a demon figure, rather than an elephant" (Gavin 2004: 100–103). As a rule, regardless of regional variations, *Nising* is never portrayed on cloth. Every Iban weaver the length and breadth of Borneo, from the acolyte to the grandmaster, is fully cognizant of this injunction. The Iban mindset maintains that the entire pantheon of Iban gods, demigods, and mythical heroes would be utterly scandalized and insulted if they were to see their arch nemesis *Nising* displayed prominently on cloth. The deities would furthermore not deign to attend festivals celebrated in their honor if ritual blankets displayed at such festivals were to glorify *Nising* instead of them. It is akin to Christians putting an effigy of Satan on a high altar instead of a crucifix or cross. If ever *Nising* were to be woven into a design, which would be extremely rare and allowed only if a weaver were specifically instructed by weaving deities to do so through dream encounters, he would be depicted as defeated, decapitated (without a torso), and subjugated, assuming a subservient role. As Jabu explains, "At the base of [a ritual] pole (*tiang ranyai*) is a face with pierced earlobes representing *Nising*, a demon giant, who is keeping watch over the trophy heads. This *pua kumbu* comes from the Saribas area, where there are restrictions on the weaving of human forms, and for this reason, the face of *Nising* is of minimal size" (Jabu 1991: 82). *Nising* is the reviled demon ogre impaled at the base of a ceremonial pole and tasked with the burden of propitiating trophy heads, while *Gajah Meram* is the celebrated valiant warrior protecting his prized trophy heads. No Iban weaver would confuse the two, or call one design by the other name.

CAT. 49

1. Personal communication between Steven Alpert and Michael Heppell, in the notes of Alpert, 2010.

2. Linggi 2001: 107.

3. Maxwell's proposition that "patterns are highly schematic depictions of ideas drawn from the natural world and the shared repertoire of Iban mythical and legendary designs" (R. Maxwell 1990: 44) succinctly describes the *Rang Jugah* in the Australian National Gallery (1981.1097). An interesting *Rang Jugah* is found in Heppell et al. (2005: 74) in which the design (pl. 62) is halved, the warp threads folded before the weaver tied the knots of the design to re-create a mirror image. This suggests a very spiritually mature weaver, seeing as she had the audacity to take shortcuts. The only known *Rang Jugah* woven as a *pua sungkit selam* (supplementary weft embroidery technique) is found in the Sarawak Museum (88/310) and is documented by Margaret Linggi (2001: 115) and Traude Gavin (1996: 38, pl. 35). Startlingly, Edric Ong (2000: 36) identifies the clearly discernible *Rang Jugah* as *Buah Berinjan* (mistranslated as "vine pattern") and describes it as pendant flowers interspersed

among jungle vines (EO.42P). It is important to set the record straight with such an important and well-known design.

4. Personal communication: Steven G. Alpert, 2012.

CAT. 50

1. Personal communication: Steven G. Alpert, 2012.

CATS. 51–52

1. Being from the Saribas, my understanding of the *Lebur Api* reflects the Saribas conventions associated with it, though it must be understood that different river systems and, in some cases, different longhouses have unique conventions with regards to weaving. It would be rash to generalize about Iban weaving.

2. Margaret Linggi translates this name as "White Hot" (2001: 35), while much earlier Benedict Sandin (1980: 85), erroneously described the *Lebur Api* as "Red Flames." Sandin, despite his undisputed status as a towering authority on Iban studies, was not intimately familiar with Iban weaving, which was perceived during his time as a female occupation and therefore peripheral to the male-dominated oral wisdom that he had meticulously documented.

3. Personal communication: Michael Heppell, 2012.

4. In the current literature, there is confusion concerning the *Lebur Api*. First, Traude Gavin is wrong in stating that the name "refers to the red colour of the cloth" (Gavin 2004: 84). The correct term for cloths dyed a rich ruby red by repeated immersions in an *engkudu* bath is *Pua Mansau* (Deep Red Blanket Successfully Treated and Exposed to Catch the Dew), not *Lebur Api* (White Heat). She arrives at her conclusion by arguing that "nowadays, *sungkit* cloths are made with store-bought thread of different colours, and such cloths are not called *lebur api*" (ibid.: 85). She further supports her argument with reference to the red bamboo baskets used in the *Gawai Antu* (Festival for the Dead): "The highest-ranking basket for women, called *lebur api*, is red in colour" (ibid.: 85). At the *Gawai Antu*, a festival unique to the Saribas region, the highest-ranked basket for master and grandmaster weavers is the *Mudor Ruroh Garong Ranggong Tujuh* (Seven-tiered Basket to Gather the Fallen Fruit of the Palm Tree of the Afterworld). It is also expressly referred to as the *Lebur Api*, not because it is colored red but because it recalls the pedigree of the blanket of the same name that was used to receive trophy heads, such blankets having been woven by master and grandmaster weavers. It is colored red to *reflect* this pedigree, not to imitate the color of the *Lebur Api*. Such a basket of the highest rank could be plaited only by a fellow master weaver. When the Iban weaver mentions *Lebur Api*, she is referring not to the red warp threads but instead to the white supplementary threads "floating" above the red warp, which suggest a three-dimensional effect of white-hot flames erupting from the cloth, especially when the cloth is about a trophy head. Modern *pua sungkit* are not called *Lebur Api*, because these new cloths are not meant for the *Gawai Enchaboh Arong*. They are woven by modern weavers who find they can express themselves better in a more modern idiom through *sungkit*.

For the Iban, a cloth's purpose and use are paramount in terms of rank and function. A *pua sungkit* with a plain design in white supplementary weft threads, and woven for the *Gawai Enchaboh Arong* a century and a half ago, would be known as a *Lebur Api* and have ritual currency, while a *pua sungkit* with an elaborate design woven for the purpose of demonstrating a weaver's skill would not be as highly valued and would certainly not be called a *Lebur Api*. The Iban ordinarily prize skill, but they regard ritual use even more highly. Second, Gavin's assertions that "*sungkit* cloths most probably were never made" in the Saribas and that "*sungkit* cloths that are found in Saribas longhouses had been obtained during raids to other areas" (Gavin and Barnes, "Iban Prestige Textiles and the Trade in Indian Cloth" in Barnes and Crill, eds. 1999: 87) deny a whole tradition of great *sungkit* weaving of the Saribas—despite the fact that she knew that Saribas weavers wove the *sungkit pua' belantan*, a shawl used to carry babies, oftentimes used to swaddle trophy heads in the absence of a full-sized *Lebur Api* or during a *Nyangkah* at a *Gawai Antu* (Gavin 2004: 38–40). The Batang Ai region, according to Gavin, was the center for *pua sungkit* weaving (ibid.: 291), and she presumably surmised that the Saribas plundered their deep red *pua sungkit* from the Iban of the Batang Ai. Enmity between the Batang Ai and the Saribas did not occur until the late 1880s during the Brooke expeditions up the Batang Ai (Pringle 1970: 227). The only possibilities of the Saribas plundering *pua sungkit* would be from the Balau, Undup, and Sebuyau. However, there are no histories in the Saribas of looted *pua sungkit* from these particular peoples, whom the Saribas did have contact with before the arrival of James Brooke, the first White Raja of Sarawak, in the mid-1800s. The only mention of a looted enemy's cloth in Saribas oral history is the *Bali Bugau Kantu* design (see cat. 45) woven by Saribas weavers, who remember that it was copied from a cloth taken by the Orang Kaya Pemancha Dana Bayang when he raided the Ulu Undup in 1834 and crossed the watershed into the Ulu Ketungau, where he also raided the Bugau (Sandin and Sather 1994: 175–76). Despite Gavin's claims, Saribas women are adamant that they wove and continued to weave the *Lebur Api*, and Datuk Sri Empiang Jabu, from the Saribas herself, published a family heirloom *Lebur Api* passed down to her through seven generations (Jabu 1991: 81, 82, 85, pl. 127). In the oral history of the Saribas, Dimah, the formidable wife of Orang Kaya Aji Apai Limpa, famously flung her *Lebur Api* on the ground, spurring her husband to return to her only after he had gained enough severed heads to fill her cloth. The *pengap* (chants) and *timang* (praise songs) of the Saribas further support this compelling argument with frequent mention of the *Lebur Api* and how it was beautifully woven by skilled and spiritually experienced weavers. It takes a great leap of logic to assert that Saribas women, who knew and mastered the technique and wove elaborate *sungkit* shawls, jackets, vests, ceremonial loincloths, and skirts, were entirely dependent upon their men to acquire not only trophy heads but also the cloth required so that the former could be received appropriately.

5. Kedit 2009: 234–36.

6. Heppell et al. 2005: 26, 49 (see also pl. 26), 50 (see also pl. 29).

7. Personal communication: Steven G. Alpert, 2012.

8. Freeman, John Derek, unpublished field notes held in the Tun Jugah Foundation.

9. Heppell et al. 2005: 78 (see also fig. 7), 79, 44 (pl. 18), 75 (pl. 63).

10. Heppell et al. 2005: 79.

11. Linggi 2001: 93, ML035.

12. Gavin did not regard them as anthropomorphic figures, commenting on various *sungkit* motifs that "when scanning patterns in an attempt to 'read' them, figures are frequently projected onto patterns where none were intended by the weavers who produced them" (Gavin 2004: 208). In this case, following her sensible advice that you ask the weaver to name the motif (ibid.: 211), Heppell's description of the dancing figure as Dara Meni, the goddess of dyeing, as communicated to him by Enyan, the weaver who wove it (Heppell et al. 2005: 81; see fig. 74), refutes Gavin, who incorrectly jumped to the conclusion that Enyan, on being asked what the figures represented and replying "scorpion" (thus contradicting herself), in fact had no idea what the motif represented (Gavin 1996: 73). A colossal oversight on the part of many uninformed observers in the field is to ask an Iban weaver what a design, pattern, or motif means without realizing that it is utterly taboo, especially in the Saribas, for the weaver to publicly name a design or motif that she herself has woven! When pressed, the weaver will have little option but to cursorily give an innocuous euphemism or a completely nonsensical name. The reason for this taboo is a fear of offending the said design, pattern, or motif, along with the attending spirits they represent. The proper protocol in the Saribas is always to ask a more senior weaver, related by blood to the weaver or from the same longhouse, the name of the weaver's work in her presence, as the senior weaver would be shielded from harm by virtue of being more experienced and spiritually mature. Nevertheless, weavers who have "adopted" anthropologists into their homes and fostered a trusting relationship with them would be more forthcoming with information, as in the case of Enyan, who named a number of figures accurately in Melbourne when she welcomed some cloths she had woven into Heppell's *bilek*, or home (Heppell 2010: 290). Given the circumstances, and the fact that she named other figures accurately on the same cloth, there would be no reason for her to substitute a euphemism for the dancing figure. Nevertheless, Enyan's identification of the dancing figure as Dara Meni does raise some questions. This goddess is much revered in both the Batang Ai and Baleh regions as one of the principal deities of dyeing, as opposed to Ragam Indai Manang Jarai in the Saribas, who taught the Iban how to weave, as described in the chronicles of *Raja Durong* (see Sandin 1976: 48). Dara Meni is given prominence by Batang Ai and Baleh weavers in the *takar* and *gaar* rituals. This elaborate process involves treating threads in a bath of scalding water, vegetable oil, ash, salt, and crushed gingers and subsequently exposing the threads to sun and dew continuously

for two weeks in order to prepare them to "successfully receive and bite" the dye of the *engkudu* after the *ikat* process has been completed. Among the questions posed by identifying the figure as Dara Meni are these: First, why is the goddess of dyeing woven onto a highly ritual cloth reserved specifically for head-taking, and how is she associated with the whole practice of head-taking? Second, if one of the figures really is Dara Meni, which one is she and who are the other two?

13. Iban weavers have no qualms about copying motifs from non-Iban cloths. But when they do so, they give them an indigenous Iban interpretation, as they have no understanding of the original meaning of the motif on the original cloth.

14. Gittinger 2005: 113, from Gavin and Barnes 1999.

15. This series consists of the calls of Nendak, Kelabu, Embuas, and Pangkas, all on the right, then Nendak on the left, then Ketupong on the right, then Beragai on the left, and finally Ketupong again on the right. See also the definition of *Lebur Api* in Richards 1981.

16. In the Saribas, Indu Dara Tinchin Temaga is known as a patroness and tutelary spirit to leading families, master weavers, and war leaders.

17. Heppell et al. 2005: 81.

18. My tutors and principal informants, Lemuti Indai Gulang and Jelia Indai Nan, were great-aunts of master weavers, and both studied weaving under the tutelage of the last Saribas grandmaster weaver, Sendi Indai Gumbek, my paternal great-grandmother.

6 THE ART OF SULAWESI

INTRODUCTION

1. Wallace 1989. For a full account of Sulawesi's remarkable geology and ecology, see Whitten, Muslimin, and Henderson 1987.

2. Bronson 1992: 89; Zerner 1982.

3. This period is vividly described in Bigalke's excellent social history of Toraja (2005).

4. Nooy-Palm 1979: 110–21.

5. Waterson 1989.

6. See for instance the photographs of the house at Orobua in Nooy-Palm 1988: 90–91.

7. See the illustration in Nooy-Palm 1988: 89.

8. See Waterson 2009.

9. For fuller discussions and illustrations, see Guy 1998, R. Maxwell 2003, Crill 2006, Barnes and Kahlenberg 2010. The Roger Hollander collection, recently purchased by the Asian Civilisations Museum, Singapore, contains several fourteenth-century pieces found in Toraja, while one or two have date ranges extending back into the late thirteenth century. Kahlenberg (2003) and Barnes and Kahlenberg (2010) discuss some fifteenth-century examples. An equally early date has been established for some indigenous *ikat* weavings from Sulawesi, including an exquisite example from Poso (Central Sulawesi), suggesting a sophisticated tradition that must have existed prior to the arrival of Indian imports but has now vanished.

10. The term *palampore* derives from Tamil *palang-posh*, "bedcover" (Guy 1998: 106), but in Southeast Asia the cloths were generally used in a ritual context as decorative hangings.

11. Ibid.: 115.

12. Eighteenth-century Dutch correspondence, for instance, records that the Sultan of Palembang once demanded 500 *patola* cloths from officials of the Dutch East India Company (VOC) in a single presentation, cloths that he doubtless intended to use to cement his own alliances through relations of gift-exchange and trade (Guy 1998: 72).

13. Nooy-Palm 1979: 257.

14. Helms (1988) has documented this pattern cross-culturally in an interesting comparative study.

15. A fine example of a *palampore* with flowering tree motif is illustrated in Barnes and Kahlenberg (2010: 237), together with an indigenous Toraja *mawa'* that would seem clearly to have been inspired by this design (280). See also the discussion by Gavin (2010) in the same volume.

16. For more on Toraja textiles, see J. Kruyt 1922, van Nooyhuys 1925, Nooy-Palm 1989, Holmgren and Spertus 1989, and Kusakabe 2006. On the concept of *pelambean* in Toraja religious thought, see Waterson 2009: 338–40.

17. van Nooyhuys (1925) tracked down the manufacture of *sarita* to the factory of Fentener van Vlissingen in Helmond, where they continued to be made until 1930. Nooy-Palm (1989) visited the van Vlissingen archives, where she found photographs from the 1920s, showing how the cloth was wound onto large reels for dyeing.

CAT. 53

1. Shields of the more remote cultures of the Indonesian islands were popular items of collection by Europeans during the nineteenth and early twentieth centuries. This particular item was originally part of the collection of a well-known Dutch military commander, Major General Johannes Benedictus van Heutzs (1851–1924). As military governor of Aceh (north Sumatra), he succeeded in forcing an end to its bitter and protracted war of resistance, after which he was promoted to the position of Governor-General of the Dutch East Indies (1904–9) (Alpert 1995: 19 and nn. 2, 3). It is most probably during these latter years that the shield came into his possession, since he returned to the Netherlands in 1909, later donating his collection to the Leger Museum, a military museum originally housed at Doorwerth Castle near Arnhem and now in Delft.

2. For a fuller discussion, see Waterson 1988: 44–45 and 1989.

CATS. 54–55

1. In some areas, these ornaments were attached to headcloths, in others, fastened directly into the hair.

2. Although Kaudern describes the *sanggori* as being made of "brass," "copper alloy" is technically more accurate. Brass is an alloy of copper and zinc, but it is highly likely that these items contain copper and tin. They look different from the yellow brass

taiganja ornaments and the *pinetau* figures from this area. The Dutch obtained zinc from Japan in the seventeenth century, so it was in circulation in this region. Zinc is presently mined in north Sumatra. It is possible that it was known in earlier times, but in many parts of the archipelago it would have been difficult to get hold of. Bronze, with copper and tin and some other trace elements, was much more common in Indonesia.

3. Kaudern 1938: 320–29; Rodgers 1988: 137.

4. Kaudern 1938: 323.

5. Rodgers 1988: 137.

6. Sarasin and Sarasin 1905, vol. 2: 70, and illus. p. 37.

7. Kaudern 1938: 324–25.

8. Adriani and Kruyt 1912–14.

9. An example has been illustrated in Grubauer 1923: 61.

10. Kaudern 1938: 327.

CAT. 56

1. The *keris* was a characteristic weapon not only in Java, but also in Bali, Sumatra, Sulawesi, and throughout the Malay world. They differ somewhat in style in each of these areas. Many of the *keris* held as heirlooms by Toraja noble houses appear to be the work of Bugis or Makassarese smiths.

2. Several related families of Toraja goldsmiths still live and work at Pao near Karassik, south of the town of Rantepao. They are descendants of *tongkonan* Pao, an ancestor house that once held much wealth in land. Traditionally they have also manufactured the beaded ornaments called *kandaure*. The original goldsmiths, according to them, made themselves a workshop high up in a tree, so as to keep their closely guarded skills a secret from the prying eyes of passersby. Pak Nita, one of the current generation of Pao goldsmiths, is of the opinion that the making of *lola'* is a tradition no older than about two hundred years. He recounts how in the past silver *lola'* were made by melting down Portuguese silver dollars, which circulated in small quantities before the introduction of Dutch guilders in the early twentieth century, being used more for display than as currency. Sometime in the mid-nineteenth century, about five generations ago, an ancestor of his was sent by his father to Mamasa, west of Tana Toraja, where there was a greater supply of river gold to be found. This ancestor settled down and practiced his craft there, marrying a woman of Mamasa. He must have enjoyed success, for a descendant of his, Rante Lembang, later returned to Pao, bringing with him many gold objects such as bracelets and necklaces of gold beads.

3. Carpenter 2011: 168–69.

CAT. 57

1. Such a collar can be seen in a 1936 photograph showing a female shaman from western Central Sulawesi (K.I.T., VIDOC, File 49/1). Beads were considered to be powerfully protective objects and were also a mark of nobility.

2. It is also possible that these patterns represent tattoos formerly worn by warriors. In the 1970s,

Steven Alpert met elderly informants in Mamasa who claimed to remember, as small children, seeing the last surviving men with such tatoos; the practice had apparently died out by the end of the nineteenth century. See unpublished typewritten documentation in the collection files of the Dallas Museum of Art.

3. It is illustrated in Barbier and Newton 1988: 87, 258–59; see also Nooy-Palm 1988 and photograph on p. 89, showing the figure in situ on the right side of the façade.

4. *Naga* symbolism is discussed in Waterson 1989.

5. Nooy-Palm 1988 includes several photographs taken in Mamasa in the 1970s, which show such figures on a house-shaped tomb (*batutu*), on houses, and on what appears to be a granary (1988: 95).

CAT. 59

1. Other names for these trailing weeds are *doke-doke* and *dongka-dongka*.

2. These funnel-shaped traps of woven bamboo are used in the fallow season to catch the carp with which the pond is stocked at the beginning of the growing season; the trap is plunged down into the mud, then a hand is inserted from above to grasp any fish trapped inside.

3. This is a ubiquitous border motif in textiles throughout Indonesia, and in different cultures it is given different names, ranging from "bamboo shoot" or "banana flower" to "scabbard" or "point of a lance." In the literature, it has often been referred to by the Javanese term *tumpal*, but this may simply mean "border." Though its origins have been much disputed, it appears to be an indigenous preference with a long history, for rows of triangles were already a characteristic motif on objects of the Bronze Age Dong Son culture. Indian textiles made for the Southeast Asian market often incorporated this feature; an example is illustrated in Gittinger 1982: 141. For a fuller discussion, see Gavin 2010.

CAT. 60

1. Nooy-Palm 1979: 166–68.

2. For an Indian example, see Gittinger 1982: 150. John Guy (personal communication, 2012) is of the opinion that in Indian examples, the stepped shape (which often has a flower pattern at the center) may represent water tanks in which lotuses blossom.

3. Information from Toraja indigenous priest and cultural expert Ne' Sando Tato' Dena'.

4. Nooy-Palm 1989: 176.

CAT. 63

1. In house carvings, the design takes the form of unbroken loops in an octagonal arrangement, a motif with Hindu origins that is also common in Bali, where it called *windu*, and among the Toba Batak, where it is called *bindu matoga* (Nooy-Palm 1979: 293; Waterson 1988: 47).

2. Information on the *sarita* motifs was generously provided by Ne' Sando Tato' Dena' and by Pong Boni, a master carpenter with extensive knowledge of Toraja design motifs who comes from Randan Batu in Sangalla' district.

CAT. 65

1. Personal communication: Steven G. Alpert and Carol Robbins, 2010.

CAT. 67

1. This idea was expressed to me by Ne' Sando Tato' Dena', a special priest of the Toraja traditional religion, and it reinforces the importance that the Toraja attach to carefully preserving the bones of the ancestors in the family *liang* in order to be assured of their blessing (Waterson 1995).

7 THE ART OF EAST NUSA TENGGARA: SUMBA AND FLORES

INTRODUCTION

1. Hoskins 1988: 174.

2. Glover 1998: 25. Glover states that they were attributed not only to Europe, the Mediterranean, and India but also to "racially superior Caucasians including golden-locked Scandinavian sea travelers and sun worshippers from Egypt."

3. Ibid.: 25–26, fig. 24.

4. The standing figure is now in the collection of the Honolulu Museum of Art (formerly the Honolulu Academy of Art, col. no. 2001 [10469.1]). The second is in the collection of the National Gallery of Australia, 2006.412.

5. See R. Maxwell 2010: 73.

6. See Antonio Pigafetta's intriguing account of early contact in *The First Voyage around the World: An Account of Magellan's Expedition, 1519–1522* (Pigafetta 1995).

7. Sandalwood was widely sought after, valued, and used for the creation of incense, perfume, medicine, and carvings, particularly in China.

8. In the 1970s, two Indonesians, Yamin Makawaru and Baha Ruddin, encouraged the revival of weaving, utilizing homespun cotton and natural dyes. They created a number of textiles that approximate the quality of antique pieces, though a true expert can tell the difference. As a result of their efforts, local Chinese families, in concert with aristocratic Sumbanese weavers, began to produce the occasional textile of superlative quality. Personal communication: Steven G. Alpert, 2012.

CAT. 68

1. Rodgers 1988: 49, figs. 43, 44, and Villegas 1983: 32, 82–83.

2. Though it has no direct bearing on the origins of *mamuli*, it is interesting to note that at the moment when the sun sinks into the ocean, it sprouts "feet" caused by certain atmospheric conditions. This phenomenon, called the "omega sunset," is instantaneously followed by a pulse of green light called the "green flash."

3. Holmgren and Spertus 1989: 32.

4. Elaborate gift exchanges occur before and at the marriages of aristocrats in East Sumba. For instance, male gifts to the family of the future wife (wife-givers) include gold ornaments, spears and swords, brass bracelets, slaves, and horses, while female gifts to the future husband's family

(wife-takers) comprise textiles, beadwork, ivory bracelets, and porcelain.

5. Rodgers 1988: 330, 331. The contexts in which *mamuli* exist are mentioned. See also the Sumba section, pp. 165–77, for additional information.

6. Horses were a source of wealth and symbols of status for noble families. Their trade to the Dutch in exchange for gold coins was a major factor in the great accumulation of wealth by the aristocracy. During important ceremonies, they served as sacrificial animals and are a frequent motif on upper-class textiles, particularly on *hinggi*.

7. Rodgers 1988: 167; Taylor and Aragon 1991: 207; Hoskins, "Arts and Cultures of Sumba," in Barbier and Newton 1988: 125.

CAT. 69

1. See Rodgers 1988. Illustrated are a number of pendant-shaped ornaments that range from Nias (273, fig. 7), north Sumatra (276–77, figs. 21, 22, 24), as well as others from Sumba, Flores, Timor, Sulawesi, and the Moluccas. Their specific function and decoration differ, but the basic crescent form is the same. See also note 21 from the introduction to this catalogue.

2. Fontein 1990: 282–83. Illustrated is a gold pendant from Nayan, Yogyakarta, central Java, dating from the eighth to ninth centuries CE. The repoussé decoration depicts a lotus blossom surrounded by foliate designs. Two additional excavations in the same area yielded similar objects, one piece inlaid at the center with a single semiprecious stone. The function of these pieces is not known.

3. Ibid.: 330, no. 114. Buffalo are highly valued sacrificial animals in many areas including Sumba, where their slaughter proclaims the wealth and status of their owners.

4. Clan treasuries include heirlooms of past and present noble lineages and are thought to symbolize the "soul" of a given clan. In addition to gold and silver jewelry, exceptional textiles, beads and beaded bags, swords, Chinese porcelain, and ivory bracelets are included.

5. See Rodgers 1988: 329, no. 113A, for a more complete description of function and use.

6. Ibid.: 330, no. 114.

7. Hoskins, in Barbier and Newton 1988: 127.

8. See Rodgers 1988: 290–91 for examples she attributes to either West or East Sumba. No. 13A (East Sumba) is remarkably similar to the Dallas example from West Sumba.

9. Most gold objects from Sumba have been attributed to goldsmiths from Savu or Ndao, nearby islands.

CAT. 70

1. There are newer post-Majapahit and recent imitation *mendaka*. In the early 1980s, these pendants were still being made by one Chinese goldsmith in Sumba for sale to the foreign market.

2. Rodgers 1988: 330.

3. Umbu Sangera of Anakalang claimed that these pendants were not made in Sumba. He also

asserted that they originally came from the Majapahit kingdom (1294–c. 1520).

4. Ibid. Personal communication: Umbu Sangera, Anaklang, 1989.

5. It is not clear whether *burung badak* refers to an actual hornbill or a dream-inspired image of a bird that resembled a hornbill.

6. Personal communication: Amawau, Bogar Kahale, Lamboya, September 27, 1989. On this date, by sheer serendipity, I happened to visit Amawau the morning after his visitation or vision, and inherited this pendant in a ritually prescribed manner.

7. Personal communication: Cornelis Kadobo, 1989.

8. Personal communication: Amawau, Bogar Kahale, Lamboya, 1989.

CAT. 71

1. Rodgers 1988: 296, no. 147. Illustrated is a comb from Timor, for which no information is available, including the gender of its wearer. Few other combs are pictured in the literature, Sumba being a notable exception. See also Taylor and Aragon 1991: 298, fig. x.29. Illustrated is a spectacular turtle shell head ornament from Gorontalo, North Sulawesi.

2. Rodgers 1988: 55, no. 52. Shown is a photograph of a young girl wearing a turtle shell comb and a striking women's skirt (*lau pahudu*).

3. Ibid.: 329, no. 110.

4. Breguet 2006: 201–33. Figure 12 on p. 212 depicts objects from the Rindi Treasury. Among the treasures is a turtle shell comb.

5. *Penji* are tall upright stone slabs placed at one end of royal tombs. See Hoskins, in Barbier 1998: 177, fig. 251. Illustrated is a *penji* with turtle imagery.

6. Hoskins 1988: 120, 294–95.

7. Only found on Sumba, combs of this type echo examples from Spain. One could speculate that they might be influenced by a trade item, but this cannot be proved.

CAT. 72

1. Jessup 1990: 150. Jessup cites one early account, which notes betel nut chewing in marriage ceremonies in Tang dynasty China, and Bellwood (in R. Maxwell 1990: 409, n. 44) cites evidence of betel nut chewing in Thailand that can be traced back to between 10,000 and 6,000 BCE.

2. Jessup 1990: 165, fig. 124. A complete set is illustrated.

3. Ibid.: 154. "Sharp teeth are thought by the Balinese to be signs of undesirable human traits of lust, anger, greed, stupidity, intoxication and jealousy." The teeth were filed to flatten the six upper teeth so that these bad characteristics were eliminated.

4. See Rodgers 1988: 54, no. 50, and Breguet 2006: 212, fig. 12.

5. Alpert 1977: 85, fig. 48.

6. Adams and Forshee 1999: 138, 146.

CAT. 73

1. Adams 1969: 83.

2. "Supplementary warp" refers to a technique in weaving whereby pattern yarn is added between two regular foundation yarns. It has a purely decorative function.

3. Personal communication: Steven G. Alpert, 2010.

4. Adams 1969: 133. Some fish on *hinggi* depicted with two eyes on the top surface have been identified as plaice (flatfish).

5. Personal communication: Steven G. Alpert, 2012.

CAT. 74

1. Gillow 1992: 117.

2. Ibid.: 117. Gillow provides a good overview of the supplementary warp weaving technique. See also Adams 1969.

3. A similar *ikat*-dyed band is illustrated in Adams 1969, fig. 18.

CAT. 75

1. *Ikat* means "to bind." Prior to the weaving process, patterns and motifs are formed by binding the unwoven yarn. Unbound areas accept dyes, while bound areas do not. Yarn can be dyed many times to produce different or more intense colors. Depending on the complexity of the design, the process requires months of work.

2. An excellent source for information on Sumbanese culture and textiles are the works of Marie J. Adams, particularly *System and Meaning in East Sumba Textile Design: A Study in Traditional Indonesian Art* (1969).

CAT. 76

1. The number eight signifies fulfillment or completeness (Robbins 1984: 9).

2. Crocodiles are extremely rare motifs on *hinggi*, and they are sometimes difficult to distinguish from lizards. Adams illustrates one *hinggi* with very similar designs, which Wielenga identified as a crocodile. See Adams 1969: 135, illus. 55.

3. *Patola* are double-*ikat* silk cloths imported from India. They had a major influence on Indonesian textile design and were highly valued, becoming important heirlooms and forming part of clan treasuries.

4. Holmgren and Spertus 1989: 26.

CAT. 77

1. Personal communication: Steven G. Alpert, 2012.

2. Hoskins 1988: 120, 294.

3. Forshee (2001) presents a fascinating account of Sumba weavers' response to a burgeoning tourist market for Sumba cloths in the 1980s and later. Included is a discussion of a new format referred to as "narrative cloths."

4. This blanket and one exactly like it were woven as a pair; they had been intended as burial shrouds. Instead, the weaver sold this cloth in the mid-1970s.

5. LeBar 1972: 74.

CAT. 78

1. Glover 1998: 23. Glover states that in Indonesia the term "megalith," from the Greek words for "large" and "stone," refers to rock-cut tombs, stone seats, terraces, cairns, stone-built platforms, crudely shaped statues of men and animals, cylinders, stone urns, rectangular sarcophagi, and stone slabs with cup holes. Megaliths are found in many parts of the world, date to many different time periods, and generally can be described as massive funerary monuments and gathering places.

2. Ibid. Glover notes that an early report (1890s) by ten Kate described the now well-known dolmens (tombs) of Sumba.

3. Hoskins, in Barbier 1998: 174. According to Hoskins, records regarding burial practices on Sumba do not exist before the last quarter of the nineteenth century. It is therefore impossible to determine what occurred before that time. The only archaeological discoveries on Sumba to date are unearthed urn burials dating to c. 500 BCE. Today's inhabitants state that their ancestors were buried in stone tombs.

4. Hoskins (in Barbier 1998: 167–97) provides an excellent overview of stone tombs in Sumba.

5. Hoskins 1988: 136.

6. *Penji* are also found in West Sumba, but are more common in the east.

7. Taylor and Aragon 1991: 206. These writers state that *penji* means "flag" or "flag pole," and that the shape is phallic. The form also recalls an unfolding fern spiral, a frequent image of generation in Southeast Asia. This author has seen fern motifs on *penji*, but most motifs represented on these structures do not necessarily suggest ferns.

8. Boats figure prominently in the myths and religion of many Indonesian cultures. In Tanimbar, great stone boats located in village centers feature prows that echo the shape of Sumba *penji*. See McKinnon 1988: 155–57.

9. Fig. 98 may depict the reverse side of this *penji*. The motifs are essentially the same. See Hoskins 1988: 124, fig. 130.

10. Hoskins 1988: 120.

11. Ibid.: 131–32.

12. Taylor and Aragon 1991: 206.

CAT. 79

1. The undecorated base was likely anchored in the ground, as suggested by a difference in patina from the decorated area. It seems unusual, however, to carve a figure there, since it would not be seen.

2. Maybury-Lewis 1992: 71.

3. Ibid.: 72.

CAT. 80

1. Erb 1988: 110–11.

2. Ibid.: 113.

3. Ibid.: 114.

4. Ibid.: 280, citing Rodgers 1988: 280.

5. A field photograph from the 1920s depicts a Nage male figure standing inside a woman's shrine (de

Hoog 1981: 123, fig. 4). Figures such as these were most often housed in small raised dwellings in the center of the village. The central figures would be surrounded by goods and offerings for their pleasure and maintenance. In the village of Udi-Maunori, Mahpongo district (Ngada), this included buffalo horns and the mandibles of pigs. Personal communication: Steven G. Alpert, 2012.

6. Feldman 1985: 178, fig. 225. Feldman illustrates a standing male figure that seems to be stylistically related to the Dallas couple. The most striking difference is the facial expression. In the Feldman piece, large circular eyes produce a demonic and menacing countenance, in contrast to the Dallas couple. Designs carved above each nipple seem identical to some beadwork attached to special Ngada textiles (*lawo butu*). A pair of stylistically similar figures are in the Yale University Art Gallery, a promised gift of Thomas Jaffe. Thanks are owed to Dr. Ruth Barnes and her assistant Benjamin Diebold for providing images and collection data for the Yale pair, which are attributed to "the Ngada people, somewhere near Ende."

CAT. 81

1. Hamilton 1994: 12. Hamilton quotes Kennedy 1955: 26: "The colors are always dull [and the] designs are small and indecisive." Kennedy's observation would indicate that he saw few or poor examples of Flores cloths, certainly not those of noble families.

2. Kjellgren 2007: 236.

3. Hamilton 1994: 109.

CAT. 82

1. See de Jong 1994: 213, fig. 10.3; 216, fig. 10.6; 223, fig. 10.15; and 224, fig. 10.16.

2. R. Maxwell 1990: 141.

3. de Jong 1994: 220.

4. R. Maxwell 1990: 140, fig. 202.

5. Ibid.: 141.

8 TRADITIONAL ART IN TIMORESE PRINCEDOMS

INTRODUCTION

1. Timor-Leste (East Timor) became an independent state in 2002, after a long period of occupation by Indonesia. In late 1975, the Indonesian army invaded the region, which had a profoundly destructive effect on the traditional culture. Many of the villages were relocated, which endangered the old traditions and led to the confiscation of valuable family heirlooms. Moreover, Indonesians were resettled into East Timor on a large scale from other overpopulated regions (at a rough estimate approximately 150,000 people), and more than 200,000 Timorese died as a result of violence.

2. The primary reason that sandalwood would grow only in the Lesser Sundas, on Timor, and several nearby islands (despite many unsuccessful efforts at planting elsewhere) is climate. On Timor, in contrast to the majority of the Indonesian archipelago, the climate is affected most of all by neighboring Australia, a continent with many desertlike

regions. In particular, the eastern monsoon (April to December) is often remarkably dry as a result. During this period, parts of Timor—and even further to the east, areas in Maluku Tenggara—often have the lowest precipitation levels of all of Indonesia.

The rains that do fall typically are distributed very unevenly over the island. This is the result of the jagged mountain ranges that have their highest peaks (approximately 6,500 feet high) in East Timor. These ranges cross Timor along its longitudinal axis (approximately 310 miles) and have many foothills that nearly reach the coastline. This central highland is home to most of the inhabitants of Timor.

3. Populations of the Bunak and the Kemak, two smaller ethnolinguistic groups, can likewise be found on both sides of the border.

4. Besides its abundance of spoken languages (at least fourteen are currently used), Timor is remarkable because it features Austronesian as well as non-Austronesian languages. These languages belong to completely separate linguistic families and indicate previous mass migrations.

5. Around 1725, sixteen princedoms existed in West Timor and forty-six in East Timor (Schulte Nordholt 1966: 77). In 1885, Forbes mentioned forty-seven princedoms in East Timor (1885: 425).

6. Totemism is a system of belief in which humans are said to have a connection or a kinship with a spirit-being, such as an animal or plant. The totem is thought to interact with a given kin group or an individual and to serve as its emblem or symbol.

7. Grijzen (1904) on the Tetun and Shulte Nordholt (1966 and 1971) on the Atoni.

8. Middelkoop (1949 and 1958) on the Atoni.

9. For an overview of the life and work of B. A. G. Vroklage, see de Jonge 2005.

10. "Foreign" (that is, non-Dutch) researchers did not start working on the island until the second half of the twentieth century. During this time period, scholars became somewhat more focused on East Timor. Examples are Traube (on the Mambai), Clamagirand (on the Ema), and Hicks (on the Eastern Tetun). As compared to publications on the cultures of West Timor, research into the art of East Timor has always been limited. Among others, the articles of Hicks, published in 1988 and 1999, provide short but valuable contributions on Timorese art.

11. Series of techniques as mentioned by Gittinger (1979: 175).

12. Leibrick 1994: 17.

13. Warp *ikat* involves resist-dyeing decorative patterns into threads before they are woven.

14. Middelkoop 1949: 48.

15. See also van Hout 1999: 29–32.

16. Schulte Nordholt 1966: 165.

17. Middelkoop 1949: 77.

18. These are stimulants such as tobacco and *sirih*, better known as betel (*Piper betle*), of which the fruits or leaves are chewed with bits of *pinang* nut

(from the *Areca catechu* tree) and lime on Timor (see also the entry for cat. 83).

19. Besides the containers made of wood, gourd, bone, and bamboo, which were produced by men, specimens made from leaves plaited by women existed as well. These were sometimes splendidly adorned with embroidery and beads, a tradition that has persisted particularly on the southern coast of Central Timor. In many places, women would also decorate with beads the containers fashioned by men.

20. Based on data gathered from civil servants and early museum collections, the study (done by Loebèr and published in 1903) reviews bamboo specimens (the most common type) and focuses on the so-called *tibak*. These demonstrate exceptionally fine carving, the likes of which was hardly ever found in Central and East Timor. Loebèr (1903: 17) points out that the decorative techniques of Central and East Timor are much less complicated and have in fact remained at the engraving level. In West Timor, the patterns would be cut deeply into the skin of the bamboo, whereupon they were painstakingly filled in with black beeswax or tin, combined with a natural adhesive.

21. See Loebèr 1908.

22. The relation between the members of a social group and a house of origin was (and is) at times less obvious than is indicated here. Even though clans and lineages had such (named) houses, there were also social groups—with houses of origin—for which the affiliations were diffuse and varied. Besides alliances based on descent or marriage, residence too could play a role, and outsiders (former slaves or refugees) could be admitted to the group as well (Schulte Nordholt 1966: 62–63).

23. Vroklage 1953: photographs 361–69.

24. Elbert 1911: 237, fig. 149.

25. Vroklage 1953: photographs 227–37.

26. Forbes 1885: 442–47; Vroklage 1953: photographs 182–83; see object details of Middelkoop, as published in *Notulen van de algemeene en directievergaderingen van het Bataviaasch Genootschap van Kunsten en Wetenschappen* 1926–27: 376–77.

27. Schulte Nordholt 1971: 41.

28. Vroklage 1953: 178–81, 197.

29. See also Fox 1977: 29.

30. Vroklage 1953: 180. In large parts of Central Timor, the name of the ornament, *kae bauk*, was derived from the word for water buffalo horns.

31. Schulte Nordholt 1966: 166. The meaning of the three "fingers" (called "teeth" by Schulte Nordholt) has been forgotten. In addition to the association with water buffalo horns, Schulte Nordholt also points out the connection with the crescent moon.

32. See, for example, M. King 1963: 146 and Hicks 1999: 134.

33. See Rouffaer 1899.

34. de Roever 2002: 187–90. Usually the sword blades bore the stamp of the Dutch United East India Company (VOC).

35. Grijzen 1904: 21–23, 28.

36. Ibid.: 18–25.

37. Ibid.: 21.

38. Many colonial civil servants did not recognize the twofold leadership and encountered difficulties as a result. The passive attitude of the spiritual leader often caused this ruler to be thought of as an insignificant person. Similarly, treaties were entered into with the *kolnel* without realizing that he was in fact not the highest-ranking person.

39. For the symbolic meaning of the traditional Timorese house (the house as a model of society), see, for example, Cunningham 1964 and Hicks 1988.

40. See Forbes 1885: 451 regarding East Timor. The crescent-shaped head ornament (present in Central Timor) that is referred to in the text also appears to have functioned as a headhunting trophy. Vroklage (1953: 181) reports that bundles of hair from a severed head would have originally been attached to it. Likewise, see entries for cats. 99–101 in this volume.

41. For the Makassae bride price, see Forman 1980: 158–59; for the Northern Tetun bride price, see Vroklage 1953: 288; for the Atoni bride price, see J. Kruyt 1922: 356. Early sources indicate that enormous quantities were involved in these transactions, in particular among the aristocracy. For instance, a description of an Atoni wedding ceremony that took place in the mid-nineteenth century near Kupang (West Timor) mentions a bride price consisting of seventy to eighty water buffalo and twenty-five units of valuables. In exchange, the bride's family would give no fewer than 100 textiles and sixteen to twenty large pigs as a counter-presentation (Heijmering 1844: 128).

42. Schulte Nordholt 1966: 161 and Forbes 1885: 450–52. Schulte Nordholt explicitly mentions the obligation of support on the part of the wife-takers. Forbes, on the other hand, speaks in more general terms. This form of compulsory assistance, however, was commonplace on many Indonesian islands. Examples for Eastern Indonesia include Halmahera (see Platenkamp 1988: 207–8 about the Tobelo) and Tanimbar (see Drabbe 1940: 187).

43. See, for example, McWilliam 2002: 277.

CAT. 83

1. As a result of fashion, modernity, hygiene, and government and religious policies, the habit of betel nut chewing has been slowly disappearing. In fact, "betel nut" is a misnomer, as betel actually refers to leaves (*daun sirih*), which are chewed with slices of an Areca palm seed.

2. Modern research has also shown that habitual chewing can be carcinogenic.

3. Betel nut customs are much more than simple habits. Betel nut is often eaten when meeting others and before engaging in conversation. The deft preparation and chewing of a betel quid provides a self-absorbed, quiet moment. It is also an icebreaker that reflects the core values and good manners of traditional Indonesians.

4. Alpert 2003: 103. See Barbosa, Magalhães, and Dames 1918–21, originally written c. 1518.

CAT. 84

1. Middelkoop 1949: 47–48. As a man of strongly professed faith, Middelkoop admired their ritual use and felt that their beauty went "far beyond art for art's sake."

2. Ibid.

3. Ibid.

4. Personal communication: Goh Tjin Liong, 2011.

5. Ibid.

6. Ibid.

CAT. 85

1. Beginning in the late 1970s, the surfaces found on old masks began to be emulated on modern ones.

2. Cinatti 1987: 45.

3. M. King 1963: 78–79.

4. de Hoog 1981: 123.

5. M. King 1963: unnumbered.

6. One of the eyes has a small hole allowing just enough vision for ceremonial dances.

CAT. 86

1. Middelkoop 1958: 384–405.

2. Waterson 1990: 129.

3. Hicks 1984: 38–49.

4. Ibid.: 33.

5. Waterson 1990: 130.

6. Hicks 1988: 147.

7. Our preoccupation with fertility is reflected in the oldest images created by humankind, the so-called Venus figures. The oldest of these from the Upper Paleolithic Period is the Venus of Hohle Fels, which has been dated to 35,000 to 40,000 years old.

8. Personal communication: Goh Tjin Liong, 2011.

9. Accession no. 2380-268.

10. Accession nos. 70.2001.27.487 and 70.2001.27.530.

CATS. 87–89

1. R. Hamilton, in Barnes and Kahlenberg 2010: 345.

2. R. Maxwell 1990: 247.

3. De Young Museum, San Francisco (1998.74), Australian National Gallery (1984.610); Barnes and Kahlenberg 2010: 344–45.

4. Personal communication: Goh Tjin Liong, 2011.

5. Ibid.

6. Rodgers 1988: 333.

CAT. 90

1. M. King 1963: 155.

2. Cinatti 1987: 59, fig. 40.

CAT. 91

1. Duarte 1984: 136.

2. Barbier 1984: 19.

3. Duarte 1984: 137.

4. Ibid.

5. Personal communication: Goh Tjin Liong, 2009.

CAT. 92

1. Duarte 1984: 75–79.

2. Ibid.

3. Ibid.

4. Ibid.

CAT. 93

1. Duarte 1984: 77; Hicks 1988: 298–99.

2. Duarte 1984: 169–74; Hicks 1988: 298.

3. Alpert 2003: 102–3.

4. Barbier 1984: 130–31; de Hoog 1981: 131, item 78.

5. Alpert 2003: 102–3.

6. Duarte 1984: 135–39, 149–53.

7. Personal communication: Goh Tjin Liong, 2009 and 2010.

CAT. 94

1. This spoon's material suggests either an Indonesian, Indian, or African origin. It was sold at auction at Christie's London, June 23, 1993, lot 58, and described as a "superb ivory spoon probably Baga, possibly 18th century or earlier. Provenance: James T. Hooper." It was also thought possibly to be Afro-Portuguese. Subsequently, it was exhibited as an Indonesian spoon in the Smithsonian's 2007 exhibition *Encompassing the Globe: Portugal and the World in the 16th and 17th Centuries*; see Levenson 2007: 46.

2. See Alpert 2003: 100–107.

3. Ibid.

4. Jacobs 1970: 141.

5. Earl 1850: 176–77.

6. Personal communication: Dr. Stephen Hooper, 2003.

9 LIFE AND DEATH IN SOUTHEAST MOLUCCAN ART

INTRODUCTION

1. For an overview of some fine examples of Southeast Moluccan art, see de Jonge and van Dijk 1995a.

2. On the island of Moa, such practices were mentioned as early as 1892 (Langevoort 1892: 268). The most recent example of ancestor statue burning known to this author occurred in 1981 during the celebration of Christmas in the Babar archipelago.

3. Regarding Tanimbar, this chapter uses the terminology that is part of the local languages of Yamdena and Fordate.

4. For Southeast Moluccan boat-building rituals, see, among others, de Jonge and van Dijk 1995a: chs. 3 and 5. In the Kai and Babar archipelagos, for example, the imagery could also be found in house-building rituals. The recurring central issue is dependence on the availability of both a male and a female contribution in order for the whole (society) to come into being. Boat imagery was not the only social metaphor; the human figure was also used as a symbol for the creation of society.

5. See Drabbe 1940: 270, 284. Regarding the western islands (Leti, for example), see Riedel 1886: 391.

6. The mythical founding fathers appear to have assumed the shape of animals on Aru in particular. On other islands, this role could also be played by humans that were associated with animals because of the qualities attributed to them.

7. See Osseweijer 2001: 86.

8. See, for example, Jacobsen 1896: 185, 221; Drabbe 1940: 106, 111; Barraud 1979: 35–36.

9. See Barraud 1979: 71.

10. See, for example, Drabbe 1940: 388–89.

11. See Rumphius (1678) in Buijze 2001: 105.

12. Drabbe remarks that the island of Selaru has a special position within the Tanimbar archipelago. Here, more than elsewhere, a "totemic cultural complex" would have left its mark (1940: preface).

13. Müller-Wismar collected eleven *tavu* on Selaru in 1913 and identified the carved animal figures, which he called "totems," or *faniak* (1914). Engelhard (1994) discusses his data and provides an overview of golden valuables represented on *tavu*. Of interest here are chest pendants and "male earrings," heirloom valuables that always remain in the clan and do not circulate in society, constituting the strength and prestige of the descent group involved (see also the gold chest pendant from Tanimbar, cat. 103, p. 298).

Because of its ancient culture, Selaru also appears to be the obvious place to provide the exact meaning of the *tavu*. We hypothesize that in this case—as with the *luli* statue—we find a female figure that uses its outstretched arms to depict a boat. Similar to early war or celebration proas, this symbolic boat—at least on Selaru—always has a male clan emblem (*faniak*) on it, accompanied by the depiction of status-enhancing treasures (symbols of trophy heads). The resulting image appears to leave little room for doubt; this is a visualization of the grandness of the clan by means of showing it as a boat, laden with hunting trophies. It is a familiar image on Tanimbar (the traditional house would in fact embody the same message), which would particularly be expressed during the renewal of intervillage alliances. Their consummation would be celebrated by female dancers, their arms stretched sideways and covered with valuable heirlooms, upholding the reputation of the descent group (see also Geurtjens 1941: 175).

14. The Nautilus shell was widely used as a substitute headhunting trophy within the region; see, for example, Drabbe 1940: 235, and de Jonge and van Dijk 1995a: 96. In the Babar archipelago as well as on Kisar, the traditional houses were even decorated with them; see, for example, Brommer 1979: pl. 94.

15. This is a reenactment of the situation at the start of the twentieth century. Much but not all of the available data from this period points to the *aitiehra* as being representative of the heavenly deity. However, it is certain that the "holy" stake in the Babar archipelago was the symbol of this deity.

16. At the beginning of the twentieth century, people on Tanimbar endeavored to marry at least one son (preferably the eldest) to a daughter of the mother's brother (Drabbe 1940: 188; Geurtjens 1941: 58), so that there were permanent marriage alliances within the same descent groups.

17. Even today, wife-takers on Tanimbar have an obligation to help their wife-givers in cases of *ngrije*, a term now meaning "a matter," but formerly also referring to war. In the northern Moluccas "armed" assistance by wife-takers is still common (see, for example, Platenkamp 1988: 207–8).

18. See Drabbe 1940: 282; McKinnon 1991: 233; Barraud 1994: 68.

CAT. 95

1. See Riedel 1886: 395.

2. See, for example, de Hoog 1959: 1–89.

CAT. 96

1. Pleyte 1892b: 1058 (the name of the village is sometimes written as Tomra).

2. Col. no. Tropenmuseum: A 1021; col. nos. Rautenstrauch-Joest-Museum 36653 and 36655.

3. Original notes from Müller-Wismar, Rautenstrauch-Joest-Museum, Cologne; Planten and Wertheim 1893: 164.

4. Müller-Wismar 1914: 31.

5. Riedel (1886: 372) notes, among others, a "bean dance by women alone" (*lauraru*), a "black billy goat dance" (*pipmiëtme*), and a "sea worm dance" (*medi*).

6. Ibid.: 373.

7. Description of the small dance masks as used in the village of Nurnyaman.

8. Riedel 1886: 363.

CAT. 97

1. The language of the island of Yamdena is used in this entry.

2. A *krai silai* was approximately thirty inches in length; a sword for daily use was approximately twenty inches.

3. The blades probably came from East Sulawesi. Riedel (1886: 300) and Drabbe (1940: 139) mention "tombukuan swords," which refers to Tamboku, one of the few places in Indonesia where iron can be found and the home of many blacksmiths. Furthermore, the shape of the Tanimbarese blades suggests Tamboku: narrow near the hilt, widening downward and with a slanted tip.

4. Drabbe 1940: 270.

5. See ibid.: 235. Instead of heads, coconuts or Nautilus shells were sometimes used.

6. See Pleyte 1892b: 1079–81; Jacobsen 1896: 214; and the model of a proa, col. no. 392-1 of the Amsterdam Tropenmuseum, which Drabbe had made for him on Fordate in 1927.

CAT. 98

1. The language of the island of Yamdena is used in this entry.

2. Drabbe 1940: 27–28.

3. Even though these ornaments were indispensable for acting dignitaries, Drabbe (1940: 28) refuses to call them insignia.

4. See, for example, Riedel 1886: 298 and van Hoëvell 1890: 170.

5. See Rumphius 1678 in Buijze 2001: 105.

6. See also the drawing in Forbes 1885: 316.

7. Jacobsen 1896: 217.

CATS. 99–100

1. See Rumphius 1999: 232.

2. Moluccan Malay is used in this entry.

3. As a variation to the hexagonal model, rare octagonal dishes also exist.

4. Documentation col. no. 903-1 (Wetan) in the Leiden Museum Volkenkunde, the Netherlands.

5. de Vries 1900: 619.

6. In the event of a solar eclipse, for example, it was said that a great warrior would die. See also Riedel 1886: 398 and Tersteege 1935: 10.

7. See, for example, the hexagonal gold dish depicted in de Jonge 2005: 176.

8. Similarly, Rodenwaldt (1927: 6) suggests an incorporation of Chinese ornamentation by the goldsmiths of Kisar.

CAT. 101

1. Jacobsen 1896: 123–24.

2. Moluccan Malay is used in this entry.

3. See MNI col. no. 6791d/E 1129 (published in van der Hoop 1949: 59 and de Jonge 2005: 176).

4. Forbes 1885: 451.

5. See, among others, Tersteege 1935: 10.

6. This occurred on Kisar, Moa, Roma, Teun, Nila and Serua, for example.

CAT. 102

1. Moluccan Malay is used in this entry.

2. The ornament in the photograph, like the Dallas necklace, consists of a string of beads with three golden pendants, of which the figure in the middle is the largest. It is interesting to note that the diamond-shaped element of this figure—suggesting a humanlike creature—is quite similar in both pieces, although the face of the Rodenwaldt necklace appears to be more detailed in its design.

The similarities make it likely that the two artifacts share the same place of origin, most likely Kisar. Rodenwaldt tentatively attributes the jewelry that he encountered to the island's goldsmiths, even though the jewelry's ornamentation remained a mystery to him (Rodenwaldt 1927: 6). Today, it can be stated with reasonable confidence that the fish shapes, in particular, do indeed indicate Kisar as the place of manufacture. The hexagonal golden dishes that were produced on the island were known to be adorned with identical fish shapes. Additionally, the finishing of the edges (using wire soldering) and the decorations (using point engraving) were typical for Kisar. Finally, Kisar was the only island in western Maluku Tenggara where real wrought metalwork was produced. While there were goldsmiths on the neighboring islands, they limited themselves to casting rings and earrings (see de Jonge and van Dijk 1995a, ch. 7).

3. See Pannell 1992: 166; de Josselin de Jong 1987: 25; and van Dijk and de Jonge 1990: 13–14.

4. Rodenwaldt 1927: 6.

5. We are dealing exclusively with goldsmiths here; blacksmiths had no special status, as far as we know.

6. Regarding *kukuwe* statues, see object documentation col. nos. ET 38131 and ET 38132 from the former Tilburg Missiemuseum (Netherlands); see also Drabbe 1940: 112, 135–38; regarding Kai, see Planten and Wertheim 1893: 103; regarding the Ambon region, see Rumphius 1678 in Buijze 2001: 63.

7. See de Jonge and van Dijk 1995a: 122–23.

8. van Hoëvell 1890a: 231.

CAT. 103

1. Drabbe's study led to the publication of "Het leven van den Tanémbarees" (1940), a splendidly illustrated standard work about the local culture (see also de Jonge and van Dijk 1995b).

2. The term *mase* is from the language of Yamdena.

3. This was done particularly in connection with the trade of sago; see van Dijk and de Jonge 1991: 22 (also Drabbe 1940: 139–40). After the extirpation of the population of Banda by the Dutch in 1621, the traffic of course dwindled.

4. See, for example, Pleyte 1896: 347 and de Vries 1900: 618–19. At the end of the nineteenth century, the English golden sovereign and the Dutch silver thaler were much used coinage.

5. See, among others, Drabbe 1940: 140.

6. See also Riedel 1886: pl. 40; *mas bulan* and *mas tanduk* are type specifications in Moluccan Malay.

7. See de Jonge and van Dijk 1995a: ch. 7.

8. Other examples are gold chest pendants that circulated within the community as part of a bride price or as imposed fines.

9. See also de Jonge and van Dijk 1995a: 96 and pl. 6.10 (*tavu* with "fish man" *faniak*).

10. Women advertised the family status by wearing the smaller pieces on their foreheads (Drabbe 1940: 31).

CAT. 104

1. Regarding this facial type, see also the general introduction to the catalogue.

2. See, for example, the *luli* figure Huxrainna-Huxtuallina from Leti, published in de Jonge and van Dijk 1995a: 56. The *wutulai* on this statue has boat and tree decorations that are similar to those in the object illustrated here.

CAT. 105

1. Rinnooy 1892: 74. This quote has been translated from Dutch into English.

2. Indications exist, too, that a founding mother was depicted as a splendidly dressed bride.

3. See, for example, McKinnon 2000: 172.

4. *Sirih* is a kind of pepper (*Piper betle*); *pinang* is a kind of nut (*Areca catechu*).

SELECTED BIBLIOGRAPHY

Note: For Dutch, German, and other authors, last names containing particles, such as de and van, are listed alphabetically by the main portion of the name.

Adams, Marie Jeanne. "Structural Aspects of East Sumbanese Art." In *The Flow of Life: Essays on Eastern Indonesia*, edited by James J. Fox, 208–20. Cambridge: Harvard University Press, 1980.

——. *Symbols of the Organized Community in East Sumba, Indonesia*. Bijdragen tot de Taal-, Land- en Volkenkunde, vol. 130, no. 2/3. The Hague: Martinus Nijhoff, 1974.

——. *System and Meaning in East Sumba Textile Design: A Study in Traditional Indonesian Art*. Southeast Asia Studies Cultural Report Series 16, New Haven: Yale University, 1969.

Adams, Marie Jeanne, and Jill Forshee. *Decorative Arts of Sumba*. Amsterdam: Pepin Press, 1999.

Adelaar, K. Alexander. "An Exploration of Directional Systems in West Indonesia and Madagascar." In *Referring to Space: Studies in Austronesian and Papuan Languages*, edited by Gunter Senft. Oxford and New York: Clarendon, 1997, 53–81.

Adriani, Nikolaus, and Albert C. Kruyt. *De Bare'e-sprekende Toradja's van Midden-Celebes*. 3 vols. Batavia, Indonesia: Landsdrukkerij, 1912–14.

Aeckerlin, J. A. "De pangkat papadon in de Lampongsche Districten." *De Indische Gids* 16e Jrg. II (1894): 1532–42.

Alpert, Steven G. "An Early Ivory Spoon with Stylistic Connections to Eastern Indonesia." *Tribal Art* 33 (Winter 2003): 100–107.

——. "Indonesian Shields." In *Protection, Power and Display: Shields of Island Southeast Asia and Melanesia*, edited by Andrew Tavarelli, 19–35. Boston: Boston College Museum of Art, 1995.

——. "Sumba." In *Textile Traditions of Indonesia*, edited by Mary Hunt Kahlenberg, 79–86. Los Angeles: Los Angeles County Museum of Art, 1977.

Avé, Jan B. "The Dayak of Borneo, Their View of Life and Death, and Their Art." In *Art of the Archaic Indonesians*, edited by Waldemar Stöhr, 94–100. Dallas: Dallas Museum of Fine Arts, 1982.

Avé, Jan B., and J. van der Werff. *Kalimantan Mythe en Kunst: Tentoonstelling*. Delft: Indonesich Ethnografisch Museum, 1973.

Bakker, Laurens. "Art and Art Trade in Siberut, Mentawai Archipelago. Part 2: These Are My Feet: Local Culture and International (E)valuation: Mentawaian Objects as Art or Invention." *Indonesia and the Malay World*, vol. 30, no. 88 (2002): 336–56.

Barbier, Jean Paul. *In North Sumatra, An Unknown Group: The Kalasan Batak*. Geneva: Fondation Culturelle Musée Barbier-Mueller, 2011.

——. *Indonesian Primitive Art: Indonesia, Malaysia, the Philippines, from the Collection of the Barbier-Müller Museum, Geneva*. Dallas: Dallas Museum of Art. 1984.

——. *Messages in Stone: Statues and Sculptures from Tribal Indonesia in the Collections of the Barbier-Mueller Museum*. Geneva: Musée Barbier-Mueller; Milan: Skira, 1998.

Barbier, Jean Paul, and Douglas Newton, eds. *Islands and Ancestors: Indigenous Styles of Southeast Asia*. Munich: Prestel; London: Thames and Hudson, 1988.

Barbosa, Duarte, Fernão de Magalhães, and Mansel Longworth Dames. *The Book of Duarte Barbosa: An Account of the Countries Bordering on the Indian Ocean and Their Inhabitants*. London: printed for the Hakluyt Society, 1918–21.

Barnes, Ruth. "Early Indonesian Textiles: Scientific Dating in a Wider Context." In *Five Centuries of Indonesian Textiles: The Mary Hunt Kahlenberg Collection*, edited by Ruth Barnes and Mary Hunt Kahlenberg, 34–44. Munich: Prestel; New York: Delmonico Books, 2010.

Barnes, Ruth, and Mary Hunt Kahlenberg, eds. *Five Centuries of Indonesian Textiles: The Mary Hunt Kahlenberg Collection*. Munich: Prestel; New York: Delmonico Books, 2010.

Barraud, Cécile. *Tanembar-Evav: Une Société de Maisons tournée vers le large*. Cambridge: Cambridge University Press, 1979.

Barraud, Cécile, Daniel de Coppet, André Iteanu, and Raymond Jamous. *Of Relations and the Dead: Four Societies Viewed from the Angle of Their Exchanges*. Translated by Stephen J. Suffern. Oxford and Providence, MA: Berg Publishers, 1994.

Bastin, John Sturgus, and Bea Brommer. *Nineteenth-Century Prints and Illustrated Books of Indonesia with Particular Reference to the Print Collection of the Tropenmuseum, Amsterdam: A Descriptive Bibliography*. Utrecht: Spectrum, 1979.

Beatty, Andrew. "Ovasa: Feasts of Merit in Nias." *Bijdragen tot de Taal-, Land- en Volkenkunde* 147 (1991): 216–35.

——. *Society and Exchange in Nias*. Oxford: Clarendon Press, 1992.

Bellwood, Peter. *The Polynesians: Prehistory of an Island People*. London: Thames and Hudson, 1987.

——. *Prehistory of the Indo-Malaysian Archipelago*. Rev. ed. Honolulu: University of Hawai'i Press, 1997.

Bernet Kempers, August J. *The Kettledrums of Southeast Asia: A Bronze Age World and Its Aftermath*. Rotterdam; Brookfield, VT: Balkema, 1988.

——. *Monumental Bali: Introduction to Balinese Archaeology and Guide to the Monuments*. Berkeley: Periplus Editions, 1991.

Bertling, C. T. "Hampatongs of tempatong van Borneo." *Nederlandsch-Indië Oud en Nieuw*, 12 (1927): 131–44, 179–92, 223–36, 249–54.

van Beukering, J. A. *Bijdrage tot de anthropologie der Mentaweiers*. Utrecht: Kemink, 1947.

Bigalke, Terence. *Tana Toraja: A Social History of an Indonesian People*. Singapore: Singapore University Press, 2005.

Blust, Robert A. "The Prehistory of the Austronesian-Speaking Peoples: A View from Language." *Journal of World Prehistory* 9, no. 4 (1995): 453–510.

Bock, Carl, with an introduction by R. H. W. Reece *The Head-Hunters of Borneo: A Narrative of Travel Up the Mahakkam and Down the Barito*. [1881] Reprint. Oxford and New York: Oxford University Press, 1985.

du Bois, J. A. "De Lampongsche Districten op het eiland Sumatra." *Tijdschrift voor Nederlandsch-Indië* 14, no. 4 (1852): 245–75; no. 5: 309–33.

Breguet, George. "Life and Death of Tamu Rambu Yuliana, Princess of Sumba." In *Arts and Cultures*, edited by Laurence Mattet, 200–233. Geneva: The Association of Friends of the Barbier-Mueller Museum; Barcelona: Somogy / Editions d'Art, 2006.

Brinkgreve, Francine, and Retno Sulistianingsih, eds. *Sumatra: Crossroads of Cultures*. Leiden: KITLV Press, 2009.

Broersma, Roelof. *De Lampongsche Districten*. Batavia, Rijswijk: Javasche Boekhandel & Drukkerij, 1916.

Brommer, Bea. *Reizend door Oost-Indië: Prenten en verhalen uit de 19ᵉ eeuw*. Utrecht: Het Spectrum, 1979.

Bronson, Bennet. "Patterns in the Early Southeast Asian Metals Trade." In *Early Metallurgy, Trade and Urban Centres in Thailand and Southeast Asia*, edited by Ian Glover, Pamchai Suchitta, and John Villiers, 63–114. Bangkok: White Lotus, 1992.

Budiarti, Hari, and Francine Brinkgreve. "Court Arts of the Sumatran Sultanates." In *Sumatra. Crossroads of Cultures*, edited by Francine Brinkgreve and Retno Sulistianingsih, 121–51. Leiden: KITLV Press, 2009.

Buijze, W. *De generale Lant-beschrijvinge van het Ambonse Gouvernement: ofwel de Ambonsche Lant-beschrijvinge door G. E. Rumphius*. The Hague: Houtschild, 2001.

Capistrano-Baker, Florina H., with an introduction by Paul Mitchell Tayor. *Art of Southeast Asia: The Fred and Rita Richman Collection in the Metropolitan Museum of Art*. New York: The Metropolitan Museum of Art, 1994.

Carpenter, Bruce. *Ethnic Jewellery from Indonesia: Continuity and Evolution; the Manfred Giehmann Collection*. Singapore: Editions Didier Millet, 2011.

Chin, Lucas. *Cultural Heritage of Sarawak*. Sarawak, Malaysia: Sarawak Museum, 1980.

Cinatti, Ruy. *Motivos Artísticos Timorenses e a Sua Integração*. Lisbon: Instituto de Investigação Científica Tropical, Museu de Etnologia, 1987.

Clamagirand, Brigitte. "Marobo: Organisation sociale et rites d'une communauté Ema de Timor." PhD diss., Université René Descartes, Paris, 1975.

———. "The Social Organization of the Ema of Timor." In *The Flow of Life: Essays on Eastern Indonesia*, edited by James J. Fox, 134–51. Cambridge, MA, and London: Harvard University Press, 1980.

Cornelissen, P. F. J. J. "Totemisme op Flores en Timor." *Nederlandsch-Indië Oud & Nieuw* 13th year, vol. 11 (1929): 331–44.

Crill, Rosemary, ed., *Textiles from India: Global Trade: Papers Presented at a Conference on the Indian Textile Trade, Kolkata, 12–14 October 2003*. Calcutta and New York: Seagull Books, 2006.

Cunningham, Clark E. "Order in the Atoni House." In *Bijdragen tot de Taal-, Land- en Volkenkunde* 120 (1964): 34–69.

Darwin, Charles Robert. *The Voyage of the Beagle*. The Harvard Classics, edited by C. W. Eliot. New York: P. F. Collier & Son, 1909–14.

Degroot, Véronique, Nandana Chutiwongs, and Endang Sri Hardiati. "Early History and Archaeology of Sumatra: An Overview." In *Sumatra: Crossroads of Cultures*, edited by Francine Brinkgreve and Retno Sulistianingsih, 41–50. Leiden: KITLV Press, 2009.

van Dijk, Toos, and Nico de Jonge. *Shipcloths of the Lampung, South Sumatra*. Amsterdam, Galerie Mabuhay, 1980.

———. "After Sunshine Comes Rain: A Comparative Analysis of Fertility Rituals in Marsela and Luang, South-east Moluccas." *Bijdragen tot de Taal-, Land- en Volkenkunde* 146, no. 1 (1990): 3–20.

———. "Bastas in Babar: Imported Asian Textiles in a South-east Moluccan Culture." In *Indonesian Textiles*. Ethnologica Symposium 1985, NF Band 14 (1991): 18–33.

Drabbe, Petrus. "Het Leven van den Tanémbarees. Ethnografische Studie over het Tanémbareesche Volk." *Internationales Archiv für Ethnographie* 38, supplement. Leiden, E. J. Brill, 1940.

Drake, Richard Allen. "The Cultural Logic of Textile Weaving Practices among the Ibanic Peoples." In *Female and Male Borneo: Contributions and Challenges to Gender Studies*, edited by Vinson H. Sutlive, Jr., 271–94. Borneo Research Council Monograph Series, vol. 1. Williamsburg, VA: Borneo Research Council, 1991.

Drewes, G. W. J. "De biografie van een Minangkabausen peperhandelaar in de Lampongs." *Verhandelingen van het Koninklijk Instituut voor Taal-, Land- en Volkenkunde* 36. The Hague: Martinus Nijhoff, 1961.

Duarte, Jorge Barros. *Timor: Ritos e mitos Ataúros*. Lisbon: Ministério da Educação. Instituto de Cultura e Língua Portuguesa, 1984.

Earl, George Windsor. "On the Leading Characteristics of the Papuan, Australian, and Malay-Polynesian Nations." *The Journal of the Indian Archipelago and Eastern Asia* 4 (1850): 176–77.

Elbert, Johannes. *Die Sunda-Expedition des Vereins für Geographie und Statistik zu Frankfurt am Main*. Frankfurt am Main: Hermann Minjon, 1911.

Engelhard, J. B. "Von der goldenen Mondsichel zum hölzernen Schlips: Ahnenaltäre aus dem Tanimbar-Archipel—eine vergleichende Betrachtung." *Baessler-Archiv*, NF, Band XLII: 157–201. Berlin: Dietrich Reimer, 1994.

Erb, Maribeth. "Flores: Cosmology Art and Ritual." In *Islands and Ancestors: Indigenous Styles of Southeast Asia*, edited by Jean Paul Barbier and Douglas Newton, 106–19. Munich: Prestel; London: Thames and Hudson, 1988.

Feldman, Jerome Allen. *Arc of the Ancestors: Indonesian Art from the Jerome L. Joss Collection at UCLA*. Los Angeles: Fowler Museum of Cultural History, 1994.

———. "Ceremonial Attire in Nias." In *To Speak with Cloth: Studies in Indonesian Textiles*, edited by Mattiebelle Gittinger, 199–219. Los Angeles: University of California, Museum of Cultural HIstory, 1989.

———. "Dutch Galleons and South Nias Palaces." *Res (Peabody Museum, Harvard, Journal of Anthropology and Aesthetics)* 7/8 (1984): 21–32.

———, ed. *The Eloquent Dead: Ancestral Sculpture of Indonesia and Southeast Asia*. Los Angeles: University of California, Museum of Cultural History, 1985.

———. "The House as World in Bawömataluo, South Nias." In *Art, Ritual and Society in Indonesia*, edited by E. M. Bruner and J. O. Becker, 127–89. Athens, OH: Center for International Studies, 1979.

———. "Nias and Its Traditional Sculpture." In *Nias, Tribal Treasures: Cosmic Reflections in Stone, Wood and Gold*, edited by Jerome Feldman et al., 21–43. Delft: Volkenkundig Museum Nusantara, 1990.

Fischer, Hendrik Willem. *De eilanden om Sumatra*. Leiden: E. J. Brill, 1909.

Fischer, Joseph. *Threads of Tradition: Textiles of Indonesia and Sarawak*. [Oakland, CA]: published for the University of California by Fidelity Savings and Loan Association, 1979.

de Flines, E. W. van Orsoy. *Guide to the Ceramic Collection*. 4th ed. Jakarta: Museum Pusat, 1975.

Fontein, Jan. *The Sculpture of Indonesia*. Washington, D.C.: National Gallery of Art; New York: Harry N. Abrams, 1990.

Forbes, Henry O. *A Naturalist's Wanderings in the Eastern Archipelago*. London: Sampson Low, Marston, Searle and Rivington, 1885.

Forman, Shepard. "Descent, Alliance, and Exchange Ideology among the Makassae of East Timor." In *The Flow of Life: Essays on Eastern Indonesia*, edited by James J. Fox, 152–77. Cambridge, MA, and London: Harvard University Press, 1980.

Forshee, Jill. *Between the Folds: Stories of Cloth, Lives and Travels from Sumba*. Honolulu: University of Hawai'i Press, 2001.

Forth, Gregory. *Rindi: An Ethnographic Study of a Traditional Domain in Eastern Sumba*. The Hague: Koninklijk Instituut voor Taal-, Land-, en Volkenkunde, Martinus Nijhoff, 1981.

Fox, James J., ed. *The Flow of Life: Essays on Eastern Indonesia*. Cambridge, MA, and London: Harvard University Press, 1980.

———. *Harvest of the Palm: Ecological Change in Eastern Indonesia*. Cambridge, MA, and London: Harvard University Press, 1977.

———, ed. *To Speak in Pairs: Essays on the Ritual Languages of Eastern Indonesia*. Cambridge and New York: Cambridge University Press, 1988.

Fraser, Douglas. *The Many Faces of Primitive Art: A Critical Anthology.* Englewood Cliffs, NJ: Prentice Hall, 1966.

Freeman, John Derek. *Report on the Iban.* London: Ashlore Press; New York: Humanities Press, 1970.

———. "Severed Heads That Germinate." In *Fantasy and Symbolism*, edited by R. H. Hookook. London: Academic Press, 1979.

Funke, Friedrich W. *Orang Abung: Volkstum Süd-Sumatras im Wandel.* Band I—Kulturgeschichte der Abung-Stämme von der megalithischen Zeit bis zur Gegenwart. Leiden: E. J. Brill, 1958.

———. *Orang Abung. Volkstum Süd-Sumatras im Wandel.* Band II—Das Leben in der Gegenwart. Leiden: E. J. Brill, 1961.

Gavin, Traude. *Iban Ritual Textiles.* Singapore: Singapore University Press, 2004.

———. "Triangle and Tree: Austronesian Themes in the Design Interpretation of Indonesian Textiles." In *Five Centuries of Indonesian Textiles: The Mary Hunt Kahlenberg Collection*, edited by Ruth Barnes and Mary Hunt Kahlenberg. Munich: Prestel; New York: Delmonico Books, 2010.

———. *The Women's Warpath: Iban Ritual Fabrics from Borneo.* Los Angeles: UCLA Fowler Museum of Cultural History, 1996.

Gavin, Traude, and Ruth Barnes. "Iban Prestige Textiles and the Trade in Indian Cloth: Inspiration and Perception." In *Textile History* 30, special issue on South and South-East Asian Textiles, edited by Ruth Barnes and Rosemary Crill, 1999.

Geirnaert-Martin, Danielle C. "The Snake's Skin: Traditional Ikat in Kodi." In *Indonesian Textiles.* Ethnologica Symposium 1985. NF Band 14 (1991): 34–42.

———. "Purse-Proud: Of Betel and Areca Nut Bags in West Sumba, Eastern Indonesia." In *Dress and Gender: Making and Meaning in Cultural Contexts*, edited by Ruth Barnes and Joanne Bulbolz Eicher. New York: Berg, distributed by St. Martin's Press, 1992.

Geurtjens, Henrik. *Zijn Plaats onder de Zon.* Roermond: J. J. Romen & Zonen, 1941.

Gillow, John. *Traditional Indonesian Textiles.* London: Thames and Hudson, 1992.

Gittinger, Mattiebelle. *Master Dyers to the World.* Washington, D.C.: The Textile Museum, 1982.

———. "A Reassessment of the Tampan of South Sumatra." In *To Speak with Cloth: Studies in Indonesian Textiles*, edited by Mattibelle Gittinger, 225–39. Los Angeles: UCLA Museum of Cultural History, 1989a.

———. "The Ship Textiles of South Sumatra: Functions and Design System." *Bijdragen tot de Taal-, Land- en Volkenkunde* 132, nos. 2–3 (1976): 207–27.

———. *Splendid Symbols: Textiles and Tradition in Indonesia.* Washington, D.C.: The Textile Museum, 1979. New York and Toronto: Oxford University Press, 1991.

———. "A Study of the Ship Cloths of South Sumatra: Their Design and Usage." PhD diss. Columbia University, 1972.

———. *Textiles for This World and Beyond: Treasures from Insular Southeast Asia.* Washington, D.C.: Textile Museum, 2005.

———, ed. *To Speak with Cloth: Studies in Indonesian Textiles.* Los Angeles: University of California, Museum of Cultural History, 1989b.

Glover, Jan C. "The Archeological Past of Island Southeast Asia." In *Messages in Stone: Statues and Sculptures from Tribal Indonesia in the Collections of the Barbier-Mueller Museum*, edited by Jean Paul Barbier, 17–34. Geneva: Musée Barbier-Mueller and Skira, 1998.

Granucci, Anthony F. *The Art of the Lesser Sundas.* Singapore: Editions Didier Millet, 2005.

Grijzen, H. J. *Mededeelingen omtrent Beloe of Midden-Timor.* Verhandelingen van het Bataviaasch Genootschap van Kunsten en Wetenschappen. LIV (3), Batavia: Albrecht and Co; The Hague: M. Nijhoff, 1904.

Grubauer, Albert. *Celebes: Ethnologische Streifzüge in Südost- und Zentral-Celebes.* Hagen im Walk und Darmstadt: Folkwang-Verlag, 1923.

Guy, John. *Woven Cargoes: Indian Textiles in the East.* London: Thames and Hudson, 1998.

Guyt, Hendrik. "Hoofdlijnen van het huwelijksrecht in de Lampongs." *Indisch Tijdschrift van het Recht* 145 (1937a): 178–246. Batavia: N. V. Uitgevers.

———. "Inleiding tot een studie van de proatin-adat in de Lampongs." *Indisch Tijdschrift van het Recht* 145 (1937b): 157–77.

Hacker, Katherine F., and Krista J. Turnbull. *Courtyard, Bazaar, Temple: Traditions of Textile Expression in India.* Seattle: University of Washington Press, 1982.

Haddon, Alfred C. and Laura E. Start. *Iban or Sea Dayak Fabrics and Their Patterns.* [1936]. Carlton, Bedford: R. Bean; McMinnville, OR.: distributed by Robin and Russ Handweavers, 1982.

Haeckel, Ernst. *Aus Insulinde: Malayische Reisebriefe.* Bonn: E. Strauss, 1901.

Hamilton, Roy W. "Ngada Regency." In *The Gift of the Cotton Maiden: Textiles of Flores and the Solor Islands*, edited by Roy W. Hamilton, 99–121. Los Angeles: University of California, Fowler Museum of Cultural History, 1994.

———. "Textiles and Identity in Eastern Indonesia." In *Five Centuries of Indonesian Textiles: The Mary Hunt Kahlenberg Collection*, edited by Ruth Barnes and Mary Hunt Kahlenberg, 300–313. Munich: Prestel; New York: Delmonico Books, 2010.

Hamilton, Roy W. and Joanna Barrkman, eds. With essays and contributions by Ruth Barnes et al. *Textiles of Timor, Island in the Woven Sea.* Los Angeles: Fowler Museum at UCLA, 2014.

Hämmerle, Johannes M. "Die Megalithkultur im Susua-Gomo-Gebiet, Nias," *Anthropos* 79 (1984): 587–625.

———. *Nias—eine eigene Welt: Sagen, Mythen, Überlieferungen.* Sankt Augustin: Academia Verlag, 1999.

Harrebomée, G. J. "Eene bijdrage over de feitelijke toestand der bevolkingin de Lampongsche districten." *Bijdragen tot de Taal-, Land- en Volkenkunde van Nederlandsch-Indië.* Volgreeks 4. Vol. 10 (1885): 371–94.

van Heekeren, H. R. *The Bronze-Iron Age of Indonesia.* 's-Gravenhage: M. Nijhoff, 1958.

Heijmering, Geerlof. "Zeden en gewoonten op het eiland Timor." *Tijdschrift voor Nederlandsch-Indië* 7, no. 3 (1844): 121–46; 273–313.

Heine-Geldern, Robert. "Vorgeschichliche Grundlagen der kolonialindischen Kunst." *Wiener Beiträge zur Kunst- und Kulturgeschichte Asiens* 8 (1934): 5–40.

Helfrich, Oscar L. "Bijdragen tot de geographische, geologische en ethnographische kennis der afdeeling Kroë." *Bijdragen tot de Taal-, Land- en Volkenkunde van Nederlandsch-Indië*, Volgreeks 5. Vol. 4 (1889): 517–629.

Helms, Mary. *Ulysses' Sail: An Ethnographic Odyssey of Power, Knowledge, and Geographical Distance.* Princeton: Princeton University Press, 1988.

Henley, David. "The Idea of Celebes in History." Monash University Centre of Southeast Asian Studies, Working Paper 59, 1989.

Heppell, Michael. "Rejoinder: On My Late Iban Co-Author." *Borneo Research Bulletin* 41 (2010): 286–93.

Heppell, Michael, Limbang anak Melaka, and Enyan anak Usen. *Iban Art—Sexual Selection and Severed Heads: Weaving, Sculpture, Tattooing and Other Arts of the Iban of Borneo.* Amsterdam: KIT Publishers, 2005.

Heppell, Michael, and Robyn J. Maxwell. *Borneo and Beyond: Tribal Arts of Indonesia, East Malaysia and Madagascar.* Singapore: Bareo Gallery, 1990.

Hicks, David. "Art and Religion on Timor." In *Islands and Ancestors: Indigenous Styles of Southeast Asia*, edited by Jean Paul Barbier and Douglas Newton, 138–49. Munich and New York: Prestel, 1988.

———. *A Maternal Religion: The Role of Women in Tetum Myth and Ritual.* Northern Illinois University, Center for Southeast Asian Studies, Report No. 22, 1984.

———. *Tetum Ghosts and Kin: Fieldwork in an Indonesian Community.* Palo Alto, CA: Mayfield Publishing Co., 1976.

———. "Timor." In *Arts of the South Seas: Island Southeast Asia, Melanesia, Polynesia, Micronesia: The Collection of the Musée Barbier-Mueller*, edited by Douglas Newton, 130–39. Munich and New York: Prestel-Verlag, 1999.

Hissink, J. H. "Het pepadonwezen en zijne attributen in verband met de oude staatkundige indeeling in marga's en het huwelijks- en erfrecht in de afdeeling Toelang Bawang der Lampongsche Districten." *Tijdschrift van het Bataviaasch Genootschap* 47 (1904): 69–167.

van Hoëvell, G. W. W. C. "Leti-Eilanden," *Tijdschrift voor Indische Taal-, Land- en Volkenkunde* 33 (1890a): 200–232.

———. "Tanimbar en Timorlaoet-Eilanden." *Tijdschrift voor Indische Taal-, Land-en Volkenkunde* 33 (1890b): 160–86.

Holmgren, Robert, and Anita Spertus. *Early Indonesian Textiles from Three Cultures: Sumba Toraja Lampung.* New York: The Metropolitan Museum of Art, 1989.

de Hoog, J. "The Lesser Sunda Islands and the Moluccas." In *Art of the Archaic Indonesians*, edited by Waldemar Stöhr, 120–27. Geneva: Musée d'Art et d'Histoire, 1981.

———. "Nieuwe methoden en inzichten ter bestudering van de funktionele betekenis der beelden in het Indonesisch-Melanesisch kultuurgebied." *Kultuurpatronen* 1 (1959): 1–98.

van der Hoop, Abraham Nicolaas Jan Thomassen à Thuessink. "De Megalitische hoofdenzetel oorsprong van den Lampongschen Pepadon?" *Tijdschrift voor Indische Taal-, Land- en Volkenkunde* 80 (1940): 60–77.

———. *Indonesische Siermotieven—Ragam-ragam Perhiasan Indonesia—Indonesian Ornamental Design.* Batavia: Koninklijk Bataviaasch Genootschap van Kunsten en Wetenschappen, 1949.

Horridge, Adrian. *Outrigger Canoes of Bali and Madura, Indonesia.* Honululu: Bishop Museum Press, 1987.

———. "A Summary of Indonesian Canoe and Prahu Ceremonies." *Indonesia Circle* 39 (1986): 3–17.

Hose, Charles, with a preface by G. Elliot Smith. *Natural Man: A Record from Borneo.* Singapore and Oxford: Oxford University Press, 1988 [1926].

Hose, Charles, and William McDougall. *The Pagan Tribes of Borneo.* 2 vols. London: Macmillan, 1912.

Hoskins, Janet. "Arts and Cultures of Sumba." In *Islands and Ancestors: Indigenous Styles of Southeast Asia*, edited by Jean Paul Barbier and Douglas Newton, 120–37. Munich: Prestel; London: Thames and Hudson, 1988.

van Hout, Itie. "Indonesian Weaving between Heaven and Earth: Religious Implications of Bird Motifs on Textiles." *Bulletin of the Royal Tropical Institute Amsterdam* 345 (1999): 40 pp.

Jabu, Datuk Paduka Puan Sri Empiang. "Pua Kumbu—The Pride of the Iban Cultural Heritage." In *Sarawak Cultural Legacy: A Living Tradition*, edited by Lucas Chin and Valerie Mashman, 75–89. Kuching, Sarawak, Malaysia: Society Atelier, 1991.

Jacobs, Hubert, ed. and trans. *A Treatise on the Moluccas.* Rome: Jesuit Historical Institute, 1970.

Jacobsen, J. Adrian. *Reise in die Inselwelt des Banda-Meeres.* Berlin: Mitscher and Röstell, 1896.

Jessup, Helen Ibbitson. *Court Arts of Indonesia.* New York: Asia Society Galleries in association with Harry N. Abrams, 1990.

de Jong, Willemijn. "Cloth Production and Change in a Lio Village." In *Gift of the Cotton Maiden: Textiles of Flores and the Solor Islands*, edited by R. Hamilton, 210–27. Los Angeles: University of California, Fowler Museum of Cultural History, 1994.

de Jonge, Nico. "Collectors on Distant Islands." In *Indonesia: The Discovery of the Past*, edited by Endang Sri Hardiati and Pieter ter Keurs, 172–202. Amsterdam: KIT Publishers, 2005.

de Jonge, Nico, and Toos van Dijk. *Forgotten Islands of Indonesia: The Art and Culture of the Southeast Moluccas.* Singapore: Periplus Editions, 1995a.

———. *Tanimbar-Maluku: The Unique Moluccan Photographs of Petrus Drabbe.* Alphen aan de Rijn: Periplus Editions, 1995b.

———. *Vergeten eilanden: Kunst en cultuur van de Zuidoost-Molukken.* Amsterdam: Periplus Editions, 1995c.

de Josselin de Jong, Jan Petrus B. *Wetan Fieldnotes: Some Eastern Indonesian Texts with Linguistic Notes and a Vocabulary.* Dordrecht, Netherlands, and Providence, RI: Foris Publications, 1987.

Kahlenberg, Mary Hunt. "Possessions of the Ancestors." *Hali* 131 (Nov.–Dec. 2003): 82–87.

———, ed. *Textile Traditions of Indonesia.* Los Angeles: Los Angeles County Museum of Art, 1977.

ten Kate, Herman F. C. "Beiträge zur Ethnographie der Timor-Gruppe." *International Archiv für Ethnographie* 8: 242–49 and 9: 1–16. Leiden: E. J. Brill, 1894.

———. "Verslag eener reis in de Timorgroep en Polynesie." *Tidschrift van het Koninklijk Nederlandsch Aardrijkskundig Genootschap* (2nd series), 211: 195–246, 333–90, 541–638, 659–700. Leiden: E. J. Brill, 1894.

Kaudern, Walter. *Ethnographical Studies in Celebes: Results of the Author's Expeditions to Celebes, 1917–20.* Vol. 6: *Art in Central Celebes.* Göteborg: Elanders Boktryckeri Aktiebolog, 1938.

Kedit, Vernon. "Restoring Panggau Libau: A Reassessment of Engkeramba' in Saribas Iban Ritual Textiles." *Borneo Research Bulletin* 40 (2009): 231–34.

Kennedy, Raymond. "Field Notes on Indonesia: Flores 1949–1950." New Haven, CT: Human Relations Area Files, 1955.

ter Keurs, Pieter, Sandra Niessen, and Constance de Monbrison. *Au Nord de Sumatra, les Batak.* Milan: 5 Continents Press; Paris: Musée du quai Branly, 2008.

Khan Majlis, Brigitte. *Indonesische Textilien: Wege zu Göttern und Ahnen: Bestands-katalog der Museen in Nordrhein-Westfalen.* Cologne: Weinand, 1984.

King, Margaret. *Eden to Paradise.* London: Hodder and Stoughton, 1963.

King, Victor T. *The Maloh of West Kalimantan: An Ethnographic Study of Social Inequality and Social Change among an Indonesian Borneo People.* Dordrecht, Netherlands, and Cinnaminson, NJ: Foris Publications, 1985.

———. *The Peoples of Borneo.* Oxford and Cambridge, MA: Blackwell, 1993.

King, Victor T., and Jan B. Avé. *People of the Weeping Forest: Tradition and Change in Borneo.* Leiden: National Museum of Ethnography, 1986.

Kirch, Patrick Vinton. *The Lapita Peoples: Ancestors of the Oceanic World.* Cambridge, MA: Blackwell, 1997.

Kjellgren, Eric. *Oceania: Art of the Pacific Islands in the Metropolitan Museum of Art.* New York: Metropolitan Museum of Art; New Haven, CT, and London: Yale University Press, 2007.

Komroff, Manuel. *The Travels of Marco Polo.* New York: Heritage Press, 1934.

Kosinski, Dorothy M., Lauren Schell, John R. Lane, Natalie Henderson Lee, and Queta Moore Watson. *Dallas Museum of Art: 100 Years.* Dallas: Dallas Museum of Art, 2003.

Kotilainen, Eija-Maija, "'When the Bones Are Left': A Study of the Material Culture of Central Sulawesi." *Transactions of the Finnish Anthropological Society*, no. 31. Helsinki: Lomakepaintus, 1992.

Kruyt, Albert Christiaan. "De Timoreezen." *Bijdragen tot de Taal-, Land- en Volkenkunde* 79, no. 3/4 (1923): 347–490.

Kruyt, J. "Het Weven der Toradja's." *Bijdragen tot de Taal-, Land- en Volkenkunde van Nederlandsch-Indië* 78 (1922): 403–25.

Kusakabe, Keiko. *Textiles from Sulawesi in Indonesia: Genealogy of Sacred Cloths.* Fukuoka, Japan: Fukuoka Art Museum, 2006.

op 't Land, C. "Een merkwaardige 'Tampan pengantar' van Zuid-Sumatra." *Kultuurpatronen* 10–11 (1968–69): 100–117.

Langevoort, H. L. "Lief en leed op Lettie." *Nederlandsch Zendingstijdschrift*, Jaargang 4 (1892): 260–69.

Langewis, Laurens, and Frits Wagner. *Decorative Art in Indonesian Textiles.* Amsterdam: C. P. J. van der Peet, 1964.

LeBar, Frank M., ed. and comp. *Ethnic Groups of Insular Southeast Asia.* Vol. I: *Indonesia, Andaman Islands, and Madagascar.* New Haven, CT: Human Area Relations Files Press, 1972.

Leibrick, Fiona. *Binding Culture in Thread: Textile Arts of Biboki, West Timor.* Darwin, N.T., Australia: Museums and Art Galleries of the Northern Territory and the Center for the Southeast Asian Studies, Northern Territory University Publication, 1994.

Leigh-Theisen, Heide, and Reinhold Mittersakschmöller, eds. *Indonesien, Kunstwerke-Weltbilder.* Linz, Austria: Oberösterreichisches Landesmuseum, 1999.

Levenson, Jay, ed., with contributions from Diogo Ramada Curto and Jack Turner. *Encompassing the Globe, Portugal and the World in the 16th and 17th Centuries.* Washington, D.C.: Arthur M. Sackler Gallery, Smithsonian Institution, 2007.

SELECTED BIBLIOGRAPHY

Lewis, M. Paul, ed. *Ethnologue: Languages of the World*. 16th ed. Dallas: Summer Institute of Linguistics International, 2009.

Linggi, Datin Amar Margaret. *Ties That Bind: Iban Ikat Weaving*. Sarawak, Malaysia: Tun Jugah Foundation, 2001.

van der Lith, P. A., F. Fokkens, and A. J. Spaan. *Encyclopaedie van Nederlandsch-Indië*. The Hague: Martinus Nijhoff; Leiden: E. J. Brill, 1896–1905.

Loebèr, J. A. *Bamboe-ornament van het Eiland Borneo*. Amsterdam: [s.n.], 1919.

———. "Bamboe-snijwerk en weefsels op Timor." *Bijdragen Koninklijk Instituut voor Taal-, Land- en Volkenkunde* 61 (1908): 339–49.

———. *Timoreesch Snijwerk en Ornament. Bijdrage tot de Indonesische Kunst-geschiedenis*. The Hague: Martinus Nijhoff, 1903.

Low, Hugh Brooke. *Sarawak: Its Inhabitants and Productions; Being Notes During a Residence in That Country with His Excellency Mr. Brooke*. London: R. Bentley, 1848.

Lumholtz, Carl. *Through Central Borneo: An Account of Two Years' Travel in the Land of Head-Hunters between the Years 1913 and 1917*. New York: Charles Scribner's Sons, 1920.

Maas, Alfred. "Die primitive Kunst der Mentawai-Insulaner." *Zeitschrift für Ethnologie* 38 (1906): 433–55.

Marschall, Wolfgang. *Der Berg des Herrn der Erde: Alte Ordnung und Kulturkonflikt in einem indonesischen Dorf*. Munich: Deutscher Taschenbuch Verlag, 1976.

Marsden, William. *The History of Sumatra*. London [1811]. Reprint of the 3rd ed.: New York, London, and Melbourne: Oxford University Press, 1975.

Mattet, Laurence, ed. *Arts and Cultures*. Geneva: Barbier-Mueller Museum; Barcelona: Somogy / Éditions d'Art, 2006.

Maxwell, John. "Textiles of the Kapuas Basin with Special Reference to Maloh Beadwork." In *Indonesian Textiles: Irene Emery Roundtable of Museum Textiles, 1979 Proceedings*, edited by Mattiebelle Gittinger, 127–40. Washington, D.C.: The Textile Museum, 1980.

Maxwell, Robyn J. *Sari to Sarong: Five Hundred Years of Indian and Indonesian Textile Exchange*. Canberra: National Gallery of Australia, 2003.

———. *Textiles of Southeast Asia: Tradition, Trade and Transformation*. Canberra: Australian National Gallery; London: Oxford University Press, 1990.

———. *Life, Death and Magic, 2000 Years of Southeast Asian Ancestral Art*. Canberra: Australian National Gallery; Seattle: University of Washington Press, 2010.

Maybury-Lewis, David. *Millennium: Tribal Wisdom and the Modern World*. New York: Viking, 1992.

McKinnon, Susan M. *From a Shattered Sun: Hierarchy, Gender, and Alliance in the Tanimbar Islands*. Madison: University of Wisconsin Press, 1991.

———. "Tanimbar Boats." In *Islands and Ancestors: Indigenous Styles of Southeast Asia*, edited by Jean Paul Barbier and Douglas Newton, 152–69. Munich: Prestel; London: Thames and Hudson, 1988.

———. "The Tanimbarese *Tavu*: The Ideology of Growth and the Material Config-urations of Houses and Hierarchy in an Indonesian Society." In *Beyond Kinship: Social and Material Reproduction in House Societies*, edited by Rosemary A. Joyce and Susan D. Gillespie, 161–76. Philadelphia: University of Pennsylvania Press, 2000.

McWilliam, Andrew. "Paths of Origin, Gates of Life: A Study of Place and Precedence in Southwest Timor." *Verhandelingen van het Koninklijk Instituut voor Taal-, Land- en Volkenkunde* 203. Leiden: Koninklijk Instituut voor Taal-, Land- en Volkenkunde Press, 2002.

Middelkoop, Piet. *Een studie van het Timoreesche doodenritueel*. [Verhandelingen van het Koninklijk Bataviaasch Genootschap van Kunsten en Wetenschappen 76.] Bandoeng, A. C.: Nix & Co, 1949.

———. "Four Tales with Mythical Features Characteristic of the Timorese People." *Bijdragen tot de Taal-, Land- en Volkenkunde* 114 (1958): 384–405.

Miksic, John. *Borobudur: Golden Tales of Buddhas*. Boston: Shambhala, 1990.

Mittersakschmöller, Reinhold, ed. *Joachim Freiherr von Brenner-Felsach: Eine Reise nach Nias*. Vienna, Cologne, and Weimar: Böhlau, 1998.

Modigliani, Elio. *Un viaggio a Nias*. Milan: Treves, 1890.

de Moor, Maggie. "Gold Jewellery in Nias Culture." *Arts of Asia* 19 (July–August 1989): 77–89.

Morrison, Hedda. *Sarawak*. Singapore: Time Books, International, 1982 (1976, 1957).

———. *Vanishing World: The Ibans of Borneo*. New York and Tokyo: John Weatherhill, 1972.

Müller-Wismar, Wilhelm. "Austroinsulare Kanus als Kult- und Kriegs-Symbole." *Baessler-Archiv* (Leipzig-Berlin) Band II (1912): 235–49.

———. *Leti journal* (manuscript). Hamburg: Hamburgisches Museum für Völkerkunde und Vorgeschichte, 1914.

Newman, Mark F., Peter F. Burgess, and T. C. Whitmore. *Manuals of Dipterocarps for Forresters: Borneo Island Medium and Heavy Hardwoods; dipterocarpus, dryobalanops, hopea, shorea (balau/selangan batu), Upuna*. Edinburgh: Royal Botanic Garden Edinburgh, 1998.

Nieuwenhuis, Anton W. *In Centraal Borneo: Reis van Pantianak naar Samarinda*. Leiden: E. J. Brill, 1900.

———. *Quer durch Borneo: Ergebnisse seiner Reisen in den Jahren 1894, 1896–7 und 1898–1900*. 2 vols. Leiden: E. J. Brill, 1904.

Nieuwenkamp, Wijnand Otto J. *Kunstwerke von Java, Borneo, Bali, Sumba, Timor, Alor, Leti*. Berlin: Auriga-Verlag, 1924.

Nooy-Palm, Hetty. "The Mamasa and Sa'dan Toraja of Sulawesi." In *Islands and Ancestors: Indigenous Styles of Southeast Asia*, edited by Jean Paul Barbier and Douglas Newton, 85–105. Munich and New York: Prestel, 1988.

———. *The Sa'dan Toraja: A Study of Their Social Life and Religion*. Vol. I: *Organization, Symbols and Beliefs*. The Hague: Nijhoff, 1979.

———. "Sacred Cloths of the Toraja." In *To Speak with Cloth: Studies in Indonesian Textiles*, edited by Mattibelle Gittinger, 162–80. Los Angeles: UCLA Museum of Cultural History, 1989.

van Nooyhuys, J. W. "Was-Batik in Midden-Celebes." *Nederlandsch Indië Oud en Nieuw* 10, no. 3 (1925): 110–22.

Notulen van de algemeene en directie-vergaderingen van het Bataviaasch Genootschap van Kunsten en Wetenschappen. Batavia: Lange & Co, 1926–27.

Ong, Edric. *Pua: Iban Weavings of Sarawak*. 2nd ed. Kuching, Sarawak, Malaysia: Society Atelier Sarawak, 1988.

———. *Woven Dreams: Ikat Textiles of Sarawak*. Kuching, Sarawak, Malaysia: Society Atelier Sarawak, 2000.

Osseweijer, Manon. *Taken at the Flood: Marine Resource Use and Management in the Aru Islands (Maluku, Eastern Indonesian)*. Leiden: CNWS, 2001.

Palm, Clementine H. M. "De Cultuur en Kunst van de Lampung, Sumatra." *Kultuurpatronen*, deel 7 (1965): 40–80.

Pannell, Sandra N. "Travelling to Other Worlds: Narratives of Headhunting, Appropriation and the Other in the Eastern Archipelago." *Oceania* 62, no. 3 (1992): 162–78.

Pigafetta, Antonio. *The First Voyage around the World (1519–1522): An Account of Magellan's Expeditions*. Edited by Theodore J. Cachey, Jr. New York: Marsilio Publishers, 1995.

———. *The Voyage of Magellan: The Journal of Antonio Pigafetta*. Translated by Paula Spurlin Paige. Englewood Cliffs, NJ: Prentice-Hall, 1969.

Pitman, Bonnie. *Dallas Museum of Art: A Guide to the Collection*. Dallas: Dallas Museum of Art, 2012.

Planten, H. O. W., and C. J. M. Wertheim. *Verslagen van de wetenschappelijke opne-mingen en onderzoekingen op de Key-eilanden, gedurende de jaren 1889 en 1890*. Leiden: E. J. Brill, 1893.

Platenkamp, Josephus D. M. *Tobelo: Ideas and Values of a North Moluccan Society*. PhD diss., University of Leiden, 1988.

Pleyte Wzn, C. M. "Indonesische Masken." *Globus* 61 (1892a): 321–25, 343–47.

———. "Seltene ethnographische Gegenstände von Kisar." *Globus* 70 (1896): 347–49.

———. "Systematische beschrijving van de door de heeren Planten en Wertheim verzamelde ethnographica, tijdens hun verblijf op de zuidwester- en de zuidooster-eilanden." *Tijdschrift van het Koninklijk Nederlandsch Aardrijkskundig Genootschap* (1892b): 1051–82.

Polo, Marco, Henry Yule, and Henri Cordier. *The Travels of Marco Polo: The Complete Yule-Cordier Edition.* New York: Dover, 1993.

Pospíšilová, Dagmar, Ivana Hladká, and Anna Jezberová. *Pavel Durdík (1843–1903). Life and Work: Ethnological Collection of the Island of Nias.* Prague: National Museum, 2010.

Pringle, Robert. *Rajahs and Rebels: The Ibans of Sarawak under Brooke Rule, 1841–1941.* Ithaca, NY: Cornell University Press, 1970.

Rautner, Mario, Martin Hardiono, and Raymond J. Alfred. *Borneo: Treasure Island at Risk; Status of Forest, Wildlife, and Related Threats on the Island of Borneo.* Frankfurt: World Wildlife Federation Germany, 2005.

Richards, Anthony J. N. *An Iban-English Dictionary.* New York: Oxford University Press, 1981.

Richter, Anne, and Bruce Carpenter. *Gold Jewellery of the Indonesian Archipelago.* Singapore: Editions Didier Millet, 2011.

Riedel, Johan G. F. *De sluik- en kroesharige rassen tusschen Selebes en Papua.* The Hague: Martinus Nijhoff, 1886.

Rinnooy, N. "De voormalige assistent-residentie Kisser." *Nederlandsch Zendingstijdschrift,* Jaargang 4 (1892): 65–84.

Robbins, Carol. *Selections from the Steven G. Alpert Collection of Indonesian Textiles.* Dallas: Dallas Museum of Art, 1984.

Rodenwaldt, Ernst. *Die Mestizen auf Kisar.* Batavia: Kolff & Co., 1927.

Rodgers, Susan. *Power and Gold: Jewelry from Indonesia, Malaysia, and the Philippines from the Collection of the Barbier-Müller Museum.* 2nd ed. Munich: Prestel-Verlag, 1988.

de Roever, Arend G. *De jacht op sandelhout: De VOC en de tweedeling van Timor in de zeventiende eeuw.* Zutphen: Uitgeversmaatschappij Walburg Pers, 2002.

Roth, Henry Ling. *The Natives of Sarawak and British North Borneo.* Kuala Lumpur: University of Malaya Press, 1968 (1896).

Rouffaer, Gerret P. "Waar kwamen de raadselachtige moetisalah's (aggrikralen) in de Timorgroep oorspronkelijk vandaan?" *Bijdragen van het Koninklijk Instituut voor Taal-, Land- en Volkenkunde* 6 (1899): 409–675.

Rumphius, Georgius Everhardus. *The Ambonese Curiosity Cabinet.* Translated, edited, annotated and with an introduction by E. M. Beekman. New Haven, CT, and London: Yale University Press, 1999.

Rutter, Owen, with an introduction by C. G. Seligman. *The Pagans of North Borneo.* London: Hutchinson & Co., 1929 [1985].

Sand, Christophe, and Stuart Bedford, eds. *Lapita: Ancêtres océaniens / Oceanic Ancestors.* Paris: Somogy Éditions / Musée du Quai Branly, 2010.

Sandin, Benedict. *Iban Adat and Augury.* Penang: Penerbit Universiti Sains Malaysia for School of Comparative Social Sciences, 1980.

———. *Iban Way of Life.* Kuching, Sarawak, Malaysia: Borneo Literature Bureau, 1976.

Sandin, Benedict, and Clifford Sather. "Sources of Iban Traditional History." *Sarawak Museum Journal,* vol. 46, no. 67, special monograph no. 7. Kuching, Sarawak: Sarawak Museum, 1994.

Sarasin, Paul, and Fritz Sarasin. *Reisen in Celebes ausgeführt in den Jahren 1893–1896 und 1902–1903.* 2 vols. Wiesbaden: Kreidel, 1905.

Sather, Clifford. "'All Threads Are White': Iban Egalitarianism Reconsidered." In *Origins, Ancestry and Alliance: Explorations in Austronesian Ethnography.* Edited by James J. Fox and Clifford Sather, 70–110. Canberra: Australian National University, 1996.

Schärer, Hans, with a preface by P. E. de Josselin de Jong. Translated by Rodney Needham. *Ngaju Religion: The Conception of God among a South Borneo People.* The Hague: M. Nijhoff, 1963.

Schefold, Reimar. "Art and Art Trade in Siberut, Mentawai Archipelago, Part 1: Toys for the Souls—Toys for the Shops: Siberut Art from Domestic Uses to Faking." *Indonesia and the Malay World* 30, no. 88 (2002a): 319–35.

———. *Lia; das grosse Ritual auf den Mentawai-Inseln (Indonesien).* Berlin: Dietrich Reimer, 1988.

———. "The Southeast Asian–type House: Common Features and Local Transformations of an Ancient Architectural Tradition." In *Indonesian Houses.* Vol. 1: *Tradition and Transformation in Vernacular Architecture.* Edited by Reimar Schefold, Gaudenz Domenig, and Peter J. M. Nas. Leiden: KITLV Press, 2003.

———. *Speelgoed voor de zielen: Kunst en cultur van de Mentawai-eilanden / Spielzeug für die Seelen, Kunst und Kultur der Mentawai-Inseln (Indonesien).* Delft: Museum Nusantra; Zurich: Museum Rietberg, 1979–80.

———. "Stylistic Canon, Imitation and Faking: Authenticity in Mentawai Art in Western Indonesia." *Anthropology Today* 18-2 (2002b): 10–15.

———. "Three Sources of Ritual Blessings in Traditional Indonesian Societies." *Bijdragen tot de Taal-, Land- en Volkenkunde* 157-2 (2001): 359–81.

———. "Visions of the Wilderness on Siberut in a Comparative Southeast Asian Perspective." In *Tribal Communities in the Malay World: Historical, Cultural and Social Perspectives,* edited by Geoffrey Benjamin and Cynthia Chou, 422–38. Singapore: ISEAS [Institute of Southeast Asian Studies], 2002c.

Schefold, Reimar, Vincent Dekker, and Nico de Jonge, eds. *Indonesia in Focus: Ancient Traditions—Modern Times.* Meppel, Netherlands: Edu'Actief Publishing Company, 1988.

Schnitger, Frederic Martin, Christoph von Fürer-Haimendorf, and Gerard L. Tichelman. *Forgotten Kingdoms in Sumatra.* Leiden: E. J. Brill, 1939.

———. *Forgotten Kingdoms in Sumatra.* Leiden: E. J. Brill, 1964.

Schreiber, Christine. *Sidihoni: Perle im Herzen Sumatras I: Stationen und Bilder einer Feldforschung, von Leben und Bestattung, Tradition und Moderne bei den Toba-Batak.* 2nd ed. Rottenburg, Germany: Sidihoni-Verlag Sidihoni.Com, 2012.

Schulte Nordholt, Herman G. "The Political System of the Atoni of Timor." *Verhandelingen van het Koninklijk Instituut voor Taal-, Land- en Volkenkunde* 60. The Hague: Martinus Nijhoff, 1971.

———. *Het politieke systeem van de Atoni van Timor.* Thesis, Vrije Universiteit Amsterdam. Driebergen: Offsetdruk Van Manen & Co, 1966.

Sellato, Bernard J. L. *Naga dan Burung Enggang—Hornbill and Dragon: Kalimantan, Sarawak, Sabah and Brunei.* Translated from the English by Winarsih Arifin. Jakarta: Elf Aquitaine Indonesia; Kuala Lumpur: Elf Aquitaine Malaysia, 1989.

Sellato, Bernard J. L., Gilles Perret, et al. *Hornbill and Dragon: Kalimantan, Sarawak, Sabah, Brunei.* Jakarta: Elf Aquitaine Indonesia, 1989.

Senft, Gunter. *Referring to Space: Studies in Austronesian and Papuan Languages.* Oxford and New York: Clarendon Press, 1997.

Sibeth, Achim. *Batak: Kunst aus Sumatra.* Frankfurt am Main: Museum für Völkerkunde, 2000.

———, ed. *Being Object—Being Art: Masterpieces from the Collections of the Museum of World Cultures, Frankfurt/Main.* Tübingen: Ernst Wasmuth Verlag, 2009.

———. *Gold, Silver and Brass: Jewellery of the Batak in Sumatra, Indonesia.* Milan: Five Continents Press; New York: Abrams, 2012.

Sibeth, Achim, and Bruce Carpenter. *Batak Sculpture.* Singapore: Editions Didier Millet, 2007.

Sibeth, Achim, Uli Kozok, and Juara R. Ginting. *The Batak: Peoples of the Island of Sumatra.* London and New York: Thames and Hudson, 1991.

Sibon, Peter. "Muja Menua . . . Appeasing the Angry Gods." *Borneo Post,* December 5, 2010: 18. http://www.theborneopost.com/2010/12/05/muja-menua-appeasing-the-angry-gods/.

Snelleman, Johannes F. "Nog een merkwaardig weefsel uit de Lampongs." *De Aarde en haar Volken,* Jrg. 46, no. 18 (1910): 75–76.

Solyom, Bronwen, and Garrett Solyom. *Fabric Traditions of Indonesia.* Pullman: Washington State University Press and the Museum of Art, Washington State University, 1990.

Spanjaard, Helena. *Het ideaal van een moderne Indonesische schilderkunst: De creatie van een nationale culturele identiteit.* PhD diss., Leiden University, 1998.

Steinmann, Alfred. "Enkele opmerkingen aangaande de z.g. scheepjesdoeken van Zuidsumatra." *Cultureel Indië,* Jrg. 1 (1939): 252–56.

———. "Das Seelenschiff in der Textilkunst Indonesiens." *Kultuurpatronen,* deel 7 (1965): 23–39.

———. "The Ship as Represented in the Art of Southeast Asia." *Ciba Review* 52 (1946a): 1876–83.

———. "The Ship of the Dead in the Textile Art of Indonesia." *Ciba Review* 52 (1946b): 1885–96.

Stöhr, Waldemar. *Die altindonesischen Religionen.* Leiden: E. J. Brill, 1976.

———, ed. *Art des Indonésiens archäiques.* Geneva: Musée d'Art et d'Histoire, 1981.

———, ed. *Art of the Archaic Indonesians.* Dallas: Dallas Museum of Fine Arts, 1982.

———. "Steinerner Ahnensitz von der Insel Nias, Indonesien. Eine Neuerwerbung des Rautenstrauch-Joest-Museums." *Museen in Köln Bulletin* 15, no. 2 (1976): 1407–8.

Sundari, Ekowati. "Trade Ceramics from Sumatra in the Collection of the National Museum (Jakarta)." In *Sumatra: Crossroads of Cultures,* edited by Francine Brinkgreve and Retno Sulistianingsih, 97–106. Leiden, KITLV Press, 2009.

Sutlive, Vinson H. *The Iban of Sarawak.* Arlington Heights, IL: AHM Publ. Corp., 1978.

Taylor, Jean Gelman. *Indonesia: People and Histories.* New Haven, CT, and London: Yale University Press, 2003.

Taylor, Paul Michael, ed. *Fragile Traditions: Indonesian Art in Jeopardy.* Honolulu: University of Hawai'i Press, 1994.

Taylor, Paul Michael, and Lorraine V. Aragon, with assistance from Annamarie L. Rice. *Beyond the Java Sea: Art of Indonesia's Outer Islands.* Washington, D.C.: The National Museum of Natural History, Smithsonian Institution, in association with Harry N. Abrams, 1991.

Tersteege, B. H. "Het Animisme op de Zuid-Wester-Eilanden." *Koloniaal Tijdschrift* 24 (1935): 558–74.

Tillema, Hendrik F. *A Journey among the Peoples of Central Borneo in Word and Picture,* edited and with an introduction by Victor T. King. Singapore: Oxford University Press, 1990.

Tjoa-Bonatz, Mai Lin. "Idols and Art: Missionary Attitudes toward Indigenous Worship and the Material Culture on Nias, Indonesia, 1904–1920." In *Casting Faiths: Imperialism and the Transformation of Religion in East and Southeast Asia,* edited by Thomas D. Dubois, 105–28. New York: Palgrave Macmillan, 2009.

Totton, Marie-Louise. *Wearing Wealth and Styling Identity: Tapis from Lampung, South Sumatra, Indonesia.* Hanover, NH: Hood Museum, Dartmouth College, 2009.

Traube, Elizabeth G. "Mambai Rituals of Black and White." In *The Flow of Life: Essays on Eastern Indonesia,* edited by James J. Fox, 290–314. Cambridge, MA, and London: Harvard University Press, 1980.

———. *Ritual Exchange among the Mambai of East Timor: Gifts of Life and Death.* Thesis, Harvard University, Cambridge, MA, 1977.

van der Tuuk, Herman Neubronner. *Bataksch-Nederduitsch Woordenboek.* Amsterdam: Muller, 1861.

Venable, Charles. *Dallas Museum of Art: A Guide to the Collection.* Dallas: Dallas Museum of Art, 1997.

Viaro, Alain Mario. "The Traditional Architectures of Nias." In *Nias, Tribal Treasures: Cosmic Reflections in Stone, Wood and Gold,* 45–76. Delft: Volkenkundig Museum Nusantara, 1990.

Viaro, Alain Mario, and Arlette Ziegler. *Traditional Architecture of Nias Island.* Translated by Irène de Charrière. Gunungsitoli, Indonesia: Yayasan Pusaka Nias, 2006.

Villegas, Ramon N. *Kayamanan: The Philippine Jewelry Tradition.* Manila: The Central Bank of the Philippines, 1983.

Völger, Gisela, and Karin von Welck, eds. *Indonesian Textiles.* Ethnologica Symposium 1985, Neue Folge, Band 14. Cologne: Rautenstrauch-Joest-Museum, 1991.

Volkenkundig Museum Nusantara. *Nias: Tribal Treasures. Cosmic Reflections in Stone, Wood and Gold.* Delft: Volkenkundig Museum Nusantara, 1990.

Voorhoeve, Petrus. *Critical Survey of Studies on Languages of Sumatra.* The Hague: M. Nijhoff, 1955.

Vredenbregt, Jacob. *Hampatong—Kebudayaan Material Suku Dayak di Kalimantan / The Material Culture of the Dayak of Kalimantan.* Jakarta: Gramedia, 1981.

de Vries, J. H. "Reis door eenige eilanden groepen der Residentie Amboina." *Tijdschrift van het Koninklijk Nederlandsch Aardrijkskundig Genootschap* 17 (1900): 467–502, 593–621.

Vroklage, Bernhard A. G. *Ethnographie der Belu in Zentral-Timor.* 3 vols. Leiden: E. J. Brill, 1953.

Wallace, Alfred Russell. *The Malay Archipelago: The Land of the Orang Utan, and the Bird of Paradise.* Kuala Lumpur: Oxford University Press, 1989. [Originally published in 1969 by Macmillan, London.]

Wassing-Visser, Rita. *Sieraden en Lichaamsversiering uit Indonesië.* Delft: Volkenkundig Museum Nusantara, 1984.

Waterson, Roxana. "Hornbill, Naga and Cock in Sa'dan Toraja Woodcarving Motifs." *Archipel* 38 (1989): 53–73.

———. "The House and the World: The Symbolism of Sa'dan Toraja House Carvings." *RES (Peabody Museum, Harvard, Journal of Anthropology and Aesthetics)* 15 (1988): 34–60.

———. "Houses, Graves, and the Limits of Kinship Groupings among the Sa'dan Toraja." *Bijdragen tot de Taal-, Land- en Volkenkunde* 151 (1995): 194–217.

———. *The Living House: An Anthropology of Architecture in South-East Asia.* Singapore and New York: Oxford University Press, 1990.

———. *Paths and Rivers: Sa'dan Toraja Society in Transformation.* Leiden: KITLV, 2009.

Whitten, Anthony J., Mustafa Muslimin, and Gregory Henderson. *The Ecology of Sulawesi.* Yogyakarta: Gadjah Mada University Press, 1987.

Wirz, Paul. "Het eiland Sabirut en zijn bewoners." *Nederlandsch-Indië Oud en Nieuw* 14 (1929–30): 131–39, 187–92, 209–15, 241–48, 337–48, 377–97.

Woermann, Karl. *Geschichte der Kunst.* Vol. 2. Leipzig: Bibliographisches Institut, 1915.

Wollheim, Richard. *Art and Its Objects: With Six Supplementary Essays.* 2nd ed. New York and Cambridge: Cambridge University Press, 1980.

Wright, Leigh, Hedda Morrison, and K. F. Wong. *Vanishing World: The Ibans of Borneo.* New York: Weatherhill, 1972.

Yeager, Ruth M., and Mark I. Jacobson. *Textiles of Western Timor: Regional Variations in Historical Perspective.* Bangkok: White Lotus Press, 2002.

Yunos, Rozan, and Bandar Seri Begawan. "Bedil—the Traditional Brunei Cannons." *Brunei Times,* July 22, 2007. http://www.bt.com.bn/classification /life/2007/07/22/bedil_mdash_the_traditional_brunei_cannons.

Zerner, Charles. "Signs of the Spirits, Signature of the Smith: Iron Forging Tana Toraja." *Indonesia* 31 (1982): 89–112.

Ziegler, Arlette, and Alain Viaro. "Die Steine der Macht: Statuen und Megalithismus auf Nias." *Botschaft der Steine: Indonesische Skulpturen aus der Sammlung Barbier-Mueller Genf,* edited by Jean Paul Barbier, 35–78. Geneva and Milan: Skira, 1998.

Zonneveld, Albert G. van. *Traditional Weapons of the Indonesian Archipelago.* Translated by P. Richardus and T. D. Rogers. Leiden: C. Zwartenkot Art Books, 2001.

Zweers, Louis. *Sumatra: Kolonialen, koelies en krijgers.* Houten, the Netherlands: Fibula, 1988.

Page references in *italics* denote illustrations; page references in ***boldface italics*** denote principal illustrations of catalogued objects.

A

Abung people, Sumatra, 81, 82–83, 82 (map), 84, 88
 papadon ascension and, 88
 ship cloths produced by, 86
 skirt produced by, 114–15
adat law, 44, 54, 81, 211, 212, 241
 in Maluku Tenggara, 275, 277, 281, 294
Adriani, Nikolaus, 183
aesthetics, and Batak art, 63, 65
agom, Iban sentinel figures, 146, 147
Ahe people, Borneo, 126
Alor, 16 (map), 20, 246 (map)
 drum from, 14, 15, 20
Alpert, Steven G., 11, 13, 13, 14, 15, 202, 224
Alpert, Steven G. family, 13, 14
Alukta religion (Aluk To Dolo), 174, 175
Aluk To Dolo. *See* Alukta
Amawau, 219, 219
Ambeno enclave, Timor-Leste, 245
Ambon, 276 (map), 293, 297
amulet
 Atauro, 270, 270
 Ono Niha (*rago balatu*), 48
Anakalang, Raja of, Sumba, 213, 216
ancestors, preeminence of, in Indonesia, 4, 19, 22–23
ancestor worship, 23
 in East Nusa Tenggara, 211
 in Maluku Tenggara, 4, 275, 276–79
 on Sumatra, 61, 81, 83, 87
 on Timor, 246
Angkola ethnic group, Sumatra, 61
animism, 18, 30–31
Ansberry, Louise Steinman, 14
architecture
 Nias, 44–46, 45
 Timorese, 245, 248
 Toraja, on Sulawesi, 21, 23, 24, 24, 27, 175–76, 176, 179, 186
 see also house of origin; spirit house
armor. *See* war jacket
art, non-Western indigenous (tribal), 17–18, 63
Art Museum League, Dallas Museum of Art, 11
Aru Islands, 16 (map), 276 (map)
aso (dragon-dog), 26, 120, 125
 as guardian figure, 130, 131, 132
Atauro, Timor-Leste, 245, 246 (map), 267
 art from, 266–71, 272
Atoni people, Timor, 245, 248, 255
 jewelry of, 249
 ritual spoons made by, 255, 255
 textiles used by, 247
Austronesian migration, 18–20, 20 (map), 43, 81, 117
 as influence, 21–22, 26, 83, 113, 283
Avé, J. B., 121, 123

B

Babar islands, 275, 276 (map), 287, 297
bag, betel nut (*kalimbut hada*), Sumba [cat. 72], ***222***–23, 335 (det.)
Bahau people, Kalimantan, 117
 guardian figure from, 116 (det.), 136, 137
 masks from, 144
Bahau Saa' people, Kalimantan, funerary posts by, 138, 139
Bali, 16 (map)
 Bronze Age drum from, 20–21, 20, 21, 25, 111, 139
 religion in, 210
Banda Islands, 276 (map), 299
Bantam, Sultanate of, 82, 83, 84, 91, 101, 102
Banten, West Java, 82
Barbier, Jean-Paul, 11
Barbier-Mueller, J. Gabriel, 11
Barbier-Mueller family, 12
Barbier-Mueller Museum, Geneva, 11, 12, 13
Barbosa, Duarte, 253
barkcloth, 18, 18, 21, 119
Batak or Toba Batak (Northern Sumatra), 61, 62 (map)
 art of, 11, 12, 27, 61–80
batik (wax-resist) technique, 99, 107, 178, 197, 198
Batu Islands, 43, 44 (map)
beads
 for jewelry, 185, 198, 249, 251, 267, 296–97
 prehistoric, 209
 quartz and opal rock (*mutisalah*), 249, 251, 267
 as symbolic, 89, 117, 118, 178
beadwork, 123
 on Flores, 240, 241, 242, 243
 Kalimantan, 119, 126, 140, 140, 148, 148 (det.)
 in Lampung, 86, 88
 on Sumba, 215, 223, 227, 335 (det.)
 Timorese, 246, 247, 249, 253
Beatty, Andrew, 46
Beaux Arts Ball (*Shadows of Gold*), Dallas Museum of Art, 13
bejalai (Dayak journey of self-discovery), 121
Belu, East Timor, carvings from, 264–65
Bernet Kempers, A. J., 111
betel nut chewing, accoutrements for, 11, 222–23, 252, 253, 335 (det.)
Bidayuh people, Borneo, 126
bird(s)
 carved, as "toys for the souls" (*umat simagere*), 30, 32
 omen, 96, 153, 164, 171, 219
 as textile motif, 160, 163, 168
 Sumatran symbolism of, 71
blanket, ritual. *See* cloth, Iban ceremonial
boat, symbolism of, 21, 25, 86–91, 111, 114
 in Maluku Tenggara, 275–77, 281
 see also ship cloths
Bock, Carl, 135
Borneo, 19, 21, 117
 deforestation of, 121–22, 123
 maps, 16, 118
 trade goods as heirlooms in, 117, 118

Borobudur temple, Java, 18, 19 (det.), 102, 210
bracelet (*komba lola'*), Sa'dan Toraja, Sulawesi [cat. 56], 13, ***184***–85, 185
brass casting, 71
Brenner-Felsach, Joachim von, 51
Brettell, Richard R. ("Rick"), 13
bride price, 26–27
 on Alor, 20
 in Lampung, 63
 in Maluku Tenggara, 281, 289, 294
 Mentawaian, 36
 on Sumatra, 83
 on Tanimbar, 281, 289
 on Timor, 251
British Museum, London, 154
bronze
 artifacts, from China, 25
 figures, from Borneo, 142, 142, 143
Bronze Age
 culture, 93
 drums, 21, 109, 109, 111, 139
 ritual vessel, 109, 109
Brunei, Sultanate of, 117, 118
 art from, 11, 142
Buddhism, 18, 19, 102, 106, 210
 see also Hindu-Buddhism
buffalo, water
 as measure of wealth, 178, 185, 189, 205, 206, 234
 symbolism of, 84, 90, 105, 186
buffalo head and cosmic tree, as symbol, 24, 24, 41
buffalo horn
 for ceremonial spoons, 255
 as medium, 62, 72, 75, 247, 249, 270
 as trophy, 84, 90
Bugis people, Sulawesi, 173, 174, 174 (map), 176, 177, 185, 201, 206, 299
burial site, prehistoric, 209
Buru, 16 (map), 276 (map)

C

cannibalism, alleged, 43, 61
China
 bronzes from, 25
 ceramics from, 26, 93, 119, 209, 293
 migration from, 18–19, 209, 210
Chou Ju Kua, 142
Christianity
 conversion to, 18, 41, 210
 in East Nusa Tenggara, 209, 210, 211
 in Maluku Tenggara, 275, 283, 302
 on Nias, 43–44, 51
 on Sulawesi, 23, 174–75, 176
 on Sumatra, 61, 65, 82, 87
 on Sumba, 211
 on Timor, 246, 247, 267
cist tomb, 25, 93

clan, emblem for
 Maluku Tenggara, 278, 278, 301
 Tanimbar (faniak), 277, 279, 290, 299
Clossey, Jeanne Marie, 13
cloth
 Batak, ulos, 27
 blue-ship–style. See cloth, Lampung, ceremonial
 Iban
 pua kumbu
 [cat. 45], **152**–53, 155 (dets.)
 [cat. 46], **156**–57
 [cat. 47], 158–**59**
 [cat. 48], 160–**61**
 [cat. 49], **162**–63
 pua sungkit
 [cat. 51], 26, **166**–68
 [cat. 52], 26, 167–71, **169**, 170 (det.), 171 (det.)
 Lampung
 ceremonial, blue-ship style, 104
 palepai, 25, 85, 86, 88–89, 90–91
 [cat. 24], 25, 80 (det.), 85, 91, 104–5, **104**–**5**
 tampan, 12, 12, 84, 85, 86, 89, 91
 [cat. 18], 25, **92**–93
 [cat. 19], **94**–95, 96
 [cat. 20], 96–**97**
 [cat. 21], **98**–99
 [cat. 22], **100**–101
 [cat. 23], 102–**3**
 tampan darat, 93, 112
 tampan jung galuh (great junk cloths), 91
 tampan maju, 86, 86, 88–89, 90
 tampan pasisir, 93, 112
 tampan penedung, 93
 tatibin, 86, 91
 Maluku Tenggaran, shoulder, 281 (det.)
 narrative
 Indian-style, 177
 Sumba, 233
 red-ship–style. See Kalianda
 Sumba, man's ceremonial (hinggi), 227, 228
 [cat. 75], 228–**29**, 233
 [cat. 76], 208 (det.), 228, 230–**31**, 233
 [cat. 77], **232**–33
 Timorese man's (selimut), 247
 Toraja sacred
 mawa', 177, 178
 [cat. 58], 101, 177–78, 188 (det.), 189, **189**
 [cat. 59], 101, 172 (det.), 177–78, 189, 190–**91**, 190 (det.)
 [cat. 60], 192, 193 (det.), 194
 [cat. 61], 101, 177–78, 194–**95**
 sarita, 178
 [cat. 62], 101, 177–78, 196 (det.), 197, **197**, 197 (det.)
 [cat. 63], 21, 198, **199** (dets.)
 see also barkcloth; shroud; skirt; textiles
clothing, for figures, 23, 67, 268
coins, Western, for decoration, 126, 148, 149, 249, 297
colors
 blue, for death, 153
 Toraja symbolism and, 175, 181
 see also dye
comb
 Sumba (hai kara jangga) [cat. 71], 220 (det.), 221, **221**
 Tanimbar (suar silai) [cat. 98], 279, 290–**91**
container
 carved bamboo, Kalimantan, 96, 119
 eastern Indonesian, 21–22
 medicine, Batak (naga morsarang), 62, 64
 Ono Niha (bari), 53, 53
 Timorese carved, 247
 ceremonial, for lime (ahumama) [cat. 83], **252**–53
 Toraja wooden (lado-lado), 202
Cook, Grace, 15
copper, jewelry of, 182–83
coppersmiths, on Sulawesi, 183
cosmology, Indonesian, 23–26, 81, 99, 106
 Dayak, 117–19
 Iban, 119
 in Maluku Tenggara, 279–80
 Nias and, 56, 59

Timorese, 246
 Toraja, 175, 181
Council of the Museum of Modern Art, 11
craftsmanship, in Mentawai, 29–30
crest, emblematic, 129
cult, Batak
 funeral, 63
 mask, 73
cult objects, Batak, 62, 64
currency, ikat skirts as, 151, 176

D
dagger
 Mentawaian (pattei) [cat. 2], 27, 36–**37**
 Toraja (keri), 185
Dai people, China, 102
Damar, 275, 276 (map)
Darul Islam/Tentara Islam Indonesia (DI/TII), 201
Darwin, Charles, 117
datu (Batak priest-magician), 62, 63–64, 65, 68, 71
 accoutrements of, 68, 74, 75
 as carvers, 62, 64
 representation of, 70
Dayak people, Borneo, 26, 84, 117, 125
 art of, 119–20
 headhunter's ritual sword [cat. 31], 126, **126**, 127 (det.)
 mythology of, 117, 119, 119
 see also Ngaju Dayak
deforestation, on Borneo, 121–22, 123
dish, Kisar trophy (mas piring), 293, 293
 [cat. 99 and 100], **292**–93, 294
disk, Kisar ornamental (mas bulan) [cat. 101], 283, 293, 294–**95**, 328 (det.)
DI/TII. See Darul Islam/Tentara Islam Indonesia
dolmen, 234
 Dong Son culture, as influence, 20–22, 26 Indonesian drums dated to, 209
 in Sumatra, 81, 85, 111
 see also Bronze Age
door
 Kayan, carved, 13
 (baa betamen) [cat. 34], **132**–33
 Tetun (oromatan) [cat. 86], 14, 248, 258–**59**
 Toraja tomb, 205, 206, 207
dowry, Lampung ship cloths as, 89
Drabbe, Petrus, 290, 299
drum
 Alor, 14, 15, 20
 Bronze Age, 20–21, 20, 25, 109, 109, 111, 209
 "Moon of Bali," 21, 139
Duarte, Father Jorge, 267, 268
Dutch
 coins, silver, as decoration, 126, 148, 149, 249
 colonization by
 of Maluku Tenggara, 275
 of the Mentawai Islands, 29
 of Nias, 43
 of Sulawesi, 174
 of Sumatra, 61, 91
 of Sumba and Flores, 210, 228
 of Timor, 245
Dutch East India Company (VOC), 249, 297
Dutch Reformed Church Mission, 174
dye, sources of, for textiles, 34, 36, 247
 on Sumba, 228
 on Timor, 247, 261
 Toraja, 178, 194, 197, 198, 201

E
Earl, S. W., 272
ear ornament or pendant (mamuli), Sumba [cat. 68], 214–15, 215, 216
East Malaysia, 11, 117, 118 (map)
 see also Sabah; Sarawak
East Nusa Tenggara (Lesser Sunda Islands), 209, 210 (map)
 economics of, under colonialism, 210–11
 religion in, 209, 210, 211
East Timor. See Timor-Leste
Elbert, Johannes, 248

elephant, symbolism of, 84, 90, 99
Ernst, Max, 18
Estes, Bill, 14
Estes, Sally, 12, 14
Eugene and Margaret McDermott Art Fund, Inc., The, Dallas Museum of Art, 11, 13
Eugene McDermott Foundation, The, Dallas, 12, 13
exchange, ritual, in Maluku Tenggara, 280–81
exhibitions
 Art of the Archaic Indonesians (Dallas Museum of Art, 1982), 11, 12, 121
 Budaya Indonesia (Museum of the Royal Tropical Institute, Amsterdam, 1987–88), 33
 Power and Gold: Jewelry from Indonesia, Malaysia, and the Philippines (Dallas Museum of Art, 1987), 12
 Woven to Honor: Textiles from the Steven G. Alpert Collection (Dallas Museum of Art, 1987), 12, 13
Exposition Universelle (1889), 18

F
fakes, 27, 65, 213
feast
 funeral, Timorese, 255
 of merit. See owasa
 papadon complex and, 81, 83, 95
 porka, 284
fertility
 ancestor figures and, 46, 277, 279, 283, 301, 302
 artifacts as promoting, 19, 23, 26, 89, 250, 251, 281, 289, 301
 cosmology and, 26, 83, 85, 267, 270, 280
 headhunting and, 96, 119, 228
 imagery of, 189, 194, 197
 rituals and, 22–23, 26, 89, 175, 178, 189, 194, 197, 276, 284
 social status and, 19, 26, 89–91, 251
 symbols of, 27, 75, 85, 87, 88–89, 105, 112
festival, Iban (Borneo), 167, 167
Festival of Indonesia (1990–91), 13
figure(s)
 ancestor
 Atauro (itara) [cat. 92], 11, 23, 268, 268–**69**
 Batak (debata idup), 63, 64, 67, 69, 78
 Flores (ana deo) [cat. 80], 23, 212, 238–**39**
 Maluku Tenggara, 275, 277–79, 277, 279, 301
 Leti [cat. 95], 14, 23, **282**–83
 luli, 23, 278
 [cat. 105], 274 (det.), 301, 302–**3**
 Timorese (ai tos), 14, 248, 264
 [cat. 90], 264–**65**
 Toraja, 186
 ancestor or protective
 Ono Niha (adu), 43, 46–47, 50–51
 seated (adu siraha salawa) [cat. 6], 17, 23, **50**–51
 deity
 Atauro
 (Baku-Mau) [cat. 91], 23, **266**–67
 (Lebu Hmoru), 267, 267
 Maluku Tenggara (Lamiaha), 26, 280, 280
 funeral-post, Bahau Saa' people, Kalimantan [cat. 37], 2 (det.), **138**–39
 funerary Toraja (tau-tau), 23, 27, 176
 [cat. 66], 11, 23, 176, **204**–5, 206
 granary guardian (charm, agom), Iban [cat. 41], **146**–47
 guardian
 Bahau (tepatung) [cat. 36], 13, 21, 22, 116 (det.), 136–**37**
 Kayan, 121
 [cat. 33], 13, 26, 120, 130–**31**
 guardian sentinel, Batak [cat. 11], **66**–67, 69
 house façade, Mamasa Toraja, 14, 21
 [cat. 57], 23, 24–25, 175, 186–**87**
 ornamental, on Nias, 56–57
 prehistoric bronze, 142, 142
 protective, Batak (pagar), 62, 64–65, 67, 68
 [cat. 12], 12, 69, **69**
 [cat. 16], 14, 60, 69, **76**–77, 78
 [cat. 17], 60, 69, 77, 78–**79**
 protective charm, Atauro [cat. 93], 170–**71**
 shrine object, Kalimantan [cat. 39], 26, 142–**43**
 tutelary, Modang [cat. 35], **134**–35

Fine Arts Museums of San Francisco
 Batak figure in, 68, 69
 Toraja figure in, 186, 187
Flores, 16 (map), 209, 210 (map), 211–12
 art of, 212
 social organization in, 211
 textiles woven in, 212, 241–42
Forbes, Henry, 81, 248, 294
Fowler Museum of Cultural History, Los Angeles, 154
Freeman, Derek, 120
funeral
 Sulawesi rites for, 183, 186
 Sumatran ceremony, 90, 93, 95
 Sumba, 211, 230
 Toraja, 174, 175, 181, 205
 see also cult

G
Galvao, Antonio, A Treatise on the Moluccas (c. 1544), 272
garuda (mythical bird), symbolism of, in Sumatra, 84–85, 86, 89, 90
Gates, Jay, 13
Gauguin, Paul, Orana Maria (Hail Mary), 18, 19
Germany, Batak aesthetic and, 63–64
Gittinger, Mattiebelle, 102, 104–5, 106, 112, 168
gold
 jewelry, 43
 Maluku Tenggara, 277, 280–81, 289, 292–301
 Nias, 44, 54
 Sulawesi, 177, 185
 Sumba, 215, 219
 Timor, 249, 251
 thread, for ceremonial skirt, 114, 115, 262
goldsmiths
 Bugis, on Sulawesi, 185
 in Maluku Tenggara, 275, 293, 297, 299
grave marker. See memorial stone
Grijzen, H. J., 250
Guerreiro, Antonio, 133, 142

H
Haj (pilgrimage to Mecca), 83
Halmahera, 16 (map)
Hämmerle, Johannes, 43, 44
hanging, ceremonial. See shroud
head, carved Dayak, 136
headdress
 Batak, 69, 69, 70, 71, 75, 77
 Ono Niha, 51, 51
headdress ornament
 Kayanic peoples, Kalimantan [cat. 32], 26, **128**–29
 Luang, Maluku Tenggara (wutulai) [cat. 104], **300**–301
headhunting, 26
 on Borneo, 117, 121, 125, 126, 154, 158, 167–68
 armor for, 128, 129, 164, 165
 ceremonies for, 167–68
 and textile motifs, 153, 160, 160, 163, 164, 168
 Dutch prohibition against, 29, 33, 36, 43, 44, 247, 284
 in Lampung province, Sumatra, 81, 84, 87, 96
 in Maluku Tenggara, 276, 279, 290
 ritual and, 289
 trophies for, 281, 293, 294, 297, 299
 in Mentawai, 29, 31, 33, 34, 36, 39
 on Nias, 54, 95
 on Sulawesi, 175, 183
 on Sumba, 221, 228
 on Timor, 247, 251
head ornament
 Kulawi, Sulawesi (sanggori), 183
 [cat. 54], 10 (det.), **182** (det.), 183
 [cat. 55], 183, **183**
 Sumba (tabelo) [cat. 69], 216–**17**
headwrap, Atoni warrior's (pilu saluf), 247
heirlooms
 jewelry as, 294, 297, 301
 sacred (pusaka), 61–62, 211, 247, 297
 textiles as, 154, 173, 177, 201, 241, 247
 weapons as, 248, 289
helmet, emblem for Dayak, 128, 129
Heppell, Michael, 120, 151, 163, 167

Hinako Islands, 43
Hindu-Buddhism, on Sumatra, 82–83, 84, 85, 86, 93, 210
Hinduism, 18, 210
Hooper, James, 272
Hooper, Stephen, 272
hornbill
 as motif, 71, 96, 112
 symbolism of, 84, 85, 89, 90
horse, symbolism of, 98, 99
horses, on Sumba, 212, 215, 216
house
 boat symbolism and, 275–76
 ceremonial. See temple, sacrificial
house of origin, 248, 278
Hudson, Sarah Dorsey, 12

I
Iban people, Sarawak, 117, 118, 118 (map), 120–21, 120, 126
 art of, 120
 granary charm (agom), 146, 147
 kettle from, 142, 142
 mask from, 144, 144, 145
 ritual invoked by, 123
 shield type used by, 125
 textiles made by, 120
iconoclasm, missionaries and, 43, 51, 275
iconography
 of ancestor figures, 47
 Batak, 75
 Dayak, 125, 126, 129, 148, 151, 155 (dets.)
 Dong Son, 21
 Iban, of ceremonial cloths, 119, 153
 of Lampung ship cloths, 86, 104–5, 111
 Maluku Tenggara, 278, 279, 302
 Timorese, 246, 247
 Toraja, Sulawesi, 175
ikat
 ceremonial cloth and, 26, 109, 111, 151, 167, 178
 double, Indian patola, 111, 177, 210, 227, 230
 Flores, 241
 Lesser Sunda Islands, 27, 226 (det.), 277–33
 in Maluku Tenggara, 281, 281
 patterning on, 21
 Sumba, 211
 Timorese, 246
 Toraja, 173, 201
India
 as influence, 93, 111, 168, 190, 192, 210, 227, 230, 297
 textiles from, 176–77, 178
 palampore (chintz), 111, 177
 patola (double-ikat silk), 111, 177, 210, 227, 230
 see also Hindu-Buddhism
Indiana University Museum, Bloomington, 267
Indonesia, 209
 artworks from, 11, 17–18, 213
 cultures of (overview), 18–22
 independence for, 18, 29
Indonesian Community Association, Dallas, 13
Ingan, Wellem, 123, 133
Islam, 18, 43, 61, 209, 210, 212
 in Maluku Tenggara, 275
 on Sulawesi, 174, 201
 on Sumatra, 61, 82, 83, 84, 91, 96, 102, 114
ivory, figures of, 271–73

J
jacket
 Iban headhunter's (baju kirai) [cat. 50], **164**, 164–**65**
 Maloh ceremonial (sape buri) [cat. 42], 148–**49**
Jacks, Mr. and Mrs. James H. W., 13
Jacobsen, J. A., 294
Japan, occupation of Sulawesi by, 174–75
jaraik (Mentawaian sacred carving) [cat. 4], 24, 28 (det.), 30, **40**–41, 41
Jaro, Timor-Leste, 245, 246 (map)
Java, 16 (map), 19
 art of, as influence, 84, 85, 86, 93, 99, 99, 101
 immigration from, to Sumatra, 81
 religion in, 19, 210

jewelry
 Batak, 63, 71
 on Flores, 212
 in Maluku Tenggara, 281, 281, 290–301
 from Sumba, 213, 215–21
 on Timor, 249, 251
 Toraja, 182–85
 trade in, 299
 see also copper; gold; regalia, state; silver
Johnson, Lady Bird, 12
Jonge, J. P. B. de Josselin de, 293

K
Kadobo, Cornelis, 219
Kai Islands, 275, 276 (map), 297
Kalianda, Sumatra, 102, 106
 red-ship–style cloths made in, 91, 104
 [cat. 23], 102–3
Kalimantan, 117, 118 (map), 123
 art from, 119, 140–41
Kalumpang, Sulawesi, art from, 201, 202
Kanatang, kings of, 230
Kantu' Mualang people, Borneo, 126
Karny, Heinrich Hugo, 34
Karo ethnic group, Sumatra, 61, 71
Kate, H. ten, 209
Kaudern, Walter, 183
Kayan (Kenyah) people, Borneo, 118 (map), 120, 121, 121
 door from, 132–33
 guardian figures from, 130, 131
 headdress ornament from, **128**–29
 masks by, 144
 shield from, 124–25, 130
Kendayan people, Borneo, 126
Kenyah people, Borneo. See Kayan people
kerei (shaman), 38–39
kettle, bronze Brunei, 142, 142
kettledrum. See drum
King, Margaret, 257, 264
Kisar, Raja of, 297
Kisar, Maluku Tenggara, 246 (map), 275, 276 (map), 277
 gold ornaments from, 292, 293–97, 295–96
 goldsmiths on, 293, 297, 299
Klemantan people, Sarawak, 125
knife hilt, Batak [cat. 13], **70**–71
Komodo dragons, 211
Krakatoa volcano, 81
Kruyt, Albert C., 183
Kulawi people, Sulawesi, art of, 182, 183

L
Lake Ranau, Sumatra, 81, 109
Lake Toba, Sumatra, 61, 63, 64
Lakor, 276 (map), 277
Lampung province (southern Sumatra)
 culture of, 81–82, 82 (map)
 immigration into, and economics, 81
 ship cloths of, 25, 80–105
Lane, Jack, 13
Lao Neua people, Thailand and Laos, 102
Lapita culture, Melanesia, 21–22, 22
Larat, 276 (map), 290
lasara (apotropaic animal), 26, 49, 58, 59, 59
leech, as motif, 126, 127
Lembata, 16 (map), 246 (map)
Lende Mbatu, 5, 237
leopard, tortoise-shell, 129
Leti, 16 (map), 246 (map), 275, 276 (map), 277
 ancestor figures from, 275, 277–78, 282, 283
 art from, 23, 280–87
 mouth mask from, 284–87
lid, with human hands [cat. 7], **52**–53
Linggi, Margaret, 160, 163, 168
Lombok, 11, 16 (map), 210 (map)
longhouse, 24
 Dayak, 117, 133, 147, 147
 Iban (ruai), 120, 144, 154
 Kayan, 133, 133
 Mentawaian. See uma
Luang, 275, 276 (map), 300, 301

Lumholtz, Carl, 142
Lunsford, John, 11, 12
Luwu' kingdom, Sulawesi, 173, 176, 177

M

macaque (*Macaca nemestrina pagensis; bokkoi*), 30, 40–41, 41
magician (pre-Christian). *See* shaman
Mahabharata epic, 99
Majapahit kingdom, East Java, 210, 219, 299
Makassar people, Sulawesi, 173, 174, 174 (map), 299
Malaysia. *See* East Malaysia
Maloh people, Kalimantan, 118 (map)
 ceremonial jacket from, 148, 149
Maluku Tenggara (Southeast Moluccas), 275–303
 art of, 275, 277, 277
 religion in, 275–80
 ritual in, 280–81, 284
 social organization in, 275–77, 301
 trade circuits in, 299
Mamasa Toraja, 173–74, 175, 202, 202
 art of, 24–25, 186
 see also Toraja
Mandailing ethnic group, Sumatra, 61
Mandeu, rajas of, 255
Manek, Mama Maria, 262
maps
 Alor, 246
 Atauro, 246
 Austronesian migrations, 20
 Batak (Northern Sumatra), 62
 Borneo, 118
 Brunei, 118
 East Malaysia, 118
 Flores, 16, 210
 Island Southeast Asia, 16
 Kalimantan, 118
 Lampung, Southern Sumatra, 82
 Lombok, 16, 210
 Maluku Tenggara (Southeast Moluccas), 276
 Mentawai Islands, 30
 Nias, 44
 Pagai (North and South), 30
 Sabah, 118
 Sarawak, 118
 Siberut, 30
 Sipora, 30
 Southeast Moluccas (Maluku Tenggara), 276
 Sulawesi, 174
 Sumba, 16, 210
 Sumbawa, 16, 210
 Timor, 210, 246
 see also individual islands
marga (Sumatran social group or its territory), 81, 82, 90
marriage, symbolism of, 19, 25–27, 86, 87–89
 in Maluku Tenggara, 276–77
 in Sumatra, 87–89, 87, 89–91
 in Timor, 251, 258
mask
 Batak, 73
 Iban (Sarawak) [cat. 40], 14, 144, 144–**45**
 Tetun ceremonial (*biola*) [cat. 85], **256**–57, 257
 see also mouth mask
mat, Lampung ceremonial (*lampit*), 86, 89
 [cat. 25], 101, 106–**7**, 112
Matisse, Henri, 17
Matsebu, 34
mausoleum
 Kalimantan, 119, 139
 Raja Dinda (Kalimantan), 135, 135
 roof-ridge panel from Dayak, 140, 141
 salong, Sarawak, 121
McDermott, Margaret (Mrs. Eugene McDermott), 11,
 12–13, 15, 15
Mecca, pilgrimage to, from Sumatra, 83
megaliths, 21, 23, 59, 84, 93, 176, 234
Melanesia. *See* Lapita culture
memorial stone (grave marker), Sumba
 penji, 209, 221, 234, 237
 penji reti
 [cat. 78], 14, 209, 234–**35**
 [cat. 79], 14, 209, 234, **236**–37

menhirs, 176, 234
Mentawai Islands, 16 (map), 17, 29–41, 30 (map)
 artifacts made in, 14, 30–33, 36
 drawing from, 32, 33
 social organization in, 22, 29, 33
Metal Age, 209
metalwork
 Dayak, 119–20, 142, 142, 143
 Sulawesi, 173
Metropolitan Museum of Art, New York, 109
Middelkoop, Pieter, 247, 248, 255, 258
Miró, Joán, 18
missionaries, effect of, on cultural heritage, 27, 29, 43–44,
 51, 61–62, 275, 284, 289, 302
Modang people, Kalimantan, 117, 118
 figure from, 134, 135, 135
modernization, forced, 29, 123
Moluccas, Southeast. *See* Maluku Tenggara
monuments, stone, 43, 46, 56, 234
motifs
 hands as, 34, 53
 heart-shaped face, 20, 21, 23, 128, 129, 138, 139
 spiral, 21, 30, 34
 see also iconography; ship cloths; tattoos
mouth mask, Maluku Tenggara, 287
 Leti [cat. 96], 14, 26, 284–87, **285**, 286
Muja Menua miring (Iban ritual), 123
Müller-Wismar, Wilhelm, 284, 294
Munch, Edvard, *The Scream*, 11, 205
Murut people, Sarawak, 125
Musée du quai Branly, Paris, 258
Museum der Kulturen (Museum of Cultures), Basel, 41
Museum für Völkerkunde, Berlin, 294
Museum League Purchase Fund, Dallas Museum of Art,
 13
Museum Nasional Indonesia, Jakarta, 294
Museum Pusaka Nias, 44
Museum Volkenkunde, Leiden, 248, 257, 258
music, Iban, 120
Muzakkar, Kahar, 201
mythology, 19
 Batak, 61, 71, 75
 Dayak, 117–19, 119
 on Flores, 238
 Iban, 126
 in Lampung province, Sumatra, 83, 96
 in Maluku Tenggara, 279–80
 Timorese, 250
 Toraja, 176, 192

N

Nabau Tutong, 123
naga (dragonlike serpent), on Borneo, 4–85, 112, 148, 168
Nage people, Flores, 238
Nalanda monastery, India, 102
Nasher, Patsy, 12, 14
Nasher Foundation, Dallas, 14
Nasher Sculpture Center, Dallas, 14
National Gallery of Australia, Canberra, 109
National Museum, Jakarta, 109
National Museum of Ethnology. *See* Museum Volken-
 kunde, Leiden
necklace
 (*kalabubu*) [cat. 8], 46, 54–**55**, 59
 (*nifatali-tali*), 54
 Kisar, with pendants [cat. 102], 293, 294, **296**–97, 297
 Timorese trade bead (*mutisalah*), 249, 251, 267
Neolithic period, 209
New Guinea (Papua), 16 (map), 20, 209, 276 (map)
 barkcloth from, 18, 18, 21
Ngadha people (Flores), 211
 textiles by, 212, 241–43
Ngaju Dayak, Borneo, 96, 117, 118, 118 (map), 121, 144
 see also Dayak
Nias, 16 (map), 43–60, 95
 architecture of, 44–46, 44
 cosmology and, 56, 59
 figural sculpture on, 23, 46–47, 56–57
 jewelry from, 54–55
 regions of, 44–46, 44 (map)
 stonework on, 43, 46, 58–59, 59

sword from, 42 (det.), 48–49, 48–49
utensils from, 53, 53
see also Ono Niha 53, 53
Nieuwenkamp, W. O. J., 237, 237
Niewenhuis, A. W., 133, 140
Noll (a missionary), 46
Nooy-Palm, Hetty, 192

O

Ono Niha
 art of, 43–60
 class structure among, 43, 44, 46, 47, 51, 51, 54, 59
 see also Nias
owasa (Ono Niha feast of merit), 43, 44, 46, 53, 59, 95

P

Pagai (North and South), 30 (map), 36
Pakpak/Dairi ethnic group, Sumatra, 61
Paminggir people, Sumatra, 81, 82–83, 82 (map), 84
 ceremonial mat produced by, 106–7
 sarong produced by, 109–13
 ship cloths produced by, 86, 89, 91–97, 100–105
panel, architectural, from Kalimantan [cat. 38], 23, 140–**41**
Pantar, 246 (map)
papadon complex in Sumatra, 83–85, 88, 89–91
 throne in, 83–84, 85, 90
Papua. *See* New Guinea
Parker, Harry S., III, 11
Pasisir people, Sumatra, *tampan* from [cat. 21], 98–99
patina, effect of, 63–64, 72, 75, 77, 78
patola (Indian export textiles), 111, 168, 177, 210, 227, 230
peacock, 85, 89
pectoral plates, gold Timorese, 249, 251
Penan people, Borneo, 117
pendant
 Sumba ceremonial (*mendaka*) [cat. 70], 14, 14, **218**–19
 Tanimbar, chest
 mase, 299, 299
 mas tanduk [cat. 103], 293, 294, **298**–99
penji. *See* memorial stone
pepper trade, Sumatra, 81, 82, 88, 101, 102
Picasso, Pablo, 17
Pigafetta, Antonio, 142
Pitman, Bonnie, 13, 15
Portuguese, influence, on Timor, 245
post, funerary
 double-trunk, 139, 139
 figure from Kalimantan (*jihe*), 138, 139
praise-names, for ritual cloths, 153, 154, 163
priest (pre-Christian). *See* shaman
proa (boat), Maluku Tenggara, 275, 277
 as symbol, 275, 278, 281, 290
proportions, figural, in Batak art, 63, 65, 67, 71
Pubian people, Sumatra, 81, 82–83, 82 (map), 84
 ship cloths produced by, 86
pyrography, on woven mat, 106, 107

R

Rahardja, Diane and Andyan, 14
Raja Dinda, mausoleum of (Kalimantan), 135, 135
Ramayana epic, depicted on cloth, 177
rata (carriage), Sumatran symbolic, 84, 88–89, 90, 95
Rautenstrauch-Joest-Museum, Cologne, 284
Ray, Man, *La lune se lève sur l'île de Nias* (*The moon rising over
 the island of Nias*), 17
regalia, state, Timorese sacred, 250
Rejang River, Sarawak, 125
religion
 indigenous, on Flores, 212
 and indigenous art, 17–18
 on Sumba, 211
 on Timor, 245–46
representationalism, among the Mentawaians, 30–32
Rhenish Missionary Society, 43, 51
rice cycle, Borneo, 126, 147
Richards, Anthony J. N., 151
Richman, Rita and Fred M., 11
Riedel, J. G. F., 284, 287
Rijksmuseum voor Volkenkunde. *See* Museum Volken-
 kunde, Leiden
Rinnooy, N., 302

Rites of the East, Toraja, Sulawesi, 175, 176, 177, 178, 181, 185, 189, 194, 197, 198
Rites of the West, Toraja, Sulawesi, 175, 181
Robbins, Carol, 12, 13
Rodenwaldt, Ernst, 297
Rodgers, Susan, 183, 219
Roman Catholic Church, 43
Royal Tropical Institute, Amsterdam, 33
Rumphius, Georg Eberhard, 290, 293

S
Sabah, 117, 118 (map)
sacrifice, human, 112, 139, 140, 148
Sa'dan Toraja, 173, 186, 189
 art of, 181, 185, 190, 192, 194, 197, 198, 205, 207, 234
 see also Toraja
Sakuddei clan, Mentawai, 29, 32, 33, 41
sandalwood, 252, 253
 trade in, 210, 245, 249
Sano, Emily, 13
Sarasin brothers, 183
Sarawak, 117, 118 (map), 121
 art from, 11
 textiles from, 12, 150–51, 150
Sarawak Museum, Kuching, 126
sarcophagus, Batak stone, 63
sarong
 Javanese, 99
 Lampung (tapis), 25, 86, 110–15
 Timorese, 247, 260–63
 Toraja, 198
 see also skirt
Satepu clan, Mentawai, jaraik of, 41, 41
Savu, 16 (map), 233
Schefold, Reimar, 14
 Speelgoed voor de zielen: Kunst en cultur van de Mentawai-eilanden, 41
Schnitger, F. M., 95
Schulte Nordholt, H. G., 249
sculpture
 ancestor figures (adu), 43, 46–47
 architectural, monkey (ba'e) [cat. 9], 56, 56–57
 Batak, 234
 Dayak consecrated, 120
 figurative, on Flores, 212
 Sumba grave markers, 234–37
 see also figure(s)
seat, Ono Niha commemorative stone (osa-osa si sara mbagi) [cat. 10], 14, 23, 26, 46, 58–59, 59
Sendi Ketit, 160
sengkaran (mortuary pole), 118–19, 119
Seram, 16 (map), 276 (map)
Seran, Alfonsius, 258
Sermata, 246 (map), 275, 276 (map), 293
shaman (priest-magician)
 Batak. See datu
 Mentawaian. See kerei
Shan people, Burma, 102
shells, on Maloh ceremonial clothing, 148, 148, 149
shield
 Kayan (Sarawak) ceremonial (kelbit) [cat. 30], 26, 124–25, 130
 Mentawaian, koraibi [cat. 1], 30, 34–35, 36
 Toraja ceremonial (balulang) [cat. 53], 14, 174, 180–81, 181
ship, as motif, on Flores, 241
 see also ship cloths
ship cloths, Lampung, 25, 85–86
 boat symbolism of, 85, 86–91, 104
 examples of [cat. 18–24], 92–105
shroud (or ceremonial hanging), Toraja
 Papori to Noling [cat. 64], 21, 178, 200–201
 sekomandi [cat. 65], 21, 178, 202–3
Siberut, 29, 30 (map)
 dagger from, 36–37
 jaraik from, 24, 28 (det.), 30, 40–41, 41
 shield from, 34–35
 wall panel from, 38–39, 39
Sikka people, Flores, beadwork by, 242
silver, for jewelry, 63, 71, 185, 249, 262

silversmiths
 Maloh people as, Kalimantan, 148
 on Timor, 249
Simalungun ethnic group, Sumatra, 61, 72
singa (mythological animal), 11, 12, 26, 93
Sipora, 30 (map), 36
Sisingamangaraja XII, Batak priest-king, 77
skirt
 ceremonial
 Lampung
 kain inu [cat. 26], 13, 108–9
 tapis
 [cat. 27], 25, 110–11, 110 (det.), 111
 [cat. 28], 112–13
 [cat. 29], 114–15
 tapis raja medali, 114
 Maloh (kain manik), 148 (det.)
 Flores woman's (lawo butu), 241, 241, 242
 [cat. 81], 212, 240–41
 [cat. 82], 212, 242–43
 Iban ceremonial (kain kebat)
 [cat. 43], 150–51, 150
 [cat. 44], 150, 150, 151
 Sumba woman's (lau pahudu), 227
 [cat. 73], 224–25
 [cat. 74], 226 (det.), 227, 227
 Tetun woman's (tais feto)
 [cat. 87], 260 (det.), 261, 262
 [cat. 88], 244 (det.), 261, 262, 262
 [cat. 89], 261, 262, 263
skull
 deer, painted, 32
 macaque, as jaraik, 24, 28 (det.), 30, 40–41, 41
skull-tree, as textile motif, Sumba, 221, 228, 228, 229, 304 (det.)
slavery, 43, 211, 302
songs, Sumatran love, 87–88, 89
spice, trade in, 176–77, 210, 272
spirit, protective, with heart-shaped face, 128, 129, 138, 139
spirit house, Flores, 238
spoon, ceremonial
 East Indonesian [cat. 94], 272–73, 272 (det.)
 Tetun (nura dikun) [cat. 84], 14, 254–55
 Timorese, 247
Srivijaya kingdom, Sumatra, 82, 84, 102
staff, Batak ritual
 (tongkat malehat), 64, 71, 75
 (tunggal panaluan), 62–63, 64, 68
 [cat. 15], 74–75, 77
Stanoff, Saul, 13
status
 bride price and, 63
 social, on Sumatra, 81, 83, 87, 88–91, 90, 104, 106
Steinmann, A., 95
Steven G. Alpert Collection of Indonesian Textiles, 12
Suharto, president of Indonesia, 18
Sukarno, president of Indonesia, 18, 29, 123
Sulawesi, 16 (map), 173–78, 174 (map)
 coffee on, 178, 183
 textiles from, 12
 see also Toraja
Sumatra, 16 (map), 19, 210
 Northern (Batak), 62 (map)
 guardian sentinel figure from [cat. 11], 66–67
 knife hilt from [cat. 13], 70–71
 protective figures from, 13, 68
 [cats. 12, 16, 17], 68–69, 76–79
 ritual staff from [cat. 15], 74–75
 sword from [cat. 14], 72–73, 72–73
 see also Batak
 Southern, 82 (map)
 see also Lampung province
 textiles from, 12, 21, 25, 80–105, 109–15
Sumba, 16 (map), 209, 210 (map), 211
 jewelry in, 211, 215–21
 social organization in, 211
 textiles of, 12, 211, 224–33
 tombs in, 211, 211
Sumbawa, 16 (map), 210 (map)
Sunda Islands, Lesser. See East Nusa Tenggara; Timor

Sundermann, H., 95
sword
 Batak (piso halasan), 71
 with Janus-faced hilt [cat. 14], 72–73, 72–73
 Dayak, 120
 headhunter's ritual [cat. 31], 126, 126, 127 (det.)
 Ono Niha (telögu) in sheath [cat. 5], 42 (det.), 48–49, 48–49
 Tanimbar (krai silai) [cat. 97], 279, 281, 288–89
syncretism, in Sumatra, 83, 102

T
table, ceremonial Kayan, 130
T'ai peoples, 93, 102
Tananggoendjoe, Windi, Raja of Pau, 224, 224
Tanimbar, 16 (map), 275, 276 (map), 281, 289, 297
 comb from, 279, 290, 291
 jewelry from, 294, 298, 299, 299
 sword from, 279, 281, 288–89, 289
tapis. See skirt, ceremonial Lampung
tattoos, 20, 27
 Dayak, 119, 121, 123
 motifs for, Mentawaian, 30, 32, 34, 39
tau-tau. See figure(s), funerary Toraja
Tedong anak Barieng, 122
temple, sacrificial (uma lulik), on Timor, 248, 250, 257
Tetun peoples, Timor, 245, 247, 248, 261
 carvings by, 248, 252–55, 258–59
 mask from, 256–57
 textiles by, 244 (det.), 260–63
textiles
 beadwork on, 86, 86, 88, 227, 241, 242, 247
 as currency, 151, 176
 Flores, 212, 240, 241–42, 243
 Iban, 120, 150–71
 Indian, on Sulawesi, 176–78
 in Maluku Tenggara, 281
 sacred. See cloth
 on Sumba, 11, 211, 224–33
 symbolism in, 26–27
 Timorese, 246–47, 251
 Toraja, 173, 177–78, 196–202
 trade in, 210
 traditional, 27
Threads of Life (fair trade organization), Sulawesi, 102
tiger, as mythical, in Borneo, 133
Timor, 209, 210 (map), 245–46, 246 (map)
 art of, 246–48
 princedoms of, 249–50
 social organization on, 245, 250–51
Timor Barat (West Timor), 245, 246 (map)
Timor-Leste (East Timor), 245, 246 (map)
 art from, 11
Toba Batak. See Batak
tomb
 rock-cut Toraja (Sulawesi), 176, 205, 205
 door to (tutu'liang) [cat. 67], 11, 21, 176, 206–7
 stone, Sumba, 209, 211, 211, 234
 see also cist tomb
tooth
 dugong, amulet of, 270, 271
 tiger, as ornamentation, 42, 48, 49
Toraja people, Sulawesi, 173, 174–78, 174 (map)
 architecture of, 21, 23, 24, 24, 27, 175–76, 176, 179
 carvings from, 186, 187, 204, 205–6, 207, 234
 jewelry from, 182–85
 religion of, 174–75
 ritual among. See Rites of the East; Rites of the West
 shield, 180–81, 181
 social organization of, 175–76
 textiles of, 173, 177, 178, 189–203
 see also Mamasa Toraja; Sa'dan Toraja
totemism, 246, 248, 279
trade, Bronze Age, 20
tree, cosmic, 24, 41
 Dayak (sanggaran), 117–18, 123
 Toraja (bate), 178, 197
Tropenmuseum, Amsterdam, 105, 284
Tursch, Bernard M., 14
turtle shell, comb of, 220, 221
Tycher, Judy, 11–12

U

uma (Mentawaian longhouse), 29, 31, 31, 32, 39, 41, 41
umat simagere (toys for the souls), 27, 30–31, 32
Umbu Sangera, 219

V

Venable, Charles, 13
Vietnam, Dong Son culture in, 20
Vishnu, 84–85
Vlaminck, Maurice de, 17
VOC. *See* Dutch East India Company
Vroklage, B. A. G., 246, 248, 249

W

Wallace, Alfred Russell, 173
wall panel, with relief figure
 Asumanu, 249
 Mentawaian (*tulangan sirimanua*) [cat. 3], 26, **38**–39, 39
 Tetun, 258
war jacket (Dayak headhunter's armor), 126, 129, 164, 165
warriors
 Dayak, 125
 East Sumba, 212
 Mentawaian, 36
 South Nias, 46, 49
 Timorese, 250
 Toraja, 181
water buffalo. *See* buffalo
weapons
 included in bride price, 27, 36, 251, 289, 294
 on Timor, 248, 249
weavers
 Iban, and status, 121, 153–54, 157, 167
 Maluku Tenggara, 288, 289
weaving
 in Indonesia, 209
 on Sumba, 227, 228
 on Timor, 247, 261
wedding, skirts for, 110–14
Wehali, princedom of, on Timor, 250, 251
Wehea Modang. *See* Modang people
Wetar, 16 (map), 246 (map), 276 (map)
 figure carving on, 248
White, Lely, 13
Wirz, Paul, 41

Y

Yellin, Elissa and Dr. Albert, 14
Yijing (I Tsing), 102

Z

Zimmerman, Father, 119

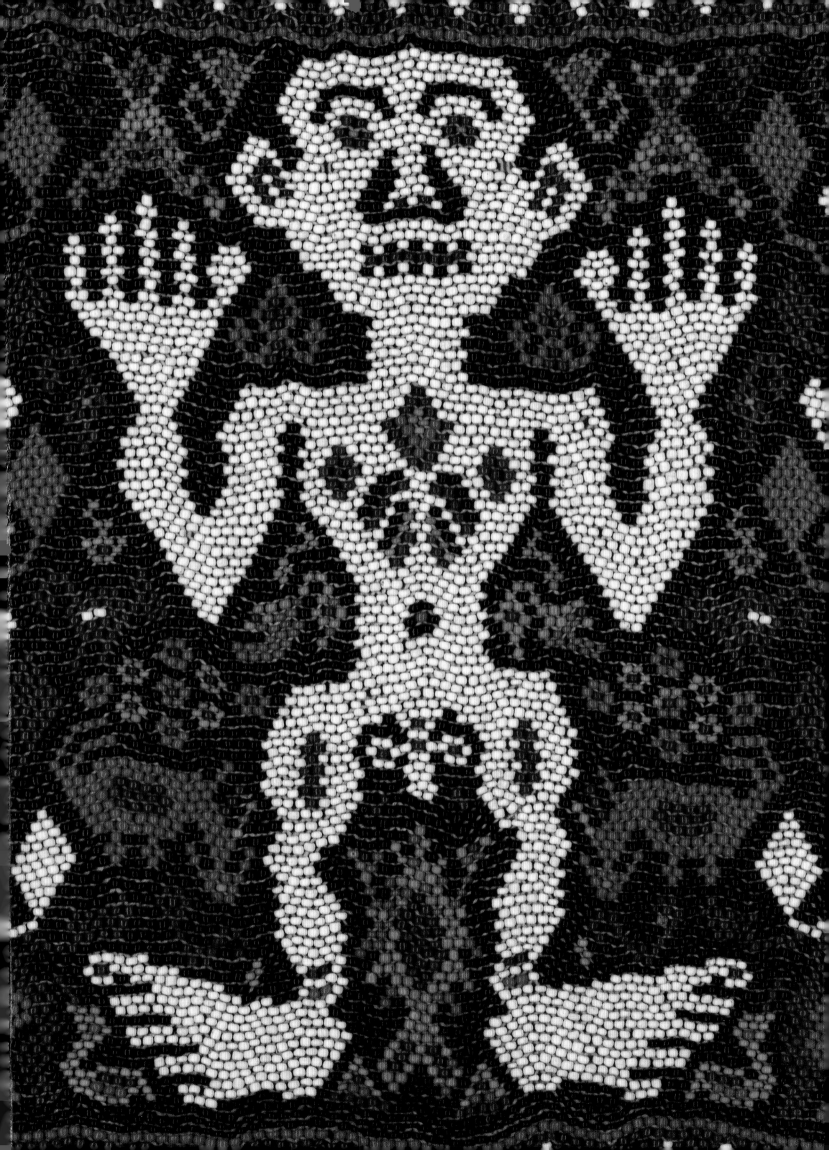

Published by Tuttle Publishing, an imprint of Periplus Editions (HK) Ltd
www.tuttlepublishing.com

Isbn 978-0-8048-4858-9

Distributed by

North America, Latin America & Europe
Tuttle Publishing
364 Innovation Drive, North Clarendon, VT 05759-9436 U.S.A.
Tel: 1 (802) 773-8930; Fax: 1 (802) 773-6993
info@tuttlepublishing.com; www.tuttlepublishing.com

Asia Pacific
Berkeley Books Pte. Ltd.
61 Tai Seng Avenue, #02-12, Singapore 534167
Tel: (65) 6280-1330; Fax: (65) 6280-6290
inquiries@periplus.com.sg; www.periplus.com

Publication of the original hardcover catalogue was generously underwritten by Steven G. Alpert and The Eugene McDermott Foundation.
Publication of the softcover edition was generously underwritten by Steven G. Alpert.

Dallas Museum of Art
Agustín Arteaga, The Eugene McDermott Director
Roslyn Walker, Senior Curator of the Arts of Africa, the Americas, and the Pacific and The Margaret McDermott Curator of African Art
Tamara Wootton Forsyth, Associate Director of Collections and Exhibitions, Exhibitions, and Facilities Management
Eric Zeidler, Publications Manager
Giselle Castro-Brightenburg, Imaging Manager

Principal photography by Brad Flowers
Edited by Kristina Youso
Proofread by Laura Iwasaki
Designed by Jeff Wincapaw and Ryan Polich
Typeset in Enigma and Fedra by Marie Weiler
Maps designed by Jeremy Linden
Indexed by Frances Bowles

18 17 16 10 9 8 7 6 5 4 3 2 1
Printed in China 1610RR